The Lure of Italy

American Artists and The Italian Experience, 1760 – 1914

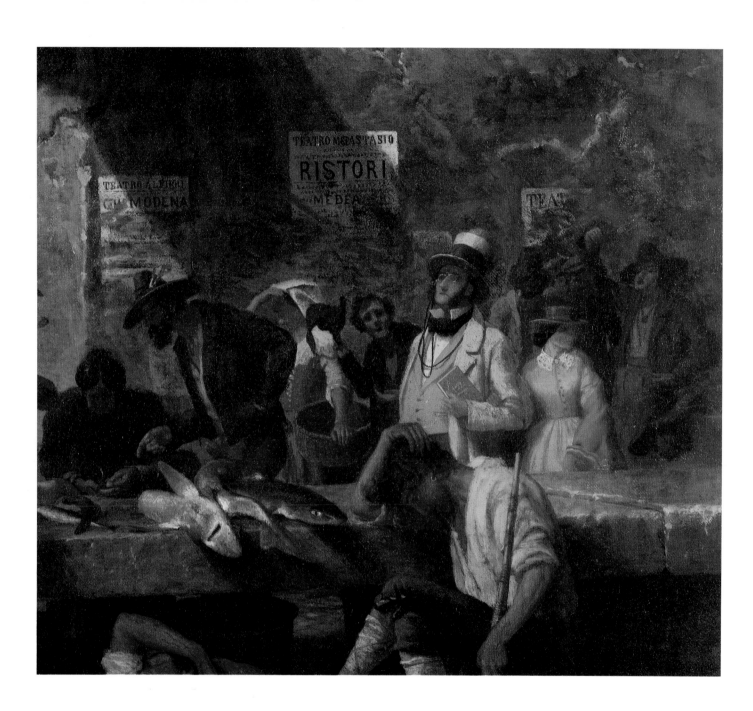

The Lure of Italy

American Artists and The Italian Experience

1760 – 1914

Theodore E. Stebbins, Jr.

with essays by William H. Gerdts, Erica E. Hirshler, Fred S. Licht, and William L. Vance

Museum of Fine Arts, Boston

in association with

Harry N. Abrams, Inc., Publishers, New York

This exhibition was organized by the Museum of Fine Arts, Boston. The exhibition and catalogue have been made possible in part by grants from the National Endowment for the Humanities and the National Endowment for the Arts, Federal agencies. Additional support has been provided by the Henry Luce Foundation, Inc., the family of Mrs. George Lewis, the Joseph Pellegrino Family Foundation, and members of the Sponsors Committee.

Copyright 1992 by the
MUSEUM OF FINE ARTS,
Boston, Massachusetts
Library of Congress Catalogue Card No.
92–54163
ISBN 0-87846-359-3 (paper)
ISBN 0-8109-3561-9 (cloth)

Printed in the U.S.A. by
Acme Printing Co., Wilmington,
Massachusetts.
Bound by Acme Bookbinding Co.,
Charlestown, Massachusetts.
Designed by Carl Zahn

Cover and jacket:
Detail of *The Fountain, Villa Torlonia, Frascati, Italy*
JOHN SINGER SARGENT (1856-1925)
The Art Institute of Chicago, Friends of American Art Collection
Back Cover:
Detail of *Gulf of Spezia*
HENRY RODERICK NEWMAN (1843-1917)
Museum of Fine Arts, Boston, Tompkins Collection
Frontispiece:
Detail of *The Arch of Octavius (Roman Fish Market)*
ALBERT BIERSTADT (1830-1902)
The Fine Arts Museums of San Francisco, Gift of Mr. and Mrs. John D. Rockefeller 3rd

Exhibition Dates:

MUSEUM OF FINE ARTS, BOSTON
September 16 – December 13, 1992

THE CLEVELAND MUSEUM OF ART
February 3 – April 11, 1993

MUSEUM OF FINE ARTS, HOUSTON
May 23 – August 8, 1993

Changes in exhibition (paintings and sculpture):

BOSTON ONLY:
cats. 5, 9, 10, 17, 32, 47, 50, 55, 72, 78, 80, 92, 93, 98, 108, 113, 122, 126

BOSTON AND CLEVELAND ONLY:
cats. 14, 15, 119

CLEVELAND AND HOUSTON ONLY:
cats. 8, 48, 49, 81, 85

HOUSTON ONLY:
cat. 130

In memory of

H. JOHN HEINZ III

(1938–1991)

Contents

Foreword, 8

Committees, 10

Lenders to the Exhibition, 11

Acknowledgments, 14

Introduction, 19

THEODORE E. STEBBINS, JR. American Painters and the Lure of Italy, 29

WILLIAM H. GERDTS Celebrities of the Grand Tour: The American Sculptors in
Florence and Rome', 66

WILLIAM L. VANCE Seeing Italy: The Realistic Rediscovery by Twain, Howells,
and James, 94

ERICA E. HIRSHLER "Gondola Days": American Painters in Venice', 112

FRED S. LICHT American Artists in Twentieth-Century Italy, 129

Catalogue of the Exhibition, 147

I Joining the Grand Tour, 149

II Dream of Arcadia, 171

III Americans in Rome', 189

IV Decline and Fall, 259

V Views Afoot, 281

VI Florence and Tuscany, 327

VII Renaissance Revival, 363

VIII Venetian Life', 385

IX Related Works, 437

Selected Bibliography, 452

Index, 455

Foreword

We are pleased to present "The Lure of Italy: American Artists and the Italian Experience, 1760-1914," the first comprehensive exhibition to survey this important subject. Numerous books, articles, and museum catalogues have studied various aspects of the attraction Italy held for the creative minds of America, beginning with the landmark exhibition, "Travelers in Arcadia: American Artists in Italy, 1830-1875," organized by the Detroit Institute of Arts and the Toledo Museum of Art in 1951; yet there has never been an attempt to survey the whole of this significant phenomenon. Our exhibition begins in the Eighteenth century with Benjamin West, the first colonial American artist in Italy, and it concludes on the eve of the First World War, which brought a sea-change to American attitudes, and marked the end of the general consensus that a trip to Italy was a virtual necessity for Northern artists. It includes many of the most compelling of the works of painting and sculpture made by Americans during or after their Italian sojourns, but it also throws a wide net, aiming to illustrate the diverse effects which Italy had on American art and American culture. Included here are the works of seventy-two American artists, ranging from Copley, Allston, Cole, and Hosmer, to Sargent, Whistler, and Prendergast, all among the best-known of our painters and sculptors. Yet introduced also is the work of lesser-known figures whose work adds to our understanding, including Elizabeth Boott Duveneck, Francesca Alexander, Julian Abele, and Hamilton Wilde, among others. Moreover, the exhibition contains a wide variety of material that illustrates the context in which the works of art were made, including sketchbooks and oil sketches, copies of European works, photographs, letters, guidebooks, maps, a group of the most important American novels and travel journals dealing with Italy, as well as a selection of the most intriguing souvenirs that the travelers brought home, from Italian fans, glassware, and jewelry, to the fragments of the Baths of Caracalla brought back by Henry Wadsworth Longfellow.

We are most indebted to the many public and private owners who have responded so kindly, lending the objects great and small that comprise our exhibition. For virtually every work in this exhibition, there was simply no alternative selection. We are gratified that nearly every loan request found a positive response, and we express heartfelt thanks to our museum colleagues and to the private collectors whose superb loans make possible this very special exhibition.

This project has received crucial and most generous support from the National Endowment for the Humanities. The research and publication of our beautiful and thorough catalogue has been made possible by The Henry Luce Foundation's Scholarship in American Art program to which we express — once again — our sincere thanks. We are also grateful for the excellent support for the exhibition received from the National Endowment for the Arts. In addition, we at the Museum of Fine Arts, Boston, are grateful for an extraordinary gift to the project from the family of Mrs. George Lewis, for gratifying support for our Symposium from the Pellegrino-

Realmuto Charitable Foundation, the Joseph Pellegrino Family Foundation, the Istituto della Enciclopedia Italiana and the Italian Cultural Institute, and for the generosity of the Sponsors Committee for the exhibition.

The exhibition has been organized by Theodore E. Stebbins, Jr., John Moors Cabot Curator of American Paintings, and Erica E. Hirshler, Assistant Curator of American Paintings, working together with their colleagues in the departments of paintings and of American decorative arts and sculpture at the Museum of Fine Arts, Boston. We owe special thanks to them, and to the other scholars whose essays form a notable part of this catalogue: Fred S. Licht, who helped to conceive the idea of this exhibition; William H. Gerdts and William L. Vance, who acted as consultants throughout the project. In addition, we express special thanks to Carl Zahn for his excellent design of this book and for overseeing its production, and to Cynthia Purvis for editing the volume so skillfully.

ALAN SHESTACK, *Director*
Museum of Fine Arts, Boston

EVAN H. TURNER, *Director*
Cleveland Museum of Art

PETER C. MARZIO, *Director*
Museum of Fine Arts, Houston

Committees

Organizing Committee

Jonathan L. Fairbanks

Jeannine Falino

William H. Gerdts

Karen Haas

Erica E. Hirshler

Eleanor L. Jones

Fred S. Licht

Karen E. Quinn

Susan Cragg Ricci

Theodore E. Stebbins, Jr.

Diana Strazdes

William L. Vance

Patricia Loiko,
Exhibition Registrar

Janet L. Comey,
Coordinator

Harriet Rome Pemstein,
Coordinator

Sponsors Committee
(as of July 15, 1992)

Mr. and Mrs. Arthur G. Altschul

Mr. and Mrs. O. Kelly Anderson

Mr. and Mrs. W. Russell G. Byers

Mr. and Mrs. Charles C. Cunningham, Jr.

Mr. and Mrs. Ronald Davenport

Mr. and Mrs. Barney A. Ebsworth

Charlene Engelhard

Mr. and Mrs. Thomas Mellon Evans

Mr. and Mrs. Stuart P. Feld

Mr. and Mrs. Jerald Dillon Fessenden

Mrs. Daniel Fraad

Mr. and Mrs. Ronald K. Greenberg

John Greenleaf

A. Lawrence Groo

Mr. and Mrs. Joseph A. Helman

Mr. and Mrs. J. Welles Henderson

Mr. and Mrs. Raymond J. Horowitz

Mr. and Mrs. George M. Kaufman

Mr. and Mrs. Edward Kilroy, Jr.

Mr. and Mrs. Arie L. Kopelman

Mr. and Mrs. William H. Lane

Mr. and Mrs. Thomas H. Lee

Mr. and Mrs. George Lewis

Mr. and Mrs. Peter S. Lynch

Mr. and Mrs. Frederick R. Mayer

Mrs. John C. Newington

The Olivetti Foundation

Gift in memory of Barbara N. Parker
 from her family

Mr. and Mrs. Joseph P. Pellegrino

Mr. and Mrs. E. Lee Perry

Nancy Ames Petersen

William Postar

The Honorable and Mrs. John D.
 Rockefeller IV

Robert M. Rosenberg

Arthur Ross Foundation

Mr. and Mrs. Thomas A. Rosse

Mr. and Mrs. John J.F. Sherrerd

Linda K. Smith and Victor E. Ferrall, Jr.

Mr. and Mrs. Peter J. Solomon

Dr. and Mrs. Richard F.X. Spagnuolo

Mr. and Mrs. James F. Stebbins

Mr. and Mrs. Norton Stevens

Jane S. Sykes

Peter Tillou

Mr. and Mrs. Gilbert P. Verbit

Mr. and Mrs. Robert C. Vose, Jr.

Dorothy C. Wallace

Mr. and Mrs. William Wilson III

Mr. and Mrs. R. Frederick Woolworth

Lenders to the Exhibition

ADDISON GALLERY OF AMERICAN ART

ALBANY INSTITUTE OF HISTORY AND ART

MR. AND MRS. ARTHUR G. ALTSCHUL

AMON CARTER MUSEUM

THE ANDALUSIA FOUNDATION

ARCHIVES OF AMERICAN ART, SMITHSONIAN INSTITUTION

THE ART INSTITUTE OF CHICAGO

JAMES BIDDLE

THE BOSTON ATHENAEUM

THE BOSTON PUBLIC LIBRARY

THE BROOKLYN MUSEUM

THE CARNEGIE MUSEUM OF ART

CINCINNATI ART MUSEUM

STERLING AND FRANCINE CLARK ART INSTITUTE

THE CLEVELAND MUSEUM OF ART

MRS. JOHN K. CONNEEN

ELAINE COOPER & COMPANY

COOPER-HEWITT, NATIONAL MUSEUM OF DESIGN, SMITHSONIAN INSTITUTION

THE CORCORAN GALLERY OF ART

THE CURRIER GALLERY OF ART

ELIZABETH DANA

THE DENVER ART MUSEUM

THE DETROIT INSTITUTE OF ARTS

H. RICHARD DIETRICH, JR.

DUVENECK FAMILY

THE ESSEX INSTITUTE

THE FINE ARTS MUSEUMS OF SAN FRANCISCO

FOGG ART MUSEUM, HARVARD UNIVERSITY ART MUSEUMS

COLLECTION OF RITA AND DANIEL FRAAD

JO ANN AND JULIAN GANZ, JR.

ISABELLA STEWART GARDNER MUSEUM

HARVARD UNIVERSITY PORTRAIT COLLECTION

HIRSHHORN MUSEUM AND SCULPTURE GARDEN, SMITHSONIAN INSTITUTION

MR. AND MRS. RAYMOND J. HOROWITZ

THE HOUGHTON LIBRARY, HARVARD UNIVERSITY

HENRY E. HUNTINGTON LIBRARY AND ART GALLERY

ALICE M. KAPLAN

KECK FAMILY

Los Angeles County Museum of Art

Lyndhurst: A Property of the National Trust for Historic Preservation

Massachusetts Historical Society

Mead Art Museum, Amherst College

The Metropolitan Museum of Art

Middleton Place Foundation

The Minneapolis Institute of Arts

Munson-Williams-Proctor Institute Museum of Art

Muscarelle Museum of Art; College of William and Mary

Museum of Art, Rhode Island School of Design

Museum of Fine Arts, Boston

Museum of Fine Arts, Springfield

National Gallery of Art

National Museum of American Art, Smithsonian Institution

New Britain Museum of American Art

The New-York Historical Society

The Newark Museum

Mrs. John C. Newington

The Newington-Cropsey Foundation

Old Saint Joseph's Church, Philadelphia

Peabody Museum of Salem

Pennsylvania Academy of the Fine Arts

Philadelphia Museum of Art

The Phillips Collection

Michael Rosenfeld Gallery

Mr. and Mrs. Thomas A. Rosse

Royal Academy of Arts

The Saint Louis Art Museum

Shaffer Library, Union College

Elma Shoemaker

The Stowe-Day Foundation

Daniel J. Terra Collection

Constance Fuller Threinen

Peter Tillou Fine Arts Gallery

Timken Art Gallery

The Toledo Museum of Art

Mark Twain Memorial

UNITED STATES DEPARTMENT OF THE INTERIOR, NATIONAL PARK SERVICE,
 LONGFELLOW NATIONAL HISTORIC SITE

UNITED STATES DEPARTMENT OF THE INTERIOR, NATIONAL PARK SERVICE,
 SAINT-GAUDENS NATIONAL HISTORIC SITE

UNIVERSITY ART MUSEUM, STATE UNIVERSITY OF NEW YORK AT BINGHAMTON

UTAH MUSEUM OF FINE ARTS, UNIVERSITY OF UTAH

THE VALENTINE MUSEUM

VASSAR COLLEGE ART GALLERY

WADSWORTH ATHENEUM

WASHINGTON UNIVERSITY GALLERY OF ART

WATERTOWN FREE PUBLIC LIBRARY

WELLESLEY COLLEGE LIBRARY

WELLESLEY COLLEGE MUSEUM

WICHITA ART MUSEUM

GRAHAM WILLIFORD

ERVING AND JOYCE WOLF

WORCESTER ART MUSEUM

YALE UNIVERSITY ART GALLERY

ANONYMOUS PRIVATE COLLECTORS

Acknowledgments

The organizers of this exhibition have received generous assistance from numerous colleagues in Boston and from all corners of the United States and Europe. We express our profound gratitude to the many people who have helped in the research and organization of this exhibition and its catalogue.

At the Museum of Fine Arts, Boston, we are especially grateful for the enthusiastic support of director Alan Shestack. Our efforts have been enhanced by the generous participation of the Department of American Decorative Arts and Sculpture, who have been valuable partners since the beginning of this project. Many of the American artists who traveled to Italy were sculptors, and without the dedicated scholarship of Jonathan L. Fairbanks and Jeannine Falino this exhibition would be severely diminished. We are also grateful to their colleagues, Edward S. Cooke, Jr.; Heather H. Hoyt; Rachel Monfredo; Maria Pulsone; and Linda Foss. Members of the Department of Prints, Drawings, and Photographs have also generously assisted our enterprise; Clifford S. Ackley, Sue Reed, Anne Havinga, and Shelley Langdale not only have generously lent to the exhibition, but also provided invaluable research assistance.

We would like to thank the Department of Classical Art, particularly Cornelius C. Vermeule III and John J. Herrmann, Jr., for sharing their expertise on those aspects of the ancient world that so intrigued American visitors; Peter Sutton and Eric Zafran of the Paintings Department for helping us to establish the international context of the "Lure of Italy"; Eleanor L. Jones, who played an important role during the first years of the project, writing grant proposals and directing research; Regina M. Rudser, Katherine Rothkopf; the Department of European Decorative Arts and Sculpture, especially Ellenor Alcorn, Joellen Secondo, and Nancy Eklund, who helped with our study of furniture and decorative arts; Trevor J. Fairbrother, Beal Curator of Contemporary Art; and Barry Gaither, director, Museum of the National Center of Afro-American Artists.

We are indebted to a faithful group of researchers, especially Janet Comey, Kathleen Mathews Hohlstein, and Susan C. Ricci, who tirelessly sought out new information for all of our authors. We would also like to acknowledge Catherine Coulter and the students in Theodore E. Stebbins's graduate seminar at Boston University, "Americans in Italy," Todd Bachmann, Jennifer Baxter, Barbara Coogan, Nancy Gruskin, Anne Haley, Hina Hirayama, Kathleen Mathews Hohlstein, Maura Lyons, Milda Richardson, Emily Terry, Sarah Vure, Sydney Warner, and Elizabeth Whiting. Special appreciation is due to Nancy Allen, Karin Lanzoni, and the staff of the William Morris Hunt Library at the Museum of Fine Arts. We are grateful for the superb cooperation of the Boston Athenaeum, the Boston Public Library, Wessell Library at Tufts University, Clapp Library at Wellesley College, Paul Haughton and his colleagues at the O'Neill Library at Boston College, the libraries of Harvard University, the Grolier Club, Christine Hennessey and the staff of the Archives of American Art, and Marnie Canick at the Library of Congress. We are most grateful to Dr. Richard Murray and Dr. Elizabeth Broun of the National Museum of American Art for sharing with us their files on Joshua Taylor's proposed exhibition, "The Italian Muse: Artists in Italy, 1800 - 1860," which sadly never came to fruition. We are especially indebted to William H. Gerdts for sharing his personal library and research materials with us.

Mounting an exhibition of this diversity and scope is an immense enterprise that requires the expertise of many people behind the scenes. At the Museum of Fine Arts we are espe-

cially grateful to the members of our Paintings Conservation Department: Jim Wright, Brigitte Smith, Jean Woodward, Irene Konefal, Rita Albertson, Rhona Macbeth, Andrew Haines, and Stephanie Vietas; Arthur Beale, Jean-Louis Lachevre, and Gary Stewart of the Research Department; and Roy Perkinson, Annette Manick, and Gail English of the Paper Conservation Laboratory. Their talents have made the objects look their best, allowing us to better understand the artists' intentions. Thanks are also due to Desirée Caldwell and the staff of the Exhibition Planning Department; Patricia Loiko, associate registrar; Tom Wong and Judy Downes of the Design Department; Janice Sorkow and the Photographic Services Department; William Burback, Barbara Martin, and Gilian Wohlauer of the Education Department; and Peter Der Manuelian of the Department of Egyptian and Ancient Near Eastern Art, and Rene Beaudette of Management Information Services for their technical expertise and good humor. We are grateful to Eliza McClennen, cartographer, for her excellent design of the three maps illustrated herein. We would like to extend special appreciation to Carl Zahn and Cynthia Purvis of the Department of Publications, who turned innumerable pages of manuscript into a coherent and beautiful catalogue.

Research on this catalogue was significantly aided by an Aimée and Rosamond Lamb/ Andrew W. Mellon Foundation Curatorial Research Grant awarded to Theodore Stebbins for travel in Italy in the fall of 1990. We are particularly grateful for the superb hospitality of the American Academy in Rome and its director, Professor Joseph Connors, to Mr. Stebbins and Susan C. Ricci.

We are especially grateful for the enthusiastic support and encouragement of the Hon. Roberto Falaschi, Consul General of Italy in Boston, Robert B. Blancato and the National Italian American Foundation, Washington, D.C., and The Council for the United States and Italy (Robert F. Agostinelli, chairman, John Clancy, president, and Susan M. Lombard, program director). In additon, Professor Irma B. Jaffe has been a valued friend of this exhibition.

On behalf of our colleagues at the Cleveland Museum of Art we would like to thank Delbert Gutridge, registrar, and William Ward, Installation Designer. At the Museum of Fine Arts, Houston, we recognize Giorgio Borlenghi, president of Interfin Corporation, which provided the lead gift for the Houston venue. We acknowledge Houston Museum staff members Celeste Adams, who served as curator-in-charge; Karen Vetter, exhibition administrator; Charles Carroll, registrar; Sara Garcia, associate registrar; Jack Eby and Constance Michiels, designers; and Ashley Scott, curatorial assistant.

On behalf of our catalogue authors we would also like to thank: Julian F. Abele, James Ackerman, Warren Adelson, Kent Ahrens, Alexander Gallery, Edith Alpers, Michael Altman, Erik Amfitheatrof, Renee Andre, Alejandro Andrews, Carol Walker Aten, D. Scott Atkinson, Billie Aul, Kevin Avery, Ida Balboul, Marjorie Balge, Elizabeth S. Banks, William N. Banks, Antonella Barone, Emilio Barone, James Barter, Judith Barter, Thomas Batchelder, Barbara Batson, Anthony Battelle, Derrick Beard, Eileen Beard, Hollis Bedell, Tritobia Benjamin, Anne Bentley, Jean N. Berry, Dierdre Bibby, James Biddle, Annette Blaugrund, William Bodine, Michael and Mark Borghi, Maurizio Bossi, Arthur Breton, Bob Brown, Celia Brown, Clementine Brown, Dwyer Brown, Jeffrey Brown, Michael Brown, Timothy Burgard, John Burrows, Ann Butler, Teresa Carbone, Elizabeth Carella, Gerald L. Carr, Susan Casteras, James W. Cheevers, Carol Clark, Harold D. Clark, Jr., John and Ann Clarkeson, Bill Cleere, Coe Kerr Gallery, Anthony Collins, Janis Conner, Julia Moore Converse, Helen Cooper,

Wendy Cooper, Kathryn Corbin, Philip Cronenwett, Adele de Cruz, William Cuffe, Marianne Curling, Susan Currie, David Park Curry, Susan Danly, Rebecca Warren Davidson, Nicholas Dean, Katherine Dibble, Lauretta Dimmick, Rebecca Dodson, Marianne Doezema, Barbara Doyle, John Driscoll, Peter Drummey, John Dryfhout, Daniel DuBois, Charles H.P. Duell, Odile Duff, Henry Duffy, the Duveneck family, Stephen Dyson, Gary Edwards, Karin Einaudi, Robert Emlen, and Kathleen Erwin.

We would also like to thank Betsy Fahlman, Martha Gandy Fales, Janet L. Farber, Marion Fasel, Stuart Feld, Linda Ferber, Richard Field, David Firestone, Ellen Fladger, Eileen Flanagan, Lawrence A. Fleischman, Kathy Flynn, Robin Frank, Deborah Frizzell, Vivien Green Fryd, Susan James Gadzinski, Galison Books, Mrs. Peter R. Gallagher, Barbara Dyer Gallati, Eleanor Garvey, William H. Gerdts, Sanford Gifford, Mary Giles, Emmanuelle Giliberti, Frances Gillespie, Angela Giral, the descendants of Jane de Glehn, Penelope Glenar, Charlynn and Warren Goins, Alain Goldrach, Hilliard Goldfarb, Glenn Gordonier, Randi Jean Greenberg, Kathryn Greenthal, Ann Greenwood, Sandra Grindley, Tammis K. Groft, Sergio Guarino, Barbara Guggenheim, George Gurney, Rollin van N. Hadley, Johnson Hagood, John and Helen Hall, Raizel Halpin, Jeanette Hanisee, Donna Hassler, Nancy Haven, Anne Hawley, Kate Heston, Carol Hevner, Juanita Holland, Holly Hotchner, Mr. and Mrs. William White Howells, Helene Huffer, John Dixon Hunt, Susan Hunter, Judith Hurd, Joseph Jacobs, Jackie Jacovini, Laurie James, Irma B. Jaffe, Dora Jane Janson, Corrine Jennings, Kate Johnson, Sona Johnston, William Johnston, Sarah Jolliffe, Steven Jones, Jordan-Volpe Gallery, Patricia Kane, Pavel Kapic, Sidney Kaplan, Lenore Karterud, Robert Kashey, Maurice Katz, John William Keck, Steven Kern, Judith Kerr, Joseph D. Ketner II, Gloria Kettleson, Donald Keyes, Norman Keyes, Frederick D. King, Harold Kirker, Elizabeth Knowles, Betsy Kornhauser, John F. Koza, Barbara Krulik, Dean Lahikainen, Rebecca E. Lawton, Judy Larson, Alyssia Lazin, Rob and Mary Joan Leith, Meg Licht, Cheryl Leibold, Edward Lipowicz, Anne Marie Logan, Dr. and Mrs. Jovin Lombardo, Richard A. Long, Alicia Longwell, David and Libby Lubin, Mary Lublin, Sarah Lytle, Angela Mack, John Manship, Bruno Mantura, Yvonne Markowitz, Arthur S. Marks, Patricia Maroni, Dennis Martin, Susan B. Matheson, Nancy Mowll Mathews, Pamela Mayo, Robert B. Mayo, Michael McCarthy, Libby McClintock, David R. McFadden, David Messum Gallery, Ruth Meyer, Thomas Michie, Samuel Miller, David Mitten, Luigi Monga, B. A. Moore, Jr., Margaret Moore, Keith Morgan, Theodora Morgan, Anndora Morginson, Alfred Morris, Jr., Dewey F. Mosby, Troy Moss, Betty Muirden, Carol Murphy, Richard Murray, Amy Myers, Mary Gardner Neill, Robert Neuhaus, Mrs. John C. Newington, Anna C. Noll, Barbara Novak, Edward Nygren, Arabella Ogilvie, Glen A. Omans, Carol Osborne, and Antoinette Owen.

Our thanks also go to Luciano Parisi, Simon Parks, Ellwood C. Parry III, Livia Pediconi, Lisa Peters, Karin Peterson, Mary Petronella, Arthur J. Phelan, William H. Pierson, Jr., Ron Pisano, Jessie Poesch, Portia Prebys, Penelope Proddow, Michael C. J. Putnam, Charlotte Quigley, Jan Seidler Ramirez, Harry Rand, Susan Rather, Carrie Rebora, Debbie Rebuck, Jonathan Reiss, Paul, Steven, and Michael Rich, Marilyn Richardson, Paula Richter, Donna M. Ridewood, Catherine Rivard, Bruce Robertson, H. Merrill Roenke, Jr., Millard F. Rogers, Jr., Ruth R. Rogers, Thomas M. Rogers, Michael Rosenfeld, Joel Rosenkranz, Anna Wells Rutledge, James Ryan, Melissa Saalfield, Andra Sammelson, Richard H. Saunders,

Charlton de Saussure, Jr., Rinault Schuman, Jacquelyn Days Serwer, Martha Severens, Darrel Sewell, Nancy Rivard Shaw, Cameron Shay, Peter Shemonsky, A. Jess Shenson, Anne B. Shepherd, Judy Simonson, Marc Simpson, Maria and Alessandra Silvietti, Susan Sinclair, Wilma Slaight, Regina Soria, Paul Staiti, Allen Staley, Susan Stein, Joel Sternfeld, Miriam Stewart, Roger Stoddard, Diana Stradling, Susan Strickler, Sherry Summer, Andrew Szegedy-Maszak, Dodge Thompson, Julia Thorne, Constance Fuller Threinen, Thurlow Tibbs, Dana Tillou, Peter Tillou, Claretta Tonetti, Lucia Tonini, Jeanette Toohey, Jim Tottis, Eleanor Tufts, Joyce Tyler, Rachel Vargas, Deborah D. Waters, Katharine J. Watson, Bruce Weber, Barbara Weinberg, Gail Weinberg, Robert Weis, Michael Wentworth, Richard and Joan Whalen, Debbie White, DeeDee Wigmore, Scott Wilcox, E. Thomas Williams, Jr., Lorraine Williams, Renee Williams, Glenn Willumson, Gertrude Wilmers, Edward T. Wilson, John Wilson, Erving and Joyce Wolf, Mitchell Wolfson, Mary K. Woolever, Richard Wunder, Richard York, Suzanne Zack, Linda Ziemer, Dean Zimmerman, Karen Zukowsky.

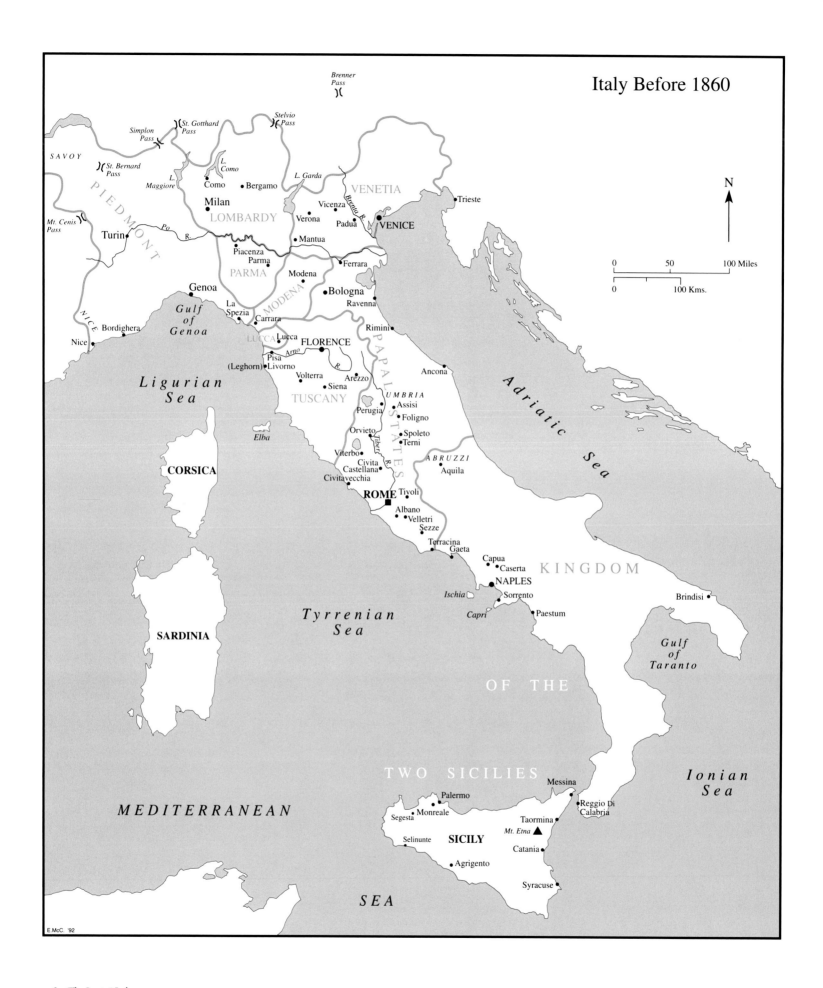

Italy Before 1860

Brenner Pass

Stelvio Pass

St. Gotthard Pass

Simplon Pass

SAVOY

St. Bernard Pass

L. Maggiore

L. Como

Como • Bergamo

Milan

LOMBARDY

Mt. Cenis Pass

PIEDMONT

Turin

Po R.

Piacenza
Parma

PARMA

Modena

MODENA

Genoa

La Spezia

Carrara

Gulf of Genoa

NICE

Bordighera

Nice

Ligurian Sea

LUCCA

Lucca

Pisa
(Leghorn) Livorno

Arno R.

FLORENCE

TUSCANY

Volterra

Siena

Arezzo

Elba

L. Garda

Brenta R.

Vicenza

Verona

Padua

Mantua

VENETIA

VENICE

Trieste

Ferrara

Bologna

Ravenna

Rimini

Ancona

PAPAL STATES

UMBRIA

Assisi

Perugia

Foligno

Orvieto

Spoleto
Terni

Viterbo

Tiber R.

Civita Castellana

Civitavecchia

ROME

Albano
Velletri
Sezze

Tivoli

ABRUZZI

Aquila

Adriatic Sea

CORSICA

Tyrrenian Sea

SARDINIA

MEDITERRANEAN

SEA

Terracina
Gaeta

Capua
Caserta

NAPLES

Ischia

Sorrento

Capri

Paestum

KINGDOM

Brindisi

Gulf of Taranto

OF THE

TWO SICILIES

Messina

Reggio Di Calabria

Ionian Sea

Palermo

Segesta

Monreale

Taormina

Mt. Etna ▲

SICILY

Selinunte

Catania

Agrigento

Syracuse

N

0 50 100 Miles

0 100 Kms.

E.McC. '92

Introduction

"A visit to Italy is perhaps more of an epoch in the life of an American artist than in that of any other. The contrast between the new and old civilization, the diversity in modes of life, and especially the more kindling associations which the enchantment of distance and long anticipation occasion, makes his sojourn there an episode in life."

HENRY T. TUCKERMAN[1]

Fig. 1. John Izard Middleton (American, 1785-1849), *Continuation of the View from the Summit of Monte Cavo* (detail), 1812. Illustration from John Izard Middleton, *Grecian Remains in Italy* (cat. 152).

Until recent years, historians of American art have tended to ignore the work done by so many of our painters and sculptors in Italy. The nineteenth-century neo-classic sculpture of Greenough, Powers, Story and their successors, mostly made in Florence and Rome, was widely dismissed as being "Victorian," "derivative," and out of the cultural mainstream. Landscape views of Tivoli and the Campagna, and of Capri and Sicily, made by Cole, Bierstadt, Inness, and the other members of the Hudson River School, were viewed as tangential to these artists's more important work depicting American scenery. American art historians from the 1920s to the 1970s – reflecting the spirit of their time – generally sought the "indigenous" and "native" qualities of American painting and sculpture, at the expense of considering the crucial significance of Europe in the formation of our art and culture. Yet even Lloyd Goodrich, a leading scholar of American art for many years, beginning in the early 1930s, and a champion of the nativist view, could write in 1971, "An essential factor in the growth of American art has been the interaction – sometimes the conflict – between native creativity and the powerful pull of European knowledge and skills."[2]

Italy was a destination unlike any other. Beginning in the 1760s, three generations of American artists went to London to study at the feet of Benjamin West, learning to compose, to draw, to paint. Then during the nineteenth century, American painters trekked to Düsseldorf and Munich, to benefit from their art academies; later in the century even larger numbers flocked to Paris, again for the training, the ateliers, the Salons. Across the years Italy, and especially Rome, represented both more and less than these other cities: less, in that artists did not go there for academic training, for exhibition opportunities, or even (with two or three exceptions) to see the work of any living artists. Yet Italy also meant more: it had been an almost holy destination for northern artists since the Fleming Rogier van der Weyden and the German Albrecht Dürer went during the fifteenth century; they were followed by wave on wave of German, Dutch, French, English, Danish, and Russian painters and sculptors. The Americans were among the last to go to Italy; they traveled the farthest, physically and emotionally, to get there; and as the nineteenth-century critic Henry Tuckerman recognized, because of the huge contrasts between fledgling America and ancient Italy, and because of the "kindling associations" the artists found there, Italy may have meant more to the American painters and sculptors than to the artists of any other land.

As early as 1903, in his biography of the sculptor William Wetmore Story, Henry James wrote: "The old relation, social, personal, aesthetic, of the American world to the European is as charming a subject as the student of manners, morals, personal adventures, the history of taste, the development of a society, need wish to take up." He added, however, that this subject "has never been 'done'."[3] The lure of Italy has to do with the vastly different "manners" and "morals" that Americans found there – to use James's words; and to look back on the American artist in Italy is to dis-

cover one "personal adventure" more extraordinary than the next. Yet the Italy that Americans experienced just a hundred years ago sometimes seems as remote as the China or the Egypt of two thousand years before, so radically has our way of seeing changed during the twentieth century. Moreover, the Italy that Copley and Gifford and Sargent visited to such great effect has virtually disappeared; it has been replaced by another country with the same language, landmarks, and place names — which make discovering the original all the more difficult.

Students of American literature were quicker than art historians to recognize the formative role of Europe for American culture. In 1947, Philip Rahv, studying American writers abroad, wrote that "Europe becomes one of the poles of American culture, the other pole being that most indigenous of indigenous places — the frontier."[4] Describing the polar orientation of the American mind, Rahv explained that Europe "has served the native imagination both as myth and reality," noting that American writers reacted to its challenges in widely varying ways, with their differing reactions offering insight into "their deepest commitments to their country and sense of participation in the national fate." Similarly, American art was formed in the crucible between two major protagonists, American memory of the European experience, on one hand, and the American land, the vast wilderness, the ever-moving western frontier, on the other. Paris, London, and Munich were important for a time as places to study; but Italy represented an ideal, archtypal aspiration of the artist, as important at times to those who rejected its siren call as to those who went. The American painter and sculptor going to Italy stepped into a haloed, time-honored international arena, unique unto itself; the artist's trip there was more than an adventure, but (as Rahv says) a cognitive act. The artist went to Italy to discover himself, and to find out what it would mean and what it would take to create an American art.

American artists and writers reported at length in their letters and journals on where they went in Italy, whom they saw, how they traveled, what they enjoyed and what they didn't, but they rarely explained why they had gone in the first place: for each generation, the reasons seemed self-evident. Yet in fact each group over time went for a multitude of diverse and changing reasons, stated or unstated, and each came home (or remained abroad) with different lessons learned. For West and Copley, in the eighteenth century, Italy's prime attraction lay in the remnants of the ancient world there, which included what they regarded as the masterpieces of fifth-century B.C. Greek sculpture in Florence and Rome, the Greek temples at Paestum, and the architecture of the Roman Republic and the early Empire. Travel to Italy remade both painters: both developed new styles and new aims there, and both settled afterwards in London, never to return to America. During the nineteenth century, the American landscapist still went to Italy for the ancient sculpture and the antique ruins, but now saw himself as following in the venerable footsteps of the seventeenth century classicists, Claude and Poussin. Washington Irving, one of the earli-

est of our writers to go, spoke for his time – and for many painters – in saying, "Europe held forth the charms of storied and poetical association. There were to be seen the masterpieces of art, the refinements of highly cultivated society, the quaint peculiarities of ancient and local custom."[5] Irving concluded, "My native country was full of youthful promise; while Europe was rich in the accumulated treasures of age. Her very ruins told the history of times gone by, and every mouldering stone was a chronicle." James Fenimore Cooper found Rome to be "a town of recollections" while New York was "a town of hopes" – but he preferred Rome.[6] Writer after writer would repeat this theme: that America represented the future, Italy the past – and as the painter Thomas Cole wrote, "Our only means of judging of the future is the past."[7] Cole specified that he went to Italy for "improvement in my art" – a reason that nearly every visiting artist would have echoed; and like so many, he found the art galleries there "a paradise."[8] Tuckerman adds that the landscape painters went in order to "learn tricks of light and how to manage color for effect;"[9] indeed, Thomas Cole and the members of the Hudson River School, returning from Italy, were quick to transfer the elegiac, golden light of the Campagna to their views of the Catskills and the White Mountains. More important, in Italy they learned of the nobility of landscape, and of landscape painting's ability to reassure a nation that it lived in a Golden Age.

Thus, American artists went to Italy for many reasons: in the eighteenth century, for ancient history, to learn the moral lessons of the past; they longed to view the classical world, the ruins of Greek culture in Italy (Greece itself being under Turkish rule and rarely visited), and of the Roman Empire. During the nineteenth century, they went for the scenery, the light, the climate, the local color. They went to copy famous paintings, to see the great galleries of Florence and Rome, and to order casts of the best of ancient sculpture. They traveled to see Italy's famous sights: Vesuvius, Pompeii, the Bay of Naples, Sicily, Capri, Venice, the Roman Forum and the Campagna, as well as her artistic monuments, St. Peter's, the Colosseum, the works of Raphael and Michelangelo, of Titian and Salvator Rosa. By the 1840s, they were going for the comraderie, for the other American artists and writers who were there. Some voyaged to Italy seeking health, inexpensive living, or easy patronage from traveling Americans. The sculptors went particularly to see the work of their Greek and Roman predecessors, and for the Carrara marble, the skilled Italian workmen who carved it for them, and the studios and patronage that William H. Gerdts describes in his essay below; they alone also went to study with living Italian masters, and they, unlike the painters, could meet in Rome the internationally acknowledged masters of their medium, the Italian Canova, the Dane Thorvaldsen, and the Englishman John Gibson. And from the beginning to the end, the Americans went for the special quality of life there, for what much later would be called "la dolce vita." Almost every nineteenth-century observer contrasted the practicality of modern, utilitarian, materialistic America with the joyfulness, the impracticality

of daily life in Italy: there they learned how to see, how to feel, how to use their senses; for James and for so many others, Italy represented simply "the sweetest impression of life" one could possibly experience.

During the twentieth century, a general upheaval in western culture has — for the reasons Fred Licht explains in his essay in this volume — almost totally changed the way in which artists and other travellers see Italy. One result is that the ambition of going to Italy is no longer a central one for American artists; the lure of the classical world has weakened as classical learning itself has declined. Some fine painters and sculptors, as Licht explains, continue to draw inspiration from living and working in that country, but it has become merely one of many possible places in the world to visit. Moreover, the modern revolution in taste has almost completely altered what Americans value about Italy. The sculpture that was so treasured a hundred and fifty years ago, today is neglected; the *Venus de' Medici* at the Uffizi and the *Apollo Belvedere* in Rome — both of which were venerated for so long — are largely ignored now, as are the American neo-classic works of the nineteenth century which they inspired. And the one sculptor who is admired today, the Baroque master Bernini, was despised by most nineteenth-century visitors. Another case in point is Michelangelo: his high reputation has remained intact, but for changing reasons: the nineteenth century most valued his sculpture and architecture, while today it is the paintings of the Sistine Chapel that attract year-round hordes of visitors. As for painting, eighteenth- and nineteenth-century travelers venerated Claude and Poussin, Raphael, Titian, and the Bolognese (Guido Reni, Domenichino, Guercino), while modern visitors crowd instead to see the earlier, starker, more conceptual work of Giotto, Masaccio, and Piero della Francesca. Siena, Arezzo, Perugia, and Ravenna, little frequented in the last century, have become major destinations today, while Naples, Bologna, and Genoa — which were so important to earlier travelers — see few American visitors now. Americans continue to flock to Rome, Florence, and Venice in ever-increasing numbers, as one sees from the lines outside the Uffizi or the throngs in Piazza San Marco; but today's visitor is even more attracted to the countryside, especially to the hill towns of Tuscany, the seaside resorts, and the villas and their formal gardens — none of which appealed much to the earlier traveler. Before, Italy seemed impractical, non-mercantile, uncrowded, inexpensive. Today's visitors still go to Italy for its art, but now they are equally attracted by its food and wine, by its restaurants and hotels, and by its fashionable products, its technology, and its glamour.

Travel itself has been transformed. Not coincidentally, the first guidebooks to Italy published as such and aimed at a broad audience were published by John Murray in London about 1843, and this date marks a turning point in terms both of the practicalities of traveling and of travelers' attitudes toward Italy itself. Thomas Cole spoke for generations of early travelers when he wrote, "He who would make a tour through this magnificent land, must make up his mind to submit to much fatigue,

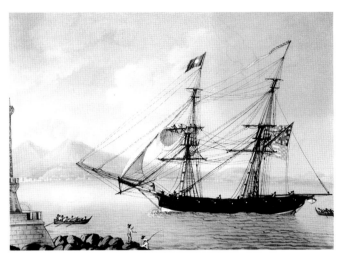

Fig. 2. Attributed to Michele Felice Corne (American, about 1752-1845), *Brig Attatant of Boston Coming into Naples*, 1800. Gouache. The Peabody Museum of Salem, Massachusetts.

Fig. 3. Edward Lamson Henry (American, 1841-1919), *The Arrival*, 1868. Oil on panel. Courtesy the Cooley Gallery, Old Lyme, Connecticut.

some danger, and innumerable annoyances."[10] Among the latter, Cole specifies "filth, bad fare, the continual torment of vermin; lodgings, to which a stable with clean hay would be in comparison a paradise." Travelers before the 1840s or 50s crossed the Atlantic uncomfortably, in small ships under sail only, and with the constant risk of storm and shipwreck, in six or eight weeks time if lucky (fig. 2). In Italy itself travel before the railroad was made possible by a wide variety of unpredictable small coastal ships, by "vettura," "diligences," and other horse-drawn carriages, on mule-back, and on foot (fig. 3). The visitor dealt with numerous and constant vexations; in pre-unification Italy, every state had its own written and unwritten rules for customs and quarantine, for innumerable fees and bribes, and there were always the importunings of beggars and the threat of banditti. To go to Italy was a lifelong ambition; as George Hillard wrote, "Every young artist dreams of Rome as the spot where all his visions may be realized" — but frequently the actual experience was a shock.[11] Describing a visit to the Colosseum by moonlight, Nathaniel Hawthorne declared, "Byron's celebrated description is better than reality."[12] Henry Wadsworth Longfellow similarly found that many things in Italy "are not altogether so delightful in reality as we sometimes fancy," while another visitor from Boston wrote, "The Rome that *is* seemed but an intruder . . . I wished it away."[13]

The earliest American artists to go to Italy inevitably modeled their itineraries and their work on the eighteenth-century English model. During the nineteenth century, however, as patronage broadened and travel grew easier, the process became increasingly democratized. Italy came to be seen as a virtual necessity for aspiring sculptors, and the first significant group of American women artists to go there came from the sculptural field. Harriet Hosmer (see cat. 33) led the way to Rome in

1852, encouraged and aided by the actress Charlotte Cushman. Louisa Lander, Emma Stebbins, Edmonia Lewis (cat. 39), Margaret Foley, and Florence Freeman all followed by 1861; they found training, materials, and patronage which would not have been available to them at home. Traveling American artists increasingly came from all classes and from everywhere in the United States; painters and sculptors from Boston, New York, and Charleston were joined by others from the west; from Springfield, Ohio; from Detroit and Chicago. Their trips were paid for by their families, or by wealthy patrons, or by groups who believed in their promise. Edmonia Lewis was helped by the poet Henry Wadsworth Longfellow and the Abolitionist William Lloyd Garrison, Robert Duncanson (see cat. 117) by both the Cincinnati Anti-Slavery League and by that city's wealthy patron, Nicholas Longworth. The artists also helped one another; Robert Weir cut his visit short in order to bring the ailing Greenough home; Thomas Hicks nursed Kensett back to health in Rome in 1847. At times they gave and lent funds to each other, as on one occasion which Sanford Gifford describes in his journal entry for July 16, 1857: "At dinner we had a call from Eugene Warburg, a negro sculptor from New Orleans, on his way to Florence, and out of money. His manner was prepossessing. He had letters from people we knew. He was modest, but full of hope and confidence."[14] Gifford and his friends in Venice raised money enough for Warburg to resume his travels.

The first modern study of the American artist in Italy occurred in 1951, with the exhibition *Travelers in Arcadia: American Artists in Italy, 1830-1875* organized by E.P. Richardson and Otto Wittmann for the museums at Detroit and Toledo. The authors called their subject "a somewhat forgotten chapter in the history of American art"; they concentrated on what they considered "the great period of study in Italy," beginning with Cole and Morse in the 1830s, and they remarked on the phenomenon that Erica Hirshler explores in her essay below, that though Americans loved Venetian painting and indeed Venice itself from early on, they didn't paint it in significant numbers until the last third of the nineteenth century. The pioneering catalogue by Richardson, who in his work on American artists was always aware of European influences and parallels, and Wittmann, longtime director of the Toledo Museum, included ninety-six works (of which nine are also found in the present show) but just four sculptures; at that time, neoclassic sculpture was still seen as "lifeless," "cold," and having other "fatal" qualities.[15]

Several other exhibition catalogues since 1951 have shed light on certain aspects of the question, beginning with *The Arcadian Landscape*, organized by Charles Eldredge in 1972, with a catalogue containing an insightful essay by Barbara Novak on the reactions of American mid-century landscapists to Italy. [16] The same painters were the subject of a 1987 exhibition at Bowdoin College, accompanied by a fine essay by John W. Coffey, who integrated both nineteenth-century photography and literature into his discussion.[17] Finally, the special question of Venice and its attractiveness for our painters from the 1860s on was examined in a recent exhibition cata-

logue by Margaretta Lovell, from whose work we have benefitted.[18]

Other studies, not exhibition-related, have also contributed very significantly to this field. William H. Gerdts, a longtime champion of neglected artists and movements, has written several important studies of American neo-classic sculpture; in the present volume he discusses the high reputation and central position of the American sculptors in Florence and Rome.[19] Equally important have been a series of books, beginning with Van Wyck Brooks's *The Dream of Arcadia* of 1958, which pioneered in considering the painters, sculptors, writers, collectors, and other travelers together, in examining the importance of Italy for American culture.[20] As Brooks suggested, interconnections between nineteenth-century artists and writers are manifest, and the written and visual media of that time shed light on one another. Washington Irving, the inventor of Rip Van Winkle and other American folk tales, visited Rome's galleries with the painter (and novelist) Washington Allston; James Fenimore Cooper, best-known as the author of *The Last of the Mohicans* and the other Leatherstocking Tales, was also an early patron of the sculptor Horatio Greenough in Rome, wrote a novel set in Venice, and left us informative journals of his travels in Italy, wherein he noted his preference for the Italian landscape over the American. The most "American" of writers, Emerson, Melville, Twain, all loved Italy, and set their Americanness off against what they saw and learned there. Margaret Fuller's career reached its apogee in Rome, as – perhaps – did Hawthorne's, despite his many complaints about the place. William Wetmore Story became the most respected of our sculptors there; but his writings are also important, and his picture of the city in *Roba di Roma* is eloquently stated (cat. 163). Henry James wrote a biography of Story as well as some of the best art criticism of the day; he counted Whistler and Sargent among his friends, and spent more years and more words than anyone else trying to define the complex, many-sided, role of Italy for American art and for the American mind. In novels from *Roderick Hudson* (1875, cat. 166) to *Wings of the Dove* (1902), James wrestled with the extraordinary attractions of Italy for Americans, especially for American artists, on one hand, and the risks and problems Italy presented them with on the other. James explored the questions that intrigue us today: why was Italy so important for the creative American? Why did some artists flourish there, and others fail? And most importantly, what did the Americans and American culture – learn from Italy?

During the 1980s, study of these questions quickened. Regina Soria's extraordinary *Dictionary of Nineteenth-Century American Artists in Italy* provides invaluable assistance to students of the field.[21] Irma Jaffe has organized three ground-breaking symposia (1987, 1989, 1991) examining Italian influence on American painters, sculptors, architects, and collectors.[22] Finally, William L. Vance in 1989 published a magisterial, two-volume study entitled *America's Rome*, which explores the attitude of American painters, sculptors, writers, political figures, and other travelers from West's time to the present toward Rome's major "subjects" – the Colosseum, the Cam-

pagna, the chief galleries of ancient sculpture, the institution of Catholicism, and the Baroque, among others.[23] Vance has contributed to the present volume an innovative analysis of the reactions to Italy of the writers Mark Twain, William Dean Howells, and Henry James, as seen through their non-fiction.

Had time and space allowed, several closely related areas might have also been explored. Each artist's itinerary in Italy is included herein, but we have not examined the practicalities of eighteenth- and nineteenth-century travel in Italy, the routes taken, the costs, the means of conveyance and the like, as those matters are well treated elsewhere.[24] A sampling of souvenirs that Americans brought back from Italy will be found in this exhibition, but the large and important questions of the taste and collecting of Italian art by Americans are dealt with only briefly. American architects from Charles Bulfinch and Thomas Jefferson to Charles Follen McKim and Charles Platt were largely influenced by Roman and by Renaissance architecture; other Americans during the nineteenth century took up Italian villa and Venetian styles — all material for yet another study. During the late nineteenth century, Americans became entranced by the gardens of Italy, by their formal qualities, their uses of water and sculpture, and by their sensuous elegance. However, though this phenomena may be traced to the 1850s, it dates primarily from the twentieth century, and so it too will be left for another occasion.[25] Finally, we have included here only a few photographs, as American photographers began to consider Italy a major subject only late in our period, with the work of William J. Stillman, Alfred Stieglitz, Karl Struss, and Esther Van Deman.

Our aim has been to survey the paintings (including watercolors) and the sculpture made by Americans in Italy, or resulting from their Italian trips, from Benjamin West's arrival in 1760 to the eve of the First World War, when the myth of Italy as Arcadia, as a place with links to a Golden Age, was finally shattered.[26] We exhibit the work of seventy-two artists, as many as space allows, knowing that dozens more of almost equal interest might have been included. Our hope is to suggest the myriad ways in which American artists saw and reacted to Italy — "that central clime," in Hawthorne's words, "whither the eyes and the heart of every artist turn, as if pictures could not be made to glow in any other atmosphere, as if statues could not assume grace and expression, save in that land of whitest marble."[27]

THEODORE E. STEBBINS, JR.
John Moors Cabot Curator of American Paintings

Notes

1. Henry T. Tuckerman, *Book of the Artists: American Artist Life* (New York: F.P. Putnam & Son, 1867), p. 152.

2. Lloyd Goodrich, Introduction, *What is American in American Art* (New York: M. Knoedler & Co., 1971), p. 13.

3. Henry James, *William Wetmore Story and his Friends* (New York: Grove Press, 1903), vol. 1, p. 5-6.

4. Philip Rahv, ed., *Discovery of Europe: The Story of American Experience in the Old World* (Boston: Houghton Mifflin Co., 1947), Introduction, p. 7.

5. Washington Irving, *The Sketch Book of Geoffrey Crayon, Gent.* (New York: New American Library, 1961), p. 14.

6. James Fenimore Cooper, *Gleanings in Europe*: Italy (Albany: State University of New York Press, 1981), p. 244.

7. Thomas Cole, "Sicilian Scenery and Antiquities," part 2, *The Knickerbocker* 23, (February 1844), p. 244.

8. Louis Legrand Noble, *The Life and Works of Thomas Cole* (Cambridge: Harvard University Press, 1964), p. 71, 101.

9. Tuckerman, *Book of the Artists*, p. 372.

10. Thomas Cole, "Sicilian Scenery and Antiquities," (Part 1), p. 105.

11. George S. Hillard, *Six Months in Italy* (Boston: Ticknor, Reed, and Fields, 1853), vol. 2, p. 253.

12. Nathaniel Hawthorne, *The Marble Faun* (New York: New American Library, 1961), p. 116.

13. Paul R. Baker, *The Fortunate Pilgrims: Americans in Italy, 1800-1860* (Cambridge: Harvard University Press, 1964), p. 42.

14. Sanford R. Gifford to Elihu Vedder, February 1, 1856, European Letters. Private Collection.

15. In E.P. Richardson and Otto Wittmann, Jr., Introduction, *Travelers in Arcadia: American Artists in Italy, 1830-1875* (Detroit Institute of Arts and Toledo Museum of Art, 1951), pp. 9-14.

16. *The Arcadian Landscape: Nineteenth-Century American Painters in Italy* (Lawrence: University of Kansas Museum of Art, 1972); includes Barbara Novak, "Arcady Revisited."

17. *Twilight of Arcadia: American Landscape Painters in Rome, 1830-1880* (Brunswick, Maine: Bowdoin College Museum of Art, 1987).

18. Margaretta Lovell, *Venice: The American View, 1866-1920* (San Francisco: Fine Arts Museums, 1984).

19. See William H. Gerdts, *American Neo-Classic Sculpture: The Marble Resurrection* (New York: Viking Press, 1973), and the bibliography therein. Also most useful is Kathryn Greenthal, et al. *American Figurative Sculpture in the Museum of Fine Arts, Boston* (Boston: Museum of Fine Arts, 1986).

20. Van Wyck Brooks, *The Dream of Arcadia: American Writers and Artists in Italy, 1760-1915* (New York: E. P. Dutton & Co., 1958). See also the perceptive study by Nathalia Wright, *American Novelists in Italy* (Philadelphia: University of Pennsylvania Press, 1965), and James W. Tuttleton and Agostino Lombardo, *The Sweetest Impression of Life: The James Family and Italy* (New York: New York University Press, 1990).

21. Regina Soria, *Dictionary of Nineteenth-Century American Artists in Italy, 1760-1914* (East Brunswick, N.J.: Associated University Presses, 1982).

22. The papers from the 1987 symposium, held at Fordham University have been published in Irma B. Jaffe, ed., *The Italian Presence in American Art, 1760-1860* (New York: Fordham University Press and Istituto della Enciclopedia Italiana, Roma, 1989).

23. William L. Vance, *America's Rome* (New Haven: Yale University Press, 1989) vols 1 and 2.

24. See Paul R. Baker, *The Fortunate Pilgrims*.

25. See Rebecca Warren Davidson, "Past as Present: Villa Vizcaya and the 'Italian Garden' in the United States." *Journal of Garden History* 12, (January-March 1992), pp. 1-28.

26. See David H. Solkin, *Richard Wilson: The Landscape of Reaction* (London: Tate Gallery, 1982), for a discussion of how the myth of Italy served political, economic, and social purposes in late eighteenth century England.

27. Hawthorne, *The Marble Faun*, p. 47.

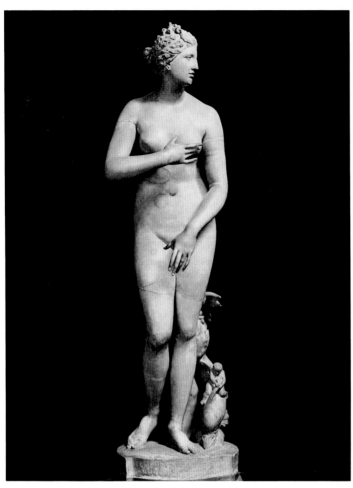

Fig. 1. *Venus de' Medici*, about 100 B.C. Marble. Uffizi Gallery, Florence. Photograph courtesy Alinari/Art Resource, New York.

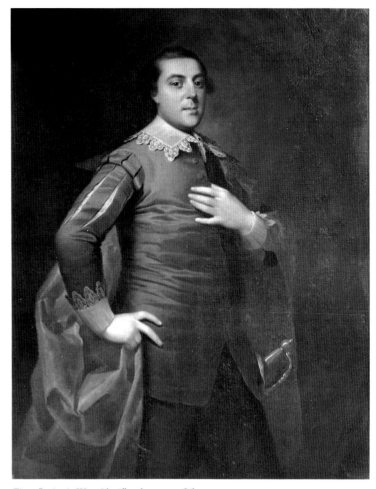

Fig. 2. Benjamin West, *John Allen*, about 1760. Oil on canvas. Private Collection.

American Painters and the Lure of Italy

THEODORE E. STEBBINS, JR.,
with the assistance of SUSAN CRAGG RICCI

"Say what ill of it you may; [Italy] still remains to the poet the land of his predilection,
to the artist the land of his necessity, and to all the land of dreams and visions of delight."
HENRY WADSWORTH LONGFELLOW[1]

I Joining The Grand Tour

When American painters began to travel abroad in the mid-eighteenth century, it was natural that they succumbed to the lure of Italy, for leading English artists and writers – their role models – had been making the same pilgrimage for many years. As early as 1595, Shakespeare in *Richard II* spoke of a "Report of fashions in proud Italy, whose manners still our tardy, apish nation limps after in base imitation." The poet Milton went to Italy in 1683, taking a fifteen-month tour and meeting Galileo near Florence. During the early years of the eighteenth century, the third Earl of Shaftesbury "preached the unity of morality and taste," and the necessity of study in Italy; and as Wittkower writes, "Shaftesbury's ideas were developed by the painter Jonathan Richardson, who defined the rules of connoisseurship to be learnt in Italy, and published in 1722, a popular guide to those monuments which every gentleman was expected to study."[2] A "Grand Tour" – as it came to be called – of three or four years duration, including extensive travels through the Continent culminating in Italy, had become practically mandatory for the sons of wealthy British families by the eighteenth century. The young man typically was accompanied by a tutor, ideally "a respectable man of mature age" who functioned as his teacher, mentor, guide, and companion.[3] Some of the outstanding thinkers of the time traveled to Italy as tutors, including Adam Smith, Thomas Hobbes, John Locke, and – importantly for later American travelers – the philosopher and future Anglican bishop, George Berkeley (1685-1753), who went abroad in the fall of 1716 as tutor to the young George Ashe.[4] While in Florence in 1720, Berkeley and Ashe had their portraits painted by a traveling British artist, John Smibert, who "had long had in mind the project of a journey to Italy, the goal of every ambitious artist of his time in the northern countries of Europe."[5] According to contemporary accounts, while he was there, Smibert – adhering to traditional practice, which would be followed by generations of Americans to come – "drew the best statues and copied many of the best paintings in the city."[6]

According to Richard Saunders, Berkeley and Smibert renewed their acquaintance in 1726 in London, at which time Berkeley likely persuaded the painter to join him in the great adventure of establishing a college in the New World.[7] They sailed together for Newport, Rhode Island, in September 1728 in pursuit of their plan, which proved to be abortive. Berkeley remained for three years – time enough to become an influential figure in the cultural and educational life of the colonies, one who must have spoken often about the glories of Italy, and Smibert played an even

greater role in America, as he stayed on to become Boston's leading painter. His studio there, which survived for many years after his death in 1751, provided an early "academy" for aspiring painters who visited it, containing as it did the many copies he made in Italy after Raphael, Titian, Tintoretto, Poussin, Van Dyck, and Rubens; his extensive collection of Italian prints; a plaster cast of the famous *Venus de' Medici* [at the Uffizi Gallery, Florence] (fig. 1), which up to the mid-nineteenth century "was revered as the most beautiful Venus and one of the half-dozen finest antique statues to have survived."[8] Years later Nathaniel Hawthorne would call the *Venus* "a miracle," while commenting, "The world has not grown weary of her in all these ages."[9]

Thus Berkeley, in choosing Smibert, and Smibert, in deciding to pursue his career in Boston, helped to bring the American colonies into the mainstream of European culture. For nearly five centuries, from the early Renaissance until the Great War, educated citizens of England, France, Germany, the Low Countries, Russia, and eventually America believed that Italy lay at the very center of western civilization. Petrarch and Boccaccio in the fourteenth century had revived the study of Greek and Latin texts; they became pivotal figures in the development of Humanism, which was seen as representing the highest ideals of western civilization from the beginning of the Renaissance in the early fifteenth century until the twentieth century.

Renaissance thought and art were based on the methodological rediscovery, frequently the literal unearthing, of the ancient world of Rome; moreover, as one scholar has put it, "the study of classical antiquity emerged as a morally formative factor and as part of the culture and erudition of the time."[10] As the Rev. Archibald Alison summed up in the late eighteenth century, in words that Thomas Cole in New York would echo a few decades later, "What is it that constitutes that emotion of sublime delight, which every man of common sensibility feels upon the first prospect of Rome? It is not the scene of destruction which is before him. It is not the Tiber. It is ancient Rome which fills his imagination. It is the country of Caesar, and Cicero, and Virgil, which is before him."[11] However much American artists, like their predecessors, might admire St. Peter's or Vesuvius, or the works of Renaissance and Baroque painters and sculptors, and however much they might — later on — enjoy Italian scenery and Italian light, at the root of the lure of Italy was its identity as hallowed, "classic ground," as the site of ancient Rome.

The English had taken to the Grand Tour early on, yet England was among the last European nations to send its artists to Italy, perhaps because the English were in the habit of importing their best art from the continent, and thus were delayed in developing their own school. The earliest important English painter in Rome, Alexander Cozens, journeyed there only in 1746; more significant was Richard Wilson, who after a year in Venice went to Rome in 1751. Wilson worked with Joseph Vernet, dean of the French landscapists in Rome, and he studied the paintings of

Claude Lorrain at first hand, then formulated his own style – cooler, emptier, less expansive than Claude's – but poetic and classical nonetheless, and influential for later Americans. When Wilson was there, there were enough English artists in Rome to attempt formation of their own academy in that city – though they only succeeded in 1823 (the French Academy in Rome, by contrast, had been founded in 1666).[12] Only the Americans went to Italy later than the English, or were longer in forging their own art; their own Academy in Rome was not inaugurated until 1894.

When Benjamin West and his friends John Allen and Joseph Shippen, all Philadelphians, all in their twenties, set off for Italy in the spring of 1760 – among the earliest colonial Americans to travel there – they became unknowing pioneers. Unknowing, because if asked they would have surely described themselves as simply carrying on two well-established British traditions: on one hand, two sons of prominent families taking the Grand Tour in order to educate their minds and their taste, and on the other, an aspiring painter going for training and inspiration as artists had long been doing. West was fortunate both in finding patrons at home to send him, the early art collectors William Allen and his brother-in-law James Hamilton, and in arriving in a Rome that was just then rejecting the rococo while again embracing the ancient world. The long-buried, first-century Roman settlements at Pompeii (first explored in 1748) and Herculaneum, and the much earlier Greek temples at Paestum, had been recently rediscovered; the German neoclassical painter Anton Raphael Mengs had come to Rome in 1741; Piranesi had begun his series of etched *Views of Rome* by 1748; and the art historian and archaeologist Johann Winckelmann had arrived in 1755, teaching several generations that the Greek sculpture in Rome contained nobility and grandeur enough to make it preeminent among all of man's work on earth.

West was fortunate also in the connections he made in Rome. The Philadelphian quickly became friends with Mengs, whom he called his "favorite master"; he promptly took up Meng's portrait style, and he followed the German painter's advice to visit Florence, Bologna, Parma, and Venice.[13] West spent his time in Italy in the way that northern painters had for almost three centuries and would for another hundred years: he drew from the accepted masterpieces of ancient sculpture in Rome, and he painted for his patrons at home copies of the most admired Renaissance masterworks including Correggio's *Madonna of St. Jerome at Parma* (see fig. 4), Domenichino's *Cumaean Sybil* in Rome, and Titian's *Venus of Urbino* at Florence. Drawing from sculpture taught a painter form, and provided a repertoire of poses for future use; West would employ his sketches of the *Ara Pacis* (the "Peace Altar," Rome, 13-9 B.C.) in composing his *Agrippina Landing at Brundisium with the Ashes of Germanicus,* 1768 (cat. 2); and those of the Vatican's *Meleager* (or *Antinous*) would be used in painting the *Choice of Hercules,* 1764 (Victoria and Albert Museum, London).[14]

West's art reached a new level almost immediately upon his arrival in Italy, when he saw master European paintings for the first time; within months he was accom-

plished enough to have his portrait of Thomas Robinson mistaken for the work of the popular Mengs. West's painting of his friend John Allen (fig. 2), which probably also dates to his first months in Italy, recalls Mengs in its pose and coloring, though revealing at the same time that West still lacked the ability to give his figures substance and weight.[15] West's own work at this time is less sophisticated than that of his friend in Rome, the Swiss-born Angelica Kauffmann, who made a pencil drawing of the aspiring, handsome American artist in 1763 (fig. 3). West's three years in Italy were of the utmost importance for his own future work, and for the future of American art. As Historical Painter to the King, President of the Royal Academy for twenty-seven years, and most significantly as teacher of three generations of visiting American painters in London, his voice was heard well into the nineteenth century: it was a voice that preached the centrality of Rome and the Italian experience for artists, along with the necessity of making paintings conveying strong, didactic messages about courage, self-sacrifice, patriotism, and loyalty, based on lessons from history, the Bible, or literature.

Some of West's American students followed him to Rome, including Allston, Rembrandt Peale, and Morse; but Italy — as an ideal, and as a standard — was no less important for others who never went. Thus John Trumbull's earliest surviving work, done as a schoolboy in Connecticut in 1770 or 1771, is the naive, painstaking *View of Part of the City of Rome*, which features a view of the Castel St. Angelo with St. Peter's in the distance; no later American ever attempted a more ambitious view of the Papal City.[16] And when Trumbull arrived in London, West quickly set him to work copying another artist's copy of Raphael's *Madonna della Sedia* (known as *Madonna della Seggiola* during the eighteenth and nineteenth centuries) in his studio, then making an additional copy (fig. 4) of West's own replication of Correggio's *Madonna of St. Jerome at Parma*, which the younger American regarded (surely emulating his master) as "one of the three finest paintings in existence."[17] Or, to take another example, Charles Willson Peale — that most American of talents — went to London (1767-69) to study with West, but never made it to Rome. Yet the Roman aesthetic was pervasive by this time; Peale's major work in England was his full-length portrait of William Pitt in a classical skirt, or Roman "consular habit," defending American liberty. And years later Peale erected in Philadelphia a spectacular triumphal arch in the shape of the famous Arch of Constantine at Rome, honoring George Washington as the American Cincinnatus, the Roman hero who briefly put down his plough to take command of an army.[18] In addition, Peale in 1787 presented the earliest exhibition of Italian paintings in North America, when he showed at his gallery a "collection of old heads, Scripture histories and landscapes" (as Rembrandt Peale later described them) that was too much before its time to elicit much interest in Philadelphia.[19]

Two other young Philadelphians, both friends of West, arrived in Italy in 1764, a year after he had left: they were Dr. John Morgan, a recent graduate of the Univer-

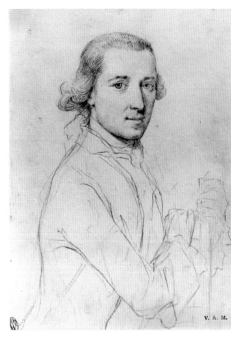

Fig. 3. Angelica Kauffmann (Swiss, 1740-1807), *Benjamin West*, 1763. Graphite on paper. Victoria and Albert Museum, London.

Fig 4. John Trumbull (American, 1756-1843), *Copy after Correggio, Madonna of St. Jerome at Parma*, 1780-81. Oil on canvas. Yale University Art Gallery, Trumbull Collection.

sity of Edinburgh, and Samuel Powel, heir to a fortune. After journeying to Florence and Rome, these two went on to become perhaps the first Americans to proceed south of Rome to visit Naples and its nearby attractions, including Vesuvius, Pompeii, and Herculaneum. In his journal, Morgan – like so many Americans who followed – kept a careful record of the sights and especially the works of art he most admired including the *Apollo Belvedere* (see ill. p. 129) and the *Laocoön* at the Vatican, the paintings of Raphael, the famous Correggio at Parma, the villas of Palladio; also like later travelers, Morgan complained about the inns, and debunked the myths and relics of Catholicism.[20] Morgan and Powel used as their guide Thomas Nugent's *The Grand Tour* of 1749, which reflected the taste of its time and helped to shape theirs; thus Morgan went to Padua, for example, and wrote of the sculptural monuments to Livy and Erasmus but – following Nugent – made no mention of Giotto's Scrovegni Chapel, which is so much revered today. Morgan developed a genuine enthusiasm for the arts, especially for the antique, writing a friend, "As to the grandeur of the ancients, from what we can see of their remains, it is most extraordinary. Arts with them seem to have been in a perfection which I could not have imagined."[21] Morgan was painted by Angelica Kauffmann,[22] and he collected and sent home a number of books, prints, drawings, as well as ten paintings, including works by or after Raphael, Titian, and Poussin, along with a marble bust, and a piece of lava from Vesuvius – all making him one of the earliest American collectors.[23] Noteworthy also are the activities of two scions of prominent Massachusetts families, John Apthorp and Thomas Palmer, who made the Grand Tour in the same years; they traveled for a time with Morgan and Powel, with Apthorp also commissioning his portrait from Angelica Kauffmann, and Palmer collecting Piranesi prints and a painting of Vesuvius erupting, which he later gave to Harvard University.[24] The collecting activities of this handful of adventurous American travelers were only a faint reflection of the wholesale purchases of Italian paintings and sculpture by the thousands of Englishmen then abroad, who were intent on furnishing their grand country houses with impressive souvenirs of the Grand Tour.[25] Nonetheless, these early collectors deserve to be remembered as important forerunners to the better-known American connoisseurs of Italian art of the mid-nineteenth century, James Jackson Jarves and Thomas Jefferson Bryan, and indeed to the great group of collectors who flourished under the tutelage of Bernard Berenson, beginning with Isabella Stewart Gardner in the 1880s.

John Singleton Copley was contemplating a trip abroad at least by 1765, when he sent *Boy with a Squirrel* (Museum of Fine Arts, Boston) to be exhibited in London. In 1766 West urged him to go to Italy, writing, "nothing is wanting to Perfect you now but a Sight of what has been done by the great Masters."[26] When Copley finally embarked in June 1774, he had received letters of introduction to people in Italy and other suggestions from earlier American travelers including Dr. Morgan, Thomas Palmer, and West himself. West, summing up the taste of his period, wrote Copley:

"In regard to your studies in Italy my advice is as follows: that you pursue the higher Excellencies in the Art, the works of the Ancient Statuaries, Raphael, Michelangelo, Correggio, and Titian, as the source from whence true taste in the arts have flow'd."[27] Copley lived almost a year in Italy, spending six months in Rome, and another in the Naples area, where he visited Paestum, Pompeii, and Herculaneum (see map, p. 259). He painted two commissioned works in Italy: a copy (now lost) made for "an English nobleman" of the Correggio *Madonna of St. Jerome* at Parma, which West had also copied, and a double portrait of the elegant South Carolinians, *Mr. and Mrs. Ralph Izard*, about 1775 (cat. 4), apparently the only full-fledged eighteenth-century Grand Tour portrait painted by an American. The master of Grand Tour portraiture in Rome was Pompeo Batoni, who painted at least two hundred twenty-six such pictures between 1744 and 1785;[28] however none of Batoni's works were more ambitious, or richer in Grand Tour references, than Copley's *Mr. and Mrs. Ralph Izard*, which included both an antique sculpture and a drawing after it, a Greek vase, and the Colosseum, along with splendid contemporary Roman furniture.[29] In Rome Copley also painted a small *Ascension* (fig. 5), describing its execution in a long letter to Henry Pelham; his composition – which was admired both by Piranesi and by the important Scottish painter and dealer in Rome, Gavin Hamilton – was inspired by the *Transfiguration* by Raphael (Vatican Museum, Rome), whom he regarded as "the greatest of the modern painters."[30]

Fig. 5. John Singleton Copley, *The Ascension*, 1775. Oil on canvas. Museum of Fine Arts, Boston, Bequest of Susan Greene Dexter, in memory of Charles and Martha Babcock Amory.

When Copley visited Florence in 1775, he could have seen Johann Zoffany working on his *Tribuna of the Uffizi* (fig. 6), the ultimate Grand Tour picture.[31] This tour de force summarizes the way in which the English-speaking world saw Italy. Crowded with portraits of prominent English tourists in Italy, it suggests something of the attraction of such travel for the English – and by extension, for the distant Americans. For many years, the Tribuna Gallery in the Uffizi was one of the most celebrated places in the artistic world, housing several of the then-undoubted master-pieces of Greek sculpture including the *Venus de' Medici* on the far right of the painting, the *Wrestlers*, the *Dancing Faun*, and the *Knife Grinder* in the left foreground. Zoffany has depicted the small, octagonal gallery imaginatively, including some of the paintings that actually hung there, while adding others from neighboring rooms in the Uffizi and still others from the Pitti Palace, such as Raphael's famous *Madonna della Seggiola* at the far left, in order to present a complete canon of accepted taste. A few years later, in London, Henry Singleton painted his *Royal Academicians Assembled in their Council Chamber* (fig. 7). Seated in the place of honor is the Academy president, Benjamin West, while standing in the right foreground is John Singleton Copley – two Americans who had gone to Italy, then went on to great success in London; surrounding them are plaster casts of the antique sculptures most admired in that day: the *Apollo Belvedere*, the *Laocoön*, and the *Belvedere Torso* (cat. 42, fig. 1), all from the Vatican at Rome, along with the *Discobolus* (Louvre) and the *Venus de' Medici* from the Tribuna, which stands in the *Laocoön's* shadow.

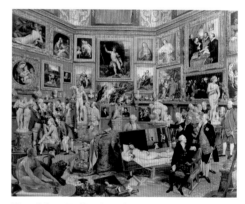

Fig. 6. Johann Zoffany (British, 1733-1810), *The Tribuna of the Uffizi*, 1777-78. Oil on canvas. Royal Collection, St. James's Palace. Her Majesty Queen Elizabeth II.

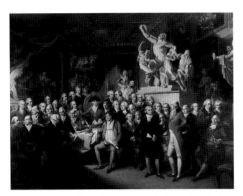

Fig. 7. Henry Singleton (British, 1766-1839), *The Royal Academicians Assembled in their Council Chamber*, 1795. Oil on canvas. Royal Academy of Arts, London.

These paintings by West and Copley, Zoffany and Singleton, are far from being isolated phenomena; rather they speak for the culture of the western world in the last half of the eighteenth century, and particularly for the cult of antiquity that swept it. Classical forms – in painting and sculpture, in literature and government – became the standard by which everything else was judged. Copley's painting of the Izards may be unique, representing a rare conjunction of an ambitious American painter and stylish American patrons finding themselves in Italy at the same moment; yet it also offers insight into American culture at the time. Just as the traveling painters were doing, the Founding Fathers at home "ransacked the ancient world as a usable past for guidelines, parallels, analogies to present political problems, and indeed for partisan politics."[32] Meyer Reinhold writes of eighteenth-century Americans' "tireless and purposeful reading" of the classics "as a repository of timeless models for guidance in republicanism and private and civic virtue."[33] American colleges of the period required for admittance the ability to translate Cicero ("Tully") and Virgil into English. Benjamin West's mentor in Philadelphia, William Smith, provost of the College of Philadelphia – who had urged him to go to Italy – had written that "The History of *Greece* and *Rome* . . . may be justly called the History of *Heroism*, *Virtue*, and *Patriotism*."[34] Alexander Hamilton described Rome as "the nurse of freedom," while John Adams believed that "the Roman constitution formed the noblest people and the greatest power that has ever existed."[35] Similarly, the greatest of American neoclassicists, Thomas Jefferson, looked to Roman models both in his political theory and his architectural practice. As early as 1770, Jefferson developed "an ambitious list of desiderata for 'Statues, Paintings & c.'" which if realized would have made Monticello "the first major art gallery in the New World" (cat. 151); on it, he listed the major pieces from the Tribuna including the *Venus de' Medici* and the *Dancing Faun*, as well as the *Apollo Belvedere* from Rome.[36]

II *Casts and Copies*

American painters of the first half of the nineteenth century, whether or not they went to Italy, learned their craft by making drawings after the best-known of ancient sculptures, and by copying Renaissance and Baroque paintings by Raphael, Correggio, Guido Reni, and a handful of others. The American artists who went to Italy worked directly from the originals in the Vatican, at the Uffizi and Pitti palaces, and elsewhere; however, their compatriots at home necessarily relied on casts of the great sculptures and on copies of the original paintings. The education of the American painter was seen as relying on the availability of the best casts and copies. Thus, when the New York Academy of the Fine Arts was founded in 1801, its primary aim was naturally "to procure Casts in Plaister [sic] of the most beauti-

ful pieces of ancient Sculpture," many of which at the time were in Paris, Napoleon having taken them from Rome in 1797.[37] It was decided that "the first to be procured are the *Apollo Belvedere, Venus de' Medicis, Laocoön, Antinous,* and such other six as the Minister may determine." By January 1803, a [second] corollary aim was proclaimed, to obtain "Good copies from the best masters in the several Schools of Painting, together with a few originals."

Philadelphia, a larger and more sophisticated city, was somewhat in advance of New York. In 1783 the painter Robert Edge Pine had brought to that city from London a cast of the *Venus de' Medici* (see fig. 1), which he kept "shut up in a case, and only shown to persons who particularly wished to see it."[38] In 1796, Joseph Allen Smith, a South Carolinian who lived in Philadelphia, and who later married Ralph Izard's daughter, returned from his Grand Tour of Italy, sending home to Philadelphia "13 cases of valuable paintings — near 3000 gems — some valuable statues, real antiques, & some copies of the most renowned statues of Rome, Florence, & Naples" which he hoped would be "of some service to his countrymen when they should turn their thoughts to the study of Painting & Sculpture,"[39] and in 1807 he gave the collection to the newly formed Pennsylvania Academy of the Fine Arts.

The pattern established by the academies in Philadelphia and New York was followed in Boston and in Charleston, then in Cincinnati, Chicago, and Springfield, Massachusetts, and elsewhere: first casts, then copies, were acquired as the foundation of their collections, and of art education in America. Samuel F.B. Morse wrote from Rome in 1831 that he was busy securing new casts for the National Academy of Design, including ones after Thorvaldsen and Gibson, then among the most admired sculptors in Rome.[40] As late as the 1850s, the *Crayon* was keeping its readers apprised of the new casts at the Academy and of its classes from the antique, and in 1855 in the same journal, Rembrandt Peale (echoing the views of Jonathan Richardson) opined that the casts were frequently more handsome than the "original marbles, which are often soiled and broken."[41]

During the same decade, Herman Melville traveled for three months from Sicily to Venice; once home, he lectured widely on the "Statues in Rome." For the author of *Moby Dick,* the *Apollo Belvedere* was still "the crowning glory": he said, "its very presence is overawing. It gives a kind of visible response to that class of human aspirations of beauty and perfection that, according to Faith, cannot be truly gratified except in another world." Like so many of his contemporaries, Melville admired sculpture more than any other medium; he felt that the *Apollo* and the *Venus de' Medici* marked the high point of that art, writing "Governments have changed; empires have fallen, nations have passed away; but these mute marbles remain — the oracles of time, the perfection of art."[42]

Copying great paintings served multiple purposes, all significant: it helped painters learn how to mix their paints and how to compose and color; it provided practice in painting nudes and allegories, subjects still unacceptable in America.

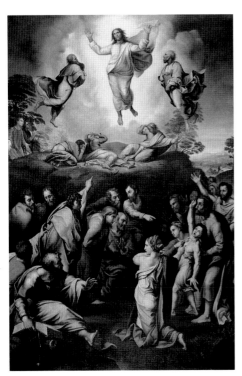

Fig. 8. George Cooke (American, 1793-1849), *The Transfiguration, after Raphael*, 1829. Oil on canvas. Collection of William N. Banks.

Often the copies literally made the artist's trip possible, having been commissioned and paid for in advance of his going; and equally important, they were sent back to America for the enjoyment of patrons, and for the edification of painters unable to make the long journey to Italy. As Vanderlyn wrote, "Copies would be infinitely preferable in every respect, to originals of inferior masters."[43] Samuel F.B. Morse, President of the National Academy of Design, took pride when in Europe (1829-32) in fulfilling numerous commissions from patrons in America for copies; in Venice he devoted himself to copying Tintoretto's *Miracle of St. Mark* (see cat. 55, fig. 1), while in Rome he spent weeks at the Vatican on his copy of Raphael's *School of Athens*. As David Brown has demonstrated, one of the few constants in American taste from the eighteenth century to our time has been an admiration for Raphael: just as West and Copley considered him in the top rank of Renaissance painters, so he was the most frequently copied Renaissance painter in the nineteenth century, and his work was most highly prized by Berenson and the great collectors of the early twentieth century.[44] Rembrandt Peale, though complaining that Raphael was "over-venerated," still made numerous copies of his work, including several of the *Madonna della Seggiola* in Florence (cat. 6). George Cooke, who lived in Richmond, Virginia, for some years, in 1836 exhibited in Charleston "copies from the most celebrated Masters, and original views, executed during a residence of five years in Europe," including his fine copy of Raphael's venerated *Transfiguration* in the Vatican (fig. 8).[45] Robert Weir was making copies on his trip of 1825; William Page twenty-five years later paid for his trip with commissions for copies. The young members of the Hudson River School also were dedicated to painting copies; John S. Casilear in 1840 wrote from Florence on this subject to John F. Kensett: "There are perhaps a greater number of fine pictures here than at Paris but it is difficult to get at them, owing to the great number of applicants. The Fornarina and 'Madonna Sedula'[sic] for example are engaged for two years to come."[46]

Just as eighteenth-century taste had been slow in coming to colonial America (arriving at the earliest in 1728, with Smibert), so it held sway longer here than it did either in England or on the Continent. Though American painters of the nineteenth century turned increasingly to landscape, they continued for many years to believe in the aesthetic theories of Joshua Reynolds, which had been so important to West and Copley — that moralizing, classical, history painting was the noblest form of art; that the best of antique art could be found in Rome and Florence, in the *Apollo Belvedere*, the *Venus de' Medici* and the like.[47]

Over the course of the century following West's arrival in Rome, Reynolds's position in the minds of American artists eroded; by the time of the American Civil War, a very different English critic, John Ruskin, had become authoritative. Yet Americans lost faith in the Tribuna and the classical ideals it represented only very gradually. During the last decades of the eighteenth century, European archaeologists had become increasingly convinced that the famous classical sculptures at the

Tribuna, the Vatican, and the Capitoline Museum in Rome were Roman copies rather than original masterworks by the Greek masters, Phidias and Praxiteles; this tendency was speeded by the arrival in London in 1806 of the Elgin Marbles – the fifth-century B.C. pedimental relief sculptures by Phidias, from the Parthenon in Athens. But Americans tended to ignore this evidence; they believed in the traditional antique canon longer than the artists of any other western nation. Thus, casts of the eighteenth century's favorite antique sculptures made by Caproni and other companies in Boston and New York, found an active market well into the twentieth century (fig. 9).[48]

Washington Allston, arriving in Rome in 1805, reveled in the *Apollo Belvedere* as "a sudden intellectual flash, filling the whole mind with light."[49] Rembrandt Peale in 1829 still found the antique sculptures at the Vatican "a delicious dream" ("above all," he wrote, "the unrivaled *Laocoön*").[50] But James Fenimore Cooper suggested something of the century's changing views when he wrote in his *Gleanings in Europe* (1838) that the Tribuna "contains the most precious collection of ancient art, perhaps, in the world," commenting that everything was a "chef-d'oeuvre," but then adding "though I am far from seeing the necessity of believing that every old statue that is exhumed is an original."[51] Two of the most popular American travel books of mid-century continued the demotion process, Bayard Taylor reporting that he felt "satisfaction," but not "raptures" on seeing the *Venus de' Medici*, and George Hillard in 1853 being "disappointed" with the Venus (he noted "a sort of vacant simper" in her face) and the whole Tribuna, as well as with the Forum at Rome.[52] In 1856 James Jackson Jarves, a key figure for American taste and especially for the lure of Italy, as an art critic, travel writer, and pioneer collector of early Renaissance painting during the 1850s, downgraded the *Apollo* and the *Venus*, "which," he said, "with connoisseurs rank as antiquities of the second class."[53] This process has continued to the present day: the eighteenth century icons – the *Apollo*, the *Venus*, and the others – have lost almost all of their popular attraction; today's visitor to the Vatican can view the *Apollo* and the *Laocoön* in peace and isolation, while a few yards away huge crowds wait to see the paintings of Raphael and Michelangelo. Ironically, as scholarly understanding of classical art and archaeology has grown, as access to ancient sites in the Greek and Roman world has become easier, popular veneration and knowledge of that world has diminished. Though today one sees the best of ancient sculpture at Reggio di Calabria, Athens, Malibu, and elsewhere, and though one can easily visit the Parthenon in Athens and other ancient sites, none of these works – either individually or as a group – has assumed the role once held by the *Apollo Belvedere* and the *Venus de' Medici* in popular estimation. Western culture's loss of faith in these works parallels its rejection of antiquity as a moral and artistic exemplar. The nineteenth century's increasingly negative opinion about the quality of certain long-accepted masterworks parallels a broader phenomenon that W.E. Calder describes: "Between the end of the Revolutionary period with its impassioned pursuit of clas-

Fig. 9. *Showroom of Casts, P.P. Caproni and Brothers, Boston,* about 1911. Photograph.

sical, especially Roman, precedent and 1876, something extraordinarily important happened. American intellectuals ceased to believe the classics."[54]

III *Allston and Irving*

For Allston and his generation, Italy still meant Rome, and for them Rome constituted, as Allston put it, "the great University of Art."[55] Even before he left Charleston to study with West in London, Allston had demonstrated his admiration for the classical landscapes of the seventeenth century; his own earliest pictures, as William H. Gerdts has pointed out, demonstrate his whole-hearted allegiance to the tradition of Claude, Gaspard Dughet, Salvator Rosa, and the Dutch Italianate painters.[56] Like West before him, Allston in Rome joined an international group of artists with which he interacted both personally and professionally. With the following generation of painters, this pattern changed: beginning with Thomas Cole and his contemporaries, visiting Americans increasingly tended to see only other Americans, and as a corollary of this (or perhaps a result), they tended to fall behind the European stylistic mainstream. Allston knew George A. Wallis, the Scot, and he was friends with the French and especially the German painters including Gottlieb Schick and, most likely, Joseph Anton Koch as well;[57] with the best of his contemporaries, Allston practiced in Rome a modern, classical landscape style whose greatest debt is to the art of Nicholas Poussin. Like Koch, he grasped the significance of Poussin's achievement; as Friedlander put it: "Poussin, for the first time in the history of landscape painting, had effectively invested the beauty of nature with didactic experience."[58] The paintings that Allston made in Italy during his only sojourn there, between 1805 and 1808, rely on Poussin for their order and their clarity, as one sees in his architectonic *Italian Landscape* (about 1805, Addison Gallery, Andover, Massachusetts) or his *Italian Landscape* (about 1805, Baltimore Museum); much the same is true for the ones he painted in later years, such as *Italian Landscape*, 1814 (cat. 11), with its dream-like evocation of history and myth, of known places and imagined ones, of reality and imagination together. Allston traveled with his friend Coleridge to the Roman Campagna and to Olevano, a favorite haunt of the German artists; he painted Tivoli and surely studied the lakes of Nemi and Albano — all the hallowed sites near Rome where picturesque, natural landscape was reinforced by important classical ruins, the very places that Claude and Poussin had painted. We should not forget how important Allston's example was for his contemporaries. For much of the nineteenth century he was considered America's greatest painter, and he was always identified with Italy, as one sees in Ralph Waldo Emerson's letter of 1843 to Margaret Fuller wherein he wrote, "Now you have already learned that Allston is dead — the solitary link as it seemed between America & Italy."[59]

Washington Irving, who in the following year became Allston's friend and companion in Rome, arrived in Italy in October 1804, landing at Genoa where he quickly boarded an American ship bound for Sicily. Irving, like Allston, loved banditti legends and imagery; his journal records his excitement when his ship was raided by pirates ("in their countenances the lines of villainy and rapacity were strongly marked. They were armed with rusty cutlasses & stilettos").[60] Surviving unscathed, he proceeded to Sicily, where few Americans had traveled before. In Syracuse, as elsewhere, the remains of antiquity – the Greek theater, the Roman aqueduct, the Temple of Minerva – fascinated him; he was everywhere attentive to Greek and Roman associations. Irving rode on muleback to Palermo, which he found disappointing, but never reached the western end of the island, with its renowned Greek temples at Segesta and Agrigentum. On his way north, in Naples, Pompeii, Herculaneum, Pozzuoli, and then Rome, the young writer made a wide variety of observations, poking fun at Catholic relics and "priest-craft," lamenting the sight of a beautiful young girl "taking the veil," but nonetheless attending Mass at the Sistine Chapel. He criticized the bad inns, the dirt and poverty, but he enjoyed the ravioli in Genoa – one of the rare positive remarks about Italian food by a contemporary American traveler. Later in Rome, Irving and Allston visited Canova's studio together, and greatly admired his work; similarly they delighted in landscapes by Dughet, Poussin, and "the inimitable Claude" (see fig. 10). For Irving, as for many others, the Pantheon represented "the most perfect and beautiful remain of antiquity in Rome." Everywhere Irving saw with the eye of a painter – a profession he considered taking up, under the spell of Allston and Rome; he marveled at the "picturesque scenery" of the Bay of Naples, traveled to Frascati and Tivoli, and was especially taken with the view back across the Campagna toward Rome. Like almost every traveler to come, Irving mused on the contrast between Rome's former greatness and her present, degenerate state; the Rome he experienced was a city of "silent retreats," one "whose deserted streets and solitary temples" encouraged inner reflection.

Just as Irving's itinerary and his attitudes were repeated by numerous later travelers, so the fiction he wrote based on his Italian journals established a precedent that other writers would follow. Irving's *Tales of a Traveller* (cat. 154) includes a number of stories that are set in Italy and make crucial use of local color and detail, especially regarding art and architecture, in their structure and development. In one, Irving describes visiting a gallery in Venice; a "mysterious stranger," a connoisseur whose taste ran to "singular extremes," liked equally the "savage and solitary scenes" of Salvator Rosa and the "softest delineations of female beauty" by Raphael, Titian, and Correggio – much as Allston or Irving himself would have. Irving described the special quality of moonlight on the Piazzetta and the "swelling domes" of San Marco years before American painters would make use of these Venetian subjects.[61] His protagonist in "The Story of the Young Italian" is an artist who loves land-

Fig. 10. Claude Lorrain (French, 1600-1682), *Landscape with Nymph and Satyr Dancing*, 1641. Oil on canvas. The Toledo Museum of Art: Purchased with funds from the Libbey Endowment, Gift of Edward Drummond Libbey.

scape; that of "The Painter's Adventure" is an historical painter who assists in archaeological digs and who broods over "the melancholy Campagna." Perhaps not coincidentally, when Allston himself turned to writing fiction, in his novel *Monaldi* (cat. 156), he developed an Irvingesque plot dealing with art and intrigue: his hero, Monaldi, a master painter with a pure and noble character, is ruined by the schemes of his conniving rival Maldura, and because he loves the beautiful Rosalia (or Italy) too deeply. This theme – of the attraction of Italy versus its risks, the play of its sensuous surface charms against the fact of its unknowable, potentially destructive depths – would be carried on in the work of Cooper, Hawthorne, Howells, and James, and it would become a matter of concern for artists as well.

For information about Italy, American travelers in the early years of the nineteenth century relied on books both fictional and factual published in England and elsewhere, due to the paucity of American publications on the subject. In Rome Irving knew Madame de Staël, whose novel *Corinne, or Italy* (1807) attracted a generation of American readers with its portrayal of the coldly rational, judgmental, constrained English struggling with the spontaneity and sensuality found in Italy. Goethe's classically oriented Italian tour of 1786-88 appealed to the American imagination, and became known through his journal, which was published as *Italian Journey*, in 1816-17. Even more alluring for American readers was Lord Byron, whose *Childe Harold's Pilgrimage* was published in 1818; years later Longfellow and others were still carrying *Childe Harold* as a kind of guide book. For Byron, Italy was "the home/ of all Art yields, and Nature can decree . . . Thy wreck a glory, and thy ruin graced." Celebrating Dante and Petrarch, Tasso and Tully, the *Apollo Belvedere* and the Pantheon, the lakes at Nemi and Albano, Byron echoes Claude and anticipates Cole; contemplating Rome, he concludes, "There is the moral of all human tales; 'Tis but the same rehearsal of the past."[62]

American travelers in Italy during the first decade of the nineteenth century were likely to reflect the tradition of the aristocratic eighteenth-century Grand Tour rather than the democratization of travel that was to come. As John Lowell (1767-1840) of Boston wrote from Rome in 1805, "For more than a century past, this city has been the fashionable resort of all the young men of fortune of every other nation in Europe. Frequently possessing very little understanding, and still less learning, they invariably carry with them the opinion, that it is very pretty, and indeed necessary, to be connoisseurs; and to prove it to their less happy countrymen upon their return, by their collections of antiques and objects of the fine arts, brought directly from the source of all taste, Rome."[63] Similarly, Joseph Carrington Cabell, a Virginian who later worked closely with Jefferson, went abroad on a classic Grand Tour in 1802 shortly after graduating from the College of William and Mary; he studied at a half-dozen universities during his three years abroad, collected works of art, books, and bric-a-brac, and met prominent citizens of every nationality along the way. In Rome he knew both Allston and Irving well, and later he traveled with

the latter; when he had his bust sculpted, he gave a replica to each. Cabell's reaction to the Italian landscape, however, marks him as a man of the nineteenth century, one whose attitudes foreshadow those of Byron and Cole. Seeing the Campagna, he wrote in his journal, "Gracious God what a spectacle. A country naturally the finest possible, & once the most populous & best cultivated part of Italy, now a naked waste." Cabell concluded: "How the soul fills at this sight with a thousand contrary emotions & reflections – admiration for the past – indignation for the present – the rise & the fall of empires – the instability of human affairs – the effects of superstition & ignorance – Oh! what a lesson for a citizen of America."[64]

John Izard Middleton provides another important link between eighteenth-century classicism and nineteenth-century Romanticism. Middleton, who knew Madame de Staël in Rome and was her houseguest in Switzerland, was related to Ralph Izard, and provides yet another example of the special connection between Charleston and Rome. As Charles Eliot Norton, who called Middleton "the first American archaeologist," explained, "When Mr. Middleton sets out from Rome to Albano, the Roman poets are his chosen companions, while the road and the scene derive their chief interest for him from their ancient poetic and historic associations."[65] Twenty-two of Middleton's watercolors were reproduced as lithographs in his book of 1812, *Grecian Remains in Italy* (cat. 152), much of which is devoted to the monumental pre-Roman "cyclopean walls" at Segni, Alatri, and Cori. Working in a restrained, classical style recalling Wilson and the mid-eighteenth century English manner, Middleton also painted distant views of Naples and Vesuvius, Paestum, and Tivoli, as well as making the earliest American depictions of Sicily, including a sweeping view of the ruins of the Greek theater at Taormina with Mt. Etna in the distance (fig. 11), which anticipates Cole's famous picture of the scene (cat. 46) by some twenty-five years.

Fig. 11. John Izard Middleton, *Greek Theater at Taormina with Mt. Etna in the Distance*, 1818. Watercolor. Private Collection.

IV Thomas Cole and the Hudson River School in Italy

Thomas Cole's arrival in Florence in June of 1831 marks the beginning of a new epoch in terms of the American experience in Italy. When he first went, in 1831, Cole was already the acknowledged leader of the American landscape school; he provided a model for the later landscapists, many of whom followed his footsteps around Italy painting the sights he had favored. Cole became the first American artist to receive a "steady stream of commissions from wealthy Americans travelling abroad."[66] Unlike Morse, Rembrandt Peale, and almost all of his predecessors, Cole made almost no copies in Italy – a fact he noted with pride; though he said that "the works of the Old Masters have been my greatest study and admiration," he had higher ambitions for American painting than copying implied.[67] Though he ranked the *Apollo*

Belvedere among "the most perfect of human productions," writing, "the things that most affect me, in Rome, are the antiquities," he spent more time — unlike any American painter before him — in Renaissance Florence than in classical Rome; he loved it for its "magnificent works of art," its "quietness and seclusion," and for offering a "delightful freedom from the common cares and business of life — the vortex of politics and utilitarianism, that is for ever whirling at home."[68]

Cole viewed Claude Lorrain as "the greatest of all landscape painters,"[69] but he led the American landscape school away from the imaginary classical imagery of Claude and Gaspard Dughet and toward the equally venerable (and often interconnected) tradition of the Italian *veduta*, which had been brought to maturity by Gaspar van Wittel, called "Vanvitelli," a Dutch painter who arrived in Rome in 1674. As Peter Galassi points out, "The *veduta* is an exact counterpart of the guidebook. Parallel to the itinerary is the repertory of *vedute*, a standard series of views, each representing a famous place."[70] The *veduta* itself could be either a *capriccio* — an imaginary combination of real views — or a *veduta esatta*, which was topographically accurate. A few of Cole's Italian paintings, such as *Dream of Arcadia* (cat. 13) are wholly simulated and look back to the classical tradition of Claude, but the vast majority — including his views of Florence (cat. 76) and Sicily (cat. 46), and even his poetic compositions such as *L'Allegro* (cat. 14) and *Il Penseroso* (cat. 15) depict accurately observed topography and thus fall to varying degrees within the *veduta* tradition. By the time Cole reached Italy, the traditions both of the *veduta* and of outdoor sketching near Rome had become highly formalized, having been practiced by several generations of artists from all parts of Europe; but the Americans saw Italy with the eyes of discoverers from a far-off land, and for a time they brought new energy to the painting of its hallowed places.

Cole at the same time was a humanist in the tradition of Joshua Reynolds, who had lectured that "like the history-painter, the painter of landskips . . . sends the imagination back into antiquity."[71] For Reynolds, painting can rank with its "sister," poetry, if the artist remembers that "it is not the eye, it is the mind, which the painter of genius desires to address."[72] Cole was a reader of Reynolds, of Archibald Alison (1757-1839), the influential Scottish associationist, and of Alison's American follower, William Cullen Bryant; the themes of *ut pictura poesis* (as with painting, so with poetry) and of associationism were much in his thoughts. In his journal, Cole paraphrases Alison's *Essays on the Nature and Principles of Taste* (1790) when he writes, "The conception and reproduction of truth and beauty are the first object of the poet; so should it be with the painter."[73] Alison had stressed that nature is beautiful or sublime only when it makes human reference, and only when moral or religious conclusions are drawn. Cole's *Essay on American Scenery* is a reprise of Alison's theories of association, applied to the natural landscapes that Cole knew best, those of Italy and of the United States. Echoing Alison, Cole wrote: "He who stands on Mont Albano and looks down on ancient Rome, has his mind peopled with the gigantic

associations of the storied past."[74] Italian landscape is taken as the standard; the major question for Cole becomes whether an art can derive from an American wilderness "destitute of those vestiges of antiquity, whose associations so strongly affect the mind."[75]

On Cole's first trip to Italy, he painted two views near Tivoli, *Cascatelli at Tivoli* (fig. 12) and *A View Near Tivoli, Morning* (cat. 57). Tivoli, eighteen miles east of Rome, provided an archtypal subject: it had been sketched and painted by Claude and Dughet two hundred years earlier, and in more recent years by Wilson and Turner, by Vernet and Corot.[76] Madame de Staël had located Corinne's house in Tivoli, "the dwelling place," she wrote, "of so many celebrated men – Brutus, Augustus, Maecenas, Catullus, and especially Horace," on a hill opposite the Temple of Sybil.[77] Cole's contemporary, the landscape painter Christopher P. Cranch, noted in his journal: "I have not seen any place that combines so much a landscape painter can make use of as Tivoli. There is a great ravine with the old picturesque town overlooking it, and its one beautiful relic of classic times, the Sibyl's temple. There are the grottos, the deep weird chasms, there are the numerous beautiful cascades. There are the beautiful views of the Villa of Maecenas and the distant Campagna, with the dome of St. Peter's looming up on the far horizon. There is the Villa d'Este."[78] Almost no other site in Italy was so rich in historic associations, and it became a favorite American subject. Washington Allston and Rembrandt Peale (see cat. 5, fig. 1) had both painted Tivoli before Cole did, but it was Cole's horizontal *Cascatelli at Tivoli* that established the norm for later Americans. His view reflects Gaspard Dughet's *Tivoli* (fig. 13), executed in the 1650s, whose composition was repeated by J. M. W. Turner, Samuel Palmer (fig. 14), and many others;[79] equally important, Cole's painting makes use of a compositional formula that he had used frequently before in paintings such as *Sunny Morning on the Hudson River* (1827, Museum of Fine Arts, Boston), in which the left half of the canvas is devoted to foreground and to a mountainous middle-ground, while the right half opens out to a distant, flat horizon. As he would typically do, Cole chose for himself – and for the American audience – a picturesque subject with well-known classical references, then depicted it within a compositional format as familiar to the American audience as possible. As he made clear in his *Essay on American Scenery*, Cole sought just the same kind of subjects – lakes, mountains, river valleys, waterfalls, and sunsets – whether in Europe or America; for Cole, as for Claude before him, a suitable landscape must have the right combination of picturesque beauty and historic (or even future) associations. Thus Lake George, Niagara, and the Catskills became the American equivalents to Tivoli, Nemi, and the Campagna.

When later American landscapists came to Italy, they typically sought out the views that Cole had painted. Variants of his composition in *Cascatelli at Tivoli* were employed by George Loring Brown (cat. 58), Joseph Ropes, and Sanford Gifford. Similarly, Cole's *View Near Tivoli, Morning* (cat. 57), depicting the "Arch of Nero,"

Fig. 12. Thomas Cole, *The Cascatelli, Tivoli, Looking Towards Rome*, about 1832. Oil on canvas. Columbus Museum of Art, Ohio, Gift of Mr. and Mrs. Walter Knight Sturges and Family.

Fig. 13. Gaspard Dughet (French, 1615-1675), *Tivoli*, late 1650s. Oil on canvas. Oxford, Ashmolean Museum.

Fig. 14. Samuel Palmer (British, 1805-1881), *Tivoli and the Campagna of Rome*, 1838. Graphite, black crayon, watercolor and gouache on paper. The Toledo Museum of Art, Museum Purchase.

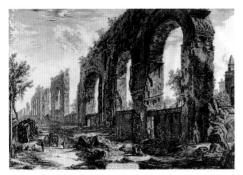

Fig. 15. Giovanni Battista Piranesi, (Italian, 1720-1778), *The Aqueduct of Nero Leading to the Palatine, a Branch of the Aqua Claudia*, 1775. Etching. Museum of Fine Arts, Boston, Bequest of Alfred Greenough.

Fig. 16. Worthington Whittredge (American, 1820-1910), *Aqueducts of the Campagna*, 1859. Oil on canvas. Cincinnati Art Museum, Bequest of Caroline Hooper.

which he himself painted again in 1846 (Newark [N.J.] Museum), was emulated in later years by Jasper Cropsey, Jervis McEntee, George Inness, and by Gifford again. Or to suggest another example, the Torre dei Schiavi (Tower of the Slaves) (cat. 52) had been depicted by Cole, then by numerous other Americans, again suggesting the high regard in which the Hudson River School held Cole, the strength of the *veduta* tradition, which encouraged repeated pictures of the same classic views, and arguably also the relative lack of adventurousness of the American landscapists in Italy.[80] Perhaps the most significant of all of these "American" landscape subjects in Italy, however, was the view of the aqueducts, built around A.D. 50 by the emperor Claudius, that stretch across the Campagna from the walls of Rome to the Sabine Mountains some twenty miles to the east. One finds them depicted in the distant background in Claude Lorrain's paintings; Tischbein included a section of aqueduct in his famous portrait of *Goethe in the Roman Campagna*, 1787,[81] and other Germans also depicted them, as did both Turner and Corot — but for most of these painters they were simply a minor detail in a larger landscape setting. However, G.B. Piranesi, the master of the *veduta*, had included an aqueduct view (fig. 15) in his famous series of etchings, *The Views of Rome*, which he published between 1748 and 1778. For Cole the subject also became a meaningful one. On his earlier trip he painted *Aqueduct Near Rome*, 1832 (cat. 45), a view of the ancient Claudian ruin stretching southward, anchored at one end by a medieval watchtower, the Torre Fiscale (Cole again suggesting the overlay of civilizations), with the rhythmic arches glowing in the late afternoon light. It was highly praised when exhibited in New York in 1833, as Ellwood Parry writes, and three years later Nathaniel Parker Willis called it "one of the finest landscapes ever painted."[82] With a skull visible at lower left, the elegiac message of the picture is clear: in Rome Cole had formed the idea for his *Course of Empire*, and in *Aqueduct Near Rome* he also reminisces on the glory that was Rome — on human vanity; on the beauty of the evocative, ancient ruins; and on the desolate, empty landscape itself.

Just after his second trip in 1841-42, Cole executed another view of the aqueducts entitled *Roman Campagna* (see cat. 45, fig. 1), a more romantic work showing the ruins, now without the anchoring Torre Fiscale, in the warm, raking light of early morning. His stylistic change over a decade, as illustrated by these two works, suggests the direction that the whole landscape school would take, toward the Beautiful and away from the Picturesque, toward a more accessible, more luminous, gentler landscape, away from a classical, moralizing one. These two paintings by Cole presaged similar compositions of the same scene made by nearly a dozen other Americans, including Benjamin Champney, Cropsey, Gifford, J. L. Tilton, Whittredge (fig. 16) and Inness. One senses in these works a slowly diminishing conviction about the importance of the subject itself, as the associationist tradition represented by Alison weakened. Though the *Crayon* and other journals continued through the 1850s to speak of the high moral duty of art, and though Tuckerman in 1867 was still advo-

cating the necessity of the painter being "by nature, a poet also," light and form gradually became dominant, and the importance of history and of the antique receded.[83] Cole had decried "mere leaf painting," but under Ruskin's new influence, that was the direction of the future.

One can see the same change of attitude in the comments of American writers. Cole's contemporaries shared his interest in the Campagna. Washington Irving, for example, spoke of "the silent deserted Campagna, formerly so celebrated, now a barren unwholesome waste."[84] Cole's friend James Fenimore Cooper had also been moved by the scene, comparing it to "a prairie of the Far West," and then writing: "The deserted appearance of the surrounding country, the broken arches of the aqueducts, and perhaps the recollections, threw around it a character of supreme solitude."[85] But attitudes began to change during the 1850s; William Wetmore Story, for instance, wrote of Rome as "a watering-place," with a "stream of strangers that pours annually into the hotels" (see cat. 163). For Story the Campagna is still "the most beautiful and the most touching" of sights; but he remarks that it has become a completely familiar area, to which "the whole world of Rome flocked"; he prefers the Anio Novus to the Claudian Aqueduct, and recommends getting off "the dusty highway of travel" to see ruins of aqueducts away from the Campagna, in the nearby mountains.[86] The Campagna, like the classical world itself, continued to lose sway over the imagination during subsequent decades. For Henry James, in his "Roman Rides" of 1873, the Campagna was seen as "more solemn and romantic than ever," but now it was a place where one rode with friends in carriages or on horseback, courting, sight-seeing, or picnicking; still, as James remarked, "at your side, constantly, you have the broken line of the Claudian Aqueduct, carrying its broad arches far away into the plain."[87] Similarly, the painter David Maitland Armstrong, American consul in Rome from 1869 to 1872, described long foxhunts on horseback across the Campagna, where the Roman nobility in red coats and high hats were joined by a variety of the English and Americans in the city (including the sculptor Harriet Hosmer) — a far cry from the empty, malaria-ridden desolation depicted by Irving.[88]

Americans were late in taking up the tradition of the *plein-air* sketch in Italy, a practice that began in the seventeenth century but became well-established only in the late eighteenth century in the hands of Thomas Jones and Pierre-Henri de Valenciennes.[89] Cole paid homage to this tradition in his oil study depicting the much-admired seventeenth-century painter, Salvator Rosa, sketching outdoors (cat. 131), but when Cole himself worked *en plein air* (see fig. 18) he mostly made pencil rather than oil sketches. His compatriot Samuel F.B. Morse made one extraordinary oil sketch (cat. 55) that rivals the work of his European contemporaries in Italy, but Morse never followed up on its implications. Among later members of the Hudson River School in Italy, Gifford, Bierstadt, Cropsey, Hotchkiss, and finally Church during his trip of 1868-69 all were enthusiastic practitioners of the medium.

Fig. 17. Thomas Cole, *The Temple of Segesta with the Artist Sketching*, about 1842. Oil on canvas. Museum of Fine Arts, Boston, Gift of Mrs. Maxim Karolik for the Karolik Collection of American Paintings, 1815-1865.

Fig. 18. Thomas Cole, *The Temple of Segesta with the Artist Sketching*, detail.

Fig. 19. Samuel F.B. Morse, *The Brigand Alarmed. Scene on the Road from Rome to Naples*, about 1830. Oil on canvas. Courtesy of Anthony P. Collins.

Cole sketched in pencil at lakes Nemi and Albano south of Rome, Claudian subjects that had been so popular with the English during the eighteenth and early nineteenth centuries, and that would be painted by many Americans; and he painted at a number of non-Roman sites as well. When he was in Sicily on his second trip (1841-42), he made sketches in both pencil and oil for his great *Mt. Etna from Taormina*, 1844 (cat. 46), again taking up the popular, oft-depicted view of the volcano; and as before, a number of Americans followed suit. In addition, he also made the arduous trek to the eastern end of Sicily, where he drew the Greek temple at Segesta (fig. 17). Cole also painted several Florentine scenes including *View on the Arno*; he made at least five replicas of this sunset view of sky and water, testifying to its popularity among American traveler-patrons, but in this case, surprisingly, no other American painter repeated his composition. During the 1830s, he also executed his extraordinary *View of Florence from San Miniato* (cat. 76), again the common, popular view of the city, a staple of the *veduta* tradition that had been painted and engraved many times, by Turner among others. This picture, too, inspired no imitations; this may be explained more easily than with *View on the Arno*, for the panoramic view of Florence simply required more ability with perspective and especially with rendering architecture than any other American landscapist of the period possessed.

It should not be implied that Thomas Cole's example determined everything that happened afterwards in American landscape painting. He never went to Venice, Byron's hedonistic, anti-classical "fairy city," as G.L. Brown, Gifford, and numerous others did. Nor did he travel across the Bay of Naples to the gloriously picturesque, sunlit island of Capri, which later became such a favorite of Bierstadt, Gifford, and Haseltine. Neither of these missed opportunities is surprising, given Cole's generally historical, moralizing approach. However it does seem peculiar in retrospect that he never painted perhaps the single most-painted view in Italy, one that had been a favorite of painters from all the European countries in both the eighteenth and nineteenth centuries: the Bay of Naples.[90] The view of Vesuvius across the bay from either north or south was wonderfully picturesque, and the area was rich in historic associations, with the Greek and Roman ruins at Baia, Pozzuoli, and Cuma (with its Cave of the Cumaean Sybil), the Lake of Avernus, the "Tomb of Virgil," and the "Grotto of Posillipo," as well as nearby Pompeii and Herculaneum. Both Robert Weir and Cole's friend Samuel F.B. Morse had painted views of Naples, Morse's being an unusual, romantic picture of a fugitive brigand in a cave near Naples (fig. 19). Cole himself painted the Greek temples at nearby Paestum, but though he made detailed sketches of Vesuvius and the Bay of Naples, he never made a painting of this much-depicted scene. According to Noble, he couldn't get permission to make the necessary, detailed drawings "from the castle that commands the town," and so gave up the project.[91] Perhaps not coincidentally, this subject was never painted by his successors in the Hudson River School, though it was done by

several of the expatriates including George Loring Brown and John Gadsby Chapman (fig. 20) — non — New York painters whose agenda and patronage were quite different than those of Cole and his followers.[92]

Though a few artists, beginning with Cole, painted the Colosseum at Rome, and though Cropsey (who had been trained as an architect) essayed several views of the Forum (cat. 24) the Americans in general avoided both architectural compositions and urban scenes, thus cutting down on the number of traditional *veduta* subjects available to them. The ruins on the Campagna or the moldering temples at Paestum or Segesta — places where landscape dominated and iconographically important buildings could be included in small or medium scale — were acceptable; but the Americans were primarily landscapists, and they tended to paint a narrow range of conventional views. American painters in Italy before 1870 tended to act conservatively, even cautiously, once they got there, perhaps — as Tuckerman suggested — because they had come so far, and because the experience meant so much. The British and Germans, for whom Italy was so much more accessible, ranged far more widely during the nineteenth century; for example, no American was nearly as adventurous or as prolific as such Englishmen as Edward Lear, who during these same years of the nineteenth century painted in every corner of Italy, Greece, Egypt, the Near East, and India. Or to suggest another example, Denmark — which was almost as distant from Italy as was the United States, in cultural terms — was represented by an active contingent of painters there through the first half of the century, led by Christoffer Wilhelm Eckersberg and later Constantine Hansen. Yet the Danes depicted Rome and its citizens without the inhibitions shown by the Americans, painting its fountains and squares, courtyards and street scenes, ancient temples and Baroque churches, making panoramic views of the city, recording its famous villas and churches — all subjects largely unknown in American painting. One exception that proves the rule is Albert Bierstadt's *Arch of Octavius (Roman Fish Market)*, 1858 (cat. 28), a rare American depiction of an urban genre scene, one that is successful both in its portrayal of the street and its buildings and figures, including a tourist couple at the right. Another anomaly is George Cooke's huge *Interior of St. Peter's*, 1847 (fig. 21); American painters in Rome before 1860 also almost never portrayed either the interior or exterior of a church, either because they were wary of undertaking architecture, which was difficult to render, or because they were generally Protestants who felt antipathy to Roman Catholicism.

Nearly every American who left behind a journal of his travels in Italy before 1870 recorded some degree of aversion to Catholicism.[93] Beginning with John Morgan, Protestant Americans found the Catholic religion to be superstitious and idolatrous, and they were inclined to blame upon it all of Italy's contemporary problems, from her lack of a democratic government to the corruption, poverty, ignorance, idleness, and widespread begging they observed. Perhaps the earliest published travel diary by an American, the 1805 volume of Joseph Sansom, is virulently anti-

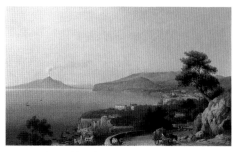

Fig. 20. John Gadsby Chapman, *Vesuvius from Marina Grande, Sorrento*, 1870. Oil on canvas. Peter Tillou Fine Arts Gallery, London.

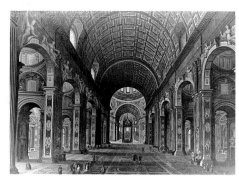

Fig. 21. George Cooke (American, 1793-1849), *Interior of St. Peter's*, 1847. Oil on canvas mounted on panel. Georgia Museum of Art, The University of Georgia, Gift of the Daniel Pratt Family.

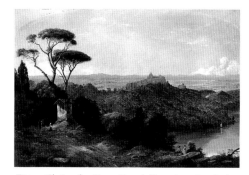

Fig. 22. Christopher Pearse Cranch (American, 1813-1892), *Castle Gondolfo, Lake Albano*, 1852. Oil on canvas. Corcoran Gallery of Art, Washington, D.C., Gift of William Wilson Corcoran.

Fig. 23. Theodore Wores (American, 1859-1939), *Interior of St. Mark's, Venice*, about 1881-82. Oil on canvas. Collection of Mrs. Ben and A. Jess Shenson.

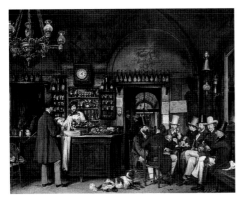

Fig. 24. Ludwig Passini (Austrian, 1832-1903), *The Caffè Greco, Rome*, 1856. Watercolor. Kunsthalle, Hamburg.

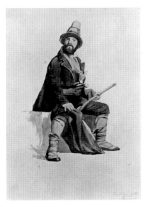

Fig. 25. John F. Kensett (American, 1816-1872), *Costume of the Brigand*, about 1845-47. Pencil and watercolor on paper. Huntington Library, Art Collections and Botanical Gardens, San Marino, California.

Catholic.[94] Samuel F.B. Morse, typically, criticized the "superstitions" of the Church, "idolatrous worship of the Virgin," and "monotonous" religious ceremonies; observing a procession of monks, he observed, they seemed "like disinterred corpses . . . pale and haggard and unearthly, the wild eye of the visionary and the stupid stare of the idiot were seen among them."[95] Yet Morse was among the earliest Americans to paint Italian peasants at a Catholic roadside shrine in a sympathetic manner (cat. 56), a theme that Thomas Cole, John F. Kensett, Christopher P. Cranch (fig. 22), and a number of others took up. Moreover, Morse — again like most of his countrymen in Italy — attended numerous ceremonies at St. Peter's, the Sistine Chapel, and elsewhere, especially around Christmas and Easter, and repeatedly he reports being moved by the music and the ritual. Almost every American traveler visited St. Peter's on the first day in Rome, typically marveling at its size and beauty, then returning again and again; many had audiences with the Pope. Some, like Cooper, grew sympathetic to Catholicism; a few became as entranced as the painter James de Veaux, who wrote "how rapidly the imposing and solemn splendor of this religion grows on one!"[96] Nonetheless, Robert Weir's *Taking the Veil*, 1863 (cat. 31) is one of the very few American representations of a ceremony inside a Catholic church in Rome. However, during the 1860s and afterwards, a number of Americans including John Singer Sargent (cat. 115), Theodore Wores (fig. 23), David Neal, and George Henry Yewell did paint the interior of St. Mark's, Venice, in some cases even including kneeling, praying figures; these subjects became increasingly acceptable as immigration during the last third of the century increased the number of American Catholics, and as Americans gradually became more tolerant.[97]

The number of American travelers in Italy grew steadily from 1825 to the end of the century.[98] By the 1830s, and especially in subsequent decades, there were active communities of American artists in Florence and Rome, led by the sculptors, who were the first to settle there permanently: Greenough and Powers in Florence, Crawford and later Story in Rome. The American artists in Rome lived together, or near one another, usually in the area around the Spanish Steps, and during the winters, socialized together at the Trattoria Lepre and the Caffè Greco (fig. 24); in the warmer months they went on sketching tours to Tivoli and the Alban hills, or to Naples and Capri; just as at home they would go to the Catskills or the White Mountains. In Rome, they studied life drawing together at the Academy of Saint Luke, the Italian Academy, the British Academy, or the French Academy — all of which were more or less hospitable to visitors. During the forties, Christopher Pearse Cranch, John F. Kensett, Benjamin Champney, and other Americans, probably including Thomas Hicks and Luther Terry, gathered frequently at "a night-school where students drew and painted in watercolors from costumed models," as Cranch reported.[99] The models would don varying costumes specific to such locales as Subiaco, Albano, Cervara, and so on — thus making possible authentic studies which the artists could use later in their paintings (fig. 25). The American painters

generally looked down on their Italian contemporaries, and criticized their work. They did not tend to mix with the artists of any other nation, but rather, socialized and worked with other Americans (see fig. 26). Thus, during the 1850s, Haseltine, Gifford, Bierstadt, and Whittredge traveled and sketched together (see fig. 27), as Hotchkiss, Tilton, and Maitland Armstrong did in the mid-sixties. Church, McEntee, Healy, Gifford, Thomas B. Read, and George H. Yewell formed a close group in Rome in 1868-69. One of the richest and last of American Grand Tour pictures was the collaborative effort of the portraitist Healy working with two landscape painters, Church and McEntee, in painting the *Arch of Titus* (cat. 40). This ambitious work includes portraits not only of each of the painters, but also of the much-admired American poet, Henry Wadsworth Longfellow, and his daughter, who were then in Rome. This painting is exceptional, for few Americans had their portraits painted in Italy, and when they did so, they were likely to turn to Italian painters. Thus, when Charles Izard Manigault, grandson of the Ralph Izards, was in Rome with his wife and children in 1831, he commissioned a family portrait from the Roman painter Fernando Cavalleri (fig. 28).

Thomas Cole, even in 1832, had found in Italy enough tourists from home to provide significant patronage, and this phenomenon grew as the number of travelers increased. Then as now, Americans abroad were more likely both to look at art and to buy it than they would be at home. As William Cullen Bryant reported from Rome, "Men who would never have thought of buying a picture or statue at home, are infected by the contagion of the place the moment they arrive."[100] Jarves in 1856 similarly theorized that American artists were drawn to Florence because American tourists were more likely to buy a painting in Italy than in their native land.[101] As Alicia Middleton wrote from Florence in 1835, American moral and artistic standards were more flexible abroad: "[We] go to the different galleries, look at beautiful pictures and statues which would have *horrified* us at home."[102] Sculpture was still considered the noblest art, but interest in painting was on the rise, and the resident Americans in those cities, including George Loring Brown, who had moved to Italy in 1840; John Gadsby Chapman, who came in 1848 (see fig. 29); Tilton; Haseltine; and later on Vedder and Coleman found enough patronage to enable them to live well abroad.[103] Brown, for example, painted some thousand pictures, repeating over and over again the same views, sometimes in sets of four depicting Rome, Florence, the Bay of Naples, and the Grand Canal in Venice. For the painter, life could be easier abroad; as Chapman wrote, "[In Italy I am] free from the wearing toil that I formerly endured in New York." As a reviewer said of Chapman, "Few of his works are visible in our exhibitions; but they are widely distributed throughout the country. Travellers possess them to the greatest extent."[104] *The Crayon* confirmed this pattern, when an anonymous writer reported from Europe in 1855 "that the American artists in Italy . . . obtain the greater portion of their support from their countrymen making the grand tour."[105] The expatriates naturally painted what the tourists

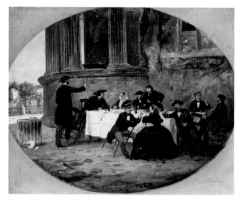

Fig. 26. Wilhelm Wider (German, 1818-1884), *Che Bella Giornata!*, 1856. Oil on canvas. Courtesy, Sotheby's, Monaco. A group of artists dining with American visitors to Rome including Mrs. Peabody of Boston and Mr. and Mrs. Sherman of Newport.

Fig. 27. Sanford R. Gifford, *Bierstadt Sketching at the Piccola Marina, Capri*, 1857. Graphite on paper. Private Collection.

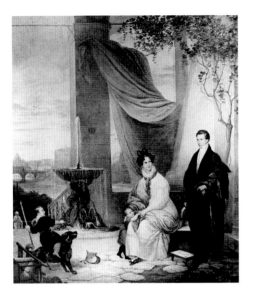

Fig. 28. Fernando Cavalleri (Italian, 1794-1865), *Charles and Elizabeth Heyward Manigault and their children in Rome*, 1831. Oil on canvas. Courtesy Gibbes Museum of Art/Carolina Art Association, Charleston, South Carolina.

Fig. 29. John Gadsby Chapman, *John Gadsby Chapman in his Studio*, 1881. Etching. Valentine Museum, Richmond, Virginia.

wanted, thus far more than their contemporaries in New York they tended to paint replicas of their own successful, standard views. Moreover, to judge from the work of Chapman and Brown, the cultural forces at home that led to subtle but real and ongoing changes in the style of a Gifford or a Kensett were largely lacking abroad. The Hudson River School during the 1850s developed a more highly realistic, topographically detailed style; but frequently the expatriates failed to take part in this trend, Tuckerman reporting of Brown, for example, that "the greater portion of [his Italian] works are compositions, many of them representing felicitous combinations of Italian scenery."[106]

Thomas Cole was also the first American painter to be warned against traveling abroad, not because of the danger of banditti, but because of the risks to his American style, his American way of seeing. William Cullen Bryant, then America's leading poet, in 1829 wrote "To Cole, the Painter, Departing for Europe," pleading with the artist to "keep that earlier, wilder image [of American wilderness] bright" (though Bryant himself later traveled to Italy four times, lectured frequently on ancient Greece and Rome, and translated the *Iliad* and the *Odyssey*). Bryant's nativist attitude had considerable precedent. Benjamin Franklin in the eighteenth century was a well-known anti-classicist, on one occasion commenting, "It's better to bring back from Italian travel a receipt for Parmesan cheese than copies of ancient historical inscriptions."[107] St. John de Crevecoeur in *Letters from an American Farmer* (1782) similarly criticized as "useless" the "viewing of temples and other buildings" in Italy.[108] The debate was not so much between individuals or schools of thought, however, as within the developing Americans consciousness itself. William Dunlap spoke of his own doubts on the matter, thinking first that travel to Italy was unnecessary for the American painters, then changing his mind on seeing the work that Cole and Morse returned with in 1832.[109] Ralph Waldo Emerson concluded oppositely, ("we have listened too long to the courtly muses of Europe"), but only after taking a Grand Tour from Sicily to Rome, Venice, and Milan with Goethe's *Italian Journey* under his arm, and then thanking God on its conclusion for having led him through "this European scene, this last schoolroom."[110]

Henry Tuckerman and James Jackson Jarves, the leading American critics of midcentury, were both lovers of Italy, and both believed in Italian travel and even residence for the American artist. However their view increasingly represented a minority opinion, as other writers more and more took up a nativist stance. William J. Stillman, caustically reviewing Jarves's book *Art Hints*, proclaimed that "Art is *not* to be carried to America at all, but if genuine, must spring up in it," and concluded, "the study of the grand galleries has made shallow critics and mannered artists, and always will do so."[111] Or to take another example, Cole's friend Asher B. Durand in the 1850s advised the young landscapists of America, "Go not abroad then in search of material . . . while the virgin charms of our native land have claims on your deepest affections." Durand's Italian pictures (like those of William L. Sonntag and

Robert S. Duncanson) are imaginary Arcadian scenes, that look to the classical, Claudian tradition rather than that of the *veduta*. Taking up the Ruskinian aesthetic and turning to American scenery during the 1850s, Durand came to reject Cole's example; during this period, he disparaged "the picturesque in the gorgeous city of domes and palaces, or in the moldering ruins" as being more useful to "the tourist and historian" than to "the *true* landscape artist," and he opined that Claude might have been greater if only his paintings had been more "true."[112] Finally, Margaret Fuller, who loved Italy as much as any American, wrote in 1849, "Then why should the American landscape-painter come to Italy? – cry many. I think, myself, he ought not to stay here very long."[113] Even the optimistic Tuckerman had equivocated on the work of such expatriates as Chapman and Brown (saying of the latter, "we are far from regarding his style as faultless. Sometimes there is a too obvious striving for effect"),[114] and Fuller was more straightforward; she described several of Brown's paintings as "coarse, flashy things," then commented, "I was told he could do better, but a man who indulges himself with such coarse sale-work, cannot surely do well at any time."[115]

Nathaniel Hawthorne deals with many of these questions in his novel of 1860, *The Marble Faun* (cat. 162). In his well-known preface, the writer echoes Cole's *Essay on American Scenery* in describing the problems faced by the artist in America: "No author . . . can conceive of the difficulty of writing a Romance about a country where there is no shadow, no antiquity, no mystery, no picturesque and gloomy wrong"; he finds Italy the very opposite, "a sort of poetic or fairy precinct," thus more congenial to his creativity.[116] Though Hawthorne takes his title from the *Faun of Praxiteles* (fig. 30), then one of the most admired of ancient statues at the Capitoline Gallery in Rome, his text suggests the beginning of sculpture's critical decline.[117] In the novel, a young American painter, Hilda, has done promising pictures at home; had she remained there, Hawthorne ventured, she might well have produced worthy original work. But instead she journeyed to Italy, where as she came to know "the miracles of art that enrich so many galleries in Rome," she herself "entirely lost the impulse of original design" and became a mere copyist.[118] Elsewhere Hawthorne laments the tragedy of American artists who "linger year after year in Italy while their originality dies out of them."[119] Thus, in his fiction Hawthorne deals with the Italian question as perceptively as any critic of the period; he describes the attraction of Italy for American painters and sculptors, but he no longer sees Rome through the old, rose-colored glasses.

Italy proved beneficial to some American painters at mid-century, and less so to others. It was apparent to some of their contemporaries that J.G. Chapman, G.L. Brown, John Rollin Tilton, Luther Terry – to name just a few of the longtime residents – had indeed stayed too long. Rome, lacking respected contemporary exhibitions and ateliers, with its comfortable, inexpensive life and its tourist trade, allowed talented artists to grow stale and repetitive. Among more temporary visitors, reac-

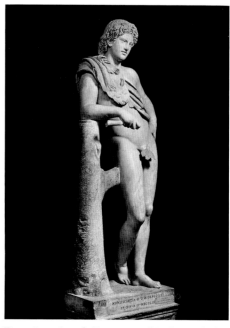

Fig. 30. *Faun of Praxiteles*, Roman copy of Greek original of 350-330 B.C. Marble. Capitoline Museums, Rome. Photograph courtesy Alinari/Art Resource, New York.

tions to Italy varied. Worthington Whittredge, for example, was amazed and discouraged to discover that "the great works of art which had stirred the world . . . were not landscapes."[120] Like many artists of all nations, he was overwhelmed by the richness and grandeur of Rome; he found himself depressed, unable to paint, suffering we are told, from "Stendahl's Syndrome."[121] Stendahl, the French writer, had recovered famously; Whittredge himself in the end produced a handful of successful pictures in Italy including a fine, luminous reprise of Cole's *Roman Campagna* (fig. 16). But years later, in his *Autobiography*, Whittredge, who spent some five years in Italy, commented: "after a long sojourn there, I came away with a feeling that it *had* been of little use to me unless possibly it may have improved my taste." He concluded – as others were doing at the same time – that the best way to create a truly American art was to do it with American subjects.[122]

There were numerous British artists of the eighteenth and nineteenth centuries who, as Duncan Bull says, "produced their finest work in Italy, or while the experience of Italy was still fresh upon them."[123] This was certainly true of many American sculptors, and of such painters as Allston, Morse, and Cole, but it seems less applicable to the artists of mid-century. Many of these were in Italy at young ages, before they had found their mature styles, or – like Frederic E. Church – were simply not inspired by it. Yet for some, Italy marked a high point. One thinks of Jasper Cropsey, who visited Rome from 1847 to 1849, and who may never have surpassed his highly romantic Italian work. Similarly, another member of the Hudson River School, Sanford Gifford, flourished in Italy, unassailed by doubts, curious and respectful, but never overwhelmed by the great sights. To prepare for his travels, Gifford learned Italian; once there, he hiked prodigious distances, and on both of his trips (1855-57 and 1868-69) he kept detailed journals. Gifford functioned exactly as he did at home, filling sketchbooks and making numerous oil studies before undertaking his finished pictures; and his luminous views of lakes Maggiore and Garda (see cat. 63) in the north (which were painted by surprisingly few Americans) and of Lake Nemi (see cat. 62), Rome (see cat. 34), and Catania, seem, if anything, even more confident than his American views. Yet he, too, was aware of the risks to be encountered abroad, commenting on one occasion, "The harm which sometimes happens to American painters from too long a sojourn in Europe cannot come from travel which brings one in constant intercourse with nature."[124]

Going to Italy was always a serious matter for an American artist. Particularly in the early years, there was a strict sense of hard work and duty involved; the eighteenth century's Puritanical attitude continued well into the nineteenth. For example, Theodore Allen, son-in-law of the wealthy Luman Reed, sent home in 1836 a collection of books and engravings, cork models of the temples at Paestum, and other souvenirs, while writing Reed, "I need not tell you that we are as economical as possible. We only seek to be comfortable and appear respectable – not a cent is expended for show or for mere amusement. We have been to the opera but twice in

Italy & only then to see the house & from curiosity."[125] J.F. Cooper, who like many travelers observed that Italians seemed happier than Americans, nonetheless concluded, "We have arts to acquire, and tastes to form, before we could enter at all into the enjoyments of these people."[126]

The American attitude stood in marked contrast to that of the English, as exemplified by Thomas Gray's description of Italy as "an excellent place to employ all one's animal sensations in, but utterly contrary to one's rational powers."[127] Gray went on to describe the daily schedule which he and Horace Walpole followed in Florence: "Up at twelve o'clock, breakfast till three, dine till five, sleep till six, drink cooling liquors till eight, go to the bridge till ten, sup till two, and so sleep till twelve again." Americans, on the other hand, were wary of succumbing to the alluring temptations of Italy – her climate, her wine, her indolent lifestyle, and her women especially. As Erica Hirshler suggests, Venice's notoriety as a city of prostitutes and loose morals may have been one reason Americans were so late in painting it, and the same thing may explain in part why there are so few American paintings of Milan and Naples, which had similar reputations. Guidebooks make no secret of the fact that in the eighteenth century young English gentlemen on the Grand Tour went to those cities unabashedly to gain sexual experience; for example Thomas Nugent in 1749 described Italian women as "handsome, witty, revengeful, and much inclined to amours, especially with strangers."[128] American writers were more guarded in their comments on such matters, but occasional remarks do occur about women and what Americans perceived as loose morality; Irving, for example, criticized the way that unmarried Italian women are confined, commenting that they rush into marriage to escape such restrictions, only to make unfaithful wives.[129] Thomas Cole's early biographer felt it necessary to assure the reader that Cole "felt it degrading to speak of the licentiousness too often indulged in by foreigners in Rome. Passion, appetite never led him astray."[130] Moral questions are similarly at the heart of much American fiction set in Italy: novels from Allston's *Monaldi* to Hawthorne's *Marble Faun* and James's *Roderick Hudson*, explore the ability of American artists to withstand the sensuousness, the different standards, indeed all the potential corruptions of the inexpensive, easy life in that country (cats. 156, 162, 166).

V Cultivated Americans: Sargent and James

"Real Rome is dirty, comfortless, and torpid; the home of beggars, indolence, and superstition" – so wrote James Jackson Jarves in 1856.[131] The American artists in Nathaniel Hawthorne's *Marble Faun*, first published in 1860, began to observe about them "abundant tokens that the country was not really the paradise it looked to be, at a casual glance."[132] Hawthorne's Italian journals, which he turned to frequently as he wrote his novel, find him highly ambivalent about Italy, like so many of his gen-

eration. At one time he doubts that he will ever "be able to express how I dislike [Rome], and how wretched I have been in it"; his catalogue of complaints included "cold, nastiness, evil smells . . . sour bread, pavement most uncomfortable to the feet, enormous prices for poor living, beggars, pickpockets, ancient temples and broken monuments with filth at the base and clothes hanging to dry about them, French soldiers, monks, and priests of every degree, a shabby population smoking bad cigars." But as he left for the last time, the writer commented, "No other place ever took so strong a hold of my being as Rome, none ever seemed so close to me, and so strangely familiar."[133] In addition, George Hillard had recently concluded that "The discoveries in Pompeii and Herculaneum present a fearful weight of evidence . . . that among the Romans the vice of cruelty was attended with its twin vice of lust."[134] Thus the city that Benjamin West and his contemporaries had viewed as the very fountainhead of ancient morality, was thought of dubious virtue by mid-nineteenth-century visitors.

In Henry James's short story of 1873, "The Madonna of the Future," the aspiring painter "turned his back on the Venus de Medici" and began to contemplate instead a triptych by Andrea Mantegna.[135] This fictional moment symbolizes the general change of taste, away from the classical world, toward the Middle Ages and the early Renaissance, that occurred through the 1850s and sixties. Italy, even Rome, would still be valued, but for reasons that the eighteenth-century Grand Tourists wouldn't have understood. The sculpture at the Tribuna and the Capitoline, the paintings of Guido Reni and Salvator Rosa, would cease to excite; the late nineteenth-century traveler would largely ignore the routes taken by Claude and Cole, the themes of the classical landscape and the *vedute*, exploring instead unknown hill-towns and by-ways, now admiring the art of Mantegna, Piero della Francesca, and Giotto, seeking pleasure rather than moral verities. This change happened gradually, though many writers in retrospect placed the moment of transition precisely at 1870, when the process of unification, which had been largely accomplished in 1861, was finally completed as the Pope gave up temporal power and retreated into the Vatican. Maitland Armstrong, who was there that year, remarked: "Rome had changed. It had jumped from the middle ages into the present and, alas! lost much of its picturesqueness."[136] Henry James long remembered 1869 and "the last winter before the deluge"; he wrote that Italian unity had punched "a hole that has never been repaired" into "the vast, rich canvas" of the old Rome.[137] Charles Eliot Norton blamed everything on "prosperity, independence, and the railroad."[138] The turnabout in taste was complete when in 1888 an American critic could describe Rome as "almost the least artistic of cities"; Italy as a whole was now deemed "not a country in modern landscape taste," because it "lacks the subtlety of atmospheric and aerial effects of moister, more shadowy lands."[139]

This changing view of Italy is also evidenced in the altered attitude of American travelers toward each other. Beginning during the 1850s, the American tourist abroad

became the subject of critical comments by his countrymen – the beginning of the "ugly American" in Europe. William D. Lewis, in his journal for 1853, reported that "[A] party of down-easters came to Europe by contract in a ship to Leghorn, and were to return in the same vessel. Of course they had but a short time to stay at any one place, but they were bent on seeing *everything*. Accordingly, I heard of them at Florence, where they spent *one day* and visited *all* the picture galleries." Lewis heard that they spent all their time in the galleries writing in their notebooks, rather than looking at the art, and asked himself, "Would it not be as well that some of my Yankee friends would stay at home, for the credit of our country?"[140] This development comes to an early climax in Mark Twain's *Innocents Abroad* (cat. 165), a book written for a mass audience while the author was taking one of the earliest American tourist cruises to Europe. This volume marks the death-knell of the Grand Tour as it had been known in the eighteenth and early nineteenth centuries, with Twain's combination of irreverence ("Isn't this relic matter a little overdone?"), guidebook facts, American practicality (comparing the skill of the Venetian gondolier to that of the "Broadway hackman," for example), homespun observations ("I do envy these Europeans the comfort they take") and musings (as when, in Pompeii, he remarks on "the unsubstantial, unlasting character of fame") all suggesting a new American attitude: cynical, sophisticated, irreverent, but still fascinated with Italy.[141] After Twain, the insecure, reverential attitude of earlier travelers toward the great icons of the past was no longer possible; in its place came a new worldliness.

All these factors led to a changed attitude toward Italy on the part of American painters and sculptors. Eighteenth-century artists who did not get to Italy, such as Trumbull and Charles Willson Peale, were nonetheless agreed on the values Rome represented; they were schooled in the same techniques and traditions and they venerated the same Renaissance paintings and the same classic sculpture as West and Copley. Similarly, there were a number of nineteenth-century landscape painters who never made the long journey from America to Italy, but who nonetheless painted Italian views; such painters as Charles Fraser of Charleston and John R. Penniman of Boston were spiritual descendants of such seventeenth-century Dutch masters as Albert Cuyp and Philips Wouwermann, who had similarly made convincing Italian pastoral scenes without leaving their native land. Edward Everett, the leading American classicist of his day, the first professor of Greek at Harvard College (1819-1826) and later a congressman and governor, was the initial owner of Penniman's large *View of the Greek Ruins at Paestum* (fig. 31), which was based on a print.[142] Similarly, William Sidney Mount and George Caleb Bingham did not make the trip to Italy, but they both learned their trade from study of antique casts, and both paid frequent homage in their paintings to these icons of Greek and Roman sculpture. Mount, for example, included in *A Painter's Triumph* (1838, Pennsylvania Academy of the Fine Arts, Philadelphia) his drawing of the head of the *Apollo Belvedere* – perhaps meaning to suggest that classic values inevitably lie behind a modern painter's suc-

Fig. 31. John R. Penniman (American, 1783-1841), *View of the Greek Ruins at Paestum*, about 1819. Oil on canvas. Fruitlands Museums, Harvard, Massachusetts.

Fig. 32. William Rimmer (American, 1816-1879), *Sunset/ Contemplation*, 1876. Oil on canvas. Manoogian Collection.

cess — and Bingham employed the pose of the *Dancing Faun* at Naples for the central character in his *Jolly Flatboatmen in Port* (1857, St. Louis Art Museum). Even more significantly, a number of Bingham's scenes of raftsmen on the Mississippi River have a warm, golden light that distinctly recalls the work of Jan Both and other Dutch seventeenth-century painters of the Campagna; whether consciously or not, Bingham was stylistically their heir. Also at mid-century, James Hamilton made it only to London, not to Italy, but nonetheless became perhaps the only American to take on as a subject the last days of Pompeii (cat. 51). Yet perhaps the most intriguing of all the non-travelers is William Rimmer, a devoted Italophile in his art who, according to the extensive researches of Jeffrey Weidman and others, never went abroad after coming to this country at the age of two. Yet Rimmer produced both paintings and sculpture that are redolent with Italian flavor. His sculptured *Torso* (cat. 42) was surely inspired by the antique *Belvedere Torso* at the Vatican, which the artist could well have known from a cast at the Boston Athenaeum; and among his paintings one thinks of *Gladiator and Lion* (1873-75, Reynolda House, Winston-Salem, N.C.) apparently based on Gérôme's interpretation of the Colosseum, and his extraordinary *Sunset/Contemplation*, 1876 (fig. 32), an evocation of Italy more effective than many painted on the scene, and one for which Rimmer's source is still unknown.

Yet despite the disappearance of the "old Rome," Italy was still much visited; more American painters journeyed there, in all likelihood, during the last quarter of the century than in all the years before. Their purpose, however, was no longer to immerse themselves in the classical world, but rather to travel throughout the peninsula. The philosopher William James, on one of several Italian trips, observed: "I should think that a painter would almost go out of his skin to wander about from town to town."[143] His brother Henry, who thought so much like a painter, had already journeyed in this manner, in 1869 going to Assisi for "a deep delicious bath of medievalism," then reveling in the picturesque beauty of Narni, Spoleto, and Perugia.[144] Surprising as it seems, this represents a new attitude: before the 1860s, American painters, as we have seen, were far from "wandering about" in search of subjects, and when a hill town was painted in earlier years, it was likely to be one with long artistic associations, a Tivoli or an Olevano. George Inness was one of the first to go further afield, painting both traditional subjects such as Albano (see cat. 67) and Nemi (see cat. 68), but also depicting anonymous Umbrian hillsides and bridges near Perugia. Inness's trip of 1870-74 was paid for by his dealer, to whom he sent the nearly two hundred resulting paintings — testimony to the constant popularity of Italian subjects for the American audience. Interestingly, Inness's Italian scenes are difficult to identify topographically; they relate more to the classical tradition than to the topographical view. Inness thus may be seen as one of the latest Americans to follow in the footsteps of Claude Lorrain; his modern style, which rejected Hudson River School literalism, suited the classical mode well. Inness's friend Elihu Vedder worked in a very different manner; he spent much of his life exploring every corner

of Italy, painting towns and rural views without regard to the Claudian tradition (see cats. 71, 94). Vedder's pictures are saleable, small to medium-scale souvenirs, each one accurate and recognizable, each carefully inscribed on the reverse with its locale.

During the last half of the century, Americans were reading Ruskin rather than Reynolds, and Ruskin — an avowed anti-classicist — led them to Venice. One of Ruskin's chief American followers was James Jackson Jarves, art critic, pioneer collector of early Renaissance painting, and chronicler of changing American attitudes toward Italy. Jarves's book of 1856, *Italian Sights and Papal Principles* (cat. 161) deals with the old questions: the quality of the *Venus de' Medici* and other antique sculpture; matters of copying and collecting; the faults of Catholicism; the good and bad aspects of Florence, Rome, Naples, and Venice. However, in that book Jarves also paved the way toward a new attitude regarding the latter city; noting that one typically associates Venice "with her vices and crimes," Jarves took pains to point out her achievements in literature and art, and particularly her long years of "resistance to the spiritual and temporal encroachment of Rome" — thus setting out to reestablish the city's moral credentials.[145] Nearly thirty years later, Jarves wrote another book, *Italian Rambles*, which presents a dramatically different view of Italy and its people. Where before he had concentrated on the cities, now he sketches for his readers "Pescaglia" and "Serra," which he describes as promising small towns in the Appenines; the virtuous "Mountaineers of Tuscany," whose industry he admires; isolated and neglected Ravenna, which he recommends to art-lovers; and picturesque Venice, where he sees "the fairest daughters of America" feeding doves at San Marco, and where he also admires the Byzantine mosaics. Jarves describes a new Italy, where Ghiberti and Michelangelo are considered the greatest artists, where one admires the picturesque fishing boats at Venice, where one strays from the guidebook routes to seek out the country's unknown pleasures. In this new Italy, the American painter would roam far and wide, painting the coast at Amalfi and La Spezia, the glorious Alpine lakes in the north, the extraordinary water and rocks at Capri, medieval Siena, picturesque villages including Fiesole, Bordighera, and San Gimignano — and every aspect of Venice from her working men and women to her quietest nooks and canals.

Henry James wrote books about both Nathaniel Hawthorne and William Wetmore Story, the writer and the sculptor, two Americans who had dealt with Italy in their own mediums as successfully, perhaps, as any members of their pre-1870 generation. In his commissioned volume on Story, James handled the question of the American artist in Italy with necessary diplomacy, theorizing at one point, "The 'picturesque' subject . . . has by no means all its advantage in the picturesque country . . . In London, in Boston, [Story] would have *had* to live with his conception. In Rome, Florence, Siena, there was too much."[146] Earlier, he had described Hawthorne as "the last of the old-fashioned Americans" in Rome, then went on: "An American

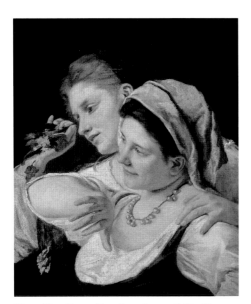

Fig. 33. Mary Cassatt (American, 1844-1926), *Two Women Throwing Flowers During Carnival*, 1872. Oil on canvas. Private Collection.

of equal value with Hawthorne, an American of equal genius, imagination and, as our forefathers said, sensibility" could now truly succeed in foreign lands. James added: "An American as cultivated as Hawthorne is now almost inevitably more cultivated, and, as a matter of course, more Europeanized in advance, more cosmopolitan."[147] As James's exemplary biographer, Leon Edel, has suggested, "A reader could hardly be in doubt who this American might be" – James, of course, was speaking of himself.[148] A new kind of cosmopolitan American had indeed been made possible by wealth, by the new ease of crossing the Atlantic, and also by the changed nature of both post-1870 Italy and post-Civil War America; James was perhaps the most articulate of this new breed, which would include other writers (William Dean Howells, Charles Eliot Norton, Edith Wharton) and painters as well – including "Jimmy" Whistler and John Singer Sargent.

Perceptions changed radically; Italy, for more than a century a "necessity" for the American artist, now became merely a beautiful, historic land that appealed to some and not to others. Interestingly, the painters who have been considered our most "American" – including Winslow Homer, Thomas Eakins, and William Harnett – were attracted to Paris but not to Rome, though each of these artists was well-versed in the lessons of Italy, Eakins undertaking numerous Arcadian themes, for example, and Harnett making reference to classical sculpture and to Dante in his work. Eakins, moreover, is representative of a new attitude toward Rome, for he virtually tells us that he wouldn't go even if he could. In a letter to his father from Paris in 1869, Eakins declared that "the nest of American artists at Rome is an infection," calling the work of Americans there "shameful"; writing of T. Buchanan Read, Eakins said, "He plots the Americans in Rome where he stays. He uses all kinds of tricks . . . Pickpockets are better principled than such artists."[149]

On the other hand, the most stylistically sophisticated American painters of the day, the ones who spent most of their lives in Europe – the "expatriates," including Sargent, Whistler, and Mary Cassatt, among others – all visited Italy. Cassatt went to Parma in 1872 after working in Paris for several years; her study of Correggio and other Renaissance masters affected her own style. Cassatt's *Two Women Throwing Flowers During Carnival*, 1872 (fig. 33) suggests the graphic boldness that would typify her mature work; it is also a rarity among American pictures both in representing a carnival scene, and in suggesting the influence of Caravaggio, whose work had been little noticed up to this date. Similarly, Whistler ventured to Italy only once, and went only to Venice: but the group of pastels he made there in 1881-82 stand out among the most brilliant of his career (cats 108-111). Ruskin's favorite city, with its magical light and its dreamlike appearance, became – for this new generation, uninterested as they were in Reynolds and associationism – a destination unto itself. The American Impressionists, for whom France meant so much, were also much drawn to Venice, and William Merritt Chase, Childe Hassam, John H. Twachtman, Robert Blum (see cats. 119, 120), and numerous others all did outstanding work there. Mau-

rice Prendergast found in Venice a combination of picturesque buildings, colorful crowds, and watery reflections that inspired some of the greatest watercolors of his life (see cats. 126-130). Thus, many painters of the period would have agreed with Henry James, who near the end of his career wrote Edith Wharton, "I don't care, frankly, if I never see the vulgarized Rome or Florence again, but Venice never seemed to me more loveable."[150]

As Edel has suggested, Sargent and James were "in certain respects, mirror images" of each other. They were friends; they admired each other's work; they moved in the same circles. Sargent, like James, represented the new kind of cosmopolitan American. Born in Florence of American parents, he took his first trip to the United States only in 1876, when he was twenty. Like James, he explored the length and breadth of Italy, never considering it home but visiting on over a dozen occasions. He went to Italy for his pleasure, with none of the sense of duty one finds in earlier generations of artists. He painted with the same kind of elegance and facility with which James wrote: his work was telling and original whether portraying the workmen at Carrara or the working women in Venice, the popular churches and bridges of Venice, or the fountains and gardens of Renaissance villas. Sargent was, like James, both a supreme observer and a gifted stylist; the fluency of his brushwork has led critics to overlook the boldness of his compositions and his astonishing eye. In work after work, Sargent takes on the challenge of a much-painted view — the Rialto Bridge (see cat. 117) or Santa Maria della Salute (see cat. 118) in Venice, for example, — and makes of it a new, original composition, one with both a debt to photography and more than a hint of modernism. Sargent's *Study of Architecture, Florence*, about 1910 (fig. 34) typifies his approach both in oil and watercolor: here he takes the Uffizi Gallery in Florence (fig. 35), a building as familiar to American tourists as any in the world, and makes of it an evocative, fresh study of architectonic form, one that is hardly recognizable. Moreover, he doesn't hesitate to make his basically realistic picture into something of a *capriccio* by substituting for the Arno and the urban buildings on its far bank a parklike setting where a fountain plays.

Venice provided the American painter during the last third of the century with much inspiration and many subjects, but Rome also continued to attract American visitors — though one observer after another took note of the vast changes that had occurred. As early as 1868, Bayard Taylor counted 1200 Americans staying there.[151] A second writer some twenty years later lamented the loss of the "old Eden," recalling Rome during the sixties as a "quiet nook in the world" with "the advantages of both town and country," while describing the rapid obliteration of the city's "former medieval character."[152] And yet another declared in 1880 that Rome no longer attracted young artists, but only older ones who had already studied in Paris, then reminisced, "In the old days, under the soft, fascinating art-laden air of Rome, it was easy to paint, and hardly less easy to sell those pleasing mellow views of the Campagna."[153]

Fig. 34. John Singer Sargent, *Study of Architecture, Florence*, c. 1910. Oil on canvas. Fine Arts Museum of San Francisco, Gift of the de Young Museum Society, purchased from funds donated by the Charles E. Merrill Trust.

Fig. 35. *The Uffizi*, Florence, 1990. Photograph the authors.

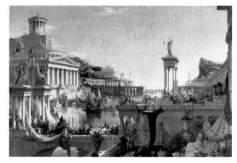

Fig. 36. Thomas Cole, *Consummation of Empire*, 1835-36. Oil on canvas. Courtesy of the New-York Historical Society, New York City.

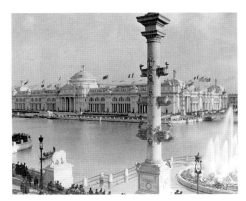

Fig. 37. *World's Columbian Exposition, Chicago, View across the Basin Toward the Agriculture Building,* 1893. Photograph by C. D. Arnold, courtesy of Avery Architectural and Fine Arts Library, Columbia University in the City of New York.

Fig. 38. Elihu Vedder, *Rome,* 1893. Oil on canvas. Bowdoin College Museum of Art, Gift of the Misses Harriet and Sophia Walker.

Nonetheless, the sense of identity with ancient Rome that Americans had felt since Jefferson's time did not die. The artists of the eighteenth century had admired the virtues of Republican Rome, but those of the nineteenth turned instead to a consideration of the Roman Empire. Thomas Cole's moralizing work, *The Course of Empire,* 1835-36, itself conceived in the Eternal City, ponders the fate of the American empire and draws a pessimistic conclusion, implying that the corruption that led to Rome's destruction might happen here. The central picture of Cole's five-part series, *The Consummation of Empire* (fig. 36) predicts in a remarkable way the physical appearance of the World's Columbian Exposition, held in Chicago in 1893.[154] But where Cole had warned against excess, the architects at Chicago, led by Daniel Burnham and Charles Follen McKim, celebrated it (fig. 37). In the eyes of its planners, the "Great White City" represented America's future, and the future was based on Imperial Rome, with bits of Venice thrown in. Enthusiasm for the fair and for the new classicism led McKim, aided by such friends as Elihu Vedder in Rome (see fig. 38), Augustus St. Gaudens, and John LaFarge in New York, and Charles Eliot Norton at Cambridge, to found the American School of Architecture in Rome in 1894. Modeled on the French Academy, the School quickly reached beyond architecture to include classicists, archaeologists, painters, and sculptors; it became the American Academy in Rome in 1897.[155]

Thus, the American artistic presence in Italy was institutionalized and made official at a time when the appeal of Rome and of the classical world had weakened in the eyes of many Americans. The general belief of Jefferson's time, that Italy lay at the center of western civilization, was increasingly replaced during the twentieth century by myriad competing views, as artistic energy shifted to Paris, then to New York, then elsewhere. America had come of age and even Henry James now sought to put the Italian experience into perspective, writing from Cambridge: "It's the same world there after all and Italy isn't the absolute any more than Massachusetts. It's a complex fate, being an American, and one of the responsibilities it entails is fighting against a superstitious valuation of Europe."[156]

Notes

We are most grateful for the invaluable research assistance of Janet L. Comey and Kathleen Mathews Hohlstein in the preparation of this essay, and to Harriet Rome Pemstein for her extraordinary skill and patience in word-processing it.

1. Samuel Longfellow, ed., *Life of Henry Wadsworth Longfellow,* (Boston: Houghton, Mifflin & Co., 1896), vol. 2, p. 200.

2. F. Saxl and R. Wittkower, *British Art and the Mediterranean* (London: Oxford University Press, 1948), no. 57; see Jonathan Richardson, Sr. and Jonathan Richardson, Jr., *Account of Some Statues, Bas-reliefs, Drawings, and Pictures in Italy, France, etc. With remarks* (London: J. Knapton, 1722).

3. Christopher Hibbert, *The Grand Tour* (London: Thames Methuen, 1987), p. 20.

4. See "Journal of a Tour in Italy in 1717, 1718," in Alexander Campbell Fraser, *Life and Letters of George Berkeley* (Oxford: Clarendon Press, 1871); A. A. Luce, *The Life of George Berkeley* (London: Thomas Nelson and Sons, 1949).

5. Henry Wilder Foote, *John Smibert* (Cambridge: Harvard University Press, 1950), p. 5; Richard H. Saunders, "John Smibert's Italian Sojourn – Once Again," *The Art Bulletin* 66 (June 1984) p. 312 ff.

6. Miles Chappell, "A Note on John Smibert's Italian Sojourn," *The Art Bulletin* 64 (March 1982), p. 133.

7. See Richard H. Saunders and Ellen G. Miles, *American Colonial Portraits 1700-1776* (Washington, D.C.: Smithsonian Institution Press for the National Portrait Gallery, 1987), p. 118.

8. Francis Haskell and Nicholas Penny, *Taste and the Antique: The Lure of Classical Sculpture 1500-1900* (New Haven: Yale University Press, 1981), p. 325.

9. Nathaniel Hawthorne, *The French and Italian Notebooks*, ed. Thomas Woodson (Columbus: Ohio State University Press, 1980), pp. 307, 308.

10. Eugenio Battisti, "Humanism and the Renaissance," *Encyclopedia of World Art* (New York: McGraw-Hill Book Co., 1968), vol. 1, p. 491.

11. Archibald Alison, *Essays on the Nature and Principles of Taste* (New York: G. & C. & H. Carvill, 1830), p. 37. Alison continues: "It is the mistress of the world which he sees, and who seems to him to rise again from her tomb, to give laws to the universe."

12. See David H. Solkin, *Richard Wilson* (London: Tate Gallery, 1982), p. 38. For an excellent summary of the eighteenth-century English experience in Rome, see Denys Sutton, "'Magick Land'," *Apollo* 99 (June 1974), p. 392-407.

13. Allen Staley, "Benjamin West in Italy" in Irma B Jaffe, ed., *The Italian Presence in American Art 1760-1860* (New York: Fordham University Press, 1989), p. 171; see also the superb monograph, Helmut von Erffa and Allen Staley, *The Paintings of Benjamin West* (New Haven: Yale University Press, 1986).

14. See Wayne Craven, "The Grand Manner in Early Nineteenth-Century American Painting: Borrowings from Antiquity, the Renaissance, and the Baroque," *American Art Journal* (April 1979), p. 5.

15. According to von Erffa and Staley, *Paintings of West*, the artist painted at least five portraits in Italy, including two done in Venice in 1762 (see their nos. 582, 658, 673, 676, 689, and 730). Note also that West's conversation piece, *The Cricketeers* (von Erffa and Staley, no. 726), was painted in London shortly after the artist returned from Rome; inspired by Nathaniel Dance's group portraits, it depicts two of John Allen's brothers, James and Andrew, as well as Ralph Izard — later to be painted with his wife by Copley in Rome (cat. 4) — and Arthur Middleton, who later married Izard's cousin.

16. Collection of the Yale University Art Gallery, New Haven; see Irma B. Jaffe, *John Trumbull* (Boston: New York Graphic Society, 1975), p. 10 (fig. 7).

17. Trumbull as quoted in Patricia Mullen Burnham, "Trumbull's Religious Paintings," in Helen A. Cooper, *John Trumbull: The Hand and Spirit of a Painter* (New Haven: Yale University Press, 1982), p. 194.

18. See Charles Coleman Sellers, *Charles Willson Peale; Early Life*, (Philadelphia: American Philosophical Society, 1947), vol. 1, p. 224 ff.

19. Rembrandt Peale, as quoted in C.E. Lester, *Artists of America* (New York: Baker & Scribner, 1846), pp. 201-202. Little is known about this exhibition, apparently consisting of about 130 works imported by the Philadelphia merchant John Swanwick, and offered for sale by Peale for several years. As late as Sept. 27, 1789, Peale noted in his diary, "I must make a new catalogue of the Italian paintings" (Lillian B. Miller, ed., *The Selected Papers of Charles Willson Peale* [New Haven: Yale University Press, 1983], vol. 1, p. 574). See also *The Crayon* 1 (January 10, 1855), p. 23.

20. *The Journal of Dr. John Morgan of Philadelphia from the City of Rome to the City of London 1764* (Philadelphia: Lippincott, 1907).

21. Letter, John Morgan to Dr. Cullen, November 10, 1764, as quoted in *The Journal of Dr. John Morgan*, p. 26.

22. Collection of the National Portrait Gallery, Smithsonian Institution, Washington, D.C.

23. See the excellent article by Arthur S. Marks, "Angelica Kauffmann and some Americans on the Grand Tour," *American Art Journal* (spring 1980), p. 11. Morgan also owned a self-portrait by Angelica Kauffmann, which he received in payment for treating her stomach problems. Marks points out that Morgan's collection influenced the taste of numerous Americans, including Thomas Jefferson.

24. Ibid., p. 20. In addition, a second Philadelphia painter, Henry Benbridge, reached Rome by 1765; he made copies, and gained some reputation when James Boswell commissioned him to sail to Corsica to paint Gen. Pascal Paoli there; see Robert G. Stewart, *Henry Benbridge (1743-1812): American Portrait Painter* (Washington, D.C.: National Portrait Gallery, 1971). The third American painter in Italy may have been the mysterious "Mr. Smith," as suggested by William Dunlap in his *History of the Rise and Progress of the Arts of Design in the United States* (New York: Dover Publications, 1969), vol. 1, p. 145.

25. See Brinsley Ford, "The Englishman in Italy" and Francis Haskell, "The British as Collectors" in *The Treasure Houses of Britain* (Washington, D.C.: National Gallery of Art, 1985). See also Albert Boime, *Art in an Age of Revolution 1750-1800* (Chicago: University of Chicago Press, 1987).

26. West to Copley, August 4, 1766, in *Letters and Papers of John Singleton Copley and Henry Pelham 1739-1776* (Boston: Massachusetts Historical Society, 1914), p. 45.

27. Ibid., p. 194. West to Copley, Jan. 6, 1773. West's spelling has been corrected.

28. See Edgar Peters Bowron, *Pompeo Batoni and his British Patrons* (London: Greater London Council, The Iveagh Bequest, Kenwood, 1982). Batoni is only known to have painted one American traveler, Philip Livingston of the prominent New York family, in 1783 (Osuna Gallery, Washington, D.C.).

29. Ralph Izard had earlier been painted in London by West (see note 15 above) and by Zoffany in 1771 (Private collection) while Mrs. Izard had been painted by Gainsborough (apparently destroyed). See Ellis Waterhouse, *Gainsborough* (London: Edward Hulton, 1958), no. 396.

30. Copley to Henry Pelham, March 14, 1775 in *Letters and Papers of John Singleton Copley*, p. 294.

31. Collection of Her Majesty Queen Elizabeth II; see Olivar Millar, *Zoffany and his Tribuna* (London: Paul Mellon Foundation for British Art, 1966).

32. Meyer Reinhold, *Classica Americana: The Greek and Roman Heritage in the United States* (Detroit: Wayne State University Press, 1984), p. 95.

33. Ibid., p. 24.

34. Ibid., p. 156.

35. Ibid., p. 98.

36. Seymour Howard, "Thomas Jefferson's Art Gallery for Monticello," *The Art Bulletin* 59 (December 1977), p. 583. Jefferson also developed a list of paintings of which he desired replicas, including two works by Salvator Rosa, and others by Rubens and Mola.

37. Theodore Sizer, "The American Academy of the Fine Arts," in Mary Bartlett Cowdrey, *American Academy of Fine Arts and American Art-Union* (New York: New-York Historical Society, 1953), pp. 8, 10, 11, 13. The painter John Vanderlyn was commissioned by the Academy in 1804 to go to Paris to procure additional casts.

38. David Sellin, "Howard Roberts, Thomas Eakins, and a Century of Philadelphia Nudes," in *The First Pose* (New York: W. W. Norton & Co., 1976), p. 21; This cast of the *Venus de' Medici* was briefly resurrected at C.W. Peale's Columbian Academy in 1794. I am grateful to Sydney C. Warner, Boston University, for bringing this to my attention.

39. Mrs. Pinckney to Mrs. Manigault, November 7, 1797, as quoted in E.P. Richardson, "Allen Smith, Collector and Benefactor," *The American Art Journal* 1 (fall 1969), p. 5 ff. The collection included casts of the *Dying Gladiator*, *Meleager*, and *Venus of the Capital* (a close variant of the *Venus de' Medici*), along with supposed originals by Salvator Rosa and Guido Reni, copies of two Raphaels, and engravings after Titian, Correggio, and Michelangelo. Equally important was James Bowdoin III (1752-1811), who took a Grand Tour in 1774-75, spending the winter in Rome, and who collected actively during his years as Minister in France and Spain (1805-1808).

40. *New York Evening Post*, May 21, 1831.

41. *The Crayon* 1 (March 14, 1855), p. 163.

42. Herman Melville, "Statues in Rome," in *The Piazza Tales and Other Prose Pieces, 1839-1860* (Evanston, Ill.: Northwestern University Press, 1987), p. 402.

43. Marius Schoonmaker, *John Vanderlyn* (Kingston, N.Y.: The Senate House Museum, 1950), p. 44.

44. See the excellent study by David A. Brown, *Raphael and America* (Washington, D.C.: National Gallery of Art, 1983), p. 22.

45. See Donald D. Keyes, *George Cooke (1793-1849)* (Athens: Georgia Museum of Art, University of Georgia, 1991).

46. Casilear to Kensett, November 20, 1840 (New York State Library, Albany), courtesy of Eleanor Jones.

47. Reynolds was still being cited as late as 1848; see Henry T. Tuckerman, *Italian Sketch-Book* (New York: J. C. Riker, 1848), p. 202; however in 1843 James de Veaux, a promising young painter from Charleston, noted that he had gone to the Academy of Fine Arts at Rome "with [Reynolds's] *Lectures* under my arm to see the Caraccis, which Reynolds so much admired, but was highly disappointed in them, preferring Domenichino and Guercino instead." (Robert W. Gibbes, *A Memoir of James de Veaux* [Columbia, S.C.: I. C. Morgan, 1846], p. 150.)

48. See *Catalogue of Plaster Reproductions*, P.P. Caproni and Brother, (Boston: P. P. Caproni & Bro., 1911), which lists several thousand casts from antique, Renaissance, and modern sculpture. See also Edward Robinson, *Catalogue of Casts, Part III: Greek and Roman Sculpture* (Boston: Museum of Fine Arts, 1896).

49. Washington Allston, *Lectures on Art and Poems* (New York: Baker and Scribner, 1850), p. 100.

50. Rembrandt Peale, *Notes on Italy Written During a Tour in the Years 1829 and 1830* (Philadelphia: Carey & Lea, 1831), pp. 136-137.

51. James Fenimore Cooper, *Gleanings in Europe: Italy* (Albany: State University of New York Press, 1981), p. 21. Of the *Apollo Belevedere* he writes, "This latter statue surpassed all my expectations, familiar as one becomes with it by copies; and yet it is now conjectured that it is itself merely a copy! I write with diffidence on so delicate a point," p. 239.

52. Bayard Taylor, *Views A-Foot, or Europe Seen, with Knapsack and Staff* (New York: John A. Alden, 1889), p. 317. George S. Hillard, *Six Months in Italy* (Boston: Ticknor, Reed & Fields, 1853), vol. 1, p. 116.

53. James Jackson Jarves, *Italian Sights and Papal Principles, Seen Through American Spectacles* (New York: Harper Brothers, 1856), p. 70.

54. W. M. Calder III, foreword, in Reinhold, *Classica Americana*, p. 11.

55. Washington Allston, *Lectures on Art*, p. 158.

56. William H. Gerdts, "The Paintings of Washington Allston," in Gerdts and Theodore E. Stebbins, Jr., *"A Man of Genius": The Art of Washington Allston (1779-1843)* (Boston: Museum of Fine Arts, 1979), p. 19 ff; see also William H. Gerdts's pioneering study, "Washington Allston and the German Romantic Classicists in Rome," *The Art Quarterly* 32 (summer 1969), pp. 166-196.

57. Gerdts, "The Paintings of Washington Allston," p. 42ff.

58. Walter Friedlaender, *Nicholas Poussin* (New York: Harry N. Abrams, Inc., 1964), p. 81.

59. Emerson to Margaret Fuller, July 11, 1843, quoted in Ralph L. Rusk, ed., *The Letters of Ralph Waldo Emerson* (New York: Columbia University Press, 1939), vol. 3, p. 182. Courtesy of Mary Jo Viola.

60. Washington Irving, *Journals and Notebooks*, ed. by Nathalia Wright (Madison: University of Wisconsin Press, 1969), vol. 1, p. 149 (Dec. 30, 1804).

61. Washington Irving, *Tales of a Traveller* (New York: G.P. Putnam and Son, 1868), "Adventure of the Mysterious Stranger," p. 81 ff; see also Nathalia Wright, "Irving's Use of his Italian Experiences in *Tales of a Traveller*: The Beginning of an American Tradition," *American Literature*, 31 (1959-60), p. 191 ff. In the harbor at Syracuse, on Sicily, Irving saw five American warships sent to fight the Tripoli pirates. Any study of the "lure of Italy" should note that thousands of American sailors, on both navy and merchant ships, visited Italy in these decades, with some staying long enough to see the sights and to collect paintings and sculpture (see cats. 75 and 153). Note also that an early American "guidebook" to Sicily, masquerading as a Romance, was Henry T. Tuckerman's, *Isabel: or Sicily* (Philadelphia: Lea and Blanchard, 1839).

62. Washington Irving used as a guide Thomas Martyn, *The Gentleman's Guide in his Tour Through Italy* (London, 1787); Byron and many Americans read Joseph Forsyth, *Remarks on Antiquities, Arts and Letters During an Excursion in Italy in the Years 1802 and 1803* (London: T.Caddell & W. Davies, 1813) and John C.

Eustace, *A Classical Tour Through Italy* (London: J. Mawman, 1814). Early American travel books included Theodore Dwight, *A Journal of a Tour in Italy in the Year 1821* (New York: Abraham Paul, 1824) and G.P. Putnam, *The Tourist in Europe* (New York: Wiley & Putnam, 1838), which includes a section on Italy.

63. John Lowell, "Letter Fifth," February 5, 1805, in *The Monthly Anthology and Boston Review* (Boston: Munroe & Francis), vol. 4, May 1807, p. 247. Another Bostonian, William Tudor, also was publishing letters from Italy in the same journal in 1806.

64. Joseph Carrington Cabell, "Diaries", 1802-1806 (manuscript, Alderman Library, University of Virginia, Charlottesville), Diary #5, p. 130 (February 10, 1805).

65. Charles Eliot Norton, "The First American Classical Archeologist," *The American Journal of Archeology* 1 (January 1885), p. 6. Middleton, who spent most of his life in Europe, was also a considerable collector of paintings; in 1811 he sent home to Charleston "five cases of books and pictures" (J.I. Middleton to Fulwar Skipwith, Jan. 1, 1811; Pennsylvania Historical Society, Philadelphia); in his collection were paintings attributed to Salvator Rosa, Vernet, Panini, Carlo Maratta, School of Caracci, a copy of Correggio, and so on. See "Salmark's List of pictures belonging to J.I.M," in the Cheves Papers, South Carolina Historical Society, Charleston; also Michael O'Brien, "Italy and the Southern Romantics" in his *Rethinking the South* (Baltimore: Johns Hopkins University Press, 1988).

66. Ellwood C. Parry III, *The Art of Thomas Cole* (Newark: University of Delaware Press, 1988), p. 116.

67. Louis Legrand Noble. *The Life and Works of Thomas Cole* (Cambridge: Harvard University Press, 1964), p. 85.

68. William Dunlap, *History of the Rise and Progress of the Arts of Design in the United States* (New York: Dover Publications, 1969), vol. 2, pp. 363-364.

69. Noble, *Life and Works of Cole*, p. 125.

70. Peter Galassi, *Corot in Italy: Open-Air Painting and the Classical-Landscape Tradition* (New Haven: Yale University Press, 1991), p. 85. See also *The Origins of the Italian Veduta* (Providence, R.I.: Department of Art, Brown University, 1978).

71. Joshua Reynolds, "Discourse XIII," *Discourses on Art*, Robert R. Wark, ed. (New Haven: Yale University Press, 1975), p. 237.

72. Ibid., "Discourse III," p. 50.

73. Noble, *Life and Works of Cole*, p. 82.

74. Thomas Cole, "Essay on American Scenery," 1835, in John W. McCoubrey, *American Art, 1700-1960* (Englewood Cliffs, New Jersey: Prentice-Hall Inc., 1965), p. 108.

75. Ibid., p. 101.

76. For a survey of Tivoli's importance for American painters, we are indebted to Kathleen Mathews Hohlstein, "Nineteenth Century American Artists at Tivoli" (Boston University, 1991).

77. Germaine de Staël, *Corinne, or Italy*, trans. by Emily Baldwin and Paulina Driver (London: George Bell & Sons, 1902), p. 149.

78. Leonora Cranch Scott, *The Life and Letters of Christopher Pearse Cranch* (Boston: Houghton-Mifflin Co., 1917), p. 120, quoting from Cranch's Journal. As quoted in Barbara Novak, "Arcady Revisited," in *The Arcadian Landscape* (Lawrence: University of Kansas, 1972), p. 18.

79. Gaspard Dughet, *Tivoli* (Ashmolean Museum, Oxford); J.M.W. Turner, *Tivoli*, 1819 (Courtauld Institute, London); Samuel Palmer, *Tivoli and the Campagna of Rome*, 1838 (Toledo Museum of Art).

80. See Charles C. Eldredge, "Torre dei Schiavi: Monument and Metaphor," *Smithsonian Studies in American Art* 1 (fall 1987), pp. 15-34.

81. Städelsches Kunstinstitut, Frankfurt.

82. Parry, *Art of Thomas Cole*, p. 130; Nathaniel Parker Willis, *Pencillings by the Way* (New York: Morris & Willis, 1844), p. 82.

83. "Duty in Art," *The Crayon* 1 (January 24, 1855), p. 49; Tuckerman, *Book of the Artists*, p. 353.

84. Washington Irving, *Journals and Notebooks*, p. 296.

85. Cooper, *Gleanings in Europe: Italy*, pp. 213, 189.

86. William Wetmore Story, *Roba di Roma* (Boston: Houghton Mifflin & Co., 1855); see chap. 13, "The Campagna," pp. 338 ff.

87. Henry James, "Roman Rides," 1873, in Henry James, *Transatlantic Sketches* (Boston: Houghton Mifflin & Co., 1903), pp. 136-155. Also see Vance's excellent "Reading the Campagna" in his *America's Rome* (New Haven: Yale University Press, 1989), vol. 1, chap. 3.

88. David Maitland Armstrong, *Day Before Yesterday: Reminiscences of a Varied Life* (New York: Scribner's, 1920), p. 230.

89. See Galassi, *Corot in Italy*, pp. 11-39.

90. See *In the Shadow of Vesuvius: Views of Naples from Baroque to Romanticism 1631-1830* (Naples: Electa Napoli, 1990); also, Raffaello Causa, "Foreign View – Painters in Naples," in *The Golden Age of Naples* (Detroit: The Detroit Institute of Arts, 1981).

91. Noble, *Life and Works of Cole*, p. 119; see also Parry, *Art of Thomas Cole*, p. 124 ff.

92. See G. L. Brown's *Bay of Naples* (Bowdoin College Museum of Art, Brunswick, Maine); J.G. Chapman's *Vesuvius from Marina Grande, Sorrento*, 1870 (Peter Tillou Fine Arts Gallery, London).

93. See Vance, *America's Rome*, vol. 2, part 1.

94. [Joseph Sansom], *Letters from Europe During a Tour Through Switzerland and Italy in the Years 1801 and 1802, Written by a Native of Pennsylvania*, 2 vols. (Philadelphia: A. Bartram, 1805).

95. Edward Lind Morse, ed., *Samuel F.B. Morse: His Letters and Journals* (Boston: Houghton Mifflin Co., 1914), vol. 1, p. 352.

96. Gibbes, *A Memoir of James de Veaux*, p. 109.

97. Theodore Wores, *Interior of St. Mark's Cathedral, Venice*, about 1881-82 (Collection Drs. Ben and A. Jess Shenson); David Neal, *Interior of St. Mark's, Venice*, 1869 (Art Institute of Chicago), George H. Yewell, *Pulpit in St. Mark's, Venice* (The Metropolitan Museum of Art, New York).

98. See Van Wyck Brooks, *The Dream of Arcadia: American Writers and Artists in Italy 1760-1915* (New York: E. P. Dutton & Co., 1958); Paul R. Baker, *The Fortunate Pilgrims* (Cambridge:

Harvard University Press, 1964).

99. Leonora Cranch Scott, *The Life and Letters of Christopher Pearse Cranch*, p. 105. See also John Paul Driscoll, *John F. Kensett Drawings* (University Park: Museum of Art, Pennsylvania State University, 1978).

100. *The Crayon* 7 (July 1858), p. 203.

101. Jarves, *Italian Sights and Papal Principles* (New York: Harper and Brothers, 1856), p. 106. James echoed this thought a half-century later, writing, "People who had never before shown knowledge, taste or sensibility, had here quite knocked under." Henry James, *William Wetmore Story and his Friends* (Boston: Houghton Mifflin & Co., 1903), vol. 2, p. 209-210.

102. Letter from Alicia Middleton to her son, N.R. Middleton, December 26, 1835, as quoted in Gene Waddell, "Where Are Our Trumbulls?," in David Moltke-Hansen, ed. *Art in the Lives of South Carolinians* (Charleston: Carolina Art Association, 1979), p. GWb-11.

103. Hawthorne in *The Marble Faun* (p. 134) wrote: "American art is much better represented at Rome in the pictorial than in the sculpturesque department. Yet the men of marble appear to have more weight with the public than the men of canvas."

104. Chapman to Gouverneur Kemble, February 28, 1854, as quoted in William P. Campbell, *John Gadsby Chapman: Painter and Illustrator* (Washington, D. C.: National Gallery of Art, 1962), p. 22; *The Crayon* 6 (December 1859), pp. 379-380.

105. *The Crayon* 1 (March 14, 1855), p. 170.

106. Tuckerman, *Book of the Artists*, p. 350. By "compositions," the author was surely referring to paintings combining landscape or architecture of more than one place, as opposed to the topographically exact pictures increasingly demanded by American patrons.

107. Franklin, as quoted in Reinhold, *Classica America*, pp. 120-121.

108. J. Hector St. John de Crevecoeur, *Letters from an American Farmer* (London: J. M. Dent & Sons, 1912), p. 11.

109. Ellwood C. Parry III, "On Return from Arcadia in 1832," in Irma B. Jaffe, ed., *The Italian Presence in American Art 1760-1860* (New York: Fordham University Press, 1989), pp. 122-123.

110. Ralph Waldo Emerson, "The American Scholar," in Brooks Atkinson, ed., *The Selected Writings of Ralph Waldo Emerson* (New York: Modern Library, 1968) p. 62. In his Journal for November 19, 1848, Emerson wrote: "[T]urning your head upside down, or, looking through your legs...changes the landscape at once from November to June. Or as Ellery declared makes *Campagna* of it at once; so he said, Massachusetts is Italy upside down" *Journals of Ralph Waldo Emerson* (Cambridge: Harvard University Press, 1975), vol. 2, p. 56.

111. William J. Stillman, "Review: 'Art Hints' by James Jackson Jarves," *The Crayon* 2 (August 7, 1855), p. 101.

112. Asher B. Durand, "Letters on Landscape Painting," in *The Crayon*; Letter II, vol. 1 (January 17, 1855), p. 34; Letter III, vol. 1 (January 31, 1855), p. 66; Letter VII, vol. 1 (May 2, 1855), p. 274.

113. Margaret Fuller, Dispatch 29, Rome, March 20, 1849, in Fuller, *'These Sad But Glorious Days': Dispatches from Europe, 1846-*

1850, ed. by L.J. Reynolds and S.B. Smith (New Haven: Yale University Press, 1991), p. 266.

114. Tuckerman, *Book of the Artists*, p. 351.

115. Fuller, *These Sad But Glorious Days*, p. 265. With regard to other Americans then in Italy, Fuller was equally critical of the work of Luther Terry and of James E. Freeman, as lacking "originality"; she preferred the paintings of Cranch, Hicks, and Cropsey.

116. Nathaniel Hawthorne, *The Marble Faun: or, The Romance of Monte Beni* (Columbus: Ohio State University Press, 1968), Preface, p. 3.

117. See Ibid., p. 118. In one instance Hawthorne criticizes the process by which the neo-classic sculptor hired workmen to do the actual carving of his work, and in another he doubts the originality of Greenough and Crawford, commenting that "Posterity will be puzzled what to do with busts like these."

118. Ibid., p. 56.

119. Ibid., p. 132.

120. John I.H. Baur, ed., "The Autobiography of Worthington Whittredge," *Brooklyn Museum Journal* I (1942), p. 33.

121. Anthony F. Janson, *Worthington Whittredge* (Cambridge, England: Cambridge University Press, 1989), p. 54. American sculptors in Italy were subject to the same staggering experience of past art, which inspired some of them and overwhelmed others; as Hillard said, "if I were a young sculptor, my heart would break at the sight of what was around me." George S. Hillard, *Six Months in Italy* (Boston: Ticknor, Reed and Fields), vol. 2, p. 256.

122. Baur, "Autobiography of Whittredge," p.39. Whittredge went on to say, "We are looking and hoping for something distinctive in the art of our country...something peculiar to our people, to distinguish it from the art of other nations and enable us to repeat without shame the oft repeated phrase, 'American Art'" (p. 40). Albert Bierstadt, like Whittredge, was moderately successful in Italy; when Bierstadt went west to the Rocky Mountains for the first time in 1859, he reported: "The color of the mountains and of the plains . . . reminds one of the color of Italy; in fact, we have here the Italy of America in primitive condition." *The Crayon* 6 (September, 1859), p. 287.

123. Duncan Bull, *Classic Ground: British Artists and the Landscape of Italy, 1740-1830* (New Haven: Yale Center for British Art, 1981), p. 6.

124. Sanford R. Gifford to Elihu Gifford, February 1, 1856, "European Letters," private collection.

125. Theodore Allen to Luman Reed, about Jan.-Aug., 1836, document #143, Luman Reed Papers, New-York Historical Society.

126. Cooper, *Gleanings in Europe: Italy*, p. 21.

127. Letter of Horace Walpole and Thomas Gray to Richard West, July 31, 1740, in W.S. Lewis et al, eds., *Horace Walpole's Correspondence with Thomas Gray, Richard West, and Thomas Ashton* (New Haven: Yale University Press, 1948), p. 228.

128. Nugent, *The Grand Tour*, p. 16.

129. Irving, *Journals and Notebooks*, p. 13.

130. Noble, *Life and Works of Cole*, p. 105.

131. Jarves, *Italian Sights and Papal Principles*, p. 351.

132. Hawthorne, *Marble Faun*, p. 215.

133. Hawthorne, *French and Italian Notebooks*, pp. 54, 524.

134. Hillard, *Six Months in Italy*, vol. 1, p. 139.

135. Henry James, "The Madonna of the Future" in Maqbool Aziz ed., *The Tales of Henry James* (Oxford: Clarendon Press, 1978), p. 206.

136. David Maitland Armstrong, *Day Before Yesterday*, p. 177.

137. Henry James, *William Wetmore Story and His Friends*, vol. 1, pp. 93-94. See also Henry Adams in *The Education of Henry Adams* (Boston: Massachusetts Historical Society, 1918), p. 89, where Adams writes: "Rome before 1870 was seductive beyond resistance."

138. Norton, as quoted in Kermit Vanderbilt, *Charles Eliot Norton: Apostle of Culture in a Democracy* (Cambridge: Harvard University Press, 1959), p. 111.

139. "Reminiscent Art Gossip," in *The Art Interchange* 21 (New York, September 8, 1888) p. 82. The writer goes on to say that Italy's "high, starry, glaring veilless skies lack the tenderness and beguiling mystery of France and England." Similarly, May Alcott Nieriker, in her *Studying Art Abroad and How to Do it Cheaply* (Boston: Roberts Brothers, 1879), written for women artists, flatly stated, "Rome, in my estimation, is the place for a student of sculpture rather than of painting" (p. 77).

140. William D. Lewis, Jr., "Journal," Historical Society of Pennsylvania, Philadelphia, 1853, entry for April, 1853. Courtesy of Eleanor Jones.

141. Mark Twain, *Innocents Abroad*, in *The Unabridged Mark Twain* (Philadelphia: Running Press, 1976), pp. 93, 129, 104, 192. In a letter of 1869 to his brother William, Henry James wrote that he had "conceived at Naples a tenfold deeper loathing than ever of the hideous heritage of the past — and felt for a moment as if I should like to devote my life to laying rail-roads and erecting blocks of stores on the most classic and romantic sites" (Edel, *Henry James: Selected Letters*, p. 59).

142. Penniman made use of Thomas Major's *View of Grecian Temples at Paestum*, plate II in his *Ruins of Paestum* (London: By the author, 1767). See Carol Damon Andrews, "John Ritto Penniman (1782-1841), an ingenious New England artist," *Antiques* 70 (July 1981), pp. 147-170.

143. William James, as quoted in Ralph B. Perry, *The Thought and Character of William James* (New York: Harper, 1964), pp. 202-203.

144. See Edel, *Henry James: Selected Letters*, p. 54.

145. Jarves, *Italian Sights and Papal Principles*, pp. 371-372; see also Jarves, *Italian Rambles* (New York: G. P. Putnam's Sons, 1883).

146. Henry James, *William Wetmore Story*, vol. 2, pp. 225-226.

147. Henry James, *Nathaniel Hawthorne* (New York: AMS Press, 1968), p. 162.

148. Leon Edel, *Henry James*, 5 vols. (New York: Avon Books, 1978), vol. 2, p. 86.

149. Thomas Eakins to Benjamin Eakins, April 29, 1869, Bregler Collection, Pennsylvania Academy of the Fine Arts, Philadelphia.

150. Henry James to Mr. and Mrs. Edward Wharton, August 11, 1907, Leon Edel, ed., *Henry James Letters* (Cambridge: Harvard University Press, 1984), vol. 4, p. 459.

151. Maria Hansen-Taylor and Horace Scudder, eds., *Life and Letters of Bayard Taylor* (Boston: Houghton Mifflin Co., 1885), vol. 2, p. 490.

152. William Davies, "Artist Life in Rome, Past and Present," *Littell's Living Age* 169 (May 8, 1886), p. 428.

153. "Art Life in Rome," *Art Amateur* 13 (July 1885), p. 30.

154. I am grateful to Professor Irma Jaffe for calling this comparison to my attention.

155. Today we continue to identify America with Rome, though now the cycle has led us back to a cautionary view not unlike Cole's: in a 1992 essay, Robert Hughes writes critically of America as "a nation like late Rome in its long imperial reach, in the corruption and verbosity of its senators, in its submission to senile, deified Emperors controlled by astrologers and extravagant wives," Robert Hughes, "The Fraying of America," *Time* (February 3, 1992), p. 44 ff. Courtesy of Elizabeth P. Valk.

156. Henry James to Charles Eliot Norton, February 4, 1872 in Edel, ed. *Henry James Selected Letters*, p. 93.

Celebrities of the Grand Tour:
The American Sculptors in Florence and Rome

WILLIAM H. GERDTS

As the nineteenth century progressed, the United States began to enjoy not only growing security but increasing wealth; a reflection of both factors was the rising number of men and women who made the "Grand Tour" of Europe at least once in their lives. Their travel plans might vary in detail, and some might cover more of the Old World than others, but the patterns were generally quite similar: after an initial ship landing in England, often in Liverpool, the travelers would visit London and the surrounding region. From there they would cross to the Continent, sometimes directly to France, but often to the Low Countries, from where they would journey down the Rhine and into Switzerland.[1] From there they would make their way into Italy, through Milan to various towns in Central Italy, though always to Florence, before reaching their destination of Rome. Some visitors detoured to Venice en route, and others made a further excursion south to Naples. If Paris had not been visited previously, then a voyage either by land or sea to Southern France was in order, the travelers then moving northward up the Rhône Valley and then on to the French capital. From there they might hie to the coast for a ship back to America, or return for a second visit to England before going home. But Florence, and especially Rome, were their furthest and usually their most anticipated destinations, at least during the second and third quarters of the century.

The attractions that the American visitors sought in these two Italian cities have been the subject of numerous studies, most recently William Vance's sterling analysis, *America's Rome*.[2] Art played an important role in the activities of such tourists, though some few seem to have spurned its enticements almost completely. Indeed, Florence and Rome were the ultimate objectives of most travelers precisely because of the historical artistic continuity and the wealth of artistic attractions that visitors found there: paintings, sculptures, and architectural monuments from the classical, Renaissance, and Baroque eras, as well as archeological ruins to inspire meditation along the lines of both *sic transit gloria mundi* and *ars longa vita brevis*.

Nor did contemporary art escape the notice of these voyagers, though here they appear to have been discriminating from the start. While they might opine or discourse sagely upon the relative merits of Raphael versus Michelangelo, or evince strong preference for Renaissance sculpture over the work of the despised Bernini, for their own times they appear to have paid no attention to contemporary Italian architecture and very little to living Italian painters. But the situation was quite different in regard to sculpture.

It is not possible here to examine American nineteenth-century evaluation of the comparative value of painting versus sculpture, but the Grand Tourists left no doubt about their preferences when in Italy. They came equipped beforehand with some knowledge – and comparative estimation – of the work of both the great Venetian-born Neoclassic sculptor, Antonio Canova (1757-1822), and his successor, the Danish expatriate, Bertel Thorvaldsen (1768-1844). The latter's art seemed to many Americans to be more consistent with the principles of antiquity more pure,

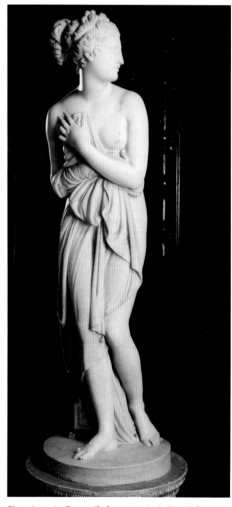

Fig. 1. Antonio Canova (Italian, 1757-1822), *Venus Italica*, 1804-1812. Marble. Galleria Palatina, Florence. Photograph courtesy Alinari/Art Resource, New York.

and far less sensual and affected than Canova's marble figures (fig. 1).[3] Once in Italy if not before, the tourists also became aware of the productions of other Italian artists, most notably Lorenzo Bartolini (1777-1850) in Florence and Pietro Tenerani (1789-1869) in Rome, the leading native sculptors of the middle decades of the century, with the former offering some degree of incipient naturalism, and the latter maintaining an unswerving classical bent.

But the American tourists did not limit their interest to the most famous glyptic luminaries, as is proven by the commissions they gave to lesser lights among the Italian sculptural pantheon — for works such as Giovanni Maria Benzoni's (1809-1873) *Veiled Rebecca*; Giovanni Battista Lombardi's (1823-1880) *Susanna*; and Rinaldo Rinaldi's (1793-1873) *Penelope*. Such sculptures may have been viewed in public exhibitions held in Rome and Florence, but were more likely first seen on visits to the artists' studios, for these were among the major tourist attractions in those cities. In Rome, particularly, the artists congregated where artists had clustered at least as far back as the seventeenth century and where they continue to live today, in the area of the Via Margutta, Via Due Marcello, and Via del Babuino, all at the foot of the Spanish Steps. Studio visits were the most common means of ascertaining the qualities and comparative merits of the painters and sculptors, both Italians and also expatriate artists of all nationalities. Visitors from the United States were likely to familiarize themselves also with the art of some of the leading English sculptors of the day such as John Gibson (1790-1866) and Benjamin Spence (1822-1866), of such German sculptors as Emil Wolf (1802-1879), and especially of course, of their fellow Americans. Gibson's occasional practice of coloring his sculptures especially attracted the attention of Americans, and not all of them disapproved of the practice, — though Nathaniel Hawthorne discussed the matter at length with Hiram Powers (1805-1873) and both found it indefensible.[4] Similarly, in 1858-59, Harriet Allen (1841-1877), daughter of the prominent Trowbridge family of New Haven, even while she found Gibson's *Tinted Venus* a "wonderfully beautiful object," nevertheless judged that there was "something false and meretricious in this coloring of pure marble . . . as if purity had in some way suffered an eclipse."[5]

Such travelers in Italy visited the studios of fellow-American painters and sculptors, and such expatriate painters as George Loring Brown (see cats. 58, 59) and John Gadsby Chapman (see cat. 66) enjoyed their share of social encounters and patronage. This was true especially during the more prosperous decades of the 1840s and 1850s, before the Panic of 1857 depressed the art market, and then the subsequent Civil War years, which brought international travel to a near halt. But while a great many of our painters visited Italy at one time or another, the ones who remained in residence there for long periods lived on the fringes of the American cultural establishment. The sculptors, on the other hand, not only represented the mainstream of our sculptural tradition, constituting in fact the first recognized school of American

sculpture, but some of them achieved contemporary international reputations beyond those of any other artists from this country.

The history of this group of Americans has been told often, and need not detain us long.[6] Boston-born, Harvard-trained Horatio Greenough (see cats. 77-79) was the first American sculptor to go abroad, settling in Rome in 1825, though illness and depression brought him home two years later, and when he returned to Europe in 1828, Greenough settled instead in Florence.[7] It was Greenough's presence there, in part at least, that led to the subsequent expatriation of numerous other American sculptors to the Tuscan capital, most notably Hiram Powers in 1837 (see cat. 82), and a good many others after him, including Shobal Clevenger (1812-1843), Joel Tanner Hart (1810-1877), and Larkin Mead (1835-1910). However, Rome was the more usual destination, with Thomas Crawford (see cats. 8, 9, 21) in 1835 the first American sculptor to settle there, followed by dozens of others.[8] Florence increasingly became a way-station for the American expatriate sculptors, with artists such as Henry Kirke Brown (1814-1886), Randolph Rogers (see cats. 26, 47, 48), Joseph Mozier (1812-1870), and others beginning their Italian residence there, but subsequently moving on to Rome for longer periods, sometimes for life. Rogers was a mainstay of a second generation of American sculptors in Italy, along with William Wetmore Story (see cats, 16, 32) and William Henry Rinehart (see cats. 83, 84), both of whom also chose to make Rome, rather than Florence, their residence.[9]

Each of the two Italian centers, rivals to some degree, had its own attractions. Florence was smaller and quieter, viewed as a more intellectual center and less subject to religious proscriptions — at least until the unification of Italy in 1870 after which Rome as the capital became effectively secular. The strong English presence in Florence made for a more homogeneous atmosphere for the American sculptors, but there were also practical considerations that made Florentine residence attractive. Florence was far more convenient than Rome to the marble quarries along the coast, those at Carrara and Seravezza from which the sculptors drew the materials for their marmorean productions (fig. 2). These were within relatively easy access; there they personally could select the blocks of marble that would subsequently be transported to their Florentine studios at less cost than shipping the heavy blocks to Rome.

Rome on the other hand enjoyed a far more cosmopolitan ambience. While the artistic community in Florence was primarily Italian and Anglo-American, artists of all nationalities congregated in Rome, fostering greater rivalries but also providing more stimulating challenges. While American travelers — prospective patrons — invariably visited both cities, more of them tended to remain longer in Rome, thus providing greater opportunities for both social intercourse and commissions. Indeed, the establishment in Rome was organized to the extent that special guide-books to the artists' studios were published, thus enabling the art lovers and patrons more easily to plan the route of their visits, just as modern-day art gallery-goers in

Fig. 2. Esther van Deman (American, 1862-1937), *Ox Carts Hauling Marble at Carrara*, 1913. Photograph. Courtesy Fototeca Unione at the American Academy in Rome, Van Deman collection.

New York circulate from floor to floor and building to building. Such guidebooks even detailed the sculptors' latest productions, noting new additions since the last edition of the directory.[10] While there were individual women sculptors of many nationalities working in Italy, only the United States knew a collective feminine presence, the group of artists referred to by Henry James as "the white, marmorean flock,"[11] and significantly, they joined the greater international community in Rome, rather than residing in Florence. Once settled in Florence and Rome, most of the sculptors made occasional visits back to their homeland, often seeking prestigious government commissions, but the majority of them elected to remain abroad. Some, such as Edward Sheffield Bartholomew (1822-1858) and Randolph Rogers, died in Italy, while Shobal Clevenger expired on the ship bringing him home from Florence. Hiram Powers, the most famous of them all, is unusual in that he never revisited the United States once he had left to go abroad in 1837.

American sculptors expatriated to Italy for many reasons, though a cosmopolitan environment within which national groups could still band together was certainly one. The accessibility of the esteemed Italian marble was another. But perhaps most important was the availability of trained and talented Italian workmen who would actually carve the sculptures. As one Grand Tourist wrote about these artisans, "These workmen often acquire rare skill in their vocation, and sometimes attempt

to model. Generally speaking, however, they are mere workmen."[12] Most of the American sculptors had learned to model before they went abroad, and some had even had experience in stone carving in the United States. Once in Florence and Rome, they might still be involved, tangentially at least, in working the marble, but usually this practice was minimal, except at the beginning of their careers when funds were not available to hire workmen, or perhaps in furnishing a final touch to the surfaces of their works (see cat. 144). Otherwise, they felt that such work would waste valuable time that could be better spent devoted to the conception of a work of art (or in entertaining prospective clients).

There were two basic subjects that the sculptors – all sculptors of all nationalities – created: portraits and works that were at once imaginative and more traditional, generically referred to as "ideal" sculptures. The methodology involved in both forms was pretty much the same, though the portraiture was simpler and more straightforward. For an ideal work, the sculptor would start – with an idea. The conception would usually be his or her own, though a patron might also offer his suggestions, either in regard to the basic theme or to the form of the interpretation. The sculptor might then make a preliminary drawing, though this seems to have been done rarely; with the exception of Horatio Greenough and perhaps Harriet Hosmer, American sculptors, at least, seem to have by-passed the two-dimensional rendering. Usually, then, the first visualization of an ideal work would have been a small clay model, a *bozzetto*, which would incorporate the basic conception.

And that, in some ways, was "it." The sculptor would turn over the small model to his workman or workmen, who would then construct a metal armature on which to build up in clay a large version of the small *bozzetto*, matching the size of the de-sired finished sculpture; if a full-length sculpture was planned, then an armature ca-pable of supporting a life-size form was necessary, although numerous full-length sculptures were also available to clients in reduced versions, usually two-thirds life-size. The sculptor would then work on the large clay model, making necessary ad-justments, refining and possibly changing his conception – advancing a leg, bending an arm, or manipulating the features. Following this, since the clay was imperma-nent owing to the possibility of cracking and breaking in the cold Italian winters, the workmen would prepare a plaster mold of the large clay piece, and then make a relatively permanent plaster cast of the piece. To shorten the work process, the inge-nious Hiram Powers invented a method of carving directly into plaster blocks, by-passing the need for the large clay *modello*. Many American tourists such as Nathaniel Hawthorne were extremely intrigued at the mechanical ingenuity of our sculptors, remarking upon Powers's invention of plaster modeling, and also upon the innovative tools he had manufactured: a sculptor's file perpetually free from clogging; a power-driven punch; and a device for cutting and finishing separate parts of a statue.[13] As early as 1842, George Henry Calvert (1803-1889), poet and essayist from a distinguished Maryland family, noted that Powers had "a talent, I may call it

a genius, for Mechanics . . . helping him to modelling tools, to facilities and securities for the elevation or removal of clay models, and to other contrivances in the economy of his studio."[14] A decade later, newspaper editor and Republican politician Thurlow Weed (1797-1882) also noted the sculptor as an "accomplished Machinist," pointing out that "Powers works as skillfully in iron, steel and brass as he does in marble."[15] In 1858, Hawthorne was interested, too, in the bronze foundry recently opened by the grand Duke of Tuscany, where Powers' *Daniel Webster* was cast.[16] Other Grand Tourists were fascinated by the pointing machine that Joel Tanner Hart created to save time and labor in transferring measurements from both sitters and models to the marble replication.[17]

And there, in the plaster, the conception often remained, unless it had been commissioned from scratch. These plasters were available for inspection by the numerous callers, who might appear either while following the tourist routine of studio visits, or to sit for a portrait bust; in either case they would be shown the accumulation of ideal pieces in plaster, and be urged to commission one or more that would then be translated into marble. Once an order was received, half-payment was the norm, the rest to be sent on receipt of the finished piece to the home city of the patron. The whole process might take six months to a year, the time necessary for the acquisition of the marble, the hiring of the marble carvers (some of whom might be specialists in flesh, in drapery, in hair, in accessories), the transportation of the sculpture to the port of embarkation, and the trip across the Atlantic. And this is an optimistic agenda, for once into the carving, the marble might be found to have a blemish which, if really significant, would cause it to be abandoned, and if not, might necessitate a reduction in price. Furthermore, more than one sculpture was lost or damaged in transit.

This method provided the artist with one tremendous advantage, for the plaster model remained in the studio, available for inspection by additional visitors even after a marble version had been shipped to a client. Barring those rare patrons who insisted upon a limitation on the number of duplications that could be made from a plaster model, these could be created almost indefinitely, over a long span of years. Some sculptors were especially successful at finding patrons for such replications; the two leaders among the expatriated sculptors were Hiram Powers, who received over 150 orders for his bust of Proserpine, and Randolph Rogers who is known to have replicated his full-length *Nydia, the Blind Flower Girl of Pompeii* (cat. 47) more than fifty times — possibly 167 times, according to his own account. Once sculptures such as these were received back in the United States by the patrons who had themselves long since returned home, the new owners often celebrated their recent acquisitions among their friends and occasionally lent them to exhibitions; in thus exposing the works either to private groups or to the general public, they actively abetted the sculptors, since these viewings would occasionally generate further commissions sent by letter across the ocean. The prospective purchasers-by-mail of a replicated

Proserpine or *Nydia* need not worry about the fruits of their patronage; they knew ahead of time exactly what they would receive and how much they had to pay.

The sculptors' clients were also usually, though not always, Americans; Powers, Hosmer, and Story particularly, also enjoyed a good deal of support from English collectors. Patrons of other nationalities were infrequent, although several very wealthy buyers did give support to individual American sculptors: The Russian, Prince Anatole Demidoff, long resident in Florence, acquired several of Powers's works, and Story's greatest patron was the Austro-Hungarian Count Janos Palffy, long resident in Paris.[18]

Thematically, the subjects sculpted by the Americans were by and large similar to those chosen by their European colleagues. With a view to the tastes and also the language familiarity of their prospective patrons, the literary sources of much American work seem to have tended more toward English, and to a lesser extent, American writers; English poets were especially popular, Tennyson particularly with the women sculptors. Naturally, also, Americans sculpted the occasional historical figure such as Columbus (see cat. 26), appropriate to their backgrounds. One theme that was favored by our artists was the American Indian, sometimes as representative Native American, and sometimes in a literary guise, the latter from both American sources (*Indian Girl's Lament* by Joseph Mozier [fig. 3] derived from a poem by William Cullen Bryant), and European ones (*Atala and Chacas* by Randolph Rogers, from Châteaubriand's *Atala*). Yet, even this is not as clear-cut as one might expect; Rogers's two-figured group is startlingly similar to the same subject sculpted some years earlier by the Florentine artist, Innocenzo Fraccaroli (1805-1882). It is likely, also, that in some cases, the interpretation of specific subjects was motivated competitively, the sculptors rendering their subjects with a view to creating an image superior to those that had preceded, both by contemporary Europeans and by fellow Americans. Thus, Randolph Rogers's first major success modeled in Rome, his *Ruth Gleaning* of 1851 – an imploring kneeling figure – stands in contrast to the most significant American *Ruth* previously completed there, Henry Kirke Brown's standing and stoical image of five years earlier.

Whatever the theme, the dominant form chosen by both the Americans and the Europeans was the single female figure, represented sometimes in bust length, sometimes as the complete figure, and often nude. But whether clothed or not, the figure was generally portrayed as modest and demure, even when her presumed circumstances were distressful, as with the most famous of all the American sculptures, Powers's *Greek Slave* (cat. 80). This reticence was particularly true of the work of the first generation of Americans, and of the earlier work of their successors. Gradually, an alternative interpretation of the female figure appeared, more dramatic and assured, at times triumphant and at others even malevolent, as seen in Story's cast of such historical and classical characters as Cleopatra, Medea, Salome, Semiramis, and Judith, and others. Cleopatra, indeed, was a favorite among our

Fig. 3. Joseph Mozier (American, 1812-1870), *Indian Girl's Lament*, 1859. Marble. Hearst San Simeon State Historical Monument. Photograph courtesy New York Public Library.

Fig. 4. Harriet Hosmer, *Zenobia in Chains*, 1859. Marble.
Wadsworth Atheneum, Hartford, Connecticut, Gift of Mrs.
Josephine M. J. Dodge.

sculptors including a number of the women artists such as Margaret Foley (1815-1877) and Edmonia Lewis (see cat. 39) who sought to project the image of an independent and assertive woman who mirrored their own autonomy; Harriet Hosmer's own most ambitious ideal sculpture, *Zenobia in Chains*, shows a similar strength (fig. 4). Again, Americans had no monopoly on marmorean Cleopatras, a popular subject also for Europeans. Some differences may exist among nationalities in that European images, whether of Cleopatra or the equally popular Sappho (see cat. 32) are often more voluptuous than those by the Americans; likewise, there are far more nude Venuses by Europeans. On the other hand, some American works — again, particularly later sculptures such as Richard Greenough's *Mary Magdalene* and Thomas Gould's (1818-1881) *Cleopatra* — are comparable in terms of sensuality.

We may scoff today at the notion that the work of such sculptors as Powers and Greenough could be mistaken for that produced in fifth-century Greece, let alone that their art embodies the principles of classical art; indeed, there are historians who question the validity of calling their work "neoclassic" at all. Nevertheless, some of the artists themselves, along with many of their patrons and champions, believed that their art revived the standards of the classical world in opposition to the so-called depravities of Bernini and even the mannerisms of Canova. The calmness and serenity of so much Neoclassic sculpture, which later viewers have (mis)interpreted as coldness and inexpressivity, derive from the artists' interpretation of High Classicism. Beauty of form and nobility of sentiment ranked highest among their goals; individual emotion or expression was to be the subject of nuance, not declamation.

Such aesthetic standards, however, gradually changed. Today it may be more profitable to recognize stylistic distinctions chronologically, rather than nationally or individually, though it should be emphasized that the works of one neoclassic sculptor can often be distinguished from those of his and her colleagues. But however much the later nineteenth-century sculptors utilized an analogous methodology and undertook themes similar to those of their predecessors, the adherence to and emulation of Classical prototypes lessened with time. More playful, sometimes more rococo, elements seep into the work of a Rinehart or a Rogers. The latter's *Nydia* is related rather to the more emotionally intense art of Hellenistic Greece than it is to the High Classicism of the fifth century, while such later pieces as his *Lost Pleiad* is truly Baroque both in form and interpretation. Even some of the figures Powers created after the mid-century, such as his *Last of The Tribes*, are more spirited than such earlier work as *The Greek Slave*, while the differences between his two *Eves* is instructive. The first, *Eve Tempted* (fig. 5), is a quiet, unemotional (though extremely beautiful) nude, meant to be viewed primarily from the front, while his later, plaintive *Eve Disconsolate* strides actively forward toward the viewer.

In some ways, the primary dependency upon commissions generated either through Italian studio visits, or offered from patrons in America for replicas of

sculptures that had gained notoriety once they had appeared in the United States, obviated the need for the sculptors to participate much in public exhibition in their native land. This was just as well, given the hazards of trans-Atlantic travel and the difficulties of handling such heavy, fragile works once on land. Furthermore, the sculptors were loath to expend their own funds on the necessary marble and work-men to create an exhibition piece purely on speculation. This is not to say that marble figures by the expatriate sculptors never appeared on public display here; at times the artists persuaded their patrons to lend pieces to important exhibitions, and occasionally a work of outstanding significance was put on public view in an exhibition of its own, as in the case of Horatio Greenough's first ideal work, his now-lost *Chanting Cherubs*, which traveled first to Boston and then to New York City. The best-known example of this kind of one-sculpture traveling exhibition was the tour in this country of Powers's *Greek Slave* (cats. 80, 81), two replicas of which at one time were simultaneously on view. In 1844, Thomas Crawford had the distinction of having a one-artist exhibition of five of his sculptures at the Boston Athenaeum, as an adjunct show to the Athenaeum's annual art exhibit. But such displays were difficult to bring together, and consequently very rare. The most important exhibitions in which the American sculptors were involved were the great international expositions that were mounted periodically, usually in European capitals, beginning with the Crystal Palace exposition in London in 1851 in which Powers's *Greek Slave* was a great success. Such participation might bring a sculptor fame and fortune, if advantageous display and positive critical notice generated subsequent sales.

Given their long, often permanent expatriation, the sculptors needed to remind their compatriots back home of their American allegiance, in order to generate sales, to ensure their place among the studio visits of the Grand Tourists, and to be considered eligible for often lucrative public commissions. Yet the ordinary sources of critical notice that were enjoyed by painters and sculptors who remained at home — American newspaper and magazine exhibition reviews and regular critical visits to studios and artists' receptions — were seldom available to the expatriate sculptors. This problem was addressed, in part, by numerous articles written for American newspapers by traveling journalists who described the activities of the artists in Florence and Rome, especially the ones that appeared regularly in *Art Journal*, the best-known art magazine in the English-speaking world. These news-paper and *Art Journal* columns generally gave far more attention to sculpture than to painting, and while English and Continental artists might occasionally be men-tioned in the American newspapers, the bulk of their attention went naturally to American artists. And though an English publication, *Art Journal* gave surprising consideration of the achievements of the American sculptors, both in articles on art matters in Florence and Rome, and even in notices given to individual works by some of the American sculptors.

Fig. 5. Hiram Powers, *Eve Tempted*, 1842. Marble. National Museum of American Art, Smithsonian Institution, Mu-seum Purchase in Memory of Ralph Cross Johnson.

Somewhat more discreet though usually no less informative were the discussions of the artists that appeared in the hundreds of travel books generated by many of the Grand Tourists themselves. Such books were not limited of course to American authors, but travelers and commentators naturally gave preference to their country-men; however, American sculptors were favored with occasional notice by foreign writers too. As some of the writers were also patrons of the sculptors, these travelers, in effect, offered their support threefold: they acquired works of art; those acquisitions in turn, once received, often generated further commissions; and their writings, which were generally very positive toward the sculptors and their creations, popularized the members of the American art colonies in Italy and confirmed their patriotism.

These books merit attention, for they record the reactions to the American sculptors by often well-read and cultured contemporaries, who understood the artists' motivations and achievements within a cultural context far removed from our own today. Most of the writers were admittedly motivated as much by pa-triotism as by aesthetics, and they came prepared with prior knowledge of the kind of art they were going to view and in some cases, familiarity with the personal characteristics and reputation of the sculptors, thanks to previously published re-ports including earlier travel books. The books have a certain quaintness to mod-ern readers, as is suggested immediately by their titles, such as Hiram Fuller's *Sparks from a Locomotive*, and especially those with double designations, such as Samuel Sullivan Cox's *A Buckeye Abroad; or Wanderings in Europe and in the Orient*; Orville Horwitz's *Brushwood, Picked up on the Continent, or Last Summer's Trip to the Old World*, and Theodore B. Witmer's *Wild Oats, Sown Abroad, Or On and Off soundings*. One can sometimes chart the career and achievements of individual sculptors by following the written reports of studio visits from year to year, though of course there was usually a delay between the actual encounters and the publication of the book. There are also travel diaries that were published only many decades after the European journey, sometimes after the writer's death. There are others that were unpublished, remaining in manuscript or typescript form, but which yield valuable comments on the expatriate sculptors, and tally with the published accounts.

American-authored books of European travel appeared even before any sculptors from the United States had settled in Europe. One of these, though published in Edinburgh in 1823, was written by Matthias Bruen — "by an American" as noted on the title page. Bruen (1793-1829), a clergyman, went too early to visit any American studios in Italy, though he did evince an interest in sculpture and its production, as expressed in his fascination with Carrara and its marble quarries, as well as in the Florentine Academy.[19] In 1831 Rembrandt Peale (see cats. 5, 6) published a travel book describing his trip of the previous two years; as a painter himself, he gave a good deal of attention to the activities of the artistic community in Florence, discussing Italians primarily, but including a notice of Horatio Greenough, our first

expatriate sculptor, whom he described as the "only American who has studied sculpture scientifically." Peale also mentioned Greenough's commission from James Fenimore Cooper for a *Group of Two Angels*, the unlocated work that became known as the *Chanting Cherubs*, which was on view in Boston and New York the year Peale's *Notes on Italy* appeared.[20]

Peale's notice of Greenough was quite brief. But in 1837, Henry Tuckerman (1813-1871), who would go on to become one of the major art writers of the mid-century, published the journal of his Italian trip of 1833-34 (see cat. 158), and devoted a full chapter to Greenough. In the few years that had elapsed since the *Cherubs* had been displayed, Greenough's reputation had sufficiently advanced to the extent that Tuckerman had prepared himself for his visit by a meeting with the family of the sculptor in Boston, where he had viewed both an inadequate portrait of Greenough as well as one of his earlier productions. In Florence, Tuckerman's conception of this artist's studio as a shrine was confirmed by his admiration for the works of art he found displayed there, ideal pieces such as Greenough's *Guardian Angel and Child* — a reinterpretation of the *Cherubs* — the dead *Medora* from Byron's *Corsair*, a commission from Baltimore's noted art patron, Robert Gilmor, as well as numerous portrait busts including those of Cooper, Lafayette, and the Boston painter, Francis Alexander (1800-1880).[21]

Tuckerman's conception of Greenough's mission as a sacred one received confirmation in the artist's description of his arrival in Genoa, where his first encounter with beautiful sculpture took place in a church. This sense of holiness was reinforced when Tuckerman accompanied Greenough to the studio, a "pretty edifice which had been formerly used as a chapel," where he proposed to create his statue of George Washington.[22] Until the arrival of Hiram Powers in 1837, Greenough was the only American sculptor in the Tuscan capital, although Greenough acted as cicerone for a number of painters. During his visit to Italy in 1836, Isaac Jewett (1808-1853), a Harvard-educated lawyer, encountered only Greenough, who was by then a nationally recognized artist then actively engaged in a government commission. Jewett was impressed by the simplicity of Greenough's heroic image of the seated *George Washington* (see cat. 77), judging it, "if anything, too sternly severe." He suspected that "critics might complain against its Romanism," but noted also that the work "appeals to admirers of genius."[23] One can, in fact, trace the progress of Greenough's heroic image of our first President through the travel literature. When Wilbur Fisk (1792-1839), a Methodist clergyman and the first president of Wesleyan University, in Middletown, Connecticut, visited Greenough at the beginning of 1836, he found that the plaster mold was completed and he learned that the cast to be taken from it would be ready in a fortnight, but that the finished statue was not expected to be realized for two years.[24] In April of 1841, Frances Trollope, the wife of novelist Anthony Trollope and herself a novelist, found Greenough on the verge of dispatching the *Washington* to the American capital. She believed it to be

a noble work, with a well-imagined attitude and expression, but her comments also eerily prefigured the problems and controversies that would overtake the work in America. She noted the inability of the available lights, and consequently, the shadows, to provide the proper effects; the disadvantage of appearing as if the roof pressed upon it (a condition still present in the statue's present position in the National Museum of American History in Washington, D.C.); and its classical designation as "a domestic Jupiter."[25] Jane Anthony Eames (1816-1894), an author who traveled extensively in Europe, arrived just after the *Washington* had been sent to the port of Leghorn for the journey to America, but Greenough was able to show her the plaster model for his *Rescue* group destined for the portico of the Capitol.[26] When George Henry Calvert visited Florence in May of 1842, *Washington* had already arrived in America, but Calvert used its absence as a springboard for an essay to justify the sculpture's nudity and to praise it as a genuine work of art.[27]

American visitors to Rome during the 1830s commented liberally upon the great works of the past that they had come to see; in regard to contemporary European art, their attention was taken especially by the sculpture of Bertel Thorvaldsen and the painting of the German Nazarene, Friedrich Overbeck (1789-1869), long expatriated to Rome.[28] Thomas Crawford had arrived in the Eternal City in 1835, impoverished and unknown. It was only about 1839 that American travelers began regularly to visit his studio, including visitors such as Charlotte Bronson who misspelled his name and found his bust of Mrs. Schermerhorn (d. 1840), daughter of New York City Mayor Philip Hone, "not so good a resemblance as I imagined; it was not all flattering."[29] Crawford's quarters were found by novelist Catharine Maria Sedgwick (1789-1867) to be "obscure, small, and sunless apartments, so cold and damp that they strike a chill through you"; the artist himself, in fact, was dangerously ill. She contrasted the American's mean studio with the magnificent quarters of Thorvaldsen, converted from the extensive stables of the Barberini Palace. Sedgwick found a few works completed by Crawford but not yet commis-sioned, and thus not put into marble; she noted a statue of Franklin, a piece described as a rain of snakes falling on a family, from the Apocalypse; and most significantly, the artist's *Orpheus* (cat. 9), the sculpture that would eventually win him great fame. In fact, after a trip to Naples, Sedgwick called again upon Craw-ford, finding him recovered in health, and while her book was going to press, she noted that the sum of $2500 had been subscribed in Boston to put the *Orpheus* into marble.[30] *Orpheus*, indeed, attracted the attention of European Grand Tourists as well; it figured prominently in the chapter on "Crawford's Studio" along with the artist's bas-relief of *Anacreon and a Nymph* in the well-known tribute of 1844 to the sculptors of Rome written by Count Hawks Le Grice, who noted that "in the *Orpheus* of Crawford we have a proof of no ordinary talent and taste, and that Col-umbia, the land of the brave and the free, has an earnest of his future eminence."[31] Despite Crawford's subsequent achievements, including a wealth of government commissions, many visi-

tors, viewing the model of *Orpheus* in his studio, continued to believe it to be the artist's finest work.[32]

Thus, by the time American engineer William Gillespie (1816-1868) visited Rome in 1843-44, Crawford had become a celebrated figure in the artistic world there. Gillespie noted that "Rome is the home of all Art, and therefore the country of Artists of all nations," reminding his readers that both Benjamin West and Washington Allston owed to Rome "the development and cultivation of their genius." He spoke of Overbeck as "first among the painters," and mentioned the leading Italian and British sculptors, John Gibson especially, while commenting at length upon the work of Thorvaldsen who had died during the period Gillespie was abroad. But after speaking about the American painters who were visiting Rome while he was there – Emanuel Leutze (1816-1868), Daniel Huntington (1816-1906), and Thomas Rossiter (1818-1971), and those already resident such as James Freeman (1808-1884), Luther Terry (1813-1900), and George Loring Brown (see cats. 58, 59) – the greater part of Gillespie's essay on the artists in Rome was reserved for Crawford, "whose poetic conception, graceful fancy, and classic feeling, have already placed him in the very foremost rank of art." Gillespie spoke glowingly of the *Orpheus*, but his main purpose appears to have been to communicate the range of Crawford's production: the classical *Sappho*, the literary *Bride of Abydos*; playful children like *The Genius of Mirth* and *Boy Playing Marbles*; ambitious, two-figure groups, among them *Hebe and Ganymede* and *Adam and Eve*, as well as over thirty bas-reliefs. The writer emphasized that the greatest merit of Crawford's art, in addition to poetic imagination, was its union of a classical spirit with a natural, though idealized execution, one of many testimonials to the classic underpinnings of the creations of our early expatriate sculptors. Gillespie's goal, as he made clear at the end of his extended essay on Crawford, was to advance the artist's nomination for public commissions.[33]

In Florence, Greenough continued to command the attention of visiting Americans, but Hiram Powers began to overshadow him in terms of his popular reputation soon after he settled there in 1837, even before the first public appearance of Powers's *Greek Slave* in London in 1845; indeed, Powers himself, along with his art, his pronouncements and opinions, and his lifestyle, were the subject of constant travel lore for three and a half decades, at times almost to the exclusion of most of the other sculptors resident in Florence. This was due at least in part to Powers's own skillful manipulation of the literary media.

Charlotte Bronson visited Powers a little over a year after he settled in Florence, where he showed her party a group of portrait busts, both plasters such as those of Andrew Jackson, Martin Van Buren, John Calhoun, and Daniel Webster that he had brought from America, and those of John Farrar and Anna Barker that he had recently modeled in Italy. Bronson found "all of them admirable likenesses" and prophesied that he would equal if not surpass Greenough.[34] Jane Eames was one of

the first visitors to single out an ideal piece of Powers's, his bust of Ginevra, which was derived from *Italy*, the poem of the English author Samuel Rogers, which Eames found "a charming thing, so chaste and so lovely." Powers was then working on his first full-length statue, his *Eve Tempted* (fig. 5), and on the basis of Powers's work, Eames predicted that America would yet produce sculptors "worthy of walking in the footsteps of Canova and [Stefano] Ricci, and Michael Angelo."[35] *Eve* was also seen in May of 1841 by Frances Trollope, who was struck, even more than by its grace and loveliness, with its "severe simplicity." She found the figure a representation of "nature in very full perfection," and subsequently defended it against charges that the work "wanted imagination" by championing Powers's subscription in his ideal works to that same "perfection of truth" for which he was universally admired in his portrait busts. Later, Trollope declared that if she "were rich enough to order a statue, large as life . . . most certainly it should be the *Eve* of Hiram Powers."[36]

George Calvert visited Powers in Florence in May of 1842 and described the triumph in portraiture that the sculptor had achieved over his Tuscan contemporaries by imparting to his work a hitherto unknown fidelity to nature and completeness of imitation, but an imitation yet reflective of an ideal of beauty of which each individual bust was a partial incarnation. Calvert almost certainly was echoing Powers's own comments, including the often-repeated praise offered by Thorvaldsen after a visit to Powers's studio in September of 1841, that he himself could not make such busts, and that there were none superior to them, ancient or modern. Like Trollope, Calvert noted that Powers's triumph with the portrait bust led to charges of his inability to conceive the ideal subject or create the full figure — charges however, he had refuted with his *Eve*. This work was completed as far as the clay model at the time of Calvert's visit; it was a sculpture described as Grecian in its beauty but recalling no Greek model, Calvert noting that Powers's *Eve* need not fear comparison with the famous *Venus de' Medici* (Stebbins, p. 28, fig. 1). On a return visit almost a year later, Calvert found the model of Powers's *Greek Slave* nearly completed, a figure "altogether of another type, slender and maidenly" though Calvert deemed both of them "a revelation of the symmetry, the inexhaustible grace, the infinite power and beauty of the human form." Already the propaganda effort justifying the nakedness of Powers's ideal female figures had been set in motion, for Calvert quoted an American clergyman on the *Slave* who had stated that "were a hundred libertines to collect round it, attracted by its nudity, they would stand abashed and rebuked in its presence."[37]

With the *Greek Slave*, the encomiums came quickly and endlessly. When John H. B. Latrobe (1803-1891), lawyer, inventor, public servant, and elder son of the architect Benjamin Latrobe, arrived in Florence, one of his first visits was to Powers's studio; he noted that "It is as well known to every vetturino in the city as the Piazza della Signoria. In the guide-books it is mentioned among the notabilities."[38]

The *Slave*, in fact, became the pivotal sculpture for American visitors to Italy in the 1840s, and several of them published brief essays about the figure in their travel books and diaries. Horace Binney Wallace (1817-1852), literary, art, and legal critic, was one, and William Ware (1797-1852), Unitarian clergyman, was another, both writers making the oft-repeated invidious comparisons between it and Canova's *Venus* and even the *Venus de' Medici*.[39] In 1847, George Palmer Putnam (1814-1872), the founder of G.P. Putnam & Son publishing company, stated that "I would sooner have either Powers's *Eve* or his *Greek Slave*, than the *Venus de' Medici*."[40] And three years later, New Hampshire physician Andrew McFarland expressed "total disap-point-ment" after viewing the *Venus de' Medici*, which lacked that "apparent perfec-tion of form that meets the eye in the 'Greek Slave'."[41] Hiram Powers lectured Nathaniel Hawthorne on the superior merits of his own work over those of the *Venus de' Medici*, and Hawthorne came to agree that Powers's sculptures — in this case his *Proserpine* and *Psyche* — were not only more accurately rendered, but possessed beauty, intelligence, and feeling that was lacking in the ancient sculpture, Hawthorne attributing this to the presence of "a soul proper to each individual character" in the modern works.[42]

James Howard McHenry (1820-1888), lawyer and gentleman farmer from Mary-land, noted in his unpublished diaries a visit to the two studios Powers now main-tained on December 16, 1845, two days after he arrived in Florence. He wrote at length of the comparative merits of *Eve* and the *Greek Slave* and of his extraordinary admiration for Powers's bust of Proserpine, for which the sculptor had at the time eleven orders, but he was equally captivated by Powers the man: "extremely polite, a charming easy man in conversation, very amiable in showing us all his objects of interest & answering all our questions. His eye was remarkably bright & quick & fixed full upon you when he spoke to you." A second visit occurred three days later, and on December 21 Powers dined with McHenry. More studio visits fol-lowed the next day and on the 25th, with a farewell visit by Powers on December 28, before McHenry left Florence the following day.[43] By 1847, the writer Margaret Fuller (1810-1850; see cat. 22) offered her praise for *Eve* and the *Greek Slave* by joining "with the rest of the world in admiration of their beauty and the fine feeling of nature which they exhibit."[44]

Other American sculptors in Florence were also noted on occasion. Jane Anthony Eames, for instance, recorded the presence there of Shobal Clevenger from Cincinnati, who had only a few heads of distinguished Americans, which he had brought with him from America.[45] George Calvert briefly mentioned Clev-enger's presence in May of 1842, noting that he had been there only a short time. In Clevenger's studio he saw busts that the sculptor had brought with him from America, commending especially that of Washington Allston, and those he had modeled in Florence, singling out that of Louis Bonaparte. On his return visit to Florence early in 1843, Calvert was one of the relatively few visitors to see the

model of Clevenger's *Indian,* a work that did not long survive the artist's death later that year on his journey back to America.[46] By 1846, both travel writer Bayard Taylor (1825-1878) and American historian Joel Headley (1813-1897) could include a whole chapter on American art and artists in their travel books published that year. Headley had been in Florence in May of 1843, and he acknowledged that critics were divided over the merits of *Eve* and the *Greek Slave,* concluding that the latter had preeminence in beauty and loveliness, but that *Eve* exhibited more character, if less sentiment, and that Powers had discarded all previous conceptions of Venuses and other goddesses. He also developed the startling thesis that French and Italian artists could express in their representations the passion and beauty of Eve, but only an American or an Englishman could embody her moral character, high purpose of calm thought, and conscious greatness.[47] By 1851, Horace Greeley could defy "Antiquity to surpass – I doubt its ability to rival – his 'Prosperpine' and his 'Psyche' with any models of the female head that have come down to us . . . I feel that Powers, unlike Alexander, has still realms to conquer, and will fulfill his destiny."[48]

Powers also received the bulk of Bayard Taylor's attention, "having gained a name in his art, that posterity will pronounce in the same breath with Phidias, Michael Angelo and Thorvaldsen." Taylor saw only the model of the *Slave* and thus spoke more about *Eve,* noting that he had seen "the masterpieces of Thorwaldsen, Dannecker and Canova, and the *Venus de' Medici,* but I have seen nothing yet that can exceed the beauty of this glorious statue." Taylor even wrote a poem about the statue which he hoped might "perhaps faintly shadow the *sentiment* which Powers has so eloquently embodied in marble"; and by the time of his visit, he could discourse at length on Powers's latest statue, the *Fisher-Boy.*[49]

Powers's *Greek Slave* attracted the admiration of traveling Americans not only on their visits to Florence, but also when they visited London, during the time that the sculpture was on public view in Henry Graves and Company's printsellers in Pall Mall beginning in May of 1845. Both American poet and editor William Cullen Bryant (1794-1878) and Henry Colman (1785-1849), Unitarian minister and agricultural writer, viewed it there the following month. Colman concluded that "Sculpture seems to me almost a divine art, and the success of Powers in this case is triumphant." Subsequently, Bryant visited Powers in Florence, and saw the original model and two more replicas being carved by Powers's workmen, and he also admired the bust of *Proserpine* and *Eve Tempted.*[50] And in 1851, American Grand Tourists marveled at the figure when it became the chief artistic triumph of the Crystal Palace International Exposition in London. Tennessee lawyer Randal MacGavock (1826-1863) echoed the majority in declaring the *Slave* "decidedly the most beautiful piece of statuary in the Exhibition," and Horace Binney Wallace agreed, noting also that Queen Victoria had sat for more than half an hour before the sculpture.[51]

Greenough was absent from Florence, but his studio could still be visited; there

Taylor saw the nearly completed group of *The Rescue*, commissioned for the portico of the Capitol in Washington. Taylor deemed it the finest work Greenough had yet created, ensuring it a "much more favorable reception than a false taste gave to his Washington" – this last surely a reference to the realism of the native subject matter of the newer sculpture as opposed to the classicizing of the "domestic Jupiter." Before leaving for Europe, Taylor had become aware of the portrait busts by Connecticut's Chauncey B. Ives who was then in Florence, having arrived in 1844, and he was now able to comment upon and appreciate the ideal subjects Ives had lately modeled, a *Jephthah's Daughter* bust, and the full-length *Boy with a Dead Dove*.[52] Greenough went unmentioned by Headley, but Clevenger was still alive and active, and following a studio visit he noted the artist's great work to be his *Indian Chief*. Headley was delighted to find that "our Indian wild bloods furnish as good specimens of well-knit graceful and athletic forms as the Greek wrestlers themselves," a conclusion reinforced by the appearance of a second, more poetic interpretation of the Indian, in the nearby studio of the newly arrived Henry Kirke Brown. Headley concluded that "Indians, among the gods and goddesses of Florence, were a new thing, and excited not a little wonder; and it was gratifying to see that American genius could not only strike out a new path, but follow it successfully."[53]

A far less noble Indian was featured in Greenough's *Rescue*, the gigantic four-figure group for the portico of the Capitol. William Ware found the sculptor engaged upon this work in the summer of 1848 and viewed the subjugation of the savage being violently restrained by the backwoodsman as an allegorical represen-tation of the triumph of American civilization.[54] Three years later, Daniel Eddy (1823-1896), Baptist clergyman and author, noted the "fiendlike" Indian, and con-trasted his nudity with the "rude yet neat dress of the backwoodsman" – overall, a "befitting monument for the halls of the nation."[55] A later Indian figure that attracted notice was Powers's final ideal work, *The Last of the Tribe*, described by Sinclair Tousey (1815-1887), humanitarian and head of the American News Com-pany, in 1868 as "symbolical of the vanishing races of American Indians."[56]

In addition to his discussion of Powers and Greenough, William Ware wrote briefly of Ives in 1848, noting that he had just completed a *Cupid* of great beauty, with a variety of accessories.[57] Horace Greeley in 1851 found Joel Hart from Kentucky, Alexander Galt (1827-1863) of Virginia, and Randolph Rogers from New York studying and working in Florence, noting also that Ives had moved on to Rome; Hart, he reported, was there to create the statue of Henry Clay commissioned by the Ladies' Clay Association of Richmond, Virginia (fig. 6).[58] Jacob Wood visited Rogers's studio around this time and found the young American engaged upon the figure of Ruth, which would become the sculptor's first major success. Wood found the work "original and beautiful," and noted that it had already been purchased by a Dudley Selden of New York.[59] In 1851, another writer-traveler, Henry Maney, also noticed both Hart and Galt, referring to Hart's Henry

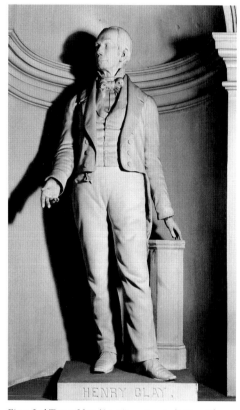

Fig. 6. Joel Tanner Hart (American, 1810-1877), *Henry Clay*, 1846-1859. Marble. Virginia State Capitol, Richmond, Virginia. Photograph courtesy of The Virginia State Library and Archives.

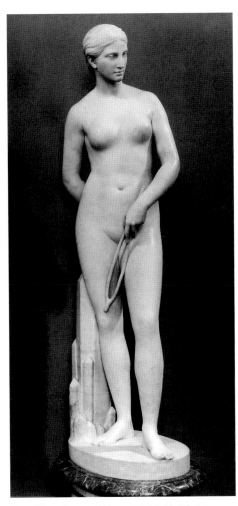

Fig. 7. Hiram Powers, *California*, 1858. Marble. The Metropolitan Museum of Art, Gift of William B. Astor, 1872.

Clay commission, and commenting on a bust of Psyche that Galt had underway.[60] Hart's Virginia commission was not completed until 1859, at which time it was noticed by Henry Allen (1820-1866), later governor of Louisiana, who also recorded that the sculptor was then engaged upon a bronze replica of it for the city of New Orleans.[61] Much later, in 1868, Samuel Tousey commented upon Joel Hart's major ideal conception, his *Woman's Triumph*, then still in the clay model, and on Larkin Mead, who was creating his three-figure group of *Columbus, Isabella, and the Page*.[62]

Other additions to the Florentine sculptural colony in the 1850s and '60s included William Randolph Barbee (1818-1868) of Virginia, who arrived in the mid-1850s. His fellow passenger on the trip from New York to Liverpool, journalist, politician and businessman Richard McCormick (1832-1901), subsequently visited him in Florence where he found Barbee's *Coquette* far advanced and an exquisite work, repeating Powers's back-handed complement that the figure was "the best first effort he has ever seen."[63] Thomas Ball (1819-1911), who had worked in Florence for several years in the mid-1850s, settled there permanently at the end of the Civil War, though in 1866 he was visiting in Rome when Amy and Mary Smith attempted to call upon him, hoping to view the model for his *Emancipation Group*; a small bronze of the sculpture was seen in Ball's studio by Alfred Huidekoper (1810-1892) of Meadville, Pennsylvania, a little later, in 1867-68.[64]

Once into the 1850s, and with Greenough departed, Powers was for several decades the mainstay of the American art colony in Florence, and visitors continued to flock to his studio. Inevitably, more recent conceptions were noted and admired, and often preferred to his earlier figures, even including the *Greek Slave*. In September of 1850, Missouri novelist Anne Bullard found Powers working on his full-length allegory of *America* which she found "splendid . . . superb," and shortly afterwards, Daniel Eddy concentrated his attention upon *America*, while Jacob Wood spoke only of this latter figure.[65] Author Sara Lippincott (1823-1904), one of the first women in the United States to become a regular newspaper correspondent, believed that *America* was the finest of Powers's statues, "a figure of much beauty, force, and grandeur," and she expressed her desire (which was the sculptor's also) to see this work and *California* (fig. 7) adorn the Capitol in Washington.[66] Samuel Fiske (1828-1864), whose letters from Europe were first published in the Springfield, Massachusetts *Republican* under the pen-name "Dunn Browne," declared in 1856 that "Powers's 'America' is one of the finest statues in the world of modern art, and has more life and spirit, and glory about it, than a dozen Greek slaves and Eves."[67] And in 1859, Henry Allen decreed the *Greek Slave* "very good" but found that it did not equal *California*.[68] Later writers such as journalist Hiram Fuller (1814-1880) and lawyer and educator Erastus Benedict (1800-1880) also wrote extensively about Powers's historical figures, such as his statue of George Washington and his *Daniel Webster*.[69]

Only occasionally were strong voices of dissent raised as to Powers's superior merits, though writers did occasionally express their belief in the superiority of Powers's portrait busts over his ideal works. Andrew McFarland, for instance, in 1850, acknowledged that, "It is conceded among artists themselves that Mr. Powers is the first bust sculptor of the age," but he also admitted that "There are those who have denied his possession of originality and creative genius."[70] Still, the universal praise of the mid-1840s gradually moderated; George Hillard (see cat. 161), for instance, visiting Florence around 1847-48, emphasized Powers's imitative faculty, and his skill with the surface of marble: "No modern artist has succeeded so perfectly in giving to his statues the peculiar and indescribable look of flesh His elastic muscle seems as if it would yield to the touch." And he was another of those who believed of Powers's portrait busts that "None better have been made since the days of antiquity."[71] Orville Horwitz, too, believed that, "As a sculptor of busts, he has certainly no living superior," while finding the nearly completed *California* "defective, in expression, in anatomical correctness, and in form."[72] Even Margaret Fuller, who had been enraptured by Powers's *Slave* in 1847, could two years later declare her admiration for its "simple and sweet beauty," but found "neither as an ideal expression nor a specimen of plastic power is it transcendent. Powers stands far higher in his busts than in any ideal statue."[73]

In 1858, Nathaniel Hawthorne's wife, Sophia, felt called upon to defend Powers's ideal conceptions against the charge — made in this instance by William Wetmore Story — that the artist had only a single type, and that there was no variety among his ideal creations. She, for one, found a tremendous difference among the *Proserpine*, "tender and emotional, with the pure sentiment of womanhood; *Psyche*, "a conception of pure soul . . . and eternal youth"; and *Diana*, with the "cold, distant air of a queen and goddess."[74]

Fellow artists could at times be particularly hard on Powers. The Philadelphia landscape painter Frederick De Bourg Richards visited Powers in 1855, and concluded that "the genius of Powers' displays itself most forcibly in his busts."[75] And one anonymous "Art-Student" complained of Powers's reliance solely upon imitative skills, and of his emphasis upon polish and elaboration of petty detail, usurping the place of great thought.[76]

Powers himself, in turn, could be unsparing of his fellow American sculptors in discussions with his American visitors; we learn this especially from the notebooks of Nathaniel Hawthorne who spent a good deal of time with Powers in 1858. Powers, in fact, had busts by several of his contemporaries in his own studio, which he offered for invidious comparison. Thus, Powers contrasted the bust of Jared Sparks by Luigi Persico with one of his own, and Hawthorne agreed that Persico's was "a lifeless and thoughtless thing," and agreed, too, that Clarke Mills (1810-1883) had created a "wretched and ridiculous image" of Mitchell King of Alabama (actually, South Carolina). Powers later told Hawthorne that neither Greenough

nor Crawford could make a good portrait bust, while allowing that Joel Hart was the best man of the day for this task.[77]

For the Grand Tourists, Rome did not offer an equivalent to Hiram Powers, a cultural "star" of international reputation, yet one whose hospitality and companionship firmly — and for the most part, attractively — delivered American sentiments, homilies, and ingenuity. Nevertheless, as the expatriate sculptural population began to concentrate in Rome, with a number of Americans settling there after their initial stay in Florence, the bulk of the attention of the travelers shifted to that more cosmopolitan center after the mid-century, and this is reflected in the travel books and diaries.

Crawford remained the preeminent figure among the expatriate American sculptors in Rome until his early death in 1857, but in his final decade, his reputation was sustained more by the successive public commissions he received, beginning with the equestrian *Washington Monument* for Richmond, Virginia, in 1849, rather than either by his ideal subjects, destined for private collectors, or by portrait busts, of the kind that had sustained Powers's repute. In 1847, George Palmer Putnam could write enthusiastically of Crawford's newly modeled *Daughter of Herodias*, his nearly completed *Mexican Girl Dying* (which Putnam referred to as a Peruvian girl), and his bust of his wife, the former Louisa Ward.[78] The last-named sculpture had just been completed, in fact, as noted by Margaret Fuller in May of 1847, who found it "extremely beautiful, full of grace and innocent sweetness." Fuller thought more highly of Crawford's art than that of John Gibson, the senior English sculptor in Rome.[79] Two years later, in March of 1849, Fuller wrote of the model of a group that Crawford had made of Washington refusing the laurel wreath from a winged Fame, which the sculptor was taking to America with him on the historic return journey from which he would reap his first government commission, that for the equestrian *Washington*.[80]

One of Crawford's most consistent champions, and also his close friend, was George Hillard, whose eulogy on the artist in 1857 was several times republished and expanded; Hillard first wrote at length on the sculptor following his visit to Rome in 1848, in an essay contained in the travel book he published five years later. While Hillard referred back to the momentous significance of the statue of Orpheus, he foresaw the direction that the artist's career would take with the assignment of the Richmond *Washington*, and pointedly denigrated Crawford's more casual, somewhat frivolous commissions. Hillard noted that he "never seemed in his appropriate element when occupied with what may be called drawing-room sculpture . . . but he required a wider field and higher tasks."[81]

Those "higher tasks" were what American travelers wrote about during the 1850s. Thurlow Weed was in Rome in March of 1852, admiring Crawford's statues of Patrick Henry and Thomas Jefferson, which were subordinate figures for the equestrian *Washington*; a year later, Sara Lippincott wrote of these same historical subjects,

as well as a number of his marble ideal pieces: *Flora*, *Babes in the Woods*, and *Hebe and Ganymede*. The statues of the two Virginians were also mentioned at about this time by both Henry Maney and Orville Horwitz. Horwitz, alone, voiced reservations in 1854 concerning the statue of Henry, finding it wanting in energy and expression and lacking the characteristics of a great orator, though he admired the companion figure of Jefferson.[82] By 1855, Frederick De Bourg Richards noted that Crawford was working as well on the pediment for the Capitol in Washington, "a work which will be viewed with pride by every American."[83] At this time, Samuel Fiske and author Octavia LeVert (1810-1877) also wrote about both government commissions, LeVert admiring the contrast between the *Jefferson* and the *Henry*, and also appreciating Crawford's *Flora* and the *Babes in the Woods*.[84]

Other sculptors in Rome, however, also drew the attention of Grand Tourists, attracted by their works' sentiment and beauty — qualities necessarily secondary in Crawford's government commissions. William Cullen Bryant, in fact, appears to have ignored Crawford when he reached Rome in 1846 and focused rather upon Henry Kirke Brown and his statue, *Ruth Gleaning in the Field of Boaz*, on which he was then engaged. Bryant, in fact, opined that Brown's figure was no less perfect in form than those of the senior English artists in residence there, John Gibson and Matthew Cotes Wyatt, and that she exhibited greater human feeling that did their works, concluding that Brown would "achieve a high reputation among the sculptors of the time."[85] In 1849, two years after her visit to Crawford's studio, Margaret Fuller wrote that "Among the sculptors new names rise up," and she offered early notice of the activities of William Wetmore Story and Joseph Mozier; both were mentioned also by Thurlow Weed three years later.[86] Indeed, by 1853, the roster of American sculptors in Rome had considerably swelled, and Sara Lippincott mentioned not only Story and Mozier — the former with his *Arcadian Shepherd Boy* (cat. 16), and the latter for *Silence* and *Daphne* — but also described the *Shepherd Boy* of Richard Greenough, the specialization in bas-reliefs of Edward Sheffield Bartholomew, and the creations of two recent arrivals from Florence, Chauncey Ives, whose *Ariadne* she praised, and Randolph Rogers, who had completed his *Ruth Gleaning* and had recently executed a genre sculpture of a young skater, entitled *The Truant*.[87] By the middle of the decade Rogers's most famous and popular work, his *Nydia, the Blind Flower Girl of Pompeii* (cat. 47), a representation of the heroine of Edward Bulwer-Lytton's popular novel of 1834, *The Last Days of Pompeii*, was attracting tremendous attention and admiration. In 1855, Josephine Young described the work and then noted that it "was all I cared for & looked at there. I gazed & gazed, & never took my eyes from it till we got into the carriage and came home."[88] Though identified with Rome rather than Florence, and a much longer-lived sculptor of a very different perspective, Richard Greenough's (1819-1904) reputation remained overshadowed by that of his more illustrious brother, Horatio; one of his greatest admirers was writer Louise Chandler Moulton (1835-1908) who singled out his

Fig. 8. *William Wetmore Story in his Studio in Rome*, 1865. Photograph. John Neal Tilton Papers, Archives of American Art, Smithsonian Institution.

seductive statues of *Circe, Cupid, Portia,* and *Nemesis* in her tour book, published only in 1898.[89]

By February of 1858, when Sophia and Nathaniel Hawthorne were in Rome, Crawford was dead, but they were still able to visit his studio, where they saw some pieces for the Richmond monument and others packed up for shipment. The new doyen of the art colony there was William Wetmore Story, about whom Hawthorne wrote extensively (fig. 8). Like many visitors, he was intrigued with the elaborate apartments the Storys maintained in the Barberini Palace. Story had completed his figure of Marguerite, from Goethe's *Faust,* while his *Hero* was then being transferred into marble. The sculptor was just two weeks advanced into the modeling of his *Cleopatra,* destined to become his most famous sculpture and one immortalized in Hawthorne's novel, *The Marble Faun* (cat. 162). Two months later, the novelist found Story sufficiently advanced on the sculpture that he could describe the conception "as work of genuine thought and energy, representing a terribly dangerous woman." Reacting against the prevalence of "nudities," Hawthorne found it "delightful to escape to his creations from this universal prettiness."[90]

Cleopatra, in fact, was to make Story's reputation very much as Crawford's *Orpheus* had made his. Unitarian clergyman and author Edward Everett Hale (1822-1909) became enraptured when he saw the figure in November 1859, for it was almost the first work of modern sculpture that satisfied him; he viewed the sculpture as a symbol of Africa's despair, "slave either of Asia's wisdom or of Europe's force."[91] Story, in fact, carved several versions as well as numerous replicas of his *Cleopatra*; Louise Moulton distinguished between the first and the second, finding the latter "infinitely more charming and seductive. She is the Cleopatra of Shakespeare, and she is the Cleopatra of Mr. Story's own poem."[92] Of course, not every visitor was enamored of Story's dramatic, often ponderous conceptions; it is somewhat re-freshing, after all the accolades paid to the American expatriate sculptors, to come across Mrs. Henry Adams's remarks written in 1873: "how he does spoil nice blocks of white marble. Nothing but Sibyls on all sides, sitting, standing, legs crossed, legs uncrossed, and all with the same expression as if they smelt something wrong. Call him a genius! I don't see it."[93]

Among the nude statues that dismayed Hawthorne in Italy was Edward Bartholomew's *Eve,* which he viewed in Rome and which elicited his derision over her "frightful volume of thighs and calves." The Hawthornes also spent a good deal of time at the studio of Joseph Mozier, where the only works the writer admired were a figure of Pocahontas and another of The Wept of Wish-ton-Wish, the latter derived from the writings of James Fenimore Cooper. These native American subjects seemed to Hawthorne to transcend the limitations that Mozier brought to his art; the writer found that "his cleverness and ingenuity appear in homely subjects, but are quite lost in attempts at a higher ideality."[94] Hawthorne's judgments tended to be more severe than those of most Americans, however; when travel writer E. K.

Washington visited Rome at much the same time, he found Bartholomew's *Eve* "a statue of most superior excellence."[95]

A new aspect of the American art colony in Rome began to attract the attention of American Grand Tourists by 1853: the appearance of women sculptors. Harriet Hosmer (see cats. 33, 144, 184) was the first and most important of these, arriving in 1852, and in January of the following year, Sara Lippincott found her in the studio of her teacher, John Gibson, copying antique sculptures. She cited not only Gibson's praise for his young pupil, but the testimonials of many other Roman artists to her "industry, her modest confidence, her quiet enthusiasm; for her fine feeling for, and knowledge of, her art."[96] About a year later, Octavia LeVert was able to admire one of Hosmer's earliest original sculptures, her *Head of Medusa*.[97]

Fig. 9. Harriet Hosmer, *Beatrice Cenci*, 1853-1855. Marble. St. Louis Mercantile Library, St. Louis, Missouri.

Hosmer was still in a studio adjoining that of her teacher in March of 1858, when the Hawthornes visited, but by then she had begun to establish an international reputation. In their accounts, both Sophia and Nathaniel devoted a good deal of attention to Hosmer's distinct personality, as well as to those sculptures that had attracted great acclaim, not only the *Medusa*, which Sophia found unsuitable, because it lacked the terrible beauty she felt essential, but her "sad, noble" *Daphne*, *Puck*, and *Beatrice Cenci* (fig. 9), just then being completed. She admired Hosmer's drawings for bas-reliefs, and learned of the sculptor's intention to model a monumental *Zenobia*.[98] Sophia Hawthorne also noted Hosmer's designs for a fountain of Hylas, one of a number of fountains that she would produce, and an aspect of sculpture in which American women artists would specialize. Nathaniel Hawthorne, in fact, suggested a design for a fountain to Hosmer, which would have depicted "a lady bursting into tears, water gushing from a thousand pores." Hawthorne doubted whether the sculptor would adopt his idea which, in fact, she (sensibly) did not.[99] A year later, the Hawthornes were back at Hosmer's studio where *Zenobia* was very far advanced, though still in the clay. Hawthorne admired the work greatly, declaring it "a high, heroic ode," but perceptively wondered if the expressivity of its present condition were due either to its incompleteness or to the superiority of clay over marble.[100] By October of 1859, Henry Allen found *Zenobia* completed in the plaster stage, and Harriet Allen marveled at the contrast offered by the diminutive sculptor mounted on steps modeling the colossal figure.[101] Hosmer was the only American sculptor to create a memorial sculpture in a Roman church, that dedicated to Mlle. Julie Falconnet in S. Andrea della Fratte, a monument judged by Alfred Huidekoper to be one of her best.[102] During the 1860s, Hosmer's works were seen by American travelers not only in Rome but at the International Expositions held in London in 1862, where *Zenobia* was on view, and in Dublin in 1865, where Amy and Mary Smith noted her prize-winning *Sleeping Faun* (cat. 33).[103]

By the end of the 1850s, Rome was awash with American sculptors, and visitor after visitor catalogued the attractions to be seen at the studios of William Wet-

Fig. 10. Emma Stebbins (American, 1815-1882), *Roma, Bust of Nanna Risi*, about 1860-70. Marble. Collection Mr. and Mrs. Herbert F. Sacks.

Fig. 11. Vinnie Ream Hoxie (American, 1847-1914), *Abraham Lincoln*, 1866-71. Marble. United States Capitol, Washington, D.C. Photograph courtesy of the Architect of the Capitol.

more Story, Randolph Rogers, Joseph Mozier, Chauncey Ives, and William Henry Rinehart, in addition to that of the deceased Crawford. In 1856, Emma Stebbins (1815-1882) had joined Hosmer among the female contingent (see fig. 10), where, in 1859, Hiram Fuller admired her figures of a sailor and a miner, created for August Heckscher who — Fuller noted — had "made a fortune in coal and commerce."[104] And after the Civil War, the expatriate colony was enhanced by the addition of its most exotic member, the half–African-American, half–Native American Edmonia Lewis (see cat. 39), several of whose works relating directly or indirectly to her heritage — *Hiawatha's Wooing*, *Hiawatha's Wedding*, *Indians Wrestling*, and a statue of *Abraham Lincoln* — were discussed by Alfred Huidekoper. However, he judged her best sculpture to be the bust of Colonel Robert Gould Shaw, which she had modeled in Boston before she left for Rome.[105]

By the end of 1869, Vinnie Ream (1847-1914) had joined the sculptors' contingent of American artists in Rome, and had set up the plaster of her statue of Abraham Lincoln for the Capitol (fig. 11). Though the commission had been controversial in America, Congressman James Hopkins (1832-1904) had no doubt that the statue would "stamp genius upon this fair young forehead," and he noted that her work had been approved by Story and the American painter, George P. A. Healy. At the time of Hopkins's visit at the end of the year, Ream was also working on busts of Mrs. General John Charles Fremont and Archbishop Martin John Spalding of Baltimore. On a succeeding visit three months later, Franz Liszt was sitting for his bust. Hopkins also admired Lewis's *Hagar*, and remarking that she was Roman Catholic, he mentioned that she had created some statues for a Catholic church in Baltimore as well as the bust of Pope Pius IX. Hopkins also alluded to still another of the women sculptors in Rome, Florence Freeman (1836-1876), and to her representation of Chibiabos, the musician in Henry Wadsworth Longfellow's *Hiawatha*.[106]

Though most of the American expatriate sculptors were not affected directly by the Civil War, Randolph Rogers turned his primary attention at that time away from his marble ideals, and began to concentrate upon bronze war monuments; the first of these was the colossal figure, *The Sentinel*, commissioned in 1863 for Spring Grove Cemetery in Cincinnati, and viewed by Amy and Mary Smith in Rogers's studio in March of 1866.[107] Three years later, Alfred Huidekoper admired the model of Rogers's *Abraham Lincoln*, commissioned for the City of Philadelphia, though he also commented upon Rogers's much earlier *Ruth Gleaning* and *Nydia*.[108] Story, too, was becoming increasingly involved with the creation of bronze public monuments of historical figures, such as those of Edward Everett for Boston and George Peabody for London, both of which were noted by Alfred Huidekoper in 1867-68.[109] Other sculptors such as Rinehart, Mozier, and Ives were regularly visited by American travelers, but they continued to work in the traditional manner and with traditional themes (see fig. 12), though around 1870 author Caroline Laing (1804-1892)

reported with keen displeasure on a colored replica of Mozier's *Wept of Wish-ton-Wish*.[110]

Perhaps the last significant visitor to the American studios in Florence and Rome who is pertinent to this survey was John Forney, a commissioner in search of works to be exhibited at the Philadelphia Centennial in 1876. He called upon the studios in Florence in the company of James L. Graham, the American consul in Florence, and on those in Rome with the Rev. Dr. Robert J. Nevin, minister of the American Church there. In Florence there were nine American sculptors still active: Thomas Ball, Pierce Connelly, Thomas Gould, Joel Hart, John Jackson (1825-1879), Larkin Mead, Richard Park (1832-after 1890), William Turner (about 1832-1917), and Preston Powers, the son of the recently deceased Hiram Powers. Forney did, in fact, see the original model of the *Greek Slave*, but his attention was directed primarily to historical busts and monuments, including Hiram Powers's statues of Daniel Webster and Edward Everett, as well as the artist's busts of Andrew Jackson and Charles Sumner; Ball's *Edwin Forrest as Coriolanus*, *John A. Everett, Charles Sumner, and Edward Everett*; Hart's *Henry Clay*; and Mead's Lincoln monument for Springfield, Illinois. In Rome, Forney called at the studios of a whole host of painters and sculptors, including Hosmer and Lewis among the women, and Story, Rogers, Franklin Simmons (1839-1913), and the young Augustus Saint-Gaudens (see cat. 183); though he was not aware of it, he was viewing the future when he saw *Hiawatha* and *Silence* by the last-named artist. Forney noted that, with Hiram Powers's death, Story could be "called the dean of his guild," though Forney's own preference seemed to lie with Rogers, who was "so essentially a Philadelphian and an American." Even with Story, Forney spoke first and more feelingly about the sculptor's portraits of his father, Judge Joseph Story, George Peabody, William Shakespeare, Josiah Quincy, and Edward Everett, only afterwards turning to his *Cleopatra* and other biblical and classical images. And of Franklin Simmons's work, he spoke only of the *Roger Williams* created for Statuary Hall in the Capitol, his larger-than-life-size figure of William King, the first Governor or Maine, and especially of his *Naval Group* for Washington, D.C.[111]

Yet, the sculptors whom Forney had visited in Florence and Rome were represented in force at the Centennial in 1876, primarily with ideal subjects rather than historical monuments. Connelly showed typical Shakespearean heroines, Viola and Ophelia as well as his complex *Honor Arresting the Triumph of Death*, and seven other works; Ives exhibited *Nursing the Infant Bacchus*; Gould, his *West Wind*, and the pair of ideal female allegories, *The Rose* and *The Lily*; Randolph Rogers, his *Atala* and his *Ruth*; Story, his *Medea*, as well as his *Beethoven*; James Haseltine (1833-1907) was seen with *Fortune*, *Spring Flowers*, *Lucretia*, *Cleopatra*, and *Lucia di Lammermoor*; William G. Turner with his *Fisherman's Daughter* and *Transition*; Margaret Foley, with her *Jeremiah* and *Cleopatra*; Edmonia Lewis with a sensational *Death of Cleopatra*; and Richard Park with a series of twelve marble pieces. The sculpture display at the Centennial would, in

Fig. 12. William Henry Rinehart (American, 1825-1874), *Thetis*, about 1861. Marble. Peter Tillou Fine Arts Gallery.

effect, be the swan-song of the American Neoclassic movement, though a good many of the artists would live on, a few even into the twentieth century. Forney himself, despite his immediate preference for the historical monuments, may have been seduced by the medium and the message of the marmorean aesthetic. During his tour he wrote: "The eloquence of marble is something very strange. . . . It seems to talk to you in what I would call the grave silence of its features. It is not so with bronze. But the spotless marble of Carrara. . . has a language of its own when translated into statuary. Every different position, as you move these figures, has a new expression, sometimes a smile and sometimes a frown, and, as you feel these emotions, you begin to understand why the world is so enthralled by Art."[112]

NOTES

I would like to express my appreciation to my graduate assistant, Mary Elizabeth Boone, for her sterling efforts in accumulating photocopies of the writings on American expatriate sculptors by the many American voyagers who subsequently published their travel diaries and letters, and to David Dearinger for organizing these writings. Mr. Dearinger is a specialist on the topic of the American Neoclassic sculptors and is writing his dissertation on their private patrons.

1. Though a number of art-oriented travelers stopped off to visit with American artists in Düsseldorf, the primary artistic goal of the Rhine journey was a visit to Bethmann's Museum in Frankfurt to view the statue of *Ariadne* by Dannecker, "colored" by light passing through red window glass that imparted rosy flesh tones to the white marble. See, among many other published travel diaries, William Coombs Dana, *A Transatlantic Tour* (Philadelphia: Perkins & Purves, 1845), p. 246; James Freeman Clarke, *Eleven Weeks in Europe* (Boston: Ticknor, Reed & Fields, 1852), p. 229; Harriet Beecher Stowe, *Sunny Memories of Foreign Lands* (Boston: Phillips, Sampson and Co., 1854), p. 317; F[rederick] DeB[ourg] Richards, *Random Sketches, or, What I Saw in Europe* (Philadelphia: G. Collins, 1857), pp. 271-272.

2. William Vance, *America's Rome* (New Haven: Yale University Press, 1989). Among many other pertinent studies, see also: Van Wyck Brooks, *The Dream of Arcadia American Writers and Artists in Italy 1760-1915* (New York: E. P. Dutton & Co., Inc, 1958); Paul R. Baker, *The Fortunate Pilgrims: Americans in Italy 1800-1860* (Cambridge: Harvard University Press, 1964); Clara Louise Dentler, *Famous Americans in Florence* (Florence: Giunti Marzocco, 1976); Erik Amfitheatrof, *The Enchanted Ground: Americans in Italy, 1760-1980* (Boston: Little, Brown, 1980); and Regina Soria, *Dictionary of Nineteenth-Century American Artists in Italy 1760-1914* (Rutherford, New Jersey: Fairleigh Dickinson University Press, 1982).

3. William Ware agreed with the opinion of Hiram Powers that Canova "was particularly inclined to carry to exaggeration any lines of beauty or grace that gave him especial pleasure." William Ware, *Sketches of European Capitals* (Boston: Phillips, Sampson and Company, 1851), p. 129. Powers also told Nathaniel Hawthorne that "Canova put his own likeness into all the busts he made." Nathaniel Hawthorne, *Passages from the French and Italian Note-books* (Boston: J. R. Osgood and Co., 1871), vol. 1, p. 304.

4. Nathaniel Hawthorne, *Passages from the French and Italian Note-books*, vol. 1, pp. 305-307. One of the major champions of coloring sculpture was Edward Everett Hale, *Ninety Days' Worth of Europe* (Boston: Walker, Wise and Company, 1861), pp. 148-151.

5. Harriet Emily (Trowbridge) Allen, *Travels in Europe & the East: During the Years 1858-9 and 1863-4* (New Haven: Tuttle, Morehouse & Taylor, 1879), p. 183.

6. The seminal work here remains Albert T. E. Gardner, *Yankee Stonecutters: The First American School of Sculpture, 1800-1850* (New York: Columbia University Press, 1944), still enlightening and vastly entertaining. See also Margaret Thorp, *The Literary Sculptors* (Durham, North Carolina: Duke University Press, 1965); and the present author's *American Neo-Classic Sculpture: The Marble Resurrection* (New York: Viking Press, 1973). More recent and obviously more specialized, but a valuable contribution to the literature is Joy S. Kasson, *Marble Queens and Captives: Women in Nineteenth-Century American Sculpture* (New Haven: Yale University Press, 1990). The careers of all the significant expatriate American sculptors — except, inexplicably, Joseph Mozier — are perceptively considered in Wayne Craven, *Sculpture in America*, 1968 (Newark: University of Delaware Press, 1984). A good many of these artists have been the subject of one or more biographies and dissertations, culminating in the exemplary study by Richard P. Wunder, *Hiram Powers Vermont Sculptor, 1850-1873* (Newark: University of Delaware Press, 1991).

7. The standard monograph here is Nathalia Wright, *Horatio Greenough The First American Sculptor* (Philadelphia: University of Pennsylvania Press, 1963).

8. The standard monograph here is Robert L. Gale, *Thomas Crawford American Sculptor* (Pittsburgh: University of Pittsburgh Press, 1964). See also Lauretta Dimmick, "A Catalogue of the Portrait Busts and Ideal Works of Thomas Crawford (1813?-1857), American Sculptor in Rome," Ph.D. diss. University of Pittsburgh, 1986.

9. For Rogers, see Millard F. Rogers, Jr., *Randolph Rogers American Sculptor in Rome* (Amherst: University of Massachusetts

Press, 1971). For Story, see Mary E. Phillips, *Reminiscences of William Wetmore Story, The American Sculptor and Author, Being Incidents and Anecdotes Chronologically Arranged* (Chicago: Rand, McNally & Co., 1897); Henry James, *William Wetmore Story and His Friends, from Letters, Diaries, and Recollections* (Edinburgh and London: William Blackwood & Sons, 1903); and Jan M. Seidler, "A Critical Reappraisal of the Career of William Wetmore Story (1819-1895), American Sculptor and Man of Letters," Ph.D. diss., Boston University, 1985. For Rinehart, see William Sener Rusk, *William Henry Rinehart Sculptor* (Baltimore: Norman T. A. Munder, 1939); and Marvin Chauncey Ross and Anna Wells Rutledge, *A Catalogue of the Work of William Henry Rinehart Maryland Sculptor, 1825-1874* (Baltimore: The Peabody Institute and The Walters Art Gallery, 1948).

10. See, for instance, *Murray's Hand-book for Travellers in Central Italy* (London: J. Murray, 1850), pp. 521-523; and the two guides by F. Saverio Bonfigli (in English), *The Artistical Director; or, Guide to the Studios in Rome with much Supplementary Information* (Rome: Tipographia Legale, 1858); *Guide to the Studios in Rome* (Rome: Tipographia Legale, 1860).

11. James, *William Wetmore Story and His Friends*, vol. 1, p. 257. See *The White Marmorean Flock Nineteenth Century American Women Neoclassical Sculptors*, essay by William H. Gerdts (Poughkeepsie: Vassar College Art Gallery, 1972).

12. John H.B. Latrobe, *Hints for Six Months in Europe* (Philadelphia: J. B. Lippincott, 1869), pp. 124-125.

13. Frederick DeBourg Richards, *Random Sketches, or, What I Saw in Europe*, p. 70; Henry Watkins Allen, *The Travels of a Sugar Planter* (New York: J. F. Trow, 1861), pp. 191-192; Thurlow Weed, *Letters from Europe and the West Indies, 1843-62* (Albany: Weed, Parsons and Co., 1866), pp. 509-510; Sophia Amelia Hawthorne, *Notes in England and Italy* (New York: G. P. Putnam & Sons, 1869), p. 367; Nathaniel Hawthorne, *Passages from the French and Italian Note-books*, vol. 2, pp. 26-27.

14. George Henry Calvert, *Scenes & Thoughts in Europe* (New York: G. P. Putnam & Co., 1855), p. 93.

15. Thurlow Weed, *Letters from Europe and the West Indies, 1843-62*, pp. 509-510.

16. Nathaniel Hawthorne, *Passages from the French and Italian Note-books*, vol. 2, pp. 157-159.

17. Samuel Wheelock Fiske, *Mr. Dunn Browne's Experiences in Foreign Parts* (Boston: J. P. Jewett & Co., 1857), p. 229.

18. Anne Hampton Brewster, "American Art in Paris. Count Palfi [sic] to Open His Gallery of Statues by Mr. Story," *World* (New York), April 12 1878, p. 5.

19. [Matthias Bruen], *Essays, Descriptive & Moral on Scenes in Italy, Switzerland, & France* (Edinburgh: Archibald Constable and Co., 1823), pp. 96-101. Carrara continued to be visited by American tourists; on his way to Pisa in 1847, William M. Gould met Hiram Powers there who was proceeding to the quarries to order marble. William M. Gould, *Zephyrs from Italy and Sicily* (New York: D. Appleton and Co., 1852), pp. 100-103.

20. Rembrandt Peale, *Notes on Italy Written During a Tour in the Years 1829 and 1830* (Philadelphia: Carey & Lea, 1831), pp. 242-243.

21. Henry T. Tuckerman, *The Italian Sketch Book* (Boston: Light & Stearns, 1837), pp. 255-261.

22. Ibid., p. 259.

23. Isaac Appleton Jewett, *Passages in Foreign Travel* (Boston: C.C. Little and J. Brown, 1838), vol. 2, p. 296.

24. Wilbur Fisk, *Travels in Europe* (New York: Harper & Brothers, 1839), p. 163.

25. Mrs. [Frances] Trollope, *A Visit to Italy* (London: Richard Bentley, 1842), vol. 1, pp. 95-96.

26. Jane Anthony Eames, *A Budget of Letters* (Boston: W. D. Ticknor & Co., 1847), pp. 161-162.

27. Calvert, *Scenes & Thoughts in Europe*, pp. 85-88.

28. American interest in Overbeck was enormous, unexpected given his adherence to the Roman Catholic faith and his dedication of his art to the Church. But many writers voiced their admiration more for the man than for his painting; Margaret Fuller was typical when she wrote that he appeared as "a lay monk, with a pious eye and habitual morality of thought," Sarah Margaret (Fuller) Ossoli, *At Home and Abroad; or Things and Thoughts in America and Europe* (Boston: 1856), p. 22. Still, Overbeck remained the most venerated painter in Rome until his death in 1869; in reference to Italian, German, English, and American sculptors, George Hillard could state in 1848 that: "Setting Overbeck aside, there were no names among the painters comparable to those of Tenerani, Wolff, Gibson, and Crawford." George Stillman Hillard, *Six Months in Italy* (Boston: Ticknor, Reed and Fields, 1853), vol. 2, p. 252.

29. *Letters of Charlotte Brinckerhoff Bronson Written during her Wedding Journey in Europe in 1838* (Cambridge, Mass.: privately printed, 1928), vol. 3, p. 459.

30. Catharine Maria Sedgwick, *Letters from Abroad to Kindred at Home* (New York: Harper & Brothers, 1841), pp. 157-161.

31. Count Hawks Le Grice, *Walks through the Studii of The Sculptors of Rome* (Rome: Puccinelli, 1844), pp. 57-59, 106-107.

32. See, for instance, Bayard Taylor, *Views A-Foot; or, Europe Seen with Knapsack and Staff* (New York: Wiley & Putnam, 1846), p. 330.

33. [William M. Gillespie], *Rome: As Seen by a New-Yorker in 1843-4* (New York: Wiley and Putnam, 1845), pp. 175-191.

34. *Letters of Charlotte Brinckerhoff Bronson*, vol. 3, p. 407.

35. Eames, *A Budget of Letters*, p. 161.

36. Trollope, *A Visit to Italy*, vol. 1, pp. 141-145, 175-176; vol. 2, pp. 8-9.

37. Calvert, *Scenes & Thoughts in Europe*, pp. 88-96, 115.

38. Latrobe, *Hints for Six Months in Europe*, p. 124.

39. Horace Binney Wallace, *Art and Scenery in Europe, with other Papers* (Philadelphia: Parry & Macmillan, 1857), pp. 202-203; Ware, *Sketches of European Capitals*, pp. 130-134. See also Samuel Young, *A Wall-Street Bear in Europe* (New York: S. Young, Jr., 1855), p. 57.

40. George Palmer Putnam, *A Pocket Memorandum Book during a Ten Weeks' Trip to Italy and Germany in 1847* (N.p., 1848), p. 83.

41. Andrew McFarland, *The Escape; or Loiterings Amid the Scenes of Story and Song* (Boston: B. B. Mussey & Co., 1851), pp. 177-178.

42. Nathaniel Hawthorne, *Passages from the French and Italian Note-books*, vol. 2, pp. 22-23.

43. "Diary," James Howard McHenry Papers, Maryland Historical Society, vol. 5, 1845-46.

44. Margaret Fuller, *At Home and Abroad*, pp. 231-232.

45. Eames, *A Budget of Letters*, p. 162.

46. Calvert, *Scenes & Thoughts in Europe*, pp. 96, 116.

47. Joel Tyler Headley, *Letters from Italy* (New York: Wiley & Putnam, 1846), pp. 197-199.

48. Horace Greeley, *Glances at Europe* (New York: Dewitt & Davenport, 1851), p. 217.

49. Taylor, *Views A-Foot*, pp. 295-299.

50. William Cullen Bryant, *Letters of a Traveller, or, Notes of Things Seen in Europe and America* (New York: G. P. Putnam, 1851), pp. 164-165; Henry Colman, *European Life & Manners in Familiar Letters to Friends* (Boston: Charles C. Little and James Brown, 1849), pp. 331-332.

51. Randal W. MacGavock, *A Tennessean Abroad; or, Letters from Europe, Africa, and Asia* (New York: Redfield, 1854), p. 45; Wallace, *Art and Scenery in Europe*, pp. 202-203. See also Daniel Clarke Eddy, *Europa* (Boston: Bradley, Dayton & Co., 1861), p. 100.

52. Taylor, *Views A-Foot*, pp. 291-299.

53. Headley, *Letters from Italy*, pp. 199-200.

54. Ware, *Sketches of European Capitals*, pp. 134-135.

55. Eddy, *Europa*, p. 433.

56. Sinclair Tousey, *Papers from over the Water. A Series of Letters from Europe* (New York: The American News Company, 1869), p. 125.

57. Ware, *Sketches of European Capitals*, p. 135.

58. Greeley, *Glances at Europe*, pp. 217-218.

59. Jacob Wood, *Notes of Foreign Travel* (New York: McSpedon & Baker, 1852), p. 137.

60. Henry Maney, *Memories over the Water* (Nashville: Toon, Nelson & Co., 1854), pp. 186-187.

61. Henry Allen, *The Travels of a Sugar Planter*, p. 191.

62. Tousey, *Papers from over the Water. A Series of Letters from Europe*, p. 125.

63. Richard Cunningham McCormick, *St. Paul's to St. Sophia's; or, Sketchings in Europe* (New York: Sheldon & Co., 1860), pp. 263-264.

64. Amy Grinnel Smith and Mary Erminia Smith, *Letters from Europea, 1865-1866*, David Sanders Clark, ed. (Washington, D.C.: n. p., 1948), p. 92; Alfred Huidekoper, *Glimpses of Europe in 1867-8* (Meadville, Pennsylvania: the author, 1882), p. 142.

65. Mrs. Anne T. J. Bullard, *Sights and Scenes in Europe* (St. Louis: Chambers & Knapp, 1852), p. 92; Eddy, *Europa*, pp. 432-433; Wood, *Notes of Foreign Travel*, pp. 136-137.

66. Grace Greenwood (pseudonym for Sara Jane Lippincott), *Haps and Mishaps of a Tour in Europe* (Boston: Ticknor, Reed & Fields, 1854), p. 358.

67. Fiske, *Mr. Dunn Browne's Experiences in Foreign Parts*, p. 229.

68. Henry Allen, *The Travels of a Sugar Planter*, p. 191.

69. Hiram Fuller, *Sparks from a Locomotive* (New York: Derby & Jackson, 1859), p. 261; Erastus Cornelius Benedict, *A Run Through Europe* (New York: D. Appleton & Co., 1860), p. 254.

70. McFarland, *The Escape; or Loiterings Amid the Scenes of Story and Song*, pp. 182-183.

71. Hillard, *Six Months in Italy*, vol. 1, p. 179.

72. Orville Horwitz, *Brushwood, picked up on the continent, or last summer's trip to the old world* (Philadelphia: Lippincott, Grambo & Co., 1855), pp. 205-206.

73. Margaret Fuller, *At Home and Abroad; or Things and Thoughts in America and Europe*, p. 372.

74. Sophia Amelia Hawthorne, *Notes in England and Italy*, pp. 365-366.

75. Richards, *Random Sketches, or, What I Saw in Europe*, p. 69.

76. *The Rambles and Reveries of an Art-Student in Europe*. (Philadelphia: T. T. Watts, 1855), pp. 106-109. The author mentioned visiting a young artist in Florence, a great admirer of Powers, who was working upon a *Bacchante*; this was very likely Alexander Galt.

77. Nathaniel Hawthorne, *Passages from the French and Italian Note-books*, vol. 1, pp. 291-292, 304-305.

78. Putnam, *A Pocket Memorandum Book during a Ten Weeks' Trip to Italy and Germany in 1847*, p. 44.

79. Margaret Fuller, *At Home and Abroad; or Things and Thoughts in America and Europe*, p. 222.

80. Ibid., pp. 372-374.

81. Hillard, *Six Months in Italy*, vol. 2, pp. 260-265.

82. Weed, *Letters from Europe and the West Indies, 1843-62*, p. 558; Lippincott, *Haps and Mishaps of a Tour in Europe*, pp. 219-221; Maney, *Memories over the Water*, p. 230; Horwitz, *Brushwood, Picked up on the Continent, or Last Summer's Trip to the Old World*, pp. 151-152.

83. Richards, *Random Sketches, or, What I Saw in Europe*, pp. 136-137.

84. Fiske, *Mr. Dunn Browne's Experiences in Foreign Parts*, pp. 224-225; Octavia Walton LeVert, *Souvenirs of Travel* (New York: S.H. Goetzel and Co., 1857), vol. 2, p. 160.

85. Bryant, *Letters of a Traveller, or, Notes of Things Seen in Europe and America*, pp. 239-240.

86. Margaret Fuller, *At Home and Abroad; or Things and Thoughts in America and Europe*, pp. 370-371; Weed, *Letters from Europe and the West Indies, 1843-62*, p. 558.

87. Lippincott, *Haps and Mishaps of a Tour in Europe*, pp. 222-223.

88. Josephine (Young) Churchill Birney, *Journals of Josephine Young* (New York: privately printed, 1915), pp. 144-147.

89. Louise Chandler Moulton, *Lazy Tours in Spain and Elsewhere* (Boston: Roberts Bros., 1898), pp. 117-119.

90. Nathaniel Hawthorne, *Passages from the French and Italian Note-books*, vol. 1, pp. 68-71, 127-129, 179.

91. Hale, *Ninety Days' Worth of Europe*, pp. 141-148.

92. Moulton, *Lazy Tours in Spain and Elsewhere*, pp. 116-117.

93. Marion (Hooper) Adams, *The Letters of Mrs. Henry Adams, 1865-1883*, Ward Thoron, ed. (Boston: Little, Brown, and Company, 1936), pp. 94-95. Adams's remark recalls the reference by David Maitland Armstrong when recollecting a visit to the studio of Randolph Rogers in Rome in 1869: "He had lately made a statue of Nydia, the blind girl of Pompeii, which had a great popular success, particularly among Amer-icans, who ordered many replicas for their houses. . . . I once went to his studio and saw seven Nydias, all in a row, all listening, all groping, and seven Italian marble-cutters at work cutting them out. It was a gruesome sight." Maitland Armstrong, *Day Before Yesterday, Reminiscences of a Varied Life* (New York: Charles Scribner's Sons, 1920), p. 194. Armstrong's publication was an autobiography, not a contemporary travel book.

94. Hawthorne, *Passages from the French and Italian Note-books*, vol. 1, pp. 154-156, 179.

95. E. K. Washington, *Echoes of Europe; or, Word Pictures of Travel* (Philadelphia: James Challen & Son, 1860), pp. 515-516.

96. Lippincott, *Haps and Mishaps of a Tour in Europe*, pp. 217-218.

97. LeVert, *Souvenirs of Travel*, p. 160.

98. Sophia Hawthorne, *Notes in England and Italy*, pp. 265-267.

99. Nathaniel Hawthorne, *Passages from the French and Italian Note-books*, vol. 1, p. 230.

100. Ibid., vol. 2, pp. 230-231.

101. Henry Allen, *The Travels of a Sugar Planter*, p. 223; and Harriet Allen, *Travels in Europe and the East: During the Years 1858-9 and 1863-4*, p. 183.

102. Huidekoper, *Glimpses of Europe in 1867-8*, p. 174.

103. Smith and Smith, *Letters from Europea, 1865-1866*, p. 7.

104. Hiram Fuller, *Sparks from a Locomotive*, pp. 270-271.

105. Huidekoper, *Glimpses of Europe in 1867-8*, p. 184.

106. James H. Hopkins, *European Letters to the Pittsburgh Post, 1869-70* (Pittsburgh, 1870), pp. 57, 84-85.

107. Smith and Smith, *Letters from Europea, 1865-1866*, p. 89.

108. Huidekoper, *Glimpses of Europe in 1867-8*, p. 183.

109. Ibid., p. 174.

110. Denison Laws Burton, "T.B. Read in Rome as seen by C.H.B. Laing," in George Norman Highley, compiler, *T. Buchanan Read* (West Chester, Pennsylvania: Chester County Historical Society, 1972), p. 32.

111. John W. Forney, *A Centennial Commissioner in Europe, 1874-76* (Philadelphia: J. B. Lippincott & Co., 1876), pp. 112-118.

112. Ibid., p. 115.

Seeing Italy: The Realistic Rediscovery by Twain, Howells, and James

WILLIAM L. VANCE

On the morning of July 14, 1867, the American steamship *Quaker City* arrived in Genoa. Carrying passengers on the first organized cruise ever made from America to Europe and the Near East, it helped to open the age of mass tourism that began after the conclusion of the American Civil War. In Genoa and later Leghorn, the local Italian authorities were distinctly unwelcoming. At Genoa a gunboat actually seized the ship for a time; it was closely watched for the nine days it remained in the port, and the Americans were kept under surveillance while ashore.[1] According to Mark Twain, who was a passenger on the *Quaker City* (fig. 1), the American tourists were suspected of being "bloodthirsty Garibaldians in disguise." This sounds like one of Twain's jokes, but it was actually true. The Italians, he explained, could not believe "that so large a steamer as ours could cross the broad Atlantic with no other purpose than to indulge a party of ladies and gentlemen in a pleasure excursion. It looks too improbable. . . . Something more important must be hidden behind it all."[2] In fact, in the person of Mark Twain the *Quaker City* did carry a true subversive. Twain despised not only monarchs and monks, but also the "celebrated rubbish" of the old masters. Art and history, Italy's chief attractions to earlier American travelers, were the least of his interests. Mark Twain was not in Europe for edification, but for a good time, and to see for himself the vaunted treasures of Europe — which, he suspected, were mostly frauds.

The second phase of the American discovery of Italy was beginning. The first phase, that of romantic classicism, had begun in 1760 with the arrival in Rome of the young artist Benjamin West; it had reached its climax in 1860 with the publication of *The Marble Faun* by Nathaniel Hawthorne. The second phase, which lasted until the outbreak of the First World War, coincided with the realistic movement in American literature and art. Consequently it registers the American attempt to discover Italy entirely on its own and to represent it in America's own idiom, rather than in the language and conventions of a tradition learned from the Latin classics, from English, French, and German romantics, from Claude, Poussin, and Salvator Rosa.

In the preface to *The Innocents Abroad* (cat. 165), Mark Twain states that the book's purpose is "to suggest to the reader how *he* would be likely to see Europe and the East if he looked at them with his own eyes instead of the eyes of those who had traveled in those countries before him." Those who had gone before had written with the purpose of telling us how we *ought* to look at foreign scenes. Mark Twain claims no such intention. He is only reporting: "I think I have seen with impartial eyes, and I am sure I have written at least honestly, whether wisely or not" (*Innocents*, p. 3). Similarly, William Dean Howells, in the preface to the second edition of his first Italian book, *Venetian Life* (cat. 167), stated confidently that "such value as my book may have is in fidelity to what I actually saw and knew of Venice."[3] In *Italian Journeys* (1867) he wrote that the "privilege" of travel is to make the traveler "forget whatever other travellers have said or written" about the places and things encoun-

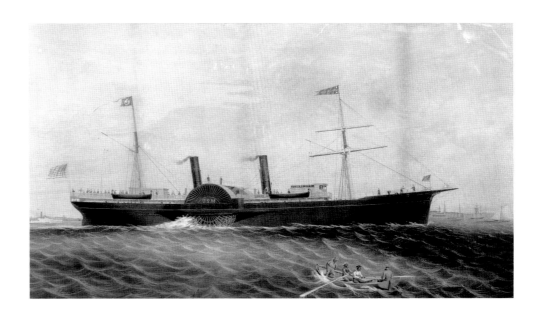

Fig. 1. F.L. Giles, *Quaker City*. Colored lithograph. Courtesy Patten Free Library, Bath, Maine.

tered.[4] Twain and Howells, in their declared intentions, define the new starting point not only for themselves but also for the young Henry James, who first visited Italy in 1869-70, and for the painters as well – Frank Duveneck, James A. McNeill Whistler, and John Singer Sargent, all of whom saw Italy in their own new ways, not in the idealized ways of Washington Allston, Thomas Cole, or Jasper Cropsey.

Italy, the most romanticized country in literature and art, thus became a testing ground for American Realism. Because there were so many preconceptions, associations, and conventions shaping and veiling the Italian reality, the struggle for original representation was all the greater. *What* Italy was behind the veil was not so easily known, and the "realists" produced widely differing visions of their own.

I

We had best begin with Mark Twain, whose view represents one extreme of that common American traveler's experience: a desire not to be fooled by European illusions combined with an incapacity to perceive what is really there. Twain must limit himself to iconoclasm. In place of the demolished romantic ideas and images, for the most part he can erect only the image of himself and his companions laughing along the way. What we get is the comic reality of the American Innocents' confrontation with what they cannot value or understand. Twain's claim to have observed Europe "with impartial eyes" is of course preposterous. No one ever saw Italy with more "partial" eyes – the wide-open eyes of the American West, sharp and bold, but looking out from an uninformed head. The very old (Pompeian

ruins), the very large (Milan cathedral), and the very strange (the echoes in the Baptistry at Pisa) could crudely impress by a simple single attribute. But anything whose "reality" lay not on the surface was suspect. The truth about Leonardo's *The Last Supper* was that it was a crumbling, fading, ugly mess; the truth about those Americans who stood before it exclaiming over its beauty was that they were frauds. "How can they see what is not visible?" asked the Innocent (*Innocents*, p. 151).

"To see what is not visible" might be said to be the function of the imagination, the chief instrument of "poetic" vision. History, legend, sympathy, idealism complete the sensual image and are those parts of it supplied by the viewer, if the viewer is able. But for Mark Twain history and legend are bogus, and idealism and sympathy a trap. All delude one into misperception and misvaluation of what one sees. Better to be offensively rejecting than foolishly gullible. After all, to discover "poetry's" falsity is not a loss but a gain. The "picturesque peasant girls, coming from work," who "hooted," "shouted," and "made all manner of game of us," proved that the romantic girls of poetry and painting are "a glaring fraud"; it is the coarse reality that "delights" (*Innocents*, p. 154).

The Innocents Abroad is not, however, a simple rejection of all received opinion and idealizing tendencies. It is, on the contrary, a record of confusions. The jokes are as often uneasily defensive as they are dogmatically aggressive. Mark Twain believed that the romantic Italy was not the real Italy, but what the real Italy was, he could not tell. Like so many travelers, he was cut off from its reality by language, by ignorance of history and inexperience of art, and by the rapidity of his travels: he visited Genoa, Milan, Lake Como, Venice, Florence, Pisa, Leghorn, Rome, Naples, Pompeii, and Ischia in less than a month, much of that time being occupied with writing the letters to his newspaper, the *Alta California*, about how little he understood. Thus all Twain can report is the reality of his travels and his quick impressions — mostly negative, occasionally sensational or sentimental.

Twain often desperately raided guidebooks, but what he wanted above all was a fresh subject, a thing not easily found in Italy. His exasperation reached its climax when he arrived at Rome. The "noblest delight" that a man can experience is that of "Discovery!" he declared; to be where no one has been before. "To be the *first* — that is the idea." To be Fulton, Jenner, Daguerre, or "Columbus, in the *Pinta's* shrouds, when he swung his hat above a fabled sea and gazed upon an unknown world!" — these are the lucky men. But, "what is there in Rome for me to see that others have not seen before me? . . . What can I discover? Nothing. Nothing whatsoever" (*Innocents*, p. 209).

This is the peculiar lament of the professional *writer*, who must write something new; it hardly matters to the rest of us if we are thinking, touching, or feeling as others have done if we are now doing it for ourselves. Twain's solution to the problem in Rome was to reverse his situation, to imagine himself an innocent from the Roman Campagna who has gone to America. *There* is the opportunity for discover-

ing and reporting novelties: streets where you could fall out of a window without landing on a priest or a foreign soldier; "common men and common women who could read"; houses made of wood that burns, but fire-fighting companies and fire insurance companies to compensate; Jews who enjoy perfect equality; a democratic government about which anyone can complain openly; steam-powered machinery; and so on (*Innocents*, pp. 210-213). Without entirely idealizing America, Mark Twain found a way to describe the most backward features of Rome, as measured by the standards of democratic and material progress.

Among the things Mark Twain does discover is his own ignorance, so the best thing to do is exaggerate it, to make it part of the fun. Twain and his small circle of friends play the role of Innocents self-consciously. In Genoa the guides particularly welcome Americans because of the "sentiment and emotion" they are expected to show before "any relic of Columbus." But when Twain's group discovers that the guide does not know whether the house they are visiting was the birthplace of Columbus himself or of his grandmother, they decide to punish him by pretending total ignorance of Columbus. Shown a letter supposedly written by Columbus himself, they regard it indifferently and criticize the penmanship, saying that children in America write much better. Shown a "splendid, grand, magnificent" bust of "Ze great Christopher Columbo," they ask what he did. "Discover America!" the guide replies in disbelief. "Discover America," retorts the doctor, "No – that statement will hardly wash. We are just from America ourselves. We heard nothing about it. Christopher Columbo – pleasant name – is – is he dead?" The doctor diverts the discussion into guesses about possible causes of Columbus's death and ends with a silly pun the guide cannot understand (*Innocents*, pp. 230-231).

In Venice Mark Twain's arbitrary improvisations are even more evident. He pretends to see Venice as a flooded "Arkansas town" – something he was familiar with. Then he sees it as a place in which the poetry can exist only in moonlight, when Shakespeare's characters – Shylock, Iago, Othello, Desdemona – come to life along with "noble fleets and victorious legions returning from the wars." In the "treacherous sunlight, we see Venice decayed, forlorn, poverty-stricken, and commerceless – forgotten and utterly insignificant" (*Innocents*, p. 173). In these familiar romantic antitheses between moonlight and the light of common day, Mark Twain pretends to take the side of the romantic – it is the sunlight that is "treacherous" – although to destroy the lying romance of moonlight is supposedly Twain's own aim. But he has read Byron, or at least a guidebook quotation, so to the question, "What would one naturally wish to see first in Venice?" he answers, "The Bridge of Sighs, of course." To get there, he must pass through the Ducal Palace, which inspires a brief account of patrician government in "the old days" when "the common herd had no vote and no voice" (*Innocents*, pp. 174-75). But Mark Twain revels in those undemocratic "old days" every bit as much as James Fenimore Cooper had in *The Bravo* (1831), for he devotes three pages to the spies, the accusations, the secret votes

and masked judges, the blood-stained instruments of torture, the dungeons, the executions or life imprisonments in damp cells below the water level. All this is very exciting, unlike the Basilica of St. Mark: "I could not go into ecstasies over its coarse mosaics, its unlovely Byzantine architecture, or its five hundred curious interior columns from as many distant quarries. Everything was worn out" (*Innocents*, p. 177). The differing reactions to the prison and the church are significant.

Certainly Mark Twain can see far more in the bridge and the prison than can have met his eyes, because their romantic "reality" in this case appeals to his popular sense of political conspiracies, crimes, and injustice. The church, on the other hand, requires response to a focused religious aesthetic related to nothing he can feel. Saint Mark himself is to be reduced to a nursery rhyme: "Every where that Saint Mark went, the lion was sure to go" (*Innocents*, p. 178).

There are perhaps only three constants in Mark Twain's attempt to represent not the reality of Italy but the limited reality of his varying reactions to it, although one can find a few exceptions to the first two: First, a devaluation of the fine arts, based upon his total lack of experience (which he admits), but also upon the evident services that art had provided to the church and to the aristocracy in their suppression of the people. Consequently, Florence was the city Mark Twain disliked the most. Secondly, a loathing for the Church, its priests and monks, and for the superstitions of Italy manifested in the ubiquitous sacred relics. And finally, almost uncontrollable rage at the extremes of "opulence and poverty" visible in the streets (*Innocents*, p. 252). These last two aspects – superstition and class inequity – became only more evident as Twain moved south to Rome and then to Naples, so by the end of his Italian visit he has hardly a good word to say about anything except the beauty of the Bay and the wonder of Vesuvius, from the heat of which he and "the Boys" light their cigars.

The American dislike for the Church and for the extreme social conditions of Italy was nothing new in 1867. But these considerations were usually subordinated to other, more ideal, aspects. In Mark Twain they are leading motifs of his vision, his humor, his satire; the traditional venerated objects are those that are subordinated. In *The Innocents Abroad*, Protestant, progressive, and democratic themes are validated by what is *visible* to anyone: the tomb of San Carlo Borromeo in Milan *is* loaded with costly jewels; in Naples princely carriages *do* run among begging cripples on the streets. The material fact exists and can be honestly reported. Twain cannot imagine any point of view from which such facts can be justified, nor any "historical" explanation to excuse them.

II

William Dean Howells – who came to know and admire both Twain and James, while neither of these had much regard for the other – is in this as in all things a

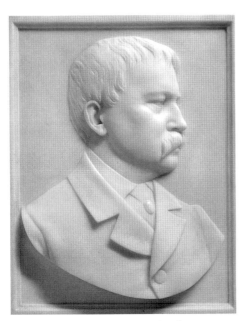

Fig. 2. Larkin Mead (American, 1835-1910), *William Dean Howells*, 1860s(?). Marble. Lent by William White Howells, Courtesy of Museum of Fine Arts, Boston.

man-of-the-middle, a mediator and moderator. Howells (fig. 2) strove for the realistic ideal of disciplined impersonality, while Mark Twain and Henry James moved toward opposite extremes of idiosyncratic vision – far from any sense of objective truth.

When Howells arrived in Venice on December 7, 1861, he knew almost nothing about Italy. He had been appointed the American consul to a place where not one American dollar was invested and where only four American ships arrived in port in a year.[5] He could neither read nor speak Italian. But he set about to learn all he could, and he had plenty of time to do it. Within a year he was fluent in Italian. And, in the absence of any Americans to distract him, by the time he left Venice four years later he was also widely acquainted with Venetians at various levels of society and was intimately familiar with the city. The account he was able to give of Venice differed entirely from the brash tourist's impressions rendered by Mark Twain. His way of seeing Venice was transformed from one of exclusively visual externality to one of dramatic involvement, vision enlarged by language.

Howells begins *Venetian Life* (cat. 167) with a demolition of the romantic Venice of one's dreams, the "Venice of Byron, of Rogers, of Cooper" (*Life*, p. 11). Byron's fabricated history and factitious emotions are recurrent targets. In a list of "sentimental errors" about Venice, the first is "that pathetic swindle, the Bridge of Sighs," about which Byron had written so histrionically that even Twain had been entrapped, but which was built long after the "romantic episodes[s] of political imprisonment and punishment" had ceased (*Life*, p. 12). Byron himself is a *cosa di Venezia* that Howells would like to forget (*Life*, p. 236).

If Howells wishes to destroy the false dream of Venice, with what does he replace it? First of all with a report of its most negative aspects as he himself experienced them. He arrived in winter, and the unexpectedly cold and wet climate, of which no adequate recognition is made by the Venetians, was the first objective fact he confronted. The second was that Venice was in a state of almost complete economic decline, from which Howells saw virtually no prospect of recovery beyond the manufacture of mosaics and glass. Finally, Venice was desolate under Austrian domination. Political tensions divided the city, and most pleasures were boycotted in protest; terrorist attacks (a bomb in St. Mark's Basilica) were not unknown. Howells's picture of Venice must be painted in terms of these negative facts if it is to achieve something fundamental to realistic truth: *particularity* of time and place. Venice is no timeless realm of poetry; one experiences it under specific circumstances of weather, economics, and politics, and the gloom that results is not the romantic gloom of heroes languishing in dark prisons, but the gloom of actual lives of ordinary citizens living in the 1860s.

Even more than this particularity, Howells wishes to achieve *comprehensiveness* of vision. His "lowly-minded muse," Howells writes, calls him to "tell what I found most books of travel very slow to tell, – as much as possible of the everyday life of a

people whose habits are so different from our own; endeavoring to develop a just notion of their character, not only from the show-traits which strangers are most likely to see, but also from experience of such things as strangers are most likely to miss." So Howells's picture of Venice includes lengthy depictions of Venetians shopping, cooking, eating, drawing water, lighting their rooms, and trying to keep warm, as he himself learned to do from living of necessity in "the frugal Venetian fashion" (*Life*, p. 94). We see Venetians at work, at play, getting acquainted and getting married, being baptized and being buried.

Howells's account of these mundane matters transcends the commonplace for two reasons. First the Venetian ingenuities of adaptation to a unique environment — a city of canals — make what is ordinary there seem picturesque to a non-Venetian.[6] The second, and more important, reason for Howells's success in providing a fresh way of seeing Venice is in his management of a complex outsider-becoming-insider point of view. While gradually overcoming the ignorance that limits an outsider's understanding, he retains the outsider's disinterested perspective. The observer's detachment is complemented by a participant's sympathy.

Venetian Life begins with a metaphor of the theater. On a visit to Padua, Howells once sat in a stage-box, which allowed him a view not only of the public performance of the actors but also of their behavior back-stage and of the stage-machinery as well. He believes that his years in Venice afforded him something like this view of Venetian life: not only as it is publicly displayed but also as it is privately, unguardedly lived and managed. It is not that one view replaces the other, but that a double-view is maintained. The truth is in the totality.

The public life of Venice was easy to come by through diligent observation of life in the streets and *campi*. The theatrical metaphor for this aspect of Venetian life was of course not invented by Howells. Venice as a stage set and Italians as highly expressive participants in the spectacle of their communal life are notions the Italians themselves adopt. Instances of the blurring of the metaphor into the reality of the actual life of the Venetians, and of Italians generally, are evident in an early chapter, "Comincia Far Caldo." There Howells describes himself joining the ever-increasing number of Venetians who sit out in the cafés as spring begins, watching the passing community life. A chapter called "The Balcony of the Grand Canal" records the colorful and varied floating life of the city passing by — not grand regattas, but boats loaded in the daytime with English and German tourists, in the evening with Venetian families, and at nightfall "the market boats on their way to the Rialto market, bringing heaped fruits and vegetables from the mainland" (*Life*, p. 132).

To witness life from cafés or from balconies encourages its perception in limited visual terms, and the metaphor of life-as-theatre easily reduces itself to the purely visual metaphor of life-as-art. Howells, who arrived in Venice hardly knowing more about art than Mark Twain, conscientiously attempted to learn all he could. Although he repeatedly contemplated all the Venetian painting said to be of any

worth, in the end "the only paintings which gave me genuine and hearty pleasure were those of Bellini, Carpaccio, and a few others of that school" (*Life*, pp. 165-166). The realism of Bellini and Carpaccio – the recognizability of the populated places they depicted in the Venice Howells knew – was undoubtedly the basis of this pleasure. Howells's own exuberant description of a "superb ecclesiastical procession" in the Piazza San Marco on the Feast of Corpus Christi shows perfect affinity with Gentile Bellini's *Procession in the Piazza San Marco* (cat. 129, fig. 1). Both scenes show, in Howells's words, "every window fluttering with rich stuffs and vivid colors; the three great flag-staffs hanging their heavy flags; the brilliant square alive with a holiday population, with resplendent uniforms, with Italian gesture and movement, and that long glittering procession, bearing slowly on the august paraphernalia of the Church." Howells asserts that "You must see all this before you can enter into the old heart of Venetian magnificence, and feel its life about you." A vivid two-page description ends with the image of one old man who, in taking the Patriarch's blessing, "found it inconvenient to kneel, and compromised by stretching one leg a great way out behind him" (*Life*, pp. 284-287). This suggests one of those casual incidents, contained within the formal splendor of a Bellini or a Carpaccio, that complete the picture and make it "real."

Committed as Howells is to a realism of the "average experience," he must remind himself occasionally "how marvelous" – how anything but "average" – Venice actually is, a fact "you sometimes for a little while forget" while you are living there constantly (*Life*, p. 125). Howells wishes as much as Mark Twain to debunk romantic illusions about Italy, and he does so far more accurately, but he by no means wants to deny its genuinely wondrous aspects. He writes that "there can be nothing else in the world so full of glittering and exquisite surprise, as that first glimpse of Venice which the traveler catches as he issues from the railway station by night, and looks upon her peerless strangeness" (*Life*, p. 28). And yet "modern life" in such a place offers, "according to the humor in which it is studied, constant occasion for annoyance or delight, enthusiasm or sadness" (*Life*, p. 31). From the beginning Howells showed a preference for "dirty neighborhoods" over "proper Objects of Interest." He was more attracted to a little courtyard with "its carven well . . . in the noisy keeping of the water-carriers and slatternly, statuesque gossips of the place" than to the Piazza San Marco (*Life*, p. 33). But Venice's "peerless strangeness" was evident everywhere.

Two consecutive and deliberately contrasted pictures-in-prose show Howells struggling in his first year to find language adequate to the scene and to his response to it simply as visual spectacle. The first is of a moonlit view of the Basin from the Public Gardens. Written in a throbbing romantic mode, it is closer to Turner than to the pure aestheticism of the Venetian *Nocturnes* Whistler would paint at the end of the next decade, but it does bring Whistler to mind (cat. 107). It evokes "the dim bell-towers of the evanescent islands in the east (a solitary gondola

gliding across the calm of the water, and striking its moonlight silver into multi-tudinous ripples)," "the vague shipping in the basin of St. Mark," "the lights from the Piazzetta to the Giudecca, making a crescent of flame in the air, and casting deep into the water under them a crimson glory." The description continues, ulti-mately falling into quasi-poetic rhythms:

> Behind these lamps rose the shadowy masses of church and palace; the moon stood bright and full in the heavens, the gondola drifted away to the northward; the islands of the lagoons seemed to rise and sink with the light palpitations of the waves like pictures on the undulating fields of banners; the stark rigging of a ship showed black against the sky; the Lido sank from sight upon the east, as if the shore had composed itself to sleep by the side of its beloved sea to the music of the surge that gently beat its sands [Life, p. 34].

As though disturbed by his own passionate attention to the aesthetics of inhuman spectacle, Howells immediately claims that "there is a perfect democracy in the realm of the beautiful, and whatsoever pleases is equal to any other thing there, no matter how low its origin or humble its composition." The magnificent scene over the lagoon, he claims, gave him "no deeper joy than I won from the fine spectacle of an old man whom I saw burning coffee one night in the little court behind may lodgings." Even the "low" and "humble" are required to provide a "fine spectacle." As Howells goes on to describe the coffee-roaster, he cannot resist converting him from a simple working man into an emblem and finally into an instance of the sub-lime:

> [A]ll day long this patient old man – sage, let me call him – had turned the sheet-iron cylinder in which [the coffee-berry] was roasting over an open fire after the pic-turesque fashion of roasting coffee in Venice. Now that the night had fallen, and the stars shone down upon him, and the red of the flame luridly illumined him, he showed more grand and venerable than ever. Simple, abstract humanity, has its own grandeur in Italy; and it is not hard here for the artist to find the primitive types with which genius loves best to deal. As for this old man, he had the beard of a saint, and the dignity of a senator, harmonized with the squalor of a beggar, superior to which shone his abstract, unconscious grandeur of humanity. A vast and calm melancholy... dwelt in his aspect and attitude; and if he had been some dread supernatural agency, turning the wheel of fortune, and doing men, instead of coffee, brown, he could not have looked more sadly and weirdly impressive. When, presently, he rose from his seat, and lifted the cylinder from its place, and the clinging flames leaped after it, and he shook it, and a volume of luminous smoke enveloped him and glorified him – then I felt with secret anguish that he was beyond art, and turned sadly from the spectacle of that sublime and hopeless magnificence [Life, pp. 34-36].

Such a strenuous – and finally futile – attempt to see supernatural significance in a common sight is contrary to Howells's more authentic tendencies. Only by super-imposing upon the poor visible man a set of conventionally elevating types and

terms – sage, saint, and senator; grand, venerable, and weirdly impressive – could Howells construct a "sublime" reality "beyond art." He misleads himself as successfully as Byron.

All this – the *public* spectacle of Venetian life, whether grand or humble – was available to anyone going about with his eyes open. But the other side of the truth – the "back-stage" or "real-life" view for which Howells had a far more genuine affinity – was far less accessible. Late in the book Howells admits that he had lived in Venice for two years without knowing how Christmas was celebrated. He mentions this as "curious proof of the difficulty of knowledge concerning the in-door life and usages of the Italians" (*Life*, p. 297). He finally learned the truth about Christmas by consulting his barber, the person who, he says, is in Italy always a man's chief source of intimate local information. And, after Howells's own marriage in his second year, when he ceased to be a lonely bachelor and became a husband and in due time a father (fig. 3), he was invited ever more fully into the ordinary indoor life of the town, and was thus enabled to develop the double view with great confidence in its fidelity to reality. Venice at this point ceased to be mere visual spectacle – however elaborately interpreted – and became living drama: a matter of language, of character, and of conflict.

Howells several times turns to narrative to convey this domestic reality, drawing upon his own interaction with the Italians. Here his sense of the human comedy comes out most strongly as people define themselves in action and dialogue. Un-

Fig. 3. Augustus Saint-Gaudens (American, 1848-1907), *William Dean Howells with Daughter, Mildred Howells*, 1898. Bronze. National Portrait Gallery, Smithsonian Institution, Transfer from the National Gallery of Art, gift of Miss Mildred Howells, 1949.

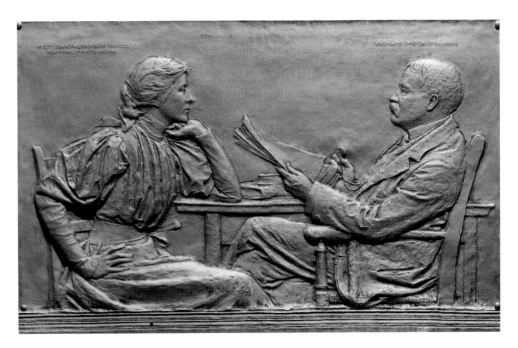

doubtedly this comic realism owes much to Howells's great love for the dramas and the memoirs of Carlo Goldoni (1707-1794), to whom he constantly refers.[7] "The love-making scenes in Goldoni's comedy of *Il Bugiardo*," he claims, "are photographically faithful to present usage in Venice" (*Life*, p. 316n). The best of Howells's own Goldonian comedies concerns his and his wife's experience with their *cameriera*, Giovanna. Giovanna gradually took over their household, determined what purchases they would make and from whom, and eventually insinuated all her relatives and friends into their lives, so that finally the only way Howells and his wife could liberate themselves was by moving to the other side of the Grand Canal. The story is told with a mixture of affection, compassion, and dismay that brings to life an assortment of ordinary people, both in their individual distinction and in their typicality.

By the end of his stay — and of his book — Howells feels exceptionally capable of describing and analyzing Venetian society, a confidence that he does not express in his later Italian travel books, which were based upon much briefer observations of the major towns of Italy. In those books he is constantly reminding himself and his reader not to make generalizations based upon superficial random observations. But about Venice he is sure, so much so that he does not hesitate to correct even Venetian writers on the subject, and to move beyond analysis to judgment — usually showing more leniency than the Italians. One Venetian complains of modern Venetian indolence with as much disdain as the usual Anglo-Saxon tourist; but Howells, who has observed that indolence closely, understands it to be "as much their fate as their fault" (*Life*, p. 339). In considering the future, Howells finds in Italy that the class differences are not characterized by the "aggressive pride" and "abject meanness" one witnesses elsewhere in Europe, nor by the "brutality" with which class distinctions are maintained in "our own *soi-disant* democratic society." This leads him to conclude that there is an "equality in Italian fibre which I believe fits the nation for democratic institutions better than any other, and which is perhaps partly the result of their ancient civilization" (*Life*, p. 382).

In contrast to the usual American traveler in the nineteenth century, Howells comes to look sympathetically even upon ecclesiastics. Those whom Howells came to know were "kind and amiable," and one was "one of the most agreeable and cultivated gentlemen I ever met" (*Life*, p. 377). In one area only — that of sexual morality — does Howells prove to be absolutely unconvertible to the Venetian point of view. Both extremes — from the sexually frustrated celibate priest to the leering old lecher in the Piazza San Marco and the socially tolerated adulterous woman — are equally repugnant sights to Howells. In the very paragraph where he is praising the realism of Goldoni, Howells refers to the autobiography of Casanova as "a source of much information about things that had best not be known" (*Life*, p. 393). On no other subject does Howells show himself so much the Victorian moralist willing not only

Fig. 4. *Henry James on the steps of the Galleria Borghese, Rome, 1899.* Photograph. By permission of the Houghton Library, Harvard University.

Fig. 5. *Henry James (standing) with friends Howard Sturgis (left) and Mr. and Mrs. Edward Darley Boit on a terrace, Vallombrosa, 1907.* Photograph. By permission of the Houghton Library, Harvard University.

to condemn an aspect of social reality but even to draw a line around what should be seen and told.[8]

III

Moral judgment of this sort was very far from the interests of Henry James (figs. 4 and 5), who in contrast to both Mark Twain and Howells, at first found in Italy a purely aesthetic experience. In Venice above all James saw how life and art were "interfused," "consanguineous." "You don't go into the churches and galleries by way of a change from the streets; you go into them because they offer you an exquisite reproduction of the things that surround you," he wrote in 1882, after his seventh visit to Italy in twelve years. "All Venice was both model and painter, and life was so pictorial that art couldn't help becoming so," he wrote in *Italian Hours* (cat. 171). This correspondence between life and art is what makes the Venetian paintings so accessible; "you enjoy them because they are so social and so true."[9] But this is true of the whole of "this rich old Italy, where art, so long as it really lived at all, was spontaneous, joyous, irresponsible." In Florence in 1877 James realizes that that is why the kill-joy Ruskin "will never bear the test of being read" there; his schoolmasterly tone becomes comically incongruous. "To justify our presence" in the world of art, says James, "the only thing demanded of us is that we shall have felt the representational impulse" (*Hours*, pp. 181-182).

James's own "representational impulse" is amply displayed in the essays on Italy and in the fictions he wrote with Italy as a setting.[10] The "reality" of his early writing especially depended upon its referential quality — its own sociability and truth in representing precious places of the historical world, whether it was himself or his characters that he showed realizing themselves through their sensuous response to those places.[11] James explicitly recognized an analogy between his own task and that of the great Venetian painters. Like Howells, he loved Bellini and Carpaccio above all, but to these he added Tintoretto, referring to him and Carpaccio as "the two great realists" (*Hours*, p. 35). He responded most fully and most originally to Tintoretto:

> Before his greatest works you are conscious of a sudden evaporation of old doubts and dilemmas, and the eternal problem of the conflict between idealism and realism dies the most natural of deaths. In his genius the problem is practically solved; the alternatives are so harmoniously interfused that I defy the keenest critic to say where one begins and the other ends. The homeliest truth melts into the most ethereal poetry — the literal and the imaginative fairly confound their identity.

More specifically, Tintoretto had "unequalled distinctness of vision. When once he had conceived the germ of a scene it defined itself to his imagination with an intensity, an amplitude, an individuality of expression, which makes one's observation of

his pictures seem less an operation of the mind than a kind of supplementary experience of life" (*Hours*, pp. 79-81).

One recognizes in all these terms James's own aims. For James the tasks of painter and writer were identical in both inspiration and form; only the medium differed.[12] He adds: "You get from Tintoret's work the impression that he *felt*, pictorially, the great, beautiful, terrible spectacle of human life very much as Shakespeare felt it poetically" (*Hours*, p. 81). After James had written such large-scale works as *The Portrait of a Lady* and *The Princess Casamassima*, he looked again at Tintoretto in 1892 with particular interest in the compositional challenge and mastery displayed by his *Marriage at Cana* in Santa Maria della Salute. James notes that "his subject was always a cluster of accidents; not an obvious order, but a sort of peopled and agitated chapter of life." The "heterogeneity" and "abundance" of the figures may make "the principle of selection seem in comparison timid, yet the sense of 'composition' in the spectator — if it happen to exist — reaches out to the painter in peculiar sympathy. Dull must be the spirit of the worker tormented in any field of art with that particular question who is not moved to recognize in the eternal problem the high fellowship of Tintoretto" (*Hours*, pp. 49-50).

James undoubtedly most felt this fellowship with Tintoretto when engaged in his larger fictional compositions, but even in the smaller sketches of Italy he faced the essential problems of representation. Certainly his Italian essays often seem to be "a cluster of accidents" without "obvious order," yet they are sustained by the "individual expression," or personal style, of a brooding mind with "distinctness of vision." In Venice especially James seems delighted to have found a place as subtly varied as his own sensibility and as complex in texture as his own evolving style. An essay on Venice may be simply a sequence of "little mental pictures" rising in the memory of the essayist after his visit. But these little pictures display in small the entire compositional challenge. Like the watercolors of Sargent, they tend to be of less monumental scenes than former painters and writers had chosen:

> It is not of the great Square that I think, with its strange basilica and its high arcades, nor of the wide mouth of the Grand Canal, with the stately steps and the well-poised dome of the Salute; it is not of the low lagoon, nor the sweet Piazzetta, nor the dark chambers of Saint Mark's. I simply see a narrow canal in the heart of the city — a patch of green water and a surface of pink wall. The gondola moves slowly; it gives a great smooth swerve, passes under a bridge, and the gondolier's cry, carried over the quiet water, makes a kind of splash in the stillness. A girl crosses the little bridge, which has an arch like a camel's back, with an old shawl on her head, which makes her characteristic and charming; you see her against the sky as you float beneath. The pink of the old wall seems to fill the whole place; it sinks even into the opaque water. Behind the wall is a garden, out of which the long arm of a white June rose — the roses of Venice are splendid — has flung itself by way of spontaneous ornament. On the other side of this small water-way is a great shabby façade of Gothic windows

and balconies — balconies on which dirty clothes are hung and under which a cavernous-looking doorway opens from a low flight of slimy water-steps. It is very hot and still, the canal has a queer smell, and the whole place is enchanting [*Hours*, pp. 17-19].

The only weak spots in this are the superfluous notes of appreciation ("characteristic and charming," "splendid," "enchanting") that try too explicitly to provide a sociable tone. Everything else shows the specificity, "distinctness of vision," inclusiveness, and "individuality of expression" that achieve the intensity James sought. Venice lent itself to "impressions in prose" as well as in paint:

> Every patch of colour, every yard of weather-stained stucco, every glimpse of nestling garden or daub of sky above a *calle*, began to shine and sparkle — began, as the painters say, "to compose." The lagoon was streaked with odd currents, which played across it like huge smooth finger-marks [*Hours*, p. 19].

No wonder, then, that James envied a young American artist he encountered there. The painter could pass the entire day "unperplexed by the mocking, elusive soul of things and satisfied with their wholesome light-bathed surface and shape." James concludes that the "mere use of one's eyes in Venice is happiness enough" (*Hours*, p. 75).

But James was not a painter, "unperplexed by the mocking, elusive soul of things." Increasingly he alludes to this soul, even in a genre like the travel-sketch where it may be unwelcome. Italy's depths of human misery, duplicity, evil, and mystery are most evident in James's fiction, but in the essays the aesthetic response is often edged with an ironic awareness that does not weaken the aestheticism, but frames it. Modern Italy and a reality behind the beautiful surface intrude and insist upon consideration.

It was upon his arrival in Turin from Paris in 1877 that James was most moved to meditate upon the modern reality of Italy. His essay, "Italy Revisited," is filled with doubleness of vision: contrasts between memories of his first visit in 1869, on the eve of the Unification, and his impressions now; also contrasts between the Italy of classic romanticism, in which he had so much indulged himself, and the New Italy coming into being. Turin was the right place for such contrasts. Never a major stop on the classical Grand Tour nor an art-lover's Mecca, it was the city most associated with the Risorgimento. So James, longing for an immediate revival of his "comparatively youthful" sense of wonder of eight years earlier, looks out upon Turin and is forced into new thoughts: "We sometimes learn to know things better by not enjoying them too much," he tells himself. Anyway, "a visitor who has worked off the immediate ferment for this inexhaustibly interesting country has by no means entirely drained the cup":

> After thinking of Italy as historical and artistic it will do him no great harm to think of her for a while as panting both for a future and for a balance at the bank; aspira-

tions supposedly much at variance with the Byronic, the Ruskinian, the artistic, poetic, aesthetic manner of considering our eternally attaching peninsula. He may grant — I don't say it is absolutely necessary — that its actual aspects and economics are ugly, prosaic, provokingly out of relation to the diary and the album; it is nevertheless true that, at the point things have come to, modern Italy in a manner imposes herself [*Hours*, p. 158].

"Young Italy," after all, "preoccupied with its economical and political future, must be heartily tired of being admired for its eyelashes and its pose." James recalls an artist in a novel by Thackeray — although the artist could have been America's own John Gadsby Chapman (cat. 66) — who painted a picture called "A Contadino dancing with a Trasteverina at the door of a Locanda, to the music of a Pifferaro." James imagines an antithetical image of Young Italy triumphantly riding on the "democratic" new streetcar from the Porta del Popolo to the Ponte Molle, which has been built without regard to sentimental tourists. "Like it or not," he adds, "I see a new Italy in the future which in many important respects will equal, if not surpass, the most enterprising sections of our native land. Perhaps by that time Chicago and San Francisco will have acquired a pose, and their sons and daughters will dance at the doors of *locande*." As he moves about such a city as Turin, James seems to see "a vision of the coming years" which "represents to our satisfaction an Italy united and prosperous, but altogether scientific and commercial" (*Hours*, pp. 159-60).

Having thus rationalized the modern to himself, James, moving on to Genoa, is nevertheless glad to see that the "wonderful crooked, twisting, climbing, soaring, burrowing Genoese alleys" fully retain the "old Italian sketchability" and would be "impossible to modernize." Genoa still produces the "visible and reproducible 'effect' for which one revisits Italy." True, the Duke of Galliera has just given funds for the improvement of the port, which will no doubt make it "one of the great commercial stations of Europe" (*Hours*, pp. 162-163). Also, nearby La Spezia is now the "headquarters of the Italian fleet," with the result that "since it has become prosperous Spezia has grown ugly." Its "great raw expanses of artificial land" give it the "look of monstrous, of more than far-western newness which distinguishes all the creations of the young Italian State." The only antidote is to retire to the lyrical bay of Lerici and think sad thoughts of Shelley (*Hours*, pp. 168-170).

Watching the people moving through the narrow streets of Genoa, James wonders how much the traveler deceives himself about the true state of their lives. Has he come so far from home "only to encounter new forms of human suffering, only to be reminded that toil and privation, hunger and sorrow and sordid effort, are the portion of the mass of mankind. To travel is, as it were, to go to the play, to attend a spectacle; and there is something heartless in stepping forth into foreign streets to feast on 'character' when character consists simply of the slightly different costume in which labor and want present themselves." James wishes to believe that there is a greater difference than this, that "the sum of Italian misery is, on the whole, less

than the sum of the Italian knowledge of life." But to believe that is possibly "great nonsense," and "half the time we are acclaiming the fine quality of the Italian smile the creature so constituted for physiognomic radiance may be in a sullen frenzy of impatience and pain. Our observation in any foreign land is extremely superficial" (*Hours*, pp. 164-165).

That truth is brought home to James when, on a visit to a picturesque old gateway in the ancient wall of a hill-town, he sees a young man coming toward him. "Like an operatic performer . . . he sang as he came; the spectacle, generally, was operatic, and as his vocal flourishes reached my ear I said to myself that in Italy accident was always romantic and that such a figure had been exactly what was wanted to set off the landscape." He seemed to embody that resigned "knowledge of life for which I just now commended the Italians." But James struck up a conversation with the young man, who turned out to be "a brooding young radical and communist, filled with hatred of the present Italian government, raging with discontent and crude political passion. . . . He was an unhappy, underfed, unemployed young man who took a hard, grim view of everything and was operatic only quite in spite of himself." To someone like James perceiving him as "a graceful ornament to the prospect, an harmonious little figure in the middle distance," he would have cried, "Damn the prospect, damn the middle distance!" (*Hours*, pp. 165-166). Later, in Florence, reading Ruskin's curses upon modern Italy, James can add that "it savours of arrogance to demand of any people, as a right of one's own, that they shall be artistic. 'Be artistic yourselves!' is the very natural reply that young Italy has in hand." Any gift of beauty displays a generosity beyond what the world requires of any people, and Italy has already given us more than any other (*Hours*, p. 177).

In spite of his disillusion with the operatic peasant, James persisted in the belief that even modern Italians possessed a superior "knowledge of life" — a kind of fatalism, vitalizing and informing their daily lives, that was a gift of their history and landscape. Such knowledge expressed itself in styles of being, and — at least formerly — had expressed itself in styles of architecture and art. James aspired to such knowledge and its consequent style. At the end of *The Portrait of a Lady* he has his American heroine, Isabel Archer, return to Rome instead of America *because* she has gained an Italian "knowledge of life"; her own small personal history and identity have merged with those of the city of history. James himself, on his last visits to Italy in 1899 and 1907, puzzled ever more over the "horror" that was inseparable from Italy's beauty. On the "prodigious island" of Capri — "beautiful, horrible, haunted" — he gazes out at the Bay of Naples from Axel Munthe's Villa San Michele and wonders again at Italy's secret. The view alone was "a lesson in the grand style," he says; and one notes the degree of abstraction in his rendering of it (the specificity and color of the little side-canal of the earlier James are wholly gone):

> Sorrento and Vesuvius were over against you; Naples furthest off, melted, in the
> middle of the picture, into shimmering vagueness and innocence; and the long arm

of Posilippo and the presence of the other islands, Procida, the stricken Ischia, made themselves felt to the left [*Hours*, p. 491].

One got no nearer to the "essence" of the secret simply "feeling afresh the old story of the deep interfusion of the present with the past," although certainly at San Michele "the present appeared to become again really classic, to sigh with strange elusive sounds of Virgil and Theocritus." To say that the secret of Italy was one of "style" also helped little, for "what in the world was the secret of style?" "Everything, at any rate, that happy afternoon, in that place of poetry, was bathed and blessed with it." But the place's "style" included Barbarossa and "black Tiberius," who contributed to its "extraordinary uplifted distinction." If the "splendid light" seemed to kill every shadow, yet the "imagination" could not exclude "horror," for it is "a predestined victim always of the cruel, the fatal historic sense. To make so much distinction, how much history had been needed!" (*Hours*, pp. 492-93).

Later James tells of another "demonstration of the grand style of composition and effect" from a promontory at Posillipo. The "Natural Elegance" in the panoramic view of the Bay of Naples seems all-sufficient, rendering quite superfluous "any successfully working or only struggling and floundering civilization." But Natural Elegance is only part of Italy's "style." There is also, inevitably and indispensably, "History," but history as transcendent idea, as "experience outlived":

> The way in which the Italian scene on such occasions as this seems to purify itself to the transcendent and perfect *idea* alone — the idea of beauty, of dignity, of comprehensive grace, with all accidents merged, all defects disowned, all experience outlived, and to gather itself up into the mere mute eloquence of what has just incalculably *been*, remains forever the secret and the lesson of the subtlest daughter of History [*Hours*, p. 498].

James's last word on Italy attempts to "associate" these views of the great Bay from classic terraces with the different, modern sensations gained from watching the landscape unfold from a motor-car, only to find his impressions of the "exquisite grand manner" reinforced. A truly realistic vision of Italy and a style adequate to represent it are in the end not those devoted to the demolition of illusion, like Twain's; or to the impersonal rendering of the actual and the ordinary, like Howells's; but those with an imaginative creative power analogous to Italy's own. "Seen thus in great comprehensive iridescent stretches, it is the incomparable wrought *fusion*, fusion of human history and mortal passion with the elements of earth and air, of colour, composition and form, that constitutes her appeal and gives it the supreme heroic grace" (*Hours*, p. 502).

1. See Dewey Ganzel, *Mark Twain Abroad: The Cruise of the "Quaker City"* (Chicago: University of Chicago Press, 1968), pp. 151-152.

2. Mark Twain, *The Innocents Abroad* (New York: Library of America, 1984), p. 199. Further references within the text are to this edition.

3. William Dean Howells, *Venetian Life* (New York: Hurd and Houghton, 1866), p. 3. Further references within the text are to this edition.

4. William Dean Howells, *Italian Journeys*, enlarged ed. (Boston: J.R. Osgood and Company, 1877), p. 29.

5. See James L. Woodress, *Howells and Italy* (Durham, N.C.: Duke University Press, 1952), pp. 3-10.

6. For a discussion of "picturesque realism" in American writings and paintings depicting Italian scenes, see William L. Vance, *America's Rome* (New Haven: Yale University Press, 1989), vol. II, pp. 139-160.

7. The importance of Goldoni to Howells is discussed in Woodress, *Howells and Italy*, pp. 131-147.

8. One of Howells's most interesting Italian novels, *A Foregone Conclusion* (1875), concerns an agnostic Venetian priest's attraction to a young American woman. *The Lady of the Aroostook* (1879) and *A Fearful Responsibility* (1881) also use the Venetian scene, but the Italian characters are subordinated. A popular later novel, *Indian Summer* (1886), makes effective use of Florence as a setting. Characters with any social standing or aesthetic taste in other novels by Howells usually have visited Italy.

9. Henry James, *Italian Hours* (New York: Horizon Press, 1968), pp. 25-26. Further references within the text are to this edition.

10. In addition to many short tales set in Italy, James's major novels and novellas using the Italian setting symbolically or exploiting stereotypical traits of Italian character include *Roderick Hudson*, 1876, (Rome); *Daisy Miller*, 1879, (Rome); *The Portrait of a Lady*, 1881, (Rome); *The Aspern Papers*, 1888, (Venice); *The Wings of the Dove*, 1902, (Venice); and *The Golden Bowl*, 1904, (a Roman prince). *William Wetmore Story and His Friends* (1903), a biography, extravagantly evokes mid-nineteenth-century Rome. The fullest study is Carl Maves, *Sensuous Pessimism: Italy in the Work of Henry James* (Bloomington, Indiana: University of Indiana Press, 1973).

11. A detailed recent study of the evolution of James's representational style in the essays collected in *Italian Hours* is Bonney MacDonald, *Henry James's Italian Hours: Revelatory and Resistant Impressions* (Ann Arbor: University of Michigan Press, 1990).

12. In "The Art of Fiction" (1884) he asserted: "The analogy between the art of the painter and the art of the novelist is, so far as I am able to see, complete. Their inspiration is the same, their process (allowing for the different quality of the vehicle) is the same, their success is the same. They may learn from each other, they may explain and sustain each other. Their cause is the same, and the honour of one is the honour of another."

"Gondola Days": American Painters in Venice

Erica E. Hirshler

During the nineteenth century Venice underwent a remarkable transformation, from a city of decay, redolent of the sensual excesses of the past, to a city of light and color, immune to most of the unpleasant changes wrought by the modern world.[1] British traveler the Reverend John Eustace's "foul abode of effeminacy, of wantonness, and of debauchery" (1817) became Anton Chekov's "inebriating architecture in which everything is as graceful, light, as the birdlike gondola . . . inundated by the sun" (1891).[2] Venice's changes were not physical; they existed only in the minds of her visitors, whose shifting comments about the city reflect a turnabout in attitudes about both history and art. For Americans, who traveled there for a variety of reasons throughout the nineteenth century, Venice became the spot where, at last, American painters participated equally in an international artistic community.

Venice had been a major tourist center since the fifteenth century, when it was included in the itinerary of one of the earliest package tours, arranged for the devout traveler: Easter services in Rome, sightseeing and shopping in Venice, and spring sailing to the Holy Land. The main attractions offered to the medieval pilgrim remained remarkably unchanged throughout the centuries; they included the square and cathedral of St. Mark's, where government-licensed guides were stationed to assist travelers, and the famous naval Arsenal, where tourists could not only marvel at ships and munitions, but also enjoy a complimentary beverage from the government wine cellar.[3] Three hundred years later, Dr. John Morgan of Philadelphia followed the same program during his ten-day sojourn in Venice, visiting both St. Mark's and the Arsenal "of which they boast so much, and not without some foundation."[4] Morgan was not making a pilgrimage to the Holy Land, but to Rome, valued by Americans as the birthplace of modern secular civilization (not for its Catholic associations). Morgan was delighted with the unique beauty of Venice upon his arrival there in July 1764. The first American known to record his travel experiences in a journal, Morgan well represents the early American response to Venice.

Morgan's trip to Venice was an intentional detour; it allowed him to study the paintings of Titian, Veronese, and Tintoretto, who, along with Raphael, Michelangelo, and Correggio, were among the most admired Italian painters of the age. In his account, Morgan described their work, lamenting the fact that the pictures seemed somewhat damaged by "the Air from the Sea Waters." Nevertheless, he pronounced several of them "most capital."[5] It is likely that Morgan's itinerary replicates at least in part the Venetian tour of Benjamin West, whom he mentions in his journal as having provided several members of the English community at Venice with an entertaining account of his native Philadelphia. West, the first American artist to travel to Italy, spent the fall of 1762 in Venice, setting the agenda for the American visitors and artists who followed.

Few details of West's Venetian stay are known, but the painter associated with several British residents of the city. Presumably he came to study Titian, whose

Fig. 1. Benjamin West (American, 1738-1820), *Anne Compton, Countess of Northampton, with her Daughter Elizabeth*, 1762. Oil on canvas. Bass Museum of Art, Miami Beach, Fla., Gift of John and Johanna Bass.

work he greatly admired, but while in Venice West made a portrait of the Lady Anne, Countess of Northampton, and her baby daughter Elizabeth (fig. 1). West's painting perhaps typifies the American response to Venice during the neoclassical period – there is nothing of the city to be seen in it. Despite West's respect for the Venetian painters, he did not use their works as prototypes, preferring instead Florentine examples. Anne Compton, who was the wife of the English ambassador to Venice, is shown in the guise of the Raphael madonnas West had admired at the Pitti Palace. Nor is Lady Anne situated in her foster city, for the landscape West painted behind her, with its mountains and trees, is distinctly non-Venetian.[6]

Even so, West inspired other American artists to follow him to Venice, including John Singleton Copley, Washington Allston, and Rembrandt Peale. Copley stopped in Venice on his way north to Germany in the fall of 1775, no doubt to study the works of Titian, which West had recommended he scrutinize, but whose technique Copley found puzzling.[7] Allston may have visited Venice in 1805; he deeply admired the Venetian school of artists, writing that their use of color gave "birth to a thousand things which the eye cannot see."[8] Allston emulated in his own work their sophisticated method of applying paint in thin translucent glazes to create rich coloristic effects. Rembrandt Peale, who met West in London, soaked up all he could of the Venetian painters in the four days he spent in Venice in May 1830. Yet all of these artists used Venice only as a museum, visiting her galleries, palaces, and churches for the art contained in them, not for their intrinsic beauty. To paint Venice herself was as yet of little interest.

From the beginning, however, Americans were entranced with the look of Venice. Morgan found it to have "a very romantic appearance or air of Enchantment," writing that at first glimpse it "has a most striking effect to those who never before saw any thing of the kind. A City rising out of the waves of the Sea, so large and so handsome as Venice is indeed a beautiful object."[9] His image of Venice as a fairytale vision was echoed by many compatriots. For the poet Henry Wadsworth Longfellow in 1828, who was so enamored of Italy that he signed his letters "Enrico," Venice was "the most wonderful city I ever beheld"; he expected it to "disappear like an optical delusion or some magic city in the clouds."[10] Two years later Rembrandt Peale described "a magnificent harbor, resembling a great river, lined with good houses . . . the magnificence of the palaces, and their peculiar style of architecture, rich in bold ornaments, balconies, and sculptures, excited us to frequent exclamations of admiration."[11] At the same time James Fenimore Cooper professed that "no other place ever struck my imagination so forcibly," and he used it as the setting for his next novel, *The Bravo*, although he tired of the city's novelty.[12] In 1831, Boston portraitist Amasa Hewins celebrated Independence Day in Venice, sharing a celebratory dinner with Samuel F.B. Morse; Hewins described the city as "exceedingly rich and beautiful."[13] Yet despite all of this early enthusiasm, tempered only by Ralph Waldo Emerson's 1833 remark that it was "a city for beavers . . . a most dis-

agreeable residence,"[14] and despite the impressive numbers of Americans who traveled there, Venice, unlike Florence or Rome, did not become a subject for American painters for another decade, and only in the 1860s would it become a common motif.

The reasons for this long indifference to the pictorial possibilities of Venice are complex. To understand Thomas Rossiter's comment in 1843 that Venice was "not . . . a place to paint original pictures in . . . [but] a place essentially for copies and sketches,"[15] one must recognize the artistic aspirations of that early generation of travelers. Only then can one determine whether images of Venice could fulfill their goals. Allston would seem to be a logical candidate to have made a Venetian view, but he never did. It can be argued that few of Allston's landscapes depict actual sites and are instead the product of his imagination, but it is also true that Allston's artistic formula had little in common with the appearance of the Venetian lagoon (see cats. 10-12). Allston most often preferred compositions after the manner of Claude: pastoral, framed by arching trees, and anchored with a background mountain. Venice could offer none of these, as George Stillman Hillard succinctly pointed out in his travel book, *Six Months in Italy* (cat. 159):

> In external Venice there are but three things to be seen; the sea, the sky and architecture. There are no gardens, no wide spaces over which the eye may range; no landscapes properly so called. There are no slopes, no gradations, no blending of curved lines.[16]

Hillard's remark that Venice had "no landscapes" is significant, for it reflects the pervasive assumption that "landscape" was defined in Claudian terms. Venice could not offer such ingredients; it was flat, its low horizon line broken solely by the rigid verticals of man-made towers, bereft even of trees to soften the effect. Distant views could be perceived only from the watery perch of a gondola, leaving no stable foreground in which to place the customary staffage or the meandering path toward the horizon. Within the city itself, there was virtually no open space large enough to accommodate a panoramic vista; even the Piazza San Marco was boxed in by colonnades and cafés. Thus Venice could not be a locus for landscape painters, as long as landscape was interpreted in such terms.

Equally important was Venice's lack of a classical past, for it was the crumbling reminders of ancient civilization that captivated visitors in the neoclassical age. Venice had not even been founded when Rome prospered; it was created only when the invading Visigoths, Huns, Vandals, and Lombards drove the Romans into the swampy lagoon from the mainland province of Venetia. There they could build only low wooden houses and a few stone buildings, which in appearance reflected the colony's political ties to the eastern empire of Constantinople. To a generation raised on Edward Gibbon's *History of the Decline and Fall of the Roman Empire* (1776), who came to Italy to see "the glory that was Rome" for themselves, Venice as a city had

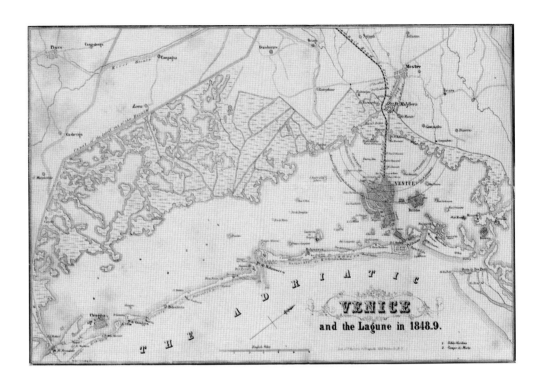

Fig. 2. Venice and the Lagoon, 1845. From Edmund Flagg, *Venice: The City of the Sea* (New York: Charles Scribner, 1853). Photo courtesy of the Museum of Fine Arts, Boston.

Fig. 3. Canaletto (Italian, 1697-1768), *Bacino di San Marco, Venice*, about 1735-40. Oil on canvas. Museum of Fine Arts, Boston, Abbott Lawrence Fund, Seth K. Sweetser Fund, and Charles Edward French Fund. This painting was once in the collection of the Earl of Carlisle at Castle Howard, Yorkshire.

little to offer. Gibbon himself had derided the buildings in the Piazza San Marco as "the worst architecture I ever saw."[17] There were no ruins to explore and to sketch, and therefore no classical icons to use in paintings to suggest great moral or histori- cal themes, an important ingredient in early nineteenth-century landscape.

Even so, Venice had always been one of the main stops on the eighteenth-century Grand Tour, particularly for the British, who purchased Canaletto's *vedute* as sou- venirs (fig. 3). But what attracted them to Venice held less appeal for the straitlaced Americans, most of whom had justified the expense of their travels by considering their journeys academic, the apt conclusion to a classical education. The British usually came for Carnival or other organized festivals, which occasioned masked balls, avid gambling parties, music, theater, and opera, not to mention the exquisite courtesans who had earned the city an international reputation in the seventeenth century. "As for women," wrote the prominent Swiss philosopher Jean-Jacques Rousseau in 1770, "it is not in a city like Venice that a man abstains from them."[18] These aspects of Venice were confirmed in the public imagination with the publica- tion in 1826 of the memoirs of her native son, Giovanni Casanova. They were hardly the ideals for an American painter to present to his earnest sponsors at home: Ben- jamin West received financial support from Chief Justice William Allen and Lieu- tenant Governor James Hamilton of Pennsylvania; Rembrandt Peale from both New York politician and collector Philip Hone and Philadelphia merchant Reuben

Haines, a secretary of that city's Academy of Natural Sciences; and Thomas Cole from Baltimore's most important collector, Robert Gilmor. Samuel F.B. Morse was a staunch Calvinist, shocked by luxury and libertines; Cole's moral Christianity played a central role in his art, and most other painters of this period recognized their mission in Italy as work, not play. Thus, when they went to Venice, it was to examine the much-admired glazing technique and jewellike colors of the Venetian school, not to be seduced by the city itself or by its inhabitants. As Matthias Bruen, pastor of the Bleecker Street Presbyterian church in New York City remarked of Venice in 1823, "this city [has been] for ages a loathsome and infectious depository of malignant moral poison."[19]

There were also political reasons to avoid Venice. In May 1797, after several years of ambivalent negotiations with France in an attempt to maintain political neutrality, the Venetian Republic succumbed to Napoleon Bonaparte, who already controlled much of northern Italy. Napoleon ordered that emblems of the Lion of Saint Mark be destroyed, that other symbols of the republic be burned at the foot of a "Tree of Liberty" in the Piazza San Marco, and that French troops take over the Arsenal. Among the riches the French seized to add to the trophies accumulating at the Louvre in Paris were two major paintings by Veronese, the central ceiling panel from the Hall of the Council of Ten in the Doge's Palace and the *Marriage at Cana* from San Giorgio Maggiore. Although the city was ceded to the Austrians by the Treaty of Campoformio in October, the final French insult to the Venetians came on December 13, 1797, when the great bronze horses that had graced the façade of St. Mark's for five hundred years were lowered onto carts and shipped to Paris, where the following July they were paraded through the French capital in celebration of Napoleon's victories (see cat. 105).

From 1797 to 1814, Venice changed hands four times, alternating between French and Austrian control. The unstable political situation discouraged visitors and ruined the local economy. Among the first tourists to return were the British, who could now easily approach Italy from the north by way of the road Napoleon had blasted through the Alps in 1805, shortening the trip from Brig to Domodossola to one day. The poet Samuel Rogers came in 1816, penning his tremendously popular poem *Italy*, which included the lines "There is a glorious City in the Sea . . . the salt sea-weed clings to the marble of her palaces," verses quoted by nearly every subsequent visitor. Byron arrived later that year, finding the city still "very agreeable for gentlemen of desultory habits – women – wine – and wassail"; he did his best to live up to the city's reputation.[20]

Rogers and Byron would do much to restore Venice's aura for both British travelers and painters; their romantic delight in the city marked an end to the dominance of classicism. The decay they found so picturesque was recent, the result of the preceding decade of political and economic unrest, but for these poets it had sublime appeal. Byron wrote several major works in Venice, including *Beppo*, *The Two Foscari*,

Ode on Venice, and the last portion of *Childe Harold's Pilgrimage*, in which he created an image of a declining "fairy city of the heart" that would capture the public imagination for the rest of the century. Nevertheless, the moral lessons characteristic of classicism were not left behind completely, for to English eyes, the crumbling island republic that had once been a prosperous mistress of the seas was a token for Britain herself.

British painters followed in Byron's footsteps, among them William Etty (1787-1849), Samuel Prout (1783-1852), and Richard Parkes Bonington (1802-1828). Unlike the Americans who came to Venice, these artists took the city itself as their subject. Etty stayed several months in 1822, describing Venice as the "the birthplace and cradle of color."[21] His most famous Venetian scene shows the Bridge of Sighs, complete with two men hauling a senseless figure into the prison from a gondola (1835, York City Art Gallery), recalling Byron's description in *Childe Harold* of "a palace and a prison on each hand." Prout and Bonington, who came in 1824 and 1826, favored picturesque architectural views of Venetian monuments: the Rialto Bridge, the Ca d'Oro, the Doge's Palace, and the Palazzo Mocenigo, where Byron had lived. But by far the most important British painter to visit Venice during this time was Joseph Mallord William Turner (1775-1851).

Turner arrived in Venice for the first time in September 1819. He spent only about five days sketching there, his trip possibly the request of James Hakewill, with whom he worked on *A Picturesque Tour of Italy*, a book of thirty-six engravings of Italian views. During this trip, Turner made just four watercolor studies, but he filled his sketchbook with pencil drawings of palaces and the lagoon. His first Venetian oil, *Bridge of Sighs, Ducal Palace and Custom-House, Venice: Canaletti Painting* (The Tate Gallery, London), was painted in London fourteen years later, apparently in response to the scenes of Venice exhibited at the Royal Academy by his British colleague Clarkson Stanfield (1793-1867). In this composition, Turner included a small figure of Canaletto painting, demonstrating the continued identification of scenes of Venice with that Italian master's matter-of-fact, linear images, particularly in England. It would be Turner himself who would shatter those expectations in a series of more than twenty oil paintings and more than 150 watercolors that established Venice as an acceptable subject for modern landscape painters. Turner's pictures were based on sketches he made during two more trips to Venice, one for only about ten days in 1833, and one for two weeks in 1840.

Turner exhibited Venetian subjects in London almost every year from 1833 to 1846. Most were sold, primarily to Britain's new collectors, wealthy industrialists and merchants. Only one was purchased by an upper-class landowner.[22] While the aristocracy had purchased the majority of Canaletto's scenes of Venice as souvenirs of their own travels, by Turner's day Venetian pictures appealed to the prosperous middle class, perhaps in emulation of their blue-blooded predecessors. It was a new market, one that maintained the necessary financial resources to purchase works of

art, but that altered the conception of Venice as the playground of the elite. A member of this new group of patrons, John Ruskin (1819-1900), the son of a sherry merchant and the owner of Turner's *Grand Canal, Venice* (fig. 4), became one of the most influential proselytizers on behalf of both Turner and Venice.

The British were not alone in painting Venice during the second quarter of the nineteenth century. Such other European painters as German-born Carl Friedrich Werner (1808-1894), the Italian Ippolito Caffi (1809-1866), and the French master Jules Joyant (1803-1854) also painted images of Venice in the 1830s and 1840s, many of them reminiscent of the tightly rendered architectural views perfected by Canaletto. Their artistic efforts coincided with the revival of tourism in Venice, where, under the control of the Austrian government, new facilities were established to accommodate visitors. These included eleven large hotels, among them the popular Europa, where both Turner and Ruskin stayed; seven theaters, open every evening during the summer; and a fashionable bathing establishment near the Custom House at the entrance to the Grand Canal. The Piazza San Marco was illuminated with gas lamps in 1843, and Austrian bands provided entertainment at the elegant sidewalk cafés. That year, 112,644 visitors came to Venice; their arrival would be facilitated in 1846 by the opening of the railroad bridge across the Lagoon.[23]

Where were the Americans during this revival? Although still drawn primarily to Rome, many Americans did travel to Venice in the 1830s and 1840s. Francis Alexander (1800-1880), a New England portraitist, spent two years in Italy in 1831-1833. He stayed in Venice for seven months, and described the city to his friend Thomas Cole:

> The architecture of this city would please you *certemente* [sic], 'tis so quaint, so oriental and ornamental – I may call it picturesque – it belongs to no particular order; – there is no edifice here that you would not recognize as belonging to Venice were you to see it or its similitude in America, i.e., if you had been here long enough to become acquainted with the "Venetian order."[24]

Alexander encouraged Cole to visit, adding "I anxiously hope, friend Thomas, that you will yet come to Venice."[25] But Cole's sojourn in Italy was cut short by news of family illness, and he never reached Venice. Alexander later told him that he had missed "some of the most beautiful effects of light and shade and of coloring . . . the water and architecture and then the Venetian painting."[26] Despite Cole's absence, many other Americans did travel there. Amasa Hewins and Samuel F.B. Morse have been mentioned; their compatriots included John Gadsby Chapman, who visited Venice in 1831; G.P.A. Healy (1835); Asher B. Durand (1840 and 1841); and Thomas Rossiter, who noted that during his own sojourn in Venice in 1843, several other American artists were present, including James de Veaux, Louis Lang, Luther Terry, Miner Kellogg, Daniel Huntington, and Emanuel Leutze.[27] Robert Salmon apparently also traveled to Venice in the mid 1840s; John F. Kensett spent a month there in 1847.

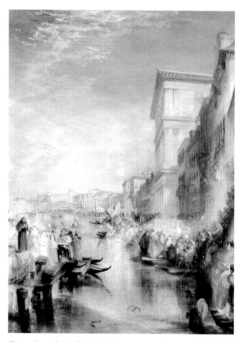

Fig. 4. Joseph Mallord William Turner (British, 1775-1851), *The Grand Canal, Venice*, 1837. Oil on canvas. Henry E. Huntington Library and Art Gallery, San Marino, California.

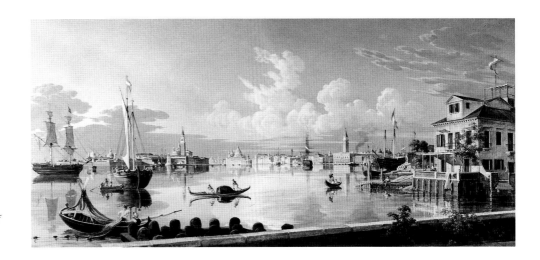

Fig. 5. Robert Salmon (American, 1775- about 1848-51), *View of Venice*, 1845. Oil on canvas. Thyssen-Bornemisza Collection, Lugano, Switzerland.

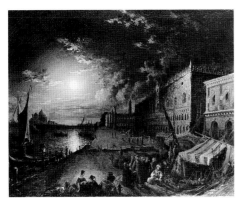

Fig. 6. George Loring Brown (American, 1814-1889), *The Doge's Palace in Moonlight*, 1846. Oil on canvas. Location unknown. Photo courtesy of Hirschl and Adler Galleries, New York.

Most of these painters seem to have come to Venice for the same reasons that West and Copley had – to study the works of Titian, Veronese, and Tintoretto. Calling these artists the "great triumvirate," James de Veaux, a portraitist from Charleston, South Carolina, remarked "how utterly impossible to judge the strength of these men, until Venice has been visited."[28] Yet there are indications that the city itself began to appeal to Americans as a subject. Robert Salmon made a panoramic image of Venice in 1845 (fig. 5), one of a pair of Italian scenes discovered in the 1970s that may have had a decorative purpose similar to entrepreneur J.R. Smith's "grand topographical view of Venice." That scene was part of "the largest moving panorama in the world," some 30,000 square feet of canvas portraying a trip to Europe, exhibited in New York in 1855.[29] Recently come to light is a picturesque genre scene of the courtyard of the Doge's Palace by Miner Kellogg, dated 1843.[30] During his month-long stay in Venice in 1847, John F. Kensett made at least three paintings that appeared in his 1873 estate sale: *Grand Canal, Venice*; *Venice, Santa Maria della Salute*; and *Venice, 1847.*[31]

One of the most prolific early American painters of Venetian scenes was George Loring Brown (see cats. 58, 59), who began to paint the city in 1845. His *Doge's Palace in Moonlight* (fig. 6), a romantic vision of the Bacino San Marco, was exhibited in New York in 1846, where it was admired by William Cullen Bryant as "the best southern moonlight ever painted," although Bryant would have preferred that Brown address American landscapes instead.[32] In 1847, Brown painted *View of the Grand Canal, Venice, Recollections of Turner*, the title a clear indication that the artist was aware of Turner's success with the subject. Brown often included Venetian scenes in a set of four Italian views commissioned by a single patron, most frequently along with images of Florence, Naples, and Rome.[33] He painted Venice throughout his career, although the demand for his Venetian scenes increased dramatically in the

1870s and 1880s, when, as a resident of Malden, Massachusetts, Brown continued to paint Italian motifs from memory. His speciality would be adopted by another American devotee of Turner, Thomas Moran, who painted dozens of scenes of Venice in the 1890s (see cat. 123).

By the time George Stillman Hillard visited Italy in 1847, there were enough images of Venice in pictures and prose for him to remark that "we come into its presence with an image in our thoughts, and are not unprepared for what we see."[34] But these early efforts came to an abrupt halt in 1848, with renewed hostilities between Venice and Austria. Under the leadership of Daniele Manin (1804-1857), the principal citizens of Venice sought economic reform, an end to censorship, and union with Italy. Manin's imprisonment early in the year only served to solidify Venetian opposition to the distant control of Vienna. He was released by force two months later, and despite the reservations of many prominent citizens over the notion of revolution, he attempted to restore Venice as a political entity, a new Republic. There were riots in the Piazza San Marco; angry Venetians tore up its paving stones to hurl at Austrian soldiers, who retaliated with gunfire. Manin and his followers captured the Arsenal and declared the new Republic of Saint Mark, but their political and military troubles increased with the success of Austrian troops in Piedmont and Lombardy, on the mainland. By the end of the year Venice was cut off from *tèrra fèrma* and thus from most supplies; in May 1849, the Austrians blockaded the Lagoon, destroyed the railroad bridge, and started to bombard the city with cannon. The summer brought significant shortages of food and water, and an outbreak of cholera claimed three thousand lives by August. Manin and his followers surrendered the city to Austrian control later that month, and the standard bearing Austria's double-headed eagle flew in the Piazza San Marco once again.[35]

The Americans maintained a presence in Venice throughout these difficulties. Philadelphian William Lewis reported that "the beautiful song of the Gondoliers has been hushed by the cruel oppression of their Austrian masters," but Consul Edmund Flagg described a city where "not less than two hundred American travelers, alone, passed through . . . in 1851." Flagg denied that Venice was but a wreck of its former self, calling that report "folly," the creation of "famous bards [whose] poetical idea was indulged."[36] His Venice, described in detail in two thick volumes published in New York in 1853, was a city visitors were loath to leave; it was inexpensive and well-supplied with food, hotels, and wonderful sights, if only tourists would stay long enough to enjoy them.[37] By the mid-1850s, the railroad was restored, and during the 1860s Venice resumed its position as a tourist attraction. The city's renewed appeal was enhanced by the essays of the influential critic John Ruskin.

Ruskin had first visited Venice in 1835, two years after Turner exhibited his earliest Venetian oil. Ruskin was familiar with Turner's work; he was first exposed to it as a boy of thirteen, when he was given a copy of poet Samuel Rogers's *Italy* with Turner's illustrations.[38] He would become an impassioned partisan of Turner's

Fig. 7. John Ruskin (British, 1819-1900), *Part of a Sketch of the Northwest Porch of St. Mark's*, 1879. Watercolor, graphite, and white gouache on cream paper. Courtesy of The Fogg Art Museum, Harvard University, Cambridge, Massachusetts. Gift of Samuel Sachs.

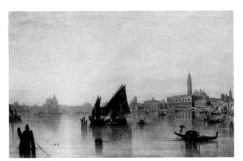

Fig. 8. John Rollin Tilton (American, 1828-1888), *Grand Canal, Venice*, about 1860-70. Oil on canvas. Yale University Art Gallery, Anonymous Gift.

paintings and shared the painter's relish for Venetian subjects, but Ruskin was so taken with Venice that he could not be content to appreciate it only through the eyes of another. The city became his life-long obsession, partly because it lacked the very elements of classicism that others so admired. Ruskin, diametrically opposed to Edward Gibbon's comments about the deficiency of Venetian architecture some seventy-five years earlier, wrote that "it is in Venice . . . and in Venice only, that effectual blows can be struck at this pestilent art of the Renaissance."[39]

Ruskin took it upon himself to save Venice, not from the Austrians, but from the modern world. He returned seven times, seeking to preserve his favorite city by immortalizing it in his own drawings and prose. Convinced that the city's monuments were steadily being destroyed by restoration efforts, he recorded them with daguerreotypes, plaster casts, and meticulous watercolors (fig. 7). The tangible result was his comprehensive three-volume *Stones of Venice*, published in 1851 and 1853, in which he not only described Venetian buildings, but also their social value as creations of an age of faith. The first volume of Ruskin's book was published simultaneously in England and America, while the second and third did not appear in the United States until 1860. His ideas were well known, however, through the reviews appearing in contemporary periodicals and the excerpts published in *The Crayon*, a journal committed to Ruskinian ideals founded in 1855. Through his own work and through that of his American followers, including critic James Jackson Jarves and Harvard professor Charles Eliot Norton, Ruskin influenced a generation to turn away from the classicism of Rome and to look toward Venice for more relevant moral and aesthetic lessons.[40] As Jarves wrote, "Venice and Ruskin are almost synonymous words. . . . Venice now belongs more to mankind than to its own impoverished citizens."[41]

Ruskin's message fell on receptive ears. His closest American followers, including painters Henry Roderick Newman and Charles Herbert Moore (see cats. 72, 85-87, 106), would inevitably find Venice appealing, but they were far from the only painters attracted to the city. Many Americans began to paint Venice in the 1860s, inspired equally by Ruskin's praise and by the end of overt political hostilities.[42] The earliest images, by such artists as John Rollin Tilton (1828-1888) and Christopher Pearse Cranch (1813-1892), were panoramic visions of the Bacino San Marco (fig. 8). These painters chose the traditional vantage point of Canaletto and Turner and sought to emulate the rich color effects of the English master. Critic Henry Tuckerman wrote that Tilton's Venetian scenes displayed "a remarkable feeling for color [and] a rare ability to represent the effects of sunshine and vapor."[43] Cranch popularized Venice not only in his own work, but also in his essays for *The Crayon* in 1860. While he commented as most Americans did on the persistent tension between the Italians and their Austrian overlords, he also created a poetic vision of the city that would encourage visitors, reinforcing the spell Ruskin had cast.[44] Cranch noted that he saw the city through the eyes of the European artists who had preceded him —

Titian, Veronese, Turner, Canaletto, and a contemporary painter, Felix Ziem, whose Venetian scenes grew steadily more popular in Europe and America (fig. 9). Cranch wrote:

> I see Ziem everywhere. I understand things in his pictures I did not before. I saw one of his twilights the other evening, from the public garden, the only place, by the way, where there are trees, which it is refreshing to see, after so much water.[45]

Thus Cranch presented the city as a suitable subject for modern art, one appropriate both for painters who shared Ruskin's philosophy and for those who did not.

While Cranch and Tilton spent large parts of their careers as expatriates in Italy, their interest in Venetian subject matter was not an anomaly born of their European isolation, for many other American artists, ones less associated with Europe, began to depict Venice as well. William Stanley Haseltine was among the first; he had been in Italy in 1857. Two years later it was reported in *The Crayon* that Haseltine's studio was "filled with souvenirs of European scenery" including sketches of Venice.[46] Jervis McEntee traveled to Venice in 1869, calling it "the soul of poetry"; he exhibited a Venetian subject at the National Academy of Design in 1870.[47] Sanford Gifford, who visited in 1857 and 1869 and who made several paintings of Venetian scenery (fig. 10), described a city that "even in her rags and tatters and old age . . . is the loveliest, the most glorious and the most superb of cities."[48] Samuel Colman (1832-1920), who was in Venice in the early 1870s, would continue to paint Venetian subjects throughout his career.[49]

Gifford and Colman were both adventurous travelers, the former painting in Egypt and Palestine, the latter in Spain and Morocco. Gifford was captivated by the exotic, and he found it in Venice as well as in the Near East. He wrote of St. Mark's that "it was as if the Arabian Nights had come true, and I saw before me the gorgeous creations of Eastern fancy."[50] Gifford enjoyed Venice as the most eastern of European cities, and by far the most exotic. Politically affiliated with the Byzantine Empire at its foundation, Venice had always maintained close mercantile and aesthetic links to the Islamic world. Her eastern aspects had been noted consistently by American writers, perhaps predisposed by their familiarity with Byron, who had written of Venice in those terms. Longfellow called the Doge's Palace "completely Arabic," Cooper (probably providing inspiration for Gifford) compared St. Mark's to a palace from the Arabian Nights, and Hillard, who disliked the basilica, described it as "a strange jumble of architectural styles, partly Christian and partly Saracenic."[51] James Jackson Jarves wrote that Venice was "half Western and half Oriental," and that commerce had suffused the city with "the brilliant tints of the Orient," while Melville noted in his journal that it looked as though "the Grand Turk had pitched his pavilion here for a summer's day."[52]

Gifford's interest in exotic subject matter was matched by many of the American painters who depicted Venice in the last third of the nineteenth century, including

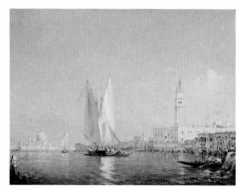

Fig. 9. Felix Ziem (French, 1821-1911), *Bacino di San Marco, Venice,* about 1900. Oil on canvas. Museum of Fine Arts, Boston, Bequest of Ernest Wadsworth Longfellow.

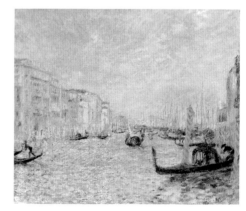

Fig. 10. Sanford Gifford (American, 1823-1880), *Venetian Sails: A Study,* 1873. Oil on canvas. Collection of Washington University, St. Louis.

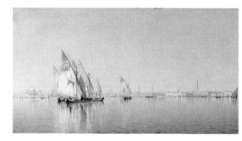

Fig. 11. Pierre Auguste Renoir (French, 1841-1919), *Grand Canal, Venice,* 1881. Oil on canvas. Museum of Fine Arts, Boston, Bequest of Alexander Cochrane.

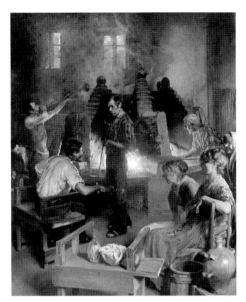

Fig. 12. Charles Frederick Ulrich (American, 1858-1908), *Glass-blowers of Murano*, 1886. Oil on panel. The Metropolitan Museum of Art, Gift of Several Gentlemen, 1886.

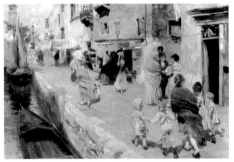

Fig. 13. Ettore Tito (Italian, 1859-1941), *Breezy Day in Venice*, 1895. Oil on canvas. Museum of Fine Arts, Boston, Bequest of Ernest Wadsworth Longfellow.

Robert Blum, Frederick Bridgman, Henry Roderick Newman, John Singer Sargent, Joseph Lindon Smith, and George Yewell. American artists were developing the taste for unusual, foreign motifs that had been fashionable in France since the beginning of the nineteenth century. Studying in Paris in great numbers after the Civil War, they frequently worked in the ateliers of the painters known for their orientalist themes, particularly Jean-Léon Gérôme, Léon Bonnat, and Charles Gleyre.[53] The Americans now deliberately sought competition with the international art world, and spurred perhaps by their pivotal experience at the Exposition Universelle in Paris in 1867, American artists were encouraged to go abroad, to leave their native scenery for the sophistication of Europe.[54]

If early nineteenth-century painterly ambitions did not harmonize with the visual appearance of Venice, the artistic aspirations of this later generation suited the Venetian landscape perfectly. The great moral themes and classical references so important to earlier painters no longer seemed relevant; instead artists sought to explore the natural world of light and color, characteristics that had always been associated with Venice. As critic Bernard Berenson wrote in 1888, "one soon forgets to think of form here, going almost mad on color, thinking in color, talking color, almost living on color. And for one that enjoys color this certainly is paradise."[55] It is not coincidental that the incredible multiplication of images of Venice in the 1880s and 1890s occurred at the same time as a new artistic philosophy began to dominate western art, a technique concerned with color, light, and images of everyday life — that is, Impressionism. Several of the French innovators of the Impressionist style painted in Venice — Manet came in 1875, Renoir in 1881 (fig. 11), and Monet in 1908.

Venice became a magnet for painters, writers, poets, and photographers, all of whom paid homage to its peculiar beauty. A multitude of books and articles describing the city appeared, each one making it sound more interesting than the last. As early as 1871 the painter Charles Caryl Coleman remarked to his friend Elihu Vedder that "Venice swarms with artists"; while twenty-three years later F. Hopkinson Smith, describing the equipment for painting out-of-doors, noted that "every morning, all over the canals and quays, you find a new growth of white umbrellas, like mushrooms, sprung up in the night."[56] Three of America's most influential painters, Frank Duveneck, James Abbott McNeill Whistler, and John Singer Sargent, inspired their younger colleagues to attempt Venetian subjects. Nor were the Americans alone, for once they came to Venice, they joined an international circle of artists, whose "names are legion," as Smith declared, stating "they have all had a corner at Florian's. No matter what their nationality or speciality, they speak the common language of the brush."[57] American painters, who earlier had traveled to Italy hoping to catch up with the accomplishments of their European colleagues, now took an equivalent position on Venice's watery stage, creating works that closely match those of European artists in style and subject (figs. 12-15).

With ever-increasing numbers of Americans traveling to Venice, with the popularity of Ruskin's work in the United States, and with the enhanced eclecticism of the second half of the nineteenth century, it was unavoidable that Americans would find a way to bring Venice home. They had been trying to define Venice in distinctively American terms since they first saw it. Some equated their first glimpse of the city with something more familiar; both Matthias Bruen and James Fenimore Cooper likened their first sight of Venice to a view of New York City from Long Island.[58] Herman Melville wrote in 1857 that "approaching Venice [was] like approaching Boston from the West," and he compared the serpentine curve of the Grand Canal to the Susquehanna, the great winding river of Pennsylvania. Mark Twain called Venice "an overflowed Arkansas town . . . there was nothing the matter here but a spring freshet."[59] Even Henry James, on his first visit, said Venice resembled Newport.[60] Everyone described gondolas as resembling Native American bark canoes. And as inevitably as America came to Venice, Venice came to America.

Many travelers had returned with souvenirs, particularly Murano beads and glass. By the 1880s, American companies were attempting to replicate its deep colors and distinctive designs. While some restricted themselves to these easily portable objects, other tourists returned with larger mementos. Thomas Moran brought home a gondola (see cat. 123), which he installed in a pond near his home in East Hampton, Long Island. There, poled by George Fowler, a Mohawk employed by the family, the gondola became a pleasure craft for the family and guests. Moran was not the only extravagant consumer, others bought gondolas as well. Hollis Hunnewell of Wellesley, Massachusetts, had one, providing a charming if inaccurate counterpoint to the Italianate garden, with its topiary and classical balustrade, that he constructed on the shores of Lake Waban (fig. 16).[61] And gondolas earned a place at the World's Columbian Exposition in Chicago in 1893. While the United States heralded itself at the fair as the New Rome, Venetian gondolas serenely glided their way through the pomp and circumstance of the Court of Honor, captured in a monochromatic oil sketch by Winslow Homer that is his only attempt at an Italianate subject (fig. 17). Americans sought to borrow the trappings of an ancient culture not only with souvenirs, but also by recreating it with newly designed buildings, clearly expressive of their new fascination with Venice.

Among the earliest of these aesthetic transfers was the first permanent home of the National Academy of Design, at the corner of Twenty-Third Street and Fourth Avenue in New York (fig. 18). Peter B. Wight, the architect, was a devotee of Ruskin; in 1863, the year construction on his academy building began, he became a founding member of the American Pre-Raphaelite group, the Association for the Advancement of Truth in Art, whose number included the painters Henry Roderick Newman and Charles Herbert Moore. Wight's National Academy of Design was modeled after the Doge's Palace, Ruskin's favorite building, although Wight took great care to distinguish his work from its Venetian prototype.[62] Yet the idea that

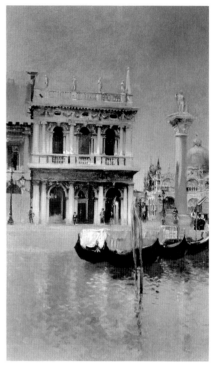

Fig. 14. Robert Blum (American, 1857-1903), *The Libreria, Venice*, 1886-89. Oil on canvas. Private collection. Photo courtesy of Hirschl and Adler Galleries, New York.

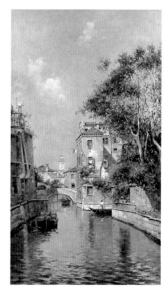

Fig. 15. Antonio Reyna (Spanish, active late 19th, early 20th century), *Canal in Venice*, about 1900. Oil on canvas. Museum of Fine Arts, Boston, Bequest of Maurice Longstreth.

Fig. 16. Hollis Hunnewell's gondola on Lake Waban, Wellesley, Massachusetts. Photo by Seaver courtesy of Wellesley College Archives.

Fig. 17. Winslow Homer (American, 1836-1910), *The Fountains at Night, Chicago*, 1893. Oil on canvas. Bowdoin College Museum of Art, Brunswick, Maine, Bequest of Mrs. Charles S. Homer, Jr.

Fig. 18. Peter B. Wight (American, 1838-1925), National Academy Building, New York, 1863-65 (demolished). Photo courtesy of the National Academy of Design, New York City.

Fig. 19. Windward Avenue, Venice, California, 1906. Photo courtesy of the Seaver Center for Western History Research, Natural History Museum of Los Angeles County.

the home of the country's preeminent art institution would be a Venetian rather than a classical design demonstrates a remarkable shift in the aesthetic attitudes of America.

For most Americans, however, the fairy-tale appearance and perception of Venice precluded its use as a model for many serious civic buildings. Cummings and Sears's New Old South Church in Boston (1874) is a stylistic successor to the National Academy, although it is not a direct copy of an Italian building. Its picturesque details include a campanile and trefoil arches embellished with decorative foliage; it is best described as Ruskinian Gothic, or Veneto-Byzantine. Francis Kimball's Montauk Club in Brooklyn (1891), home of a private society, was designed after the Ca d'Oro, the best-known Venetian palazzo. Inspired perhaps by the synergy of gondolas and canoes, it is decorated with a frieze portraying the history of the Montauk Indians. York Hall, the headquarters of the Sheffield fraternity in New Haven, Connecticut (1897, Grosvenor Atterbury, now Stoeckel Hall, Yale's music department), was also designed after a Venetian palace, in this case, the Palazzo Contarini Fasan, a decorated thirteenth-century Gothic building on the Grand Canal that was the legendary home of Desdemona, the ill-fated heroine of Shakespeare's *Othello*.

It is somehow appropriate that the ultimate American version of Venice was an amusement park in southern California. There, in a sea-side swamp just south of fashionable Ocean Park, Abbot Kinney planned a fifteen-acre resort, modeled on the city born of the salt marshes of the Venetian lagoon. Dredging for the Grand Canal began on August 15, 1904, and within months two linear miles of interconnecting canals, curbed with concrete, took form next to the Pacific Ocean. Hotels, pavilions, and a large auditorium were built, boasting such names as the St. Mark's, the Venice, and the Gondolier, and featuring elegant arched colonnades at street level and diaper-patterned brick and Gothic arches above (fig. 19). Forty thousand people visited "Kinney's Folly" on opening day, July 4, 1905. They were greeted by a forty-piece Italian band and 17,000 electric lights lining the streets and canals. While the city enjoyed great success as an amusement park, it soon lost its Venetian flavor. The canals, first plied by twenty-four imported Italian gondoliers, soon became the province of canoes, rowboats, and motorcraft; they would be filled in 1929. The illusion of Venice disappeared into a west coast Coney Island.[63]

More long-lasting was Isabella Stewart Gardner's palace in Boston. She did not copy a Venetian palazzo, nor did she, as the local newspapers speculated, bring to America an Italian building and reconstruct it stone by stone. Nevertheless, Fenway Court echoes the city she adopted as her own (fig. 20). Situated on a curve along the Fens, Frederick Law Olmsted's reconstruction of the Muddy River and a tidal swamp, Mrs. Gardner's museum was described as "strongly akin to that of a similar edifice standing upon a Venetian waterway." The writer continued:

Yes, we are in Italy! Or, at least, Italy has come to us, just as the Romans carried Rome with them throughout their empire . . . there are Venetian colonnades about the cloisters, Venetian windows looking upon the court, Venetian balconies, Venetian loggias, Venetian carvings embedded in the walls, Venetian stairs – all genuine, all ancient, all Stones of Venice . . . reverently placed to endure for a new lifetime in a new Renaissance for the New World.[64]

Mrs. Gardner's stones of Venice were not just fond recollections, but genuine fragments, as the critic noted. Purchased in Venice in the summer of 1897, they were "grotesquely cheap from the American point of view," according to Mrs. Gardner.[65] Among the most significant are the balconies from the Ca d'Oro, that most admired palace. As early as 1845, Ruskin had remarked that "workmen were hammering it down before my face";[66] the Gardners took advantage of the restoration, bought the pieces considered superfluous, and later installed the balconies on the east and west walls of Fenway Court. Venetian dealers provided other fragments: columns and capitals, Gothic windows, balustrades, and a marble pride of Venetian lions that were placed throughout the building. If an item could not be purchased, it was reproduced, in the manner of the elaborate courtyard parapet, first modeled after the Ca d'Oro, but finally designed to mimic the ornate spikes of the Doge's Palace.

Mrs. Gardner's dream of Venice manifested itself not only in stone, but also in the objects she housed in her palazzo. Her passion was shared especially by three friends and advisors: Bernard Berenson, who frequently acted as her agent and who helped her to acquire several of the Venetian masters in her collection; Henry James, who stayed with the Gardners during their residence at the Palazzo Barbaro, later using it as the setting for his novel *The Wings of the Dove* (1902, see cat. 116); and John Singer Sargent, whose cousins owned the Barbaro and whose Venetian watercolors, difficult to acquire, would tantalize her for years. Mrs. Gardner bought modern images of Venice, but she also admired earlier paintings associated with the city. Berenson remarked in 1888 that Venetian art was "the freest from all affectation, the most sensuous, [and] the most beautiful";[67] his gift to Mrs. Gardner in 1894 of his newly published *Venetian Painters of the Renaissance* (cat. 168) revitalized their relationship and marked the beginning of the period in which the bulk of the Gardner collection was purchased. Among her treasures, Mrs. Gardner brought to America the very objects that had first enticed Americans to Venice – paintings by Titian, Veronese, and Tintoretto. The paintings Benjamin West had advised John Singleton Copley to travel to Italy to see, for only by so doing would he complete his artistic education, were now available in America.[68]

Venice did not lose its appeal for Americans after the turn of the twentieth century. The influential critic Royal Cortissoz called it "the most paintable city on earth" in 1925, and Robert Henri, William Glackens, John Marin, Alfred Stieglitz, Edward Steichen, Karl Struss, and Alvin Langdon Coburn, all artists associated with a modern aesthetic, worked there (figs. 21, 22). The establishment in 1895 of

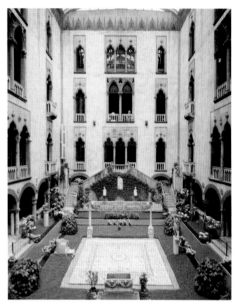

Fig. 20. Courtyard of the Isabella Stewart Gardner Museum, Boston, Massachusetts, Photo courtesy of the Isabella Stewart Gardner Museum.

Fig. 21. Edward Steichen (American, 1879-1973), *Late Afternoon, Venice*, 1907. Gelatine-carbon print selectively applied with yellow tone. The Metropolitan Museum of Art, The Alfred Stieglitz Collection, 1933.

Fig. 22. Karl Struss (American, 1886-1980), *Reflections, Venice*, 1909. Platinum print. Collection of The J. Paul Getty Museum, Malibu, California.

Venice's important international art exhibition, the Biennale, enhanced its reputation as an artistic center, while the proliferation of books and articles describing the city kept it in the public eye. Yet the very qualities that had attracted great numbers of American painters in the late nineteenth century — picturesque, exotic architecture; evanescent light; and a timeless sense of freedom from the reality of contemporary life — would be of little interest to a later generation captivated once again by its native landscape and the innovations of the modern world. Few artists could reconcile Venice with modernity, as George Hillard had done when he described the new railroad in 1853, calling it the connection between the past and the future, the "artery by which the living blood of to-day is poured into the exhausted frame of Venice."[69] But for a time, Venice had been an artist's paradise.

NOTES

1. This essay owes a scholarly debt to Margaretta Lovell, who first studied the role of Venice for American artists in her catalogue *Venice: The American View, 1860-1920* (San Francisco: The Fine Arts Museums of San Francisco, 1984), and her subsequent book *A Visitable Past* (Chicago: University of Chicago Press, 1989).

2. John Chetwode Eustace, *A Classical Tour Through Italy* (London: J. Mawman, 1817), vol. 1, pp. 179-180; Anton Chekov to his sister-in-law, 1891, *Letters of Anton Chekov*, selected and edited by Avrahm Yarmolinsky, excerpted in Michael Marqusee, *Venice: An Illustrated Anthology* (Topsfield, Mass.: Salem House Publishers, 1989), pp. 182-183.

3. Maxine Feifer, *Tourism in History: From Imperial Rome to the Present* (New York: Stein and Day, 1985), pp. 31-50.

4. *The Journal of Dr. John Morgan* (Philadelphia: J. B. Lippincott Company, 1907), p. 125.

5. Ibid., pp. 130-131.

6. See Helmut von Erffa and Allen Staley, *The Paintings of Benjamin West* (New Haven: Yale University Press, 1986), pp. 538, 541. West completed another picture in Venice, a portrait of John Murray, who was the British Resident in Venice from 1754 to 1766 (current location unknown).

7. Copley discussed at length his conception of Titian's technique, based on the works he saw in Rome, in a letter of March 14, 1775, to Henry Pelham, concluding "Titiano . . . sacrifices all the small parts to the General effect," (quoted in Harold Spencer, editor, *American Art: Readings from the Colonial Era to the Present* [New York: Charles Scribner's Sons, 1980], pp. 35-36).

8. Quoted in Nathalia Wright, *American Novelists in Italy* (Philadelphia: University of Pennsylvania Press, 1965), p. 38.

9. *The Journal of Dr. John Morgan*, pp. 130, 113.

10. Henry Wadsworth Longfellow to George Washington Greene, December 17-18, 1828, and to Zilpah Longfellow, December 20, 1828, in *The Letters of Henry Wadsworth Longfellow*, edited by Andrew Hilen (Cambridge, Mass.: The Belknap Press of Harvard University Press, 1966), vol. 1, pp. 285, 288.

11. Rembrandt Peale, *Notes on Italy* (Philadelphia: Carey and Lea, 1831), p. 279.

12. James Fenimore Cooper, *The Letters and Journals*, quoted in Wright, *American Novelists in Italy*, p. 117.

13. Amasa Hewins, *A Boston Portrait-Painter Visits Italy*, edited by Francis H. Allen (Boston: The Boston Atheneum, 1931), p. 66.

14. Ralph Waldo Emerson, *The Journals and Miscellaneous Notebooks*, edited by Alfred R. Ferguson (Cambridge, Mass.: The Belknap Press of Harvard University Press, 1960), vol. 4, p. 186.

15. Thomas B. Brumbaugh, "A Venice Letter from Thomas P. Rossiter to John F. Kensett — 1843," *The American Art Journal* 5, no. 1 (May 1973), p. 76.

16. George Stillman Hillard, *Six Months in Italy* (Boston: Ticknor, Reed, and Fields, 1853), vol. 1, p. 39. Hillard was in Italy in 1847.

17. *The Letters of Edward Gibbon*, edited by J. E. Norton (London: Cassell Publishers, Ltd., 1956), vol. 1, p. 193.

18. Jean-Jacques Rousseau, *Confessions*, excerpted in Marqusee, *Venice: An Illustrated Anthology*, p. 103. *Confessions* was first published in 1781. For the Grand Tour and Venice, see Feifer, *Tourism in History*; and Christopher Hibbert, *Venice: The Biography of a City* (New York: W. W. Norton and Company, 1989).

19. [Matthias Bruen], *Essays, Descriptive and Moral; on Scenes in Italy, Switzerland, and France, by an American* (Edinburgh: Archibald Constable and Co., 1823), p. 158.

20. Samuel Rogers, "Italy, a poem," and George Gordon, Lord Byron to James Wedderburn Webster, May 31, 1818, excerpted in Marqusee, *Venice: An Illustrated Anthology*, pp. 22, 85.

21. Quoted in Julian Halsby, *Venice: The Artist's Vision* (London: B. T. Batsford, Ltd., 1990), p. 31.

22. Lindsay Stainton, *Turner's Venice* (New York: George Braziller, Inc., 1985), pp. 30-32. For more information on Turner in Venice, see H. George, "Turner in Venice," *Art Quarterly* 53 (1971), pp. 81-87 and Max F. Schulz, "Turner's Fabled Atlantis: London, Venice, and Carthage as Paradisal Cityscape," in the same author's *Paradise Preserved* (Cambridge: Cambridge University Press, 1985), pp. 195-215.

23. Hibbert, *Venice: The Biography of a City*, pp. 215-220.

24. Francis Alexander to Thomas Cole, August 12, 1832, Thomas Cole Papers, New York State Library, Albany.

25. Ibid.

26. Francis Alexander to Thomas Cole, December 18, 1833. I am grateful to William H. Gerdts for providing me with a transcription of this letter; an unidentified photocopy of the original is in his possession.

27. Brumbaugh, "A Venice Letter from Thomas P. Rossiter to John F. Kensett – 1843," p. 75-76.

28. James de Veaux, *Memoir* (Columbia, South Carolina: J.C. Morgan's Letter Press Print, 1846), p. 167.

29. Salmon's other Italian view is of Palermo. Salmon is known to have produced theatrical backdrops, but there is no proof that his Venetian scene was used for this purpose, although the composition, with its foreground balustrade, is reminiscent of a panorama. J.R. Smith's moving panorama was shown with piano accompaniment in the "Chinese Rooms" on Broadway in New York in 1855. A descriptive pamphlet was available (Collection of the New York Public Library, Astor, Lenox, and Tilden Foundations). That Venice had firmly entered the American imagination is indicated by the increasing number of college commencement addresses devoted to the subject, including speeches at the University of Pennsylvania in 1832, at Columbia in 1835, and Wesleyan University in 1837. I am grateful to Annie Storr for sharing this information from her dissertation, "Ut Pictura Rhetorica: The Oratory of the Visual Arts in the Early Republic and the Formation of American Cultural Values, 1790-1840," Ph.D. diss., University of Delaware, 1991-92.

30. Sotheby's, New York, *19th Century European Paintings, Drawings, and Sculpture*, October 17, 1990, lot number 308, as "Mary Kellogg." I am grateful to Dodge Thompson for calling this picture to my attention.

31. *Executor's Sale: The Collection of Over 500 Paintings and Studies by the Late John F. Kensett*, March 24-29, 1873, Association Hall, New York (reprinted 1977). Kensett also owned four Venetian scenes by other artists, paintings that were exhibited at the estate sale. These included Amides Romen, *Venetian Twilight*; Samuel Coleman, *Venice*; Julius Ravel, *Venetian Girl*; and Felix Ziem, *Bay of Venice*.

32. Bryant is quoted in Thomas W. Leavitt, "The Life, Work, and Significance of George Loring Brown, American Landscape Painter," Ph.D. diss., Harvard University, 1957, p. 72.

33. Brown's account books are in the collection of the Museum of Fine Arts, Boston. See also Anne Rogers Haley, "George Loring Brown, 1814-1889: A Look at Patronage and the Italian Years," typescript, Paintings Department files, Museum of Fine Arts, Boston.

34. Hillard, *Six Months in Italy*, vol. I, p. 37.

35. See the detailed account of these events in Hibbert, *Venice*, pp. 215-254 and particularly in Edmund Flagg, *Venice: The City of the Sea* (New York: Charles Scribner, 1853).

36. "Journal of William D. Lewis, Jr.," 1853, manuscript, Historical Society of Pennsylvania, p. 25; and Flagg, *Venice: The City of the Sea*, pp. 52, 55.

37. Flagg wrote, "few tourists, especially Americans, remain long enough at Venice, or indeed at any other city, save, perhaps, Paris, to get more than one impression of it; and if that impression chance to be unfavorable, why, the case for them is hopeless" (ibid., p. 78).

38. See Dinah Birch, *Ruskin on Turner* (London: Cassell Publishers, Ltd., 1990), p. 11.

39. John Ruskin, *The Stones of Venice*, edited and introduced by Jan Morris (Mount Kisco, New York: Moyer Bell Ltd., 1989), p. 46.

40. For Ruskin's influence in the United States, see Roger B. Stein, *John Ruskin and Aesthetic Thought in America, 1840-1900* (Cambridge, Mass.: Harvard University Press, 1967); Susan Casteras, *English Pre-Raphaelitism and Its Reception in America in the Nineteenth Century* (Cranbury, N. J.: Associated University Presses, 1990); and Linda S. Ferber and William H. Gerdts, *The New Path: Ruskin and the American Pre-Raphaelites* (New York: The Brooklyn Museum, 1985).

41. James Jackson Jarves, *Italian Rambles: Studies of Life and Manners in New and Old Italy* (New York: G. P. Putnam's Sons, 1883), p. 190.

42. The Prussians, who were allied with Italy, defeated the Austrians at Königgrätz in July 1866, marking the end of the Austro-Prussian war. The Prussian victory liberated Venice, and later that year, by popular vote, Venice joined newly united Italy.

43. Henry T. Tuckerman, *American Artist Life* (New York: G. P. Putnam and Son, 1870), p. 559.

44. C.P.C., "Foreign Correspondence," *The Crayon* 7 (December 1860), pp. 351-352.

45. Christopher Pearce Cranch to his wife, September 13, 1860, *The Life and Letters of Christopher Pearce Cranch*, edited by Leonora Cranch Scott (Boston: Houghton Mifflin Company, 1917), pp. 245-247. Ziem, a French artist, had first visited Venice in 1842; he was so entranced with it that he returned every year, painting hundreds of color-filled images of the city that became immensely popular.

46. *The Crayon* 4 (December 1859), p. 379.

47. Jervis McEntee to Richard Henry Stoddard, April 11, 1869, A. W. Anthony Collection, Manuscript and Archives Division, The New York Public Library, New York, quoted in Jennifer Saville, "Jervis McEntee (1828-1891): Artist of Melancholy," M.A. thesis, University of Delaware, 1982.

48. Sanford Gifford to Elihu Gifford, July 17, 1869, "European Letters." Private Collection.

49. These artists are among the first of many American painters who began to portray Venice at this time. See Lovell, *Venice: The American View, 1860-1920*.

50. Gifford to Elihu Gifford, July 1857, "European Letters." Private Collection.

51. Henry Wadsworth Longfellow to his mother, December 20, 1828, in *The Letters of Henry Wadsworth Longfellow*, p. 289; James Fenimore Cooper, *Gleanings in Europe: Italy*, 1838 (Albany: State University of New York Press, 1981), p. 279; Hillard, *Six Months in Italy*, vol. I, p. 41.

52. James Jackson Jarves, *Italian Sights and Papal Principles Seen Through American Spectacles* (New York: Harper and Brothers, 1856), p. 378; Herman Melville, *Journals*, with historical notes and annotations by Howard C. Horsford and Lynn Horth (Evanston, Ill.: Northwestern University Press, 1989), p. 120.

53. See H. Barbara Weinberg, *The Lure of Paris: Nineteenth-Century American Painters and Their French Teachers* (New York:

Abbeville Press, 1991), as well as Donald A. Rosenthal, *Orientalism* (Rochester, New York: Memorial Art Gallery of the University of Rochester, 1982) and MaryAnne Stevens, *The Orientalists: Delacroix to Matisse* (Washington, D. C.: National Gallery of Art, 1984).

54. See Carol Troyen, "Innocents Abroad: American Painters at the 1867 Exposition Universelle, Paris," *The American Art Journal* 16 (autumn 1984), pp. 2-29.

55. Bernard Berenson to Isabella Stewart Gardner, October 11, 1888, *The Letters of Bernard Berenson and Isabella Stewart Gardner*, edited by Rollin van N. Hadley (Boston: Northeastern University Press, 1987), p. 27.

56. Charles Caryl Coleman to Elihu Vedder, quoted in Lovell, *Venice: The American View, 1860-1920*, p. 15; F. Hopkinson Smith, *Gondola Days* (Boston: Houghton Mifflin and Company, 1897), p. 56.

57. Smith, *Gondola Days*, p. 56.

58. [Bruen], *Essays, Descriptive and Moral*, p. 156 and Cooper, *Gleanings in Europe: Italy*, p. 276.

59. Melville, *Journals*, pp. 117, 119; Mark Twain, *Innocents Abroad*, 1869 (New York: Signet Books, 1966), p. 158.

60. Henry James to his brother, 1869, quoted in Marqusee, *Venice: An Illustrated Anthology*, p. 18.

61. Mabel Choate of Stockbridge, Massachusetts, had a small garden with a Venetian motif designed for part of her estate, Naumkeag, by Fletcher Steele in 1926. Old oak pilings from Boston harbor were carved to resemble Venetian gondola poles; they provided the structure for an outdoor garden "room." See Robin Karson, *Fletcher Steele: Landscape Architect* (New York: Harry N. Abrams, 1989), pp. 109-119.

62. For Wight, see Sarah Bradford Landau, *P. B. Wight: Architect, Contractor, and Critic, 1838-1925* (Chicago: The Art Institute of Chicago, 1981).

63. Most of the Venetian buildings were demolished by 1965, despite an effort to have them declared historical replicas. See Jeffrey Stanton, *Venice of America: 'Coney Island of the Pacific'* (Los Angeles: Donahue Publishing, 1988).

64. Sylvester Baxter, "An American Palace of Art," *Century Magazine* 67 (January 1904), pp. 363, 368.

65. Isabella Stewart Gardner to Henry Swift, July 2, 1903, Gardner Museum Archives, quoted in Karen Haas, "Isabella Stewart Gardner, Willard T. Sears, and the Building of Fenway Court," M. A. thesis, Boston University, 1989. I am indebted to the work of Ms. Haas for the details of Fenway Court's Venetian architecture.

66. John Ruskin to his father, September 23, 1845, quoted in Robert Hewison, *Ruskin and Venice* (Louisville, Kentucky: J. B. Speed Art Museum, 1978), p. 46.

67. Bernard Berenson to Isabella Stewart Gardner, April 19, 1888, quoted in Rollin van N. Hadley and Frances L. Preston, "Berenson and Mrs. Gardner: The Venetian Influence," *Fenway Court*, 1972, p. 11.

68. While other Americans, notably James Jackson Jarves and T.J. Bryan, had also collected Italian paintings, only Mrs. Gardner housed them in a Venetian setting.

69. Hillard, *Six Months in Italy*, vol. I, p. 87.

American Artists in Twentieth-Century Italy

FRED S. LICHT

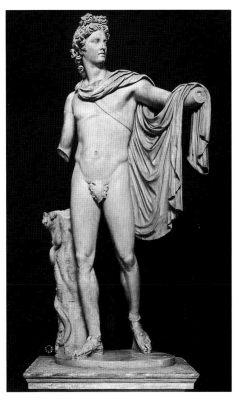

Fig. 1. *Apollo Belvedere*, Roman copy of Greek original of about 350 B.C. Marble. Vatican Museum, Rome. Photograph courtesy Alinari/Art Resource, New York.

When the venerable and seemingly vigorous tradition of young American artists turning to Italy for training and inspiration came to an abrupt end shortly before the beginning of the First World War, the causes lay primarily with a change of heart on the part of the Americans. For many young artists coming to maturity at the time, the heady prospect of America taking on a specific physiognomy was the only challenge worthy of their attention. Travel abroad consequently no longer held its former allure even for artists aspiring to cosmopolitan recognition. The spectacular rise of American museums contributed to this altered attitude. In seventeenth-century Holland, Rembrandt had claimed that there was no point in going to Italy because he could see all the Italian art he needed in the auction houses of Amsterdam. With Titians and Raphaels suddenly available on the walls of The Metropolitan Museum in New York or in the Museum of Fine Arts in Boston, American artists felt justified in a similar indifference to study abroad. Many others in the wake of Whistler and Sargent, for whom America was still too raw to engender art, were irresistibly caught up by the upward draft of Paris. After the clamorous triumph of Impressionism and the heated discussions surrounding a vast range of new movements, Paris was more than ever the uncontested capital of world art. Still, the most important reasons for Americans' changed attitude lay with the radical transformations undergone by Italian civilization.

When Benjamin West arrived in Rome in 1759 and was shown the *Apollo Belvedere* (fig. 1) and exclaimed, "How like a Mohawk Warrior," he did more than make a shrewd move in public relations that instantly made him the darling of the Roman intelligentsia. He also defined the particular character that bound the budding civilization of then still colonial America with the sophisticated views of Europe's most prestigious cultural modes. The classical tradition as embodied by Rome was enjoying a vigorous renaissance under the aegis of Johann Joachim Winckelmann (1717-1768), who by then had won over all the leading cosmopolitan minds and talents. The *Apollo Belvedere*, symbolizing the classical past, was no longer thought of as the ultimately solemn relic of past glory. Winckelmann's ecstatically erotic prose transformed earlier visions of Greco-Roman art from hoary dignity to sparkling new youth, to that stage of "primitive" fervor that both the outgoing Age of Reason and the beginning Age of Romanticism saw as representing the ideal form of all human existence. With a stroke, Benjamin West had proved that this ideal could be attained equally in the museums of the Vatican as in the mysteriously attractive forest of Pennsylvania. By title of their primordial innocence, Americans were the true heirs to all that made the classical tradition intoxicatingly contemporary. By the same token, the over-cultured arbiters of European civilization living in Rome could see the *Apollo Belvedere* not only through Winckelmann's visionary prose but much more concretely, guided by West, as their authentic contemporary. From that moment on, Italy for American artists became not only the goal of the Grand Tour as it had been for generations of Europeans, but also their natural habitat by right of

the primitive nature shared by nascent America and the high noon of classical civilization.

But what if – a contingency beyond Benjamin West's worst nightmares – what if the *Apollo Belvedere* and his alter ego, the Mohawk Warrior, were to be dethroned? What if the exhaust from a FIAT were to smell sweeter than the perfumes Winckelmann had sniffed in the locks of his marble idol? What if the entire cultural system based on a romantic view of both the classical age and of its concomitant, the savage nature of life as yet unspoiled by the strictures of modern civilization, were to break down, as it effectively did with the advent of Italian Futurism? It was a question that American artists based in London or Paris did not have to ask themselves. In the more advanced capitals of the western world a slow process of evolution had steadily transmuted society and the values by which that society lived. Italy, in spite of sporadic fits of political violence and attempts at modernization, had nevertheless remained sufficiently somnolent to be taken as an Arcadia under the spell of perpetual classical simplicity and dignity. It was inevitable therefore that in Italy the realization of what modernity was all about came as a shock that blasted the myths and dreams of a golden age. So sudden and so total was the revolution of Futurism that it went far beyond the most adventurous experiments made in the ateliers of Paris or Munich. You could, after all, convert to Cubism or to the dictates of the Blue Rider and continue to live a comfortable life. Italian Futurism, on the other hand, demanded infinitely greater sacrifices, infinitely more unconditional obedience. Filippo Tommaso Marinetti's (1876-1944) campaign to regenerate Italy, with its consequent shift from Rome-Naples to Milan-Turin as the pilgrimage centers of a new cult, spelled the end of America's dream of Italy. Henry James, so contentedly comfortable in the curtained atmosphere of great Roman *saloni* sufficiently tarnished to avoid the suspicion of modern elegance, could not possibly be happy among the grit and glitter of brawny Milan.

Futurism, like any decisive revolution, has a hundred roots and tributaries. Seized in its quintessence it was the cultural concomitant of the Risorgimento. Politically and economically, the unification of Italy, achieved during the 1860s after a series of costly wars and social upheavals, turned out to be a rather disappointing affair that smacked more of arrogant conquest on the part of the House of Savoy than of a popular urge toward building a modern nation. Illiteracy, government corruption, banditry, antiquated systems of agriculture, and malaria all persisted and made mock of the notion of Italy as a nation that could stand shoulder to shoulder with France, Germany, or Great Britain. Worst of all, an element that had been a constant in drawing Italy together throughout its history was noticeably missing in the formation of the new state: a highly characteristic cultural coherence. From the days of ancient Rome, throughout the period of the Barbaric invasions, the Middle Ages, the Renaissance and the Baroque, Italy, though politically fragmented into myriad splinter states, was a recognizable cultural unity. It was a poet, Dante, who had given

Italians from Palermo to Venice a proud common identity just as the work of Michelangelo, Titian, Bernini, Monteverdi, and Galileo had always been recognized as glorifying all the inhabitants of the peninsula that reached from the Alpine lakes to the ancient temples of Agrigento. Just as important, this unrivaled cultural tradition had served not only to bring together politically disparate and economically divergent areas of the country but it had cut across all social classes as well. The early nineteenth century saw the first collapse in Italy's longstanding, undisputed leadership in the arts, literature, science, and philosophy. Even the work of an Alessandro Volta (1745-1827), a Giacomo Leopardi (1798-1837) or a Gioacchino Rossini (1792-1868) could not hope to rise to the mark set by Italian civilization of earlier times. But the most appalling symptom of Italian bankruptcy in areas in which they had once held a virtual monopoly, was to come with unification under the crown of Savoy. Just as political independence was being achieved, Italy lost most of its cultural identity. Where once Italy had been a leader it was now being led. For all the qualities of Andrea Appiani (1754-1817), Italy's finest painter of the neoclassic period, he cannot seriously be compared to David. Throughout the nineteenth century foreign painters working in Italy were far ahead of local artists. One need only think of Jean-Auguste Dominique Ingres (1780-1867), Anselm Feuerbach (1829-1880), Edgar Degas (1834-1917), Jean-Baptiste Carpeaux (1827-1875) and Arnold Böcklin (1827-1901) to feel the full extent of Italy's backwardness — a backwardness made all the more dramatic by its former preeminence. Never had circumstances in Italy been so unfavorable for the native artist. No dynasty in Italian history had ever been so completely indifferent to the arts as were the Savoy once they became rulers of Italy. A bourgeoisie capable of intelligent patronage comparable to the middle classes of France, England, or Germany was barely beginning to develop in Italy's northern industrial centers. Traditional support from the Church was practically non-existent and when an elected government was finally convened after 1861, it too was remarkably shy of cultural patronage. A people that had been strongly united by poetry, architecture, music, sculpture, painting, and the sciences paradoxically found itself bereft of all cultural cohesion at the very moment it became a politically united nation.

It has recently become fashionable to glorify Italian civilization of the nineteenth century. One suspects that, at least where painting is concerned, this trend is the work of art dealers anxious to present novel merchandise in a market depleted of authentically important paintings. Certainly all of the exhibitions mounted recently in the vain hope of elevating the Macchiaioli to the rank of French Impressionists have had a distinctly commercial flavor. The nineteenth century did produce some respectable works of art initially. Certainly Leopardi, Alessandro Manzoni (1785-1873), and Giovanni Verga (1840-1922) deserve to be read by a wider international audience than is presently the case just as Appiani, Francesco Hayez (1791-1882), Giovanni Fattori (1825-1908), and Giovanni Segantini (1858-1899) created pictures

that must be taken into consideration by anyone who wants to understand nineteenth-century painting. The point is that all of the viable works of art produced in Italy (with the remarkable exception of opera) have to be seen against the foil of what was going on in France, England, and Germany, whereas in previous centuries, French, German, English or Flemish art were all measured against Italian standards.

It is in this context that the ferocity of Italian Futurism becomes understandable. Not content with reviving literature and the visual arts, Marinetti wanted to accomplish the miracle of a new Florentine quattrocento, taking the arts out of the studios in order to make of them a force that would galvanize every aspect of Italian life. It is Marinetti's acute sense of the abject humiliation of Italian culture in the decade preceding the First World War (a humiliation he had lived with as a child when he was the butt of anti-Italian jokes on the part of the other pupils at the French Jesuit school he attended in Egypt) that also led to the grotesque exaggerations, the violent impatience and the appalling brutality of the Futurist program. Later, at the end of the First World War when Italy had to deal with yet another national adventure as disastrous and as disenchanting as the Risorgimento had been, the resentments that had motivated Futurism spilled over into the post-war years. The irreconcilable discrepancy between Italian hopes and Italian realities created, *mutatis mutandis*, a very similar launching pad first for Futurism and then for Fascism.

Futurism as such was enthusiastically welcomed all over the western world. Especially in culturally lagging areas such as Russia, Spain, and America it had an immensely tonic effect. At the same time, however, it completely shattered the old enchantment Italy had cast over susceptible young American artists. What was the point of going to Italy when Italy was desperately trying to adopt all the crassest aspects of American life? Perhaps the artists around John Sloan may be perceived as constituting a kind of American Futurism in terms of intention if not style. Though technically the Ashcan School was unsophisticated compared to Umberto Boccioni, Giacomo Balla or Gino Severini, it too maintained as its goal the glorification of the contemporary urban, industrial scene in all its rawness. In fact, some of the early adherents to Futurism abandoned Marinetti precisely because they felt he was trying to Americanize Italy. Under such circumstances there was little to be gained by forsaking New York for Rome.[1]

Another aspect of Futurism that made Italy less and less interesting for foreign artists was its outspoken xenophobia. Marinetti's aggressive exaltation of Italian supremacy in all fields of human endeavor, one of the many elements of Futurism quickly absorbed by Fascism after 1922, made the atmosphere increasingly inhospitable. Hemingway's superb short story, "Che ti dice la Patria?" transmits this truculent mood to perfection. Starting with the first publication of the Futurist Manifesto in 1909, Italy swiftly rejected those aspects of its heritage that had meant so much to foreign artists. Paris, which once shared with Italy the glamour of being the destination of international cultural pilgrimages, now became the exclusive breeding

ground for all those young talents (including, ironically enough, Italians) anxious to look beyond the narrow horizons of their native land. Never were Italy and America spiritually further apart than in precisely those decades in which Italy tried to re-model itself on what it presumed to be an American model. Only after the Second World War did Italy once again begin to exercise some of its traditional fascination for the American imagination.

American artists by and large simply abandoned Italy during the first half of the twentieth century. This was particularly true of the painters.[2] If American painters could turn their backs on Italy with impunity, American sculptors found themselves in a very different position. True, the avant-garde worked almost exclusively in Paris where a large number of non-French sculptors such as Constantin Brancusi, Jacques Lipchitz, Alexander Archipenko, Ossip Zadkine had not only sounded the battlecry of a new kind of sculptural expression but had also proved that one need not come from a widely recognized national cultural tradition in order to rise to success in the world's artistic capital. However, the work of these pioneers and their intrepid disciples accounts for only a small fraction of the sculpture produced during the first half of our century. By far the major output, reckoning in terms of quantity and not quality or originality, was created by what is generally called conventional, Beaux-Arts, or academic sculptors.[3] The French bourgeoisie, subject to continuous revolutions and *coups d'état* from 1789 to 1870, had lost faith in the durability of monumental sculpture. The great wave of iconoclasm that had destroyed most of the French sculptural patrimony was bound to change attitudes regarding the uses of sculpture. The French bourgeoisie also regarded monumental sculpture as dangerously identifiable with the *ancien régime;* nor did a society intent on the principle of *enrichissez-vous* care to spend large amounts of government funds on sculpture. In Italy circumstances were immensely different, making Italy a continuing place of great importance in the development of any young sculptor.

Italy's authority in sculpture was supreme because sculpture is *par excellence* an art linked to classical antiquity and nowhere else could a similar density of ancient monuments be found. The genealogy that links the antiquities of Rome, Naples, and Florence to the early twentieth century is unbroken and includes all the greatest names of sculptural history from Bonanno to Antelami to Nicola and Giovanni Pisano, Ghiberti, Donatello, Verrocchio, Michelangelo, Giambologna, Cellini, Bernini, and Canova to name only the most important artists of this astonishing tradition. No sculptor anxious to create monuments can be considered sculpturally literate unless he has seen what can only been seen in Italy.

Only in Italy did the tradition of public sculpture admit of no interruptions, of no hostile reaction. France, though it certainly produced a vast number of superb sculptures throughout the nineteenth century, did not produce a climate in which sculpture was universally accepted and demanded. Baudelaire's famous essay "Why is Sculpture So Boring?" is an eminent symptom of the malaise that beset sculpture

in France even among the most advanced critics. The erection of important monuments was always harassed by violent debate, and the suspicion that sculpture was both futile and related to the *ancien régime* never quite died down. It was the art-bronze, the reduced sculptural reproduction, and the love of luxuriant architectural decoration, especially under the Second Empire, that kept sculpture alive in France. In Italy, the situation was very different.

Nobody would be foolish enough to claim that nineteenth-century Italian sculpture is a worthy successor to the glorious Italian tradition of medieval, Renaissance or baroque sculpture. Compared to its own glorious past, Italian nineteenth-century sculpture is indeed a disappointment. However, if we compare it to the best that was produced elsewhere during the century, it quickly becomes evident that the field, though led by France, is followed very closely indeed by Italy, with the other western nations running far behind. It is only after the sixties with the advent first of Carpeaux and subsequently of Rodin (both ardent admirers of the Italian tradition) that France surges ahead and leaves its close rival behind. Considered all in all, Italian nineteenth-century sculpture gives proof of an enormous vitality. Even discounting such great but eccentric artists as Giuseppe Grandi (1843-1894) and Medardo Rosso (1858-1928) who never received the fame due their great talents, artists like Lorenzo Bartolini (1777-1850), Vincenzo Vela (1820-1891), and Domenico Trentacoste (1859-1933), though known today primarily among specialists, were once internationally admired and dominated the market. It is indicative that the first sculpture to enter the collections of the Museum of Fine Arts, Boston, was *Young Christopher Columbus* by Giulio Monteverde (1837-1917) (fig. 2).

American museums by 1900 were able to offer young artists a respectable assemblage of first-rate paintings ranging from the Middle Ages to the end of the Baroque and well into modern times. The same could not be said for sculpture. For one thing, American tastes and sensibilities tended to be anti-sculptural for religious and for political reasons. The Puritan strain, ever-strong in America, regarded any graven image with suspicion but held sculpture to be the very essence of all that was suspect in art. Politically, it was difficult to reconcile monumental sculpture with the democratic ideal of equality. As if these reasons weren't a sufficient obstacle to the successful collecting of sculpture by American museums, sculpture produced in Europe from the Middle Ages onward was commissioned for a precise purpose and for a precise location. Such sculpture could be destroyed but it could not be moved. As for the terracotta *bozzetti* and small-scale bronzes so avidly collected by the Victoria and Albert Museum in England and by the Kaiser Friedrich Museum in Berlin, they could serve a thoroughly practical purpose for artists and art students who could at any moment and at little cost get on a train to compare the diminutive sculptures in museums with the full-scale monuments in Italy. For young American sculptors, things were not that easy. For a budding sculptor, forced to choose where to spend the little time he could afford in Europe, the choice was clear: one had to

Fig. 2. Giulio Monteverde (Italian, 1837-1917), *Young Christopher Columbus*, 1871. Marble. Museum of Fine Arts, Boston, Gift of Augustus Porter Chamberlain.

go where even the greatest and most dyed-in-the-wool French sculptor, Auguste Rodin (1840-1917), had gone. One had to go to Italy.

For painters, what was unavailable to them in American museums could, if necessary, be gleaned from photographs or gravure reproductions. For sculptors, observation of the original was a *sine qua non*. Changing lights, dimensions, relation of sculpture to surrounding space, and nuances of surface treatment, all absolutely central to sculpture, could only be studied by direct confrontation. Moreover, sculpture, unlike painting, is very expensive and cannot be produced on speculation. It needs a sponsor willing to underwrite large-scale expenses *before* the sculptor can begin his work. Such patrons quite naturally demanded credentials, and no credentials could match a successful apprenticeship in Italy. How great American trust in Italian sculpture was can easily be seen in the rotunda of the Capitol in Washington. Almost all commissions given out to non-Americans went to Italians, and of the Americans almost all could claim familiarity with the entire gamut of Italian sculpture as well as with the training and technical facility obtainable first and foremost in Italy.

More important for the young American sculptor hoping to fulfill the great dream of American sculpture on a grand scale was the Italian attitude toward sculpture in the nineteenth and early twentieth centuries. Here and only here, monumental sculpture was widely and unquestioningly accepted as one of the major attributes of civilized life. The middle class in England, France, Germany and America, if it considered sculpture at all, was satisfied with a knick-knack for the mantelpiece. In Italy the middle classes passionately aspired to monuments for themselves, for their achievements and for their family. Monumental sculpture, instead of representing a vexing problem, was a way of life — and of death. The great cemeteries of Italy, especially Staglieno in Genoa and the Campo Santo Monumentale in Milan, now ignored, were sites of prime importance on the itinerary of every tourist who came to Italy during the last half of the nineteenth and the first half of the twentieth centuries. This exuberance of private monuments spread from Italy to the rest of Europe and to both of the Americas. The marble ateliers of Pietrasanta and Carrara maintained warehouses of their most popular statues all the way from Brooklyn to Buenos Aires from where they carried on a frequently thriving catalogue-order business. No young sculptor who wanted to know more about the marketing of sculpture could fail to understand the importance of acquainting himself with the Italian centers that had turned sculpture into viable merchandise.

Last but certainly not least, there was the attraction exercised by Italy on young sculptors because of its infinite supply of the finest materials and the still finer craftsmen who had been trained from childhood to solve any and all technical problems. There were lessons to be learned in how to establish and how to maintain a sculptural enterprise, in how to judge the skill of workmen, in how to appraise blocks, that could be learned only in Italy. Less pragmatic but nevertheless powerful

indeed was the fascination of the marble quarries in Versilia. John Singer Sargent, better than anyone else, has rendered the powerful impression of this vast lunar landscape, which challenges even the most casual visitor to take up mallet and chisel. Nowhere is the material nobility of marble more impressive, nowhere is the universal human desire to give permanent form more powerfully stimulated.

Obviously, all of these considerations had little appeal to those modern American sculptors who have now become household names. Alexander Calder, Theodore Roszak, and Richard Stankiewicz had no business in Italy. Others, whose significance has been eclipsed but who are bound to be rediscovered in a not-too-distant future, maintained an American sculptural tradition that began with Horatio Greenough and Hiram Powers. From this great number of what have generally (but inaccurately) been called "academic" sculptors, it may be sufficient to choose two examples: one a virtual hermit who never sold a sculpture and who remained almost completely unknown in America, and one whose monumental creations have become such overwhelmingly self-evident presences that we notice them as little as Edgar Allen Poe's "Purloined Letter." One is Hendrik Christian Anderson (1872-1949), the other is Paul Manship (1885-1966). For both of them the experience of Italy was essential even though both were staunchly American in their aspirations and in their determination. Each in his way belongs to the category of what Baudelaire called "curiosités esthétiques."

Anderson and Manship

Anderson, born in 1872 of Scandinavian parentage, went to Rome in the early years of this century, and spent the rest of his life there. A man of more than comfortable means, he had no need to sell his sculptures and jealously kept his life's work with him in the splendid Villa Hélène, which he had built halfway between the Porta del Popolo and the Ministry of Marine. Though a few erudite architectural historians may be familiar with his publication of megalomaniac plans for ideal cities to be built all over the world, his sculptures remain hidden away in the vast rooms on the ground floor of his villa. There would be no need to recall him from oblivion if it weren't for the extraordinary insight his work allows into the taste, the ambitions, and the dreams of an American sculptor to whom the experience of living and working in Italy was essential. What influence he may have had on other American pilgrims will not be known until his sculptures and his archives at the Galleria Nazionale d'Arte Moderna in Rome have been ordered and studied. That he is a full-fledged exemplar of some of the most important tendencies of public sculpture of the first half of the twentieth century, however, is already perfectly clear.[4]

Basically, Anderson's sculpture is loyal to principles of late nineteenth-century

Fig. 3. Hendrik Christian Anderson (American, 1872-1949), *Allegory*, 1910-1920. Gesso. Villa Hélène, Rome. Photograph courtesy Galleria Nazionale d'Arte Moderna.

academic sculpture but without the tendency toward ornamental flourishes that marks similar sculpture elsewhere in Europe or in Beaux-Arts–influenced America (fig. 3). It is very possible that Anderson was familiar with the writings and perhaps even the sculptures of Adolf von Hildebrand (1847-1921). Certainly there is a starkness of composition and modeling in Anderson's work that is reminiscent of Hildebrand's demand for greater formal abstraction. Yet if one compares Anderson's major groups with Hildebrand's large-scale sculpture (e.g. the Wittelsbach Fountain in Munich), one finds Hildebrand's chastity supplanted by a curiously surreptitious sexuality. This element of intimate erotic confession expressed on a monumental scale is as fascinating as it is unsettling. It is also a prelude to an official governmental style in sculpture that first makes itself felt in the reliefs of the monument to Victor Emmanuele in Rome. The fullest flowering of Anderson's insidious blend of erotic impulses with utopian socio-political ideals occurs first in Italy and then rapidly spreads worldwide with what is often and probably erroneously called the Fascist style. For emotionally colored political reasons, this style, though it has become once more acceptable to architectural historians, is still largely unstudied. It, too, is essentially academic and it, too, has that aggressively erotic undertone that was part and parcel of Fascism's adulation of virility. The note of implied rather than candidly outspoken sexuality gave a powerful sensual impact to these propagandistic sculptures – an impact that was ably exploited by the reigning party in Italy throughout the twenties and thirties. In the mid-twenties it was exported throughout Europe and the Americas, achieving varied national inflections wherever it appeared. What makes Anderson's sculptures so fascinating is that he should have hit upon such expressive devices in the realm of studio art. For all their size and pretentious titles, his sculptures are not really meant for public spaces. They are private confessions that are shouted instead of whispered.

Paul Manship's sculptures (see cats. 103, 104), though not unrelated to Anderson's (whom he may very well have known) best represent the American translation of that international governmental style first broadcast by Italy in the twenties. Compared to Anderson, Manship is far more chaste and far more dedicated to decorative appeal. During his frequent stays in Italy (he was something of a tutelary deity at the American Academy in Rome from the 1920s to the forties), he not only studied governmental art of the time but must also have come in contact with such artist-designers as Giò Ponti (1891-1979). This training as well as his informed study of Renaissance and Baroque Roman sculpture gave Manship the means of adjusting monumental sculpture to the needs of large-scale mainstream American architecture. The buildings of Rockefeller Center, rather than the villas of Frank Lloyd Wright, best represent this pole of twentieth-century American architecture, and it is precisely in this context that Manship achieved his greatest triumph with his *Prometheus* and *Atlas*. In many ways, the strange amalgam of Manship's style was fruitful well beyond the bounds of his own studio. Isamu Noguchi's (1904-1988)

great bas relief on the communications building of Rockefeller Center shows more than one characteristic of Manship's ability to insert expressive sculptural accents within the context of an anonymous, anti-expressive, architectural framework. We may look with ambivalent feelings at the results obtained by American sculptors in Italy during the first half of the twentieth century but their importance cannot, or rather should not, be overlooked.[5]

Recent American Painters in Italy

While the creation of official American sculpture continued to draw on Italy's past and present, American painting in the decades between the two world wars renounced its former allegiance entirely. If any relations between the two national cultures persisted, it was entirely due to the great number of talented emigrés from Italy. Men such as Giorgio Cavallon (1906-1989), Atillio Salemme (1911-1955) and Costantino Nivola (b. 1911) did indeed make an enduring and precious contribution to the development of American painting, but they did so by joining in the increasingly powerful current of American art, bringing with them from their Italian backgrounds only very tenuous memories of Mediterranean sensibility.

No picture illustrates more strikingly the negative attitude of American painters of the twenties and thirties toward Italy than Peter Blume's remarkable *Eternal City* (fig. 4). For the past thirty years, this picture has been absent from the consciousness of our art-interested public but it is safe to say that from the late thirties to the mid-fifties, this painting was among that small handful of images that formed the visual education of Americans, and it was surely among the most admired possessions of The Museum of Modern Art. The picture, an orgy of emotion-ridden hatred of clerical obscurantism and of Fascism, satisfied the demand of the entire spectrum of the American art audience. Its surrealist atmosphere, its social message, and its invitation to "read" an infinity of telling and feverish details appealed equally to high-, low-, and middle-brow audiences, and any discussion of "taste" in America during the crucial period of America's awakening to its own artistic potential must take the painting into account at least as a foil against which the changes in art and art criticism were taking place. Certainly, it presented an indignantly hostile picture of contemporary Italy. At the same time, it kept alive the nearly extinct dream of an exotic, ancient Italy.[6]

Blume's *Eternal City* generated an ambitious offspring in the post – World War II era, Paul Cadmus's *Bar Italia* (1953-55). A similar heaping of hyper-real details, garish color and vitriolic social commentary, as well as a similar subject matter, links these two pictures. But whereas Blume's picture (quite aside from its superior quality and more seriously imaginative approach) was congruent with the sentiment of its generation, Paul Cadmus's adverse vision of modern Italy found no responsive chord at the time of its creation. Attitudes toward Italy, toward Italian art and toward Italian

Fig. 4. Peter Blume (American, b. 1906), *The Eternal City*, 1934-37. Oil on composition board. The Museum of Modern Art, New York, Mrs. Simon Guggenheim Fund.

civilization in general had by then undergone a drastic change. Though American artists no longer flocked as "passionate pilgrims" in large numbers and for long periods to work in Italy, the notion of Italy as a major fount of all western civilization was once more triumphant.

The historical influences that made this change possible are infinite and infinitely complex. Italo-Americans, who up to the Second World War had played a relatively small role in the development of contemporary American art, now represented a numerically large and qualitatively important contingent. Unlike their parents, artists such as Corrado Marca-Relli (b. 1913) no longer felt deep seated rancor toward Italy. The chronicle of Italian resistance during the war, so much more effective, unambiguous and energetic than the resistance to Nazism elsewhere in Europe, the brilliance of Italian modern literature hitherto almost unknown to American readers, and the Italian willingness to come to terms with the dark side of its twentieth-century history all combined to lend Italy a very special new appeal that stood in odd contrast to the sentiment directed at the other erstwhile European goal of American artists, France.

The dogged and earthy confidence in a better future that emanated from every aspect of Italian public and private life proved far more attractive than the dispiriting existentialist gloom that dominated post-war France. Also, the glamour that sur-

rounded both the reality and the myth of American artists in Paris during the period between wars had become highly suspect to the post-war generation. Though figures like F. Scott Fitzgerald (1896-1940) continued to be admired, post-war sentiment was unhesitating in its contempt for the waste, the selfishness and hedonism of the Jazz Age and of many Parisian expatriates associated with it. Picasso, Matisse, and many of the greatest Parisian pioneers already belonged to history and lacked the promise of future excitement. Other, subtler reasons for the vogue enjoyed by Italy still await proper study and interpretation. For instance, art history — after having taken root in America slowly and laboriously during the twenties and thirties as a career for a very small number of moneyed students studying at the Ivy League colleges — suddenly swept like wildfire through every provincial American college. With unparalleled enthusiasm and abetted by the volcanic energies of the art market, aided by art publications and by revolutionary changes in the management of art museums, America took art history to its heart until lack of knowledge in this field became tantamount to illiteracy. The American artist was far more intensely involved in this turn of events than has generally been supposed. Recent fashions of seeing post-World War II art as a "vernacular" manifestation as well as the perennial idea of the artist as the intuitive agent of forces beyond intellect have obscured certain essential features of American art from the triumph of Abstract Expressionism to our own day. Showing that men like Philip Guston (1913-1980) enjoyed the sophisticated cartoons (Krazy Kat) as well as the more pedestrian comics (Mutt and Jeff) may cast an amusing side-light on Guston's painting but also irresponsibly perverts Guston's real interests and the sources that constantly sustained and nourished his painting.

In the studio of every major New York artist, the images pinned to the walls or strewn about tables were not culled from the Sunday funnies but represented works by Paolo Uccello, Piero della Francesca, Titian or Tiepolo. Monumental vision; intense individualization of expression; and ambitious, public format were aspects of Italian art that were of particular importance to almost all the members of the New York School and kept the presence of Italian art and Italian sensibility very much alive in their ateliers. Yes, there was a great deal of emphasis on spontaneity of "gesture" but it was the spontaneity of artists steeped in admiring study of Renaissance masters. The importance of such standards becomes even more obvious in a second stage of most artists' activity, a point that is all too often forgotten. For every painting that Willem de Kooning (b. 1904) or Guston or Robert Motherwell (1915-1991) kept, sold or exhibited, four or five paintings were destroyed as inadmissible to his *oeuvre*. And it is in this act of judgment that the intellectual, not-so-spontaneous will of the artist exerts itself most clearly. Though we must be grateful to the artist for destroying everything he finds unworthy of his best abilities, it is a pity that we no longer have these paintings to compare to what was allowed to survive. If we had these rejected works, it would become obvious that these life-and-death standards

were not based on Mutt and Jeff or on the advertisements of Times Square but on the precedent of Masaccio or Uccello. The childhood and youth of these artists who came into their own during the forties and fifties had stood under the sign of French art from Impressionism to Matisse, but their maturity was stimulated and conditioned by their deepening knowledge of more remote epochs of European art, among which the Italian tradition once again claimed pride of place. The roster of American artists working in the second half of the century who were deeply and lastingly marked by their experience of Italy is long and distinguished. Philip Guston comes immediately to mind as does Saul Steinberg (b. 1914). Adja Yunkers' (1900-1983) "Ostia" woodcuts are among the great summits of post – World War II graphics in America and one could expand the list by simply culling the most illustrious names of artists who were guests of the American Academy in Rome or who were recipients of Fulbright Scholarships. A proper study of the significance of Italy past and Italy present in the work of just one major artist, Cy Twombly (b. 1929), would require a chapter much longer than this essay.

The year 1948 is the *anno mirabilis* for a deep and enduring change of attitude that altered the relationship between Italian and American art. At the Biennale of that year, the first since the beginning of the Second World War, Peggy Guggenheim exhibited her extraordinary collection in the Greek pavilion, and at a blow history reversed itself. Just as Benjamin West had recognized the paradoxical relationship between venerable tradition and contemporary reality when viewing the Apollo, so young Italian artists at the sight of Peggy Guggenheim's collection recognized the vital continuity of past and present in the arts. It was a recognition that was to bear rich harvests. The roles were exchanged, and while the Italians marveled at Jackson Pollock (1912-1956), whom they had heard of but never seen (just as West had heard of but never seen the *Apollo*), the Americans derived new confidence in their ideals by seeing that their work could be received with wonder by those who were just beginning to lay the foundations of a new tradition, and they drew courage from the admiration expressed by their European colleagues. The Italians, cut off first rather loosely by Fascism, then more drastically by the war from the mainstream of twentieth-century art, were indeed primitives confronted, as West had been, by the very symbol of a continuing tradition. The harmony of spiritual exchange between the Italian and the American arts was finally reestablished.

For the first few years of this renewed and very different encounter between American and Italian artists, it is probably correct to say that it was the American contingent that exercised the greater influence, and that for the first time in history, the course of Italian art was decisively altered by art from beyond the Atlantic.

The exuberance unleashed by the encounter with American art ushered in a season of creativity in Italy that lasted well into the sixties. If it is true that at first it was American art that influenced and benefited the rising tide of Italian painters and sculptors, the balance quickly redressed itself into an equilibrium of inter-

change between the Tiber and the Hudson. Rome as well as Milan became a field of galvanizing force. As always, frivolous over-enthusiasm as well as calculated hype played a part in all this hectic activity. If there was a lot of "*dolce vita*" nonsense going on, there also was Fellini's *Dolce Vita*, an intelligent attempt to understand and honestly portray the tenor of the period. For all the lunatic fringe that latched on to the momentum generated by the times, an astonishing body of work was created and has endured. A recent exhibition dealing with Roman art of the 1960s was dazzling in its wealth of paintings and sculptures that can no longer be excluded from the central repertory of late twentieth-century art.[7] Nowadays, of course, the impulse toward a thoroughly international tone in art, which started so happily in the fifties, has mooted the very idea of there being much difference between contemporary Italian and American art. It would be foolish, for instance, to think of the *Arte Povera* group as an Italian phenomenon. Its premises and stimuli are so intricately interwoven with earlier American and French achievements that its categorization as an Italian movement has very little meaning.

 Though the constant and fruitful interplay between artists based in America and the art and artists of Italy has lost much of its former importance, several other elements link the cultural destinies of America and Italy. The self-knowledge of nations is inevitably enriched by reflection in foreign mirrors. What would our knowledge of America be without de Tocqueville, whose definition of the character, weaknesses and potential of the United States has never been superseded by any American observer? American artists, both literary and visual, have furnished such a mirror to modern, that is, nineteenth and twentieth-century Italy. In many ways, all of us who were born into the post-revolutionary world no matter whether we were born in Scandinavia, France, America or Italy, are equidistant from the great traditions of western mankind, the classical, medieval, and Renaissance-Baroque past. Daily contact with the relics of this past undoubtedly gives greater familiarity and perhaps even greater knowledge of this past. But when it comes to interpreting in terms of our contemporary needs, it may very well be that the recently arrived artist or poet furnishes us with the best methods and strategies. The newcomer's approach is bound to be at once fresher, less charged with prejudices, less jaded with familiarity and also more urgent since he perforce feels immediately and profoundly challenged by the palpable traces and remnants left by Italian history. He must make his own way, unguided but also un-mis-guided by the kind of schooling, the kind of routine salon-cant to which every young Italian is exposed from the tenderest age. Thus, the ability of contemporary Italian artists to consult and use the lessons of the great Italian past may have in many devious and subterranean ways been helped by the struggles, the victories and the defeats of any number of American artists of the past and present who were impelled to undertake the pilgrimage to Italy.

Fig. 5. Dimitri Hadzi (American, b. 1921), *River Legend*, Federal Office Building, Portland, Oregon, 1976. Basalt. Photograph courtesy of the artist.

Fig. 6. Dimitri Hadzi (American, b. 1921), Fountain sculpture, Copley Place, Boston, 1984. Photograph courtesy of the artist.

By the same token, of course, the ineffable glamour (and I use the word in its Conradian sense) and thrill of things Italian continues to leaven the work of any number of young American artists. The list of contemporary artists who continue to draw strength from their contacts with all that complex of sensuous or impalpable experience of real and mythic Italy is long and distinguished. Painters as surprisingly diverse as Gregory Gillespie (b. 1936) and Philip Perlstein (b. 1924), artists devoted to assemblage such as Varujan Boghosian (b. 1926), and such sculptors as Beverly Pepper (b. 1924) and Richard Lippold (b. 1915), and artists one might classify as belonging to the "avant-garde establishment" such as Cy Twombly and Frank Stella (b. 1935).

Best known to New England audiences of these truly cosmopolitan artists is the highly inventive sculptor, Dimitri Hadzi, whose 1984 fountain sculpture is installed in Copley Place in Boston. There can be little doubt of the deep and lasting influence Italy has had on him (see figs. 5, 6). His remarkable ability to reconcile opposites — the austere with the seductive, an intensely intellectual discipline with sensuous exuberance — would probably never have come to such perfect harmony without his protracted and very personal contact with Italy. Certainly his sensitivity to materials, and his fine *sprezzatura* are all elements which were given their ultimate polish by a profound and seasoned knowledge of Italy. It is only fitting that it is Hadzi who should have the last word:

> It was by chance that I came to Rome on the G.I. Bill in 1951 immediately after an extraordinary, eye-opening year in Greece, as a Fulbright Fellow. The year in Greece turned out to be the proper introduction to Italy in so many ways. To be in Italy, actually to see the classical Greek forms work their their way through the Romanesque, the Renaissance, the Mannerist, and the Baroque, to the Modern, was a wonderful education. It didn't take long for it to become clear to me that I was in the land of miracles.
>
> Surrounded by the multi-level cultures of the past, I began to study directly with master artisans and professional artists at the Museo Artistico Industriale. There I was introduced to the techniques of mold making, casting, ceramic and jewelry making. It was there that I met some of the Italian artists who were later to become my friends, including Pericle Fazzini and Emilio Greco; I would often visit them in their studios, and would share the problems and the joys of our lives as artists. I got to know them even better in places like Caffè Rosati on Piazza del Popolo where the artists and literati met — and argued — through the night. We looked forward to the openings of artists' exhibitions, which were always lively. Here painters and sculptors old and young, famous and not so famous, would greet you warmly, showing interest and concern. I was always enormously impressed with the facility and crisp intelligence of the artists in Rome, with their powers of invention, and their generosity. I think it was then that I knew that the Italian artist is blessed.

There is nothing like making art in Italy. Stepping out of the studio, one becomes exposed immediately to the mind and the hand of the Italians, past and present. Everywhere one sees facades, cupolas, columns, pilasters, sculptures, paintings, fountains, stone and brick work, all endlessly repeating. The range of expression is limitless, from the severe Florentine Bramante, to the playful wit of Borromini. Simply living amongst, and being aware of, the scale and richness of the art and architecture in Italy had a powerful, irreplaceable influence on my own work. I think of the huge portone more visual than useful (with always a small entrance on the side for functional purposes), or the large bases which hold up columns, pilasters, and facades again, all more visual than functional. And what are the vast number of columns on Bernini's colonnade holding up? A few saints? What a visual concept, what drama! Sheer invention and colossal audacity![8]

I felt both great humility and great joy when I became one of the few foreign artists to be commissioned to make doors for a church in Rome. Little wonder that faced with this challenge, I took many years to complete the work! Although during these years I certainly knew that the so-called "action" was happening in New York, I felt that there was too much in Italy for me to leave; where else could I be with artists and artisans with such eyes, minds, hands, and hearts? And of course realizing that my own ecumenical doors at St. Paul's Within the Walls will be there breathing the same air as the work of all the earlier masters, continues to mean a great deal to me.

Always during these years I was fortunate to spend a great deal of time at the foundries, and later, in the stone yards of Tuscany, working closely with the masters on my own work. On some of the larger and more complicated pieces there was a very close collaboration with these artisans as we searched for solutions which would satisfy us all. Eventually, after a number of years, I was honored by being called "maestro" — then I knew I had finally arrived.

The American Academy in Rome played a great role in my Italy. Here I knew and heard sculptors, painters, poets, writers, composers, art historians, architects, archaeologists. At the Academy they were all intermingled, and the combinations were constantly varied. There I was exposed to some of the freshest, most inventive and encyclopedic of American minds. Some were already great and highly established in their fields, while others had their greatness awaiting them; it was heaven on the Janiculum!

I came to Italy with an open mind and left (though one never leaves completely) with an equally fresh and searching one. The layers and layers of art there are unchanging, but the artist in Rome changes and grows in the absorption of Italian culture. The *Pietà* of Michelangelo that I first saw in 1951 is not the same *Pietà* to me now, as I look at it forty years later. It, like Italy, is never-ending, and the discoveries continue.[8]

1. Yet the links between Italian Futurism and American art are of course far more complex. It may be more than just a coincidence that the only American artist who rises fully to the challenge of Futurism is a painter of Italian extraction, Joseph Stella.

2. Of course even here there are exceptions. Prendergast and Sargent continued to visit Italy well into the twenties. But these artists are really left-overs of a late-nineteenth-century tradition and have essentially little to do with the heroic phases of twentieth-century art.

3. This is not the place for a discussion of the infinitely complicated history of nineteenth-century sculpture. The simplistic schematization into "good guys" (innovators) and "bad guys" (conservatives) which once was current for painting and still persists in popular literature though it has been rejected by the higher echelons of art history, never applied to sculpture. The margin of diversity that marked painting simply never existed in the field of sculpture. For the most succinct information one is well advised to turn to H.W. Janson's *Nineteenth-Century Sculpture* (New York: Abrams, 1985) and *The Romantics to Rodin: French Nineteenth-Century Sculpture from North American Collections* (Los Angeles: Los Angeles County Museum of Art, 1980).

4. Ignored by art historians, Anderson is well known to scholars of literature. Henry James had met and encouraged Anderson when he was still a young art student in America. Visiting him years later when Anderson had established himself in Rome, James fell in love with the young and fiery sculptor with all the pent-up passion of a long life utterly devoid of anything more comforting than friendly affection. For students of American sculpture, this incident is far more important than a bit of yellow journal gossip. As early as 1878, in *Roderick Hudson*, James had declared his interest in sculpture as the great vehicle by which America would be able to declare its destiny and its ultimate contributions to the history and achievements of mankind. This vision may have been partly inspired by his admiration for Hawthorne, and Hawthorne's ideas regarding the nobility of sculpture as expressed in the *Marble Faun.*

5. The series of bronze doors ornamenting several of the buildings at Rockefeller Center yield a sense of the variety possible within the general framework of the style that first achieved maturity under the Fascist aegis. The doors of the French building are illustrative of the authority of Bourdelle's example in giving decorative elegance to this international style while the doors of the British building, blind to compositional structure, concentrate on a competently superficial, readable quality. Unfortunately, the original doors of the Italian building were removed in the 1960s and replaced by insipid bronze doors by Manzù. The original doors, probably because of their moldings carried the words to "Giovinezza" have disappeared without a trace. Serious efforts should be made to discover their whereabouts and preserve them in suitable fashion. They are among the finest public sculpture of the entire decade anywhere in the western world.

6. In spite of all the tensions that existed between the America of Roosevelt and the Italy of Mussolini, relations were never quite as strained as one might think, and interest in Italian civilization past and present remained strong. Exploits such as Italo Balbo's sensational flight to America were favorably reported in the popular press, while on a higher level, the steady stream of Italian emigré intellectuals brought a new stimulus to Italian studies at American universities. Little was known about the Italian painters and sculptors of the later twenties and thirties although generally speaking, official public sculpture was favorably received by American tourists in Italy. As for the pioneers of modern Italian art, they remained very much alive in the memory of American artists, collectors, and museums. James Thrall Soby continued to champion the cause of de Chirico through publications and exhibitions, and the consistent collecting of Futurist work in America ultimately made American museums the prime repository of Futurist masterpieces. Still, it was probably in the field of architecture that Italian art was best able to catch American sympathies. Prestigious journals such as *Casabella* were relatively free of Fascist propaganda and Fascist censorship and enjoyed the serious attention of the best among American architectural schools and enterprises.

7. Particularly useful in this regard is the catalogue of the exhibition held in Rome at the Palazzo delle Esposizioni December 1990 to February 1991 titled Roma anni '60. Aldilà della pittura" curated by R. Siligato and M. Calvesi.

8. Dimitri Hadzi to the author, October 21, 1991.

Catalogue of the Exhibition

Contributors of Catalogue Entries

Janet L. Comey

Jeannine Falino

Karen Haas

Erica E. Hirshler

Kathleen Mathews Hohlstein

Heather H. Hoyt

Eleanor L. Jones

Natascha Otero-Santiago

Karen E. Quinn

Susan Cragg Ricci

Theodore E. Stebbins, Jr.

Diana Strazdes

Carol Troyen

I Joining the Grand Tour

Benjamin West

Born Springfield, Pennsylvania, 1738;
died London, England, 1820

Benjamin West, described by Dunlap as "the first of our countrymen to go to Rome to study the fine arts," sailed on April 12, 1760, from Philadelphia on the Betty Sally, which was carrying a cargo of sugar to Italy. West's mentor, the Rev. William Smith — Provost of the College of Philadelphia and one of the leading classicists in America — arranged for the twenty-one-year-old painter to travel with John Allen and his cousin Joseph Shippen, two young Philadelphians just setting off on a Grand Tour. West left his companions when they reached Leghorn on June 16, then traveled to Rome, which he reached on July 10. Shortly after his arrival there, he met Anton Raphael Mengs, Gavin Hamilton, Nathaniel Dance, and Pompeo Batoni, and took up a course of travel and study of the masters of the Italian Renaissance prescribed by Mengs, whom he would ever after regard as his mentor. During these years he visited Florence (where he met Angelica Kauffmann, who would become a close friend), Bologna, Parma, and Venice, an ambitious itinerary interrupted by frequent retreats to Leghorn to recover from recurring illnesses. In Italy he painted several portraits from life, including one of John Allen (private collection), and made a number of copies for his wealthy patrons, William Allen (John Allen's father, and Chief Justice of Pennsylvania), and Lt. Gov. James Hamilton of Pennsylvania. There West copied works then ascribed to Titian, Domenichino, Correggio, Guido Reni, Annibale Carracci, Van Dyck, and Mengs. Though West settled in London in August 1763, and never returned to Italy, his enthusiastic recommendation of the country and its masterpieces influenced three generations of American students.

Benjamin West

1. *Angelica and Medoro*, 1763-64
Oil on canvas, 36¼ x 28¼ in.
University Art Museum, State University of New York at Binghamton

Angelica and Medoro was painted at a critical and exciting point in West's development. There is some debate about which of the four (or possibly five) recorded versions of the subject is the original, and whether it was the last of three subject pictures he painted in Italy or the first he produced in England.[1] Rensselaer Lee has convincingly argued that the picture was begun in Italy and "taken under [West's] arm when he went to London in 1763, and finished in the autumn of that year, having had a good look, as the landscape background testifies, at the rolling downs and grazing sheep of the English countryside."[2] West drew his subject from Ludovico Ariosto's *Orlando Furioso* (1532), a masterpiece of High Renaissance literature. Although *Angelica and Medoro* is not characterized by the classical allusions and portentous morality of his mature subject pictures, it is a remarkable advance in complexity, ambition, and execution over his earlier work, and in its chaste translation of an image with a sensuous, even ribald, tradition, it reflects West's keen assessment of his future market.

Angelica and Medoro comes from the nineteenth canto of *Orlando Furioso*, and represents something of a pastoral oasis in that action-packed epic. In this canto, the heroine, a symbol of unattainable beauty who spends the first half of the poem thwarting noble suitors, meets her match. Eluding yet another admirer in the forest, she comes across the wounded Medoro, a handsome, low-born Moor, whose social status makes him an unlikely lover for the aristocratic Angelica. Cupid, turning the tables on the heroine, wounds her with his arrow, and she falls in love. Angelica and Medoro marry, and the woodland honeymoon that follows contains the famous and frequently depicted episode in which the besotted lovers carve their names into the bark of a tree.

For West, who painted this picture and its now-lost companion, *Cymon and Iphegenia*, on the advice of Mengs,[3] the choice of subject for his first historical composition is not so odd as it might first appear. *Orlando Furioso* would enjoy a revival in late eighteenth-century Rome,[4] and West's choice of subject is an early example of his uncanny ability to anticipate public taste.[5] The story required that the young artist paint a group of figures (although since this episode contained only two protagonists, the problem was of limited complexity) against a pastoral setting of his own invention. West chose *Angelica and Medoro* to make his debut at the critical Society of Artists exhibition of 1764, much as Copley would do with his famous *Boy with a Squirrel* (1765, Museum of Fine Arts, Boston) two years later; and just as the enthusiastic reception given Copley's picture at the 1766 exhibition ultimately led to his migration to England, so the attention paid to *Angelica* was part of what induced West to remain in England, rather than to return to America.[6] On a personal level, the subject may have appealed to West as a tribute to Angelica Kauffmann, whom he met in Florence in 1762, and whom he clearly admired. Whether he — dark-eyed, dark-haired, and from an exotic land himself — hoped for success similar to Medoro's with the fascinating Angelica can only be guessed at, but her attraction was legendary.[7]

West's Angelica is very much the Angelica subdued, submissive — as Lee notes, she is a much less interesting character after she falls in love with Medoro, although in many painted versions of the scene she retains something of her old spunk by taking an active role in the amorous play (the poem does not specify which of the lovers actually did the carving).[8] In the rococo conceptions of the story that preceded West's (and in the many scenes of dal-

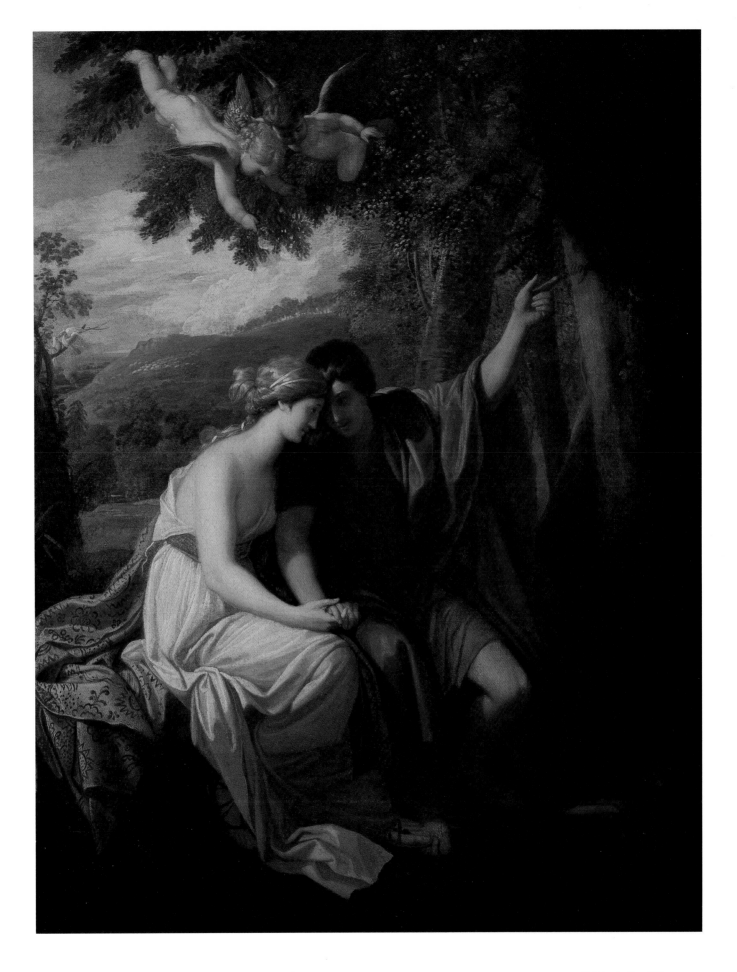

Benjamin West

2. *Agrippina Landing at Brundisium with the Ashes of Germanicus*, 1768

Oil on canvas, 64½ x 94½ in.
Signed l.c.: B. West PINXIT. 1768
Yale University Art Gallery, Gift of Louis M. Rabinowitz

liance that are related to this subject), the mood is playful, and the image portrays a pastoral interlude that is about attaining happiness in the present. The figures are generally shown embracing, entwined, and are frequently scantily dressed, rather than sitting demurely side by side, and fully clothed, as here. West has Medoro point to Angelica's name, which he clearly carved; she listens intently to her husband's instruction, and looks on with more affection than passion. West's Angelica seems admirably serious and chaste. No longer the object of pursuit, she has become the image of the devoted wife. Her profile, bent head, and noble yet passive posture, all of which suggest her virtue, anticipate a series of similarly characterized heroines, of whom the best known is, of course, Agrippina (cat. 2).

C. TROYEN

1. This debate is clearly summarized in Helmut von Erffa and Allen Staley, *The Paintings of Benjamin West* (New Haven: Yale University Press, 1986), no. 188.

2. Rensselaer W. Lee, *Names on Trees: Ariosto into Art* (Princeton, N.J.: Princeton University Press, 1977), p. 70.

3. Mengs counseled West to produce a historical composition to be exhibited to the Roman public. Allen Staley, "Benjamin West in Italy," in Irma B. Jaffe, ed., *The Italian Presence in American Art, 1760-1860* (New York: Fordham University Press, 1989), pp. 1-2, 6-8.

4. Lee, *Names on Trees*, p. 56.

5. The ultimate example of West's translating an event of current interest into a distinguished pictorial subject is, of course, *The Death of General Wolfe* (1770, National Gallery of Canada, Ottawa). For a survey of contemporary compositions depicting the famous name-carving incident, none of which seems to have influenced West's composition, see ibid., pp. 58-65.

6. Von Erffa and Staley, *West*, no. 188.

7. According to Lee, West "probably was as taken with her airs and graces as Sir Joshua Reynolds and others were to be a few years later in England. There she rivaled Ariosto's Angelica in the number of her suitors, though not, I should think, in narrow escapes." Lee, *Names on Trees*, pp. 65, 68.

8. Ibid., p. 43.

West's genius lay in adapting the new artistic enthusiasms of the Continent to the more measured taste of his English clientele. The electricity that would characterize Jacques-Louis David's treatments of subjects from Greek and Roman history is in West's painting a more sonorous drama, and is coupled with a concern for archeological correctness highly appealing to the many veterans of the Grand Tour.

This is nowhere more apparent than in West's first neoclassical masterpiece, *Agrippina Landing at Brundisium with the Ashes of Germanicus*. According to John Galt, West's biographer, the painter's interest in the subject, and "an idea of the manner in which . . . [it] should be treated,"[1] evolved during a dinner conversation with the politically powerful Robert Hay Drummond, the Archbishop of York, who was one of West's first supporters in England and who would provide his introduction to King George III. That evening, the Archbishop read to West from Tacitus (*Annals*, III, 1-2) the story of the popular general Germanicus, who was believed poisoned in Syria on the order of his jealous uncle, the Emperor Tiberius; and of Germanicus's noble wife Agrippina, who bravely returned to Rome, bearing her husband's ashes. At Drummond's request, West chose to depict the moment when Agrippina landed at Brundisium (now Brindisi, on the Adriatic coast), to be greeted by her many supporters.

Drummond's recommendation of this particular episode may well have reflected his own political agenda. As Albert Boime has pointed out, the 1760s in England was an era of religious and political factionalism.[2] The king was attempting to pacify an unruly Parliament and, by rising above partisan squabbles, claim more authority for the throne. At the same time, the Anglican leadership was attempting to ap-

pease the increasingly influential Deists and Methodists in the name of a higher unity. Both Church and Crown became enthusiastic supporters of the neoclassical style, since it was dedicated to illustrating significant moral themes without a specifically religious or political vocabulary. In such a climate, Agrippina's modest demeanor and conjugal devotion would have been understood as an exemplar for larger loyalties.[3]

Certainly West's interpretation advocates fidelity and conciliation more clearly than the other major contemporary treatment of the subject, Gavin Hamilton's tumultuous *Agrippina* (exhibited 1772; Tate Gallery, London).[4] There Germanicus's wife stands at the apex of an almost Baroque pyramid of intertwined mourners, soldiers, and hangers-on. The classical monuments behind them make no particular comment on the action. West, on the other hand, crafted a composition marked by measure, one that aspired to the dignity of Poussin,[5] and one whose archeological accuracy heightened its appeal. Agrippina appears with head bowed, the urn containing the ashes of her husband borne almost as an offering. Her posture is conciliatory, rather than confrontational. She is the principal in a community of mourners whose configuration, as has often been noted, was modeled after the frieze from the Ara Pacis Augustae (fig. 1), fragments of which were on display in the Uffizi Gallery in Florence when West was there.[6] West's quotation from that monument underscores his theme of dignity and reconciliation. Agrippina, her children and her attendants, are flanked by a group of grief-stricken sympathizers at left,[7] and at right by soldiers whose brilliant drapery and vigorous motion not only provide counterpoint to the sculptural gray garb and portentous rhythms of the central group, but

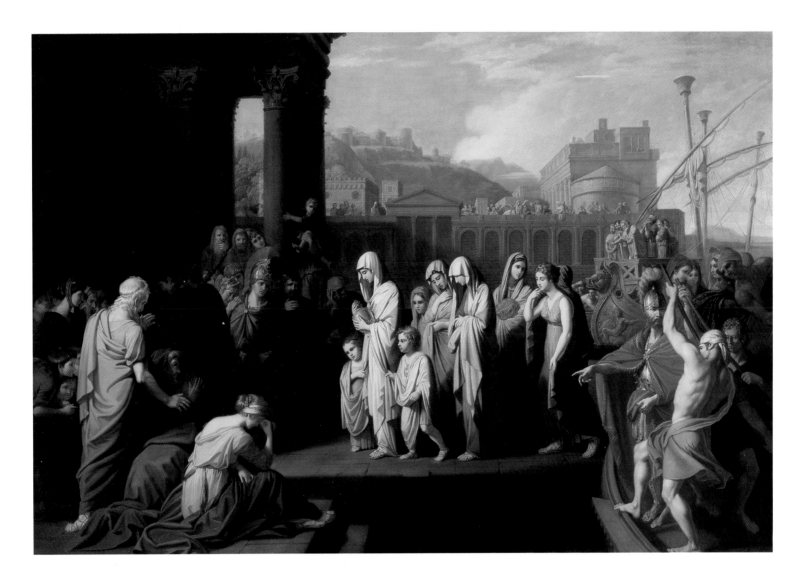

also allowed West to exercise an interest in high-keyed color and veristic anatomical rendering.

The success of this image launched West's remarkable career as a history painter. Exhibited twice at the Society of Artists in 1768, and, through Drummond, presented to the king, it led to the order for the *Departure of Regulus from Rome* (1769, Her Majesty the Queen) and many other royal commissions. In 1770, at the request of the ninth Earl of Exeter, West painted a full-scale replica of *Agrippina* (Philadelphia Museum of Art); another variant followed. And about 1773, he tackled the theme again in *Agrippina and the Children Mourning Over the Ashes of Germanicus* (Ringling Museum of Art, Sarasota), but in that image, his emphasis is on the family's grief rather than on their exemplary dignity and restraint.[8]

C. Troyen

Benjamin West

3. *Portrait of Mrs. West with her son Raphael,* about 1770
Oil on canvas, diam., 36 in.
Signed l.r.: B. West
Permanent Collection of the Utah Museum of Fine Arts,
University of Utah, Gift of the Marriner S. Eccles Foundation for
the Marriner S. Eccles Collection

Like Sir Joshua Reynolds, whom he would succeed as president of the Royal Academy, West often ennobled his sitters by depicting them in poses borrowed from celebrated examples of classical and Renaissance art. Nowhere does he do this more tenderly than in his portrait of his wife Elizabeth Shewell and their first-born son, Raphael (named for the Italian painter who provided the model for this picture,[1] but perhaps also with an affectionate nod to his Roman mentor Anton Raphael Mengs). West's source was the *Madonna della Sedia,* which he had studied at the Pitti Palace in Florence in 1762 (see cat. 6, fig. 1); in fact, he had been hired to make a copy of the Raphael by the Duke of Grafton but was unable to complete the commission because of the ill health that would dog his years in Italy.[2] He later hung a copy (by another painter) in his London studio and recommended the picture to the young Trumbull, among others;[3] however, because the present picture reverses the composition, it seems likely West used a print as an *aide-memoire.*

Portrait of Mrs. West with her son Raphael is one of several versions of the subject West painted in London in the early 1770s. It is not the first of these, but is the largest and most expansive,[4] and includes a dashingly painted flourish of drapery above, and the back and arm of a chair at lower right, details that give the painting a more opulent feeling than the other versions. Nonetheless, West retains a domestic scale, thus perpetuating the intimacy of his model. The tondo format, which itself evokes the Renaissance, was used by West on only a few occasions. He seems to have reserved it for a series of small, highly personal family portraits, done at the same time as the present picture, among them the *Self Portrait with Raphael West* (considered a com-

panion to another version of *Mrs. West and Raphael,* both in the Yale Center for British Art, New Haven) and the *Self Portrait* in Baltimore.[5]

Admiration for Raphael was characteristic of West's age. Reynolds particularly recommended the study of Raphael's work, and borrowed poses and motifs from that master's frescoes and easel paintings, as did Mengs and Pompeo Batoni; West copied Raphael's tapestry cartoons at Hampton Court and throughout his career adapted Raphael's compositions for his portraits.[6] He also directed many of his pupils to the study of that master. For this portrait West sought guidance from Raphael in combining two figures harmoniously in a single composition; the association with Raphael's *Madonna* furthermore idealized his family and demonstrated his own fluency with the vocabulary of the old masters.[7] And in choosing the *Madonna della Sedia,* West emulated what would become the most popular of Raphael's works in Britain and America during the succeeding century, anticipating in this affectionate portrait the Victorian era's admiration for Raphael's ability to "glorify the most noble feelings — maternal and filial love — [which] is assuredly the best form of religious art."[8]

C. TROYEN

1. John Galt, *The Life, Studies, and Works of Benjamin West, Esq., President of the Royal Academy of London* (London: T. Cadell and W. Davies, 1820), vol. 2, p.232, as quoted in Helmut von Erffa and Allen Staley, *The Paintings of Benjamin West* (New Haven: Yale University Press, 1986), p. 46.

2. Albert Boime, *Art in an Age of Revolution, 1750-1800* (Chicago: University of Chicago Press, 1987), p. 123.

3. For an intriguing association between *Agrippina* and specific events of the day — namely the scandal surrounding the "infamous Lord Bute, chief adviser to the royal family," see Ann Uhry Abrams, *The Valiant Hero: Benjamin West and Grand-Style History Painting* (Washington, D. C.: Smithsonian Institution Press, 1985), p. 139 ff.

4. It is not clear whether West and Hamilton would have known anything of the other's work while each was formulating his own design. Although West completed and exhibited his painting before Hamilton, the latter's work was commissioned in 1765, before West began his. Furthermore, it is possible that Hamilton painted a sketch of the subject in Rome before West left that city in 1763. See von Erffa and Staley, *The Paintings of Benjamin West,* p. 44.

5. Ibid. As von Erffa and Staley have noted, Poussin's treatment of the Germanicus subject (Minneapolis Institute of Arts) may well have provided additional inspiration for West.

6. According to Allen Staley, the connection with the Ara Pacis reliefs was first published in Grose Evans, *Benjamin West and the Taste of His Times* (Carbondale, Illinois: Southern Illinois University Press, 1959), p. 1, and has been noted in almost every subsequent discussion of the picture. West made drawings after the procession of Romans on the Ara Pacis (Philadelphia Museum of Art and The Pierpont Morgan Library), which provide clear evidence for his knowledge of the monument. See Ruth S. Kraemer, *Drawings by Benjamin West and his son Raphael Lamar West* (New York: The Pierpont Morgan Library, 1975), cat. 2. Staley has identified the background architecture in *Agrippina* as based on the palace of the Emperor Diocletian at Spalatro (Split) on the Dalmatian coast, which West knew, not from the original but from Robert Adam's book, *The Ruins of the Palace of the Emperor Diocletian at Spalatro* (1764), to which his patron, Archbishop Drummond, was a subscriber. See Allen Staley, "The Landing of Agrippina at Brundisium with the Ashes of Germanicus," *Philadelphia Museum of Art Bulletin* 61 (fall 1965-winter 1967), p. 14.

7. Sources for some of these other figures also have been proposed: the seated figure at lower left assumes a posture traditionally associated with sorrow, for which the best-known representation is probably Dürer's *Melancholia,* and the soldier at right seen from behind reflects a figure in Raphael's *Disputà* in the Vatican. See Staley, *Philadelphia Museum Bulletin,* p. 17.

8. The various versions, studies and replicas are enumerated in von Erffa and Staley, *West,* nos. 29-37.

1. Allen Staley, *Benjamin West: American Painter at the English Court* (Baltimore: Baltimore Museum of Art, 1989), p. 21.

2. Allen Staley, "Benjamin West in Italy," in Irma B. Jaffe, ed., *The Italian Presence in American Art, 1760-1860,* (New York: Fordham University Press, 1989), p. 3.

3. According to Helmut von Erffa and Allen Staley, *The Paintings of Benjamin West* (New Haven: Yale University Press, 1986), p. 458, the copy was painted by John Downman during his visit to Italy in 1773-75; Trumbull, Thomas Sully, and Rembrandt Peale (cat. 6) all made copies.

4. Von Erffa and Staley, *West,* nos. 535-538.

5. In reserving the circular format for pictures of a personal nature, West was not without precedent among his con-

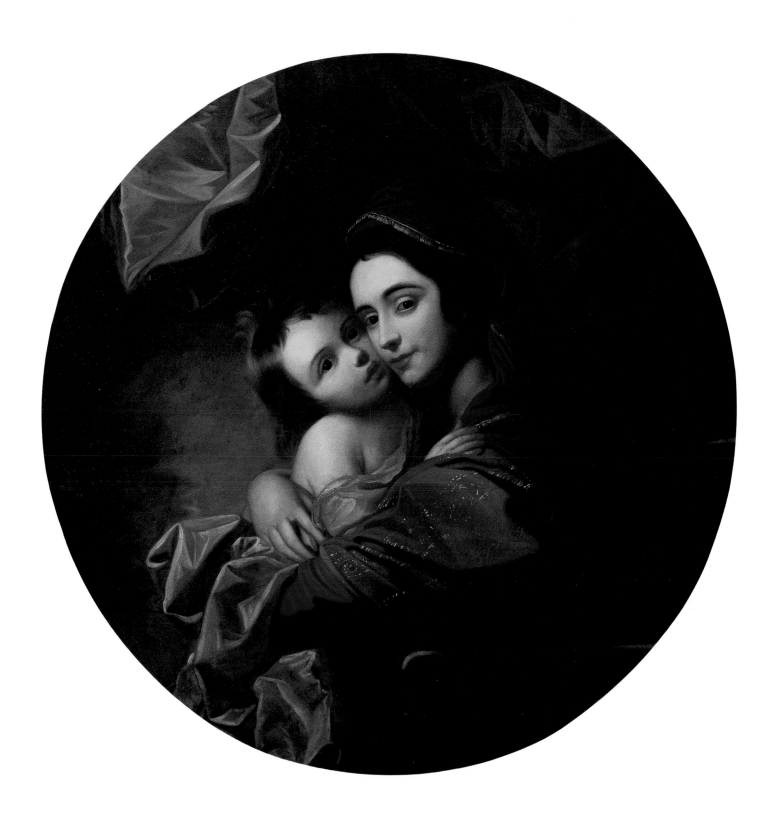

John Singleton Copley

Born Boston, Massachusetts, 1738;
died London, England, 1815

temporaries: Reynolds used small-scale oval canvases for moving portraits of his father and sister; in 1764, Angelica Kauffmann used an oval format for a hauntingly beautiful self portrait (Pennsylvania Academy of the Fine Arts, Philadelphia). Her *Self Portrait as Hope*, presented to the Accademia di San Luca in Rome and engraved in London in 1775, also uses the tondo format to make an intimate statement.

6. See von Erffa and Staley, *West*, nos. 513, 514 and pp. 19-20.

7. Staley in Irma Jaffe, *The Italian Presence in American Art*, p. 5.

8. Eugene Muntz, *Raphael, His Life, Works and Times,* second rev. English ed., trans. Walter Armstrong (London: Chapman and Hall, 1896), p. 121.

John Singleton Copley sailed for England in June 1774, arriving in England in early July; he went directly to London, where West welcomed him. After six weeks, on August 26 he set off with George Carter, an English artist, for Paris; after studying the old masters there, they traveled via Marseilles to Genoa, Leghorn, Pisa, and Florence, arriving in Rome about October 26, 1774. Between then and December he visited the major monuments and museums in the city, and sketched the statuary in the French Academy and the Capitoline Museum. On a side trip to Florence Copley met Ralph and Alice Izard, who persuaded the artist to accompany them on a trip to Naples in January 1775. In Naples Copley viewed the collection of the King of Naples, which included works by Raphael, Leonardo, Correggio, and Titian, and he visited the catacombs. On January 27, Copley and the Izards traveled to Pompeii and Herculaneum, and took a three-hour tour of Paestum together. Copley spent a month in Naples, returning to Rome in mid-February. On June 4, 1775, Copley left Rome for Florence. En route he stayed in Bologna for two days, and in Modena saw works by the Carracci. Copley remained in Florence four days, and on June 10 arrived in Parma for a three-month stay. There he copied Correggio's Holy Family with St. Jerome, *to fill a commission. On July 25 he met Joseph Wright of Derby, and in September Copley left Parma for London via Venice, the Tyrol, Mannheim, and Cologne.*

John Singleton Copley

4. *Mr. and Mrs. Ralph Izard*
(Alice De Lancey), 1775
Oil on canvas, 69 x 88½ in.
Museum of Fine Arts, Boston, Edward Ingersoll Browne Fund

Copley left America on June 10, 1774, as the increasing political turmoil in the colonies placed the artist in a precarious position between his Whig and Tory patrons. After spending several weeks in England, Copley made his way to Italy, settling in Rome.[1] On a side trip to Florence, Copley was sought out by Ralph Izard, a wealthy merchant from Charleston, South Carolina,[2] who desired to have his portrait painted by the young American artist. Copley and the Izards traveled together to Naples, where they toured Pompeii, Herculaneum, and Paestum.[3] Returning to Rome, Copley began this monumental double portrait of the Izards, building on the traditional repertoire of formal portraiture to depict the Izards as connoisseurs on the Grand Tour.

Seated opposite each other at a polished porphyry table, Mr. and Mrs. Izard are surrounded by opulent furnishings and classical references that connote their wealth, discriminating taste, and cultural sophistication. The high-style Piranesian table and elaborately carved chairs are Roman in design, while the column and plinth behind Ralph Izard are faced with "verde antiqua," a rare green marble from Thessaly. The distant view includes the Colosseum, symbol of ancient Rome and the most important monument for early American travelers to Italy. Ralph Izard holds a drawing of the sculptural group located directly behind them. The inclusion of this sculpture, often identified as *Orestes and Electra*, and the fifth century B.C. Greek vase at the upper left, are important reminders of the Izards' interest in art and antiquities. The *Orestes and Electra* (fig. 1), which dates from around A.D. 10, was then in the Palazzo Grande, on the Ludovisi estate located on the Pincio,[4] and a rare cast stood in the French Academy in Rome during the eighteenth century; the version

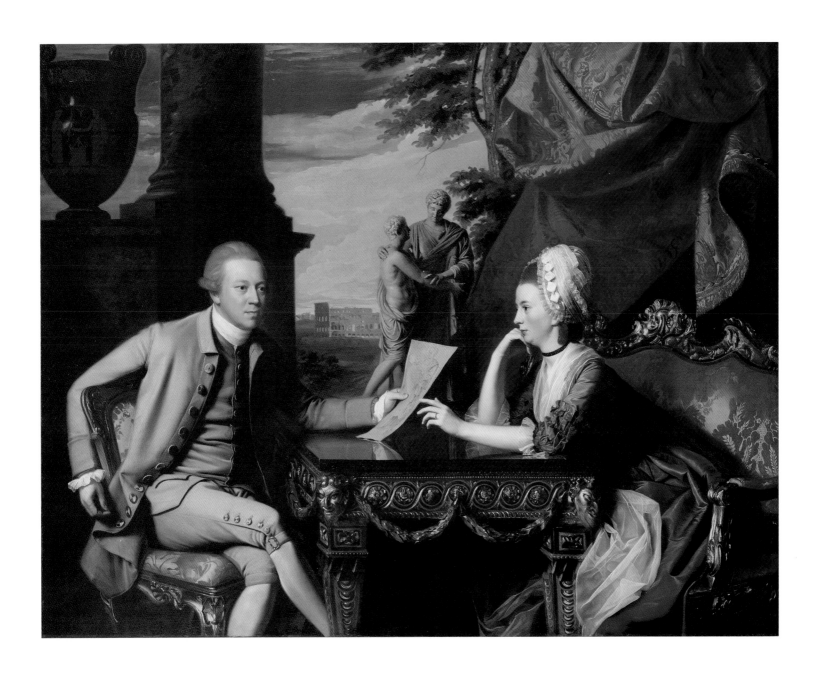

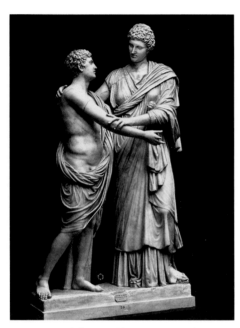

Fig. 1. *Orestes and Electra*. Marble. Museo Nazionale Romano, Rome. Photograph courtesy Alinari/Art Resource, New York.

in this painting is a reduced-scale carved copy.[5] The identity of its subject has been the focus of much discussion since the seventeenth century; originally called "fraternité," it acquired several descriptive titles linking it with various pairings, all of which played on the general theme of fraternal and erotic love.[6] The drawing of *Orestes and Electra* is in the manner of Pompeo Batoni (1708-1787), a painter and professional copyist whose drawings of classical statuary were commissioned by collectors and other travelers to Rome. The inclusion of both the drawing and the sculpture indicate that the theme of friendship and love held special significance for the Izards. Further, the subject of the Attic red-figure vase above Ralph Izard's head is Apollo and Artemis, twin brother and sister from Greek mythology. As twins, they represent the closest bond between two people, further reference by Copley to the Izards' love for each other.[7]

Copley clearly considered *Mr. and Mrs. Ralph Izard* to represent a very important advance in his career as an artist. In a letter to his step-brother Henry Pelham, he recounts praises for the painting from his close friend, the Scottish artist Gavin Hamilton, recalling with pride that "Mr. Hamilton observed just before I left Rome that I was better establish'd than Mr. West, because he could not paint such portraits as those of Mr. Izard and Lady, and portraits are always in demand."[8] The Izards never took possession of their portrait, having left Rome late in 1775 to return to London, and moved to Paris during the Revolutionary War. Copley completed the painting, which he then took to London; Jules Prown surmises that it may have been the picture exhibited at the Royal Academy, London in 1776, titled "A Conversation."[9]

E. JONES

1. Jules D. Prown, *John Singleton Copley* (Cambridge: Harvard University Press, 1966), vol. 2, pp. 249-250.

2. *Dictionary of American Biography*, Dumas Malone, ed., vol. 9 (New York: Charles Scribner's Sons, 1932), p. 524. Ralph Izard (1741/2-1804) was a Revolutionary patriot, diplomat, and senator; his wife, Alice De Lancey (1745-1832), was the niece of the chief justice and lieutenant governor of New York. The Izard family was one of the oldest and wealthiest in the province, the family fortune based on indigo and rice. Ralph Izard lived in London much of his early life, coming into his inheritance in 1764. While a Loyalist sympathizer, he found living in London after 1775 impossible. Izard eventually returned to America with his family and became a highly respected senator from South Carolina.

3. Copley to his mother, dated Parma, June 25, 1775. *The Letters and Papers of John Singleton Copley and Henry Pelham, 1739-1776*. (Reprint edition, New York: Kennedy Graphics, Inc./Da Capo Press, 1970), p. 330.

4. Francis Haskell and Nicholas Penny, *Taste and the Antique* (New Haven: Yale University Press, 1981), pp. 288-91.

5. Ibid., p. 290; see also Hugh Macandrew, "A Group of Batoni Drawings at Eton College, and Some Eighteenth-Century Italian Copyists of Classical Sculpture," *Master Drawings* 16, no. 2 (1978), p. 132.

6. Haskell and Penny, *Taste and the Antique*, pp. 288-291. In 1806 Herder wrote, "The relationship of the figures provided poignant proof of the power of immobile sculpture to convey feelings of quiet and mutual trust between friends, lovers, or members of a family." Johann Gottfried von Herder, *zur schoenen Litteratur und Kunst (Saemmtliche Werke)*, VII, I (Tubingen, 1806), p. 172, quoted in Haskell and Penney, *Taste and the Antique*, p. 290, note 28.

7. This volute krater (unlocated) is described in Sir John Beazley, *Attic Red-Figure Vase Painters*, 2nd ed. (Oxford: Clarendon Press, 1963), p. 608; also Adolf Greifenhagen, "Greichesche Vasen auf Bildnissen der Zeit Winkelmanns und des Klassismus," *Nachrichten von der Gesellschaft der Wissenschaften zu Goettingen, Philologisch-Historische Klasse*, neue folge III, no. 7 (1939), pp. 199-230ff.

8. Copley to Pelham, March 25, 1775, Parma. *Letters and Papers of John Singleton Copley and Henry Pelham, 1739-1776*, p. 340.

9. Prown, *John Singleton Copley*, vol. 2, p. 387.

Rembrandt Peale

Born Bucks County, Pennsylvania, 1778;
died Philadelphia, Pennsylvania, 1860

Rembrandt Peale studied in London with Benjamin West in 1802–03 and visited Paris in 1808 and 1810, but the Napoleonic wars prevented his traveling on to Italy during these years. Inspired, however, by the French and Italian paintings he had seen Paris, Peale returned to Philadelphia and began to produce such grand manner historical compositions as The Roman Daughter *(1811, National Museum of American Art, Washington, D.C.) in addition to the portraits for which he was already well known.*

The artist finally visited Italy in 1829–30, financed by a group of supporters in Philadelphia, Boston, and New York and accompanied by his son, Angelo, whom he wished to educate in the history of art. Father and son arrived at Le Havre in mid-November, then traveled by coach to Paris. In December they journeyed on to Marseilles and boarded a ship for Naples, where they spent most of January 1829. At the end of the month they traveled on to Rome and remained there through the spring. Peale met a number of European artists in Rome, including Horace Vernet, director of the French Academy; the Swiss landscape painter Franz Keiserman; and the Danish sculptor Bertel Thorvaldsen, whose portrait he painted. In early spring, Peale made an excursion to Tivoli, where he painted two views of the falls (see fig. 1). However, he concentrated his efforts on studying old master paintings in the galleries of Rome.

In June, the Peales departed Rome, traveling north. They visited Siena and by July 7 were in Florence, where Rembrandt painted his portrait of Horatio Greenough (National Portrait Gallery, Washington, D.C.) and copied paintings in local collections. In April 1830, father and son left Florence for Leghorn, Pisa, Genoa, Parma, Piacenza, Modena, and Ferrara. After several days in Venice, the pair went on to Milan by way of Padua, Vicenza, Verona, and the southern end of Lake Garda. They crossed Lake Maggiore, then made their way over the Alps at the Simplon Pass.

Fig. 1. Rembrandt Peale, *Falls of Tivoli*, about 1831. Oil on canvas. Private collection.

After stops in Geneva, Paris, and London, the Peales sailed for New York at the end of September 1830.

In 1831, Peale published Notes on Italy, *a diary of his travels, and exhibited his Italian work in Philadelphia.*

Rembrandt Peale

5. Portrait of William Short, 1806

Oil on canvas, 30½ x 25⅛ in.

Muscarelle Museum of Art, College of William and Mary in Virginia

Soon after Rembrandt Peale completed his *Thomas Jefferson* (1805, New-York Historical Society), he received a portrait commission from William Short (1759-1849), Jefferson's protegé and informally adopted son. A 1779 graduate of the College of William and Mary, Short shared many of Jefferson's intellectual interests, and had served as Jefferson's private secretary during the latter's term as Minister to France (1784-89).[1]

Jefferson had hoped to visit Italy during his stay in Europe, and in 1787, he managed to travel as far south as Milan and Genoa before official duties called him back to Paris. Frustrated, he wrote to a friend that he had been permitted "a peep only into Elysium."[2] The following year, at Jefferson's urging, Short departed Paris on an eighteen-month tour of Italy. He met another of Jefferson's protegés, John Rutledge, Jr., of South Carolina, in Milan in the fall of 1788, and together they visited Verona, Vicenza, Padua, Venice, Bologna, Rimini and Ancona before arriving in Rome on December 22. They explored the city and visited Tivoli and other sites on the Campagna nearby, then left for Naples in January 1789. On their way back north, Short and Rutledge visited Florence and Genoa. As they traveled, both men wrote frequently to Jefferson, detailing their impressions of places he had been unable to go, and in some cases answering his specific inquiries.[3]

When Jefferson returned to America in 1789, Short remained in Paris as secretary of the American legation and chargé d'affaires. A long and tender but ultimately disappointing romance with the Duchess de la Rochefoucauld began during this period. He subsequently served as Minister to the Hague (1792-93) and as envoy to Spain (1794-95). After retiring from public service in 1795, Short settled in Philadel-

phia in 1802 and devoted himself to study and to the management of his ample assets. Two years later, in recognition of his scholarly achievements, he was elected to the American Philosophical Society.[4]

Peale emphasized his sitter's classical interests and romantic fascination with the past by placing a wistful Short before the looming ruins of the Temple of Neptune at Paestum. There is no evidence that Short visited this site near Naples when he was in the area in 1789, but he may have owned the Piranesi etchings that Peale used in composing the background of the portrait.[5] Peale's *William Short* is one of only a few American works inspired by the eighteenth-century grand tour portraiture of Pompeo Batoni and his imitators (see cat. 4). The worldly, aristocratic Short would certainly have known such portraits, and Peale himself may have seen examples in London in 1802-03. In its romantic mood, however, Peale's portrait of Short differs from its neoclassical forebears.

Rembrandt Peale longed to visit Italy, and his contact with William Short must have stimulated his desire for travel. The artist finally reached Italy in 1828-29, but his experiences in the Naples area in 1829, like Short's some forty years earlier, did not include a fifty-mile excursion to the ruins of Paestum.[6]

K. MATHEWS HOHLSTEIN

1. On Short's career, see Marie Goebel Kimball, "William Short, Jefferson's Only 'Son,'" *North American Review* 223 (1926), pp. 471-486 and Lucille M. Watson, "William Short: America's First Career Diplomat," *The William and Mary Alumni Gazette* (summer 1982), pp. 23-27.

2. Thomas Jefferson to Maria Cosway, July 1, 1787, in Julian P. Boyd et al., eds., *The Papers of Thomas Jefferson* (Princeton: Princeton University Press, 1950-), vol. 11, pp. 519-520.

3. On Jefferson's and Short's Italian travels, see George Green Shackelford, "A Peep into Elysium," in William Howard Adams, ed., *Jefferson and the Arts: An Extended View* (Washington, D.C.: National Gallery of Art, 1976), pp. 237-265, and letters from Short to Jefferson in Boyd et. al, eds., *The Papers of Thomas Jefferson*, vol. 14, pp. 310-312, 377-383, 405-406, 448-452, 541-543, 571-574.

4. William Howard Adams, ed., *The Eye of Thomas Jefferson*, (Washington, D.C.: National Gallery of Art, 1976), p. 200.

5. Carol E. Hevner *Rembrandt Peale 1778-1860: A Life in the Arts*, [Philadelphia: The Historical Society of Pennsylvania, 1985], points out (pp. 44 and 98, n. 8) that Peale conflated two of Piranesi's views of the Temple of Neptune. Giovanni Battista Piranesi's *Différentes vues de quelques restes de trois grands édifices qui subsistent dans le milieu de l'ancienne ville de Pesto, autrement Posidonia* were published in 1778. Peale relied on plates x and xi and even duplicated Piranesi's staffage.

6. On Peale's travels in Italy, see Rembrandt Peale, *Notes on Italy* (Philadelphia: Carey & Lea, 1831) and Carol E. Hevner, "Rembrandt Peale's Dream and Experience of Italy" in Irma B. Jaffe, ed., *The Italian Presence in American Art 1760-1860* (New York: Fordham University Press, 1989), pp. 9-25.

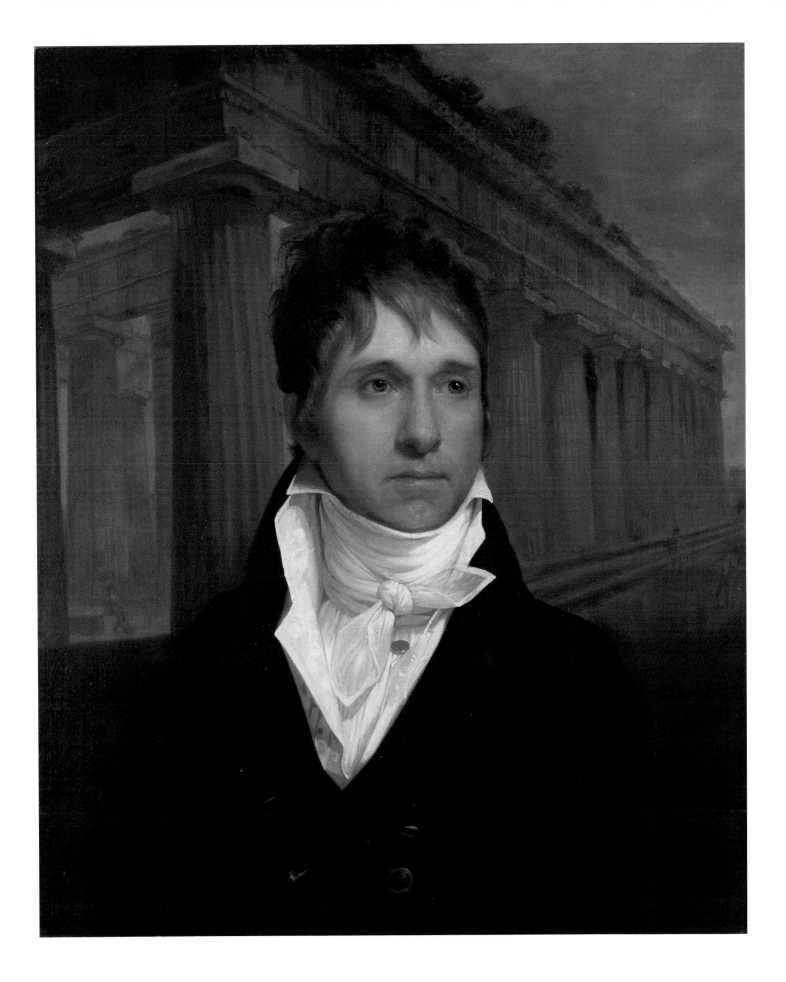

Rembrandt Peale
6. *Madonna della Seggiola*, after
 Raphael, after 1830
Oil on canvas mounted on panel, 22½ x 18½ in.
Old St. Joseph's Church, Philadelphia

In the years after his Italian journey of 1829-30, Rembrandt Peale produced the present painting and at least seven others based on his copy of the *Madonna della Seggiola* (fig. 1),[1] the "chef d'oeuvre of the divine Raphael."[2]

Cool grace, compositional resolution, and an intimate and sentimental portrayal of maternity made the *Madonna della Seggiola* one of the most celebrated pictures in Europe during Peale's lifetime,[3] and he was familiar with the image long before his arrival in Italy. He certainly knew the widely disseminated engraving of Raphael Morghen.[4] In London during 1802-1803, Peale must have seen both the oil copy that Benjamin West kept in his London studio[5] and West's *Portrait of Mrs. West with her son Raphael* (cat. 3), a work inspired by the Italian painting. In 1808 and 1810, Peale may even have seen the original itself in Paris, where Napoleon had brought it as booty along with other Italian treasures. By 1829, when Peale arrived in Florence, the famous painting was back in the Pitti Palace, where it attracted copyists in such numbers that Peale had to wait almost three months for his turn.[6]

Peale's copy closely follows Raphael's painting in its size, circular format, and inclusion of the young St. John in addition to the Madonna and Child. However, Peale omitted John's reed cross and the halos that crown Raphael's figures, perhaps sensing the preferences of a pragmatic, primarily Protestant American audience.

In 1831, soon after his return to Philadelphia, Peale made his *Madonna della Seggiola* the centerpiece of an exhibition of his Italian work at Sully and Earle's Gallery. Sixteen other copies were also exhibited, as were an unfinished view of the Falls of Tivoli; five portraits of eminent men, primarily artists, whom Peale had met on his travels; and three portraits completed

Fig. 1. Raphael (Italian, 1483-1520), *The Madonna della Sedia*, about 1514. Oil on panel. Galleria Pitti, Florence.

prior to his trip, including *George Washington, Pater Patriae* (United States Capitol, Washington, D.C.),[7] a work the artist had proudly displayed in Rome, Florence, and London.[8]

In efforts to enlighten American viewers and generate commissions for duplicates, Peale showed some of his Italian pictures in New York and Boston, in addition to Philadelphia, during the 1830s. His plans to establish a permanent "Italian Gallery" proved financially impracticable,[9] but his repeated adaptations of the *Madonna della Seggiola* attest to strong public interest in Raphael's renowned picture. Peale clearly conceived of the present version as an oval, leaving the corners of the rectangular canvas blank. Although he omitted the figure of St. John entirely, the artist was careful to include the famous chairpost.[10]

It is not known when Peale executed this painting or when it was acquired by Old St. Joseph's Church, Philadelphia. Interestingly, it was in this Roman Catholic church that Peale, a Protestant, married Eleanor May Short against his father's

wishes in 1798;[11] several of the artist's children were later baptized there.[12]

K. MATHEWS HOHLSTEIN

1. Raphael's painting is known today as the *Madonna della Sedia*. Information on Peale's adaptations of Raphael's painting was kindly provided by Carol E. Hevner.

2. Sully and Earle's Gallery, *Catalogue of Peale's Italian Pictures*, p. 4.

3. On the fame of the *Madonna della Seggiola* during the eighteenth and nineteenth centuries, see David Alan Brown, *Raphael and America* (Washington, D.C.: National Gallery of Art, 1983), pp. 24-25.

4. Rembrandt Peale, *Notes on Italy* (Philadelphia, Carey & Lea, 1831), p. 241.

5. The copy that West owned was probably painted by John Downman between 1773 and 1775. See Helmut von Erffa and Allen Staley, *The Paintings of Benjamin West* (New Haven: Yale University Press, 1986), p. 458.

6. See Sully and Earle's Gallery, *Catalogue of Peale's Italian Pictures*, p. 4. By the 1850s, James Jackson Jarves reported in *Italian Sights and Papal Principles, Seen Through American Spectacles* (New York: Harper Brothers, 1856) that artists were waiting ten to fifteen years for the opportunity to copy the painting (p. 105).

7. These included replicas of Dominichino's *Cumaean Sibyl*, Correggio's *Danaë*, Titian's *Flora*, Guido Reni's *Cleopatra*, Bronzino's, *Judith with the Head of Holofernes*, and landscapes by Salvator Rosa. For a complete listing of Peale's European copies and of the portraits he executed during his travels, see Sully and Earle's Gallery, *Catalogue of Peale's Italian Pictures* and Carol E. Hevner, "Rembrandt Peale's Dream and Experience of Italy," in Irma B. Jaffe, ed., *The Italian Presence in American Art, 1760-1860* (New York: Fordham University Press, 1989), pp. 18 and 23 and p. 25, n. 22.

8. See Peale, *Notes on Italy*, pp. 7-8.

9. See Hevner, "Rembrandt Peale's Dream and Experience of Italy," pp. 18 and 20, and *Rembrandt Peale 1778-1860: A Life in the Arts* (Philadelphia, The Historical Society of Pennsylvania, 1985), p. 74.

10. In another adaptation of the *Madonna della Seggiola*, the rectangular *Portrait of Hannah Hansen and daughter, Lydia* (private collection), Peale omitted the chairpost as well as the third figure, retaining only the embracing mother and child.

11. Charles Coleman Sellers, *Charles Willson Peale* (Philadelphia, The American Philosophical Society, 1947), vol. 2 p. 102.

12. Information courtesy of the Archdiocese of Philadelphia archives.

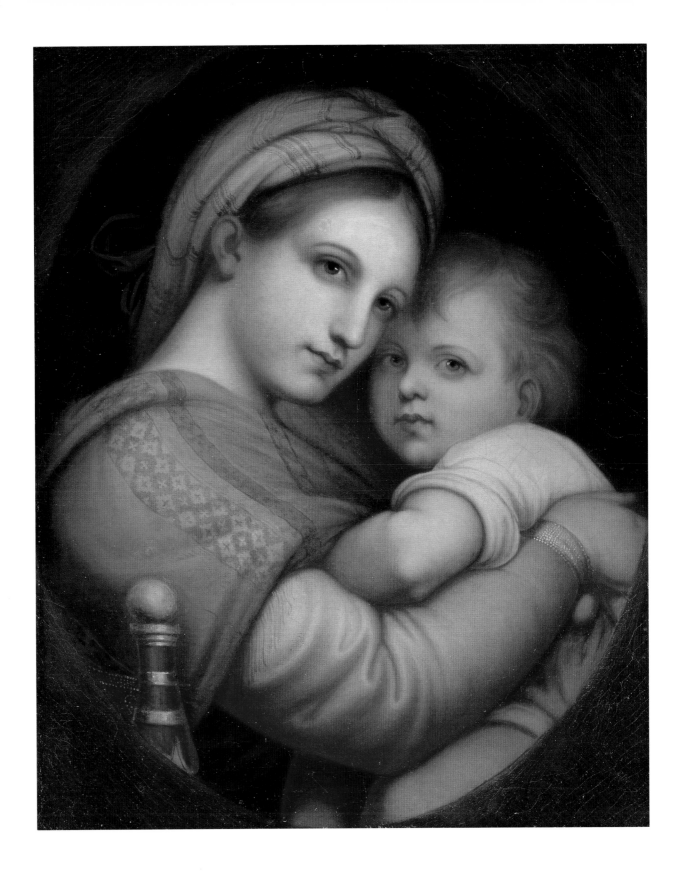

John Vanderlyn

Born Kingston, New York, 1775;
died Kingston, New York, 1852

John Vanderlyn

7. *Caius Marius Amid the Ruins of Carthage,* 1807

Oil on canvas, 87 x 68½ in.
Signed l.r.: J. Vanderlyn / Roma 1807
*The Fine Arts Museums of San Francisco, Gift of
M.H. de Young*

*In 1803 the newly formed American Academy of
the Fine Arts in New York commissioned the
Paris-trained Vanderlyn to purchase casts of fa-
mous ancient sculptures and copies of old master
paintings. His commissioners imagined that he
would transact his business in Florence and
Rome, but because Napoleon had removed so many
of Europe's art treasures to Paris, the Louvre in-
stead became Vanderlyn's base of operations. After
twenty-two months there, in August 1805 he fi-
nally departed for Italy.*

*After traveling and sketching in Switzerland
for several weeks, Vanderlyn crossed Mount
Cenis; stopped briefly at Turin, Milan, Parma,
Bologna, Modena, Piacenza, and Florence; and
arrived at Rome in November 1805. He moved
into the residence said to have been Salvator Rosa's
at 30 Via Gregoriana, across the street from
Washington Allston, who had arrived several
months earlier. Vanderlyn befriended a number of
young French artists, whom he joined in excur-
sions to such places as Albano and Frascati. He
made drawings after Giulio Romano, Raphael,
and antique statuary; studied from the nude;
made a few portraits; and produced a watercolor
of the Arch of Titus, perhaps with its publication
as a print in mind. The rest of his time was de-
voted to a single, large painting,* Caius Marius
Amid the Ruins of Carthage *(cat. 7).*

*Vanderlyn keenly felt the effect of the Napole-
onic wars on Rome. Because the hazards of travel
in French-occupied Italy had drastically reduced
Rome's English-speaking residents, Vanderlyn was
unable to support himself by painting portraits as
he had in Paris. He left Italy in December 1807,
traveling from Rome to Florence, to Turin, then
across the Alps into France. In early January he
reached Paris, where he remained until 1815,
when he returned to the United States.*

*From 1839 to 1846 Vanderlyn was in Paris
working on a large canvas of Columbus discover-
ing America, commissioned for the U.S. Capitol
rotunda. During this interval, in 1843, he made
a brief second visit to Rome.*

In December 1806 Vanderlyn wrote from
Rome that in twelve months he expected
to have "something that may establish me
a reputation in my profession."[1] By the fol-
lowing December he had completed *Marius
on the Ruins of Carthage.* His first classical
subject and nearly three times the size of
his largest previous painting, it presented
the Roman general as a solitary, brooding,
half-draped figure, his helmet and sword
cast aside.[2] With architecture crumbling
around him, he sits in a landscape whose
only sign of life is a fox darting across a
temple ruin. After exhibiting his canvas to
a warm reception in Rome,[3] Vanderlyn
sent it to Paris, where it won a medal at
the Salon of 1808 and secured his place as
one of America's most respected history
painters.

The story of Caius Marius was widely
known in Vanderlyn's day, thanks mainly
to Langhorne's translation of Plutarch's
Lives and to Charles Rollin's *Roman History.*
Like the story of the blind Belisarius, it
became a staple for painters interested in
the tragic fate of former heroes. Marius,
who was made consul seven times because
of his ability to drive back barbarian at-
tacks, eventually turned his pugnacious
zeal against Rome, from which he was
banished in 88 B.C. He went to Carthage
hoping for asylum, but the Roman gover-
nor there sent a messenger ordering him to
leave. Asked for a reply, Marius said defi-
antly, "Tell him that thou hast seen the ex-
iled Marius sitting on the ruins of
Carthage," linking his fate with that of the
city as a warning.[4] Marius took his revenge
on Rome, returning to kill many of his en-
emies, yet dying ignominiously.

Marius's exile may have reminded Van-
derlyn of the political misfortunes of his
patron Aaron Burr, as has been suggested
many times. However, the painting does
not merely present a maligned hero, it

shows a wronged general still capable of
doing great harm. Vanderlyn said that he
wished to convey the instability of human
grandeur by juxtaposing a city in ruins and
a fallen general, whereas "in the counte-
nance of Marius, in which there is more of
rude and savage nature than dignified, I
have endeavored to express the disappoint-
ment of ambition with the meditation of
revenge."[5] He created a vaguely menacing
Marius who is reminiscent of the malevo-
lent Brutus in J.-L. David's *Lictors Returning
to Brutus the Bodies of his Sons* (1789, Musée
du Louvre, Paris).

Vanderlyn stated that Washington All-
ston had suggested the subject to him.[6]
Allston had read Langhorne's Plutarch in
college and had painted a *Marius at Mintur-
nae* (now lost) in London, but, more im-
portant, he, like Vanderlyn, had become
interested in pictorial themes that focus
upon the protagonist's troubled thoughts.
Allston's mammoth *Jason Returning to De-
mand his Father's Kingdom* (1806-08, Lowe Art
Gallery, University of Miami, Coral
Gables, Fla.), which he worked on at just
the time Vanderlyn painted *Marius,* has at
its center a shadowy, pensive figure whose
hidden thoughts are the true subject in the
painting, just as they are in Vanderlyn's. By
seizing a moment devoid of action, both
Vanderlyn and Allston were able to pre-
sent an emotionally charged image while
retaining outwardly the calm severity of
the Neoclassical style. Vanderlyn said he
copied the head of an ancient portrait bust
of Marius and placed it onto the body of
one of the Pope's guards, whom he used as
a model.[7] He also used the pose and
weapons of the Ludovisi Mars (Museo
Nazionale delle Terme, Rome), but re-
placed its youth and playfulness with a
tense gesture of the hand and a harsher,
more careworn character.

Part of the painting's mood derives from

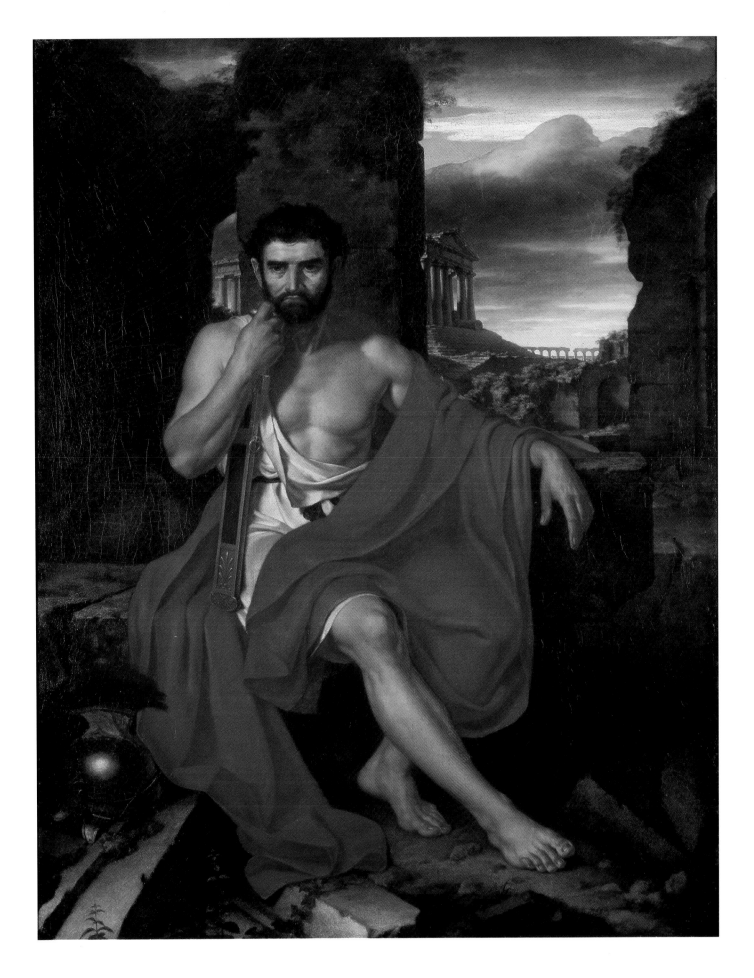

its coloring, in which Vanderlyn made use of bitumen glazes, common in London but then a novelty in Rome. The sky is particularly evocative. Dark, pink-tinged clouds cover all but a few patches of blue-streaked sky, creating a sunset one would expect from Poussin.

In the background of the painting stand ruins that Vanderlyn had seen in Italy. The vault in the foreground resembles the the Baths of Caracalla; the Doric temple behind it is suggestive of Paestum's; to the right are the ruins of the Claudian aqueduct. Vanderlyn thus sets up a sequence of epochs from earliest Rome (represented by the aqueduct) to Periclean Greece, to the Roman empire. Perhaps living in a city under threat of French occupation made Vanderlyn sensitive to the relationship of thwarted ambition and the destruction of civilizations, for these structures have been destroyed in their turn, presumably by war and the vengeance of generals such as Marius.

D. STRAZDES

1. John Vanderlyn to William McClure, December 8, 1806, The New-York Historical Society.

2. Vanderlyn wrote to a friend in January 1807 that artists in Rome were painting very large canvases. He intended to follow *Marius* with a work of five or six figures. Marius Schoonmaker, *John Vanderlyn, Artist* (Kingston, N.Y.: Senate House Association, 1950), pp. 19-20.

3. See [Giuseppe Guattani], *Memorie enciclopediche sulle belle Arti, antichità ecc.* (Rome: Salomini, 1807-8), vol. 3, pp. 101-102.

4. *Plutarch's Lives*, trans. John Langhorne and William Langhorne, 6th ed. (London, G. G. and J. Robinson, 1801), vol. 3, pp. 162-163.

5. John Vanderlyn to John R. Murray, July 3, 1809, Charles Henry Hart Autograph Collection, Archives of American Art, Smithsonian Institution, Washington, D.C.

6. Robert Gosman, "Biographical sketch of John Vanderlyn, Artist," The New-York Historical Society, p. 337, in Louise Hunt Averill, "John Vanderlyn, American Painter," Ph.D. diss. Yale University, 1949.

7. Henry T. Tuckerman, *Book of the Artists: American Artist Life*, 1867 reprint (New York: James F. Carr, 1967), p. 129.

Thomas Crawford

Born New York, New York, 1813 (?); died London, England, 1857

Crawford was introduced to the classical sculpture of Italy through sketching plaster casts at the American Academy of Fine Arts and the National Academy of Design in New York while working for the sculptors John Frazee and Robert Launitz. In May 1835 he sailed to Rome, intending to study there two years. He arrived in September 1835, after his ship was delayed in quarantine for seventy days in Leghorn.

A letter from Launitz introduced Crawford to the Dane Bertel Thorvaldsen, senior figure among sculptors in Rome, who invited him to draw and model under his guidance, which Crawford did for nearly a year. Crawford also studied the sculptures of the Vatican, drew from life at the Accademia di San Luca, and dissected at the hospital mortuary. Living almost ascetically as he pursued his studies, he rented a variety of rooms, all between the Piazza del Popolo and Piazza Barberini. By 1837 he had his own studio, making portrait busts and copies of antique sculptures for visiting Americans. Among his visitors was the Bostonian Charles Sumner, who became Crawford's ardent supporter and helped sell to the Boston Athenaeum Orpheus and Cerberus (cat. 9), the work that created Crawford's reputation.

In Rome Crawford met Louisa Ward, whom he married in New York in November 1844. In late 1845 he returned with her to Rome, where he was soon acknowledged as the city's leading American artist. In 1849 they went briefly to the United States, where Crawford won from Richmond, Virginia the contract for an equestrian statue of George Washington. In 1853 and 1855 he received commissions for the embellishment of the enlarged U.S. Capitol, which made his studios in the Villa Negroni, across from the Baths of Diocletian, the site of great activity. He made another trip to the United States in 1856.

Crawford traveled within Italy periodically. After 1845 he and his wife summered in Fras-

Thomas Crawford

8. *Hyperion*, 1841

Marble, h. 23¾ in., w. 12½ in., d. 12½ in.
Signed on back: T. Crawford Fect. Rome - / 1841
The Carnegie Museum of Art, Pittsburgh, Museum Purchase,
Mrs. George L. Craig, Jr. Fund and Patron's Art Fund

cati; in 1847 they made a tour through Florence,
Bologna, Rovigo, and Venice. Crawford visited
Florence several times more to call on colleagues.
His last stop there was in early 1857 when, in
search of treatment for a cancerous tumor behind
his eye, he went to Paris, then London, where he
died after surgery.

9. *Orpheus and Cerberus*, modeled 1839; carved 1843

Marble, h. 67½ in., w. 36 in., d. 54 in.
Signed on base at left: T. G. CRAWFORD.
FECIT./ROMAE/MDCCCXLIII
Museum of Fine Arts, Boston, Gift of Mr. and Mrs.
Cornelius Vermeule III

Crawford intended *Orpheus and Cerberus* to be his masterpiece, the work by which his skills, inventiveness, and ambitions would be judged. He began modeling it in early 1839 and exhibited the plaster model in Rome that November, when it was favorably reviewed in the art annual *L'Ape Italiana*.[1] Charles Sumner had seen the plaster during the summer of 1839 and on returning to Boston he set to work obtaining $2500 in subscriptions so that a marble version could be purchased by the Boston Athenaeum. After three years of discouraging delay, *Orpheus and Cerberus* was finally translated into marble and shipped to Boston, where it was the centerpiece of a special Crawford exhibition in 1844, the first solo exhibition of a sculptor in the United States.

The American reviews of *Orpheus and Cerberus* noted with pride that Crawford had presented a scene from Greek legend never depicted in either ancient or modern sculpture.[2] The story of Orpheus, the poet who enters Hades in search for his lover Eurydice, is told in the tenth book of Ovid's *Metamorphoses*. Crawford shows the poet, having lulled to sleep the three-headed dog Cerberus, guardian at the gates of the Underworld, stepping into the darkness to begin his search. Crawford was particularly proud of the novel gesture by which Orpheus shades his eyes, "as I have often observed persons to do when entering any dark place."[3] Thomas Hicks proposed that Orpheus's search symbolized the artist's quest for the ideal.[4]

From its first public appearance on,

Orpheus and Cerberus was compared to the *Apollo Belvedere*, named as Crawford's model. Their faces are indeed similar, but mainly the Vatican's most famous god suggested a standard of excellence for Crawford, as it had done for artists since the sixteenth century. For his direct inspiration, Crawford looked elsewhere, if only because the "Apollo Belvedere" was already so ubiquitously quoted to have become a cliché and better avoided by an artist intent on demonstrating his originality.

Crawford instead melded gestures and motifs from other famous examples of classical sculpture in Rome, but so skillfully that his sources recombine seamlessly into a vigorous, new creation. He used the laurel crown and cithara of the *Apollo Musagetes* in the Vatican, the striding gait of the so-called *Capitoline Runner*, the clasped, wind-blown cloak of the Vatican's *Meleager*, and the Hellenistic mastiff in the Cortile del Belvedere. By choosing such diverse motifs, Crawford created for himself a great artistic and technical challenge surpassing that of the *Apollo Belvedere*. His statue, he remarked, "throws in my way all the difficulties attending the representation of the human figure."[5]

At the same time, Crawford intended to keep simplicity and a sense of authenticity uppermost. He wrote to his sister Jenny that he was "keeping clear of all extravagance in the movement and working as nearly as possible in the spirit of the ancient Greek masters."[6] In doing so, he reflected Thorvaldsen's attitude toward the classical tradition: that sculptures should speak primarily to the intellect. To further this goal, Crawford refrained from polishing his surfaces but kept the finish flat, like the sculpture of Greek high classicism.

Hyperion, which replicates the head and shoulders of *Orpheus*, was carved in the year Crawford ordered the marble for the larger statue. It retains the inclination of the

Thomas Crawford

8. *Hyperion*, 1841

head, the sweep of drapery around the shoulders, and the implied forward movement of the torso, all features that make it unusual for a marble bust in the classical idiom. The bust was purchased by Mr. P.T. Homer of Boston, who initially requested a copy of the head of Orpheus.[7] However, because the head lacked the eye-shading gesture that made Orpheus who he was, Crawford recast it as that of a sun god, like the *Apollo Belvedere* on which Orpheus's head was patterned. Crawford gave it the title Hyperion, perhaps in honor of Henry Wadsworth Longfellow's recently published novel by the same name. In Greek mythology, Hyperion was one of that group of most ancient Titans who fathered the rest of the Greek pantheon. Because his domain was the sun, he was often given the attributes of Apollo, as Crawford shows him here. This transfer may have been Crawford's attempt to allude to a greater antiquity than Apollo normally represented, and to emulate a purity of Greek style like that which Thorvaldsen had also sought.

D. Strazdes

1. Giuseppe Melchiorri, *L'Ape Italiana* 5 (1839), plate 36. The engraving is reproduced in Lauretta Dimmick, "Thomas Crawford's Orpheus: The American *Apollo Belvedere*," *American Art Journal* 19, (1987), p. 59.

2. This statement appeared at least three times, in George W. Greene's "Letters from Modern Rome," *The Knickerbocker* 15 (June 1840), pp. 488-496; in Catharine Maria Sedgwick's *Letters from Abroad to Kindred at Home* (New York: Harper and Brothers, 1841) vol. 2, pp. 158-59; and in Charles Sumner's "Crawford's Orpheus" in *United States Magazine and Democratic Review*, May 1843, pp. 451-55.

3. Crawford to his sister, quoted in George S. Hillard, "Thomas Crawford, A Eulogy," *The Atlantic Monthly* (July 1869), p. 45.

4. Thomas Hicks, *Thomas Crawford: his Career, Character, and Works* (New York: D. Appleton and Co., 1858), pp. 16-17.

5. Hillard, "Thomas Crawford: a Eulogy," p. 45.

6. Ibid., p. 46.

7. Robert L. Gale, *Thomas Crawford, American Sculptor* (Pittsburgh: University of Pittsburgh Press, 1964), p. 25.

II Dream of Arcadia

Washington Allston

Born Georgetown County, South Carolina, 1779;
died Cambridgeport, Massachusetts, 1843

10. *Diana in the Chase*, 1805
Oil on canvas, 65⅝ x 97⅝ in.
Signed l.r.: W. Allston pinx. Roma
Fogg Art Museum, Harvard University
Art Museums, gift of Mrs. Edward W. Moore

After studying for two years in London and ten months in Paris, Allston took his only trip to Italy, departing Paris some time after the Salon opened on September 1, 1804. Only scattered indications of his itinerary have survived. Traveling overland, he crossed the French and Swiss Alps, entering Italy through the Saint Gotthard Pass, then passed Bellinzona, Lake Maggiore, and Vigevano near Milan on his way to Bologna and Florence. Despite his early biographers' desire to have "the American Titian" visit Venice, Allston, like John Vanderlyn, probably never saw it. By December 29, 1804, he had reached Siena, where he likely spent the winter before heading to Rome in early spring.

By late March 1805 Allston was in Rome. He took an apartment at the top of the Spanish Steps that afforded a panoramic view of the city and he rented a studio on Via Orto di Napoli below. Allston made excursions to such country towns as Olevano and Tivoli, but stayed principally in Rome, where he became friendly with other foreign writers and artists, notably Washington Irving, Samuel Taylor Coleridge, and those associated with the Danish sculptor Bertel Thorvaldsen, in particular the Germans Gottlieb Schick and Joseph Anton Koch.

In Rome Allston visited art collections, studied the nude, modeled in clay, bought prints, and painted his most ambitious works to date, including his largest landscape, Diana in the Chase *(cat. 10) and his largest history painting, the unfinished* Jason Returning to Demand His Father's Kingdom *(1807, Lowe Art Museum, University of Miami, Coral Gables, Florida). Fearing that the United States would be drawn into war with France, whose army already occupied Rome, Allston reluctantly sailed from Leghorn on April 24, 1808.*

For Allston, Italy was a state of mind as much as a physical place. His experience there fused with its art, making Italy home to invisible truths found nowhere else. Having fantasized about

Italy since college, Allston's allusions to it lingered in his painting and writing. In 1821-22 he wrote a novel, Monaldi *(cat. 156), set in Florence and Rome. He encouraged every art lover to go to Italy and urged young painters to learn from the old masters who made it their home.*

The largest painting Allston had attempted, his first presentation of himself as a mature painter, and the work that created most attention for him on the Continent was *Diana in the Chase*. During the months he had just spent in Paris, Allston had the opportunity to see at the Louvre an astonishing collection of Poussin's greatest landscapes. For a young artist already deeply interested in seventeenth-century Italian landscape, Poussin offered dignified, philosophical images suited to the most elevated ambitions of painting.

Before leaving Paris, Allston quite likely painted *Landscape with a Lake* (1804, Museum of Fine Arts, Boston).[1] It featured a blue-white lake bordered by snow-capped mountains and, in the foreground, a tree trunk fallen over a chasm in the earth, a motif that appears in Poussin's *Diogenes*, at the Louvre.

On his way to Italy, Allston, who rarely produced landscape sketches from nature, made careful pencil drawings of the Alps. His most finished of these depicted Mount Pilatus on the edge of Lake Lucerne (1804, Fogg Art Museum, Harvard University Cambridge, Mass.). Once in Rome and casting about for work suited to public exhibition, he painted *Diana in the Chase* "alla prima, in extremely little time."[2] It shows an icy blue lake against a snowy mountain derived from the drawing of Mount Pilatus. The dark, wooded foreground reveals the goddess Diana in the hunt (quoting the classical sculpture of *Diana of Ephesus*, fig. 1) and the same Poussin-inspired fissure in the earth Allston had previously used.

His new painting was *Landscape with a Lake* made larger, with all contrasts sharpened. While remaining in the tradition of classical landscape, its shadows are deeper, its glassy areas more transparent, and its mountain more dominant. Allston en-

larged the mountain backdrop to unprecedented proportions and placed in the shadowy foreground tall, rugged trees and deep crevices that heighten the sublime effect he sought.

In Rome Allston found a sympathetic environment for this kind of picture. Rome's landscape painters, who included Joseph Anton Koch, Johann Christian Reinhart, and George Wallis, were among the foreign art community's most prominent members. Their works showed a serious interest in the expressive possibilities of Poussin's style, possibilities well demonstrated in Joseph Anton Koch's *Heroic Landscape with Rainbow* (1805, Staatliche Kunsthalle, Karlsruhe).[3] In addition, recent paintings in Rome were often much larger than customary in Paris, which doubtless encouraged Allston to give *Diana in the Chase* its outsized proportions.

In the later months of 1805 Allston exhibited *Diana in the Chase* in his studio just off the Piazza di Spagna. It earned a discussion in that year's review of art in Rome, which reported that it attracted crowds of connoisseurs and art lovers.[4] The reviewer praised the painting's novelty of style and naturalness, together with its recollection of past Italian art. "For the tone of air that represents a beautiful morning and for the entirety of the composition, it seems to us to come nearest the style of [Claude] Lorrain; the greenery, however, is absolutely of the Venetian school."[5] However, the striking emergence of the icy mountain from the deep shade on either side recalled the effects, not of landscape painters, but of those who were

Fig. 1. *Diana*, Roman marble copy after Greek bronze original, about 370 B.C. Museé du Louvre, Paris. Photography courtesy Giraudon/Art Resource, New York.

Italy's old masters of dramatic naturalism, for the review concluded: "the effect . . . is exactly the sensation that would be borne by the sight of a beautiful Caravaggio, or Guercino in his strongest manner."

Samuel Taylor Coleridge was greatly moved by *Diana in the Chase* and wrote a lengthy, poetic description of it in his Roman notebook of April-May 1806.[6] Gottlieb Schick saw the painting and became interested in learning Allston's glazing technique, which he then employed in a number of paintings, including *Landscape with the Education of Achilles* (1808, Staatsgalerie, Stuttgart).

D. STRAZDES

1. The signed and dated *Landscape with a Lake* was created either in Paris or, less likely, en route to Rome but not in Rome itself. Allston had only reached Siena by the end of 1804, posting a letter from there (Massachusetts Historical Society, Boston) to his friend Benjamin Welles on December 29, 1804.

2. Giuseppe Antonio Guattani, *Memorie enciclopediche romane sulle belle arti, antichita. . .* 5 vols. (Rome: Salomini, 1806), vol. 1, p. 64.

3. See William H. Gerdts, "Washington Allston and the German Romantic Classicists in Rome," *Art Quarterly* 32 (summer 1969), pp. 166-96 and Gerdts in William H. Gerdts and Theodore E. Stebbins, Jr., *"A Man of Genius": The Art of Washington Allston* (Boston: Museum of Fine Arts, 1979), pp. 46-49.

4. Guattani, *Memorie*, p. 64.

5. Ibid., p. 65.

6. Kathleen Coburn, ed., *The Notebooks of Samuel T. Coleridge* vol. 2, 1804-08 (New York: Pantheon Books, 1961), doc. no. 2831.

Washington Allston

11. *Italian Landscape*, 1814
Oil on canvas, 44 x 72 in.
Signed l.r.: w. allston / 1814
Toledo Museum of Art, Purchased with funds from the Florence Scott Libbey Bequest in memory of her Father, Maurice A. Scott

First exhibited at the Royal Academy in London, this painting was one of eleven works included in Allston's first solo exhibition, which opened on July 25, 1814, at Merchant Tailors' Hall in Bristol, England.[1] It was Allston's first large classical landscape since *Diana in the Chase* (cat. 10). "My own works have suffered very much from their long imprisonment," Allston wrote when his Roman works finally arrived from Livorno, where he had stored them six years before.[2]

He continued to think highly enough of those early productions however, to include two other landscapes, the *Diana* and *Thunderstorm at Sea* (1804, Museum of Fine Arts, Boston) in his exhibition. He may have wanted his Bristol audience to see a freshly made, undamaged example of his landscape-painting skill. He may have also wanted a gentler, pastoral work as a foil for the more austere, mountainous *Diana in the Chase.*

Italian Landscape was described by Allston's first biographer as "a broad and brilliant composition, replete with music and perfume, and overspread with sweet sunshine and poetic repose."[3] It was built around the features most frequently associated with Claude Lorrain (and most thoroughly assimilated into British landscape painting): a foreground framed by low vegetation and set off by a few figures, an arched bridge over a still river in the middle distance, a deep plain leading to hazy mountains on the horizon, and a sky tinged with golden-pink clouds.

Allston embroidered the Claudian theme by various means. First, he created a setting that would stand for all Italy. His body of water suggests Lake Albano, with its flat terrain and distant villas. However, a bit further in the distance, the lake becomes a winding river. To the right is an arched bridge, like those on the Tiber in Rome; to the left, medieval buildings sug-

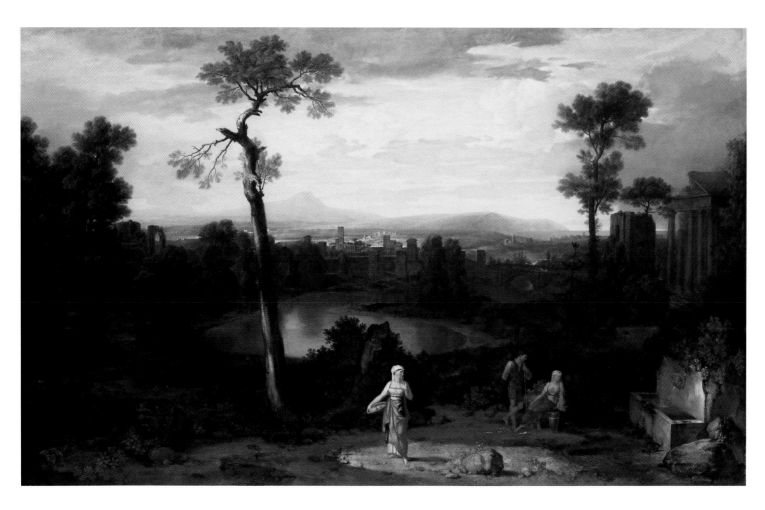

gest the walled towns of Tuscany – of which he had made a pencil sketch (Fogg Art Museum, Harvard University, Cambridge, Mass.) because they were new to him. In the distance a crescent-shaped bay recalls the Bay of Naples.

Allston then gave over his landscape to meditations on transience. Cloaking the foreground and middle ground, he dotted this area with classical and medieval ruins. In the right foreground he placed a sarcophagus and three peasants in the garb of some remote time (perhaps the sixteenth century), who turn toward it. This vignette restates the theme *Et in Arcadia Ego*, known best from Poussin's work – not his early

Arcadian Shepherds (about 1630, Chatsworth),[4] but his later, more orderly, and more widely known painting in the Louvre. Poussin's spareness and calm create the philosophic mood that Allston wished to replicate here.

Allston induced his viewer to meditate on death, ruins, and the passage of time, but not without thoughts of regeneration and renewal as well. The sarcophagus has become a fountain, a source of refreshment and life. A stone pine, prominent in the center foreground, conveys a similar symbolism (later repeated in so many landscapes of the Hudson River School): the tree has one broken, dead trunk; but also

possesses one living trunk, whose branches have died, then blossomed again.

D. STRAZDES

1. For a full description of Allston's Bristol exhibition, see William H. Gerdts and Theodore E. Stebbins, Jr. "*A Man of Genius*": *The Art of Washington Allston* (Boston: Museum of Fine Arts, 1979), pp. 81-86.

2. Washington Allston to John Vanderlyn, Aug. 17, 1815 [1814?]. Allston Papers, Massachusetts Historical Society, Boston.

3. [Moses Foster Sweetser], *Allston* (Boston: Houghton, Osgood, & Co., 1879), p. 115.

4. See Brian Wolf, *Romantic Re-Vision* (New Haven: Yale University Press, 1982), p. 102.

Washington Allston

12. *Moonlit Landscape*, 1819
Oil on canvas, 24 x 35 in.
Museum of Fine Arts, Boston, Bigelow Collection, Gift of
William Sturgis Bigelow

Allston never tired of creating variations of the classical landscape type as developed by artists who worked in Rome around in the seventeenth century. After returning permanently to America in 1818 he regularly painted such landscapes. All of these were imaginary views and most were suggestive of Italy, which he identified as a place for poetry, music, or meditation. *Moonlit Landscape* was one of the first works Allston painted on returning to America and it remains one of his most subjective and enigmatic renditions of Italianate landscape.

That the painting recalled Italy to Allston's contemporaries is indicated by the three poems about it written (in 1822, 1828, and 1830) by Henry Pickering of Salem, who corresponded with Allston about acquiring the painting and who may have been its first owner. Pickering's second poem, which accompanied an engraving of painting in *The Atlantic Souvenir*, was called "Moonlight. An Italian Scene" and asks, "this is Rome? I know not. . . . 'tis the land she sway'd."[1] That Allston intended his landscape to recall Italy is indicated by the painting it most resembles, Jan Asselijn's mid-seventeenth-century *View of the Tiber* (fig. 1), which had been one of the highlights of the Louvre in Napoleon's time and which Allston may have owned as an engraving.[2]

Allston altered the shores of the Tiber to suit his own purposes. In the distance he created a hazy string of crowded buildings combining domes, towers, and low, tightly massed masonry structures, some on flat land, some on hills. Some have a seemingly recognizable character: a dome to the right could be the Pantheon; the long, low building at the center might be a cloister, perhaps the monastery at Subiaco; the bridged ravine to the left suggests Tivoli; the hill town at the far left could be Olevano. In the background Allston sug-

Fig. 1. After Jan Asselijn (Dutch, 1610-1652), *View of the Tiber*. Engraving in S.C. Croze-Magnan, *Le Musée Français* (Rome: Robillard-Peronville, 1805, vol. 2, plate 60).

gests the Roman Campagna and the Alban hills. He obviously intended these landscape elements to be barely discernible to the viewer and, true to his frequently described glazing technique, they dissolve on close inspection. In the shifting, cloud-covered moonlight, the terrain bespeaks transience as well as eternity.

Moonlit Landscape has long been thought to be self-referential. The picture seems to deal with a voyage taken, or rather two voyages, one by sea just finished (indicated by the beached boat in the foreground) and one on land just begun (indicated by the horse and rider).[3] Perhaps not coincidentally, Allston's own return into Boston Harbor in October 1818 occurred by moonlight on a calm sea.[4] Yet boat, horse and rider, and moonlight also carry allegorical meaning, if one judges by the appearance of these motifs in Allston's poetry. In "Sylphs of the Seasons" he equates the rider on horseback with the poet; in his "Sonnet to Coleridge" the sailboat represents the soul and night-travel with the search for truth.[5]

The arched bridge in the middle ground does less to link two sides of a river than to create a divide between the Italian scenery and the shore where the travelers –

and we the (American) viewers – stand. This shore is very different from the far bank of the river. It possesses only scattered rocks, low bushes, and young undergrowth, all scenery appropriate to the usual contrast between the old world and the Americas. Yet here, at least for Allston, is where the soul ends its journey and the poet mounts his steed.

D. STRAZDES

1. Henry Pickering, "Moonlight. An Italian Scene," *Atlantic Souvenir* (Philadelphia: H.C. Carey & I. Lea, 1828), pp. 210-13. Pickering's other two poems were published in his *Ruins of Paestum and Other Compositions in Verse* (Salem, Mass.: Cushing and Appleton, 1822), pp. 91-94 and *Poems by an American* (Boston: Carter and Hendee, 1830), pp. 50-52.

2. In his paintings Allston quoted a number of works that had been on display in Napoleon's Louvre, which suggests he had purchased for such purposes one of the editions of engravings illustrating its collections.

3. Marcia Briggs Wallace, "Washington Allston's *Moonlit Landscape*," in Irma B. Jaffe, ed., *The Italian Presence in American Art 1760-1860*, (New York: Fordham University Press, 1989), pp. 82-94 places this work in the context of voyage-of-life imagery in Romantic literature and art.

4. Barbara Novak, *American Painting of the Nineteenth Century: Realism, Idealism, and the American Experience* (New York: Harper and Row, 1969), pp. 53-54.

5. Richard Henry Dana, ed., *Lectures on Art and Poems by Washington Allston* (New York: Da Capo Press, 1972), pp. 200-201, 346.

Thomas Cole

Born Bolton-le-Moor, England, 1801;
died Catskill, New York, 1848

Cole arrived in London June 27, 1829, remaining in England twenty-two months, during which time he met Joseph Mallord William Turner, John Constable, Charles Robert Leslie, and Sir Thomas Lawrence, and exhibited paintings in two Royal Academy exhibitions. On May 4, 1831, Cole sailed to France; after a week in Paris he departed for Genoa, where he arrived on May 27. From Genoa, he sailed to Leghorn, then made his way overland by vettura to Florence, arriving there on June 7, 1831. He was joined there by James Fenimore Cooper, and took lodgings in the same building as Horatio Greenough. Cole, Henry Greenough, and John Cranch attended classes in human anatomy and drawing at the Academy of St. Luke, in Florence. Around August 24, they traveled to Volterra, where they spent ten days sketching in the countryside. On February 3, 1832, Cole left for Rome traveling via Siena with Francis Alexander, remaining there until early May. Cole stayed in rooms first on the Via del Tritone, then on the Pincian Hill, sharing with Alexander a studio reputed to have been that of Claude Lorrain. While based in Rome, Cole made trips to Tivoli, Albano, Nemi, and Ariccia. In early May, 1832, he traveled to Naples, visiting Pozzuoli, Mt. Vesuvius, and Salerno. By May 23, Cole had been to Pompeii, Herculaneum, and Paestum. He briefly returned to Rome, and by June 5 had departed for Florence. On October 8, he sailed from Leghorn to London and New York.

On his second trip to Europe, Cole sailed for England on August 7, 1841, remaining in London until October. In October he traveled to Paris accompanied by Mrs. Anna Jameson, and during the second week of October, left Paris with Thomas P. Rossiter for Switzerland. After touring Switzerland and southern France, they sailed to Genoa. Cole continued by sea to Leghorn, then to Civitavecchia. He then traveled to Rome, arriving by November 9, 1841. Cole remained in Rome until April 1842, when he embarked on a six-week tour of Sicily, accompanied by English

landscape painter Samuel Ainsley. They traveled overland to Naples, visiting Mt. Vesuvius before sailing across the Tyrrhenian Sea to Palermo. Cole and Ainsley circled Sicily counter-clockwise on mule-back, making stops at Segesta, Selinute, Agrigento, Syracuse, Catania, and Mt. Etna, where Cole ascended the volcano in time for sunrise on May 10. They visited Taormina on May 16, then returned to Palermo, where they boarded a steamer, arriving in Rome by May 20, 1842. Seven days later, Cole sailed from Rome to Genoa, then traveled by land to Milan, where he stayed long enough to see Leonardo's Last Supper. He made his way to Lake Maggiore and then to Switzerland; he arrived in London in mid-June, and embarked for New York on July 9, 1842.

Thomas Cole

13. *Dream of Arcadia*, 1838
Oil on canvas, 39 x 63 in.
Collection of the Denver Art Museum, Gift of Mrs. Lindsey Gentry

Cole's Arcadia is a fertile realm bounded by ancient trees and a range of craggy mountains, encompassing a valley fed by a stream and a waterfall. On the highest of the grassy slopes is a Doric Greek temple, before which smoke rises from an outdoor altar. Sheep dot the hillside, while below, the sheltered vale basks in the warmth of a late afternoon sun. In the middle distance a shepherd returns with his flock as two horsemen canter off into the forest. Closer to the center foreground, a woman carries an infant while two children gather flowers at the edges of the stream. On the far left, a stand of trees forms a natural path, and under the watchful eye of a herm,[1] a group of people dance to the music of tambour and pipes; old and young alike partake of the merriment. Arcadia is a land evoking the classical ideals of harmony and prosperity of the Golden Age, traditionally set in an Italianate landscape. Cole's vision of Arcadia evolved from a long tradition of similar pastorals, notably those of Poussin and Claude, whose works he had studied in London on his first trip to Italy.[2]

In a letter to Asher B. Durand (see cat. 20), Cole expressed the difficulties he was encountering painting the work, and sent him a trompe-l'oeil study of *Dream of Arcadia*, presenting the illusion of an oil sketch on paper tacked down to a board (fig. 1).[3] In the finished work, Cole altered the size

Fig. 1. Thomas Cole, Study of *Dream of Arcadia*, 1838. Oil on wood panel. Courtesy of The New-York Historical Society, New York City.

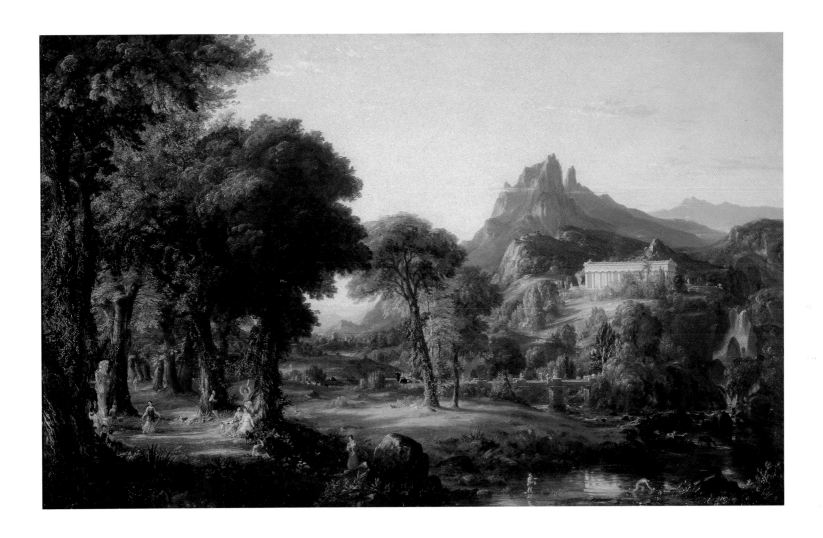

and placement of the herm in the left foreground, extending the glen to accommodate the music makers.[4] Louis Legrand Noble identified the importance of this work in its moral commentary on the virtues of rural life, noting, "thus childhood and youth, manhood . . . and old age . . . all unite spontaneously, each according to the laws of its nature, in giving one accordant response to the genial influences of the place and moment." Acknowledging Cole's ambition to paint landscapes whose significance rivaled traditional history

painting, he concluded: "as the honour of introducing the pastoral, after the order of Theocritus, into Roman literature, belongs to Virgil, so the same honour is due to Cole as the parent of true idyl, or pastoral painting in America."[5] In this respect there is also an echo of Cole's *Course of Empire* (1835-36) in this work. In composition and subject, *Dream of Arcadia* most closely resembles the *Pastoral State* (also called "Arcadian State"), the second of Cole's five canvases from his epic cycle (1836, The New-York Historical Society). The pastoral

state represents man existing in harmony with nature, and with himself. Earl Powell has interpreted this painting as a deliberate turning away from the present, evoking nostalgia for a lost state of innocence, as rapid changes in the land and expansion of the continent forever changed the character of the American wilderness.[6] Cole's belief in the wilderness state as ideal had given way to a more profound understanding of man's place in the cosmos, a harmonious coexistence between man and the natural world. Cole commented on this el-

ement in his work in his "Essay on American Scenery," delivered as a lecture three years earlier:

> Poetry and painting sublime and purify thought, by grasping the past, the present, and the future - they give the mind a foretaste of its immortality, and thus prepare it for performing an exalted part amid the realities of life. And *rural nature* is full of the same quickening spirit — it is, in fact, the exhaustless mine from which the poet and the painter have brought such wondrous treasures.[7]

Looking back on the nineteenth-century fascination with Italy, one writer called *Dream of Arcadia* "the dream for a hundred years of all the travelling American artists and writers,"[8] the visualization of an ideal setting that served as a wellspring for all artistic inspiration.

E. JONES

1. A herm is a square stone pillar surmounted by the bust, usually of Hermes, to whom travelers prayed for safe passage. Here it is more likely that of Pan, guardian of Arcadia.

2. Regarding the tradition of European pastoral landscapes in art, see Robert Cafritz, et al., *Places of Delight: The Pastoral Landscape* (London: Weidenfeld and Nicolson, 1989), esp. pp. 17-129.

3. Cole in particular was having trouble painting the figures in the landscape. He had enrolled in life drawing classes in Florence in an attempt to surmount his lifelong difficulty in painting figures; clearly, in 1838 he did not feel he had entirely succeeded (Cole to Durand, March 20, 1838, New York Public Library, Asher B. Durand Papers).

4. Both the sketch and the painting are dated 1838, however the differences between the two works suggest the sketch was completed first.

5. Louis Legrand Noble, "Cole's Dream of Arcadia," *The Literary World* 5 (September 29, 1849), pp. 277-278. William Vance (*America's Rome* [New Haven, Yale University Press, 1989], vol. 1, p. 98) notes that *Dream of Arcadia* also warranted the longest discussion of any single painting in Noble's book on Cole. Among the American artists who painted pastoral landscapes was Robert Scott Duncanson, whose *Dream of Italy, Recollections of Italy,* and *Arcadian Landscape* were products of his own trip to Italy (see cat. 17).

6. Earl A. Powell III, "Thomas Cole's 'Dream of Arcadia,'" *Arts* 52 (November 1977), pp. 113-115. In his recent monograph on Cole, Ellwood C. Parry III notes *Dream of Arcadia*

is identical in size to *Schroon Mountain,* and that the two paintings were exhibited together in 1838 as unofficial pendants (Ellwood C. Parry III, *The Art of Thomas Cole: Ambition and Imagination* [Newark, Del., University of Delaware Press, 1988], p. 205).

7. Thomas Cole, "Essay on American Scenery," reprinted in John W. McCoubrey, *American Art, 1700-1960: Sources and Documents* (Englewood Cliffs, N.J.: Prentice-Hall, Inc., 1965), pp. 98-99.

8. Van Wyck Brooks, *Dream of Arcadia* (New York: E.P. Dutton & Co., 1958), p. 54.

Thomas Cole

14. *L'Allegro,* 1845

Oil on canvas, 32⅛ x 47⅞ in.
Signed l.r.: T. Cole 1845
Los Angeles County Museum of Art, Gift of the Art Museum Council and the Michael J. Connell Foundation

15. *Il Penseroso,* 1845

Oil on canvas, 32⅜ x 48⅛ in.
Los Angeles County Museum of Art, Trustees Fund, Museum Acquisitions Fund, Corporate Donor Fund

In 1844 Thomas Cole wrote to patron Charles Parker[1] of his intention to paint for him two canvases, *L'Allegro* and *Il Penseroso,* the titles taken from Milton's poems of the same names:

> In the first picture, I should represent a sunny, luxuriant landscape, with figures engaged variously in gay pastimes or pleasant occupation. In the second picture, I would represent some ivy clad ruin in the solemn evening twilight, with a solitary figure musing among the decaying grandeur.[2]

Cole had been contemplating this pairing since 1829, when he included the titles on a list he kept of potential picture subjects. The presence of several pairs of titles on this list indicates Cole was already thinking in terms of suitable linked images. Landscape pendants of morning and evening or the seasons emerged as a popular convention in Europe during the seventeenth century, practiced by Claude and his contemporaries, and remained popular in England into the nineteenth century. Cole certainly would have become familiar with examples of these works during during his stay there in 1829-31.[3]

Milton's poetry retained its popularity during the early nineteenth century, and examples of paintings and sculpture bearing titles from his *Paradise Lost* as well as these two early poems are numerous.[4] Cole apparently went to Italy steeped in Milton's verse, reminding himself on one occasion that Fiesole was "a hill that Milton mentions in his *Paradise Lost.*"[5] As a pair, Cole's canvases explore the emotional

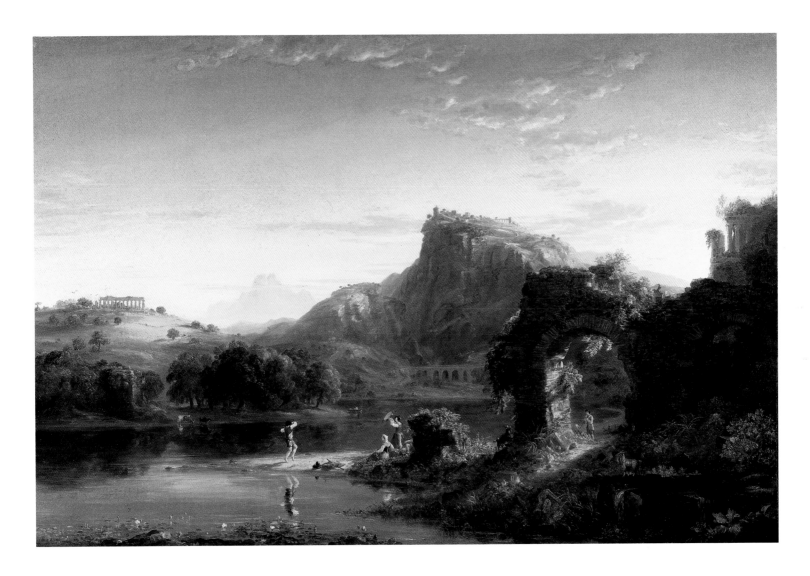

states of joy and pensive melancholy at the heart of Milton's poems, rather than illustrating specific lines or imagery. *L'Allegro* (Mirth) combines elements of Italian scenery transposed to create an Arcadian pastoral: a hill town, fragments of an aqueduct, a round temple reminiscent of the Temple of the Sibyl at Tivoli, and a Greek temple resembling the one at Segesta. The setting is an idealized landscape in the manner of Claude, the waning light foretelling the closure of the pagan Arcadian

age (see cat. 13). Cole has borrowed the pose of the pagan dancer from the *Dancing Faun* from the House of the Faun at Pompeii (Museo Nazionale, Naples).[6]

For *Il Penseroso* Cole chose the present-day setting of Lake Nemi, his topographically accurate rendering of the lake and surrounding hills adapted from sketches drawn during his first trip to Italy.[7] Cole has included the Christian shrine at Lake Nemi, in front of which a young woman in nineteenth-century dress kneels, overcome

by emotion. Cole has underscored the theme of melancholy by choosing the light of late afternoon, which Louis Legrand Noble described as "expressive of the tender, pensive spirit of the hour, and the pleasing loveliness of shadowy woods and waters";[8] however, here the light is crisper and clearer, without the golden Arcadian glow. Although Milton's poems were set in England, Cole has chosen Italy, whether in response to the language of the titles, or his own strong feelings for the country.

Thomas Cole

15. *Il Penseroso*, 1845

Intriguingly, when *L'Allegro* and *Il Penseroso* were exhibited at the National Academy of Design in 1846, they appeared with the titles "Italian Sunset" and "View of Lago di Nemi, near Rome," respectively.[9] By the middle of the century, literary allusions in landscapes had fallen out of favor, and Cole may have realized his own interest in Milton was outweighed by the prevailing interest in Italy. By this time Cole had experienced the lukewarm response from patrons for his *Course of Empire*

and *Voyage of Life* series, and may have approved alternative titles for this pair in order to broaden their appeal to a general audience.

E. JONES

1. Parker was a collector with particular interest in Italian scenes; nothing more about him is known. See Wayne Craven's paper, "Thomas Cole's L'Allegro and Il Penseroso," p. 3, courtesy Los Angeles County Museum of Art files.

2. Cole to Parker, Jan 8, 1844; Archives of American Art, Smithsonian Institution, Washington, D.C., ALC1.

3. Cole had just finished painting another set of Italian pendants, *Evening in Arcady* and *Roman Campagna*, for Miss Sarah Hicks, when he wrote to Parker. He painted a number of pendants, among them *The Departure* and *The Return*, and *The Past* and *The Present*. See also cat. 76 for a discussion of his pairing of Old and New World scenery as unofficial pendants. Cole was also familiar with Reynolds's *Discourse XIII*, in which the President of the Royal Academy expounded

William Wetmore Story

Born Salem, Massachusetts, 1819;
died Florence, Italy, 1895

on the virtue of landscapes invested with allegorical or as-
sociative titles, as being of richer material for the imagina-
tion than descriptive titles of recognizable views. See Bar-
bara Novak O'Doherty, "Thomas Cole," *RISD
Bulletin* 52 (December 1965), pp. 1-19.

4. Among the other American artists who created tributes
to Milton's poems are Harriet Hosmer, Robert W. Weir,
and George Inness.

5. Cole's journal entry for June 7, 1831, draft of a letter to his
parents from Florence. Louis Legrand Noble, *The Life and
Works of Thomas Cole* (Cambridge, Mass.: Harvard University
Press, 1964), p. 93.

6. Susan Ilene Fort and Michael Quick, "L'Allegro/Il
Penseroso," *American Art: A Catalogue of the Los Angeles County
Museum of Art Collection* (Los Angeles: Los Angeles County
Museum of Art, 1991), p. 115.

7. Thomas Cole sketchbook no. 7, Detroit Institute of
Arts, pp. 56-57.

8. Noble, *Thomas Cole*, p. 266.

9. Fort and Quick, "L'Allegro/Il Penseroso," pp. 114, 116-
117.

When William Wetmore Story arrived in Rome in 1847, he was a twenty-eight-year-old, Harvard-educated lawyer essentially untrained in the formal techniques of modeling sculpture. A commission Story received for a monument to his deceased father, Judge Joseph Story, had emboldened him to move to Italy, where he intended to carve the portrait. This apparently dramatic change of career from lawyer to artist was a natural choice for this multi-talented amateur draftsman and modeler of clay, who had witnessed, first-hand, the growing popularity of sculpture in Boston. Between 1847 and 1855, Story took two long trips abroad, during which time he studied the works of antiquity and completed his father's monument. By 1856, Story resolved to pursue his career as a sculptor in Italy and only grudgingly returned to the United States thereafter. In 1856, Story and his wife, Emelyn, settled into spacious quarters on the second floor of the Palazzo Barberini, where they became celebrated hosts to the Anglo-European elite. The sculptor maintained a studio on Via San Nicolo di Tolentino, until he moved to a much enlarged working space at No. 7 Via San Martino a Macao in 1876. Despite the commission for his father's sculpture, Story's next ten years of effort in sculpture were rewarded by relative obscurity, during which time he contemplated a return to his law practice. Fortunately, public curiosity about him was aroused by Nathaniel Hawthorne, who saw Story's Cleopatra (1858, Los Angeles County Museum of Art) in the artist's studio and described the figure in The Marble Faun, (cat. 162). When Pope Pius IX included Cleopatra and The Libyan Sibyl (1860, The Metropolitan Museum of Art, New York) in the Roman pavilion at the International Exhibition of 1862 in London, Story's sculptures were hailed by the international press. It was not long before the sculptor's studio became an essential stop on the itinerary of wealthy visitors from Europe and America. Story's two-volume guidebook, Roba di Roma was published in London by Chapman and Hall in 1862 (cat. 163). To

this day it is highly valued for its quiet celebration of the public and private life of nineteenth-century Italy. He worked as a sculptor until late in life, relinquishing his studio to his son, the sculptor Thomas Waldo Story (1854-1915) only two years before his death in 1895.

William Wetmore Story

16. *Arcadian Shepherd Boy*, modeled
1850, carved 1855
Marble, h. 58 in., w. 28 in., d. 21 in.
Signed: w.w. story. fect. a. 1855
*Courtesy of the Trustees of the Public Library of the City of
Boston*

As one of the first full-length marble fig-
ures attempted by Story, *Arcadian Shepherd
Boy* marks the artist's change from sober
portraiture to ideal sculpture.[1] Drawn from
classical sources, the figure indicates a rad-
ical change of heart by this nativist who,
ten years earlier, had urged Americans to
seek inspiration from their own country
instead of ancient Greece and Rome.[2]
However, by the time he arrived in Europe,
Story had revised his opinions and pur-
posefully visited museums in England,
France, Germany, and Italy, where he
sketched and educated himself in the mas-
terpieces of his chosen medium.[3]

Story's idea for this sculpture may have
been inspired by two paintings by Wash-
ington Allston of a seated Italian shepherd
boy. Story could have seen the paintings in
Allston's Cambridgeport home when he
visited the artist in 1837, through the ef-
forts of Charles Sumner.[4] Another inspi-
ration may be a pastoral painting entitled
The Piping Shepherd. This copy after Aelbert
Cuyp had been owned by the Boston
Athenaeum since 1837.[5] The position of
the shepherd's legs in the painting and the
pastoral flute he plays may have offered
Story a point of departure for his sculp-
ture, which he embellished with classical
drapery and details.

The rustic subject matter of the *Arcadian
Shepherd Boy* was close to Story's heart, for
he and his family spent memorable days in
such country residences as Bagni Caldi in
Lucca, Sorrento, Castel Gandolfo, and the
hill towns near Siena. His love of the Ital-
ian countryside is known from his numer-
ous vivid descriptions of the landscape and
its sturdy, handsome inhabitants.[6]

The figure of the *Arcadian Shepherd Boy*
was modeled by Story in 1850 during a
summer spent in England. One of his
hosts, the English poet Leigh Hunt, later
commented upon the figure in a congratu-
latory letter to Story expressing confidence
in the sculptor's efforts, writing that

"America will one day possess an Italy of
her own."[7] The figure was set aside until
spring of 1853, when Story completed the
finishing touches at the end of the summer.

Like most of Story's sculptures, *Arcadian
Shepherd Boy* is of a pyramidal composition,
a shape said by his critics to be proof of
his weakness in modeling standing figures.
The sculpture follows at least two known
classical works, the *Spinario* (Capitoline
Museum, Rome) and *Seated Mercury* (Na-
tional Museum, Naples) in its placement
of a seated figure upon a tree stump or low
rock. The young man's head is tilted in an
attitude of thoughtful listening, while he
plays the pastoral flute. Pan-pipes and a
laurel wreath lie against the tree, signifying
the shepherd's faun-like nature, with its
gift of music; a lizard scampers along the
ground as further evidence of the shep-
herd's natural surroundings. Much of this
imagery was to be reprised in Harriet
Hosmer's later *Sleeping Faun* (after 1865, cat.
33). The surface of the figure has a soft,
matte appearance, while such special at-
tributes as the pan pipes and wreath are
polished to a high finish; the rougher treat-
ment of the tree and subsidiary elements
emulates the wooded setting.

This ambitious sculpture was a strong
indication that Story had put away his law
briefs for good and was firmly set upon
the path of an artist. Its purchase by sub-
scription for the Boston Public Library in-
dicated the interest and acclaim of his
peers, mostly relatives and colleagues,
across the Atlantic. Despite the promi-
nence of the sculpture in Boston, it
strangely did not elicit further requests for
commissions of ideal sculpture from
Story, who was to toil for another seven
years in Italy before his work was ac-
claimed at the London International Exhi-
bition of 1862.

J. FALINO

1. *Little Red Riding Hood* is a lost work by Story, which sur-
vives as a sketch dated about 1853. Jan M. Seidler, "A Criti-
cal Reappraisal of the Career of William Wetmore Story
(1819-1895), American Sculptor and Man of Letters." Ph.D.
diss., Boston University, 1985, vol. 1, pp. 278-79, notes 52, 53.
p. 387-88.

2. William Wetmore Story, *Nature and Art: A Poem* (Boston:
Charles C. Little, and James Brown, 1844).

3. Among the works admired by Story was the *Barberini Faun*
in the Munich Glyptothek. Seidler, "Career of William
Wetmore Story," vol. 1, pp. 289-91.

4. Seidler, "Career of William Wetmore Story," vol. 1,
p. 83; and p. 140 note 135.

5. The copy was painted about 1835 after Cuyp's painting in
the Louvre, and was accepted by the Boston Athenaeum in
1837. Jonathan P. Harding, *The Boston Athenaeum Collection:
Pre-Twentieth-Century American and European Painting and Sculp-
ture* (Boston: The Boston Athenaeum, 1984), p. 72, plate 79.
Accession number U.R. 1942.1837. Two works by Thor-
valdsen that may also have influenced Story are *Mercury, The
Slayer of Argus* (1819), and *The Shepherd's Boy* (1820), illustrated
in J.M.Thiele, *Thorwaldsen and His Works*, Professor Paul C.
Sindig, transl., (New York: John G. Unnevehr, 1869), pp. 11-
12; 14-15, plates 97, 100.

6. A sample of these descriptions is found in a letter from
William Wetmore Story to Christopher Pearse Cranch,
Bagni di Lucca, August 22, 1853, in *The Life and Letters of
Christopher Pearse Cranch*, Leonora Cranch Scott, ed. (Boston:
Houghton Mifflin Company, 1917), pp. 192-95.

7. Seidler, "Career of William Wetmore Story," vol. 1,
p. 286.

Robert Scott Duncanson

Born Seneca County, New York, 1821(?);
died Detroit, Michigan, 1872

*Robert Scott Duncanson was the first landscape
painter of African-American descent to gain in-
ternational recognition. He spent his childhood in
Wilberforce, Ontario, a free black settlement, and
in 1832 his family moved back across the border to
Monroe, Michigan. In 1838 Duncanson adver-
tised in the local Monroe newspaper as a house
painter, a trade he probably learned from his fa-
ther. Around 1840 he moved to Mt. Healthy,
Ohio, a town outside Cincinnati; here he began to
paint portraits and secured his first and largely
abolitionist patronage. He supplemented his in-
come from painting by working as a daguerreo-
typist. Throughout the 1840s and early 1850s
Duncanson divided his time between Cincinnati
and Detroit.*

*Duncanson went to Europe three, perhaps four
times, (possibly before 1842, 1853-54, 1864-67
and 1870-71) but only once, it seems, to Italy.
This 1853-54 trip was probably sponsored by the
Cincinnati Anti-Slavery League. Duncanson
traveled with fellow-artists William Sonntag
(1822-1900) and Sonntag's student John Robin-
son Tait (1834-1909). Armed with a letter of
introduction to Hiram Powers from their mutual
patron Nicholas Longworth, Duncanson must
have at least visited Florence, where Powers had
established his studio in 1837. The rest of Dun-
canson's itinerary is unknown, but based on the
subjects of extant paintings, other destinations on
this trip included Tivoli and Pompeii; he also
traveled to England and Scotland, where he exhib-
ited to critical acclaim.*

*After this European sojourn Duncanson re-
turned to Cincinnati, again alternating residence
between there and Detroit. In 1863 he left the
uncomfortable wartime atmosphere in the United
States for Montreal, where he stayed for about a
year prior to his leaving again for the British Isles.
In 1867 Duncanson went back to Cincinnati,
remaining there until he left on a final trip to
Scotland in 1870-71. He died in Detroit
in 1872.*

Robert Scott Duncanson

17. *Recollections of Italy, 1864*
Oil on canvas, 21 x 39¾ in.
Signed l.l.: R. S. Duncanson/1864/Montreal
*Wadsworth Atheneum, Hartford, Conn., The Dorothy Clark
Archibald and Thomas L. Archibald Fund*

Duncanson painted *Recollections of Italy* a
decade after his 1853-54 trip to Europe. All
of the almost dozen known Italian compo-
sitions by Duncanson were executed after
his travels "from sketches taken while
abroad."[1] He was commissioned to paint
Italian subjects as soon as he returned to
Cincinnati in January 1854,[2] and he con-
tinued to draw on his Italian material
throughout his career.

Recollections of Italy is a composite view in-
cluding ruins of ancient Tivoli, with the
round Temple of Vesta (also known as the
Temple of the Sibyl) on the right. Dun-
canson called Tivoli "one of the grandest
scenes in Italy,"[3] and painted at least three
idealized versions of it. The compositions
range in size from a tiny souvenir to a full-
size landscape, with *Recollections of Italy*
falling in the middle.[4] While none of the
paintings is topographically accurate, the
site is identifiable by the presence of the
Temple of Vesta.

Duncanson's *Recollections of Italy* follows
the American Arcadian tradition estab-
lished in the 1830s by Thomas Cole (see
cats. 13-15). Duncanson, in fact, acknowl-
edged his debt to the earlier master by
copying Cole's *Dream of Arcadia* (cat. 13).[5] In
Recollections of Italy, Duncanson has created a
classical landscape in Cole's style with the
view to the distant mountains framed by
the Temple of Vesta on the right and trees
on the left. Ancient architectural rubble
litters the foreground on either side of a
stream that gently cascades from a placid
lake in the middle ground. The waterfalls
of the stream may suggest but bear no re-
semblance to the actual Falls of Tivoli. To
the right of the stream two goatherds and a
contadina converse as goats rest nearby. A
fourth figure reclines to the left of the
stream beneath the tallest tree. On the far
shore of the lake a cluster of buildings
somewhat reminiscent of the temples at
Paestum huddles in decay, once accessible

by the remains of a bridge or aqueduct across the water. The ruins of a hill town of indeterminable date are visible in the distance and the entire scene is bathed in a golden light.

Unlike Cole's *Dream of Arcadia*, Duncanson's landscape clearly takes place contemporaneously rather than in the past. The figures are dressed in nineteenth-century attire, not classical drapery, and rather than representing the pristine architecture as it once was, Duncanson painted the decaying remains of the great structures.[6] Even though Duncanson's composition lacks topographical exactitude, his "recollections of Italy" are rooted in his experience of the place and make Italy a present-day pastoral.

K. QUINN

1. William Miller to Isaac Strohm, April 10, 1854, Cincinnati Historical Society. Miller discusses Duncanson, "he has been executing some beautiful Italian 'compositions' from sketches taken while abroad." None of the sketches have survived.

2. Joseph D. Ketner II, "Robert Duncanson" in J. Gray Sweeney, *Artists of Michigan from the Nineteenth Century*, (Muskegon, Mich.: The Muskegon Museum of Art, 1987), p. 64. Mr. Ketner has been extraordinarily generous in sharing his research on Duncanson. See also Ketner's article "Robert S. Duncanson (1821-1872): The Late Literary Landscapes," *The American Art Journal* 15 (winter 1983), pp. 35-47; Guy McElroy, *Robert S. Duncanson: A Centennial Exhibition*, (Cincinnati: Cincinnati Museum of Art, 1972); and Alan Pringle, "Robert S. Duncanson in Montreal," *The American Art Journal* 17 (autumn 1985), pp. 28-50.

3. Robert Scott Duncanson to Junius Sloan, January 22, 1854, Newberry Library, Chicago.

4. *Italian Landscape*, 10 x 8 in., includes the Temple of Vesta and is one of a pair of souvenirs painted in 1861 (private collection). *Temple of the Sibyl* (1859) is 36 x 60 in. (private collection).

5. Duncanson's landscapes in general reflect the style of the Hudson River School.

6. Cole's Arcadian landscapes in general include classical figures. It should be noted that William Sonntag, Duncanson's traveling companion in Italy, painted a composition similar to Duncanson's entitled *Classical Landscape with Temple of Venus* (about 1859, The Corcoran Gallery of Art, Washington, D.C.) which also includes contemporary figures.

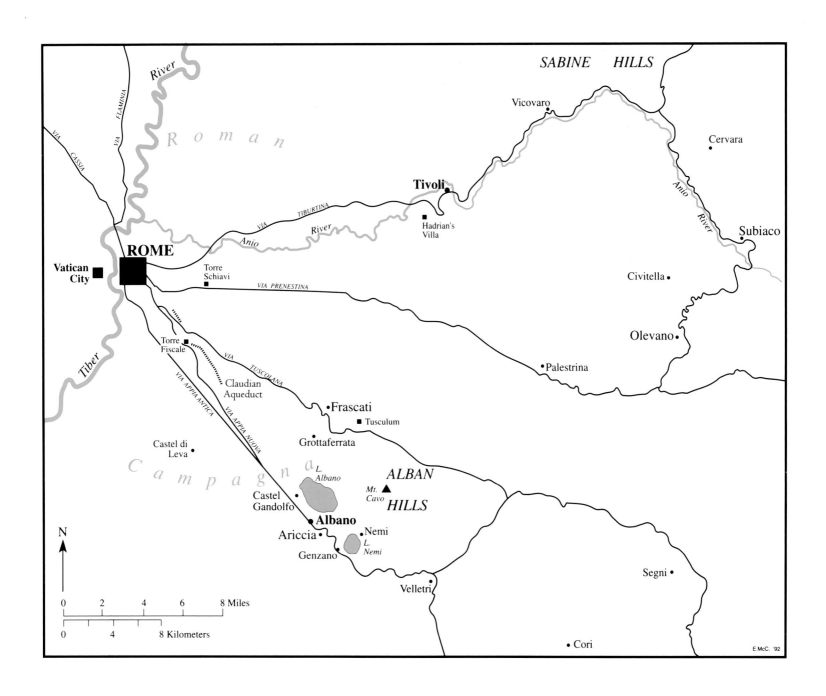

River

SABINE HILLS

VIA FLAMINIA

VIA CASSIA

R o m a n

Vicovaro

Cervara

Tivoli

VIA TIBURTINA

Anio *River*

Hadrian's
Villa

Anio River

Subiaco

ROME

**Vatican
City**

Torre
Schiavi

VIA PRENESTINA

Civitella

Torre
Fiscale

VIA TUSCOLANA

Olevano

Tiber

VIA APPIA ANTICA

Claudian
Aqueduct

VIA APPIA NUOVA

•Palestrina

•**Frascati**

■ Tusculum

Castel di
Leva •

Grottaferrata

C a m p a g n a *L.
Albano*

ALBAN

Castel
Gandolfo

*Mt.
Cavo* ▲

HILLS

Albano

Nemi
*L.
Nemi*

Ariccia

Genzano

Segni •

Velletri

N

0 2 4 6 8 Miles

0 4 8 Kilometers

• Cori

E.McC. '92

Washington Allston

18. *Self-Portrait*, 1805
Oil on canvas, 31½ x 26½ in.
Signed l.c.: W. Allston / Romae 1805.
Museum of Fine Arts, Boston, Bequest of Miss Alice Hooper

The one published account of Washington Allston while he was in Rome called him "a noble Englishman from Carolina" and a relation of George Washington.[1] It described a young man eager to practice landscape, history painting, and even sculpture. "He has a decided talent not only in art but also in literature, in the category of poetry," it added.[2] In this self-portrait, painted between March 1805 and the end of the year, Allston depicts himself in accordance with the impression he gave others, as a fastidiously dressed gentleman. Declining to include the usual attributes of the painter, he suggests that his mind is the chief tool of his trade.

The cool, aloof figure cut by Allston is in part attributable to the Neoclassical influence of Jacques-Louis David's school, which was as strong in Rome as in Paris, especially among younger artists. Here the technique is somewhat naive and flat, similar to the style practiced in Rome by the German artists Johannn Friedrich Overbeck and Peter von Cornelius some years later. This quality, which in Allston's case may have come from his tentative grasp of David's style, seems to have been encouraged in Rome, where simplicity and purity in figural representations were promoted by such leaders of the new school as Bertel Thorvaldsen and Joseph Anton Koch.

Despite the attention given to his fine clothing and to the Phi Beta Kappa key on his vest, Allston's composition is remarkable for its restraint. It is more severely simple even than his portrait of Coleridge (1806, Fogg Art Museum, Harvard University, Cambridge, Mass.), which he began a few months later. His self-portrait trims away superfluous gesture and background, the result is a new beauty based on essentials. The color scheme is limited to black, gold, and a medley of subdued grays that match Allston's gray eyes and set off his pale complexion. The colors gain subtlety and depth from the glazing he had learned in London, and for which he became well known in Rome.

The most intriguing aspect of Allston's self-portrait is its enigmatic background, which shows a patched masonry wall, a stone ledge, and an archway (or perhaps an empty niche). This vaguely classical architecture substitutes blankness where the viewer would expect images of a sitter's interests, experiences, or profession. Even as an emblem of Allston's environment, it is not identifiable as an actual structure and so removes him from contemporary Rome to an imagined, eternal world.

Although the setting is unusual for a portrait of the early nineteenth century, similar walls of masonry occur in several portraits of the sixteenth and seventeenth centuries that Allston would have seen. These include Raphael's self-portrait in the Uffizi Gallery and three paintings then in the Louvre: a self-portrait of the young Andrea del Sarto; a Rubens portrait of Nicholas Roncox; and a self-portrait of Rembrandt as a young man, which has an archway about where Allston placed his. By adopting their devices, Allston indicates his intention to hew to the traditions of artists in the sixteenth and seventeenth centuries, admiring the mystery of antiquity as they did.

D. STRAZDES

1. Giuseppe Antonio Guattani, *Memorie enciclopediche Romane sulle belle arti, antichita. . .* 5 vols. (Rome: Salomini, 1806), vol. 1, p. 64.
2. Ibid., p. 65.

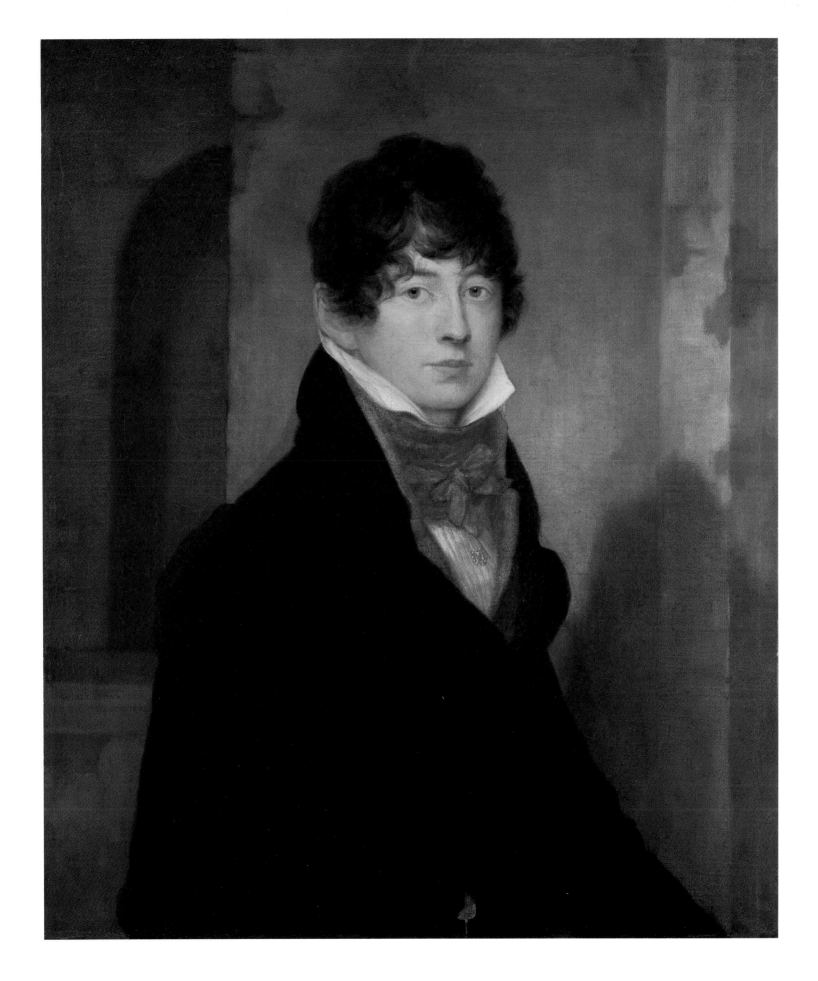

Thomas Cole

19. *Interior of the Colosseum, Rome,*
 about 1832

Oil on canvas, 10 x 18 in.
Collection of The Albany Institute of History & Art,
Albany, New York

Thomas Cole was the first of many American landscape painters to choose the Colosseum itself as a subject. The Colosseum fascinated Cole, who collected plants from its walls[1] and sketched the ruin's contours in pencil and oil.[2] After leaving Rome in early May, 1832, he wrote:

> I would select the Colosseum as the object that most affected me – Beautiful as well as stupendous It looks like a work of Nature not of Man for the regularity of art is in great measure lost in ruin, and the luxurious herbage that clings around, as if to "mantle its distress," completes the illusion . . . to climb its remaining steps, & to wander through its long arched passages, treading where Emperors & hundreds of thousands of Ancient Rome have trodden gives the mind to melancholy though delightful meditation.[3]

Cole's words reflect his fascination with changes wrought by time and nature, a recurring theme in his work,[4] as well as his grasp of the important elements of the picturesque. He was well versed in the power of ruins to inspire viewers' meditation,[5] and was familiar with Byron's famous description of the Colosseum in *Manfred,* written in Rome in 1817-18.[6] To the modern tourist, the Colosseum was "a striking image of Rome itself, – decayed, vacant, serious, yet grand."[7]

Construction on the Colosseum began in A.D. 72 under the Emperor Vespasian, and it was dedicated in A.D. 80 by his successor, Titus. For nearly 900 years it hosted all manner of spectacles, ranging from gladiatorial contests and religious martyrdoms to theatrical events. It was flooded for mock naval battles, and served as a fortress and a hospital before being partially dismantled to provide building stones for other projects. Originally called the Flavian Amphitheater, the building was

Fig. 1. *Interior of the Colosseum, Rome.* Photograph, 1990.

Fig. 2. Christoffer Wilhelm Eckersberg (Danish, 1783-1853), *Det indre af Colosseum med en gaende mand i forgrunden,* 1815-16. Oil on canvas. Private Collection.

given its more common name by the Venerable Bede, who penned the proverb: "While stands the Coliseum, Rome shall stand;/ When falls the Coliseum, Rome shall fall;/ And when Rome falls, the world."[8] A series of earthquakes from the fifth to the eighteenth centuries damaged the structure severely, and restoration efforts began in earnest early in the nineteenth century.

In 1744 Pope Benedict XIV consecrated the Colosseum to the memory of the Christian martyrs who died there. He erected the black cross in the center of the floor, and the stations of the cross around its perimeter, which were removed during the 1870s when the floor was excavated (fig. 1).[9] Flanked by the stations of the cross, and facing the large crucifix in its center,

the viewer focuses on these religious emblems while facing East, as though toward an altar. This cross held special significance: local legend promised the redemption of sins for those who kissed it.[10] The shadow cast by the cross indicates it is early morning, before the arrival of the throngs of tourists depicted in many European prints and paintings of the structure.[11] Cole's emphasis on the elements of Christianity is in keeping with his own intensely spiritual nature. His fluid brushwork captures the play of light over the fragmented and overgrown surface of travertine and brick, lending it the quality of a completed oil sketch rather than a highly finished painting.

C.W. Eckersberg's *Det indre af Colosseum* (fig. 2) depicts the small wooden church dedicated to S. Maria della Pieta, built into the wall just to the left of the east entrance.[12] In this painting, executed fifteen years earlier than Cole's, the restoration of the upper tier of the structure is more complete, suggesting that Cole deliberately rusticated the Colosseum, its irregular contours lending a patination of age and emphasizing the sense of picturesque melancholy Cole associated with the scene.[13] Although Cole found the Colosseum the most potent of the Roman ruins, he did not return to the subject. Never exhibited publicly, this work remained in Cole's possession throughout his life.

E. JONES

1. Cole collected plants, which he pressed in an album later belonging to his friend and pupil Frederic Church, now at Olana, Church's home in New York. Interest in the many plants flourishing in the Colosseum is evident by 1813, the year Antonio Sebastiano published *Flora Colisea,* which identified more than 200 species of plants growing there. See Margaret Scherer, *The Marvels of Ancient Rome* (London: Phaidon Press, 1955), p. 87.

2. Cole's sketchbook (Detroit Institute of Arts no. 39.566, p. 89) contains a pencil and charcoal study of the Colosseum, bounded by a thick pencil border, probably a record drawing made after the painting. Sketchbook 39.565 con-

tains a pencil sketch of the Colosseum on p. 17, dated 1832. A sketch in oil on paper of the Colosseum (39.584A) depicts a smaller slice of the interior of the Colosseum.

3. Cole kept part of his journal in his sketchbooks. This entry is dated Naples, May 14, 1832 (Detroit Institute of Arts sketchbook 39.566). Cole transcribed this passage in his journal, in the New York State Library, Albany N.Y., Manuscripts and Special Collections division. Louis Legrand Noble would paraphrase this passage in his book, *The Life and Works of Thomas Cole* (Cambridge: Harvard University Press, 1964), pp. 115-116.

4. This perspective is clearly articulated in Cole's "Essay on American Landscape," in which he describes the eventual decay of man's most resilient achievements. William Vance also takes up Cole's longstanding interest in "the transmutation of man-made objects by time and nature," in his chapter on the Colosseum in *America's Rome* (New Haven: Yale University Press, 1989), vol 1, p. 45.

5. Cole did quote the works of Mrs. Felicia Hemans, who wrote "The Widow of Crescentius":

Each stone, where weeds and ivy climb,
Reveals some oracle of Time;
Each relic utters Fate's decree,
The future as the past shall be.

The Poetical Works of Mrs. Felicia Hemans (Philadelphia: Grigg & Elliot: Philadelphia, 1845), pp. 127-133; quoted in Bruce W. Chambers, "Thomas Cole and the Ruined Tower," *Currier Gallery of Art Bulletin* (1983), pp. 17 and 30, note 27. Cole was also likely familiar with Volney, *The Ruins: or Meditations on the Revolutions of Empires*, written in 1799.

6. Scherer, *The Marvels of Ancient Rome*, pp. 86ff. Both *Manfred* and *Childe Harold's Pilgrimage* contain descriptions of the Colosseum; both were written while Byron was in Rome during the winter of 1817-18.

7. Josiah Conder, *Italy*, (London: J. Duncan, 1834), vol. 3, p. 229.

8. Byron's translation of Bede's Latin in *Childe Harold's Pilgrimage*, as cited in Scherer, *The Marvels of Ancient Rome*, pp. 8ff.

9. Excavations of the interior of the Colosseum did not unearth the subterranean levels until the 1870s; over the ages, debris and dirt had filled this space to the level visible in Cole's painting.

10. *Murray's Handbook for Central Italy and Rome* (London: John Murray, 1850), pp. 339-340. Nathaniel Hawthorne describes this in *The Marble Faun* (New York: Washington Square Press, 1958), p. 125; quoted in Lois Dinnerstein, "The Sig-

nificance of the Colosseum in the First Century of American Art" in *Arts Magazine* 58 (June 1984), pp. 116-118. This cross was removed when the subterranean levels were exposed. In 1927 it was restored to the inner perimeter of the Colosseum.

11. One such example is a watercolor by John 'Warwick' Smith (British, 1749-1831) depicting a pilgrim kneeling to kiss the cross, now in the Yale Center for British Art, New Haven. See Louis Hawes, *Presences of Nature: British Landscape 1780-1830* (New Haven: Yale Center for British Art, 1982), pp. 146-7.

12. Statens Museum for Kunst, *Danske Malere I Rom, i det 19. arhundrede* (Copenhagen: Staten Museum for Kunst, 1977), p. 28.

13. Gaspar van Wittel (1652/3-1736) painted a view of the interior of the Colosseum (private collection) prior to the addition of the central cross and Stations of the Cross. The house-like pulpit in Eckersberg's painting appears in this work as well; either it was removed between 1815 and 1832, or Cole simply omitted it from his painting. See Giuliano Briganti, *Gaspar van Wittel* (Rome: Ugo Bozzi Editore, 1966), p. 181, no. 39.

Asher B. Durand

Born Jefferson Village [Maplewood, New Jersey], 1796; died Maplewood, New Jersey, 1886

In June 1840, with money advanced by Jonathan Sturges, the son-in-law of his patron Luman Reed, Durand embarked on his only trip abroad. The year-long voyage was the customary tour of Europe's art centers and scenic beauties, which progressed from London to Paris, then overland to Rome. Leaving his wife and children behind because of the expense, he undertook the journey with utmost seriousness. In the countryside he sketched constantly and in the cities he studied the old masters assiduously.

Durand arrived in London with the painters John Kensett, John Casilear, and Thomas Rossiter, and spent seven weeks meeting artists and visiting galleries. He then devoted a month to seeing Paris, the Low Countries, and the Rhine valley, and another month to touring Switzerland. In October 1840 he crossed into Italy, visiting lakes Como and Maggiore, and then Milan, Venice, and Bologna. By November he was in Florence, enjoying the company of Horatio Greenough, copying old masters, and painting a view of the city in the manner of Claude Lorrain.

Durand spent the winter of 1840-41 in Rome, attending a life academy, making studies from the live model with Casilear, copying paintings, and working on a landscape to send back to New York for exhibition. The arrival of the painter Francis W. Edmonds in February led to an excursion to Tivoli and a month-long trip in March to southern Italy (Naples, Herculaneum, Pompeii, Sorrento, Amalfi, and Paestum) with Edmonds, Casilear, and another young American.

By early April 1841 Durand and Edmonds were back in Rome preparing their departure. Leaving Italy, they stopped for a week in Florence, passed quickly through Bologna and Ferrara, and stayed three days in Venice. On May 6, three days after reaching Milan, they crossed the Simplon Pass and on May 15 arrived in Paris. Five weeks later, Durand was in Liverpool awaiting a steamer to New York where, for the next two years, he painted landscapes based on drawings he had made abroad.

Asher B. Durand

20. *Head of a Roman,* 1840-41
Oil on canvas, 29½ x 24½ in.
The New-York Historical Society, Gift of Mrs. Lucy M. Durand Woodman

Head of a Roman is one of numerous painting exercises, many of them now lost, that marked the weeks Durand spent in Florence and Rome in pursuit of the techniques necessary to a history painter. One of his priorities in both cities was copying from the old masters. In Florence, after finding that other copyists had claimed the best-known paintings, he settled on a picture of Ruth and Naomi and a self-portrait by Rembrandt. In Rome's Galleria Colonna he copied a portrait bust of a monk (1841, The New-York Historical Society) believed to be by Titian.

At the same time, Durand made oil studies from life. The first of these was the head of a Turkish street vendor who agreed to pose for him in Florence.[1] In Rome, his models included a donkey that had to be hauled into his studio by ropes.[2] He painted a woman and her daughter in Italian costume, availing himself of the abundance of townspeople who, as he wrote his wife, "make a business of sitting for artists, 3 or 4 hours at a stretch, for which they receive 5 pauls, about 50 cents."[3] However, his main interest continued to be oil studies of heads. These provided Durand with grand and exotic characters that he intended to use in paintings whose themes he had not attempted before.

Durand reported painting "some of the old bearded patriarchs that go about the streets here looking as if they belonged to a period at least 2000 years ago."[4] Casilear estimated that he produced a dozen of them.[5] *Head of a Roman* is one of four that survive, all now in The New-York Historical Society. Two, who may be Roman Jews, have flowing locks, uncut beards, and heavy robes suggestive of Old Testament prophets. The other two, including the one shown here, are also ancient-looking personages, but of a different type, perhaps laborers, soldiers, or vagabonds.

These studies are similar to a preliminary history-painting exercise called "tête d'expression," a mainstay of French academic instruction also adopted in Rome, where French influence was strong and artists from all regions of the country came for formal training.[6] Durand's polished naturalism was in keeping with that of contemporary Italian history painters, who populated their romantic melodramas with characters who nonetheless seem to be "real" people. Durand, however, showed an ambivalence toward the staged emotions then expected of Continental history painters. Instead of proceeding with fully-fleshed compositions, he continued to paint solitary figures, as shown by his most elaborate Roman production, *Il Pappagallo* (about 1841, The New-York Historical Society), an ideal portrait in the manner of the old masters. *Head of a Roman,* even with his bared chest, looks more like a portrait than part of a history painting, and was probably considered as such when exhibited at the National Academy of Design in 1842. Here, Durand seemed unwilling to exceed simple transcription, as if the straightforward human presence were more interesting to him than theatrical illusion.

D. STRAZDES

1. John Durand, *The Life and Times of A.B. Durand* (New York: Da Capo Press), 1970, p. 157.

2. John Durand, ibid., p. 163.

3. Asher B. Durand to Mary Durand, January 15, 1841. Asher B. Durand Papers, New York Public Library.

4. Ibid.

5. John Casilear to John Kensett, February 1, 1841, John Frederick Kensett Papers, New York State Library, Albany.

6. See Sandra Pinto, "La promozione delle arti negli stati italiani dall'età delle riforme all'Unità," in *Storia dell'arte italiana: Dal cinquecento all'ottocento,* (Rome: Einaudi, 1982), vol. 2, pp. 957-80.

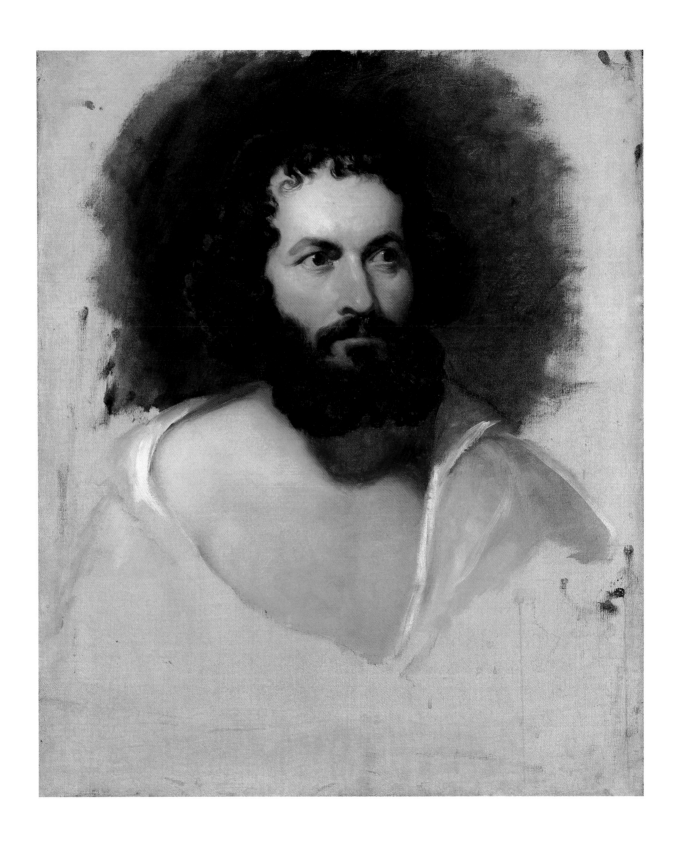

Thomas Crawford

21. *Christian Pilgrim in Sight of Rome*,
 modeled 1845/46; carved 1847
Marble and bronze, h. 31, w. 10¾, d. 11 in.
Signed on back of base: CRAWFORD FEC^T ROMA 1847
The Boston Athenaeum, Gift of the heirs of Eliza Callahan Cleveland, 1914

After *Orpheus and Cerberus* was exhibited in Boston, a friend of Charles Sumner's, Edward Austin, asked Crawford to make him a sculpture "without resorting to the fields of Mythology in search of a subject."[1] The figure of a Christian pilgrim allowed the sculptor to present an idealized subject while maintaining a high moral tone. Boston patrons competed for the work even before its completion, with the result that Austin apparently deferred to Charles Perkins, who purchased it for his sister, Mrs. Henry Russell Cleveland.

The pagan origins of classicism notwithstanding, the marriage of religious subject matter to classical form was greeted enthusiastically wherever Neoclassicism was introduced. An international trend toward church buildings and religious sculptures in the Grecian style began around 1790 and gained strength in the next decades. The first American sculptors to turn to such themes did so between 1837 and 1845. Greenough's *Head of Christ* (1837, Fogg Art Museum, Harvard University, Cambridge, Mass.) was followed by his *Lucifer* (1841-42, Boston Public Library), Hiram Powers's *Eve Tempted* (1839-42, National Museum of American Art, Smithsonian Institution, Washington, D.C.), Henry Kirke Brown's *Ruth* (1845, The New-York Historical Society), and several works by Crawford.

In 1842 Crawford made his first marble sculpture with a religious theme, a relief called *Christ Blessing the Children* (1842-43, unlocated). This was followed by two more reliefs, *Christ and the Woman of Samaria* (about 1846, Villa Crawford, Sant'Agnello di Sorrento) and *Christ Ascending from the Tomb* (about 1846, location unknown), all indebted to Thorvaldsen's example. Between the fall of 1845 and the summer of 1846 Crawford conceived and executed *Christian Pilgrim*, a free-standing work about two-thirds life size.

Seeking a treatment that would remove the subject from time and place, Crawford seems to have looked to Thorvaldsen's statue of the Apostle James the Greater (1821-39), which belonged to his ambitious assemblage of Christ and the Apostles for the Church of Our Lady in Copenhagen, a work that occupied his energies until 1842. As the plaster models for the commission long dominated Thorvaldsen's studio in Rome, Crawford could not have failed to notice them. Another inspiration for the theme *Christian Pilgrim* may have been the six popular paintings Sir Charles Eastlake made between 1827 and 1841, all titled *Pilgrims Arriving in Sight of Rome*, all crowded scenes of contemporary peasants in the manner of Leopold Robert's dramatic genre.

Christian Pilgrim portrays a young woman, wearing a cloak over a loose shift and sandals, who steps among barren rocks over broken pavement where blades of grass grow in the fissures, probably symbolic of hope. She carries the traditional emblems of the pilgrim, a scallop shell on her cloak and a thin bronze staff surmounted by a cross. With one hand on her breast in the usual gesture of avowal, she gazes upward.

In this work Crawford put to a new use the surface finish he employed on *Orpheus and Cerberus* (cat. 9), in which the skin of the marble appears cool, almost lusterless, in imitation of Greek high classical sculpture. This "chaste" finish he found equally appropriate in alluding to the unsensual, otherworldly temperament of his *Christian Pilgrim*. He heightened his marble's whiteness by setting it off with a bronze staff, which also offers a more delicate support than would be possible in stone. Admiring the completed effect, a writer in the *American Quarterly Church Review* in 1858 remarked, "Would that there had been more Christians in the flesh to encourage the devotional imaginings of the sculptor!"[2]

D. STRAZDES

1. Crawford to Charles Sumner, Aug. 2 1845, Houghton Library, Harvard University, Cambridge, Mass.
2. S. Eliot, "Thomas Crawford," *American Quarterly Church Review and Ecclesiastical Register* XI (April 1858), p. 42, quoted in Lauretta Dimmick, "Catalogue of the Portrait Busts and Ideal Works of Thomas Crawford," Ph.D. diss., University of Pittsburgh, 1986, p. 356.

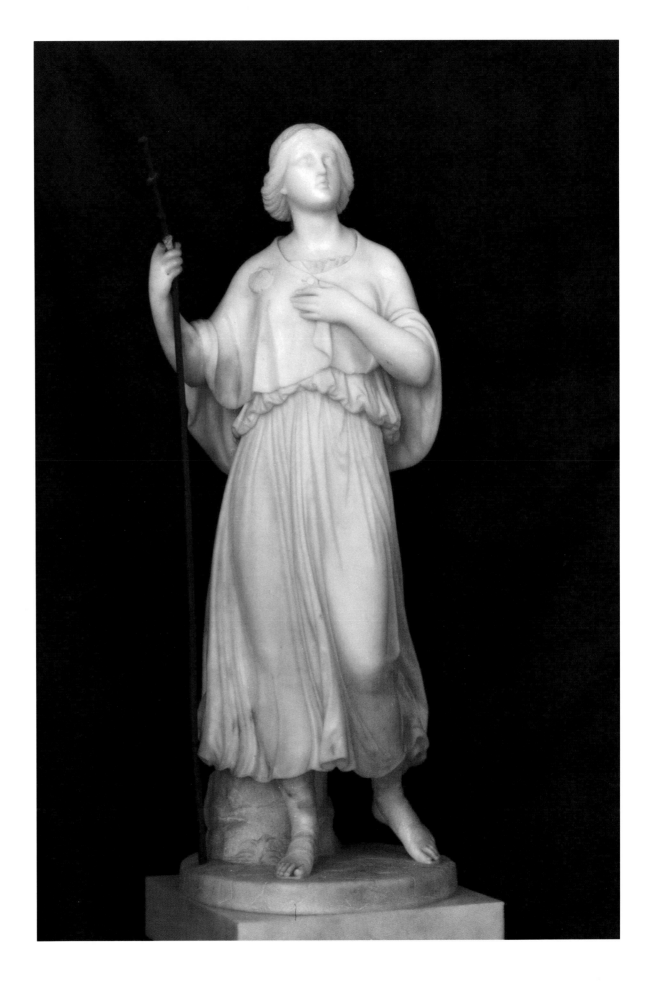

Thomas Hicks

Born Newtown, Pennsylvania, 1823;
died Trenton Falls, New York 1890

Thomas Hicks was a youthful prodigy who won a major reputation with his portraits and genre paintings. In his teens he worked with his cousin Edward Hicks, went briefly to the Pennsylvania Academy of the Fine Arts to draw casts of classic sculpture, then moved to New York in 1838 to study at the National Academy of Design, where he exhibited for the first time the following year.

In 1845, Hicks traveled to Europe, going first to London, then to Paris, making copies in both cities. By October of 1845, he was in Rome where he shared a studio with John F. Kensett on the Via Margutta. Among his first works in Rome was Italia, a half-length ideal female figure. In the spring of 1846, on the last night of the Carnival, he was stabbed in the back with a stiletto, but recovered. In July, 1846, he joined Kensett in the Alban and Sabine hills near Rome for an extensive sketching tour, and returned to Rome in early October. During the winters in Rome, Elizabeth Cranch reported in her journal, Hicks dined regularly at the Lepre, a popular trattoria in Rome, with such friends as the Cranches, Luther Terry, George and Burril Curtis, Benjamin Champney and Thomas Crawford; later, they would go to the Caffè Nuovo or "to see the Coliseum by moonlight."

In July 1847, Hicks joined Kensett and the Curtis brothers in Florence for a trip via Bologna and Ferrara to Venice, where he remained until September, when he returned to Rome for the winter. Finally in June 1848, Hicks left for Paris where he studied with Thomas Couture; George Curtis noted in his journal that he often visited Hicks's studio there. Hicks went to London briefly before returning in 1849 to New York.

In Italy, besides painting copies of the old masters and portraits, Hicks was a prolific painter of Italian scenes, though few are known today. The Leeds and Minor auction catalogue of works that he sold in 1865 lists many titles resulting from his excursions into the Roman countryside, including genre scenes and views of Olevano, Subiaco, Genzano, Palestrina, Nemi, and Albano, as well as views in Rome itself (such as Fountain in Front of the French Academy, and House on the Piazza Barberini). In addition, he painted numerous views of Naples (including Vesuvius and Capri) and of Venice.

Thomas Hicks

22. *Margaret Fuller,* 1848
Oil on canvas, 16 x 13 in.
Signed l.r.: T. HICKS, ROMA 1848
Courtesy of Constance Fuller Threinen

Sarah Margaret Fuller (1810-1850) was one of the most extraordinary women of the nineteenth century. The daughter of a U.S. Congressman, she grew up in Cambridge, Massachusetts, and by the age of fifteen was reading literary and philosophical works in four languages. In the 1830s Fuller formed friendships with Ralph Waldo Emerson and other members of the Transcendental Club; she became the first editor (1840-42) of the *Dial,* contributing articles, reviews, and criticism. In 1844, Horace Greeley appointed her literary and art critic of the *New York Daily Tribune;* over the next few years she wrote 250 reviews and essays including literary criticism and articles on social reform. In 1845, Greeley published Fuller's *Women in the Nineteenth Century,* a wide-ranging feminist manifesto, one of the first of its kind by an American, in which Fuller criticized stereotypical male and female roles, and advocated equality for women.

Fuller sailed for Europe in August 1846, as foreign correspondent to the *Tribune.* In London she met Wordsworth, Carlyle, and Giuseppe Mazzini, the Italian patriot in exile who became her friend and correspondent (see cat. 149).[1] By mid-November 1846, she was in Paris, where she knew George Sand and the poet Adam Mickiewiez;[2] in February 1847, she traveled to Marseilles where she sailed for Genoa, Leghorn, and Naples before going to Rome. Meeting Thomas Hicks shortly after arriving in Rome, she praised him in several of her articles on American artists in Italy, commenting in one, "of Hicks I think very highly. He is a man of ideas, an original observer."[3]

In June 1847, after two months in Rome, Fuller traveled to Florence, where she visited the studios of the sculptors Mozier, Powers, and Greenough, and then in early July went to Venice. She visited Milan in

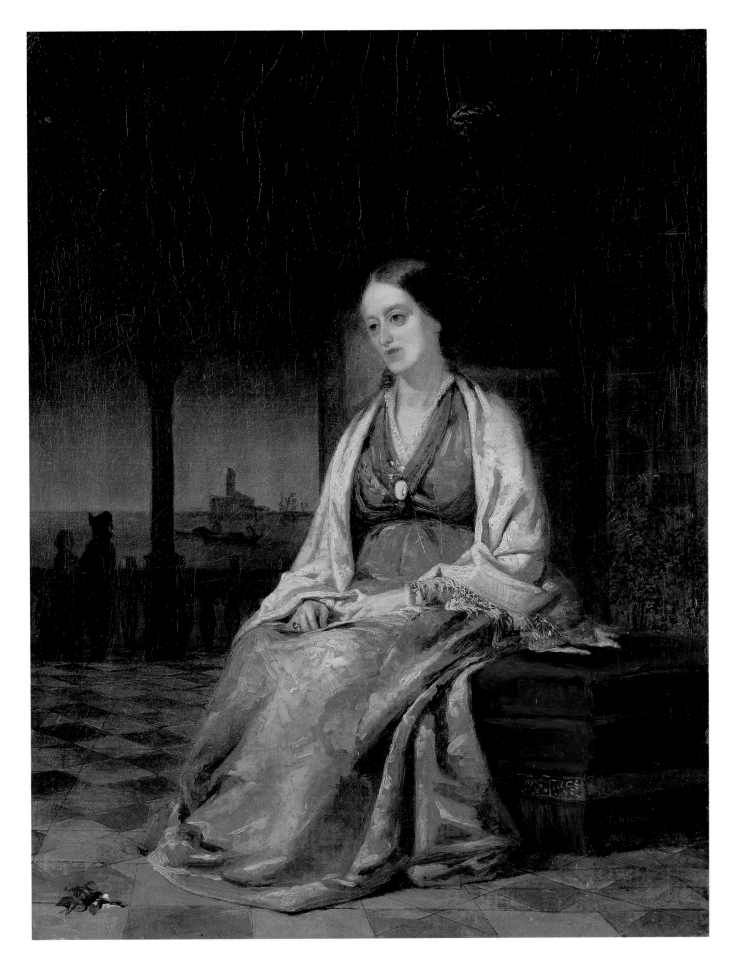

August and met the novelist Manzoni; in September, Fuller was in Florence again, staying with the Moziers. Enamored of a young Roman aristocrat, the Marchese Angelo Ossoli, whom she had met in Rome in April, Fuller returned to Rome in October for the winter of 1847-48; at her residence on the Corso, she received her friends "every Monday evening."[4]

Hicks and Fuller were both in Venice in July of 1847 and her picture could have been conceived at that time. Fuller had written after her visit, "Venice was a dream of enchantment, there was no disappointment, art and life are one."[5] Though this cabinet portrait was painted in Rome in 1848, Fuller is shown seated in Venice near the Gothic arcade of the Doge's Palace, with a garden to one side and gondolas in the distance; the statue behind her head is the *Eros of Centocelle* (Vatican Museums, Rome), suggesting Fuller's amorous involvement with Ossoli. Hicks further implies his sitter's encounter with Eros by placing a fallen flower at her feet and a courting couple in the background.

In June 1848, while pregnant with Ossoli's child and with Rome in increasing turmoil, Fuller moved to Aquila, then to Rieti where their son Angelino Ossoli was born on September 5, 1848.[6] Fuller then returned to Rome to report on developments in the Italian revolution for the *Tribune*, and to arouse American sympathy for the liberal cause. She wrote, "This cause is OURS, above all others. . . . In many ways Italy is of kin to us; she is the country of Columbus, of Amerigo, of Cabot."[7] In late April 1849, Rome came under French siege, and Fuller became director of the Fate Bene Fratelli Hospital while Ossoli, a Republican, served in the Civic Guard. After the fall of Rome, (Fuller wrote, "Yes; July 4th, the day so joyously celebrated in our land, is that of the entrance of the French into Rome!"), Fuller fled

Fig. 1. A. H. Ritchie (American, 1822-1895), after Thomas Hicks, *Authors of the United States*, 1866, Boston Athenaeum (detail).

Fig. 2. Thomas Hicks, *Fountain a la Palestrina*, 1850, oil on canvas, Photograph courtesy Vose Galleries.

with Ossoli and their son to Rieti in mid-July, then to Florence in late September where they were welcomed by the Moziers, Greenoughs, and Brownings.[8] On May 17, 1850, she and her family sailed for America on the *S.S. Elizabeth*; all three tragically drowned when the ship was wrecked off the shore of Fire Island, near Long Island, New York, in a storm on July 19, 1850. The manuscript of a history of the Roman revolution which she had begun in Rome was also lost.

Years later, Hicks included Fuller in the same pose, as number thirty-one of forty-four American writers in his composition, *The Authors of the United States*, a large steel engraving published in 1866 by Henry Bowen, New York (fig. 1).[9]

S. RICCI

1. See Paula Blanchard, *Margaret Fuller, From Transcendentalism to Revolution* (New York: Delacorte Press/Seymour Lawrence, 1978); and Laurie James, *Men, Women, and Margaret Fuller* (New York: Golden Heritage Press, 1990).

2. Mrs. Margaret Spring, who traveled with Fuller in Europe in 1846-47 reported to F.B. Sanborn, "In Paris, Adam Mickiewicz . . . came often to see Margaret, and sometimes dined with us Afterwards, in letters, he encouraged Margaret to marry Ossoli, visited her in Rome after the marriage, and had our American artist Thomas Hicks, make a portrait of her for him." See F. B. Sanborn, "A Concord Notebook," *The Critic* 48, (January-June 1906), pp. 251-252.

3. Dispatch no. 29 dated Rome, March 20, 1849 to the Tribune, *These Sad But Glorious Days, Dispatches from Europe, 1846-1850*, ed. by Larry J. Reynolds and Susan B. Smith (New Haven: Yale University Press, 1991) p. 265.

4. Frequent visitors included the Storys and Cranches. Margaret Fuller to her mother, Margaret C. Fuller, from Rome, December 16, 1847 in *The Letters of Margaret Fuller*, ed. by Robert Hudspeth, (Ithaca: Cornell University Press, 1988) vol. 4, p. 307. Thomas Hicks in a condolence letter written August 2, 1850, to Mrs. Margaret C. Fuller related, "in the winter of '48 in Rome in many of her hours of loneliness, I stood in the relationship to her of a brother." Fuller Manuscripts, Houghton Library, vol. 16, no. 65.

5. Fuller to Caroline Sturgis, from Lake Como, August 22, 1847. Hudspeth, vol. 4, p. 290.

6. Fuller was frequently referred to in the nineteenth century as the wife of Ossoli, but there is no certainty that they were ever actually married. See Joseph J. Deiss, *The Roman Years of Margaret Fuller* (New York: Thomas Y. Crowell Co., 1969), and Bell Gale Chevigny, *The Woman and the Myth*, (Old Westbury, New York: The Feminist Press, 1976).

7. Margaret Fuller to the Tribune, Letter 17, Rome, October 18, 1847. Margaret Fuller, *At Home and Abroad*, ed. by Arthur B. Fuller (Boston: Crosby, Nichols and Co., 1856) pp. 248-49.

8. Margaret Fuller to the Tribune, Letter 33, Rome, July 6, 1849. Ibid, p. 419. Margaret Fuller to Samuel G. Ward, Oct. 31, 1849, Hudspeth vol. 5, p. 278.

9. In a dispatch to the Tribune dated Rome, March 20, 1849, Fuller wrote that "Hicks has made the drawings for a large picture of many figures; the design is original and noble, the grouping highly effective," possibly referring to Hick's *Authors of the United States*. See Reynolds and Smith, *These Sad But Glorious Days*, pp. 265-66. In the painting, Fuller is seated between R. H. Dana to her right and E. Channing on her left, with G. W. Curtis and R. W. Emerson directly behind her.

Martin Johnson Heade

Born Lumberville, Pennsylvania, 1819;
died St. Augustine, Florida, 1904

Martin Johnson Heade

23. *Roman Newsboys*, about 1848-49
Oil on canvas, 28½ x 24⅜ in.
*Toledo Museum of Art, Purchased with funds from the
Florence Scott Libbey Bequest in Memory of her Father,
Maurice A. Scott*

*Heade received his earliest training as a teenager in
Bucks County, Pennsylvania, from the Quaker
painter Edward Hicks; at this time he became
friends with Edward's nephew Thomas Hicks (see
cat. 22), who painted Heade's portrait about 1841.
Heade's obituary in* Forest and Stream *maga-
zine reported that "His father . . . sent him while
still in his teens to Italy for study." However, there
is no other evidence for such an early venture
abroad, and the writer may well have simply mis-
dated Heade's documented travels of 1848-49. At
least two figurative paintings resulted from this trip,*
The Goat-Herd, *which was exhibited in
Cincinnati in 1850, and* Roman Newsboys.
*Heade's friend Thomas Hicks was also in Rome in
these years, and he may well have played a role in
Heade's travels. Later in his life Heade journeyed to
South and Central America on several occasions,
and went back to London in 1865, but apparently
never returned to Italy.*

Between 1839, when he was twenty, and 1859,
when he moved to New York and began his
successful career as a landscape and still-life
painter, Heade made his living as a journey-
man painter, doing mostly portraits and
moving frequently from one city to another.
During this time he made one extended trip
to Europe, as Henry Tuckerman reports:
"He passed two years in Rome, [and] so-
journed in France and England."¹ His pres-
ence in Rome was confirmed in a "Letter
from Rome" in the *Literary World*, dated Jan-
uary 21, 1848 ("Heade, of Philadelphia, is
here, but I know not what about.")² In 1850,
the artist exhibited two products of his Ital-
ian trip at the Western Art Union, Cincin-
nati, Ohio, *The Goat-Herd* (now lost) and
Roman Newsboys, which still bears a fragmen-
tary Art Union label on its stretcher. These
were Heade's only known genre scenes.

Roman Newsboys looks in many ways like
the innumerable pictures of street urchins
that were being painted in Italy in these
years by artists of many nations, but at the
same time it is very distinctive. The paint-
ing is not a sentimentalized genre scene, but
rather represents with great immediacy a
highly important, specific moment in Ital-
ian history. The year 1848 was marked by
both hopefulness and conflict, as the
Risorgimento Movement (the "Reawaken-
ing") flowered briefly, and it seemed for a
time as if Italy might be peacefully unified
as a single nation. The election of the lib-
eral Pius IX as Pope in June of 1846 had
been greeted by popular enthusiasm; he
began by declaring a general amnesty for
political prisoners. Revolutionary fervor in-
creased in January 1848, when an uprising in
Palermo led to the establishment of a con-
stitution in the Kingdom of the Two Si-
cilies; and in March the new Republic of
Venice was founded and the rule of Austria
overthrown. In Rome at the same time, Pius
IX granted a constitution to the Papal
States, a move signalling to visiting Ameri-

cans a new era for Italy.

By May 1848, the pope had lost much of
his popularity as he wavered between the
unification movement and autocracy. In this
moment of crisis, the popular Piedmontese
leader of the Risorgimento, Vincenzo
Gioberti, visited Rome, temporarily calm-
ing passions. After a summer of turmoil,
culminating in the assassination of his min-
ister of state, Count Rossi, the pope fled
from Rome.

Heade in this painting clearly sides with
the Risorgimento, just as he took the liberal
side forty years later in his articles about
hunting rights and land ownership in
Florida.³ One newsboy wears a papal
"dunce cap," as William Vance points out,
while the other wears a Greek cap, symbolic
of the liberal cause. They hand out copies
of the "savagely satirical" *Il Don Pirlone*,
which Margaret Fuller had called "The
Punch of Rome,"⁴ to someone approaching
from the left whose shadow is already visi-
ble. On the wall behind them are a variety
of topical graffiti and torn posters, includ-
ing at top a proclamation "Gioberti Ai Ro-
mani" (Gioberti to the Romans); just
below it is an older poster for an English-
language weekly journal (whose headline
reads ROMAN...RE...SED, perhaps "Romans
Released," a reference to the general
amnesty), while to the left is another one
that is largely undecipherable except for the
date, "1848." The graffiti includes a carica-
ture labeled "cardinale" at left, and one of
the Pope, "Papa," at right, along with sev-
eral renditions of his name ("Pio IX") and
of "Viva l'italia." With hindsight, one can
see in this remarkable work Heade's great
interest in the exact rendition of sunlight
and shadow, a concern which became more
apparent in his later marsh scenes. Similarly,
in *Roman Newsboys* he freezes the action with
unusual immediacy, just as he would do fif-
teen years later in Brazil as he began his
long series of paintings of hummingbirds.

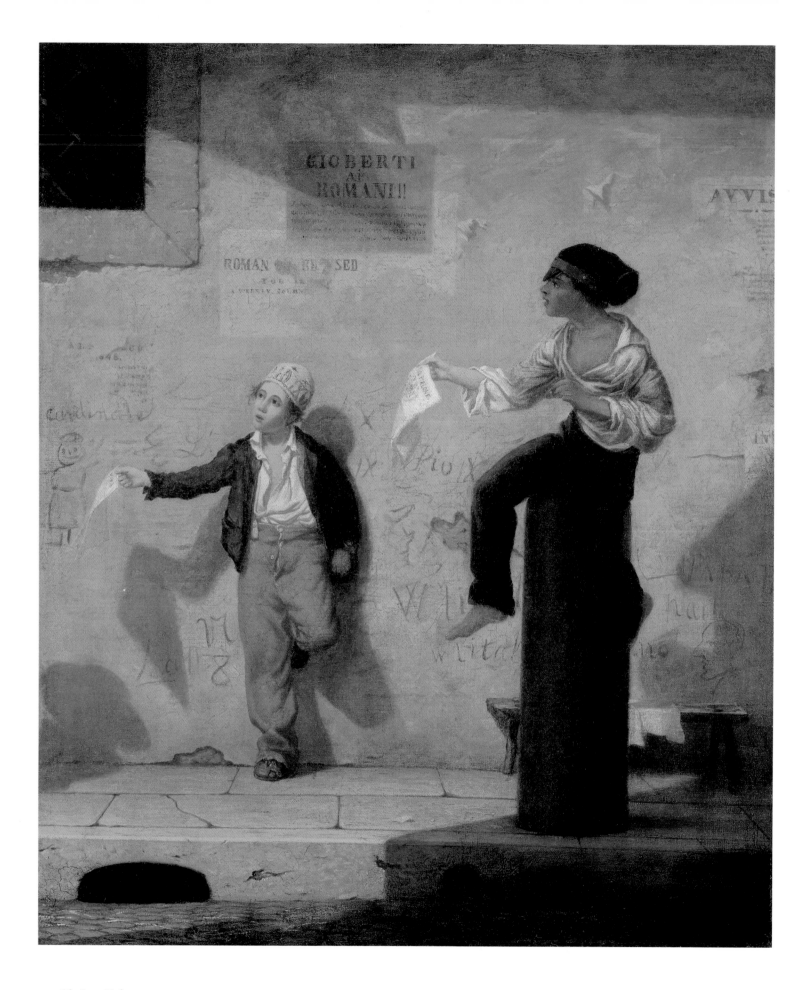

Jasper Francis Cropsey

Born 1823, Staten Island, New York;
died Hastings-on-Hudson, New York, 1900

24. *Roman Forum*, 1849-95
Oil on canvas, 33 x 40 in.
Signed l.r.: J.F. Cropsey
Mrs. John C. Newington

Fig. 1. Martin Johnson Heade, *Roman Newsboys II*, 1849. Oil on canvas. Private collection. Photo courtesy Museum of Fine Arts, Boston.

Finally, Heade made a replica of *Roman Newsboys* (fig. 1), which was probably executed after July 4, 1849, when the short-lived Roman Republic was put down by French troops and the Pope restored to power, for in it the barred window at the upper left has become larger and more oppressive, most of the revolutionary posters and graffiti are gone, and the lengthening shadows seem more ominous.

T. STEBBINS

1. Henry T. Tuckerman, *Book of the Artists: American Artist Life* (New York: G. P. Putnam & Sons, 1867), p. 542.

2. As quoted in Theodore E. Stebbins, Jr., *The Life and Works of Martin Johnson Heade* (New Haven: Yale University Press, 1975), p. 9.

3. See Stebbins, *Heade*, pp. 156, 202-204.

4. William L. Vance, *America's Rome* (New Haven: Yale University Press, 1989), vol. 2, p. 126. I am particularly indebted to Professor Vance's superb analysis of this painting, and for his discussion of the Risorgimento and American attitudes toward it.

Jasper F. Cropsey made his only trip to Italy in 1847-1849. Honeymooning with his wife, Maria, he sailed for Liverpool in mid-May 1847, arriving on June 17. The Cropseys toured England and Scotland until mid-September and visited Paris and Geneva briefly before crossing the Alps at the Simplon Pass on September 31. Traveling by way of Lake Maggiore, Milan, Genoa, and central Italy, they arrived in Rome before the middle of October and rented Thomas Cole's old studio on the Via del Babuino. They became friendly with Mr. and Mrs. Christopher P. Cranch, Thomas Crawford, Thomas Hicks, Luther Terry, and the William Wetmore Storys.

During the summer of 1848 the Cropseys shared a villa in Sorrento with the Storys. Cropsey sketched there and in Amalfi and Capri with Cranch, and with Cranch and Story, he visited Paestum. Returning to Rome in the fall, Cropsey visited Tivoli, Ariccia, Lake Nemi, and other scenic places near the city. Amid political unrest, the Cropseys left Rome in early April 1849. They visited Lake Nemi once more before traveling north. The couple stopped at Terni and possibly Perugia on their way to Florence, where they stayed until April 25. From there they went by train to Pisa, then took a steamer from Leghorn to Genoa and Marseilles. They reached Avignon by rail, took a Rhône steamer to Valence and Lyon, and then traveled by coach to Paris. By late June the Cropseys were back in England. They sailed from Liverpool on July 14, 1849, and arrived in New York in late July or early August. The artist lived in England from 1856 until 1863, but he never returned to Italy.

For nineteenth-century travelers, the ruins of the Roman Forum palpably evoked ancient Rome's glory and decline. This large public plaza between the Capitoline and Palatine hills was the civic and religious heart of the ancient city, a site of major building projects throughout the Republic and the Empire, and the setting of many specific events, both historical and mythical, that were well known to generations of travelers schooled in ancient history and Latin literature.

Despoiled by barbarian invaders in late antiquity, the Forum was mined for building materials during the Middle Ages and the Renaissance. By the mid-sixteenth century, herdsmen from the Campagna regularly grazed their livestock among the half-buried ruins, and the area was still known as the Campo Vaccino (cattle pasture) late in the nineteenth century.[1]

Scientific excavation of the Forum began early in the century, but tourists were free to stroll among the ruins and often attempted, with the help of guidebooks (see cats. 157, 172, 173), to reconstruct the Forum in their minds. Inevitably, like Kenyon, Hilda, and Miriam in Hawthorne's *The Marble Faun* (cat. 162), they reflected on the moral lessons inherent in the crumbling remains of a fallen empire.

The Roman Forum became a favorite subject for visiting artists during the sixteenth century, when the Dutchman Marten van Heemskerck recorded its appearance in drawings and prints. Claude Lorrain painted one of his few topographical views here in 1636,[2] and Canaletto, Pannini, Piranesi, and Turner were among eighteenth- and early nineteenth-century artists who produced views of the Forum. It remained a popular subject with European artists throughout the first half of the nineteenth century, though excavation and

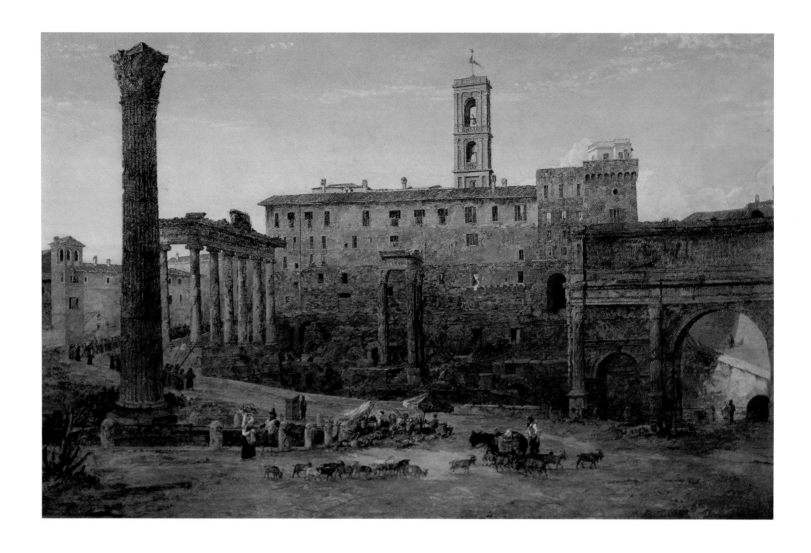

antiquarian research steadily demystified the site and reduced its picturesque appeal.

Few American artists undertook this urban subject. Surrounded on all sides by the streets and buildings of modern Rome, the Forum was devoid of the trees, mountains, and expansive distances to which American landscape painters were partial.[3] Jasper Cropsey was an exception for, having trained as an architect before devoting himself to painting, he was comfortable with urban subjects and well-versed in architectural history.[4] Soon after their arrival in Rome, he and his wife purchased a *Guide of Rome and the Environs* by Mariano Vasi and Antonio Nibby, antiquarians who went far beyond other guidebook authors in discussing architecture (see cat. 157).

For his painting, Cropsey selected the western end of the Roman Forum below the Capitoline Hill, where architecture told the story of Rome's past. Standing some fifteen feet above the level exposed today, Cropsey faced the Capitoline, where the Palazzo Senatorio with its medieval watchtower and Renaissance belfry rises on the stone foundations of the Tabularium, a structure begun in 78 B.C. to house the records of the Roman Republic. The three Corinthian columns at the center of the picture were thought to date from the reign of Augustus, Rome's golden age,[5] while to the right, the Arch of Septimius Severus, erected in A.D. 203, represented a later, brutal chapter in Roman history. Cropsey carefully reproduced the arch's inscription, which bore muted witness to imperial fratricide.[6]

The columns on the left side of the painting, still supporting their entablature, belonged to a temple whose identity in 1847 was debated, but Vasi and Nibby assigned its unmatched columns and capitals to "the period of the decline."[7] Finally, standing alone in the foreground, the Column of Phocas dates from late antiquity, when building all but ceased as Rome shrank, eclipsed by Constantinople to the east.[8]

Cropsey rendered the ruins and their surroundings accurately and in careful detail. The foundations of the various monuments had been excavated and enclosed with railings, but much of the Forum remained under the debris of centuries, traversed daily by peasants, goatherds and priests. These picturesque types animate Cropsey's picture, underscore the monumental scale of the architecture, and mark the contrast between ancient and modern Rome – a contrast that amazed and often depressed American travelers.[9]

Cropsey began *The Roman Forum* in 1849 while in Rome and completed it in 1895 in his studio at Hastings-on-Hudson, New York.[10] The heavily worked surface suggests that Cropsey painted over much of the canvas in 1895, but he remained faithful to architectural details he had meticulously recorded in Rome nearly fifty years before.

K. MATHEWS HOHLSTEIN

1. For a summary of the burial of the Roman Forum and its excavation during the nineteenth century, see Christian Huelsen, *The Forum and the Palatine* (New York: A. Bruderhausen, 1928), pp. 53-58.

2. Paris, Musée du Louvre. Claude shows the Forum from the foot of the Capitoline Hill looking east toward the Temple of Castor and Pollux, the Arch of Titus, and the Colosseum. This eastward prospect was frequently chosen by artists both before and after Claude, but the westward view toward the Capitoline was also popular.

3. See William L. Vance, *America's Rome* (New Haven: Yale University Press, 1989), vol. 1, p. 4.

4. For an exploration of Cropsey's dual career, see Ella M. Foshay and Barbara Finney, *Jasper F. Cropsey: Artist and Architect* (New York: New-York Historical Society), 1987.

5. Vasi and Nibby, *Guide of Rome and the Environs* (Rome: L. Phiale, 1847) pp. 90-91, believed that the columns belonged to a temple of Jupiter Tonans erected by Augustus during the last quarter of the first century B.C., and that the inscription on the frieze, (R)ESTITVER, referred to minor restorations by Severus and Caracalla. Later in the nineteenth century, it was established that the columns belonged to the temple of the deified Vespasian, built by Titus and Domitian late in the first century A.D. and restored under the Severans. See Margaret R. Scherer, *The Marvels of Ancient Rome* (New York and London: Phaidon Press), pp. 65-66.

6. The arch was erected to commemorate military victories of Septimius Severus and his sons Geta and Caracalla, but after Severus' death, Caracalla ordered the murder of Geta and removed his brother's name from all public inscriptions. See Vasi and Nibby, p. 102, and Scherer, p. 69.

7. The proposed identifications are summarized in Vasi and Nibby (pp. 88-90). Nibby believed it to be the Temple of Fortune, but today the temple is identified as that of Saturn, founded in c. 500 B.C., reconstructed in 42 B.C., probably destroyed by fire in A.D. 283, and restored again during the fourth century. See John J. Herrmann, Jr., *The Ionic Capital in Late Antique Rome* (Rome: Giorgio Bretschneider Editore, 1988), pp. 103-104.

8. Vasi and Nibby (p. 105) note that the inscription, pedestal, and pyramid of steps beneath the column were uncovered in 1813 and 1817. The Corinthian column was taken from an earlier Roman edifice and raised in the Forum in A.D. 608 by the exarch Zmaragdus in honor of the Byzantine emperor Phocas.

9. James Jackson Jarves in *Italian Sights and Papal Principles, Seen Through American Spectacles* (New York, Harper Brothers, 1856) was disgusted by the poverty and "priestcraft" that pervaded Rome (ch. 11 and 12), but for Hawthorne and many others, clerics and beggars were a part of the city's picturesque charm.

10. The painting is inscribed as follows on the reverse: The Roman Forum in 1849 by J.F. Cropsey N.A. Hastings-on-Hudson begun in Rome, 1849, and finished at Hastings in 1895.

George Henry Hall

Born Boston, Massachusetts, or Manchester, New Hampshire, 1825; died New York, New York, 1913

George Henry Hall

25. *Roman Wine Cart*, 1851
Oil on canvas, 42⅝ x 39⅞ in.
Signed l.l.: G.H. Hall / Rome, Dec / 22d 1851
Museum of Fine Arts, Boston, Gift of Miss Jennie Brown-scombe

Hall enrolled at the Düsseldorf Academy with his friend Eastman Johnson in the fall of 1849. He studied there for a year, long enough to absorb a discipline for figure drawing and elaborate painterly finish. He spent the next year in Paris, then went to Italy where he also stayed a year, mainly in Rome. There he painted genre subjects and his first still-lifes of fruit in outdoor light. Hall returned to America in 1852 and set up a studio in New York. He became a member of the National Academy of Design and concentrated on literary themes and genre subjects, especially those derived from his travels, balancing his work with small, informal, and very popular still-life paintings of fruit and flowers depicted outdoors.

After a trip to Spain in late 1860 or early 1861, and a return trip there in 1866, Hall revisited Italy in 1872. He lived for a year in Rome, married a young woman from Capri, and after returning to New York, painted numerous Italian genre subjects bearing such sentimental titles as "Graziella, a Little Neapolitan Girl" (1874, location unknown) and "Adio: Peasants of Olevano" (1876, location unknown).

A trip to Egypt and Palestine in 1875 resulted in a spate of large paintings of bazaars and around 1880 he began to paint large, dramatically lit still-life compositions featuring Middle Eastern bric-a-brac. Hall's next trip abroad, in 1883, brought him back to Italy. This time he remained for four years, living in Rome, where he became friends with American painters Elihu Vedder (see cats. 71, 94-96) and Charles Coleman (see cats. 100, 105). Until the 1890s he returned periodically to both Rome and Paris, while exhibiting such canvases as A Fountain at Frascati *and* Nenilla: A Neapolitan Girl *back in New York.*

One of Hall's major figure paintings, *Roman Wine Cart* was created toward the end of his first trip to Italy as a showcase for the controlled, highly finished painting style he learned in Düsseldorf.[1] It depicts a festively attired peasant couple riding leisurely into Rome in a canopied wagon, presumably to play music and sell their casks of wine. Glancing down at the spectator, they are framed by bright blue sky, with the Colosseum and Arch of Constantine to either side in the distance. The woman holds a tambourine in her lap; the man draws her close as he drives. Their rural origin is suggested by such details as hay used as padding between the wine casks and a fur pelt hung over the canopy for warmth.

Belonging to the large-scale representations of European peasantry that proliferated from the 1840s onward, the work depicts a specific category of Italian peasant. The bagpipes hanging inconspicuously beside the driver and the inscription "Rome Dec / 22d 1851" at the lower left suggest that Hall's protagonists are *zampognari* or *pifferari*. These peasants, originally shepherds from the mountains of Calabria and Lazio, traveled to Rome, Naples, and other large cities during the Novena, that is, the nine days before Christmas, with their pastoral instruments, the *zampogna* (bagpipes) and *piffero* (wooden flute). In return for a few coins, they played in pairs before street and household shrines dedicated to the Madonna, imitating the shepherds who came to Bethlehem on the first Christmas.

The Christmas visits of the *pifferari* were well enough established by the early nineteenth century for Stendahl, in his Italian journal, to deride their ceaseless cacophony. Generally however, artists of the Romantic era were attracted to the *pifferari*, whom they saw as picturesque modern-day troubadours.[2] Hall may have first encoun-

Fig. 1. Hendrik Leys (Belgian, 1815-1869), *Pifferari*, 1856. Koninklijk Museum voor Schone Kunsten, Antwerp.

tered the *pifferari* in depictions of them in France and Germany, where interest in them was quite strong.[3] They were Italian counterparts to the French peasants of Jean-François Millet and Jules Breton — tenaciously independent, unchanged by time, long-suffering, untrammeled, yet perhaps more mysterious because of their wandering ways.

Like the French peasantry, the *pifferaro's* lot was a hard one. Essentially migrant workers, they came into town during the winter, when shepherding and field work were unavailable. Some brought goods to peddle while others hired themselves for any manual labor. For all the picturesqueness of their piping, their welcome was limited, for they were driven out of town on the second day after Christmas.

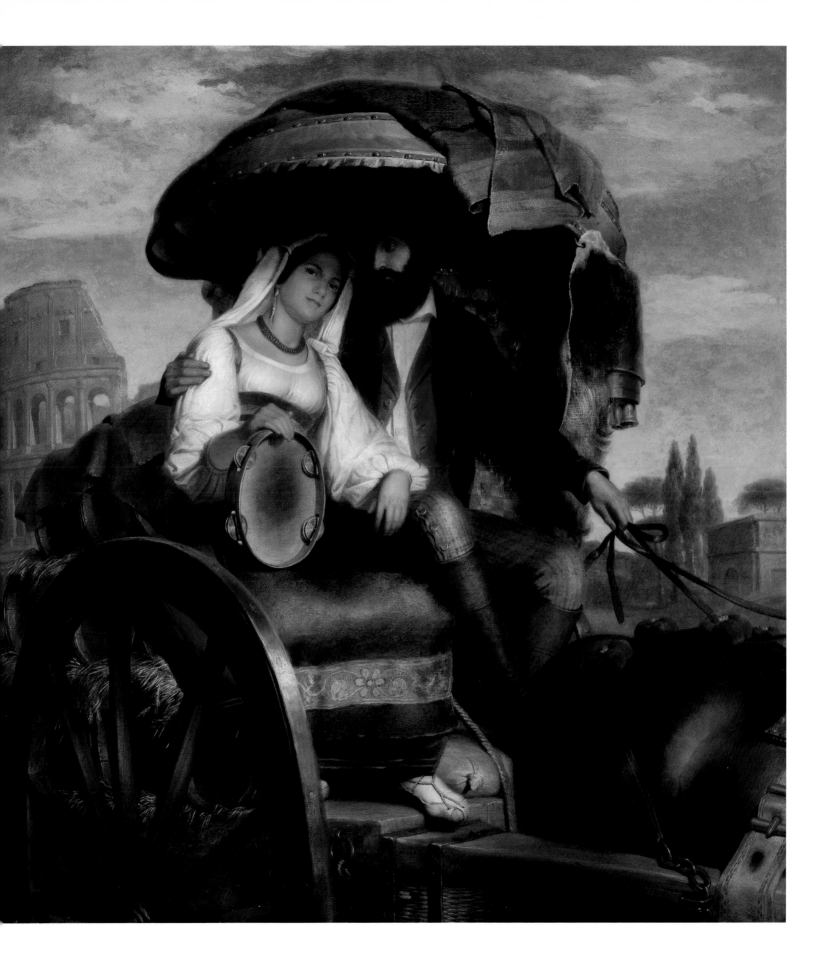

Randolph Rogers

Born Waterloo, New York, 1825;
died Rome, Italy, 1892

European artists generally presented *pifferari* as loners, outcasts, or melancholy vagabonds (fig. 1). Hall's depiction avoids these harsher, darker, more tragic notes, perhaps because Americans did not look at their own rural population in this way. He exchanged the pathos of peasant life for a homely sentimentality more in keeping with the manner in which American country life was depicted. In doing so, he produced a remarkably empathetic portrayal of lower-class Italians. In New York, where Hall's canvas was exhibited at the National Academy in 1853, former tourists could readily imagine themselves on such a pleasure ride, while wishing the contentment expressed in the picture to be theirs.

D. STRAZDES

1. *Roman Wine Cart* was followed by *A Parisian Market Cart*, (about 1854, location unknown); *Un Carro de Sevilla*, (1862, location unknown); and a few pictures of fruit and flower vendors that may have been variations on the theme of market wagons.

2. The Swiss painter Léopold Robert's *Pifferari before the Madonna* (1829, Musée Jenisch, Vevey) marked the beginning of a tradition of depicting these people that lasted through the 1870s.

3. The French artists Alexandre-Gabriel Descamps, Rosa Bonheur, and Thomas Couture, as well as such Belgian and German contemporaries of Couture as Hendrik Leys and Franz von Lenbach depicted the *pifferari*. See Albert Boime's account of French interest in the *pifferari* in *Thomas Couture and the Eclectic Vision* (New Haven and London: Yale University Press, 1980), pp. 379-84.

Randolph Rogers arrived in Florence in 1848, at a time when the first generation of American sculptors in Italy was beginning to pass from the scene. Like Greenough, Rogers studied briefly with the Italian sculptor Lorenzo Bartolini (1777-1850), director of sculpture at the Accadèmia San Marco in Florence, and absorbed Bartolini's quattrocento-derived lessons in naturalism. In September of 1851, shortly after Bartolini's death and the departure of Greenough for America, Rogers took up residence at the Palazzo Barberini in Rome, where he was to reside for the next twenty years. In Rome, Rogers enjoyed expatriate camaraderie with Thomas Crawford, Chauncey B. Ives, William Wetmore Story, and William Henry Rinehart, among others. Ruth Gleaning (1853, Toledo Museum of Art) was Rogers's first ideal sculpture, and its popularity, along with that of the more sentimental, narrative Nydia: The Blind Flower Girl of Pompeii *(cats. 47, 48), which he produced in life-size and half-life-size versions, enabled him to focus his energies upon such challenging and prestigious civic commissions as the bronze doors he created for the United States Capitol (cat. 26). A contented and productive expatriate sculptor, Rogers seldom returned to visit the United States. His growing financial successes led to the construction of an expansive house and studio near William Wetmore Story at 5 Via Magenta where he frequently entertained the colony of American artists in Rome. Of this group, Rogers was among those most deeply involved with Italian culture. The artist and his Catholic wife raised their children in the Catholic faith, and took part fully in Italian life. Rogers himself was a deathbed convert to Roman Catholicism. In 1873, Rogers was appointed academician of merit and resident professor of sculpture at the Accademia di San Luca in Rome. In recognition of Rogers's lifetime achievements, King Umberto of Italy knighted the sculptor in 1884, and decorated him with the order of Cavalière della Corona d'Italia.*

Randolph Rogers

26. *Columbus Departing from the Convent of La Rabida, 1492,* modeled 1855-59; cast 1881
Bronze, h. 26¼ in., w. 25⅞ in., d. 2¾ in.
Lent by Mrs. John K. Conneen

Fig. 1. Randolph Rogers, *Columbus Doors*, 1855-59. Bronze. Rotunda (East Entrance), United States Capitol, Washington, D.C. Courtesy Architect of the Capitol.

The measure of Rogers's artistic accomplishments, after a residence of only five years in Italy, can be well appreciated in his *Columbus Doors* (fig. 1). Along with Thomas Crawford and William Henry Rinehart, Rogers was among the few sculptors who received important commissions to assist in the decoration of the United States Capitol during the years of its expansion. Rogers was selected, following the death of Crawford, to design a door to stand between Statuary Hall and the south extension of the United States Capitol.[1] The artist chose to depict scenes from the life of Christopher Columbus, a topic that had received intermittent attention earlier in the century, but that had renewed appeal in the age of manifest destiny.[2] Rogers insisted upon sculpting and casting the doors in Italy, over the objections of Capitol engineer, Captain Montgomery C. Meigs. Despite the latter's mis-

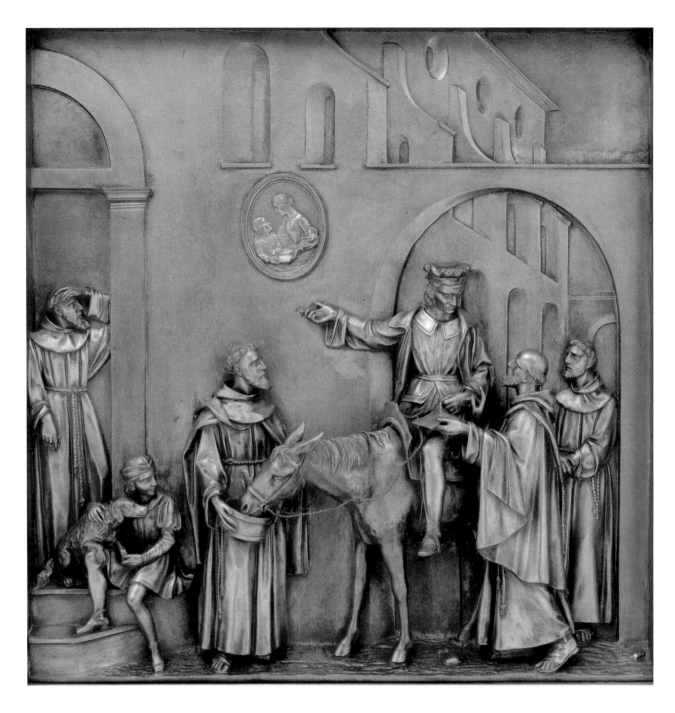

givings, Meigs submitted Rogers's half-size model and proposal for approval to Jefferson Davis, and offered the following description of the sculptor: "Mr. Rogers is young, full of ambition, self-reliant, [and] not younger than [Lorenzo] Ghiberti when his designs secured him the preference over all the competitors for the Florence Baptistery. If he can succeed as well with these as with his *Ruth*, of which you have a photograph, it will be well enough."[3] Davis approved of the sketch on the next day and Rogers began what was to

be a four-year project made arduous by considerations of casting and shipping.[4] During his early studies with Bartolini, Rogers had ample opportunity to examine the so-called 'Gates of Paradise', the doors of the Florence Baptistery by Ghiberti. Rather than simply imitating such an acclaimed, seemingly perfected work, Rogers aimed to improve upon what he perceived as flaws in the door's design.[5] Rogers knew that his own work would be judged against those of the Italian masters. As his work neared completion, Rogers challenged

Meigs to judge his reliefs against any by Ghiberti "without fear for the comparison," and expressed characteristically American confidence in having fully mastered the artistic lessons that he learned in Italy.[6] *Columbus Departing from the Convent of La Rabida, 1492* is the only known panel to have been cast as an independent relief by Rogers. In this scene, Columbus and his son, Diego, leave the convent of La Rabida, where they were befriended by Juan Perez, confessor to Queen Isabella, and Lady Bobadilla, an attendant of the queen.

George Inness

Born Newburgh, New York, 1825;
died Bridge-of-Allan, Scotland, 1894

Columbus and his son depart for the Spanish court, where they will receive official support for their venture. Although it is unclear why this particular panel was chosen for casting over others, requests for six such bronzes were recorded in the sculptor's journal in 1881.[7] This sole surviving panel was ordered from Rogers by Miss Harriet Porter of Easton, Pennsylvania for three hundred dollars on April 11, 1881.

J. FALINO

1. The doors were removed in 1871 to the East Portico entrance. In 1961, as part of the Extension of the Capitol Project, the doors were moved a second time to its present location at the eastern entrance to the Rotunda.

2. Earlier works on Columbus appeared primarily in literature. Washington Irving (1783-1859) wrote *The History of the Life and Voyages of Christopher Columbus* (1828) while serving as American attaché in Madrid. William Hickling Prescott (1796-1859) wrote several books on Spanish history, including *The History of the Reign of Ferdinand and Isabella, the Catholic* (1837). With specific relation to the Capitol, John Vanderlyn's painting, *The Landing of Columbus* (1847), in the United States Capitol preceded the Rogers doors by some sixteen years.

3. For a full description of the creation of the Columbus Doors, and the artist's life, see Millard Rogers, Jr., *Randolph Rogers, American Sculptor in Rome* (Boston, Massachusetts: The University of Massachusetts Press, 1971). Meigs to Jefferson Davis, May 24, 1855 in Rogers, *Randolph Rogers*, pp. 51-52.

4. The doors were eventually cast in 1859 under the direction of Ferdinand von Miller at the Royal Bavarian Foundry in Munich due to considerations of quality and expense. For a recent biography on Rogers, see Jan Seidler Ramirez, "Randolph Rogers (1825-1892)" in Kathryn Greenthal et. al., *American Figurative Sculpture in the Museum of Fine Arts, Boston* (Boston: Museum of Fine Arts, 1986), pp. 153-54.

5. Rogers to Meigs, August 20, 1856, in Rogers, *Randolph Rogers*, pp. 54-55. Rogers may have been referring to the doors of Pisa's Duomo, whose bronze were executed by several artists in collaboration with Gianbologna. See "Gianbologna's followers: A European Phenomenon" in Charles Avery, *Gianbologna, The Complete Sculpture* (Oxford, England: Phaidon, Christie's Limited, 1987), pp. 225-33.

6. Rogers to Meigs, May 5, 1857, in Rogers, *Randolph Rogers*, pp. 57-59.

7. Randolph Rogers Journal entries for February 15, March 16, 21, and April 11, 1881 in Rogers, *Randolph Rogers*, p. 203-04. Millard Rogers speculates that casting was done in Munich by Miller.

Inness's first trip to Italy (to Florence and Rome from February 1851 to May 1852) was sponsored by a wealthy New York auctioneer, Ogden Haggerty. Having recently married, Inness and his new wife sailed directly to Italy, spending the first part of their trip in Florence where Inness had a studio on Via Sant'Apollonia, then moving to Rome. As a result of an incident in 1852 where Inness refused to lift his hat to the Pope, was assaulted by a French officer and briefly imprisoned, he cut short his trip and returned home by way of Paris, where he visited the Salon and saw the paintings of the Barbizon school. The Innesses arrived back in New York on the S. S. Great Britain on May 15, 1852.

In 1853-54, Inness visited Europe a second time, but did not go to Italy, instead spending most of the time in France where the Barbizon painters greatly affected his style.

Inness's second sojourn in Italy from May 1870 to the spring of 1874 was sponsored by his dealer, Williams and Everett of Boston, to whom he sent all his Italian paintings with the exception of those he sold in Italy. The Innesses sailed to Europe on April 30, 1870 and after brief stops in London and Paris, settled in Rome on Via Sistina and later on Via Ripetta. He painted frequently in the environs of Rome including the Alban Hills, Tivoli, and Anzio, and during the summers went farther afield to Perugia, Venice, the Tyrol and Titian's birthplace, Pieve di Cadore. In the spring of 1874 the Innesses went to Paris and to Etretat. They arrived back in New York on the Algeria on February 26, 1875. Inness painted approximately 200 paintings of Italy, most of them during this second trip.

Among Inness's acquaintances in Italy were the poet and painter, T. Buchanan Read, and Elihu Vedder (see cats. 71, 94-96), who occupied a nearby villa in Perugia during the summer of 1871. The painter and American consul to Rome, Maitland Armstrong, described Inness in his reminiscences, Day before Yesterday, as "a small, nervous man, with ragged hair and beard, and a vivacious manner, an excellent talker and much occupied with theories and methods of painting, and also of religion . . . on the whole he was an interesting man and undoubtedly one of the first of American painters."

George Inness

27. *St. Peter's, Rome, 1857*
Oil on canvas, 30 x 40 in.
Signed l.l.: GI (monogram) 1857
Charles F. Smith Fund, Permanent Collection, The New
Britain Museum of American Art, Connecticut

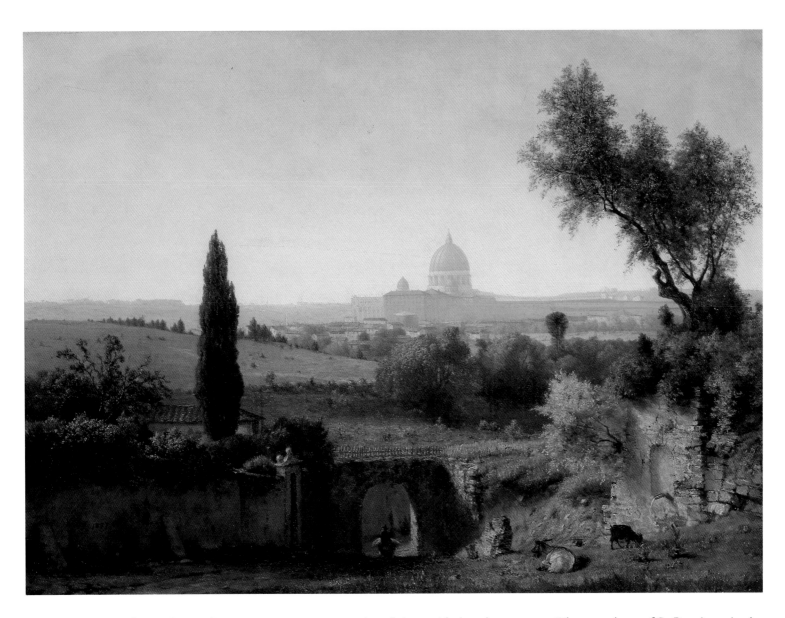

For Americans traveling to Rome, the dome of St. Peter's was the first landmark that they saw of the Eternal City. In 1853 George Stillman Hillard expressed the importance of St. Peter's to the nineteenth-century traveler:

> When Rome is viewed from a distance, the dome of St. Peter's is the central point of observation, and seems to be gathering the rest of the city under its

enormous wings. It is so with thoughts and associations. St. Peter's is the first object of interest, around which all others group themselves. Here the traveler hurries as soon as the dust of the journey is shaken from his feet; and here he comes, at the last moment, as the spot from which he is most reluctant to part.[1]

The great dome of St. Peter's marks the center of Rome's skyline, as it does the center of the Christian world. The great baroque church whose size and magnificence awed generations of American visitors, was begun in 1506 after the designs of Bramante. It was finally dedicated in 1626 after a series of architects, including Raphael and Michelangelo, had worked on its construction. In the mid-seventeenth

century Bernini created the enormous Piazza San Pietro with his majestic double colonnade. Michelangelo's dome, completed in 1590 after his death by Giacomo della Porta, has served as a model for many architects, including Thomas U. Walter, designer of the dome on the United States Capitol in Washington, D.C.

Inness's painting of St. Peter's is the result of his first trip to Italy in 1851-2, although it was not executed until 1857.[2] The view is from the Arco Oscuro near the grounds of the Villa Giulia, built by Pope Julius III in 1551 as a summer villa, now a museum devoted to the Etruscan civilization. Augustus J.C. Hare in 1876 described Inness's vantage point: "Close to the Villa Papa Giulio is the tunnel called Arco Oscuro, passing which, a steep lane with a beautiful view towards St. Peter's, ascends between the hillsides of the Monte Parione."[3] Ingres executed an exquisite pencil sketch from almost the exact same site between 1808 and 1811, and the German artist Georg von Dillis also painted St. Peter's from this very spot in 1818.[4]

While many European artists included St. Peter's in their views of Rome, it was not as common a subject for American artists. However, in addition to Inness, Elihu Vedder, George Loring Brown, and Benjamin Champney did paint landscapes with St. Peter's dome featured prominently.[5] Inness painted at least seven landscapes with St. Peter's in the distance, three as the result of his first trip, and four, including a watercolor, from his second trip to Italy in 1870-74.[6] Three of these paintings are very similar to the present work, and two were painted from the Tiber, with a barge in the foreground and St. Peter's silhouetted against the sky. *St. Peter's, Rome, From the Tiber* (location unknown) was exhibited at the Exposition Universelle in Paris in 1878, winning favorable notice from English critic Philip Hamerton.[7]

Showing his admiration for Claude, Inness carefully composed the work, painting a shadowed foreground, trees framing the dome, trees and fields in the middle ground, and finally, a hazy distant view. Inness used staffage, the goat and the figure on the donkey, to lead the eye into the depth of the painting. The veil of atmospheric haze enveloping St. Peter's in the distance evokes the beauty and warmth of Italy. In this relatively early work, Inness was inspired to deal confidently with elements of light, landscape and architecture, and he must have agreed with Jean Jacques Ampère who called the dome of St. Peter's in 1867, "the sole work of man that has something of the grandeur of the works of God."[8]

J. COMEY

1. George S. Hillard, *Six Months in Italy*, (Boston: Ticknor, Reed, and Fields, 1853), vol. 1, p. 205.

2. For information about Inness's life and work in Italy, see Nicolai Cikovsky, Jr., *George Inness* (New York: Praeger Publishers, 1971). See also Nicolai Cikovsky, Jr. and Michael Quick, *George Inness* (Los Angeles: Los Angeles County Museum of Art, 1985); LeRoy Ireland, *The Works of George Inness* (Austin: The University of Texas Press, 1965); and Alfred Werner, *Inness Landscapes* (New York: Watson-Guptill Publications, 1973).

3. Augustus J. C. Hare, *Walks in Rome* (London: Daldy, Isbister & Co., 1876), vol. 2, p. 420.

4. For Ingres, *The Vatican Seen from the Arco Oscuro*, see fig. 110 in Hans Naef, *Ingres in Rome*, (Washington, D.C.: International Exhibitions Foundation, 1971). For von Dillis, see Horst Keller, *Deutsche Maler des 19 Jahrhunderts* (Munich: Hirmer Verlag, 1979), plate 75. European artists who painted views of Rome are too numerous to mention. Beginning with Claude and the Dutch vedutisti, urban views crowned by St. Peter's dome were popular with German, Dutch, Scandinavian, Russian, English, and French artists.

5. For Vedder see *The Flood of 1870* (about 1870, Scripps College, Claremont, California) and *The Tops of the Piers in the Central Hall of the Baths of Caracalla* (1857, private collection). See also George Loring Brown's *Sunset on the Tiber, Rome* (1876, Robert P. Coggins Collection), and Benjamin Champney's *Roman Landscape* (1846, Henry Melville Fuller Collection).

6. Ireland, *The Works of George Inness*, nos. 129, 225 (*Roman Campagna* known only from a photograph, having been stolen from a residence in Dedham, Massachusetts in 1912), and 577 are similar to the present painting which Ireland lists as no. 142. Ireland, nos. 531-533 (listed but not illustrated) are views of St. Peter's from the Tiber.

7. Cikovsky, *George Inness*, p. 42.

8. Quoted in Margaret R. Scherer, *Marvels of Ancient Rome* (London: Phaidon Press, 1955), plate 154.

Albert Bierstadt

Born Solingen, Prussia, 1830;
died New York, New York, 1902

Bierstadt went to Italy twice, during very different times in his career. His first visit, which lasted from September 1856 to July 1857, came at the end of two and a half years of study in Düsseldorf. It continued a sketching tour down the Rhine from Düsseldorf into Switzerland, begun in June 1856 with his friends Worthington Whittredge and W.S. Haseltine. After weeks of hiking and sketching in the Alps, they crossed the Saint Gotthard Pass to Lake Maggiore and in October took a steamer from Genoa to Livorno. After a brief time in Florence, Bierstadt continued to Rome, spending the winter painting and the spring of 1857 sketching in the countryside. From May to July, he and Sanford Gifford journeyed into Campania as far as Capri and the Amalfi coast. Throughout, traveling conditions were spartan: Bierstadt and his companions covered much of the distance on foot, sketching and camping outdoors as weather permitted (see cat. 138).

This trip resulted in a handful of major landscapes, notably Lake Lucerne (1858, National Gallery of Art, Washington, D.C.) and The Marina Piccola, Capri (1859, Albright-Knox Art Gallery, Buffalo). It also yielded hundreds of studies of the landscape and local people in oils and pencil. His figure sketches show an attentiveness to dress and facial features similar to those he subsequently made of Native Americans while traveling through the Rocky Mountains.

Bierstadt was in Italy again in the spring of 1868, during a two-year tour through Europe with his wife, which included a lengthy stay in London and visits to Paris, Düsseldorf, Switzerland, Dresden, and Madrid. Throughout, they enjoyed fine hotels and lavish entertainment appropriate to an artist who by then was established, wealthy, and known internationally for his panoramic landscapes. The Bierstadts seem to have traveled directly to Rome from London in February 1868, and perhaps then to Naples. They went to Florence in April, returned to Rome in May, and departed for London in late June. Bierstadt's professed purpose in Italy at this time was to paint a large canvas showing Mount Vesuvius in eruption but he also spent much time socializing with other Americans, including Elihu Vedder in Rome and Thomas Ball in Florence.

Albert Bierstadt

28. *The Arch of Octavius*
 (Roman Fish Market), 1858
Oil on canvas, 28½ x 37½ in.
Signed l.r.: ABierstadt / 1858
The Fine Arts Museums of San Francisco, Gift of Mr. and
Mrs. John D. Rockefeller 3rd

This, Bierstadt's only urban scene, was the first finished composition to result from his travels to Italy. Painted after he returned to New Bedford, Massachusetts, it was exhibited in 1858 at the Boston Athenaeum, which quickly purchased it and included it in fourteen of its annual exhibitions over the next sixteen years. With the meticulous handling Bierstadt had mastered in Düsseldorf, it presents a tableau of life at the fish market on the ruins of Rome's Portico of Octavia, where local folk haggle, loiter, and guard their wares, seemingly oblivious to the surviving remnants of ancient Roman glory that surround them.[1]

Near the Tiber's sharp bend Caesar Augustus erected a spacious portico of 270 columns, which he named for his sister Octavia, placing it next to the Theater of Marcellus, named for her son. Two centuries later, an arch was built at its entrance to replace columns destroyed by fire. Over time, the portico was filled in with smaller structures, except for its arched entrance, which became the location of Rome's fish market. The surrounding area, graced by temples and libraries in ancient times, became Rome's Ghetto, the walled city within a city where Jews were confined until 1870 by papal decree.

This site allowed Bierstadt to depict an aspect of Rome that frequently dismayed mid-nineteenth century tourists. As Americans found, most Roman ruins

> do not stand apart in solitary grandeur, forming a shrine for memory and thought. . . . They are often in unfavorable positions, and bear the shadow of disenchanting proximities . . . and we can nowhere escape from the debasing associations of actual life.[2]

At the picture's right, a hapless tourist couple – the gentleman clutching Murray's red guidebook, the lady brushing off a beggar – are bewildered by the condition of the place they have ventured through labyrinthine streets to see.

The previous century tended to depict ruins such as the Portico of Octavia in artificially elegant, spacious settings.[3] Like other artists of his time, Bierstadt debunked that tradition.[4] He focused on the site's everyday appearance, rendering doorways, windows, ragged brickwork, crumbling stucco, even the direction of morning light with scrupulous precision. His fictive market scene is a careful editing of reality to amplify the shabbiness of the place. His selection of fish, for example, excludes the finer sea bass, whiting, sole, and gray mullet sold there in favor of the cheapest fish, that is, skate, sardines, eels, and a plethora of small shark called dogfish, which are strewn on the street and makeshift countertop.[5] Bierstadt thus makes a wry comment on the devaluation of Rome's ancient grandeur, summed up by the fallen capital in the foreground, now merely a surface for cutting fish. At the right, two demigods of the classical world, the *Barberini Faun* (Glyptothek, Munich) and the *Sleeping Endymion* (Capitoline Museum, Rome), have become a worker dozing beside his broom and a dirty, barefoot fisherman asleep on the pavement.

However, the environment Bierstadt presented is less filthy and brutish than the harrowing place chronicled by the artist's contemporaries.[6] It is also more serene and spacious, thanks to an arch made larger than its actual sixteen-foot span and seven-foot springing. While wishing to convey the decrepitude of contemporary Rome, Bierstadt seems to have been unwilling to detach it entirely from an artful ideal.

D. STRAZDES

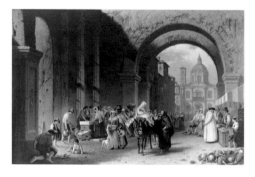

Fig. 1. Robert Weir (American, 1803-1889), *Portico of the Palace of Octavia,* 1874. Oil on canvas. The Chrysler Museum at Norfolk, Gift of Walter P. Chrysler, Jr.

1. Bierstadt's original title, *Arch of Octavius,* is inaccurate; the actual site is the Portico of Octavia.

2. George Stillman Hillard, *Six Months in Italy* (Boston: Ticknor, Reed, and Fields, 1853), vol 1, p. 291.

3. Examples of this tendency include Antonio Gaspari's *Portico of Octavia* (about 1704, Galleria Nazionale dell'Arte Antica, Rome) and Hubert Robert's rendition of the same site, *Octavian Gate and Fish Market* (about 1780, Vassar College Art Gallery, Poughkeepsie, N.Y.). A century later Robert Weir revived the eighteenth-century caprice for his *Portico of the Palace of Octavia* (fig. 1).

4. Two such depictions of the Portico of Octavia are Ernst Meyer's *A Public Scribe at the Portal of Octavia* (1829, Thorvaldsens Museum, Copenhagen) and Leopold Robert, *Arches in a Roman Street* (about 1824, Musée d'Art et d'Historie, Neuchâtel).

5. These fish are listed in *Murray's Handbook of Rome and Its Environs* (London: John Murray, 1864), p. xii.

6. For an extended descriptions of the Ghetto and its poverty, see Hillard, *Six Months in Italy,* vol. 2, pp. 47-52.

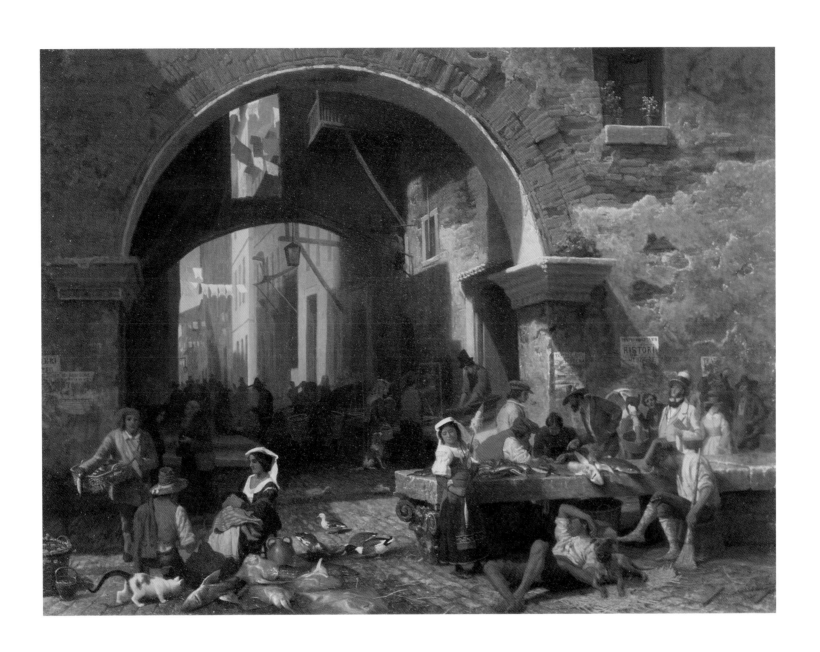

William Page

Born Albany, New York, 1811; died Tottenville,
Staten Island, New York, 1885

*Page, the "American Titian" became an exponent
of Venetian color before he went to Italy or saw
an original painting by Titian. He made his first
trip to Europe at mid-career, leaving New York
in the spring of 1850 for Paris, Marseilles, then
Nice. From Nice he proceeded by steamer to Italy,
arriving in Florence in July 1850.*

*Page financed his passage with commissions
from collectors back home for copies after Titian.
In Florence he busied himself with copying, taking
advantage of the city's impressive collection of
Titians as no previous American had. In late
summer of 1850 he visited Venice, where he again
copied Titians, including* Flora, Assumption
of the Virgin, *and* Presentation of the
Virgin. *In the fall he returned to Florence and
became friendly with other American residents,
including Hiram Powers and James Russell Lowell.*

*After a second trip to Venice in the summer of
1852 Page visited Milan, then in October 1852
he moved to Rome, taking a studio on Via del
Babuino near the Spanish Steps, in a building
shared by several foreign artists, including the
sculptor Chauncy Ives. Page spent most of the
next eight years in Rome, where he was a promi-
nent member of the city's large English-speaking
colony. He knew Harriet Hosmer, Nathaniel
Hawthorne, Robert and Elizabeth Barrett
Browning, Thomas Crawford, the actress Char-
lotte Cushman, and William Wetmore Story. His
portraits and exhibition pictures of religious and
mythological themes were noted for originality of
his ideas and the individuality of his painting
style.*

*In the spring of 1853 Page visited Naples; he
was joined in Rome by his three daughters and
moved into an apartment below the Brownings.
Abandoned by his second wife Sarah in 1854, he
returned to the United States in 1857 to obtain a
divorce in order to remarry. In 1860 he found his
portrait commissions decreasing because of the ex-
odus of American travelers from Rome and in
August of that year he, too, returned to the United
States.*

William Page

29. *Mrs. William Page (Sophia Candace
Stevens Hitchcock)*, 1860–61

Oil on canvas, 60¼ x 36¼ in.

*The Detroit Institute of Arts, Gift of Mr. and Mrs. George S.
Page, Blinn S. Page, Lowell Briggs Page, and Mrs. Leslie
Stockton Howell*

Page's third wife, Sophia Candace Stevens
Hitchcock, came to Rome in 1856 as travel-
ing companion to Bertha Olmsted, sister
of Frederick Law Olmsted. A young
widow, Sophia became Page's pupil and
they were married in Rome's Anglican
church in October 1857.[1] Page began this
portrait in Rome in 1860 and completed it
in New York the following year. He made
a nearly full-length self portrait at the
same time as a companion piece (fig. 1).
The two became the best known and most
admired works of this artist, whose repu-
tation rests on the enigmatic moods of his
paintings.

A disarmingly spare image, *Mrs. William
Page* presents a stately, nearly full-length
figure in a black bonnet and fur-trimmed
blue-black cloak, holding a pair of buff
gloves. Gazing at the viewer, she puts a
glove on her right hand, a gesture that
frames the wedding ring on her left. She
stands outdoors against a view of the
Colosseum, another ring connoting eter-
nity. The Colosseum was Rome's most fa-
mous and most mysterious ruin, especially
when seen by moonlight, as every tourist
did "as a matter of course."[2] Page, however,
gave it just as much mystery by daylight.
Silhouetted against a blue-green sky that
fades to white at the horizon, the Colos-
seum is shown as if from the vantage point
of the Via Sacra. The view is not strictly
accurate, for the Colosseum lacks the but-
tresses added in the 1820s, and the ruins of
the Temples of Venus and Rome have been
brought closer for greater effect.[3] The bar-
ren landscape appears as if from a dim,
distant, and half-imagined past. A solitary
shrub grows from a fissure in the earth
next to a fallen column, its scattered seg-
ments sunken in brown dust.

The iconic appearance of Page's picture
is due in part to his method of sketching
compositions on a grid, as artists of the
Renaissance did. Insisting that a picture

Fig. 1. William Page, *Self Portrait*, about 1860-61. Oil on can-
vas. The Detroit Institute of Arts, Gift of Mr. and Mrs.
George S. Page, Blinn S. Page, Lowell Briggs Page and
Mrs. Leslie Stockton Howell.

should be understood at a glance, he gen-
erally prepared a small, squared drawing,
eliminating unnecessary details and fixing
those that remain into a grid. This tech-
nique helped Page emphasize the relation-
ship of shapes, such as his wife's bonnet,
which echoes the broken profile of the
Colosseum behind it. The juxtaposition of
a sitter in the foreground against a distant
background derives less from past masters
than from photography.[4] Presenting a por-
trait subject as if standing against the
Colosseum was a convention both for
painters and photographers, seen in an
1861 photograph of Elizabeth Barrett
Browning (cat. 143).

His wife's gesture of holding a glove
brings to mind numerous Titian portraits,

John Linton Chapman

Born Washington, D.C., 1839;
died Westchester, New York, 1905

the landscape recalls the imaginary terrain in the background of Titian's mythological and religious paintings, and the sharp silhouettes like the portrait's coloring recall Titian's technique generally.[5]

Prior to going to Europe, Page developed a technique that he believed to be based on Titian's in which he applied paint to canvas in a series of tinted glazes. His firsthand study of Titian's paintings reinforced his commitment to his glazing method, while giving it a greater nuance of texture and tone. The brown and ocher hues in *Mrs. William Page* are made up of complex veils of pigment, one thin layer over another. The fallen columns in the background, for instance, are a combination of pink and green; together they create a brown tone subtly different from that of the ground itself or the Colosseum. The skin tones are the result of a painstaking overlay of blues and yellows on a red ground, like blood beneath the skin.

Page, who felt he had discovered the secret of portraying living flesh in Titian, labored over his wife's face and hands. He was still adding to these areas in May 1861, to make her figure "stand out rounded and alive," as he put it.[6] Despite Page's considerable effort to give a natural appearance to the flesh tones, Mrs. Page seems as remote from the viewer as the setting behind her.

D. STRAZDES

1. Joshua C. Taylor, *William Page: The American Titian* (Chicago: University of Chicago Press, 1957), p. 156.

2. George Stillman Hillard, *Six Months in Italy* (Boston: Ticknor, Reed, and Fields, 1853), vol. 1, p. 307.

3. Joshua C. Taylor, "The Fascinating Mrs. Page," *Art Quarterly* 20 (winter 1957), pp. 347, 362n.

4. Ibid., pp. 351-53.

5. Samuel Taylor Coleridge, in writing about an Allston painting mistaken for a Titian, disclaimed the similarity saying, "the outline is too soft for Titian — he was *crisp* to a defect." Coleridge to Washington Allston, June 29, 1817, Houghton Library, Harvard University.

6. William Page to Mrs. Page, May 19, 1861, Page Papers, Archives of American Art, Smithsonian Institution, Washington, D.C.

The elder son of John Gadsby Chapman (see cat. 66) and brother of painter Conrad Wise Chapman, John Linton Chapman was named after one of his father's early patrons. Although born in the United States, he spent much of his life in Italy with his expatriate family, who sailed for Europe in the spring of 1848. The Chapmans spent several months in London and a year in Paris before reaching Florence in 1849 and finally settling in Rome by the end of 1850.

John Linton Chapman and his brother were recognized as artists with potential by a correspondent for the Crayon *who wrote in August 1858, "Chapman's sons both promise well, and a study from nature by the elder one is characterized by vigor, and a fine feeling for color" (p. 231). In June 1859, another correspondent from Rome in the* Crayon *reported, "Mr. Chapman has two sons, who are rapidly preparing to take his place in the first rank of American painters. Though both are still in their minority, they have produced some costume pieces which are not only admired, but bought" (p. 184). In December 1859, the* Crayon *reported on John Gadsby Chapman's visit to the United States from Italy: "Mr. Chapman has brought home with him several of his recent productions, together with specimens of his sons' ability; the latter indicating fine promise. His own works represent some of the picturesque spots of the Pope's garden at Castel Gondolfo; and those of his two sons, John and Conrad, life-studies of Albano peasants" (p. 380). Tuckerman (*Book of the Artists, *1870, p. 221) also mentioned John Linton Chapman's work when writing about his father, "His vivid coloring and facility of execution enable him to profitably supply visitors at Rome with local illustrations, and his talent seems to be inherited by his son, who is active and successful in the same sphere."*

Chapman, known to his family as "Jack," returned to the United States in 1878, living in New York City and Brooklyn for a time and then in Baychester, New York. Most of the paintings that Chapman exhibited at the National Academy of Design in 1881, 1882, and 1883 were of Italian subjects. He drew the illustrations for John S. Wise's book, Diomed: The Life, Travels, and Observations of a Dog, *published in 1897. Divorced and impoverished, Chapman died in May 1905 and was buried next to his father several months later, after Conrad Wise Chapman earned sufficient funds for a proper burial by coloring engravings.*

John Linton Chapman

30. *Tomb of Shelley*, 1862
Signed l.l.: JLC. (in monogram) Prot.
Cemetery / 1862.
Oil on board, each, 9¾ x 6¾ in.
Lent by Mr. Graham Williford

Tomb of Keats, 1862
Signed l.l.: JLC. (in monogram) / Old Prot.
Cemetery 1862

John Keats died at Rome of a consumption in his twenty-fourth year . . . and was buried in the romantic and lonely cemetery of the Protestants in that city, under the pyramid which is the tomb of Cestius, and the massy walls and towers . . . which formed the circuit of ancient Rome. The cemetery is an open space among the ruins, covered in winter with violets and daisies. It might make one in love with death, to think that one should be buried in so sweet a place.

Percy Bysshe Shelley, who wrote these lines in 1821 in his preface to *Adonais: An Elegy on the Death of John Keats*, himself died a year later in 1822, and his ashes were also buried in the New Protestant Cemetery in Rome. Although their tombs are in different parts of the cemetery (Keats having been buried in the old section), John Linton Chapman joined them by framing his paintings of their tombs together. They were also joined in the minds of nineteenth-century visitors as well as in the Keats-Shelley Memorial Association, whose headquarters is in the house where Keats died at the foot of the Spanish Steps. Keats (1795-1821), the English Romantic poet famed for his "Ode to a Nightingale" (1820) and "Ode on a Grecian Urn" (1820), had been ordered by his doctor to go south in 1820 for his health. He died of consumption on February 23, 1821 after only a few months in Rome, tended by his loyal friend, the artist Joseph Severn, who is buried next to him. Shelley (1792-1822), whose well-known "Ode to the West Wind" (1819) was written near Florence, spent almost four years in Italy, where almost all his important works were written. Shelley left England in 1818 and traveled to Italy for his health and to escape the land of his tragic first marriage. Leading a peripatetic existence in Italy with his second wife Mary Wollstonecraft

Shelley, he wrote most of "Prometheus Unbound" in the Baths of Caracalla, and Renaissance Rome was the setting for "The Cenci," his tragedy in five acts, written in Leghorn in 1819. He died when a storm overtook his boat sailing from Leghorn to a summer villa on the Gulf of Spezia (see cat. 72).

Begun as a burial ground for non-Catholics (the earliest graves are from 1738), the Protestant Cemetery is located near Porta San Paolo and the Pyramid of Gaius Cestius (died 12 B.C.) and is bordered by the Aurelian wall in the southern section of Rome. In addition to Keats and Shelley and their countrymen, many Germans (including Goethe's only son), Swiss, Russians, and Swedes were buried there. Among Americans buried there were Richard Henry Dana, author of *Two Years Before the Mast*, sculptors Thomas Crawford, Joseph Mozier, Chauncey Bradley Ives, and William Wetmore Story, and painters James De Veaux, Luther Terry, Charles Temple Dix, John Rollin Tilton, William Stanley Haseltine, and Elihu Vedder.[1]

Chapman painted the tombstones so that the inscriptions are easily read. Under Shelley's name is "Cor Cordium" which Murray's 1869 *Handbook of Rome and Its Environs* translates as "the heart of hearts" and explains as an "allusion to the story that when his body was burnt on the shores of the Gulf of Spezia, the heart was the only portion that the fire did not consume."[2] When Shelley's body had washed up on the shore near Viareggio, his friends, Edward Trelawny and Lord Byron, had his body burned and the ashes, as well as the heart which Trelawny was said to have snatched from the flames of his funeral pyre,[3] buried in Rome under the tombstone with three lines from Shakespeare's *The Tempest*:

Nothing of him that doth fade,
But doth suffer a sea change
Into something rich and strange.

Beneath a lyre, attribute of Apollo and of Erato, the muse of lyric poetry, Shelley had the following epitaph engraved on Keats's grave stone on instructions from Keats who was embittered by some adverse criticism that had greeted his poetry:

This grave contains all that was mortal of a young English poet, who, on his death-bed, in the bitterness of his heart at the malicious power of his enemies, desired these words to be engraven on his tombstone: 'Here lies one whose name was writ in water.'

Chapman's selection of these two tombstones evokes both romantic and melancholy thoughts about the international expatriate community in Rome to which the Chapman family belonged for decades. Thomas Cole also had painted the Protestant Cemetery but from a more distant view and included the Pyramid of Gaius Cestius and parts of the Aurelian wall.[4] However, Chapman chose to portray the tombs of the two figures most frequently associated with this burial ground and to evoke the solitude but also the sunshine, gentle wind, and profusion of wild flowers that inspired many writers who visited the cemetery. George S. Hillard wrote:

Though a graveyard of strangers who have died in a foreign land, many of them friendless and alone, and nursed by cold and mercenary hands, is an object to awaken sad thoughts, yet the general aspect of this cemetery is soothing, and even cheerful The turf even in the heart of winter is freshly green, and there is a profusion of flowers, both wild and cultivated. The common rose of our conservatories grows here with great luxurance, and is always in bloom,

Robert Walter Weir

Born New York, New York, 1803;
died New York, New York, 1889

Robert Walter Weir

31. *Taking the Veil*, 1863
Oil on canvas, 49½ x 39¾ in.
Signed l.l.: Robert W. Weir 1863
Yale University Art Gallery

hanging its flowers over the monuments and filling the air with a delicate and spiritual fragrance.[5]

And, finally, Henry James wrote of this mingling of beauty and melancholy in his *Italian Hours*:

Here is a mixture of tears and smiles, of stones and flowers, of mourning cypresses and radiant sky, which gives us the impression of looking back at death from the brighter side of the grave.[6]

J. COMEY

1. Regina Soria, "Gli Artisti Americani al Cimitero del Testaccio," *Studi Romani* 28 (April-June 1980), pp. 201-211. For information about John Linton Chapman see William P. Campbell, *John Gadsby Chapman* (Washington, D.C.: National Gallery of Art, 1962), and Louise F. Catterall, ed., *Conrad Wise Chapman* (Richmond, Virginia: The Valentine Museum, 1962).

2. *Murray's Handbook of Rome and Its Environs* (London: John Murray, 1869), p. 316.

3. Neville Rogers, *Keats, Shelley & Rome* (New York: Frederick Ungar Publishing Company, 1961), p. 40.

4. Cole's painting, *The Protestant Cemetery in Rome* (Olana State Historic Site, Hudson, New York), is based on an oil sketch painted in 1832, which is in a private collection.

5. George Stillman Hillard, *Six Months in Italy* (Boston: Ticknor, Reed, and Fields, 1853), vol. 1, p. 429.

6. Henry James, *Italian Hours* (Boston : Houghton Mifflin Company, 1909), p. 270.

Robert Weir was fortunate in finding two patrons, John Delafield of New York and the Philadelphian Henry Carey, whose generosity enabled the just twenty-one-year-old painter to set off for Italy on December 15, 1824. Weir sailed directly for the then-busy port of Leghorn (Livorno); on the way over he sketched illustrations for Dante's Inferno. *Arriving in late February 1825, he went first to Pisa, before settling for a year in Florence, where he studied briefly with the leading neoclassic history painter, Pietro Benvenuti. About December 1825, Weir went to Rome, stopping in Siena for a day. In Rome he and Horatio Greenough took rooms together on the Pincian Hill near the former studios of Claude Lorrain, Salvator Rosa, and Nicholas Poussin - on what Weir considered "holy ground." Weir explained that typically they would draw from the antique at the French Academy in the morning; then Greenough would go to his studio while Weir copied Raphael, Michelangelo, or Titian at the Vatican or one of the private galleries; after lunch at three, he would stroll around the sights or would draw from casts or from nature. After supper at six, he and Greenough would gather with the other foreign artists at the Caffè Greco, and would then go to the English Academy's life school from seven to nine. In January 1827 he traveled to Naples and Paestum; in February, he met up with Greenough, who was ill with malaria, in Naples.*

Weir abandoned his own plans to go on to Florence and Venice, to accompany the still sick Greenough back home on a ship from Leghorn to Boston, leaving in late March 1827. Weir's two years in Italy - his only European experience - played an important role in his development, and he continued to paint Italian subjects throughout his long career.

Shortly after arriving in Rome, Weir witnessed the scene described in the following newspaper account:

Early in the winter of 1826 great interest was exhibited among the nobility and foreign residents of Rome by the announcement that Carlotta, the young and beautiful daughter of the Lorenzana family, was about to enter her novitiate, preparatory to taking monastic vows in the Ursuline convent. The ceremony attending this act, as is well known, is one of the most picturesque and affecting in the whole range of the Roman Catholic ritual, and when the subject of these holy vows is young and fair, and of high social position, the occasion is anticipated and attended with no ordinary emotions of curiosity and sympathy.[1]

This event "made a strong impression" on Weir, who "carefully sketched it on the spot."[2] He exhibited a sketch — of unknown medium — of the subject at the National Academy of Design, New York, in 1832, but apparently did not undertake the larger composition until the 1850s. The picture must have been largely finished in October 1860, when the *Crayon* described it in detail, and became the first of many to lavish praise upon it ("We regard this work as one that gives new value to our school of art").[3] *Taking the Veil*, alternately called by the artist "The Consecration of a Nun" was the subject of a special month-long exhibition at Goupil's Gallery in New York, beginning with a private viewing on February 16, 1863. It attracted large paying crowds (admission was 25 cents) and enthusiastic reviews: it was called "a superb picture by our gifted countryman" and "one of the choicest interiors, from the brush of an American artist, ever exhibited in New York."[4] In following years, the work was included in numerous exhibi-

tions, including the Philadelphia Exposition of 1876.[5] In the foreground of the painting Carlotta Lorenzana is dressed in a white wedding dress and veil. She kneels at the altar with her hands clasped in prayer; the Cardinal Bishop stands before her, blessing her, while a priest, in white, places a crown of roses upon her head. Just behind Carlotta kneels her mother, dressed in red. Younger priests hold the cross and the cardinal bishop's crozier, while acolytes lift his train, swing a smoking censer, and hold a burning taper. Weir had originally viewed this scene in the small baroque church of San Guiseppe in Orsala in Rome, home church of the Ursuline order; but in the painting the setting is clearly a large cruciform Gothic church, one based on no particular American or European model, but rather one that Weir carefully invented and arranged to suit his painting.[6] At the far left of the composition we see part of the pulpit, which casts a dark shadow across the foreground of the picture; we look out past the pulpit and the highlighted figure of Saint Margaret[7] standing with her cross, to the north transept, where a crowd of onlookers has gathered behind a railing inscribed – in Italian – "only one faith, one baptism, one God." Above them is a gallery holding an antiphonal choir (which never would have appeared in a Gothic church); behind the singers we see an elaborate baroque organ and – just to the right – a Gothic stained glass window. Though most of the critics at the time believed that Weir's painting was truthful in all its aspects, including architecturally, the early *Crayon* review gave an important hint in saying: "We admire the design of the cathedral, which is in many respects original."[8] Apparently Weir, with considerable sophistication, combined the Gothic structure with which he felt most comfortable as a high Episco-

palian, with Baroque space and other elements that would place the scene firmly in Italy. Weir was devoted to religious art, and had made a number of earlier paintings, such as his *Presentation in the Temple* (1835, private collection), which foreshadow *Taking the Veil* in its celebratory, sympathetic mood and in the Rembrandtesque composition of its central group.[9] Weir's subject in *Taking the Veil* is perhaps unique in American art, and his treatment stands in contrast to that of many English paintings of the nineteenth century, which portrayed similar scenes in sensational or critical ways.[10]

T. STEBBINS

1. New York *Evening Post*, February 19, 1863. In 1825 Donna Carlotta Lorenzana went through the "Vestizione" ceremony dressed as a bride, and took the name of Suora Maria Nazarena di San Giuseppe; in 1826 she took her final vows, not dressed as a bride. In 1846, she was elected Mother Superior of the Ursuline Order. For this information, we are most indebted to Dr. Portia Prebys, Saint Mary's College, Rome, Italy and South Bend, Indiana.

2. Ibid.

3. "Domestic Art Gossip," *Crayon*, October 1860, p. 298.

4. Journal of Commerce, New York, n.d.; New York Evening Express, n.d., Yale University Art Gallery curatorial files.

5. According to Susan P. Casteras's excellent study, "Robert W. Weir's *Taking the Veil* and 'The Value of Art as a Handmaid of Religion'," *Yale University Art Gallery Bulletin* 39 (winter 1986), pp. 12-23. The painting was also exhibited in the annual exhibitions at Yale from 1870 to 1875. It apparently remained unsold until Weir's estate sale of 1891; how it came to the Yale Collection is unknown, but the artist's son John F. Weir, longtime director of the Yale School of Fine Arts, likely played a role.

6. The church and monastery of San Giuseppe were expropriated by the State of Italy from the Order of the Ursulines between 1894 and 1896, according to the research of Dr. Portia Prebys. The buildings in Via Vittorio, not far from the Spanish Steps, became the Conservatorio di Santa Cecilia.

7. Professor William Pierson further suggests that the four sculptures all relate to Weir's theme of the nobility of Carlotta's induction. He identifies the large figure on the left, on the edge of the chancel steps, who holds a tall cross, as Saint Margaret, patron saint of womanhood and the exemplar of all women in holy orders. Atop the pedestal next to the choir is Saint Cecilia, patron saint of music, and herself a wealthy noblewoman who gave all her property to the poor when she took her vows; below her is Saint Lucy; and just to the right, seen from the side, is Saint Anne, mother and teacher of the Virgin Mary, and especially appropriate as the Ursuline order was founded primarily for the teaching of girls.

8. "Danish Art Gossip," *Crayon*, October 1860, p. 298.

9. See Casteras, "Taking the Veil," who suggests as prototypes for Weir's composition two of Rembrandt's etchings *Presentation in the Temple*, and his *Christ Before Pilate* (*Ecce Homo*), 1635. Weir collected Rembrandt's prints, and as a young man made numerous copies of his paintings.

10. See Susan P. Casteras, "Virgin Vows: The Early Victorian Artists' Portrayal of Nuns and Novices," *Victorian Studies* 24 (winter 1981), pp. 157-84. Note that American writers frequently commented on such scenes, beginning with Washington Irving (*Notes and Journal of Travel in Europe 1804-1805*, 3 vols. 1921, pp. 100-101) who observed a beautiful young Sicilian girl "taking the veil," which he found "a painful sight."

William Wetmore Story

32. *Sappho*, 1863
Marble, h. 54⅞ in., w. 32⅛ in., d. 34 in.
Signed on back: WWS (monogram) / ROMA 1863
Museum of Fine Arts, Boston, Otis Norcross Fund

The sculptures of heavily draped, brooding, seated women like Sappho, which became Story's trademark works, were acclaimed for their exotic origins and emotionally charged subjects. These women were often troubled individuals, well-known from the Bible or world literature. Often portrayed in deep thought, these seemingly passive figures, through pose, attitude, and various attributes, conveyed to Story's admirers a powerful psychological drama, often enhanced with poetry written by Story himself. *Sappho* was one of Story's favorite ideal works; as the chronological successor to *Cleopatra* and the *Libyan Sibyl*, it represents a further distillation of his vision of deeply tormented women.[1] Story and his friend, the poet Robert Browning, both strove to express the inner thoughts of their subjects. Browning employed dramatic monologue to reveal the personalities of his characters, while Story chose to depict an arrested moment of thought in his figures.[2] Similarly, Story's fascination with sensational crimes of passion was shared by Browning and is readily apparent in such prose works as *The Marble Faun* (1860, cat. 162) by their mutual friend Nathaniel Hawthorne.

Unlike his contemporaries, Story preferred the draped figure as opposed to the nude for its melodramatic possibilities. *Sappho*, like most of Story's seated figures, is based upon the *Seated Agrippina* (Capitoline Museum, Rome).[3] The sculpture of this mature woman, often identified as Agrippina the elder, wife of Germanicus, had more in common with portraiture than with such nudes as the *Venus de' Medici*. In choosing such a model for his sculpture, Story freed himself from notions of ideal beauty in the female form, and thus allowed himself to focus upon his impassioned subject. The dramatic events of Sappho's rejected love and subsequent suicide by drowning were common themes in

a Victorian culture preoccupied with both subjects in literature and art. Discussion of her alleged homosexuality in the nineteenth century eventually gave way to a romanticized view of Sappho as a brilliant woman whose psyche and gift of poetry were paralyzed by unrequited love. Story selected Ovid's less controversial account of Sappho's suicide in his depiction of a despondent Sappho who, after rejection from the Greek boatman Phaon, has found peace in her resolve to end her life.[4] The Greek poet's unstrung lyre leans, forgotten, against her *klismos* chair while a rose, symbolic of her failed love affair, droops sadly across the instrument once given life by her genius. James Jackson Jarves praised Story for the "antiquarian knowledge" he displayed in delineating the dress, jewelry, and decorative elements of *Sappho*. In addition to faithful renditions of Greek dress and hair, Story may also have consulted portraits of Sappho known from ancient coins, or an image at the Villa Albani in Rome, the latter then believed to be a true portrait of the poet.[5] Sappho was a popular subject among such nineteenth-century American sculptors as Thomas Crawford, Edward Sheffield Bartholomew, and Chauncey B. Ives. The most direct influence on Story's *Sappho* may have been Florentine sculptor Giovanni Dupré's (1817-1882) *Sorrowful Sappho* (fig. 1), which was exhibited in Florence at least twice in 1861.[6] Story's seated *Sappho* resembles that sculpted by Dupré five years earlier, but the figure's casual, yet alert posture shows more inner control and self-awareness than that conveyed by the vacant stare and lowered head of Dupré's dejected poet. In Story's hands, Sappho's forgotten lyre and dying rose show little of the sensual surface treatment evident in Dupré's accessories, but the fine decorative vine and flower decoration on the lyre may be a quote from Dupré's work. Story probably

Fig. 1. Giovanni Dupré (Italian, 1817-1882), *Sorrowful Sappho*, 1857. Marble. National Gallery of Modern Art, Rome. Photograph courtesy Alinari / Art Resource, New York.

had ample opportunity to view the plaster study or marble of *Sorrowful Sappho* in Dupré's Florentine studio, for the sculpture remained with the Italian artist until his death. Despite the breast revealed by the poet's loose-fitting *chiton*, Story's sculpture is chaste in its presentation, as Sappho, lost in thought, gives no apparent consideration to her appearance. The sculptor's compact, pyramidal composition focuses attention on the slightly tilted head of Sappho and her quiet contemplation of the watery death she has chosen. The esoteric, literary nature of this sculpture, one of Story's most romantic works, is indicative of his life-long ambition to create refined works of art for an elite group of educated collectors.

J. FALINO

1. For a full discussion on the life of William Wetmore Story, see Jan Seidler Ramirez, "A Critical Reappraisal of the Career of William Wetmore Story (1819-1895), American Sculptor and Man of Letters," Ph.D diss., Boston University, 1985.

2. For a discussion of the intellectual relationship between Browning and Story, see Seidler, "William Wetmore Story (1819-1895), American Sculptor and Man of Letters" vol. 1, pp. 363-376.

3. Frances Haskell and Nicholas Penny, *Taste and the Antique, The Lure of Classical Sculpture 1500-1900* (New Haven, Connecticut: Yale University Press, 1981), pp. 133-34.

4. See Ovid's "Epistle from Sappho to Phaon," in *Heroïdes*, trans. Harold C. Cannon (New York: E.P. Dutton & Co., 1971).

5. Jan Seidler Ramirez, "William Wetmore Story (1819-1895)" and "Sappho" in Kathryn Greenthal, et al., *American Figurative Sculpture in the Museum of Fine Arts, Boston* (Boston: Museum of Fine Arts, 1986), pp. 107-110; 115-119.

6. Story must have been on good terms with Dupré, for in 1886 he wrote an introduction to the Italian sculptor's autobiography. Jan Seidler Ramirez, "The Lovelorn Lady: A New Look at William Wetmore Story's Sappho," *The American Art Journal* 15 (summer 1983), pp. 86-87.

Harriet Hosmer

Born Watertown, Massachusetts, 1830;
died Watertown, Massachusetts, 1908

Harriet Hosmer was the first American woman to make her career in Italy as a sculptor. Hosmer arrived in Rome in 1852 accompanied by her father and the internationally acclaimed American actress, Charlotte Cushman, who had encouraged her to pursue a career in sculpture. Hosmer quickly sought out English sculptor John Gibson (1790-1866), the foremost practitioner of the neoclassical style in mid-nineteenth century Rome; Gibson accepted the twenty-two-year-old woman as his pupil and settled her into his studio near the Spanish Steps at Via Fontanella, formerly occupied by his own master, Antonio Canova (1757-1822). Through Cushman and Gibson, Hosmer was welcomed into a small expatriate circle of English-speaking artists, writers, and collectors in Rome, including the English painter Frederick Leighton, poets Robert and Elizabeth Barrett Browning (see cat. 143), William and Evelyn Story, author William Makepeace Thackeray and his family, and William Page.

The joy Hosmer found in Rome is evident in a letter of 1853 to her school friend Cornelia Carr:

> *I wouldn't live anywhere else but in Rome, if you would give me the Gates of Paradise and all the Apostles thrown in. I can learn more and do more here, in one year, than I could in America in ten. America is a grand and glorious country in some respects, but this is a better place for an artist.*

A brief, unpleasant chapter in Hosmer's career revolved around a misleading rumor in 1864 that she did not carve her own sculpture (see cat. 144). This episode may suggest the hazards encountered by women sculptors hoping to join this formerly all-male enclave. Hosmer responded to the accusation by lampooning her opposition in "The Doleful Ditty of the Roman Caffè Greco." A more serious response by Hosmer in The Atlantic Monthly *(December 1864) noted the standard practice of all sculptors, including such highly esteemed artists as Thorvaldsen and*

Crawford, to retain marble carvers who carried out the artist's vision as created in clay. Hosmer spent her entire career in Rome, her success an inspiration to many women sculptors who followed her path to Italy. Her body of work is notable for several sculptures that addressed the dignity and courage of women in history. Among them were Beatrice Cenci *(1856, St. Louis Mercantile Library), murderer of her incestuous father;* Zenobia *(1859, location unknown; reduction, Wadsworth Athenaeum, Hartford Conn.), the defeated African queen of Palmyra; and* Queen Isabella of Castile *(1893, location unknown), shown offering her jewels to Columbus. Hosmer produced little sculpture after the 1870s. She returned to Massachusetts in 1900, where she died in 1908.*

Harriet Hosmer

33. *The Sleeping Faun,* after 1865
Marble, h. 34½ in., l. 41 in., d. 16½ in.
Signed at back of base: HARRIET HOSMER FECIT
ROMAE
Museum of Fine Arts, Boston, Gift of Mrs. Lucien Carr

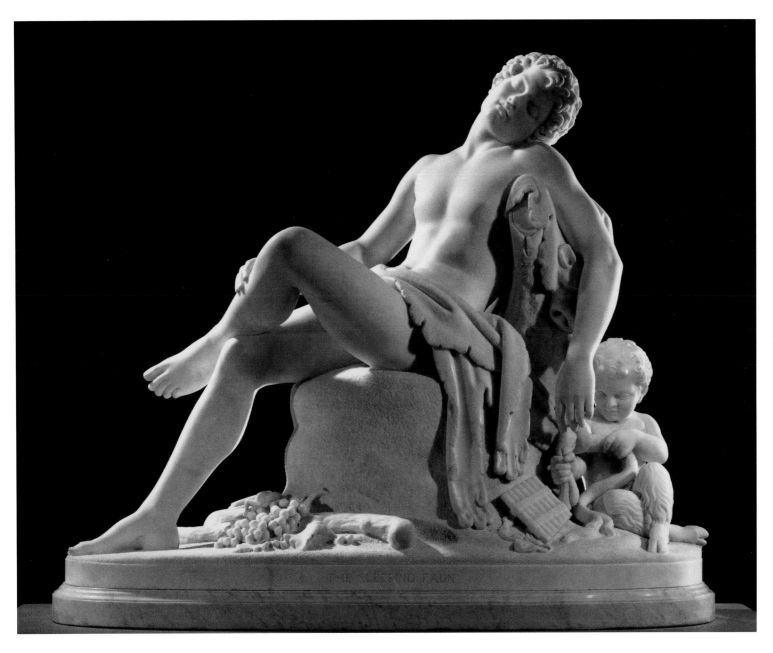

To nineteenth-century eyes, Hosmer's mastery of the principles of antique sculpture was supremely evident in *The Sleeping Faun,* whose classical sources were approvingly noted by more than one reviewer at the Dublin Exhibition of 1865. "No one can look at the 'Sleeping Faun' of Miss Hosmer without feeling that the artist was penetrated with the very spirit of the antique; that she has produced a work which, were it dug out of the ruins of the Forum Romanum, might be held in public estimation as a fit companion of the Apollo Belvedere."[1] Another reviewer noted that both she and the sculptor William Wetmore Story "received their inspiration under Italian skies, in [the] presence of the great models of ancient Greece and Rome."[2] Unlike some American sculptors in Italy, Hosmer happily embraced the study of the antique, particularly the Hel-

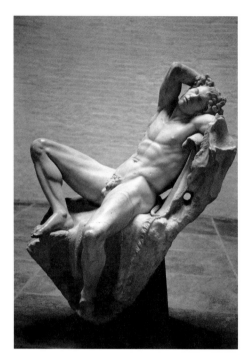

Fig 1. *Barberini Faun*, about 200 B.C. Marble. Staatliche An-tiken-Sammlungen, Munich. Photograph courtesy Vanni/Art Resource, New York.

lenistic Praxitilean school so admired by her mentor, John Gibson. The frankly sensuous *Barberini Faun* (fig. 1), long since removed to Munich, was still easily available for study in Italy through the use of casts.[3] Despite the *Barberini Faun's* deeply drunken sleep, and rather provocative arrangement of legs, its subject and pose served Hosmer with the essential elements on which to base her more chaste work. Hosmer's *Sleeping Faun* also recalls the art of Michelangelo, whose sculpture she had admired long before her arrival in Rome.[4] The pose of the dead Christ in Michelangelo's *Pietà*, (1498-99/1500) at Saint Peter's in Rome, with its thrown-back head and dangling arm, bears a resemblance to that of Hosmer's *Faun*. Hosmer's choice of subject in *The Sleeping Faun* may have been dictated in part by shrewd economics; her *Puck on a Toadstool* (1856), based upon Shakespeare's *Midsummer Night's Dream*, had

been a great financial success. She may have hoped that a sculpture of a faun, well-known to the public through numerous antique renderings and through Nathaniel Hawthorne's novel of 1860, *The Marble Faun* (cat. 162), would receive a similar reception. In some ways, Hawthorne and Hosmer were mutually indebted to one another for their subject matter. In creating the main characters for his novel, Hawthorne drew upon a number of individuals, including his own wife, Sophia Peabody Hawthorne, and William Wetmore Story, among others. Hawthorne met Hosmer in Rome in 1858, and it is likely that he included a bit of the strong-willed, resolutely unmarried sculptor in the characters of Miriam, the independent woman; Hilda, the celibate painter; and Kenyon, the sculptor.[5] Hosmer herself was probably aware of the inevitable comparisons that would be made between *The Sleeping Faun* and Hawthorne's widely read novel. Although there is little physical resemblance of Hosmer's work to the Capitoline *Faun in Repose* described by Hawthorne, at least one reviewer of the Dublin Exhibition prefaced a favorable discussion of Hosmer's sculpture with an extensive quotation from Hawthorne's descriptive passage of the Capitoline *Faun*. The strength of Hosmer's pyramidal composition, her sensitivity to the figure and the technical virtuosity of the surface treatment won her accolades as heir to "Praxiteles' chisel."[6] Despite her fervent admiration for the antique, Hosmer's modest arrangement of the nude faun's limbs was more in keeping with American mores. The faun's crossed legs and his discreetly draped animal skin, with its humorous subtext represented by the mischievous satyr who uses the animal skin to tie the faun to a tree stump, are more suggestive of an innocently napping arcadian dweller, and less a subject of erotic,

Dionysian interest as represented by its classical prototype, the somnolent *Barberini Faun*.[7]

J. FALINO

1. *The (London) Art Journal* 27 (November 1865), p. 346. In that same year, the painter Sir Charles Eastlake (1793-1865), director of London's National Gallery, and tastemaker of Victorian England, acclaimed the sculpture, writing that *The Sleeping Faun* "would have been pronounced one of the best Grecian statues" had it been uncovered among the ruins of Rome or Pompeii." Eastlake's is quoted in Wayne Craven, *Sculpture in America*, (New York: Thomas Y. Crowell Company, 1968), p. 329. For recent biographies on Hosmer, see Jan Seidler Ramirez "The Sleeping Faun" in Kathryn Greenthal et al, *American Figurative Sculpture in the Museum of Fine Arts, Boston* (Boston: Museum of Fine Arts, 1986), pp. 159-67; Dolly Sherwood, *Harriet Hosmer American Sculptor 1830-1908*, (Columbia, Missouri: University of Missouri Press, 1991). For a summary of the controversy surrounding Hosmer's working methods, see Charlotte Streifer Rubenstein, *American Women Sculptors* (Boston: G.K. Hall & Co., 1990), pp. 41-2. For Hosmer's quote on her life in Rome, see Harriet Hosmer to Cornelia Crow Carr, April 22 1853, in Cornelia Carr, ed., *Harriet Hosmer, Letters and Memories* (New York: Moffat, Yard and Company, 1912), pp. 26-7.

2. Henry Parkman and Peter L. Simmonds, eds. "The Sculpture Court," *The Illustrated Record and Descriptive Catalogue of the Dublin International Exhibition of 1865*, (London, 1866), p. 474.

3. William L. Vance, *America's Rome* (New Haven: Yale University Press, 1989) vol. 1, p. 316. Vance notes that in 1874, William T. Walters of Baltimore was informed by the sculptor William Henry Rinehart in 1874 that casts of the Barberini *Faun* were available for 450 francs.

4. Carr, *Harriet Hosmer, Letters and Memories*, pp. 15, 334.

5. Nathaniel Hawthorne, *The French and Italian Notebooks*, Thomas Woodson, ed., (Columbus: Ohio State University Press, 1980), p. 157-58.

6. Carr, *Hosmer*, pp. 221-224. Nathaniel Hawthorne, *The Marble Faun* (New York: New American Library, 1980). *The Faun in Repose* at the Capitoline Museum is a Roman copy of a Greek original dating to 350-30 B.C. Haskell and Penny, 1981, 202-05; 209-10. Parkman and Simmonds "The Sculpture Court," pp. 474-75. *Sleeping Faun* was reviewed in "The Dublin International Exhibition," *The Illustrated London News* August 19, 1865, p. 165; J.H.P. "The Fine Arts at the Dublin International Exhibition of 1865," *The Month*, (August 1865), pp. 186-93; Frances Power Cobbe, "Ireland and Her Exhibition in 1865," *Fraser's Magazine* 72 (July-Dec 1865); H.W., Lady-Artists in Rome," *The (London) Art Journal* 28 (June 1866), pp. 177-78.

7. For a discussion of the evolving attitude toward arcadian subject matter and other examples of classical fauns, see Andrea Mariani, "Sleeping and Waking Fauns, Harriet Goodhue Hosmer's Experience of Italy, 1852-1870" in Irma Jaffe, ed., *The Italian Presence in American Art 1760-1860* (New York: Fordham University Press, 1989), pp. 66-81.

Sanford Robinson Gifford

Born Greenfield, New York, 1823;
died New York, New York, 1880

The first of Gifford's two trips to Europe took place in 1855-57. He left New York on the steamer Atlantic on May 17, 1855, arriving in Liverpool May 27. After traveling for a year through England, Scotland, and the Low Countries, he sailed down the Rhône to Switzerland in June of 1856, then on foot crisscrossed the Alps between Switzerland and Italy several times before arriving at Lake Maggiore on August 17. The artist traveled to lakes Orta and Como before continuing by rail to Milan, Turin, and Genoa. He continued through La Spezia, Carrara, and Pisa, where he studied Giotto's frescoes, and arrived in Florence on September 5. There he met Hiram Powers and Horatio Greenough. Between September 22 and 29, Gifford traveled to Rome via Siena, Arezzo, Perugia, Assisi, and Terni. In Rome he took a studio at 55 Via Sistina, near the Pincian Hill. Gifford spent the winter in Rome, along with such other Americans as Albert Bierstadt, William Page, William Holbrook Beard, Richard Henry Wilde, Thomas Crawford, Randolph Rogers, Joseph Mozier, Peter Frederick Rothermel, Edward Bartholomew, Worthington Whittredge, John Rollin Tilton, and George Loring Brown. In May 1857 Gifford and Bierstadt traveled to Mt. Vesuvius, Pompeii and Herculaneum, and Naples before landing on Capri May 30. They remained on the island until June 10, when the they sailed to Sorrento, then saw Paestum. On July 5 Gifford sailed alone to Civitavecchia and then Leghorn, from which he took a train back to Florence on the sixth. The next day the artist set out for Venice via Bologna and Padua. He arrived on July 10 and met up with Beard and Wilde. On July 23 Gifford and Beard left Venice for Verona and Lake Garda. Gifford continued on foot over the Stelvio Pass into Austria, traveling extensively there and in Germany and Czechoslavakia before returning home to New York.

Gifford made his second European trip in 1868-69. With Mr. and Mrs. Jervis McEntee aboard the steamship Manhattan, he sailed on May 27, 1868, landing in Liverpool on June 8. Gifford continued immediately to London and on June 17 left for the continent. On July 9 he crossed the Col de la Seigne Pass on muleback into Val d'Aosta, climbing the Matterhorn before walking to Monte Rosa and Ceppo Morelli. From there, Gifford traveled first to Lake Orta, and on July 21 he arrived at Stresa on Lake Maggiore. Four days later he left by rail for Milan and then Lake Como, where he spent three weeks exploring the region. On August 12 Gifford returned to Milan and Genoa, then went by coach to Oneglia and by steamer to Monaco, walking the rest of the way to Nice. From Nice he sailed to Genoa, then traveled to Perugia, where he met George Henry Yewell and Charles Caryl Coleman. Gifford returned to Genoa and took a coach first to Florence and then to Rome, arriving August 29. On September 1, he left for Naples, and on the fifth he sailed from there to Messina. Gifford spent eleven days on Sicily before sailing from Palermo back to Naples. Back in Rome in late September, Gifford found apartments for himself and the McEntees at 58 Via del Babuino. They spent the winter in Rome with Frederic Church and his wife, along with Yewell, Mozier, Rogers, William Henry Rinehart, Thomas Hotchkiss, Chaucey Ives, and Robert MacPherson.

Gifford spent the winter painting and making side trips into the Campagna. On January 1, 1869, he left Rome, taking the train to Brindisi via Naples and Foggia. On January 4 Gifford sailed for Greece. He traveled on to Egypt, Palestine, Hungary, and Austria before returning to Italy to meet John Ruskin and the Henry Wadsworth Longfellows in Verona on June 4. On June 6 Gifford arrived in Venice, where he stayed for six weeks at the Hotel Laguna on the Riva degli Schiavoni with Yewell and Tilton. On July 18 he left Venice via Lake Garda, Milan, and Lake Como, crossing the St. Gotthard Pass into Switzerland on the July 21. He made a brief stop in Paris before sailing home from Le Havre, arriving in New York August 14, 1869.

Sanford Robinson Gifford

34. *St. Peter's from Pincian Hill*, 1865

Oil on canvas, 9⅞ x 15⅝ in.
Signed l.l.: SR Gifford 1865
*Courtesy of the Pennsylvania Academy of the Fine Arts,
Philadelphia. Gift of Mr. and Mrs. Edward Kesler*

Eight years after he returned from his first trip to Italy, Sanford Gifford painted *St. Peter's from Pincian Hill.*[1] He had brought back many small sketches of Italian scenery, both in pencil and in oil, which served as the basis for works painted throughout his career. During his stay in Rome in 1856-57 Gifford had occupied a studio near the Pincian Hill in Rome, and had, like many other American artists, been drawn to the views of the city with the dome of St. Peter's looming above the skyline.[2]

Gifford's vantage point is from the grounds of the Villa Medici, long the home of the French Academy in Rome. The site was a popular one with artists, photographers, and other travelers who strolled along the Viale della Trinita dei Monti as it ascended the Pincian Hill from the Piazza del Popolo. Not surprisingly, French artists painted numerous views from this vantage point. Jean-Baptiste Camille Corot, who stayed in Italy 1826-27, painted several small oil sketches for *La Vasque de l'Academie de France à Rome* (fig. 1), placing the viewer close to the fountain, its dome echoing those of St. Peter's.[3] The overhanging trees frame the composition, echoing the fountain's silhouette.[4] Gifford's space is deeper and more atmospheric, the water in the basin and overflow of the fountain reflecting the afternoon light. On the right stands a tonsured monk who has stopped to survey the scene, his presence and thoughtful gaze directing our own attention toward St. Peter's.

Photographer Robert MacPherson, whom Gifford met in Rome in 1868, made an albumen print of the site around 1860 that encompasses a wider angle across the right-hand edge of the basin of the fountain, looking across to the trees and the dome of St. Peter's.[5] Of this view, George

Fig. 1. Jean-Baptise Camille Corot (French, 1796-1875), *La Vasque de l'Academie de France à Rome*. Oil on canvas. Beauvais, Musée Departemental de l'Oise. Beauvais. Photograph courtesy Service Photographique des Archives de l'Oise.

Hillard noted, "The view of St. Peter's, over [the fountain's] flowing and restless waters, though not set down in the guidebooks, is well worth a long and patient look. The massive and silent bulk of the distant dome is brought into vivid contrast with the dancing sparkle and silvery foam of the fountain, (which) . . . forms a picture not easily forgotten."[6]

E. JONES

1. Listed as no. 413 in the Metropolitan Museum of Art, *Memorial Catalogue of the Paintings by Sanford Robinson Gifford, N.A. with a Biography and Critical Essay by Prof. John F. Weir of the Yale School of Fine Arts,* 1881, Reprint (New York: Olana Gallery, 1974). "Twilight on the Pincian Hill. Size, 10 x 16. Sold in 1865 to J.P. Waters, and by him through Leavitt & Co.; present owner unknown." The *Memorial Catalogue* also lists an oil sketch, no. 519. "On the Pincian Hill, Rome, A Sketch. Not dated. Size, 3½ x 6 in. Owned by the Estate," location unknown, which probably dates from Gifford's first trip to Rome.

2. Including George Inness (see cat. 27), John Linton Chapman, Eugene Benson, and Frank Dumond. English artist Edward Lear also sketched this view in 1838, standing in front of the fountain (St. Peter's from Monte Pincio, Rome; Houghton Library, Harvard University).

3. Peter Galassi has noted that since one of the small, flanking domes of St. Peter's is blocked from this angle, Corot chose an angle that replaced it with the dome of the fountain, restoring the symmetry of the basilica structure. See Peter Galassi, *Corot in Italy* (New Haven: Yale University Press, 1991), pp. 158-161. For views of St. Peter's from the Pincian Hill by Corot and other European artists, see

Marie-Jose Salmon, *Vasques de Rome, Ombrages de Picardie: Hommage de L'Oise à Corot* (Beauvais: Musée Departemental de L'Oise, 1987), pp. 24-63.

4. The fountain was built in 1587, "of an antique red granite vase, and a cannon ball said to have been shot from Castel Sant'Angelo by Queen Christina of Sweden, when late for an appointment with the painter Charles Errard who was staying at the French Academy." Alta Macadem, ed. *Blue Guide: Rome and Environs* (New York: Rand McNally & Company, 1979), p. 174.

5. See Wendy M. Watson, *Images of Italy: Photography in the Nineteenth Century* (South Hadley, Mass.: Mount Holyoke College Art Museum, 1980), p. 39.

6. George Hillard, *Six Months in Italy* (Boston: Ticknor, Reed, and Fields, 1853), vol. 2, p. 40.

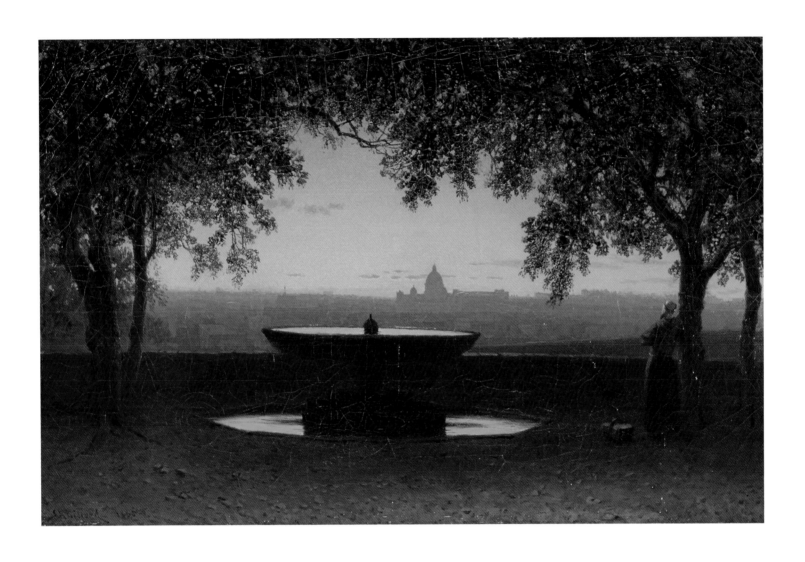

Sanford Robinson Gifford

35. *Villa Malta, Rome,* 1879
Oil on canvas, 13¼ x 27⅜ in.
Signed l.l.: SR Gifford 1879
National Museum of American Art, Smithsonian Institution,
Gift of William T. Evans

In 1856 Gifford arrived in Rome for the first time, taking a studio at 55 Via Sistina, near the Pincian Hill. His window overlooked the Villa Malta, residence of Prussian Consul Wilhelm von Humboldt, noted patron of the arts and brother of the eminent naturalist Alexander von Humboldt. Villa Malta had been a center for the German artists' community in Rome since 1827, when Crown Prince Ludwig of Bavaria purchased the residence specifically for that purpose.[1] In fact, the villa hosted the German Artists' Club activities, which were attended by Gifford and fellow American painters Albert Bierstadt and Worthington Whittredge, whom Gifford had met in Düsseldorf earlier that year.[2]

Villa Malta was a popular subject for artists, especially views of the grounds, which were noted for their elaborate gardens. Pictures of the building itself were less common. John Vanderlyn was probably the first American artist to sketch the Villa Malta, from a studio on the Pincian Hill.[3] Washington Allston may have been the only American artist to live in the Villa Malta, between 1805 and 1807, before its purchase by the German government.[4]

During the winter of 1856-57 Gifford worked on several large paintings, and made a number of sketches. It was at this time that he first sketched the Villa Malta in oil. That sketch, now lost, was described as "A sketch of Villa Malta, Rome, as seen from Mr. Gifford's studio. Dated February 14th, 1857."[5] Gifford returned to this subject late in his life, some ten years after his last trip to Italy and twenty-two years after painting the preliminary oil sketch. In *Villa Malta* he captures the warm, clear light of late afternoon on the villa's sun-drenched walls, accented by the sharper highlights on the treetop foliage below and the cloudless sky framing the rooftops. The clarity and warmth of light,

and the architectonic composition are reminiscent of Corot's Italian sketches from the 1820s.[6] Gifford's use of the villa walls as his subject lends his composition an element of abstraction similar to that found in the Italian rooftop studies painted in the 1790s by English artist Thomas Jones.[7] Few American artists painted Italian architecture, aside from ancient monuments, until their interest shifted to Venice late in the nineteenth century.

E. JONES

1. William Gerdts, "Washington Allston and the German Romantic Classicists in Rome," *Art Quarterly* 4 (1952), p. 177. In 1817-18 Crown Prince Ludwig of Bavaria rented the Villa Malta for a trip to Italy, purchasing it nine years later specifically to be used by German artists. See *German Masters of the Nineteenth Century* (New York: Metropolitan Museum of Art, 1981), p. 88.

2. Gifford to Elihu Gifford, May 2-4, 1857, "European Letters." Private collection. In Rome, the American artists paid visits to the studios of prominent German Nazarene painters Overbeck and Cornelius. Both Bierstadt and Whittredge spoke passable German, while Gifford did not, although his Italian served him well during his stay in Rome.

3. John Vanderlyn to S.R. Murray, quoted in Regina Soria, *Dictionary of Nineteenth-Century American Artists in Italy 1760-1914* (New Brunswick, N.J.: Associated University Presses and Fairleigh Dickinson University Press, 1982), p. 312: "a small view from my lodgings – the same house in which Salvatore Rosa lived and which is still occupied by his descendants. The view included the garden trodden by the artist, terminates by several buildings with the . . . Villa di Malta."

4. Diana Strazdes, "Washington Allston's Early Career: 1796-1811," Ph.D. diss., Yale University, 1982, pp. 262-263.

5. Listed as no. 111, owned by the estate, 3 x 7½ in., in Metropolitan Museum of Art, *Memorial Catalogue of the Paintings by Sanford Robinson Gifford, N.A., with a Biography and Critical Essay by Prof. John F. Weir of the Yale School of Fine Arts* (New York: 1881). Gifford also began work on a larger painting of the Villa Malta based on this sketch, but set it aside until 1878, when he completed it, before painting this version in 1879. *Memorial Catalogue* no. 683 lists "Villa Malta, in Rome, As seen from Mr. Gifford's Studio. Begun February 14th, 1857; finished 1878. Size 11 x 24 [in.]. Owned by Mrs. S.R. Gifford." The present painting is no. 711 in the Memorial Catalogue, "Villa Malta, Rome. Dated 1879. Size, 13 x 27 [in.]. Owned by S.M. Vose, Providence, R.I."

6. See Peter Galassi, *Corot in Italy* (New Haven: Yale University Press, 1991).

7. Illustrated in Galassi, *Corot*, p. 32. Jones was one of Richard Wilson's most gifted pupils. His oil sketches are remarkably fresh and abstract to the modern eye, while his large canvases resembled his master's work in their adherence to Claudian models.

William Morris Hunt

Born Brattleboro, Vermont, 1824;
died Isles of Shoals, New Hampshire, 1879

William Morris Hunt

36. *Italian Peasant Boy*, 1866

Oil on canvas, 39 x 25½ in.
Signed l.l.: W M Hunt / 1866 (initials in monogram)

Museum of Fine Arts, Boston, Gift of George Peabody Gardner

After withdrawing from Harvard College when it became obvious that he was more interested in music and drawing than in his studies, Hunt made the first and longest of his three trips to Italy at age nineteen, when his mother took him and his siblings to Europe to continue their education. Traveling by way of Paris and Geneva, they arrived in Rome in November or December 1843, where Hunt began taking lessons in sculpture from the American Henry Kirke Brown.

With a career as a sculptor in mind, Hunt left Rome in the fall of 1845 for the Düsseldorf Academy, but the next year he joined his mother in Paris to study sculpture there. After seeing the work of Thomas Couture he shifted his interest to painting, and in 1847 entered Couture's studio. In the winter of 1849-50 he returned briefly to Rome, where he painted from Italian models. In 1852 Hunt left Couture and began a close association at Barbizon with Jean-François Millet. Under Couture's and Millet's influences he became a colorist whose examples were the Venetian painters of the Renaissance and whose goal was to create a poetic, golden age based on contemporary rustic life.

In 1855 Hunt returned to New England, continuing to create landscapes and peasant pictures in the Barbizon mode. In 1862 he settled in Boston where he became the city's tastemaker. In May 1866 he returned to Europe with his wife and children. Using Paris as his base, he summered in Brittany and went briefly to London and the Low Countries before leaving for Italy in late September 1867 by way of Lyon and Nice. The Hunts stayed a month in San Remo then proceeded to Rome. Although he enjoyed the company of his colleagues Elihu Vedder, Hamilton Wild, and William Wetmore Story, Hunt disliked the constant socializing expected of artists in Rome and so, in late April 1868, he departed with his family for Florence. After a week he returned to Boston, leaving his family to visit Venice and Germany without him.

Italian Peasant Boy is the most refined and idealized of several paintings of Italian models by Hunt. This one was made in Paris, probably in the fall of 1866, a year before Hunt was once more in Italy. Exhibited in October 1867 at the Exposition Universelle under the title *Petit Italien*, it exemplifies the solitary, rustic Italian youth, a subject that had become almost an international icon in Hunt's time, especially for artists of Romantic-realist tendencies.

Hunt's boy stands, arms crossed, outdoors against a stone wall. Although he does virtually nothing to tell a story, his costume hints at one, for he wears the short wool jacket, buff trousers, and hat (decorated with flowers, a feather, and a bit of wheat) of a central Italian wagon driver at harvest time.[1] He is bathed in bright light and defined by somewhat dry, grainy brushwork borrowed from the portrait style Hunt developed in Boston in the 1860s. However, the boy possesses a sensuality that is unique in Hunt's art. Apparently self-confident, a bit defiant, innocent yet worldly, he occupies the gray area between portrait and a type.

Italian Peasant Boy is a variant on a well-worn theme whose predecessors included Eastman Johnson's *Savoyard Boy* (1853, Brooklyn Museum) and was painted when a number of French artists were making large paintings of Italian peasants. Corot, for example, whom Hunt visited during his stay, made a large picture of an Italian woman at virtually this time, *Agostina* (about 1866, National Gallery of Art, Washington, D.C.) and William Adolphe Bouguereau exhibited in the 1866 Salon two large canvases showing an Italian mother and child that Hunt may have seen, *First Caresses* (1866, Lyndhurst, Tarrytown, N.Y.) and *Covetousness* (1866, now lost). Some of the sensuality and precision of Hunt's picture are borrowed from the French academic manner, Bouguereau's in particular.

A preparatory charcoal drawing (1866, Museum of Fine Arts, Boston), which shows the boy with longer hair, a cape, and staff suggests that Hunt first intended to portray the boy as a shepherd. In a small oil study (1866, The Metropolitan Museum of Art, New York), the boy is dressed as he is here, but holds a riding crop, a detail eliminated in the finished canvas. On arriving in Rome in November or December 1867 Hunt continued his theme by painting a seated female, *Roman Girl* (1867, Bennington Museum, Bennington, Vermont) as a companion piece.[2]

Italian Peasant Boy demonstrates that Hunt did not need to be in Italy to be reminded of Italian peasants or to paint from Italian models. He kept Italian peasant costumes in his Boston studio, lending one for a Roman peasant girl to the painter Albion Bicknell.[3] Young Italian males were themselves a common sight in most major cities by the 1860s. Migrants from the mountain towns of Tuscany and elsewhere, they engaged themselves as artisans and peddlers before returning home.[4] These young men, aloof from the mainstream of city life, may have inspired Hunt to create an homage to the transient, self-reliant, worldly innocent.

D. STRAZDES

1. Similar costume appears in Leopold Robert's *Arrival of the Harvesters in the Pontine Marshes* (1830, oil on canvas, Musée du Louvre, Paris).

2. Martha Hoppin in *William Morris Hunt: A Memorial Exhibition* (Boston: Museum of Fine Arts, 1979), p. 66; and Natalie Spassky, *American Paintings in the Metropolitan Museum of Art* (New York: Metropolitan Museum of Art, 1985), vol. 2, pp. 204-205.

3. Helen M. Knowlton, *The Art-life of William Morris Hunt* (Boston: Little, Brown, 1899), p. 58.

4. "Italian Versus English Character," anon. review of *Life in Tuscany* in the *Crayon* 7, part 1 (Jan. 1860), p. 8.

Jervis McEntee

Born Rondout, New York, 1826;
died Kingston, New York, 1891

With Sanford R. Gifford on the steamship Manhattan, Jervis McEntee and his wife sailed for England on May 27, 1868. Gifford soon embarked for the continent, but the McEntees spent three weeks in England before traveling on to Paris and then Italy, meeting Mr. and Mrs. Frederic Church at the Simplon Pass early in September. By October 1, the two couples had arrived in Rome. The McEntees shared an apartment with Gifford at 58 Via del Babuino near the Spanish Steps, and McEntee and Church occupied a studio in the same building with William Stanley Haseltine. McEntee visited Tivoli October 10-17 with the American painter George Henry Yewell, the sculptor Joseph Mozier, and Gifford. Other Americans in McEntee's circle in Rome included William Henry Rinehart, T. Buchanan Read, John Ferguson Weir, G.P.A. Healy, and Launt Thompson.

On March 22, 1869, the McEntees left Rome and traveled north. They were with the American artist Samuel Thompson in Pisa on March 4 and then spent three weeks in Florence, where they met the sculptors Hiram Powers and Thomas Ball and the British painter Holman Hunt. From Florence the McEntees traveled to Venice and the Italian lakes, then crossed the Alps. By May 26 they were in Brussels, and in early June they left Antwerp for England. They visited Scotland before sailing for America sometime around July 1.

Jervis McEntee

37. *The Ruins of Caesar's Palace,* about 1868-69

Oil on canvas, 24¼ x 40⅛ in.
Courtesy of the Pennsylvania Academy of the Fine Arts, Philadelphia, Funds provided by the Fine Arts Ball and Discotheque, courtesy of the Pennsylvania Academy Women's Committee

Soon after their arrival in Rome, Jervis McEntee and his wife accompanied Sanford Gifford on a visit to the ruins of the Palace of the Caesars on the Palatine Hill. Among the overgrown remains, McEntee found a Roman coin, and his wife collected bits of ancient glass.[1] McEntee probably executed *The Ruins of Caesar's Palace* during the winter of 1868-69 or soon after his return to New York the following summer, but he never sold the painting. It was one of more than 100 works, including several Italian subjects, that remained in McEntee's studio at his death in 1891. The painting was considered one of the finest offered in the auction of the artist's estate in 1892. Its title derives from the catalogue of that sale.[2]

Spread over a large area of the Palatine, the ruins of the imperial palace were far less legible than those of the Roman Forum in the valley below, but the utter desolation of this once-splendid site awed many nineteenth-century American tourists. Here Romulus, the mythical founder of Rome, was said to have erected his hut in the eighth century B.C., and during the Republic the hill was a prestigious residential area, home to Cicero, Catiline, Hortensius, and other distinguished Romans. Later, the modest home of the emperor Augustus became the nucleus of a sumptuous complex expanded by Tiberius, Caligula, Nero, and Domitian during the first century A.D.; Hadrian in the second century; and Septimius Severus between 193 and 211. After its depredation by barbarian invaders in the fifth century, the complex was repaired, but it fell into severe ruin after the sixth century.[3] In 1851, this "complete annihilation of ancient grandeur" stirred Benjamin Silliman, professor of science at Yale,[4] and in 1853 the romantic George Stillman Hillard mar-

Fig. 1. The Arch of Constantine, Rome, with the Palatine Hill beyond (detail). Photograph, 1934. Courtesy Alinari/Art Resource, New York.

veled: "The luxuriance of nature, in this soft climate and upon fertile soil, has so successfully struggled with the decay of the works of man, and so veiled it with foliage and verdure, that one hardly knows whether to call the scene a landscape or a ruin."[5]

Artists' renderings typically show the Palatine from a distance and focus on the great vaulted substructures of Severus on the southeast side of the hill.[6] McEntee, however, selected a vantage point on the hill itself, a point so unusual that scholars have been unable to identify the remains in the picture with any of the Palatine ruins as they appear today.[7] Indeed, the site is much changed today, but the area of the hill that McEntee depicts is recognizable in the background of a 1934 Alinari photograph of the Arch of Constantine (fig. 1).[8] Taken from the upper level of the Colosseum looking southeast, the photograph encompasses the large, rounded, niched structure that dominates the right side of McEntee's picture and, to the left, the slender pair of columns supporting an arch; these were part of the Baths of Septimius Severus, as was the diagonal wall in

the foreground of McEntee's painting. The eastern end of the Severan substructures, pierced by sunlight in the center of the painting, and the arches of the Claudian-Neronian aqueduct extending to the left are also visible in the photograph. In addition, the pyramidal tomb of Gaius Cestius can be seen in the distance in both images.[9]

McEntee compressed the foreground space in the painting, added fallen columns and capitals for picturesque effect, and enshrouded the ruins in melancholy shadow that obscures architectural detail. Silhouetted against a dramatic sunset, the ruins bear witness to the inexorable passage of time. For McEntee as for Silliman and Hillard, the crumbling palaces of once-mighty emperors spoke eloquently of human vanity.

K. MATHEWS HOHLSTEIN

1. Gifford to Elihu Gifford, October 19, 1868, "European Letters." Private collection. Gifford is not known to have painted a Palatine view.

2. The present painting is listed as no. 75 in *The Executor's Sale, Catalogue of the Paintings By the Late Jervis McEntee, N.A.* (New York: Ortgies and Company, 1892). For highlights of the sale, see "Paintings by Jervis McEntee" in the *New York Times*, March 27, 1892, p. 12.

3. *Oxford Classical Dictionary* (Oxford: Oxford University Press, 1978), pp. 770-771.

4. Benjamin Silliman, *A Visit to Europe in 1851* (New York: George P. Putnam & Co., 1853), vol. 1, p. 341.

5. George Stillman Hillard, *Six Months in Italy* (Boston: Ticknor, Reed, and Fields, 1853), vol. 1, p. 300.

6. See, for example, views by E. Du Perac (1575) and L. Rossini (about 1827), illustrated in *Bullettino della Commissione Archeologica Comunale di Roma* 41 (1986), pp. 482, 487.

7. In *American Paradise: The World of the Hudson River School* (New York, The Metropolitan Museum of Art, 1987), p. 280, it is suggested that the site represented in McEntee's painting is not the Palatine Hill but an "obscure" site, possibly the Temple of Jupiter Anxur at Terracina, south of Rome.

8. I am grateful to Fred S. Kleiner for calling this photograph to my attention and to John J. Herrmann, Jr., Fred S. Kleiner, and Eric Hostetter for discussing the archeology of the Palatine with me.

9. Erected late in the first century B.C. to house the ashes of the tribune and praetor Gaius Cestius, the pyramid reflects Roman interest in Egyptian ideas during the years after the conquest and annexation of Egypt in 31-30 B.C.

Anne Whitney

Born Watertown, Massachusetts, 1821;
died Boston, Massachusetts, 1915

Anne Whitney arrived in Rome in 1867 at the age of forty-six, having worked in sculpture for a dozen years, including brief but encouraging studies in Boston under William Rimmer (see cat. 42). With the assistance of sculptor Margaret Foley, Whitney and her companion, the painter Adeline Manning, found accommodations at 107 Via Felice on the Pincian Hill. Shortly afterwards they moved to rooms at 15 Trinita de' Monti, where Foley took rooms above them. Artists and writers before them who had also chosen this location were well-known to Whitney. The English painter John Flaxman had occupied a small studio above their rooms, while Claude Lorrain, Salvatore Rosa, and Bertel Thorvaldsen had lived nearby. As Whitney's move to Rome had been delayed by her abolitionist concerns during the Civil War, the sculptor immediately set to work in a somewhat noisy but well-lit studio at Via San Nicolo di Tolentino beneath that of the German Nazarene painter Freidrich Overbeck.

Whitney kept her distance from the constant whirl of visiting among the Anglo-American community in order to rework several plasters that she had brought with her from Boston, including the Lotus Eater (1867, Newark Museum, Newark, N.J.), and The Chaldean Shepherd (about 1868, Smith College Museum of Art, Northampton, Mass.). More germane to her anti-slavery sentiments was a now-lost sculpture modeled by Whitney in Rome of the black Haitian leader Toussaint L'Ouverture (about 1743-1803), whose death by starvation under Napoleon was the focus of much American abolitionist literature.

With the exception of summer travel to Paris and Munich, and her trip to the United States during Garibaldi's siege of Rome in 1870, Whitney remained in Rome from 1867 until her return to Boston in 1871. Her sculpture of Samuel Adams for the United States Capitol prompted a final journey to Italy in 1875. Whitney supervised the carving in marble from her plaster model of the American Revolutionary patriot in Florence at the studio of sculptor Thomas Ball.

Anne Whitney

38. *Roma*, modeled 1869; cast 1890
Bronze, h. 27 in., w. 15½ in., d. 20 in.
Signed on base at rear: Anne Whitney / Sc. /
Rome 1869
Collection of the Wellesley College Museum, Gift to the College by the Class of 1886

The fallen condition of Italy's poorer citizens, particularly in the central and southern regions, was frequently commented upon by foreign travelers. In 1816, it was believed that about 40,000 Neapolitans were homeless, having only "the Streets to look for their provisions, no homes . . . to shelter them from the heavy dews that fall by night."[1] Anne Whitney wrote of the poor within months of her arrival in Rome:

> Old beggar women (and men) come round you and plead, with eighty and more winters . . . and when the *sou* stands for so much, I for one cannot refuse. They are so clearly looking, so pathetic, so pleasant. What if some of them make a trade of their infirmities and prize a crippled limb as a soldier's widow might a pension? There are enough who have worked their day out and now only ask not to die by starvation.[2]

She expressed amazement at the contrasts between papal Rome and the "poor old beggar women [who] sit in the chill mornings in the sun with their hands folded round the friendly *scaldino* [small brazier] under their rags."[3]

In choosing to create a personification of Rome, Whitney sculpted such a dejected seated woman. The figure holds a license to beg with the cynical inscription "QUESTEVANTE IN ROMA," or "this is what comes to you in Rome." The coin in her hand slips out of listless fingers and her inward gaze suggests troubled thoughts. The woman's bowed head, pursed lips, and lined face imply reduced circumstances, while she sits upon evidence of Italy's former greatness: an animal-skin such as that worn by Hercules, and an up-ended Corinthian column. The medallions that grace the hem of the beggar's still-handsome dress illustrate celebrated sculpture from antiquity and include the *Apollo Belvedere*, the *Laocoön* and the *Dying Gaul*, all symbols of Rome's illustrious role in western myth and art.[4]

Fig. 1. *Drunken Woman*. Roman copy, about first century A.D. after Greek original, fifth or second century B.C. Glypto-thek, Munich. Photograph courtesy Foto Marburg/Art Resource, New York.

One element of the sculpture later expunged by Whitney was an image of Cardinal Giacomo Antonelli. The face of the hated cardinal was once recognizable in a carnival mask which had fallen into the folds of the beggar's garment.[5] In April of 1869, Whitney placed her plaster version of *Roma* with this mask in her studio for visitors to see, but within a short time its blunt reference to the corrupt papacy brought Whitney unwelcome notoriety.[6] By June, out of fear for her own safety, she and Adeline Manning left Rome for the summer. Meanwhile *Roma* was shipped to Florence, where the sculpture was displayed in the home of George Perkins Marsh (1801-82), then American minister to Italy. Whitney later transformed the mask into a less volatile emblem of the papacy by placing an orb and truncated or sunken cross in its place.[7]

Whitney's grieving woman of Rome was not the first of her kind; similar allegorical figures had been evoked in literature by

Dante and Petrarch, and some sculptural precedents exist in *Head of an Old Woman* (100-50 B.C., Staatliche Skulpturensammlung, Dresden) or the *Drunken Woman* (fig. 1).[8] Still, the political nature of her sculpture rendered it more desirable for special exhibitions than for domestic interiors. The only known marble version of *Roma* was sold in 1871 to family friend Charles How, who exhibited it in the London International Exhibition of 1871. This marble may be the same shown at the Boston Art Club and Dol! and Richard's Gallery in 1873, and the Philadelphia Centennial in 1876. A monumental plaster of the sculpture was seen in Chicago at the World's Columbian Exposition of 1893. This bronze version, presented to Wellesley College by the Class of 1886, was cast in 1890 from a plaster brought back to the United States by Whitney.[9]

J. FALINO

1. Information about Whitney's early accommodations have been gleaned from letters to her family, May 2 and 16, 1867, Anne Whitney Papers, Wellesley College Archives, Wellesley, Mass. For information on the poor of Naples, see Logbook, U.S.S. Washington, Naples Bay, Italy, August 1816, unpaginated. Library, Museum of Fine Arts, Boston.

2. Anne Whitney to her family, April 17, 1867, Anne Whitney Papers, Wellesley College Archives.

3. Anne Whitney to her family, December 1, 1867, Anne Whitney Papers, Wellesley College Archives.

4. All three works were discovered in the area around Rome. Francis Haskell and Nicholas Penny, *Taste and the Antique* (New Haven, Conn.: Yale University Press, 1981), pp. 148-51, 224-26, 243-47.

5. For a description of Antonelli, see William L. Vance, *America's Rome* (New Haven, Conn.: Yale University Press, 1989) vol. 2, p. 203.

6. The mask was noted in an undated newspaper clipping from the *New York Evening Post*, saved by Whitney in her Scrapbook, vol 1, p. 4A. The scrapbook is now lost, but was recorded in Elizabeth Rogers Payne, *Anne Whitney: Nineteenth Century Sculptor and Liberal*, unpublished manuscript, p. 817, Anne Whitney Papers, Wellesley College Archives.

7. Anne Whitney to her family, June 20, 1869, September 26, 1869. Anne Whitney Papers, Whitney College Archives. The sculptor wrote: "I have been from the first too dissatisfied with the other [mask of Antonelli] which I have discovered, after much thinking, to be too literal. By taking it up into the sphere of symbol it is made more in keeping with the rest and truer in point of art." Anne Whitney to her family, October 16, 1869. Anne Whitney Papers, Wellesley College Archives.

8. Vance, *America's Rome*, vol. 2, pp. 176-77.

9. Sarah Whitney to Anne Whitney, March 28 and April 11, 1869, Anne Whitney Papers, Wellesley College Archives. See also Elizabeth Rogers Payne, "Anne Whitney, Sculptor," *The Art Quarterly* 25 (Autumn 1962), pp. 244-261.

Edmonia Lewis

Born upstate New York, about 1844;
died, location unknown, after 1909

Edmonia Lewis was the first nonwhite American, man or woman, to receive international recognition for her work as a sculptor. Lewis claimed that she was raised in the Chippewa manner by her mother in upstate New York. Later reports suggest that her father, a black man, may have been from Haiti. Following studies at Oberlin, Lewis moved to Boston in the early 1860s and became involved with a powerful and wealthy anti-slavery community. An introduction to abolitionist William Lloyd Garrison led her to Boston sculptor Edward Brackett, who guided her first attempts at sculpture. Lewis determined to continue her studies abroad, and financed her trip to Italy in 1865 by selling copies of her bust of Massachusetts Civil War hero, Colonel Robert Gould Shaw, commander of the first northern regiment to consist largely of African-Americans. Lewis remarked in later years, "I was practically driven to Rome in order to obtain the opportunity for artistic culture and to find a social atmosphere where I was not constantly reminded of my color." Shortly after her arrival in Italy, Lewis was warmly received in Florence by Thomas Ball, who procured lodgings for her, and made her "some nice tools"; Hiram Powers also gave her some "things," presumably for her sculpture. Soon afterward, Lewis established a studio in Rome on Via San Nicolo di Tolentino near the Piazza Barberini. There she joined the community of women sculptors, of whom Harriet Hosmer may have been her most highly regarded colleague. The suffragist Laura Curtis Bullard, editor of Revolution, *was much impressed with Lewis's complete handling of sculpture, unlike most artists who maintained workshops of Italian carvers. "So determined is she to avoid all occasion for detraction, that she even 'puts up' her clay; a work purely mechanical, and one of great drudgery, which scarcely any* male *sculptor does for himself." Anne Whitney, who saw Lewis on a frequent basis, saw great improvement in her work, and by 1869 wrote that she was "not only sur-*

prised but greatly pleased at the progress she has made."

Lewis's sculpture is notable for its focus upon Native American and anti-slavery themes. The latter is represented partly by The Freed Woman and Her Child *(1866, location unknown), and* Forever Free *(1867, Howard University, Washington, D.C.). More ideal themes, such as* Death of Cleopatra *(1872-73, The Historical Society at Forest Park, Illinois) and the biblical* Hagar *(1875, National Museum of American Art, Smithsonian Institution, Washington, D.C.), treated historical African figures.*

Edmonia Lewis

39. Bust of Henry Wadsworth Longfellow, 1871

Marble, h. 29, w. 16¼, d. 12¼ in.
Signed proper right: EDMONIA LEWIS / ROMA 1871.
Harvard University Portrait Collection

Edmonia Lewis's penchant for creating ambitious sculptures for whom she had no clear patrons is shown in her bust of Henry Wadsworth Longfellow (1807-1882).[1] Anne Whitney wrote to her family in Watertown that Lewis caught surreptitious views of her unwary subject and set his likeness in clay before the poet learned that he was the subject of her attentions:

> Miss Lewis has been making a bust of Mr. H. Longfellow. Her studio is near the Costantze Hotel where they [the Longfellows] are, and she got glimpses of him here and there, went out to meet him and headed him off round corners ([Rev.] Sam'l [Longfellow] told us). And when he, Samuel, went into her studio one day, he found quite a respectable likeness of his brother. Then the rest of the family went in, and, the nose being a failing feature, Mr. L. sat to her, and they think it now quite a creditable performance, — better, I think he said, than many likenesses of him.[2]

That an unsolicited bust was so well received gives credit to Lewis's skill, only four years after her arrival in Rome. The sculptor's admiration for Longfellow's poetry, particularly "The Song of Hiawatha," inspired her busts of Minnehaha (fig. 1), Hiawatha (1868, Howard University, Washington, D.C.), and several group sculptures based upon the poem, including *The Old Arrow Maker and His Daughter* (1872, National Museum of American Art, Smithsonian Institution, Washington, D.C.). The slightly over-life-size head of Longfellow is strongly and deeply modeled, and bears a strong resemblance to several classical prototypes. Lewis may have wished to make a clear parallel to the the ancient poet, Homer, whose idealized portrait was well known through numerous replicas. The deeply carved beard and powerful forehead of Longfellow are clearly reminiscent of the Greek bard.[3]

Fig. 1. Edmonia Lewis, *Minnehaha*, 1868. Marble. Detroit Institute of Arts, Gift of the Centennial Planning Committee for Sharing Traditions and Romare Bearden Exhibitions with a major contribution from Founders Junior Council.

Laura Curtis Bullard noted in *The Revolution* that the marble bust of Longfellow was ordered by Harvard College. She commended the school for "admitting the work of a woman" even if it had yet to actually "open its doors to women who ask education at its hands."[4]

J. FALINO

1. Lewis's experiences in Florence were related by Lydia Maria Child in a letter to James Thomas Fields, October 13, 1865, James Thomas Fields Collection, Huntington Library, San Marino, Calif., FI643. For Bullard's commentary on her working methods, see Laura Curtis Bullard, "Edmonia Lewis," *The Revolution* (New York) April 20, 1871. I am grateful to Marilyn Richardson for this citation and for information on the possible origins of Lewis's father. For Whitney's assessment of Lewis's progress, see Anne Whitney to her family, February 21, 1869; Whitney to Sarah Whitney, January 20, 1870, Anne Whitney Papers, Wellesley College Archives, Wellesley, Mass.

2. Anne Whitney to her family, February 7, 1869, Anne Whitney Papers, Wellesley College Archives.

3. An example in the Museum of Fine Arts, Boston (acc. no. 04.13) is among the best of many known idealized likenesses.

4. Bullard, "Edmonia Lewis." Lewis's work has been addressed with increasing frequency in recent years. For a general biography of her life beyond the scope of this exhibition, see Linda Roscoe Hartigan, *Sharing Traditions, Five Black Artists in Nineteenth Century America* (Washington, D.C.: Smithsonian Institution Press, 1985), pp. 85-119. The author wishes to thank Marilyn Richardson for her helpfulness and insightful reading of this entry.

George Peter Alexander Healy

Born Boston, Massachusetts, 1813;
died Chicago, Illinois, 1894

Healy made a total of seventeen round-trip ocean voyages between 1812 and 1892, most of them to England and Paris. In April of 1834 Healy traveled from New York to Paris, where he joined the studio of Baron Gros, and met Thomas Couture. Healy copied paintings at the Louvre, and executed commissions for the court of Louis-Philippe. In the fall of 1835 Healy left Paris by stage, crossing the Mt. Cenis pass into Italy near Turin. He arrived in Alessandria where he ran into Sir Arthur and Lady Franklin, friends who insisted Healy accompany them in their coach for the journey to Rome. Their itinerary included Turin, Milan, Venice, Genoa, Pisa, and Siena en route to Florence, while Sir Arthur translated Horace's descriptions of the countryside they passed through. They spent five weeks in Florence, where Healy copied Titian's Venus. *After arriving in Rome the party continued to Naples, and then back north to Turin, where Healy continued north into Switzerland and back to Paris. After a trip to London in spring of 1836, Healy split his time between France and America for the next thirty years. He returned to Italy in 1867, living there with his family until 1873. Healy and his family lived in Italy from 1867 to 1873. In June of 1867 Healy sent his wife and nine children ahead to settle in Rome, joining them the following summer at Bagni di Lucca. In the fall of 1868 Healy returned to Rome to set up his studio, first at 14 Via Porta Pinciana, and subsequently at the Hotel Molaro on the Via Gregoriana. During the winter, Healy met Longfellow, who introduced him to Franz Liszt and Charles Gounod. The Healys socialized with the French artists in Italy, notably Regnault and Lefebvre, at the Villa Medici. In the spring of 1869 the Healy family traveled to Naples, and by June 15 they were in Venice, where Healy left his family to travel through France to England. Healy returned briefly to America, and was reunited with his family in September in Ostende, Belgium. During the Franco-Prussian war of 1870 the family remained in Switzerland, and spent August of that year in England. By the winter of 1870-71 the Healys had returned to Rome, where they kept company with the Alcott sisters and Ralph Waldo Emerson, and where Healy met Sargent and his father. In the summer of 1871 Healy traveled to Capri, and in September journeyed to England, detouring through Paris and Spain before returning to Rome by winter. In 1873 Healy maintained a studio in the Vicolo di S. Nicolo da Tobatin. In July of 1873 he and his family left Italy for the last time, living in Paris until moving to Chicago permanently in 1892.*

40. *Arch of Titus*, 1871
Oil on canvas, 74 x 49 in.
Signed u.l.: G. P. A. Healy. 1871
Collection of The Newark Museum, Bequest of Dr. J. Ackerman Coles, 1926

Rome played host to a large number of American artists during the winter of 1868-69, among them George Healy and his family, who maintained an active social life there. Healy was popular with his artistic colleagues, many of whom had studios clustered nearby, and with such international luminaries as Franz Liszt (1811-1886) and Henry Wadsworth Longfellow (1807-1882). Best known for his poem *Hiawatha*, Longfellow achieved early acclaim for his romances, among them *Hyperion* and *Evangeline*, and published a translation of Dante's *Divine Comedy* in 1865-67 (see cat. 164). When Longfellow visited Rome in 1868, accompanied by his daughter Edith, Healy began sketching a large canvas commemorating this latest trip to Italy. Healy had painted portraits of the Longfellows before,[1] but when Longfellow singled out a sketch of the Arch of Titus of which he was especially fond, Healy decided to incorporate it into the portrait. Framed by two of the most dramatic monuments in Rome, the eminent poet and his daughter stand beneath the Arch of Titus, with the Colosseum visible behind them.

The Arch of Titus was built during the reign of Emperor Diocletian, between A.D. 81 and 96 , to commemorate the sack of Jerusalem by Titus and his armies in A.D. 70. Heavily damaged over time, the monument was restored in the early 1820s,[2] evident in Healy's painting in the smooth upper portions of the columns and in the still-visible damage to the coffered ceiling of the arch. This site had long been popular with European artists, and Healy was undoubtedly familiar with the numerous paintings of people standing under this massive monument.[3] Photographers contributed to the site's popularity at mid-century, and the arch was photographed from several angles by MacPherson, Altobelli, Alinari, and Anderson, four of the

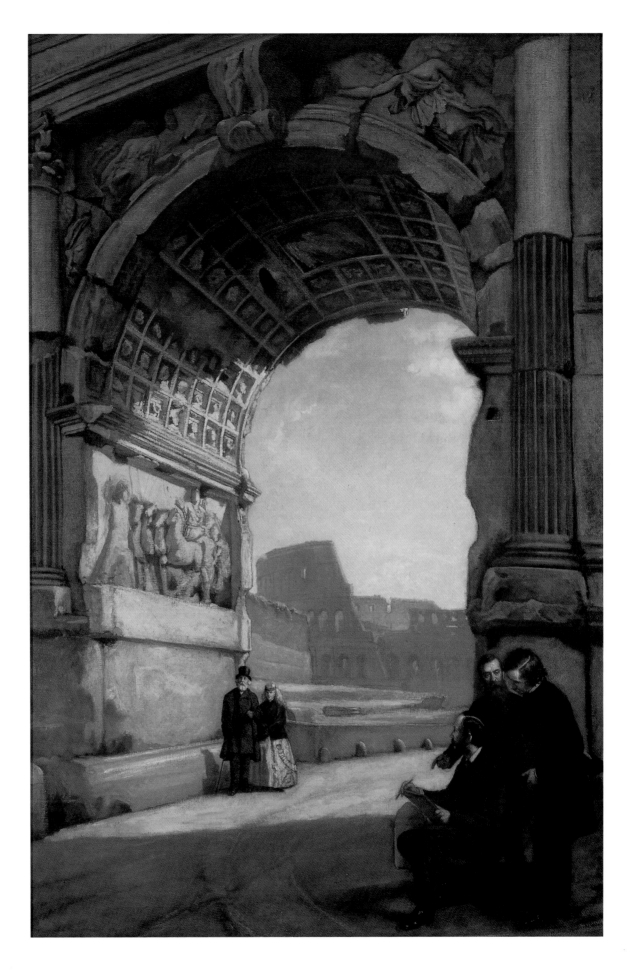

Fig. 1. *Henry Wadsworth Longfellow and his daughter, Edith,* Rome, 1868. Photograph. Archives of American Art, Smithsonian Institution, Washington, D.C.

Fig. 2. G. P. A. Healy, *Group of Artists in Rome,* about 1869. Oil on canvas. Illinois State Museum, Springfield, Illinois.

most prominent photographic firms in Rome.[4] Widely collected by tourists, these photographs played an important role for artists, who used them in addition to their sketches to compose paintings.

The Arch of Titus achieved special recognition as it became a collaborative endeavor, with Jervis McEntee painting the arch and Frederic Church adding the Colosseum and the sky to Healy's composition.[5] In return, Healy painted the three artists in the foreground: Church seated with sketchpad and brush in hand, the bearded McEntee standing behind him, with Healy himself standing at the right, looking over Church's shoulder. The surface of *The Arch of Titus* contains shifts in brushwork and clearly defined boundaries between the painted arch, sky, and figures supporting the traditional attribution of three artists' hands at work on its surface.[6] The overall broad handling of the architecture may be ascribed in part to the artists' use of a much smaller photograph of the arch. A separate photograph taken in Healy's studio in Rome provided the likeness of Longfellow and his daughter, who were painted after they had left Rome (fig. 1).[7] Healy then based his portraits of the three artists on a small group portrait he had painted that winter (fig. 2), in which he also included the likeness of sculptor Launt Thompson, a recent arrival in Rome, who stands behind the three painters.[8] Although Church and McEntee worked on this painting in 1868-69, Healy kept the painting in his Rome studio until it was completed in 1871, long after the other two artists had returned to America.[9]

E. JONES

1. Healy's best-known portrait of the Longfellows shows Edith leaning over her father, who is seated in a chair (Worcester Art Museum, Worcester, Mass.).

2. *Rome in Early Photographs: The Age of Pius IX*, trans. Ann Thornton (Copenhagen: Thorvaldsens Museum, 1977), p. 41.

3. Strikingly similar to Healy's painting is a watercolor by the English artist Thomas Cromeck (British, 1809-1873), who specialized in architectural views. In addition to Cromeck who made the Arch of Titus a favorite motif in his oils and watercolors, Philippe Jacques Van Bree (Belgian, 1786-1871) and Franz von Lenbach (Hungarian, 1836-1904) were also attracted to this site. See *The Lure of Rome: Some Northern Artists in Italy in the Nineteenth Century* (London: Hazlitt, Gooden & Fox, 1979), and *German Masters of the Nineteenth Century* (New York: Metropolitan Museum of Art, 1981).

4. Ibid., and see Wendy M. Watson, *Images of Italy: Photography in the Nineteenth Century* (South Hadley, Mass.: Mount Holyoke College Art Museum, 1980), and Karin Bull-Simonsen Einaudi, *Fotografia Archeologica 1865-1914* (Rome: American Academy in Rome, 1979).

5. During the fall of 1868 Church painted the rainbow in the background of Healy's *The Peacemakers*. This collaboration may have engendered the idea of having Church work with Healy on the *Arch of Titus.* Frederic Church to William Osborn, Rome, November 9 and November 30, 1868. Typescript of letter courtesy of Olana State Historic Site, Hudson, New York.

6. Initial reports variously ascribed the work to either Church or Healy, and confused the site with the Arch of Constantine. *The Nation* (December 10, 1874), p. 385 and *Appleton's Art Journal* (January 1875), p. 27; cited in Gerdts, "Four Significant Paintings: Acquisitions and Reattributions," *The Museum* 10 (winter 1958), pp. 19-20.

7. Emily Nathan, "Archives of American Art," *American Art Review* 2 (January-February 1975), pp. 58-59. Healy squared the photograph to transfer the composition to his much larger canvas.

8. Launt Thompson arrived in Rome in January of 1869. It has long been presumed that this fourth figure was that of Tiburce de Mare, Healy's son-in-law and father of Healy's biographer; however, a description of the painting in the *New York Evening Post* (April 16, 1869) identifies the fourth figure as Launt Thompson. Healy's granddaughter further complicated the issue when she misidentified the artists in the *Arch of Titus* as Sanford Gifford seated, with Launt Thompson and Healy looking on. Marie de Mare, *G.P.A. Healy, American Artist* (New York: David McKay Company, Inc., 1954), p. 248. According to an early photograph of *The Arch of Titus* at the Frick Art Reference Library, there was once a figure standing several paces behind the Longfellows, which Healy evidently painted out. See correspondence, Newark Museum curatorial files.

9. According to Healy's granddaughter, the artist sold *The Arch of Titus* to Marshall O. Roberts in 1874. William H. Gerdts, "Four Significant Paintings," p. 18. See also "American Art Galleries; Collection of the Estate of Marshall Owen Roberts," *Art Amateur* (October 5, 1880), vol. 3, p. 93.

Elizabeth Lyman Boott Duveneck

Born Cambridge, Massachusetts, 1846;
died Paris, France, 1888

Elizabeth Otis Lyman Boott — always known as
"Lizzie" — was the daughter of Francis Boott
(1813-1904) and Elizabeth Otis Lyman (1817-
1847). In September, 1847, Boott's recently
widowed father took her to live in Italy, settling in
Florence near his sister, Mrs. Henry Greenough,
but occasionally wintering in Rome. In 1855,
they began a decade of renting part of Villa
Castellani at Bellosguardo, overlooking Florence.
Boott and her father returned to Cambridge,
Massachusetts, in 1865, where she became friends
with Alice, William, and especially Henry James,
who found her "infinitely civilized and sympa-
thetic." Boott joined William Morris Hunt's
painting class for women which he started in
Boston in 1868-69.

Boott and her father were back in Italy, based
mainly in Rome, from 1871 to June 1873. Henry
James was a frequent visitor to their home and to
Boott's studio at the Piazza Barberini in Rome.
The Bootts returned to Europe again in the spring
of 1876, where for the next two summers Lizzie
joined a number of Hunt students studying with
Thomas Couture at Villiers-le-Bel, France. Each
fall after the class, Boott returned to Bellosguardo,
then wintered in Rome where she painted actively.
Her travels and studies are chronicled in a series
of long letters which she wrote from June 1876 to
October 1880 to the Hunt class members.

During the spring of 1875, Boott had first
seen the work of Frank Duveneck at the Boston
Art Club. She met Duveneck himself the summer
of 1878 when she said she made a "pilgrimage to
Duveneck's studio" in Venice, beginning lessons
with him the following summer in Munich. In a
letter dated September 18, 1879, Boott related to
the Hunt class that she had persuaded Duveneck
to move his class to Florence; there she found him a
studio and helped enroll a number of women
friends in his class.

Boott and Duveneck were engaged about 1881
and were eventually married on March 25, 1886

in Paris (see cat. 145). The couple returned to
Florence to live at Villa Castellani where their son
Francis Boott Duveneck was born in December
1886. In October 1887, they moved to Paris; a
few months later Boott died suddenly of pneumo-
nia on March 22, 1888.

Elizabeth Lyman Boott Duveneck

41. *Narcissus on the Campagna,*
 about 1872-73
Oil on panel, 16 x 7 in.
Duveneck Family

Lizzie Boott's nearly two years in Rome, from 1871 to 1873, mark a highlight of her career. Then in her mid-twenties, Boott had been painting and drawing for two decades, as evidenced by the profusion of drawings, watercolors and illustrations she had made from childhood on.[1] In March 1873, Henry James, with Edward Darley Boit and Frederic Crowninshield, made a visit to Boott's studio in Rome where she showed her work (including a group of sepia and watercolor sketches) to them; James reported they "were much surprised at her fertility, inventiveness and general skill."[2] He added, "She ought now to paint . . . to sell her things and make herself, if she wishes, a career."[3]

Narcissus on the Campagna, with its quickly brushed technique and its palette of somber browns, grays, and greens contrasting with the white blossoms, suggests Hunt's strong influence, while its vertical composition and the subject itself relate to John LaFarge's work, which Boott knew.[4] Her composition emphasizes the growing narcissus, but it also contains an unmistakable reference to Rome in the tiny, shadowed dome of St. Peter's on the horizon. The Campagna, which had meant so much to artists of earlier generations, still had resonance for the American painter and writer. Boott frequently described horseback riding on the Campagna alone or in company with such friends as Henry James and Alice Bartlett; they would "make expeditions on the Campagna, sketch by the hours, ride till after the sun had set in red and gold behind the great dome and the mysterious twilight hour had begun."[5]

Henry James, describing spring coming to Rome, wrote: "Far out on the Campagna, early in February, you felt the first vague, earthy emanations . . . It comes with the early flowers, the white narcissus and the cyclamen, the half-buried violets and the pale anemones, and makes the whole atmosphere ring."[6] He often refers to his rides on the Campagna with Boott during her 1872-73 sojourn in Rome, when *Narcissus on the Campagna* was probably executed.[7] Perhaps finished in the studio, this may be the kind of study Boott referred to when she wrote, "the Campagna gives one ever new and varied effects for memory sketches, and I have often blessed Mr. Hunt who first made me exert my memory in this way."[8] The painting was exhibited in New York at the National Academy in March 1876.[9]

After Boott's marriage to Frank Duveneck in Paris in 1886, they returned to Villa Castellani, Bellosguardo, where she had spent her adolescence. Boott and Duveneck both painted the villa, which was used as a setting by James in *Portrait of a Lady*. Boott's watercolor, *Villa Castellani*, September 1887, was exhibited in the Paris Salon in May 1888, a few months after her death (figs. 1, 2).

S. RICCI

I am grateful to the Duveneck family, Adele de Cruz and Carol Osbourne for providing information on Elizabeth Boott.

1. From a very young age Boott illustrated gift books for her father and made sketch-books which often included distinguished visitors to Villa Castellani: the Brownings, J.J. Jarves, Nathaniel Hawthorne, who lived briefly in 1858 at nearby Villa Montauto, and Francis Alexander, father of Boott's friend Francesca Alexander (see cats. 89, 90). See Josephine W. Duveneck, *Frank Duveneck, Painter, Teacher*, (San Francisco: John Howell - Books, 1970), p. 106.

2. Henry James to his mother, Mrs. Henry James Sr., March 24, 1873. *Henry James Selected Letters*, ed. Leon Edel, (Cambridge, Mass.: Harvard University Press, 1987), p. 108.

3. James later tried to help Boott sell her work, writing to Alice James, February 26, 1879, "She (Lizzie) appears to desire greatly to sell some of her pictures, and I am afraid she finds it very hard. She is trying to place some things in London I am doing what I can to help her." *Henry James Letters*, ed. Leon Edel, (Cambridge, Mass.: Harvard University Press, 1975), vol. 2, p. 215.

Boott's work was frequently exhibited: she showed regularly at the National Academy of Design, N.Y. (1875 to 1886) and her work was exhibited at the Philadelphia Centennial Exposition (1876), the Royal Academy, London (1885) and the Paris Salon (1888). In addition, her paintings were seen at Boston galleries: in 1882 in an exhibit at the J. Eastman Chase Gallery with her friend and Hunt classmate Anna P. Dixwell; in her large solo exhibition (66 paintings) of February 1884, at Doll and Richards; and in February 1888, with fourteen Hunt pupils at the Williams and Everett Gallery.

4. For a discussion of Boott and Hunt see Martha Hoppin, "Women Artists in Boston, 1870-1900; The Pupils of William Morris Hunt," *American Art Journal* 13 (1981) Smithsonian Institution, Washington, D.C., p. 21. Though Boott was often praised for her "technical ability," "eye for color," and "feeling for design," her work was also criticized for a lack of finish. Childe Hassam reviewed her exhibition at the Doll and Richards Gallery, saying that "Miss Boott is like those artists who look at nature in a broad way instead of a finished painting they have nothing but a sketch." Elizabeth Boott Duveneck Papers, Archives of American Art, Smithsonian Institution, Washington, D.C.

5. Elizabeth Boott to Hunt class members, Rome, December 6, 1877, Cincinnati Historical Society. Boott also wrote to William James, March 7, 1877 from Rome, "I have ridden a great deal on horseback which is the best thing in the world, and enjoyed the country in this way as no one can who does not ride. I had forgotten . . . how enchanting the Campagna is It is to some people inexpressably sad, but I rarely see it in this mood and it means to me the peace and rest of Heaven." Elizabeth Boott Duveneck Papers, Cincinnati Historical Society.

6. Henry James, "Roman Rides," *Transatlantic Sketches*, (Boston: James R. Osgood, 1875), p. 150.

7. James wrote to his father, Henry James Sr., March 4, 1873 from Rome, "The Bootts I see pretty often, especially now that I have begun to ride pretty regularly with Lizzie." Leon Edel, ed., *Henry James Selected Letters*, p. 99.

8. Elizabeth Boott to Hunt class members, Rome, January 6, 1878, Cincinnati Historical Society.

9. *Narcissus on the Campagna* was shown as no. 158, along with two Venetian scenes, at the 51st Annual Exhibition of the National Academy of Design (1876).

Fig. 1. Elizabeth Boott Duveneck, *Villa Castellani*, 1887. Watercolor. Stanford University Museum of Art. Gift of Francis and Betty Duveneck.

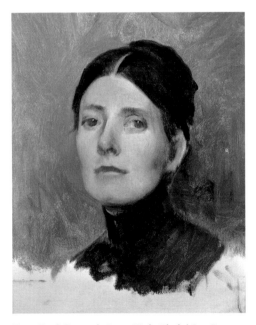

Fig. 2. Frank Duveneck. *Portrait Head of Elizabeth Boott Duveneck*, 1886. Oil on canvas. Elizabeth Dana.

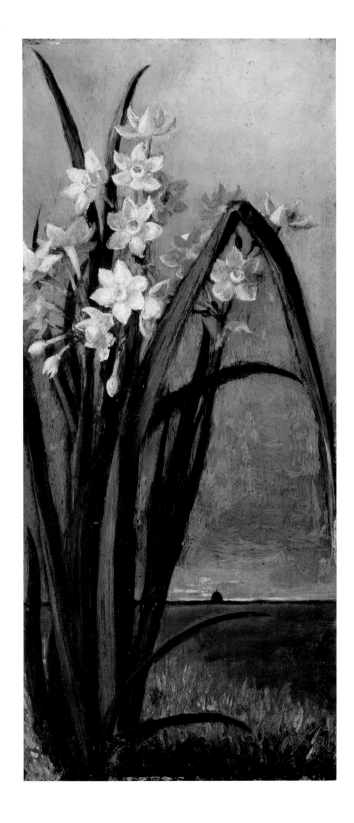

William Rimmer

Born Liverpool, England, 1816;
died South Milford, Massachusetts, 1879

As a young man, the painter Benjamin Champ-
ney (1817-1907) worked with William Rimmer
at Thomas Moore's Lithographic Shop in Boston.
Champney recalled the twenty-one-year old Rim-
mer's prodigious talent, and concluded that his
young colleague must have studied engravings and
casts after the antique then available in Boston.
For personal and economic reasons, Rimmer never
traveled to Italy, but his lifelong study of the clas-
sical tradition was made possible through many
locally available reproductions.

It was the affluent Milton patron, Stephen
Higginson Perkins (1804-1877), who recog-
nized Rimmer's greatness and urged him to pur-
sue his career. Perkins took Rimmer's granite head
of St. Stephen (1860, The Art Institute of
Chicago) and a plaster cast of The Falling
Gladiator (1861-1862, destroyed in Florence
about 1880) with him to Europe, where he lived
from 1862 to 1877. He exhibited the works in
Paris, and garnered praise in Florence from Ital-
ian sculptors Giovanni Dupré (1817-1882) and
Enrico Pazzi (1819-1899). Despite his own
taste for Europe, Perkins bluntly advised Rimmer
to remain in Boston: "There is no instruction here
or any where else in Europe which comes within
gun shot of the course you describe. They do little
more than furnish casts and living models to copy
any where. – You can learn nothing here." Al-
though Rimmer never crossed the Atlantic, like
many Americans, he was deeply influenced by the
landscape and culture of Italy. Through exhaus-
tive studies of the casts and prints available to
him, he extracted the essential lessons of western
sculpture unhindered by the props or narratives
favored by American artists in Italy; he also
painted one of the most serenely radiant land-
scapes to evoke its arcadian twilight (see fig. 32,
p. 56).

William Rimmer

42. *Torso*, 1877

Plaster, h. 11¼ in., w. 14½ in., d. 7½ in.
Signed on top of base at front: W. Rimmer 1877
*Museum of Fine Arts, Boston, Bequest of Caroline Hunt
Rimmer*

Sculpted near the end of his life, in the
same year that his book, *Art Anatomy,*[1] was
published and while he taught at the
School of the Museum of Fine Arts, Rim-
mer's *Torso* reveals the artist's knowledge of
the cast collections of the Boston
Athenaeum and Museum of Fine Arts,
Boston. A copy of the Vatican's monumen-
tal, tensed *Belvedere Torso* (fig. 1) at the
Boston Athenaeum was known to Rim-
mer, as were Michelangelo's reclining fig-
ures of the times of day for the Medici
chapel.[2] While visiting the Boston
Athenaeum with his class from the School
of the Museum of Fine Arts, Rimmer ex-
pressed his preference for the *Belvedere Torso*
to the figures by Michelangelo. He pointed
to a cast of Michelangelo's *Morning*, saying,
"That is the Black Sea; this [the *Belvedere
Torso...*] – is the ocean."[3] Other influences
upon Rimmer's *Torso* include *Ilissus*,[4] the re-
clining river god from the west pediment
of the Parthenon, sketched by the sculptor
during his Providence lecture series of
1871-73. Similar to *Ilissus* was the figure of
Theseus (also known as Herakles or
Dionysos), a better-known sculpture from
the east pediment of the Parthenon, casts
of which were frequently used in model-
ing, anatomy, and art classes.[5] Plaster casts
of both sculptures, notable for their reclin-
ing posture and twisted torso, were on
view at the Museum of Fine Arts, Boston,
by 1877.[6]

Rimmer's references to ancient sculpture
were tempered by his intimate knowledge
of the human body through his earlier
medical career, and by his repeated exhor-
tations to his students against copying
works of art. Still, Rimmer's renowned
lectures were filled with his sketches of the
human figure that included examples from
classical statuary. It has been conjectured
that this small plaster figure was created
for the purpose of class instruction, and
that the roughness of its surface is the re-

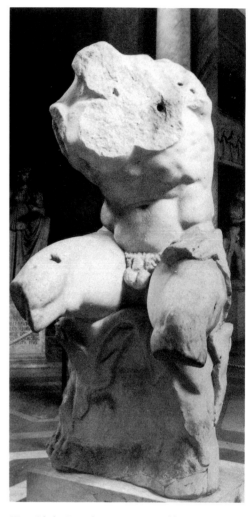

Fig. 1. *Belvedere Torso*, about 150-50 B.C. Marble. Vatican Mu-
seums, Rome.

Maurice Brazil Prendergast

Born St. John's, Newfoundland, 1857;
died New York, New York, 1924

sult of Rimmer's habit of rapidly sketching patients in his care.[7] His irrepressible penchant for working from life as well as memory, and his unwillingness to rely wholly on classical prototypes suggest that *Torso* is a distillation of several sources.

Like Rimmer's *Falling Gladiator* (modeled 1861, Museum of Fine Arts, Boston), the uncompromising nudity of the *Torso* distinguished it from much American art produced to date. Many of the American artists in Italy produced sculptures whose elaborate trappings were more Victorian than classical in sensibility. By contrast, Rimmer's unadorned figures are more in keeping with the spirit of the antique.

J. FALINO

1. Champney's recollections of Rimmer are found in Benjamin Champney, *Sixty Years' Memories of Art and Artists* (Woburn, Massachusetts: Wallace and Andrews, 1900), pp. 10-12. Perkins's advice to Rimmer was conveyed in a letter from Villa Castellani, dated January 10, 1864, quoted in Jeffrey Weidman, "William Rimmer: Critical Catalogue Raisonné," Ph.D. diss., Indiana University, 1981, vol. 4, p. 1294.

2. The pair of casts by Michelangelo, obtained by Horatio Greenough for Colonel Thomas Handasyd Perkins, were deposited by Perkins at the Boston Athenaeum in 1838, and were lent to the Museum of Fine Arts, Boston, shortly after it opened to the public. Nathalia Wright, *Horatio Greenough, The First American Sculptor* (Philadelphia: University of Pennsylvania Press, 1963), p. 197.

3. Truman H. Bartlett, *The Art Life of William Rimmer: Sculptor, Painter, and Physician* (Boston: Osgood, 1882), p. 118.

4. Bartlett, *The Art Life of William Rimmer*, p. 71. Weidman "William Rimmer," vol. 1, p. 389, cites Rimmer's February 19, 1872 lecture as the date when the artist sketched the figure of Ilissus, as published in the *Providence Daily Journal* February 21, 1872, p. 2.

5. Weidman, "William Rimmer," pp. 387-390.

6. *Museum of Fine Arts. Catalogue of Casts and other Works of Sculpture* (Boston: Alfred Mudge & Son, Printers, 1877), p. 17. The Museum of Fine Arts, Boston, opened to the public in 1876, and may have had these casts on exhibit at that time.

7. Jan Seidler Ramirez, in Kathryn Greenthal et al, *American Figurative Sculpture in the Museum of Fine Arts, Boston*, (Boston: Museum of Fine Arts, 1986), pp. 78-9.

Maurice Prendergast moved with his family to Boston at age eleven, and it was in that city that he first worked as an artisan, designing show cards for the firm of Peter Gill in the late 1880s. He traveled abroad in 1886-87, visiting England and Wales with his brother Charles, also an artist. In 1891, the two brothers returned to Europe, establishing themselves in Paris. Maurice stayed in France until 1894, studying at the Académie Julian and at Colarossi's, both popular with American art students. His next European trip, in mid-1898, was financed by Sarah Choate Sears, an important Boston collector, patron, and artist; she sponsored Prendergast for eighteen months in Italy. Although he also worked in other cities, Prendergast spent most of his time in Venice, often in the company of other American painters, including William Gedney Bunce. The vivid pageantry of street life in Venice had a special appeal for him, as did the local collections of Carpaccio's paintings, which he greatly admired for their pattern and color. Prendergast painted more than fifty watercolors of the city's piazzas and canals during the summer of 1898 and the spring and summer of 1899, which he exhibited to much acclaim upon his return to Boston. He spent the winter of 1898-99 in Rome, Naples, and Capri; he also visited and recorded Padua, Florence, Siena, Assisi, and Orvieto. He returned to Italy a second time in 1911-12, where again he concentrated his attention on Venice, depicting its canals and bridges in his new, mosaic-like neo-impressionist style, despite a period of illness and a two-month stay in Venice's Cosmopolitan Hospital. On this occasion, Prendergast also visited Rome and Palermo on his way back to the United States.

Prendergast visited and recorded several Italian cities during his extended tour in 1898-99. While his well-known Venetian scenes depict various of the city's most famous monuments (see cats. 126-130), almost all Prendergast's Roman views depict the area around the Pincian Hill, in the northern part of the city just east of the Tiber. There he painted the Borghese Gardens, the Spanish Steps, and the popular promenade on the hill itself.[1] The area had long been a center for the arts — the French Academy had been established at the Villa Medici since 1803, and although the newly founded American Academy had moved in 1896 away from the neighboring Villa Aurora, many Americans still had studios in the Via Margutta, between the Spanish Steps and the Piazza del Popolo, at the foot of the Pincian Hill.[2]

Every guidebook to Rome recommended "the beautiful and frequented promenade of Monte Pincio," famous for its view of the city.[3] However, unlike such painters as Sanford Gifford (see cat. 34), in *Monte Pincio, Rome* Prendergast literally turned his back on the panoramic vista, depicting instead the cavalcade that crowded the hillside in the late afternoon, entertained by a military band. George Stillman Hillard had described the scene in the 1850s:

> The fashionable hour of resort to Monte Pincio is that just before sunset. At this time, the gravelled terrace on the western side begins to be thronged with pedestrians. Carriages arrive in rapid succession, and, wheeling into line, move round in an unbroken succession, and soon are brought so near to each other, that no one can stop without deranging the economy of the whole circle. Nowhere in the world is seen a greater variety of equipages than on the Pincio, on a fine winter's afternoon.[4]

Maurice Brazil Prendergast

43. *Monte Pincio, Rome,* 1898-99
Watercolor and pencil on paper, 15½ x 19¾ in.
Signed l.l.: Maurice B. Prendergast / Monte Pincio,
Rome.
Daniel J. Terra Collection

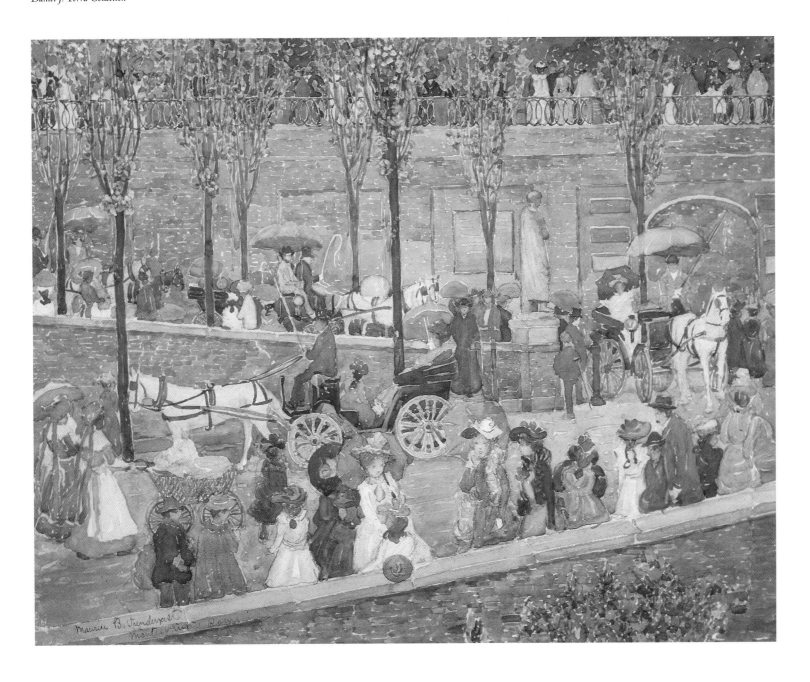

In 1878, Henry James used the promenade as the setting for one of Daisy Miller's indiscretions, allowing his ill-fated heroine to stroll improperly chaperoned among the "slow-moving, idly gazing Roman crowd."[5] The scene was little changed by the 1890s, and Prendergast recorded a steady procession of carriages and pedestrians negotiating the sharp turn leading down to the Piazza del Popolo.

Characteristically, Prendergast did not confine his view to the upper classes, preferring instead to transcribe a more democratic assortment: fine carriages with top-hatted attendants mingle with nursemaids with ribboned hats, frocked priests, fashionable young ladies with parasols, ball-playing children, and a one-legged man on crutches. A classical statue seems to watch from its pedestal, as if this diverse scene had continued for centuries. Prendergast's selection of the hairpin turn in the roadway as his subject allowed him to arrange his composition in the zig-zag bands he preferred, using them to enhance the flat, decorative effect he created with his bright colors and the short, wet brushstrokes he used to define the brick terraces and pavement.

Prendergast painted three similar watercolors of the promenade on the Pincian Hill, and one of them was included his New York exhibition at Macbeth Galleries in 1900. The critic for the *New York Times* remarked that the artist "translated not so much the color and atmosphere of those Italian cities, as their outdoor life and movement . . . The work of Mr. Prendergast shows abundant promise."[6]

E. HIRSHLER

1. See Nancy Mowll Mathews, *Maurice Prendergast* (Williamstown, Mass.: Williams College Museum of Art, 1990), p. 18.

2. The American Academy's first quarters were in the Palazzo Torlonia, near the artist's haven of the Caffè Greco and the Piazza di Spagna. In 1895 they moved to the Villa Aurora, on the Pincian Hill, and the following year to the Villa Mirafiori. See William L. Vance, *America's Rome* (New Haven: Yale University Press, 1989), vol. 2, pp. 272-273.

3. *Murray's Handbook of Rome and its Environs* (London: John Murray, 1894), p. 11.

4. George Stillman Hillard, *Six Months in Italy* (Boston: Ticknor, Reed, and Fields, 1853), vol. 2, pp. 41-42.

5. Henry James, *Daisy Miller and Other Stories*, edited with an introduction by Michael Swan (New York: Penguin Books, 1963), p. 168.

6. "The Week in Art," *New York Times*, March 17, 1900, p. 174. The other similar watercolors of the Pincian Hill are a vertical composition, *Afternoon, Pincian Hill* (1898-1899, Honolulu Academy of Arts), and another horizontal picture, *Pincian Hill, Rome* (1898, The Phillips Collection, Washington, D.C.). Prendergast also made a monotype of the scene, *Monte Pincio* (1898-99, Daniel J. Terra Collection, Terra Museum of American Art, Chicago). See Carol Clark, Nancy Mowll Mathews, and Gwendolyn Owens, *Maurice Prendergast, Charles Prendergast: A Catalogue Raisonné* (Williamstown, Mass.: Williams College Museum of Art, 1990), pp. 396-399, 612.

John Singer Sargent

Born Florence, Italy, 1856;
died London, England, 1925

John Singer Sargent was one of the most admired painters in both Europe and America; his fluid technique is the paradigm of an international style. Although he spent most of his life abroad, he considered himself an American. His parents had recently abandoned Philadelphia for a permanently itinerant European life when John was born in Italy in 1856. He became fluent in Italian, and felt equally at home in Rome or Venice as he did in Paris, London, or Boston.

Sargent received his first artistic training at the Accademia di Belle Arti in Florence in 1873-74. After a period of study in Paris, he returned to Italy, making his first mature Italian subject pictures in Capri in 1878. Two years later, he took a studio in the Palazzo Rezzonico in Venice, and spent several months painting the city's narrow streets and interiors. Sargent returned there in 1882, staying with his cousins the Curtises at the Palazzo Barbaro. In 1883, he traveled to Florence, Siena, and Rome. Save for a brief trip to San Remo in 1891, Sargent did not go to Italy again until 1897, when he was designing a series of murals on the history of religion for the Boston Public Library. He went to Sicily, Rome, and Florence for his research, and then to Venice in 1898. After 1900, Sargent journeyed to Italy almost every autumn, where increasingly he devoted himself to watercolor painting. His destination was usually Venice, but he also visited the Val d'Aosta and small towns in the Italian Alps; Milan; the northern lake region (particularly Lake Garda); Bologna, Turin, and Genoa; Florence, Carrara, Siena, and other Tuscan cities; Rome and its environs; and Sicily and Palermo. After the First World War, Sargent devoted himself primarily to his mural commissions, and did not travel to Italy again.

Fig. 1. Wilfred de Glehn (British, 1870-1951), *At the Villa Torlonia, Frascati*, 1907. Oil on canvas. Courtesy of Borghi and Company, New York.

John Singer Sargent

44. *The Fountain, Villa Torlonia, Frascati, Italy*, 1907
Oil on canvas, 28⅛ x 22¼ in.
Signed l.l.: John S. Sargent
The Art Institute of Chicago, Friends of American Art Collection

Sargent journeyed to Italy frequently after 1898, making almost annual trips, usually in autumn, to the Italian Alps and to Venice, as well as excursions to Florence and Rome, Bologna, Naples, and Sicily. In September 1907, he traveled from Venice to Rome with his sister Emily and their close friend Eliza Wedgewood. There they met Jane and Wilfred von Glehn, with whom they visited Villa Torlonia in Frascati, some fifteen miles southeast of Rome, securing permission from the owner to paint in the elaborate gardens.[1]

The von Glehns, who appear in *The Fountain*, were both painters. Sargent met Wilfred von Glehn (1870-1951) in about 1895, when he was looking for an assistant to help with his mural project for the Boston Public Library. Sargent's friend Edwin Austin Abbey, who was also painting murals for the library, introduced them, and the two men became lifelong friends. Sargent, who created nicknames for everyone, quickly christened the younger man "Premp." Jane Emmet von Glehn (1873-1961) was from New York; she was the younger sister of painters Rosina Emmet Sherwood and Lydia Field Emmet, and among her cousins were portraitist Ellen Emmet Rand and novelist Henry James. She had studied painting in Paris in the late 1890s, and in 1904 she married Wilfred von Glehn. From about 1904 to 1914, the von Glehns traveled extensively with Sargent, often in Italy.[2]

Sargent and his friends stayed at the Grand Hotel in Frascati throughout the month of October 1907. The town, famous for its white wine, was a hillside resort popular with both Roman families and foreign tourists, who gathered there in summer to enjoy its "healthy situation [and] beautiful, shady, and well-watered villas, commanding an admirable view of the Campagna," according to Baedeker.[3] Near the railway station and the public

garden, a carriage road led into the Villa Torlonia (also called the Villa Conti). The grounds of the villa, which were open to the public, were one of Frascati's major attractions, admired for their "lofty terraces, crowned with fountains, cascades, and statues, and shaded by majestic trees."[4]

The Fountain is one of at least six paintings Sargent made in the gardens at Frascati, which he especially admired, writing that he could paint them "from morning till night."[5] Sargent posed his friends the von Glehns on the balustrade of Villa Torlonia's main fountain (fig. 1), a dark pool shaped like a quatrefoil with a single jet of water rising from its center, which Edith Wharton had called one of the most beautiful in all of Italy.[6] Jane recounted the experience in her letters, writing:

> Sargent is doing a most amusing and killingly funny picture in oils of me perched on a balustrade painting. It is the very 'spit' of me. He has stuck Wilfred in looking at my sketch with rather a contemptuous expression . . . I am all in white with a white painting blouse and a pale blue veil around my hat. I look rather like a pierrot, but have rather a worried expression as every painter should have who isn't a perfect fool, says Sargent. Wilfred is in short sleeves, very idle and good for nothing . . . [he] can't pose for more than a few minutes at a time as the position is torture after awhile.[7]

She understandably loved the finished picture, for *The Fountain* is a celebration of the act of painting. Not only is it a portrait of Jane von Glehn in the midst of creating a work of her own, but it is also a lesson in professional accomplishment. Sargent displays his technical methods openly, almost as if the picture were a class exercise in painting. He skillfully experiments with using white against white, per-

Fig. 2. *Villa Torlonia*. Photograph, 1990.

fectly balancing lights and darks. With a final master touch, he uses a drier brush to drag paint across the surface of the composition, thus defining the transparent spray of the fountain and the sunlit stone in the distance.

Jane hoped that she and Wilfred might buy the painting, but Sargent misunderstood her restrained compliments and exhibited *The Fountain*, first in 1907 at the New English Art Club and then at the Art Institute of Chicago, which purchased it immediately after it was shown there in 1912. Later Sargent declared that he might have given the painting to the von Glehns if he had realized they liked it.[8]

E. HIRSHLER

1. Jane von Glehn wrote that "there is difficulty of getting permission, and we are champing at the delay. Sargent and Wil are dying to get at it. It is too beautiful," (Jane von Glehn to Mrs. W. J. Emmet, September 24, 1907, transcript courtesy of Borghi and Company, New York). One of Sargent's images of the fountain is inscribed to Don Giulio Torlonia, owner of the villa.

2. The von Glehns changed their name to de Glehn during World War I. For further information on the von Glehns, see also Laura Wortley, *Wilfred-Gabriel de Glehn (1870-1951): Paintings and Watercolors* (New York: Hirschl and Adler Galleries, Inc., 1989) and Martha J. Hoppin *The Emmets: A Family of Women Painters*, (Pittsfield, Mass.: The Berkshire Museum, 1982).

3. *Baedeker's Italy: Central Italy and Rome* (Leipzig: Karl Baedeker, 1893), p. 362.

4. *Murray's Handbook of Rome and its Environs* (London: John Murray, 1894), p. 402. The gardens were developed by the Conti family in 1632. The villa then passed to the Torlonia family, who owned it until the Second World War. Villa Torlonia was a German communications center during World War II and was bombed by the Allies. It has been repaired and substantially altered. The gardens are now a public park. See Judith Chatfield, *A Tour of Italian Gardens* (New York: Rizzoli, 1988), pp. 211-13.

5. "They are magnificent and I should like to spend a summer at Frascati and paint from morning till night at the Torlonia or the Falconiere, ilexes and cypresses, fountains and statues — ainsi soit il — amen," (John Singer Sargent, quoted in Richard Ormond, *John Singer Sargent: Paintings, Drawings, Watercolors* [New York: Harper and Row, 1970], p. 76). Jane von Glehn wrote to her mother of their stay, noting that they "found endless things to paint in the gardens of the Villa Torlonia," (September 24, 1907, quoted in *Wilfred de Glehn, 1870-1951* [New York: Borghi and Company, 1988], p. 14). Sargent's other images of Torlonia are listed in Evan Charteris, *John Sargent* (New York: Scribner's, 1927), p. 288. The von Glehns also painted at Frascati. See Wilfred's *The Statue of Vertumnus at Frascati* (1907, art market), which is similar to Sargent's painting of the same subject (1907, Municipal Gallery of Modern Art, Dublin), as well as von Glehn's *At the Villa Torlonia, Frascati* (fig. 1).

6. Edith Wharton, *Italian Villas and Their Gardens* (New York: The Century Company, 1904), p. 156.

7. Jane von Glehn to Lydia Emmet, October 6, 1907, quoted in Patricia Hills, "'Painted Diaries': Sargent's Late Subject Pictures," in Hills, et al., *John Singer Sargent* (New York: Whitney Museum of American Art, 1986), p. 191. Among Sargent's other paintings that include the von Glehns are *Wilfred de Glehn and Mrs. de Glehn Sketching in a Gondola* (1904, Private Collection), *In the Garden, Corfu* (1909, Terra Museum of American Art, Chicago) and *The Sketchers* (1914, Virginia Museum of Fine Arts, Richmond).

8. Michael Roosen and Laura Wortley, *A Painter's Journey*, p. 36, photocopied excerpt courtesy of Laura Wortley.

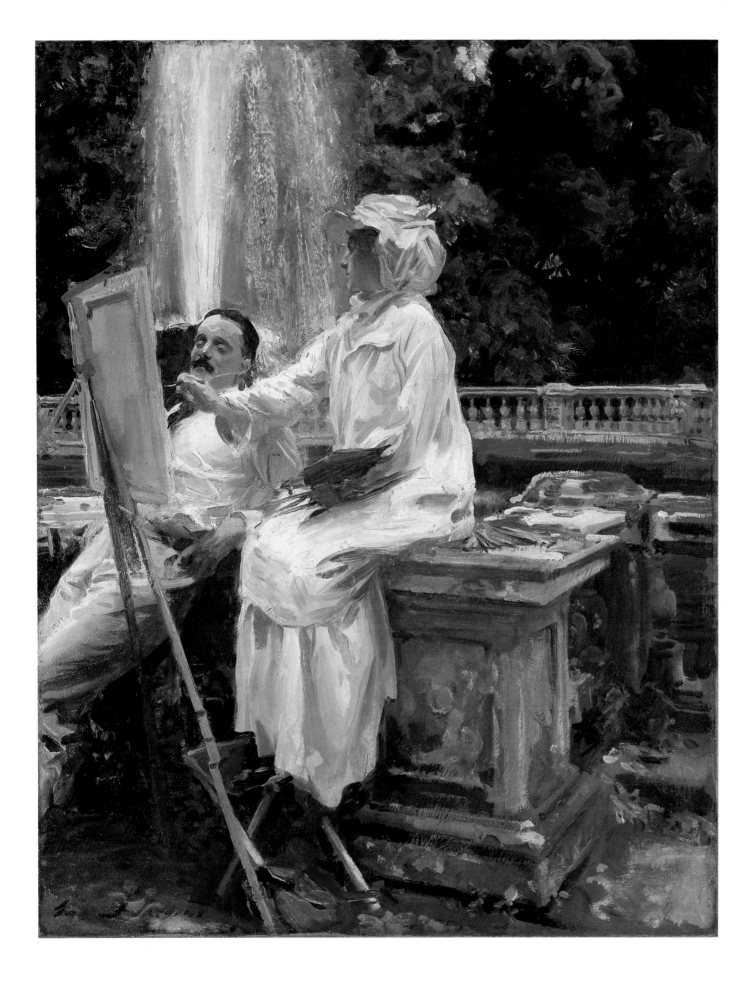

Nola

N

0 2 4 6 8 Miles

0 4 8 Kilometers

NAPLES

Cuma
Arco Felice
Solfatara
L. Avernus
L. Agnano
Grotto Posillipo
Castel dell'Ovo
L. Fusaro
Baia
Mt. Procida
Pozzuoli
Gulf of Pozzuoli

Portici
Mt. Vesuvius
Herculaneum
Torre del Greco

Pompeii

Procida
PROCIDA

Bay of Naples

Castellammare

Cava
Salerno

Ravello
Positano
Amalfi

Eboli

Sorrento

Gulf of Salerno

CAPRI

Pta. Campanella

Tyrrhenian Sea

Paestum

E.McC. '92

Thomas Cole

45. *Aqueduct Near Rome,* 1832
Oil on canvas, 44½ x 67½ in.
Washington University Gallery of Art, St. Louis University purchase, Bixby Fund, by exchange, 1987

Perhaps the single most recognizable view of Italy for Americans was the stretch of aqueducts crossing the Roman Campagna just outside the walls of Rome.[1] The ancient aqueducts, built under the Emperor Claudius in A.D. 52, carried clean water down from the surrounding mountains – the Claudian Aqueduct stretched forty-two miles from the Anio Novus river at Subiaco to Rome. Fully three-quarters of this aqueduct was underground, while its visible arches were made of ashlar, and prone to decay.[2] As the aqueducts deteriorated, the increasingly poor drainage contributed to the spread of malaria, driving inhabitants and visitors to the mountains in the summer to escape the "bad air." Visitors' reactions to the Campagna focused on its vastness, and its silent, deserted aspect. Fear of malaria tempered many descriptions of the Campagna's beauty, and the ruined aqueducts became symbols of man's retreat from its environs.[3] The ruined aqueducts thus emerged as a powerful symbol of the fallen empire, both for their endurance as an engineering marvel and mute testimony to the ravages of time.

The aqueducts had been a popular subject for artists since the seventeenth century.[4] In *Aqueduct Near Rome,* Thomas Cole painted the most famous portion of the Claudian aqueduct system, located along the Via Appia. At the far left of his composition stands the Tor Fiscale, a medieval tower marking the juncture of two of the branches of the aqueduct system (Claudian and Marcian).[5] A small stream that once flowed atop the aqueduct has reverted to its original course, and now flows between the ruined arches. A human skull and several architectural fragments overgrown with weeds serve as additional reminders of man's mortality, and of nature's eventual dominance over the landscape.[6] From the tower the broken colonnade of

Fig. 1. Thomas Cole, *Roman Campagna,* 1843. Oil on canvas. Wadsworth Atheneum, Hartford, Conn., Bequest of Clara Hinton Gould.

Fig. 2. Thomas Cole, *Study for Aqueduct Near Rome,* about 1832. Oil on canvas. Courtesy Alexander Gallery, New York.

arches curves across the Campagna toward the Sabine hills. In the middle distance a shepherd guides his flock home, while a lone goat in the near foreground turns back toward Rome, facing the sunset.[7]

In 1843 Cole returned to this subject, painting *Roman Campagna* (fig. 1), which he paired with an idealized or "fancy" landscape titled *Evening in Arcady* (Wadsworth Atheneum, Hartford, Conn.). Smaller in scale, this second view of the aqueducts is an early morning scene, the goatherd and his flock emerging onto the Campagna to graze. Here Cole underscores the beauty and fertility of the region, rather than conveying the moral message of the fall of the Roman Empire in his earlier *Aqueduct near Rome.*

Cole painted *Aqueduct near Rome* in Florence, during a three-month long burst of activity he later recalled as the most productive of his career (fig. 2).[8] This was the largest canvas Cole painted on this trip to Italy, and his most significant. Exhibited at the National Academy of Design in 1833, *Aqueduct near Rome* was engraved by James Smillie the same year,[9] and became one of the most popular images by an American of Italy.[10] Many American artists copied Cole's composition outright, or used it as the basis for their own versions of the site, including Benjamin Champney, Sanford Gifford, Worthington Whittredge, Albert Bierstadt, and John Rollin Tilton, to name but a few. Francis Alexander had visited the Campagna with Cole, and wrote to his friend, "your view of the Campagnia [sic] of Rome. . . is an *astonishing* picture, full of nature and truth – *I* thank you for it for it carries me immediately into the Campagnia, where you sat to sketch & I have stood to look, and it makes my blood tremble; this same picture does, just as the original spot used to."[11] One of Cole's obituaries noted, "his pictures of the Roman Campagna are well known, and are, without a doubt, the greatest works he has left behind him. Those who have seen the Roman Campagna in its solemn silence, combed with broken lines of aqueduct and vivid remains of temples and tombs, sleeping in the warm haze of an Italian sunset, can best appreciate these beautiful works of art."[12]

E. JONES

1. Murray's guide called the Claudian Aqueduct "the grandest ruin outside of the walls of Rome." Quoted in Wendy M. Watson, *Images of Italy: Photography in the 19th Century* (South Hadley, Mass.: Mount Holyoke, 1980), p. 8. The Roman Campagna extends from the Etrurian hills to the Circaean promontory near Terracina, bounded by the Alban Hills to the south, the Appenine and the Sabine Mountains on the east, and the Mediterranean Sea to the west. It encompasses an area 90 miles long, and 30 miles

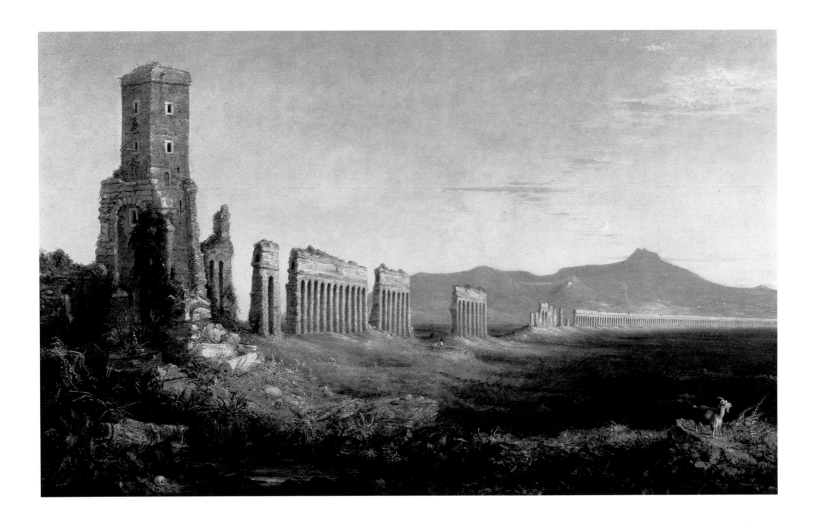

wide. Rome lies within its broad expanses; once heavily farmed and populated, the region fell fallow under the Papal administration of its large estates.

2. The aqueducts required restoration as early as A.D. 71 under Emperor Vespasian, and again in A.D. 81 under Titus. Thomas Ashby, *The Aqueducts of Ancient Rome* (Oxford: Clarendon Press, 1935), pp. 190-192.

3. William Cullen Bryant captured this in his description of Cole's painting as "silence made visible." William Cullen Bryant, *Orations and Addresses* (New York: G. P. Putnam's Sons, 1873), p. 21, quoted in William L. Vance, *America's Rome* (New Haven: Yale University Press, 1989), vol. 1, p. 68. Many authors described the Campagna and the aqueducts using similar terms, among them Hillard, Taylor, and Willis.

4. The Campagna was a favorite region for artists of all nationalities to sketch in pencil or oil *en plein-air*; English, French, German, Scandinavian, and Italian artists all made the various features of the Campagna subjects for their pic

tures. The Campagna also played a role in the daily life of many foreign residents. The British were noted for their foxhunts, and in February the artists' festival was held on the Campagna, while once a year the Germans held their Walpurgisnacht celebrations at the Torre dei Schiave (see cat. 52).

5. Thomas Ashby, *Aqueducts of Ancient Rome*, pp. 228-232; and *Thomas Ashby: Un archeologo fotografia la campagna romana tra '800 e '900* (Rome: British School at Rome, 1986), pp. 234-236.

6. Cole also positioned a skull in the foreground of his *Subsiding of the Waters of the Deluge* (National Museum of American Art, Smithsonian Institution, Washington, D.C.), which also addresses issues of man's mortality in the post-Edenic world.

7. Goats often appear in Cole's Italian landscapes. Cole owned a statuette of an Italian goat in an identical pose, which may have served as his guide; it is visible in a photograph of his studio in Catskill. Thomas Cole files, McKinney Library, Albany Institute of History and Art, Albany, N.Y.

8. The painting was commissioned in Rome by Charles Lyman, of Waltham, Mass.

9. It also appeared as the frontispiece to Henry Tuckerman, *The Italian Sketch Book* (Boston: Light and Stearns, 1837).

10. Nathaniel Parker Willis called it "one of the finest landscapes ever painted." *Pencillings by the Way* (Philadelphia: Carey, Lea, and Blanchard, 1836), vol. 1, p. 107.

11. Francis Alexander to Thomas Cole, April 2, 1834. New York State Library, Albany. MSS and Special Services Division, Thomas Cole papers, Box 2, folder 3. Cole made numerous sketches of the ruins on the Campagna in his sketchbook dated May 7, 1832, Detroit Institute of Arts.

12. Obituary in the New York *Tribune*, February 2, 1848; copy in the New York State Library, Albany, N.Y. MSS and Special Services Division, Thomas Cole Papers, box 5, folder 4.

Thomas Cole

46. *Mount Etna from Taormina,* 1843
Oil on canvas, 78⅝ x 120⅝ in.
Signed l.l.: T. Cole 1843
*Wadsworth Atheneum, Hartford, Conn., Purchased of the
Artist, 1844*

Cole's proudest moment on his second
trip to Italy came the morning of May 10,
1842, when he and English artist Samuel
Ainsley arrived at the summit of Mt. Etna
in time for sunrise. Cole recounted the ar-
duous climb and exhilarating view in the
first of two articles based on his Sicilian
travels, published in the *Knickerbocker* in
1844.[1] The experience of climbing Mt.
Etna led to at least six paintings of the vol-
cano.[2] In the first two, painted in the fall of
1842 shortly after his return to America,
Cole chose an inland site facing east, be-
tween Caltagirone and Lentini, the vol-
cano towering over a landscape of fertile
meadows and scattered ruins. A shepherd
and his flock underscore the bucolic feel of
these compositions (fig. 1).[3] In *Mt. Etna from
Taormina,* Cole's third painting of the vol-
cano, he has shifted his vantage point to
the north; he now looks south across the
bay of Naxos from the Greek theater in
the small town of Taormina, with a sweep-
ing view of the coastline below him and
the mass of Mt. Etna above, seen just after
dawn.

This is the largest and most ambitious
of the paintings Cole made of the volcano,
and the first of two versions Cole painted
using this composition.[4] In a preliminary
drawing, the light cast on the tall column
at the far left of the drawing is from the
west, indicating it was drawn close to sun-
set (fig. 2). Perched in the top row of seats
to sketch this view, he looked out to the
stage, with its ruined arches and columns.
The theater itself was built in the Hel-
lenistic period, perhaps as early as the
third century B.C., but extensively recon-
structed by the Romans, who altered much
of the stage. Carved from the bedrock, the
amphitheater was surmounted by Roman
masonry that formed its upper tiers. At
the top of this drawing Cole wrote: "What
a magnificent site! Aetna with its eternal
snows towering in the heavens – the ranges

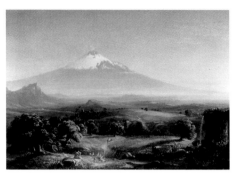

Fig. 1. Thomas Cole, *View of Mt. Etna,* about 1841. Oil on
canvas. Virginia Museum of Fine Arts, Richmond, Vir-
ginia, The Adolph D. and Wilkins C. Williams Fund.

Fig. 2. Thomas Cole, *Mount Etna from Taormina, Sicily,* 1842.
Pencil drawing. The Detroit Institute of Arts, Founders
Society Purchase, William H. Murphy Fund.

of nearer mountains – the deep romantic
valley – the bay of Naxos. . . I have never
seen anything like it. The views from
Taormina certainly excel anything I have
ever seen."[5] The view from the Greek the-
ater had long been popular with artists
and tourists alike.[6] Guidebooks, in addi-
tion to informing the traveler how to
arrange to climb Etna in time for sunrise,
recommended the view from the Greek
theatre, especially witnessed at sunrise.[7]

In 1843 Cole also arranged for a one-
man show at the National Academy of
Design, intending to showcase the *Course
of Empire.* When he discovered that Mrs.
Luman Reed would not lend the series,
Cole moved canvas and paint box into the

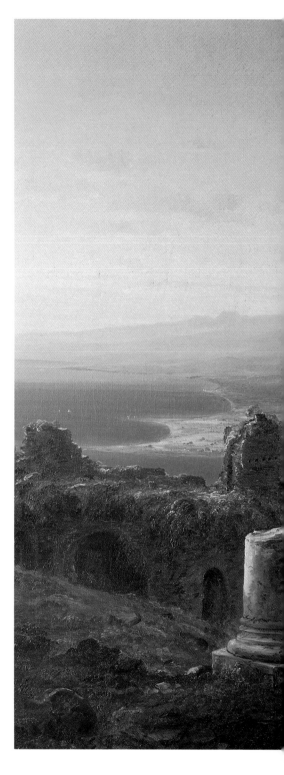

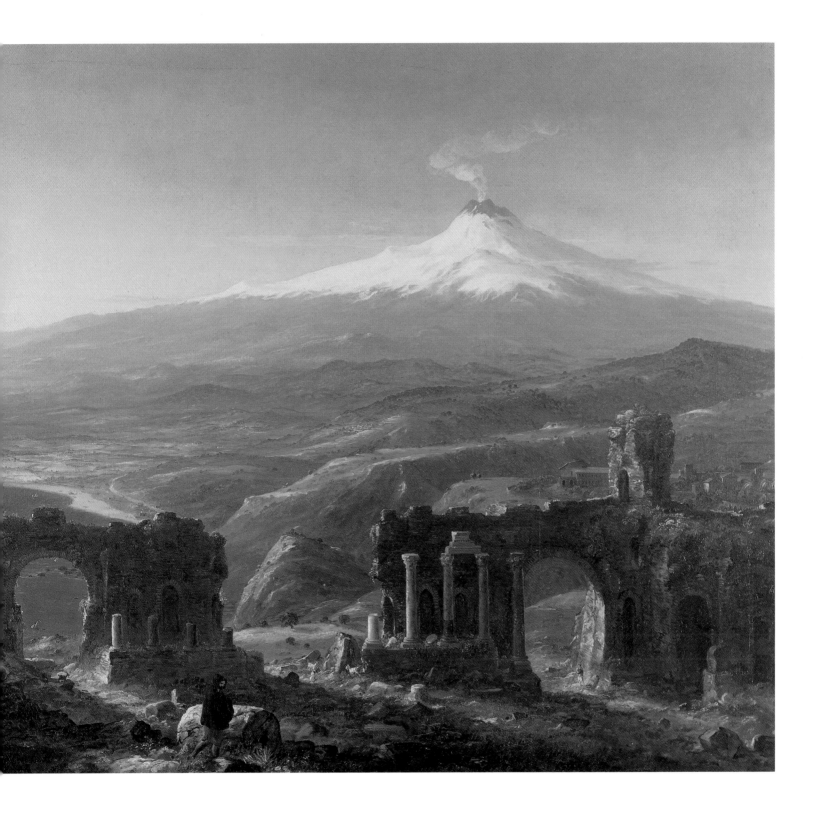

exhibition hall, and proceeded to paint *Mt. Etna from Taormina* in five days.[8] The Greek ruins on Sicily intrigued Cole, conveying to him a palpable sense of the passage of time. He could look upon the ruined theater, and beyond to the slopes of Etna, and see the panoply of history unfold, age by age, and relive its history through his mind:

> Since its huge pyramid arose, nation after nation has possessed its fertile slopes. The Siculi have labored on its sides; the Greek, Carthaginian and the Roman; the Norman and the Saracen have struggled for mastery at its foot; but the roar of the battle is past; the chariot and charioteer are mingled in the dust. Yet yon earth-born giant, fed by continual fires, each century augments, and in all probability will continue to do so. . . . May we not in these things read deep lessons applicable to ourselves?[9]

The rich associations Cole derived from this site are similar to those that fueled the *Course of Empire*. There the artist chronicled the transition from wilderness to a flourishing empire, destroyed by moral decay in concert with natural catastrophe, and the latent promise of renewal in a future time, in the vast landscape encrusted with ruins and dominated by a smoking volcano.[10]

E. JONES

1. Ellwood Parry has noted that Charles Lyell's *Principles of Geology* was published in January of 1830, and the author lecturing on his subject, while Cole was in England. Cole's assimilation of geological theory is apparent in his comments on geology in his journal and in his essays on Sicily. Ellwood C. Parry, III, *The Art of Thomas Cole: Ambition and Imagination* (Newark, Del.: University of Delaware Press, 1988) pp. 144ff. See also Franklin Kelly, "Myth, Allegory, and Science: Thomas Cole's Paintings of Mount Etna," *Arts in Virginia* 23 (1983), pp. 2-17.

2. The six paintings, in accepted order of execution, are: *View of Mt. Etna*, 1842, The Virginia Museum of Fine Arts, Richmond, Va; *Mt. Etna*, 1842, IBM Corporation, Armonk, N.Y.; *Mount Etna*, about 1842, Mrs. Charles C. Shoemaker; *Mt. Etna from Taormina*, 1843, Wadsworth Atheneum, Hart-

ford, Conn.; *Mt. Etna from Taormina*, 1844, Lyman Allyn Museum, New London, Conn.; and *Mt. Etna (Proserpine Gathering Flowers in the Fields of Enna)*, about 1847-48, an unfinished canvas owned by Edith Cole Silberstein.

3. Franklin Kelly and Ellwood Parry have identified this work as the painting belonging to the Virginia Museum of Fine Arts. Cole sketched this view in the Detroit Institute of Arts sketch, *Landscape – Etna Distant 30 Miles*, part of a sketchbook filled with Italian scenes. A later thumbnail sketch, which shows the same view, set within a heavy pencilled border occurs in the Princeton sketchbook, folio 23, verso. Louis Hawes, "A Sketchbook by Thomas Cole," *Record of the Art Museum, Princeton University* 15, no. 1 (1956), pp. 10ff.

4. Cole painted a second, smaller version of this composition, virtually identical, now in the Lyman Allyn Museum, New London, Conn. See *American Paradise: The World of the Hudson River School* (New York: The Metropolitan Museum of Art, 1987), p. 137.

5. Cole made several detailed drawings of the Greek theater, including one view looking west to Monte Tauro, inscribed upper right: "Taormina May 10th 1842 6 o'clock" (Detroit Institute of Arts). Two oil sketches of this site survive.

6. Artists of all nationalities continued to paint this site. Edward Lear was among the English artists who sketched the view from the Greek theater, in 1847. Frenchman Paul-Rene-Leon Ginain painted a watercolor of the theater in 1858. William S. Haseltine painted this view in 1889 and 1873, respectively; Sanford Gifford sketched and painted the view from the theater and from Catania in 1868.

7. In 1787 Goethe pronounced "Never did any audience, in any theatre, have before it such a spectacle," in Alta Macadem, *Blue Guide: Sicily* (New York: W.W. Norton, 1988), p. 246.

8. Cole wrote to his wife on December 9, 1843: "I . . . have commenced a large picture . . . of Mt Aetna from Taormina. I have already finished two-thirds of it, and have only painted on it two days. I have never painted so rapidly in my life." Writing again on January 5, 1844, Cole remarked on the sale of the painting to the Hartford Lyceum, "Pretty good for five days work." Louis Legrand Noble, *The Life and Works of Thomas Cole* (Cambridge: Belknap Press, 1964), pp. 264-65. Cole may have known the engraved *View of Aetna from the Theatre at Taormina*, published in a volume of Sicilian scenery illustrated with engravings after the works of Peter de Wint. Parry, *Art of Thomas Cole*, p. 292.

9. Cole, "Sicilian Scenery and Antiquities – Number Two," *Knickerbocker* 23 (March 1844), p. 242.

10. In his poem titled "Mt. Etna," Cole marveled at the inexorable cycle of civilization in the face of nature. Thomas Cole, "Mt. Etna," in Marshall Tymn, ed., *Thomas Cole's Poetry* (York, Penn.: Liberty Cap Books, 1972), pp. 134-135.

Randolph Rogers (1825-1892)

47. *Nydia, the Blind Flower Girl of Pompeii*, modeled 1855, carved 1856

Marble, h. 57 in., w. 24½ in., d. 33⅛ in.
Signed on capital: Randolph Rogers / Rome 1856
Museum of Fine Arts, Boston. Gift of Dr. and Mrs. Laurence Perchik

48. *Nydia, the Blind Flower Girl of Pompeii*, modeled 1855, carved 1855-56

Marble, h. 36¼ in., w. 17¼ in., d. 25¼ in.
Signed left side randolph rogers. / rome.
National Museum of American Art, Smithsonian Institution, Transfer from National Museum of American History, Division of Cultural History

The astonishing discoveries of ancient life at Pompeii and Herculaneum and its cataclysmic end exerted a powerful influence upon the imagination of nineteenth-century artists and writers. English and Russian artists John Martin (1789-1854) and Karl Briullov (1799-1852) painted dramatic, harshly lit scenes of the erupting Vesuvius as magnificent backdrops for the puny humans who struggled vainly against nature. Edward Bulwer-Lytton wrote the vivid and sentimental novel *The Last Days of Pompeii* (1834) in response to the Briullov painting (see cat. 51, fig. 1) he so admired. Against the author's richly worded tapestry of the doomed cosmopolitan city stood his heroine, the blind flower girl, Nydia.[1] The story of the young slave and her poignant search to rescue her friends became a popular symbol of hope and fidelity to Victorian readers. The novel's fame was such that even twenty years later Randolph Rogers created a phenomenally successful sculpture of *Nydia* based upon this literary figure.[2]

Randolph's *Nydia*, her blind eyes closed to the smoky scene around her, leans forward with her walking stick. Her left hand is cupped to her right ear as she listens fearfully and intently amidst the tumult for her beloved Glaucus. The girl's swirling, disarrayed garments indicate the haste with which she makes her way through the tempestuous landscape, and add to the melodramatic image of Rogers's heroine. First modeled in October 1855, *Nydia* helped to confirm Randolph

48.

Rogers's reputation as one of the most important American sculptors active in Rome. The version he sent to the Centennial Exposition in Philadelphia in 1876 proved to be enormously popular. The sculptor's account books record fifty-two requests for replicas in both full and half-size, but Rogers disclosed to one visitor that "to be frank . . . I can say, in confidence, that the one you see there is the one hundred and sixty-seventh. They are all over Europe and North and South America, and still going."[3] The enthusiasm for Rogers's sentimental sculpture likely benefitted by reports from Pompeii beginning in 1860, where the first systematic excavations of the site had begun, and where the first plaster casts of the actual victims of the tragedy were being made. Rogers's use of classical sources in creating *Nydia* was criticized by the art critic James Jackson Jarves, who reprimanded the sculptor for plagiarizing one of the Niobe figures in the Vatican collection.[4] Rogers was no different from his fellow sculptors in adapting aspects of ancient works to his sculpture; certainly the theatrical quality of *Nydia* is inspired by the Niobe group and other late Hellenistic sculpture, including the *Winged Psyche* (Capitoline Museum, Rome). While the pose and anguished expression of his figure owes a debt to such works, Rogers's drapery was equally influenced by such contemporary painters as Briullov and Martin who emphasized the deep shadows cast by the volcano's lurid light. So too, the fallen Corinthian capital at Nydia's feet recalls Bulwer-Lytton's own words upon seeing Briullov's painting in which "the statues toppling from a lofty gate have a crashing and awful effect."[5] The popular fascination with *Nydia* was expressed by Josephine Young, who visited Rogers's studio in 1855. Young recalled in her journal that "as soon as we entered the room, I was struck with the statue of the

blind girl . . . The expression of pain on the countenance was admirably depicted and realized Bulwer's idea of this strange yet beautiful Thessalian. This was all I cared for & looked at there. I gazed & gazed, & never took my eyes from it till we got into the carriage and came home."[6]

J. FALINO AND E. HIRSHLER

1. John Martin, *The Destruction of Pompeii and Herculaneum* (1822, University of Manchester, England), and Karl Briullov, *The Last Day of Pompeii* (1833, cat. 51, fig. 1). For Bulwer-Lytton's impressions of the Russian artist's painting, which had been exhibited in Milan in 1833, see Curtis Dahl, "Recreators of Pompeii," *Archeology* 9 (autumn 1956), pp. 182-91. Edward Bulwer-Lytton, *The Last Days of Pompeii* (Boston: Phillips and Sampson, 1834).

2. The novel also inspired George Fuller's painting of Nydia in 1882 (The Metropolitan Museum of Art, New York), and playwright George Henry Boker's *Nydia: A Tragic Play* (1885). One other sculpture which addressed the general subject was Harriet Hosmer's *Pompeiian Sentinel* (about 1878, location unknown) mentioned in "Miscellany,"
Victorian Magazine no. 32, 1878-79, p. 381.

3. *Nydia* earned Rogers at least seventy thousand dollars. See Jan Seidler Ramirez's entry on Nydia in Kathryn Greenthal et al., *American Figurative Sculpture in the Museum of Fine Arts, Boston* (Boston: Museum of Fine Arts, 1986), pp. 155-58 and *The Nutshell* 13 (April/June 1927), p. 2.

4. James Jackson Jarves, *The Art-Idea: Sculpture, Painting, and Architecture in America* (New York: Hurd and Houghton, 1864), p. 274.

5. Bulwer-Lytton's diary in *The Life of Edward Bulwar, First Lord Lytton*, (London, 1913) vol. 1, p. 440 in Curtis Dahl, "Bulwer-Lytton and the School of Catastrophe," *Philological Quarterly* 32 (1953) p. 434.

6. Josephine Churchill Young, *Journal of Josephine Young* (New York: Privately printed), pp. 144-47.

Jasper Francis Cropsey

49. *Evening at Paestum,* 1856
Oil on board, 9½ x 15½ in.
Signed l.r.: J.F. Cropsey 1856
Vassar College Art Gallery, Poughkeepsie, N.Y.
Gift of Matthew Vassar

After spending the winter and spring of 1848 in Rome, Cropsey and his wife summered near Naples, sharing a villa at Sorrento with the sculptor William Wetmore Story and his wife. With Story and Christopher P. Cranch, who lodged nearby, Cropsey made sketching trips to Capri, Amalfi, and other sites along the coast. In August, the three artists made a memorable visit to the ruins of Paestum, a Greek colonial town some fifty miles south of Naples. They traveled by boat from Amalfi to Salerno and then took a carriage across a marshy plain to the ancient site. Cranch recorded his response to the remains of three Doric temples there:

As we approached them we could none of us resist the most enthusiastic expressions of delight. Never had I seen anything more perfect, such exquisite proportions, such warm, rich coloring, such picturesquely broken columns; flowers and briers growing in and around, and sometimes over fallen capitals. Right through between the columns gleamed the sea, and beyond, the blue, misty mountains. And over all brooded such a silence and solitude. Nothing stood between us and the Past, to mar the impression. Mysterious, beautiful temples! Far in the desert, by the sea-sands, in a country cursed by malaria, the only un-

blighted and perfect things, – standing there for over two thousand years. It was almost like going to Greece.[1]

The artists picnicked among the ruins and spent the afternoon exploring and sketching the temples, reluctantly hurrying away as evening fell and the danger of malaria increased. Many American artists produced views of Paestum,[2] but the place seems to have made an especially strong impression on Cropsey, for he painted several dramatic views of the temples during the 1850s and 1870s.[3]

Founded as Poseidonia in about 600 B.C., Paestum was one of a number of

50. *Temple of Paestum by Moonlight, 1859*
Oil on canvas, 31½ x 51½ in.
Signed l.r.: J.F. Cropsey / 1859
Mrs. John C. Newington

colonies established by Greek settlers in Sicily and southern Italy between about 750 and 570 B.C. The first of Paestum's three standing temples, erroneously called the "basilica" during the nineteenth century, was built in the mid-sixth century B.C. and probably dedicated to Hera. The so-called "Temple of Ceres," erected later in the sixth century just under a mile to the north, was probably dedicated to Athena. The latest of the structures, once known as the "Temple of Neptune," dates from the mid-fifth century B.C. And was dedicated, like the "basilica" nearby, to Hera.[4] The Romans named the town Paestum when they established a Latin colony there in 273 B.C., and archaeological evi-

dence suggests that Roman ways soon replaced Greek. The town declined as a mercantile center, however, and by the third century A.D. spreading marshes made the site unhealthy for habitation.

Isolated in a seldom-traveled part of Italy, Paestum was virtually forgotten until the middle of the eighteenth century. Little was known at the time about the Greek colonization of Italy or even about Greece itself, and antiquarians debated whether Etruscans or Greeks had built the temples. Some maintained that the structures were far older than the earliest Greek colony in Italy. Though still poorly understood, Paestum became well known during the second half of the eighteenth century with

the publication of architectural engravings and precise descriptions of the temples.[5] Such publications played an important role in the spread of the Doric revival in Europe and America and made Paestum a popular destination for grand tourists in the later decades of the century, notwithstanding malaria, bandits, flooding, and other perils associated with journey from Naples.[6] John Singleton Copley and Mr. and Mrs. Ralph Izard were among Paestum's first American visitors, making the excursion together in 1775 (see cat. 4).

As the eighteenth century drew to a close, Paestum acquired a sublime image consonant with the rise of Romanticism. Instead of studying the rational design of

the Doric temples, visitors now marveled at their immensity, desolation, untold age, and mysterious origins. In a set of twenty-one etchings published in 1778, Giovanni Battista Piranesi and his son Francesco rendered the temples from close viewpoints, emphasizing the looming height and pocked surfaces of the columns by means of dramatic chiaroscuro.[7] In a watercolor of 1827 (Tate Gallery, London), J.M.W. Turner showed the temples at a distance against a stormy, lightning-streaked sky. This view was engraved as an illustration for Samuel Rogers's popular *Italy, A Poem*, in which lines on Paestum begin:

> They stand between the mountains and the sea; Awful memorials, but of whom we know not![8]

Cropsey's experience at Paestum must have been informed to some degree by his early architectural training. In *Evening at Paestum* (cat. 49) and *Temple at Paestum, Crescent Moon* (cat. 50), he recorded the Temple of Neptune's stocky, sharply fluted columns and rhythmic frieze of triglyphs and undecorated metopes with great care. Yet a strong romantic mood dominates in both paintings. The Temple of Neptune's peristyle columns, architrave, and frieze were intact, but Cropsey rendered some of the columns and much of the architrave broken. The exaggerated state of ruin; low vantage point; brilliant twilight sky in which bands of pink, gold, and blue gradually fuse; and stagnant pool mirroring the temple and sky combine to create an intensely romantic view in which the isolation, grandeur, and awesome age of the Paestan temples are stressed.

K. MATHEWS HOHLSTEIN

1. Leonora Cranch Scott, *The Life and Letters of Christopher Pearse Cranch* (Boston: Houghton Mifflin Company, 1917), p. 147.

2. A temple based on those at Paestum appears in the background of Rembrandt Peale's *Portrait of William Short* (cat. 5). In 1832-1833, Thomas Cole produced a view of Paestum (Private Collection). Cropsey, Sanford Gifford, Albert Bierstadt, M.J. Wheelock, Robert Weir, John Rollin Tilton, and William S. Haseltine all exhibited views of the site (information courtesy of the Pre-1877 Art Exhibition Catalogue Index, Research and Scholars Center, National Museum of American Art, Smithsonian Institution, Wasington, D.C.). A picture entitled *Paestum, Twilight* was among works remaining in Jervis McEntee's studio at his death in 1891. *The Temple of Neptune, Paestum*, an oil sketch by John F. Kensett, is in the collection of the Allen Memorial Art Museum, Oberlin, Ohio.

3. *Evening at Paestum* (cat. 49), a highly finished oil sketch, was painted by Cropsey in 1856 and sold to Elias Lyman Magoon in February of 1859. *Temple at Paestum, Crescent Moon* (cat. 50), dated 1859, exhibited at the Royal Academy in London, and probably sold to a J.W. Brown that same year, is based closely on the 1856 sketch but features such additional details as a bird wading in the pool in the foreground. Another oil sketch, close to *Evening at Paestum* but less finished, was on the New York art market in 1988, and there is an oil study of this temple from another angle, dated 1861, in the Indiana University Art Museum, Bloomington. In 1871, Cropsey painted a large *Paestum* (Mrs. John C. Newington), which was exhibited at the National Academy of Design in 1877. He returned to the theme yet again in 1875, when he painted *Temple of Ceres* (Mrs. John C. Newington).

4. It was from these wealthy colonies that the Etruscans and early Romans received their earliest Greek influences. For a discussion of Poseidonia and other Greek settlements in Italy and Sicily, see John Boardman, *The Greeks Overseas: Their Early Colonies and Trade* (London: Thames and Hudson, 1980), pp. 161-189. On the history and architecture of Paestum, see John Griffiths Pedley, *Paestum: Greeks and Romans in Southern Italy* (London: Thames & Hudson, 1990).

5. Seven engravings after drawings by the French architect J.G. Soufflot were published in Paris by G.P.M. Dumont in 1764. Thomas Major's *Ruins of Paestum*, featuring thirty engraved plates, appeared in London in 1768. On these and other publications, see S. Lang, "The Early Publication of the Temples at Paestum," *Journal of the Warburg and Courtauld Institutes* 13 (1950), pp. 48-64.

6. The Doric order, simpler and more austere than the Corinthian and Composite orders favored by the Romans, gained popularity on both sides of the Atlantic during the late eighteenth and early nineteenth centuries. On the rediscovery and architectural influence of the Paestan temples, see Joselita Raspi Serra, ed., *Paestum and the Doric Revival 1750-1830* (Florence: Centro Di della Edifimi, 1986).

7. The drawings and etchings of Piranesi are discussed and reproduced in Roberto Pane, *Paestum nelle aqueforti di Piranesi* (Milan: Edizioni di Comunita, 1980).

8. Samuel Rogers, *Italy, A Poem* (London: T. Cadell and E. Moxon, 1830), p. 207. The ruins of Paestum were also the subject of a long poem by the American poet Henry T. Pickering (*The Ruins of Paestum and Other Compositions in Verse* [Salem, Mass.: Cushing and Appleton, 1822]). Pickering's poem was favorably reviewed by William Cullen Bryant in *The North American Review* 19 (1824), pp. 42-49.

James Hamilton

Born Entrien, Ireland, 1819;
died San Francisco, California, 1878

James Hamilton

51. *The Last Days of Pompeii*, 1864
Oil on canvas, 60⅛ x 48⅛ in.
The Brooklyn Museum, Dick S. Ramsay Fund

Though James Hamilton had a long and success-ful career as a painter and illustrator, few details are known about his life and travels. Born in the north of Ireland of Scottish parents, at fifteen he came to Philadelphia with his family and studied with various artists in that city. Beginning in 1840, when he showed Marine View *— the type of subject in which he would specialize — and* View in Venice After Prout, *suggesting his early interest in Italy — he exhibited annually at the Pennsylvania Academy of the Fine Arts.*

In 1854 Hamilton traveled to England, but there is no evidence that he went on to visit Italy on this or any later occasion. He exhibited a painting entitled Venice *in 1861, but that alone would not necessarily suggest an Italian trip. In 1875, he sold the contents of his studio and set off on a projected world tour; however, he got only to San Francisco, where he worked for two years be-fore he died.*

The sudden and total destruction of the cities of Pompeii and Herculaneum that resulted from the eruption of Mt. Vesu-vius on August 24, A.D. 79 became a com-pelling subject for artists after the eigh-teenth-century discovery of their locations. By 1755 Charles III, King of Two Sicilies, had taken charge of the excavations and in-vited interested scientists to explore the power of volcanoes and their role in the formation of the earth. The artifacts, buildings, and murals unearthed in the cities became milestones in a renewed in-terest in classical art that rapidly spread throughout Europe.[1] Almost instantly Naples rivaled Rome as the most impor-tant city to visit during the Grand Tour. Writers, scholars, poets, and artists flocked to Mt. Vesuvius and its vicinity, entranced by the enigmatic quality of the ancient cities. Even Goethe observed that "no catastrophe has ever yielded so much pleasure to the rest of humanity as that which buried Pompeii and Herculaneum."[2]

On the reverse of the canvas Hamilton inscribed the source of inspiration for his work: "from Bulwer's/'The Last Days of Pompeii'/Jas Hamilton/Phila 1864," re-ferring to Lord Edward Bulwer-Lytton's most famous novel, published in 1834, and such a favorite of Victorian readers that it was reprinted twenty-five times before the end of the century. Bulwer-Lytton's novel dramatically recounted the days preceding the catastrophic entombment of the city. Hamilton's representation recalls the pas-sage, "High behind him rose a tall column that supported the bronze statue of Au-gustus; and the imperial image seemed changed to a shape of fire."[3]

In the summer of 1833 Bulwer-Lytton visited Naples. On his way there he passed by the Brera Gallery in Milan and admired a painting by the Russian artist Karl Pavlovic Briullov (fig. 1).[4] The painting,

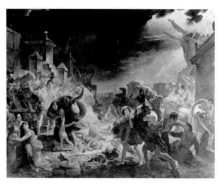

Fig. 1. Karl Pavlovic Briullov (Russian, 1799-1852), *The Last Days of Pompeii*, 1833. Oil on canvas. Russian Museum, St. Petersburg.

which went on to win the Grand Prix at the Paris Salon of 1834, was described by Bulwer-Lytton as:

> making a considerable sensation in Milan, and the subject of it is 'The Last Day of Pompeii.' This picture is full of genius, imagination, and nature. The faces are fine, the conception grand. The statues toppling from a lofty gate have a crashing and awful effect . . .the general horror of the scene is full of pathos.[5]

Although there is no record of Hamil-ton ever visiting Italy, the artist was able to reconstruct a classical stage for the vi-sual drama of *The Last Days of Pompeii*. The figures that populate the lower half of the painting are lost in the darkness of the falling ashes, only to be revealed by spots of color stroked freely on the canvas. The low vantage point transforms the explod-ing volcano and the imperial column re-spectively into larger-than-life symbols of the destructive power of nature and the impotence of the human element against it. In the midst of this pandemonium two figures embrace below the Augustan col-umn. They are the protagonists of Bulwer-Lytton's novel: the Greek Glaucus and the Roman Ione. However, the artist has cho-sen to present them in the clothes of his

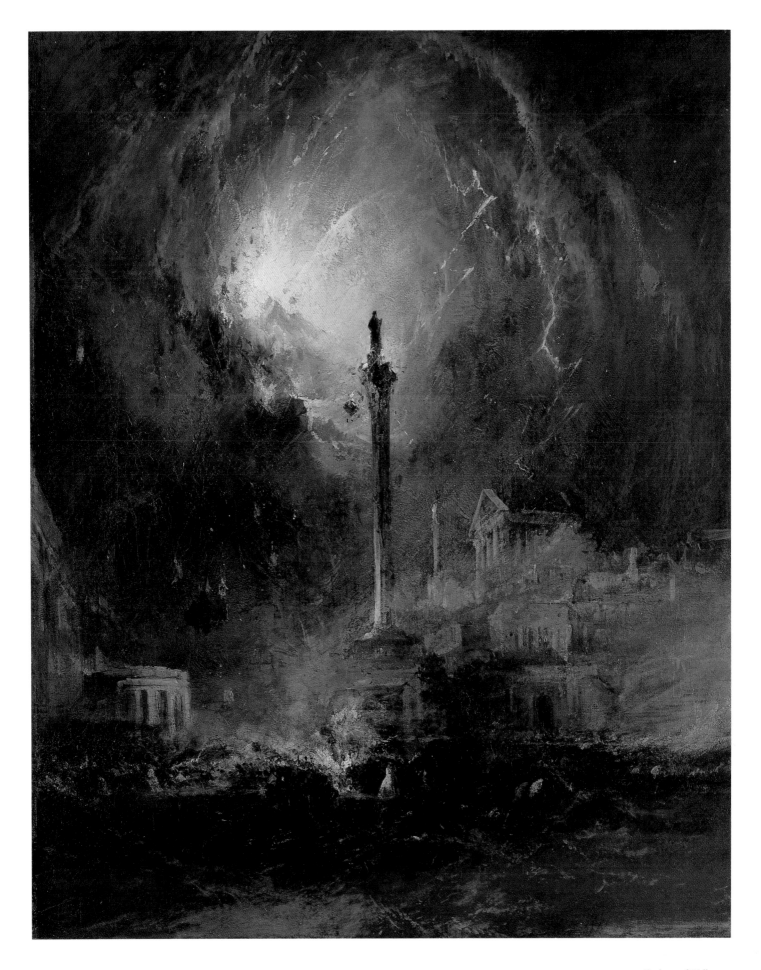

own time: Ione is dressed in a white long gown while Glaucus is wearing a red coat, black pantaloons, and buckled shoes. The artist's inspiration for the imperial column was most likely Nelson's column at Trafalgar Square in London, completed in 1842, and a site Hamilton must have visited during his year-long trip to England in 1854. Hamilton's column includes most of the details of Nelson's, including its Corinthian capital, the frame-like base, and the sculpture that surmounts it.

Other influences that Hamilton must have encountered in London were the works produced by a number of early nineteenth-century English painters, including John Martin and J.M.W. Turner. Fearing the effects of the wars in Europe at the time, the "school of catastrophe" used as its subjects the destruction of ancient civilizations. For them the destruction of Sodom and Gomorrah, Nineveh, Troy, and Pompeii paralleled the opulence and later decadence of contemporary Europe.[6] Hamilton's viewing of Turner's work seemed to have influenced his style to such an extent that the artist came to be known as the "American Turner" by his contemporaries.

The *Last Days of Pompeii* was exhibited at the Pennsylvania Academy of the Fine Arts in 1864, during the American Civil War. Its subject as well at its style suggests that Hamilton intended this work to parallel those produced by the continental "school of catastrophe," and to represent the fears of destruction of his own land.

N. OTERO-SANTIAGO

1. Christopher Hibbert, *The Grand Tour* (London: Methuen London Ltd. 1987), pp. 190-192. More precise historical information can be found in the exhibition catalogue, *The Golden Age of Naples: Arts and Civilization Under the Bourbons 1734-1805* (Detroit: Detroit Institute of Arts with the Art Institute of Chicago, 1981).

2. Reprinted in *Pompeii as Source and Inspiration: Reflections in Eighteenth-Century and Nineteenth-Century Art* (Ann Arbor: University of Michigan Museum of Art, 1977), p. 5.

3. Although it is difficult to assert which one passage from the novel Hamilton chose, this excerpt is the one that most resembles the climactic moment he is representing. Another moment that could have inspired Hamilton reads, "The lightning, as if caught by the metal, lingered an instant on the Imperial Statue-then shivered bronze and column!" From Edward Bulwer-Lytton, *The Last Days of Pompeii* (Boston: Phillips and Sampson, 1834), p. 403.

4. Briullov's inspiration in turn came from Pacini's opera *L'Ultimo giorno di Pompeii* of 1825 and from visits the artist made with his architect brother to the actual ruins. A more complete history of the provenance and importance of this work can be found in Alan Bird, *A History of Russian Painting* (Boston: Hall & Co., 1987), pp. 77-79. Other European artists that represented the "last" day of Pompeii were the Englishman Jacob More (1780); the Frenchmen Pierre-Henri Valenciennes (1813) and Joseph Franque (about 1827); and the Swiss Angelica Kauffmann (1785).

5. Journal entry reproduced in *The Life of Edward Bulwer First Lord of Lytton*, edited by his grandson the Earl of Lytton (London: MacMillan and Co. Limited, 1913), p. 440.

6. The main hypothesis of the "school of catastrophe" is found in Curtis Dahl, "Bulwer-Lytton and the School of Catastrophe," *Philological Quarterly* 32 (1953), pp. 428-42, where the author examines the historical events that influenced this movement in art and literature.

Thomas Hiram Hotchkiss

Born near Hudson, New York, about 1834;
died Taormina, Sicily, 1869

Hotchkiss traveled to Europe early in 1860.
Reaching London by February, he admired the
work of Turner, especially his watercolors. After a
brief visit to Paris, he settled in Rome in the
spring of 1860, occupying a studio in the Piazza
Barberini. Except for short trips to London in
1865, where he was the guest of Pre-Raphaelite
painter Henry Wallis and of John Linnell
(1792-1882) at Redhill, and to the United States
in 1868, Hotchkiss seems to have remained in
Italy until his death in 1869. He met Elihu Ved-
der in Florence in 1860 and during the summer
traveled with Vedder (see cat. 94) and the Italian
painter Giovanni (Nino) Costa (1827-1903) to
Volterra and San Gimignano. Hotchkiss met Ved-
der again in Rome in 1867, and they often
painted together on the Roman Campagna. In
1867 and again in 1868, Hotchkiss spent the
summer with Vedder in Umbria, painting in Pe-
rugia, Gubbio, and Narni. Vedder called Hotch-
kiss his "dearest and best-beloved friend," and
reminisced about him in Digressions of V:

> He was a very tall, spare delicate-looking
> man, who had evidently suffered in his youth
> for he had worked in a brickyard under a hard
> relative who was strongly opposed to his artistic
> tendencies, and had evidently there laid up the
> germs of that malady [tuberculosis] which was
> ultimately to be the cause of his death. For he
> died young, and now lies in his neglected grave
> in the land which he loved so passionately and
> painted so lovingly.

Sanford R. Gifford, another friend and ad-
mirer of Hotchkiss, wrote in his diary in Septem-
ber, 1868, that he had called on Hotchkiss and
had found him, "very weak from bleeding — of-
fered to remain with him, but he declined as he
had another friend who came and was with him
at night." Hotchkiss traveled to Venice, probably
in the summer of 1869, looking for "a little
change of air" and then to Taormina to fulfill a
commission to paint the ancient theater. But this
was to be his last trip, for he died in Taormina of
tuberculosis on August 18, 1869, in the arms of
the painter John Rollin Tilton.

52. *Torre di Schiavi*, 1865
Oil on canvas, 22⅜ x 34¾ in.
Signed l.r.: T. H. Hotchkiss Rome 1865
National Museum of American Art, Smithsonian Institution

Although Thomas Hotchkiss's career was
short and he never achieved widespread
fame, his paintings were admired not only
by his fellow artists but also by several
leading critics.[1] James Jackson Jarves re-
marked that Hotchkiss was "in the fore-
most rank of landscapists of any school
. . . had he lived to complete his career of
conscientious study, he would have be-
come the much-needed 'master', compe-
tent to found an American school of land-
scape, on a solid basis of faithful, realistic
observation of nature, and rare capacity of
execution."[2] Henry Tuckerman praised his
"completeness of finish" and his "just dis-
tribution of light" and singled out for spe-
cial notice Hotchkiss's view of the Torre
di Schiave.[3]

The Torre di Schiavi (Tower of Slaves)
was a Roman mausoleum on the Cam-
pagna probably built around the late third
century A.D. under Diocletian (fig. 1). Dur-
ing the mid-nineteenth century, it became
a popular subject for American painters in
Italy because it was a substantially intact
Roman ruin, notable for its oculus win-
dows and its picturesque setting on the
Campagna. Thomas Cole, William Stanley
Haseltine, Jasper Francis Cropsey, Sanford

Fig. 1. *Torre dei Schiavi, near Rome* (detail). Photograph, 1990.

R. Gifford, John Rollin Tilton and Elihu Vedder were among those who painted it, and Conrad Wise Chapman and Thomas Hicks included the Torre di Schiavi in the background of allegorical paintings of peasant women. George Stillman Hillard described the tower in his popular 1853 guidebook:

> One of the most picturesque and interesting points of the Campagna But though these ruins are not much in themselves, they are so happily placed that they form a favorite subject for artists The chief charm of the spot consists of the unrivalled beauty of the distant view which it commands; revealing as it does the characteristic features of the Campagna.[4]

The tower's name may also have accounted for its appeal to those with abolitionist sentiments.[5] Although the name dates from the sixteenth century when Vincenzo Rossi dello Schiavo was proprietor of the area,[6] many Americans erroneously associated the "Tower of Slaves" with the uprisings of Roman slaves and drew a connection with the political situation at home.

Hotchkiss's image displays the results of the excavations of the site, which went on from the 1830s to the 1870s. In the lower left he shows the recently exposed columbarium, a sepulchral building containing many small niches for cinerary urns. The columbarium had special interest for Hotchkiss, as his friend Elihu Vedder revealed in an inscription on the back of his *Ruins, Torre dei Schiavi* (about 1868, Munson-Williams-Proctor Institute, Utica, N.Y.):

> A good subject/Hotchkiss used to go out there frequently/'twas here he found a niche in this Columbarium which had not been/discovered a beautiful glass vase and sold it for a good sum/of money which came in well in those days/. . . Hotchkiss made some good things of this Torre dei Schiavi.[7]

Reinforcing the funerary aspect of the columbarium and perhaps alluding to the end of Roman civilization, Hotchkiss placed a skull and bones in the foreground. His careful depiction of the architectural fragments strewn about the landscape, a recently excavated mosaic of a winged boy on a dolphin, probably the floor of a nearby Roman bath,[8] and the mausoleum itself are evidence of Hotchkiss's interest in archeological detail. The remains of the original hexastyle portico are plainly visible. A colorfully dressed herdsman and two goats are the only living beings that inhabit the scene.

In addition to this work, Hotchkiss is known to have painted a similar smaller view of the Torre de Schiavi in 1864 (private collection, New York); there is no herdsman in that version, however. In 1865 a *Torre de Schiava* by Hotchkiss belonging to A. A. Low was exhibited at the National Academy of Design.[9] Maitland Armstrong, a painter and the American consul of Rome who took care of Hotchkiss's effects after his death, wrote that "one of his first-rate things [was] a view of the Tor degli Schiavi in the Campagna."[10]

J. COMEY

1. See Barbara Novak O'Doherty, "Thomas H. Hotchkiss, An American in Italy," *The Art Quarterly* 29 (1966), pp. 3-28; Nathalia Wright, "The Official Record of Thomas Hotchkiss' Death, Evidence for the Date of his Birth," *The Art Quarterly* 30 (1967), pp. 264-5; Elihu Vedder, *The Digressions of V* (Boston: Houghton Mifflin Co., 1910) p. 418.

2. J. Jackson Jarves, "Museums of Art, Artists and Amateurs in America," *Galaxy* (July 1870), p. 53; and "Our Painters in Europe," *The Art Review* (1871), p. 7.

3. Henry T. Tuckerman, *Book of the Artists: American Artist Life*, (New York: G. P. Putnam & Son, 1867), p. 569.

4. George Stillman Hillard, *Six Months in Italy* (Boston: Ticknor, Reed, and Fields, 1853), vol. 2, p. 66.

5. See Charles C. Eldredge's excellent article, "Torre Dei Schiavi: Monument and Metaphor," *Smithsonian Studies in American Art* 1 (fall 1987), pp. 15-33, on American and European artists who painted the Torre dei Schiavi.

6. Thomas Ashby, *The Roman Campagna in Classical Times* (London: Ernest Benn Limited, 1970), p. 131.

7. Quoted in Gwendolyn Owens and John Peters-Campbell, *Golden Day Silver Night: Perceptions of Nature in American Art 1850-1910* (Ithaca, New York: Herbert F. Johnson Museum of Art, Cornell University, 1982), p. 102.

8. The fate of this mosaic is presently unknown. John R. Clarke writes in *Roman Black-and-White Figural Mosaics* (New York: New York University Press, 1979), p. xx that black-and-white mosaics were not considered worthy of prolonged attention in the eighteenth and nineteenth centuries and that after summary descriptions and occasional drawings or photographs, "nearly all the mosaics were subsequently destroyed, with the exception of those that were detached, recemented, and either reused as pavements in modern buildings or displayed on walls."

9. Maria Naylor, *The National Academy of Design Exhibition Record 1861-1900* (New York: Kennedy Galleries, Inc., 1973), p. 456.

10. David Maitland Armstrong, *Day Before Yesterday, Reminiscences of a Varied Life* (New York: Charles Scribner's Sons, 1920), p. 189.

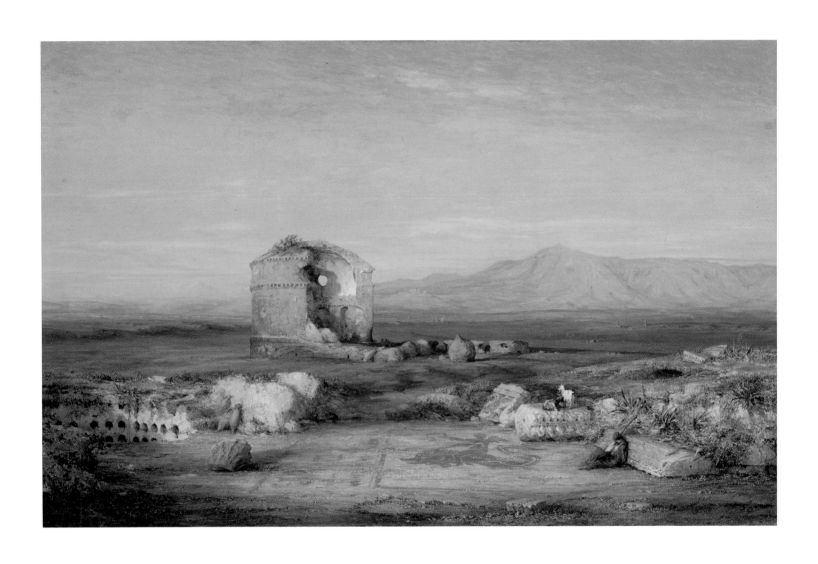

Albert Bierstadt

53. *Mount Aetna (Vesuvius)*, 1868
Oil on canvas, 17⅛ x 24 in.
Signed l.r.: Bierstadt / 68
The Cleveland Museum of Art, Gift of S. Livingstone Mather,
Phillip Richard Mather, Katherine (Mather) Hoyt Cross,
Katherine Mather McLean, and Constance Mather Bishop

The sole artistic product of Bierstadt's second stay in Italy was apparently a large, operatic canvas called *Mount Vesuvius at Midnight* (now lost). On January 4 and 5, 1868, while the painter was in London, the volcano erupted for the first time since 1861, prompting him to express a desire to paint it.[1] Bierstadt went to Rome, arriving by mid-February. Although no record exists of how he gathered visual material, he may have gone to see Vesuvius within a few weeks. He probably executed the painting in Rome during the spring, for by late June 1868, it was on view in London. An evocation of the ever-changing volcano amid night clouds and icy moonlight, *Mount Vesuvius at Midnight* is today known only through a chromolithograph published in Paris in 1869 and through this small, somewhat simplified version, perhaps a trial composition that preceded the finished work.

Since the mid-eighteenth century, whenever Vesuvius was active it attracted artists desirous of depicting nature's most dramatic phenomena.[2] As the nineteenth century progressed, the desire to monitor Vesuvius in a scientific manner increased. Around 1840 an observatory was established adjacent to the volcano, scientifically documenting the eruptions of 1855, 1858, 1861, and 1868. Bierstadt's rendition was both emotionally charged in the earlier Vesuvius tradition and true to contemporary geological evidence.

Like most previous paintings of Vesuvius in eruption, Bierstadt's was a night view. However, his vantage point was not the usual one over the Bay of Naples, but from the hills behind, which permitted him to show in ruins a building called "the Hermitage," an inn of sorts that was one of the curiosities of the Vesuvius tour. Covered by snow and dappled by moonlight, the structure recalls the ruins of a Gothic church or cloisters, of the sort used so frequently by German Romantic painters. Bringing together the volcano's destructive fire with references to the end of life, Bierstadt continued the tradition of Vesuvius as an apocalyptic metaphor.

Although his setting seems fantastic, and though Bierstadt probably never saw Vesuvius erupting, his depiction is true to nature in many details. He seems to have relied on reports of January's volcanic activity, when molten lava burst from the principal cone and streamed over the western side of the mountain in a long, rope-like flow that eventually branched north-south. Because the lateral eruption was not especially intense, the volcano's mouth would have been closed, as he showed. Nearby are the characteristic plateaus of broom and scattered trees, partially killed by the volcanic gas, and the volcanic tufa, which normally hardens into jagged peaks such as he depicted.

After having been exhibited in London, the large *Mount Vesuvius at Midnight* traveled to New York, Philadelphia, Boston, and Chicago. American critics were generally disappointed in the painting. They pronounced the volcano "dwarfish" and its eruption not sufficiently forceful.[3] Some saw too many calculated emotional effects, although no one seemed to understand the symbolism of the Hermitage in snow, perhaps because it was more of a German than an American convention. Like Clarence Cook, art critic of the *New-York Tribune*, who derided Bierstadt's "caricatures" of the Rocky Mountains,[4] most nevertheless expected to see a stereotyped Vesuvius, rising majestically against the Bay of Naples and spewing a column of fire from a yawning crater, even though it had not erupted in that manner for decades.

D. STRAZDES

1. Reported in the *New York Herald,* January 13, 1868.

2. Bierstadt's predecessors included Joseph Wright of Derby, who painted its eruption of 1774; Jacob Philipp Hackert, who depicted those of 1774 and 1779, and Johann Christian Dahl, who did the same in 1820 and 1821.

3. See "Bierstadt's Mount Vesuvius," *New York Times,* November 7, 1868, p. 4; "Bierstadt's New Picture," *The Galaxy* 6 (December 1868), p. 58; and "Art in Chicago," *The Art Journal* 2 (August-September 1869), p. 140.

4. "Mr. Bierstadt's Vesuvius," *New-York Tribune,* December 3, 1868, p. 2.

John Linton Chapman

54. *Appian Way*, 1869

Oil on canvas, 29⅜ x 71⅝ in.

Signed l.r.: J. LINTON CHAPMAN. /ROMA./ 1869.

*The Brooklyn Museum, The Roebling Fund, Carll H. de Sil-
ver Fund, Caroline H. Polhemus Fund, A. Augustus Healy
Fund, Frederick Loeser Fund*

The Appian Way, called by Statius
"Regina Viarum" (Queen of Roads), was
the first and most celebrated of the great
Roman roads. It was built as a military
road in 312 B.C. under the Roman censor
Appius Claudius Caecus. Passing south-
ward through the walls of Rome at Porta
San Sebastiano (the ancient Porta Appia),
the Appian Way leads across the Cam-
pagna to the Alban Hills and then through
the Pontine Marshes to Terracina and on
to Capua. As Rome expanded, the Appian
Way was lengthened to more than 350
miles, eventually reaching Brindisi in the
second century B.C., thus becoming, as
Murray's guidebook described it in 1858,
"not only the great line of communication
with Southern Italy generally, but with
Greece and the most remote Eastern pos-
sessions of Rome."[1]

Chapman painted the ancient section of
the Appian Way, probably the area be-
tween the fourth and fifth milestones from
Rome where the road is very straight and
lined on both sides with tombs.[2] Since
burial within the walls of the city was pro-
hibited by Roman law (by 50 B.C.), the Ro-
mans interred their dead along the busy
major arteries leading out of Rome where
the tombs served as *memento mori* as well as
monuments to the dead. The area was ex-
cavated by Luigi Canina from 1850 to 1853
under Pope Pius IX. Among the many
nineteenth-century visitors to the Appian
Way, Charles Dickens perhaps best de-
scribed the area as Chapman painted it:

> We wandered out upon the Appian
> Way, and then went on, through miles
> of ruined tombs and broken walls, with
> here and there a desolate and uninhab-
> ited house . . . past the tomb of Cecilia
> Metella . . . away upon the open Cam-
> pagna, where on that side of Rome
> nothing is to be beheld but ruin . . .
> Broken aqueducts, left in the most pic-

turesque and beautiful clusters of arches;
broken temples; broken tombs. A desert
of decay, sombre and desolate beyond
all expression; and with a history in
every stone that strews the ground.[3]

Chapman painted the Appian Way
looking back toward the city of Rome; St.
Peter's is visible on the horizon to the left
of center. To the right he included an
aqueduct and a haystack surrounded by
workers. Chapman probably based the
tomb on the right on the tomb of the Ra-
biri from the first century A.D. which Can-
ina reconstructed from fragments and
which is still visible today. Chapman de-
picted the relief on the original tomb, con-
sisting of three busts, including a priestess
of Isis and two freed slaves; probably the
slaves belonged to C. Rabirio Postumo,
defender of Cicero.

Paintings of the Appian Way were also
executed by Jervis McEntee and by the
German painter Franz Catel; the English
artist, Arthur John Strutt filled sketch-
books with views similar to Chapman's.[4]
The Queen of Roads appealed to the nine-
teenth-century imagination, as Mark
Twain wrote:

> The Appian Way is here yet and looking
> much as it did perhaps, when the tri-
> umphal procession of the emperors
> moved over it in other days bringing fet-
> tered princes from the confines of the
> earth. We cannot see the long array of
> chariots and mail-clad men laden with
> the spoils of conquest, but we can imag-
> ine the pageant, after a fashion.[5]

Chapman made at least ten paintings of
the Appian Way over a period of fifteen
years.[6] In 1868 his *Appian Way and Environs of
Rome*, painted for W. G. Moorhead (who
also owned one of the many versions of
Harvesting on the Campagna near Rome by
Chapman's father), was exhibited at the

Pennsylvania Academy of the Fine Arts.
Many of the paintings have arched tops
and frames with classical motifs, and a
number are inscribed on the reverse side
of the canvas with the patron's name.
Chapman wrote, "Via Appia/ painted for
Silas C. Herring, Esq. N.Y./ by J. Linton
Chapman. Roma. 1869" on the reverse of
this *Appian Way*, for example. Silas Herring
(1803-1881), the inventor of the Herring
Champion safe, became wealthy through
the manufacture and marketing of fire-
proof safes during an era of frequent fires.

J. COMEY

1. *Murray's Handbook of Rome and Its Environs* (London: John Murray, 1858), p. 318.

2. Nearer to Rome on the Appian Way are the little Church of Quo Vadis, where St. Peter was said to have had a vision of Christ reproaching him for fleeing Rome, and the Catacombs of St. Callistus, which were the setting for part of Hawthorne's *The Marble Faun* (cat. 162). The cylindrical Tomb of Cecilia Metella (50 B.C.), perhaps the most famous ancient site on the Appian Way, and the Circus of Maxentius (A.D. 309), where chariots raced before 10,000 spectators, were also popular tourist attractions in the nineteenth century, as they are today.

3. "Pictures from Italy," *Works of Charles Dickens* (New York: Hurd and Houghton, 1869), vol. 1, p. 158.

4. *The Art Journal* 2 (1876), p. 179, reported that McEntee had exhibited *Scene on the Via Appia, near Rome* at the Century Club in 1872. Franz Catel's *Via Appia* (1833) is in the Nationalgalerie der Staatliche Museen, Preubischer Kulturbesitz, Berlin. Arthur John Strutt's sketchbooks are in the Huntington Library and Art Gallery, San Marino, California.

5. Quoted in Erik Amfitheatrof, *The Enchanted Ground* (Boston: Little, Brown and Company, 1980), p. 36.

6. Other versions of *The Appian Way* are in the High Museum, Atlanta (dated 1867; on loan from the West Foundation), Sunrise Museums, Charleston, West Virginia (1868), Denver Art Museum (1873), San Antonio Museum Association (1875), and several private collections, including that of Henry Melville Fuller (1879). Other versions include: Christie's Sale no. 7318, lot 46 (1870) and Sotheby's Arcade Sale, September 14, 1989, lot 100 (1870). Grateful thanks to Terry Carbone of the Brooklyn Museum for sharing her research on this painting.

V Views Afoot

Samuel F. B. Morse

Born Charlestown, Massachusetts 1791; died New
York, New York, 1872

Samuel F. B. Morse

55. *Sketch for The Chapel of the Virgin at
Subiaco*, 1830
Oil on paper mounted on canvas, 8⅞ x 10¾ in.
Worcester Art Museum, Worcester, Massachusetts

*Morse studied in England from 1811 to 1815
with his friend and mentor Washington Allston;
he also worked at the Royal Academy under Ben-
jamin West, but he was unable to satisfy his
dream of visiting Paris and Rome until a second
European trip fourteeen years later. Hoping for a
mural commission from Congress for the Capitol
Rotunda, Morse believed a trip to Europe "to
study the works of art, and copy many of the best
pictures" (as William Dunlap stated) would fur-
ther his prospects. His trip was financed by pa-
trons — mostly New Yorkers — with commissions
for about twenty-eight works, including both
copies and originals, for a total of about three
thousand dollars.*

*Morse, president of the National Academy of
Design, sailed for England on the* Napoleon *on
November 8, 1829; after a month there, and an-
other in France, he arrived in Genoa on February
6, 1830. He proceeded to Rome via Spezia, Car-
rara, Lucca, Pisa and Florence, arriving on Feb-
ruary 20, and settling at number 17, Via dei
Prefetti. He painted and copied at the Vatican and
the Colonna Palace, explored sights of Rome — es-
pecially its galleries and churches — with such
friends as James Fenimore Cooper and John
Gadsby Chapman, and made several excursions
from Rome, including a lengthy one during the
summer, 1830, to Naples, Sorrento, Amalfi, and
Capri. Back in Rome in late August he began his
portrait of the Danish sculptor Thorvaldsen. On
March 4, 1831, because of political unrest in the
Papal States, he left Rome for Florence where he
copied works at the Uffizi Gallery and was him-
self sculpted by his friend Horatio Greenough.
On May 16, 1831, he left Florence for Venice,
where he stayed two months, largely spent in copy-
ing Tintoretto's* Miracle of Saint Mark *(see
fig. 1). In mid-July he left for Milan and lakes
Maggiore and Como; he traveled north to
Switzerland in late August. He then spent a year
in Paris, much of it devoted to his masterpiece*
The Gallery of the Louvre; *after a brief trip*

*to London, he sailed home from Le Havre on Oc-
tober 1, 1832, on the* Sully, *where according to
his early biographer Samuel Prime, he first con-
ceived the electromagnetic telegraph.*

Fig. 1. Samuel F. B. Morse, copy after Tintoretto, *Miracle of
Saint Mark*, 1831, Oil on canvas. Museum of Fine Arts,
Boston, Gift of Edward L. Morse.

Following a well-established route for out-
door sketching excursions from Rome,
Morse journeyed with John Gadsby Chap-
man and some "English artists and ama-
teurs" to Tivoli and the Sabine Hills for a
month long expedition.[1] Morse arrived in
Subiaco by donkey on May 11, 1830, from
Tivoli; he was enchanted by the town and
its environs, about forty-four miles east of
Rome. While it was a favorite location of
European landscape painters since the
time of Claude,[2] Morse and Chapman
were among the first Americans known to
have painted in the area;[3] Morse was per-
haps the first American to depict a road-
side shrine, which became a popular sub-
ject for his fellow countrymen during the
following decades.

Morse remained at Subiaco until May
29, referring frequently in his journal to
sketching outdoors at the local sites al-
ready popularized by English, French, and
German artists, including the distant
towns perched high on mountain preci-
pices which he described as "the scenery
of Salvator Rosa and the Poussins."[4] On
his first day at Subiaco, returning from a
visit to the Convent of San Benedetto,
which he later sketched, he noticed "a Ma-
donna, very picturesque at the side of the
road near the village; three artists were
painting it and two shepherds had their
flocks around it."[5] A week later, on May 18,
Morse reported in his journal that in the
early evening he began a sketch — probably
the present work — at this shrine, adding
that "it has been much painted by artists
from its picturesque character and structure."

He returned to the same site at about
the same time for several days.[6] On the sec-
ond day, he noted that "at sunset there was
a fine effect upon the town and the
Madonna's chapel." Morse's oil sketch ef-
fectively depicts the warm, muted light
and peacefulness of this pastoral hilltop

scene. In this study a rustic shrine of the Madonna, identified by the faint outline of a cross on the side, dominates the right half of the painting; on the left a figure in brown tends his flock while two women in colorful dress descend the hill. Rising in the distant haze is the town of Subiaco.

Morse here exhibits a range of techniques, from the more broadly painted surface of the shrine to the carefully executed leaves and vines below it. The study's freshness and immediacy mark it as an outdoor preparatory work, though the level of detail in the foliage suggests it could have been finished in the studio. Morse began by carefully outlining the major topographical forms in pencil, contributing to the relatively finished quality of the work.[7] His choice of subjects and his outdoor techniques place him within the international tradition of outdoor painting in Italy.[8] Morse's oil sketch is highly advanced for the work of an American at this time; stylistically it compares closely to the *plein-air* techniques of Morse's French contemporaries in Italy, especially certain works by Lazarin de Belmont and Corot.

Modern critics have generally preferred this study to the larger finished painting (cat. 56). They have admired the smaller work's unified tones, strongly focused composition, and observation of natural detail, while the larger painting has typically been viewed as more dramatic, but studied and formal with an artificial cast of light and staged figures.[9] Though Morse made use of the study for the studio picture, he must have also viewed it as a completed, independent work, for he chose it to fulfill a commission from John L. Morton, a founder and secretary of the National Academy of Design and a longtime friend who had requested a work from Europe for thirty dollars.[10]

S. RICCI

1. Samuel F. B. Morse to Stephen Salisbury, Rome, May 3, 1830, as quoted in Louisa Dresser, "The Chapel of The Virgin at Subiaco by Samuel F. B. Morse," *Worcester Art Museum Annual* 4 (1941), p. 66. On this same excursion Morse also visited Vicovara, Cervara, Civitella and Olevano.

2. Sandrart mentions painting with Claude in the open country at Tivoli, Frascati and Subiaco (see Philip Conisbee, "Pre-Romantic Pleine-Aire Painting," *Art History* [December 1979]). A partial list of others who painted in Subiaco would include: A. Michallon (1818), J. Fleury (1823) and J. Corot (1827) from France; J. Hackert (1769), J. Faber (1807) and J. Koch (about 1805 on) from Germany; Samuel Palmer and Edward Lear from England.

3. Morse's mentor, Washington Allston, may well have visited Subiaco on his trip to nearby Olevano in March 1806. Other American artists to work at Subiaco were John F. Kensett (1846), Thomas Hicks (1846), Christopher Pearse Cranch (1847), Albert Bierstadt (1859), Worthington Whittredge (1862), George L. Brown (1865), Elihu Vedder (1878), William Stanley Haseltine (after 1870).

Samuel F. B. Morse

56. *Chapel of the Virgin at Subiaco,*
 1830-31

Oil on canvas, 30 x 37 in.
Worcester Art Museum, Worcester, Mass., Bequest of Stephen
Salisbury III

4. Morse diaries and notebooks, May 26, 1830. Morse Papers, Library of Congress, Washington, D.C.

5. Ibid., May 11, 1830.

6. Morse had sketched outdoors as early as 1814 with his friend C.R. Leslie in England, where during the summer months they "used to paint in the open air in the fields . . . to study the morning effect on the landscape." See E.L. Morse, ed., *Samuel F.B. Morse His Letters and Journals*, (Boston: Houghton Mifflin Co., 1914) vol. I, p. 162. In this work, Morse followed the practice of Corot and others of returning to the same site on successive days at the same hour. This method differed from that advocated earlier by Valenciennes who felt that "all studies after nature should be made in a period of two hours at the most." See Peter Galassi, *Corot in Italy* (New Haven: Yale University Press, 1991), p. 27. Morse completed another finished oil study while in Subiaco, the *Interior of the Convent of San Benedetto* (1830, private collection), but also executed quicker oil sketches following the technique of Valenciennes, as in *Cervara*, (1830, Vassar College Art Gallery, Poughkeepsie, N.Y.).

7. Curatorial files, Worcester Art Museum, Worcester, Mass.

8. According to both Galassi and Conisbee, this tradition had already matured by the 1820s. In the 1830s, Rome and the surrounding countryside continued to attract large numbers of international artists. Morse noted in his journal on June 16 and 17, 1830, at the annual "Festa Infiorata" in Genzano, "not less than 150 artists of all nations from Rome." At his *locanda* there were twenty American and English artists at dinner.

9. See Paul J. Staiti, *Samuel F.B. Morse* (Cambridge: Cambridge University Press, 1989), p. 186; also Louisa Dresser, "The Chapel of the Virgin at Subiaco," pp. 70-71.

10. John L. Morton wrote from New York to Morse in Italy, May 22, 1831, "I have received three cases of casts . . . also your sketch of the chapel so this mark of your friendship gives me the greatest pleasure, and I shall assure you I value it highly." Morse had sent the sketch from Leghorn in February 1831. See Morse Papers 1828-1832, Library of Congress.

In the spring of 1830, Morse was primarily occupied at the Vatican making a commissioned copy after Raphael's *School of Athens* for a Mr. R. Donaldson, of New York City. On April 8, 1830, Holy Thursday, he attended the ceremonies at the Sistine Chapel with J.F. Cooper, J. G. Chapman and Stephen Salisbury II of Worcester, Massachusetts, who was on a Grand Tour of Europe.[1] After leaving Italy, Salisbury wrote his mother from Strasburg, "when I was in Rome I ordered a picture. I was desirous to have some such memorial of Rome."[2] After first considering commissioning Morse to make a copy, he instead requested of him a landscape with the Fountain of Egeria, near Rome, as the subject. Morse however found this subject "not extensive enough" for a large picture costing $200 and substituted what he called "the best landscape I ever painted," of the "chapel of the Madonna at Subiaco." Writing Salisbury from Rome, Morse explained that the subject "is a good example of those shrines before which the contadini bow the knee, and worship the Virgin, in the distance is the town of Subiaco; before the shrine is a female kneeling and other figures are in the road; the time is a little before sunset." In this letter dated January 19, 1831, Morse told Salisbury that he had based his painting on "one of my studies in the Sabine mountains," and that the painting itself "has been completed only about a week."[3]

This studio version of the *Chapel of the Virgin* relies on the smaller oil study (cat. 55) for its composition; however, in this painting Morse has enlarged the scene on all four sides, thus reducing the prominence of the shrine itself. For the gently colored, warm earth tones of ochre, burnt siena and olive greens of the study, Morse has substituted a more dramatic but harsher palette, adding yellows and pinks, now bathing the distant hilltop town, (capped by the medieval castle the "Rocca

Fig. 1. Samuel F.B. Morse, *Sketch of the Contadini: Study for the Chapel of the Virgin*, 1830. Oil over graphite and colored crayons on cream wove paper. Worcester Art Museum, Worcester, Massachusetts, Sarah C. Garver Fund.

Abbaziale," on the summit of the hill) in purple hues.

Morse added to the painting two figures from a watercolor sketch (fig. 1); one, a dashing "Contadino," his "sugar loaf" hat in hand, the other a gesturing shepherd with his sheep.[4] Now playing a central role in the composition is a young woman in red, with a white linen headress, who kneels at the shrine. Morse used a very similar figure at a different shrine in another painting of 1830 which he called *Contadina* or *Peasant Girl of Nettuno at the Shrine of the Madonna*, (Virginia Museum of Fine Arts, Richmond). Like his contemporaries, Morse made many sketches and recorded detailed descriptions of the regional dress of the "contadini" in his journals and sketchbooks.

Morse exhibited the present work in mid-January of 1831 at the Second Annual

Exhibition of Fine Arts at the Campidoglio in Rome. Though he removed the painting from the exhibition on February 21, it did receive a review from his friend Count Hawks le Grice who had just been appointed an art correspondent to the National Academy of Design in New York.[5] In his first letter to John L. Morton, Secretary of the Academy, le Grice praised the picture: "all Morse's landscape is glowing with the splendour of the setting sun."[6]

This appealing, romantic image of figures at a roadside shrine to the Virgin would seem an unlikely subject for Morse, who often criticized Roman Catholic ritual in his journals.[7] Morse was outspoken on the subject of the "superstitious" practices of Roman Catholics in Italy, and he especially decried the "idolatrous" cult of the Virgin. At the same time, he was a frequent visitor to the churches of Rome; he often reported being moved by the color and pageantry of ceremonies at St. Peter's and Trinita dei Monti. In choosing to celebrate this rural scene, which so clearly focuses on a religious subject, Morse seems to have left his questions about Catholicism behind, while concentrating on the picturesque beauty of the figures and landscape.

S. RICCI

1. Samuel I. Prime, *The Life of Samuel F.B. Morse* (New York: D. Appleton, 1875), p. 199. Morse had already seen Salisbury in Paris. Morse wrote to his brothers January 7, 1830 from Paris, "I was much surprised to find at the same house at which I arrived, cousin Stephen Salisbury; he intended to remain here all winter, but he has just told me that he has now determined to follow us to Italy in a week or two." Morse Papers 1828-1832, Library of Congress, Washington, D.C.

2. Stephen Salisbury II to Mrs. Elizabeth Tuckerman Salisbury, July 6, 1830, as quoted in Louisa Dresser, "The Chapel of the Virgin at Subiaco by Samuel F. B. Morse," *Worcester Art Museum Annual* 4 (1941), p. 66.

3. Morse to Stephen Salisbury II, January 19, 1831 as quoted in Louisa Dresser, ibid., pp. 67-68. The shrine, known today as the "Madonna del Salvatore," still stands beside the Via dei Monasteri. I am grateful to Diana Strazdes for this information.

Wayside country shrines or *icona* were originally altars for tree-worship, becoming shrines to the Virgin Mary by the 6th century. See Rodolfo Lanciani, *Wanderings in the Roman Campagna* (Boston: Houghton Mifflin, 1909), p. 62.

4. In his journals Morse frequently mentions sketching outdoors without specifying the medium, though he often refers to his "painting paraphernalia, *viz* a box of colors, we sling over the shoulders like a knapsack by a strap, an umbrella and field chair" (Morse Diaries and Notebooks, May 5, 1830, Library of Congress); occasionally he mentions putting pencil sketches into sepia, and on May 22, 1830, he mentions commencing a watercolor sketch in the morning at the shrine of the Madonna, perhaps fig. 1.

5. Morse's entry in his journal dated February 21, 1831, states: "This day I took my picture from the Exposition at the Campidoglio which in consequence of the state of times has not been well attended, most of the strangers having left Rome. Many of the best pictures have been removed."

6. Count Hawks le Grice to John L. Morton, March 12, 1831, Asher B. Durand Papers, New York Public Library, Box 1, folder 4. Courtesy of Eleanor L. Jones.

7. A few years later, Morse ran for mayor of New York as the nominee of a radical nativist party, with an anti-Papist platform. See Paul Staiti, *Samuel F.B. Morse* (Cambridge: Cambridge University Press, 1989) p. 210.

Thomas Cole

57. *A View near Tivoli*, 1832
Oil on canvas, 14¾ x 23⅛ in.
Lent by The Metropolitan Museum of Art, New York, Rogers Fund, 1903.

Situated along a tributary of the Anio River just south of Tivoli is a remnant of the Claudian aqueduct leading to Castel Madama. The road there, the Via Empolitana, passes under a single arch known locally as "Il Arco di Nerone," or the Arch of Nero.[1] Guidebooks singled out this site as providing ample material for the landscape painter, noting the picturesque value of the ruins and the view to the distant hills. In 1832 Thomas Cole traveled along this "beautiful old road from Tivoli to Subiaco," on one of his excursions outside of Rome, when he sketched the Arch of Nero from several vantage points on consecutive pages of his sketchbook (Detroit Institute of Arts). Initially he focused on the broad contours of the arch and distant mountains, making weather and color notes in the margins. Cole addressed the entire vista in some detail in a second sketch that spills onto two sheets, and it is this drawing that served as the preliminary

Fig. 1. Thomas Cole, *The Arch of Nero*, 1846. Oil on canvas. Newark Museum, Newark, New Jersey, Purchase, Sophronia Anderson Bequest Fund.

for Cole's painting, even to the emphasis on the weather and time of day. In a letter dated 5 August, 1832, Cole described the painting as "a view near Tivoli, representing a bridge, and part of an ancient aqueduct, called 'Il Arco di Nerone:' a road passes under the remaining arches: it is a morning scene, with the mists rising from the mountains."[2]

Cole painted *A View Near Tivoli*, along with a larger painting of the Cascatelles, when he returned to Florence.[3] Moderate in scale, it is nonetheless an ambitious composition. Cole's brushwork is loose

and fluid, his colors capturing the effects of early morning mist in the landscape. In 1834 he gave this painting to William A. Adams of Zanesville, Ohio, to retire a debt of twenty-one years. In his letter to Adams, Cole wrote: "The view taken in the vicinity of Tivoli is not one of those scenes celebrated by travelers or by historical associations. It is merely a picturesque bit that I found in my rambles among the Appenines."[4] In fact, Claude Lorrain was among the earliest artists known to have painted the Arch, which became a popular motif with a number of northern Euro-

pean painters during the nineteenth century.[5] Still, most artists who ventured to Tivoli preferred the more traditional and dramatic view of the Cascatelles, with the town of Tivoli perched high above the Anio valley (see cat. 58). Cole was the first American artist to choose to paint the Arch of Nero, and his work inspired others to follow him to this site.[6] Guidebooks described the beauty of the area, and related the storied history of the arch. During the factional wars fought in 1389, this segment of the aqueduct was fortified with both an inner arch and a watch tower to

serve as a gate, permitting soldiers to regulate the flow of traffic along the road.[7] These features appear in Cole's canvas; the secondary arch lasted until the turn of the century, when the fortifications were removed and the tower restored.[8]

In 1846, Cole drew upon his sketches of this scene in painting a second, larger version of the Arch of Nero (fig. 1). Whereas *A View Near Tivoli* depicts the cool colors of early morning and the panorama of the local landscape, the *Arch of Nero* stresses the arch itself and exudes a sense of sunlight and peacefulness. His work influenced a number of other American artists, among them Sanford Gifford and Jervis McEntee. Gifford admired Cole's second painting of the Arch, noting "this was the subject of one of Cole's finest pictures. He relieved the arch magnificently against a great white cumulus cloud."[9] He and McEntee walked to the arch in early October 1868, where both artists sketched compositions similar to Cole's earlier painting.[10]

E. JONES

1. Technically the Ponte degli Arci, part of the Aqua Marcia, one of three branches of the system of aqueducts known collectively as the Claudian aqueducts. The Arch has no special connection to the Emperor Nero. See Thomas Ashby, *Aqueducts of Ancient Rome* (Oxford: Clarendon Press, 1935), pp. 273ff; plate III.

2. Louis Legrand Noble, *The Life and Works of Thomas Cole* (Cambridge, Mass.: Harvard University Press, 1964), p. 184.

3. William Dunlap reported that among the works Cole had completed upon his return to Florence were a view of the Cascatelles at Tivoli (private collection, on loan to the Columbus Museum of Art, Ohio), and this small canvas. Cole to Dunlap, published in William Dunlap, *A History of the Rise and Progress of the Arts of Design in the United States* (New York: Dover Publications, Inc., 1969), vol. 2, p. 364.

4. Cole to William Adams, September 15, 1834. Quoted in Merritt, *Thomas Cole* (Rochester, New York: Memorial Art Gallery, 1969), p. 28.

5. Marcel Rothlisberger, "Darstellungen einer tiburtinischen Ruine," *Zeitschrift fur Kunstgeschichte* 48 (1985), pp. 300-318. Rothlisberger traces the appearance of the Arch of Nero in European and American art during the eighteenth and nineteenth centuries.

6. Among the Americans who followed Cole to the Arch of Nero were Jasper F. Cropsey, in 1848; Sanford Gifford and Jervis McEntee in 1868; and George Inness in 1870. Kathleen Hohlstein, "Nineteenth Century Artists at Tivoli," Boston University seminar paper, 1991.

7. E.B. van Deman, *The Building of the Roman Aqueducts.* (Washington, D.C., 1934), p. 298; Antonio Nibby, *Viaggio Antiquario ne Contorni di Roma III*, (Rome, 1819), p. 228. I am grateful to Carrie Rebora of the Metropolitan Museum of Art, New York, for providing me with access to the information contained in the entry for this painting, to be published in a forthcoming catalogue of the permanent collection.

8. In 1870 George Inness painted *The Commencement of the Galleria*, later mis-titled "Rome, the Appian Way," a view of the Arch without the inner fortification. LeRoy Ireland, *The Works of George Inness* (Austin: The University of Texas Press, 1965), no. 516. An Alinari photograph of the Arch of Nero taken in 1870, from which Inness worked, shows the fortification still intact. Inness's figures are dressed as Crusaders, suggesting a time preceding the addition of the fortifications in 1389.

9. Gifford to Elihu Gifford, October 19, 1868, "European Letters." Private collection.

10. "The Macs [McEntees] and I spent the day sketching at the Arch of Nero." Ibid. Gifford and the McEntees remained at the Arch sketching from the 11-13 of October; Gifford made his oil sketch of the Arch on October 21 (ibid., November 2, 1868). Gifford sketched both sides of the arch in pencil. The subject was of no small significance in Gifford's career: he painted five views of the arch.

George Loring Brown

Born Boston, Massachusetts, 1814;
died Malden, Massachusetts, 1889

On his first trip to Europe in 1832, George Loring Brown visited Antwerp, London, and Paris, where he studied under Louis Gabriel Isabey and copied old master paintings in the Louvre. Returning to his native Boston in 1834, Brown impressed Washington Allston with his copies, and the elder artist recommended a period of travel and study in Italy. Brown sailed for Europe in 1840, visiting Avignon and traveling along the Rhône before arriving in Rome in September. In the summer of 1841 he moved to Florence, where he sketched weekly with fellow Americans James De Veaux and Thomas P. Rossiter and developed a reputation as a painter of original landscapes.

During the summer of 1844, Brown visited Naples. He seems to have been in Venice sometime before 1846, when he made a brief trip to the United States, exhibiting his Italian landscapes in New York. Armed with numerous commissions, he likely departed again for Italy in November 1846; he was in Florence in 1847. Brown traveled along the Rhine in 1848 and witnessed the workers' uprising in Paris in June of that year. By the end of 1848, he had settled at Albano, making it his base for sketching trips in and around Rome. He visited Paris in 1850, and during the 1850s he seems to have had a studio in Rome, where he was friendly with Worthington Whittredge, G.P.A. Healy, and the sculptors Thomas Crawford and Randolph Rogers. Nathaniel Hawthorne visited Brown in his studio in 1858. Brown made summer trips to Naples, Capri, Sicily, Paris, England, and Switzerland during the 1850s.

The artist returned to the United States in 1860 but continued to paint Italian landscapes for the rest of his career. On a final trip to Europe in 1879-80, Brown visited Paris, but little else is known about his itinerary.

George Loring Brown

58. *Tivoli (The Falls of Tivoli)*, 1850
Oil on canvas, 25½ x 32½ in.
Signed l.l.: G.L. Brown 1850
Collection of The Newark Museum, Purchase 1957,
The G.L. Brown Fund

After a brief trip to the United States during which his Italian landscapes were acclaimed in New York, Brown returned to Europe in 1846 with his reputation established.[1] Americans were traveling in Italy in increased numbers during the 1850s, and Brown's Italian landscapes, made to order in the studio, were often purchased as mementos.[2] Among his most popular subjects was Tivoli,[3] a hill town eighteen miles east of Rome whose steep cliffs, tumbling cascades, and ancient ruins had been celebrated in art for centuries.

Horace, Virgil, and other Latin poets had sung of Tivoli's beauty, and the place delighted a succession of northern landscape painters beginning with Bartholomeus Breenbergh and Paul Bril, who sketched there during the first quarter of the seventeenth century. Claude Lorrain often included Tivoli's small round shrine,

the so-called Temple of the Sibyl, in his imaginary landscapes, and in its dramatic clifftop setting, the ruined temple also captivated Claude's rugged contemporary Gaspard Dughet. Hubert Robert and Jean-Honore Fragonard are among eighteenth-century French artists who sketched and painted the Temple of the Sibyl, the cascades, and the fountains and gardens of the sixteenth-century Villa d'Este nearby. And for English artists of the later eighteenth and early nineteenth centuries, the serene temple epitomized the concept of the picturesque, while the plunging cliffs and falls beneath it typified the sublime.

Nineteenth-century tourists could visit Tivoli and return to Rome within a single day, for the carriage ride could be made in four hours.[4] However, guidebooks encouraged tourists to stay at Tivoli for at least two days and to make it their base for exploring the scenic Sabine Hills.[5] For many Americans, including George Stillman Hillard, the cascades were Tivoli's most striking feature, inviting comparison with Niagara, Lowell, Trenton, Rochester, and other falls in the northeastern United States.[6] However, while the waterfalls at home had become symbols of America's unspoiled wilderness, those at Tivoli had been embellished and manipulated by man. The town of Tivoli (ancient Tibur) was older than Rome itself,[7] and the Temple of the Sibyl had stood on the cliffs of Tivoli since the time of the Roman Republic.[8] The broadest and most powerful of Tivoli's cascades, the Cascata Grande, had been created as recently as 1831, when a double tunnel was cut through Monte Catillo, diverting the flood-prone River Anio from the center of town.[9]

Perhaps because the Cascata Grande was an artificial cataract, it was less popular among American artists than the many narrow cascades that plunged, ribbon like, from other points along the cliffs; these, with the Campagna stretching away into the setting sun, are depicted in Thomas Cole's *Cascatelli at Tivoli* (see fig. 12, p. 44), in Sanford R. Gifford's *Tivoli* (1870; The Metropolitan Museum of Art, New York), and in other Tivoli landscapes by Brown. Brown's concentration on the man-made Cascata Grande in the present painting may reflect the choice of the commissioning patron, a Mr. Len(n)ox of New York.[10] This view allowed the artist to juxtapose the ancient Temple of the Sibyl, not encompassed in Cole's view, with the modern tunnel, whose twin mouths are visible above the falls. The engineering feat represented by the 800-foot tunnel and mighty manmade cataract must have deeply impressed visitors from developing America.

K. Mathews Hohlstein

1. In a letter to Maria Cooley dated November 12, 1846, Jasper F. Cropsey noted that Brown had recently "sailed for the sunny clime again, carrying with him commissions for the pictures to the amount of $6000." Cited in *M & M. Karolik Collection of American Water Colors & Drawings 1800-1875* (Boston: Museum of Fine Arts, 1962), vol. 1, p. 89.

2. Thomas W. Leavitt, "The Life, Work, and Significance of George Loring Brown, American Painter," Ph.D. diss., Harvard University, 1957, p. 58.

3. Between 1847 and 1855, Brown painted at least nine views of Tivoli; examples other than the present painting include *View of Tivoli at Sunset* (1848; High Museum of Art, Atlanta) and a larger version (private collection, Cambridge, Mass.). Tivoli is also among the sites depicted in a series of etchings Brown made in 1853-54. A useful checklist of works by Brown is found in Anne Rogers Haley, "George Loring Brown, 1814-1889: A Look at Patronage and the Italian Years," seminar paper, Boston University, 1991.

4. *Murray's Handbook for Travellers in Central Italy Part II: Rome and Its Environs* (London: John Murray, 1853), p. 250.

5. *Murray's Handbook of Rome and Its Environs*, (London: John Murray, 1867), p. 328 notes that public conveyances departed Rome's Piazza degli Organelli for Tivoli twice daily, at 5 a.m and noon, but recommended the more expensive and more comfortable private carriages that could be hired at Roman hotels.

6. George Stillman Hillard, *Six Months in Italy*, (Boston: Ticknor, Reed, and Fields, 1853), vol. 2, p. 214.

7. *Murray's Handbook for Travellers*, p. 253.

8. George M.A. Hanfmann, *Roman Art*, (New York: W.W. Norton, 1975), p. 64, dates the temple to about 80 B.C.

9. Hillard, *Six Months in Italy*, vol. 2, pp. 215-216. See also Alta Macadam, ed. *Blue Guide to Rome and Environs* (London: Ernest Benn, Ltd., 1979), p. 361.

10. The present painting is presumed to be the one recorded in Brown's 1851 account book as *Waterfalls of Tivoli*, sold to a "James Lennox" for 150 scudi. The *Guide to the Paintings and Sculpture Exhibited to the Public* (New York: Lenox Library, 1877), describes an unillustrated painting by Brown that had belonged to James Lenox as "painted to order, Paris, January, 1851." See *American Art in the Newark Museum* (Newark: The Newark Museum, 1981), p.304. However, the 1850 date and the name "E. Lenox" inscribed by Brown on the back of the canvas raise the possibility that he painted two Tivoli views for two different Len(n)ox patrons during 1850-1851. The complete inscription of the verso of the present picture reads: "View of the Great Cascade and the Temple of the Sybil [sic] at Tivoli; near Rome, painted from nature for E. Lenox, Esq. of N.Y." It is also signed on the verso: "G.L. Brown, Paris, 1850."

George Loring Brown

59. *Monte Pellegrino at Palermo, Italy,* 1856
Oil on canvas, 19¼ x 32 in.
Signed l.r.: Palermo/GL Brown
Museum of Fine Arts, Boston, Gift of Maxim Karolik to the
M. and M. Karolik Collection of American Paintings,
1815-1865

As an aspiring young artist, George Loring Brown visited the island of Sicily for the first time in 1841, possibly as part of a study group of artists from Florence.[1] Fifteen years later, during the summer of 1856, the artist embarked on a three-month long summer trip outside of Rome. He wrote in his account book the day of his departure, "July 1st left for Naples;" the day he returned he wrote, "spent during my absence for travelling expenses and many other objects necessary in my profession — 3,000 scudi."[2] During September he visited Palermo, the capital of Sicily, known as "La Citta Felice" because of its semi-tropical climate, great fertility, and exquisite

Fig. 1. *Monte Pellegrino,* nineteenth century. Stereograph. Museum of Fine Arts, Boston, Bequest of Mrs. Mary Stacy Holmes.

surroundings. There he painted Mount Pellegrino, admired by Goethe a century earlier as a "large rocky mass broader than it is high . . . its beautiful form cannot be described by words."[3]

Mount Pellegrino rises majestically in the Conca d'Oro, "golden shell," in the northwestern end of the bay of Palermo. In ancient times, when it was known as Heirkte, Hamilcar Barca held it at siege for three years (247-244 B.C.) during the Punic Wars. But its most important role in the history of the Sicilian city started in 1624 when the remains of a twelfth-century noble girl, Rosalia, were found in a grotto inside the mountain and brought

back to Palermo where they miraculously cured a plague.[4] Since that day Saint Rosalia became the patron saint of Palermo, and Mount Pellegrino ("Pilgrim's Mountain") her sanctuary.

Brown's *Monte Pellegrino* is a rare subject for an American; most of those artists who reached Sicily concentrated on painting the ancient ruins at Syracuse, Agrigento, and Taormina or the picturesque Mt. Etna. Brown chose to represent Mount Pellegrino as a backdrop to a peaceful and crisp morning in the marina at Palermo. At the right, next to the coastline, is the Foro Italico — a tree-lined, fashionable esplanade where carriages and citizens leisurely strolled at all times during the day (fig. 1). The Mura della Cative, a twenty-foot-high wall, encloses the promenade and gardens adjoining the seventeenth-century Palazzo Butera (used as the viceroy's quarters during the 1850s). The bird's-eye view used by Brown gives an oblique glimpse of the Porta Felice — one of the main gates of the city. Finished in 1637 by the architect Novelli, it is composed of two monumental pillars built specially so that the towering processional cart of Saint Rosalia could pass through during her festivities in mid-July.[5] Immediately inside the entrance is the Piazza San Spirito where Goethe's house can still be seen.

George Loring Brown went back to this subject several times, even after he had left Italy. In 1860 the artist exhibited at the National Academy of Design a "Monte Peligreno (sic) from Parlemo (sic) — Morning" and at the Boston Athenaeum a "View of the City of Palermo. Mt. Etna in distance"; in 1864 two views of "Palermo" were exhibited in Boston. In 1878 he painted "Morning, View of Monte Pelegrino, Port and Entrance to Palermo," which was auctioned in 1879.[6]

N. OTERO-SANTIAGO

1. Thomas W. Leavitt, "The Life, Work and Significance of George Loring Brown," Ph.D. diss., Harvard University, 1957, p. 62.

2. "George Loring Brown's Account Book, 1851-1859," manuscript in the library of the Museum of Fine Arts, Boston.

3. Goethe wrote extensively about the beauty of Palermo and Mount Pellegrino where he arrived on Monday, April 2, 1787. Enchanted by the island, Goethe wrote: "Italy without Sicily forms no image at all in my soul." Johann Wolfgang von Goethe, *Italian Journey* (New York: Suhrkamp Publishers Inc., 1989), pp. 186-214.

4. *Murray's Handbook South Italy* (London: John Murray, 1892), pp. 311-12.

5. Although the information can be found in *Murray's*, Goethe, who entered the city through Porta Felice, mentions that the "curious gate . . . must remain open on top, so that St. Rosalia's cart can pass through on her famous festival day." Goethe, *Italian Journey*, pp. 186-214.

6. The 1878 work could possibly be a copy of the present work painted from memory by Brown long after he had returned to the United States.

William Stanley Haseltine

Born Philadelphia, Pennsylvania, 1835;
died, Rome, Italy, 1900

William Stanley Haseltine

60. *Marina Piccola, Capri*, about 1856
Oil on paper mounted on canvas, 12 x 18½ in.
*National Gallery of Art, Washington D.C., Gift of Mrs.
Roger H. Plowden*

Haseltine, who had gone to Düsseldorf in 1855 to study landscape painting with Andreas Achenbach, joined Emanuel Leutze, Worthington Whittredge, and Albert Bierstadt on a sketching tour down the Rhine to Switzerland in the spring of 1856. By late summer he and his companions were in the Swiss Alps. They proceeded to Italy by the Saint Gotthard Pass, reaching lakes Como and Maggiore in October, 1856. Having passed through Civita Castellana, they toured Tuscany and arrived in Rome later that autumn.

In Rome Haseltine took an apartment at the foot of the Pincian Hill on Via Sistina. He frequently drove into the countryside to sketch, not only in the company of his American colleagues, but with other expatriates such as Dr. Wolfgang Erhardt, Lord Acton, and Ferdinand Gregorovius, author of Wanderjahre in Italien. These sojourns included Olevano, where he went often in the company of Rome's German artists. He also traveled south to the Amalfi coast and Capri, seeking out the more isolated areas along his route and enjoying the spartan living conditions they offered. He was in Olevano with Whittredge in June 1858; a few weeks later he returned to the United States.

In 1866 Haseltine returned to Europe, this time going to Paris. He spent the next two summers around Lake Como and the Italian Riviera. In 1869 he and his family left for Rome, eventually settling in the sixteenth-century Villa Alfieri in the Piazza del Gesu. The residence, which he filled with antiquities and works of art, became a gathering place for artists, writers, and foreign visitors to the city.

In the 1870s and 1880s Haseltine lived in Rome, traveling to the Low Countries, Spain, Switzerland, and Bavaria and making several trips to Venice, Tuscany, Capri, and Sicily, all of which served as inspiration for his landscapes, which he often exhibited at the Paris Salon. He returned annually to the United States to travel and exhibit. From 1890 to 1899 he lived mainly in the United States, helping to found the American Academy in Rome. In February 1900, a few months after returning to Rome from a trip to the American West and Alaska, he succumbed to a heart attack.

Haseltine's earliest drawing of Capri is dated 1856; he must have first visited the island in the last months of that year, very soon after he arrived in Rome. He seems to have visited again in the spring of 1857 and 1858, when he lodged at a local monastery.[1] During those visits he produced numerous watercolor and oil sketches that he brought back to America in 1858. A description of his New York studio noted that it was filled with souvenirs of European scenery, its walls "hung with sketches of the magnificent rocks and headlands" of the southern Italian coast.[2] He used these as motifs for larger studio paintings; of the six that he exhibited at the National Academy of Design in 1860, one was a view of Capri.

Haseltine was not the only artist to have discovered Capri. The views around the island were favored by both European and American artists. Haseltine's traveling companions, Bierstadt and Gifford, both went there to sketch and both produced finished paintings of views around the island. Capri had become popular in the second quarter of the nineteenth century, when rugged nature alone, rather than landscapes with ruins or landscapes with allusions to past art became, for the first time, desirable subjects for the artist's brush.

This sketch was probably made on the spot. Tack holes suggest Haseltine initially worked on a piece of paper pinned to a drawing board; he then attached the paper to a piece of canvas and continued to work on it, expanding it slightly and sharpening its definition. The subject, Marina Piccola, is located on the less populated south side of Capri. Haseltine's depiction of it centers on the empty, beached fishing boats with their canvas sails pulled over them, catching light from the midday sun. Bierstadt had sketched the same motif when he was there in June 1857.[3] Not long afterward, a very similar scene was produced as

William Stanley Haseltine

60. *Marina Piccola, Capri*, about 1856

a commercial photograph by the Italian Carlo Naya (1816-1882).[4] In the background of Haseltine's sketch are the primitive stucco fishing sheds with their nets nearby, drying in the sun. These are sheltered by the rock formation known as the Scoglio delle Sirene (Rock of the Sirens), which forms a cove used by the fishermen.

This oil sketch served as the central motif for a larger Haseltine painting, *Piccola Marina, Capri* (1856, formerly collection of the American Academy, Rome) in

which the boats become the foreground of a more panoramic view of the bay.[5] This oil sketch was one of the 1,500 paintings, drawings, and watercolors that remained in his Palazzo Altieri studio at his death.

D. STRAZDES

. Helen Haseltine Plowden, *William Stanley Haseltine: Sea and Landscape Painters 1835-1900* (London: Frederick Muller, Ltd., 1947) p. 64.

2. "Domestic Art Gossip," *Crayon* 6 (December 1859), p. 379.

3. The similarity of subject is particularly apparent in Bierstadt's oil sketch, *Fishing Boats at Capri* (1857, Museum of Fine Arts, Boston).

4. Carlo Naya, *La Petite Marine – Capri*, collodion photograph, about 1865, illustrated in Italo Zannier, *Venice, the Naya Collection* (Venice: O. Boehm, 1981), cat. 4.

5. Illustrated in Plowden, *William Stanley Haseltine*, pl. 26.

William Stanley Haseltine

61. *Capri*, 1869
Oil on canvas, 19⅞ x 31⅝ in.
Signed l.l.: W.S. HASELTINE / 1869 ROME
The Cleveland Museum of Art, Purchase, Mr. and Mrs.
William H. Marlatt Fund

Capri was one of Haseltine's favorite sketching sites. The island, although an established part of the tourist route by the 1850s, was not easily reached even a decade later. A contemporary guidebook recommended hiring a six-oared boat from Sorrento, boarding a market or fishing boat from Naples, or taking the once-daily steamer from Naples during the tourist season.[1] Capri also lacked the amenities desired by most tourists. It had just one hotel; the local population of 5,000 were all either farmers or fisherfolk; and for transportation around the island, a donkey was recommended.[2] For Haseltine, such primitiveness was desirable because it assured him picturesque surroundings uncompromised by modern life.

A trip to Capri meant indulging in nature in its pristine state. Although the island had a history dating back to the time of Augustus and was the site of a villa built by Tiberius, it had no ruins worth seeing.[3] Instead it offered the wilder type of terrain, "brown and picturesquely-heaped rocks, at whose feet the clear, green waters plash: they speak to the eye of science of a volcanic birth and the antiquity of man, and their surroundings . . . appeal to the lover of nature."[4]

Capri, painted soon after Haseltine relocated to Rome from Paris, was most likely based on an earlier sketch made at the site. It may have been one of many representations of Capri and Mentona described by an American visitor to Haseltine's studio in May 1869 as "good and characteristic pictures of scenery on the rock-bound coast" of the two places.[5] Here, he meticulously depicts one of the solitary rocks that rise from the sea along the uninhabited eastern extremity of Capri. The site is

Sanford Robinson Gifford

62. *Lake Nemi*, 1856-57
Oil on canvas, 39⅝ x 60⅜ in.
The Toledo Museum of Art; Purchased with funds from the
Florence Scott Libbey Bequest in Memory of her Father,
Maurice A. Scott

near the Grotta Bianca, also called Grotta Meravigliosa, just off shore from the more famous Natural Arch. In 1871 Haseltine returned to paint his *Natural Arch, Capri* (1871, National Gallery of Art, Washington, D.C.).

Portraits of coastal rocks, especially those that emerge suddenly from the earth, had become Haseltine's specialty. He found them not only along the coast of southern Italy, but along the eastern coast of the United States as well, in the rock-bound coasts of Mount Desert Island, Maine, and Nahant, Massachusetts, where he sketched during the 1860s.

Like his other views of Capri's craggy rocks, this one is subtly edited to create a tighter pictorial structure than nature allowed. Here, the rock seems gigantic compared to the tiny boats dotting the horizon, which are the only sign of man in the picture. The artist alludes to the sublime in nature, softened by still air and glasslike water, as if the violent forces that created this rock were only a memory.

D. Strazdes

1. *Murray's Handbook for Travelers in Southern Italy*
(London: John Murray, 1858), p. 244.

2. Ibid., p. 244.

3. Ibid., p. 245.

4. Henry T. Tuckerman, *Book of the Artists: American Artist Life*
(New York: G.P. Putnam's Sons, 1867), p. 557.

5. "Letter from Rome," *The Art Journal* (Chicago) 2 (May-
June 1869) p. 112. An earlier visitor to the city had already
noted, "Haseltine's easels are adorned with faithful repre-
sentations of the beauties of Capri, Amalfi, Sorrento, Is-
chia, Procide, and the Bay of Baiae," "Letter from Rome"
The Art Journal (Chicago) (June 1, 1868), p. 102.

On an excursion from Rome in early October of 1856, Sanford Gifford walked fourteen miles from the Appian Way across the Campagna to Albano and continued the next morning to Gensano, on the west side of Lake Nemi. For the rest of the day, the artist circled the lake, arriving at the town of Nemi on the far side in the early afternoon of October 6. Gifford sketched the lake twice in pencil from the window of his lodgings, the first sketch extending across two sheets in his sketchbook, accentuating the broad, panoramic view.[1] In the same book he made a thumbnail sketch of the composition, compressing the view. As was becoming his habit, the artist also made a sketch in oil of the sunset over the lake, dated the following day.[2] He described the same view as seen by moonlight in a subsequent letter:

> The lake, which is in a deep cavity of the mountains (over the crater of a volcano), is fringed with fine trees which droop in to its waters; back of these rise the lofty banks, in parts richly wooded, in parts showing the bare cliffs. . . . The view from our window was one of the most beautiful I have ever seen. We were high above the lake. On one side in the foreground were some picturesque houses and ruined walls — a tall, dark cypress, rising out of a rich mass of foliage, cut strongly against the lake, distance, and sky. Far below, the still lake reflected the full moon, and the heights of the further shore, which, crested by the light and misty expanse of the Campagna, while still farther beyond, a long line of silver light, the reflection of the moon, told where the sea was.[3]

Returning to Rome, he painted a sketch, *Lake Nemi* on October 21 (fig. 1). Such sketches typify Gifford's working method.

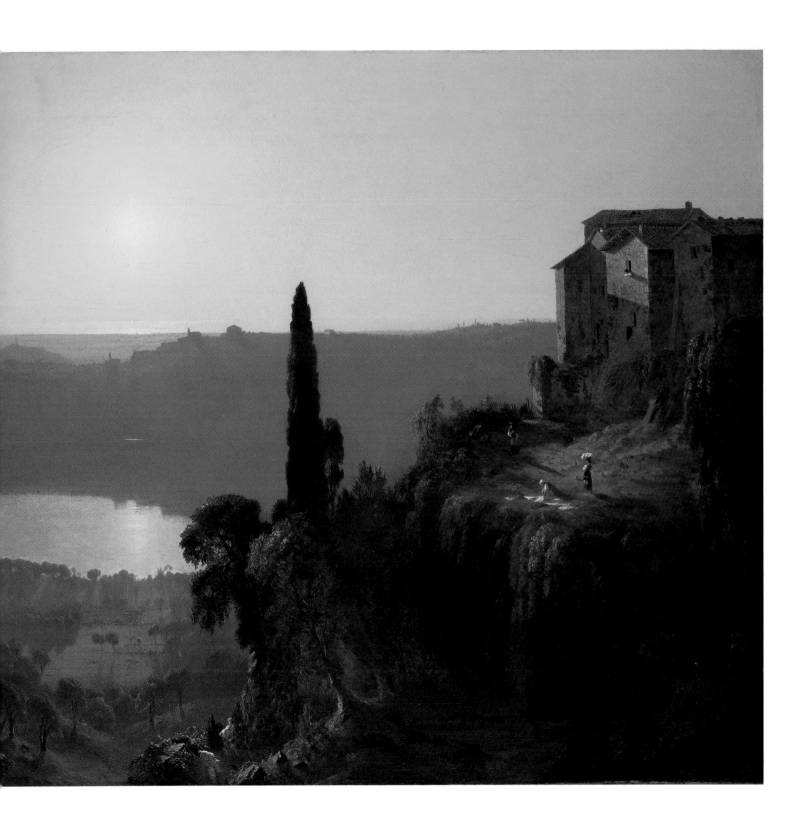

Fig. 1. Sanford R. Gifford, *Lake Nemi*, 1856. Oil on canvas. Collection of Jo Ann & Julian Ganz, Jr.

Fig. 2. John Robert Cozens (British, 1752-1797), *The Lake of Nemi*. Watercolor over pencil. Collection of the Mellon Bank Corporation, Pittsburgh, Penn.

Beginning with a spare contour drawing, sometimes accompanied by notes regarding color and the effect of the scene, he squared off a small portion of a single sketchbook page for a thumbnail compositional sketch. Typically he then painted a small sketch in oil on paper, done on the site or shortly thereafter in his studio. A larger oil sketch, either on paper or canvas, would sometimes follow. In his progression from a small oil sketch to a larger one, Gifford generally moved away from a literal transcription of the site to a more atmospheric and luminous rendering of it. The sketch for *Lake Nemi* demonstrates Gifford's interest in capturing this quality of glowing light. The brushwork is loose and vibrant, the colors applied in swift succession. Gifford would sometimes save these oil sketches for years before return-

ing to them for inspiration (see cat. 34).

Lake Nemi was hallowed ground for landscape painters of all nationalities, Americans included. In all the guidebooks, Nemi was renowned as a site associated with the antique cult of Diana. Gaspard Dughet had made this view across the lake famous, and the site attracted landscape painters from Claude Lorrain, Claude-Joseph Vernet, and Richard Wilson to John Robert Cozens (fig. 2) and J.M.W. Turner. A stop at Nemi was obligatory for nearly all travelers to Italy.[4] Thomas Cole, Jasper Cropsey, and George Inness (see cat. 68) were among the many American artists who painted the lake during the nineteenth century.[5]

Gifford spent the winter of 1856-57 in Rome struggling through a "depression of spirits" that had plagued him since mid October, when he unpacked his oil sketches from the preceding summer and winter, only to find most of them stuck together. This, and the ensuing rainy season, dampened his spirits for several months, during which time he did little work or traveling.[6] During the winter he painted three canvases, including the present painting, "a large one of Lake Nemi, (the largest I have ever painted [60 in. x 40 in.])".[7] Gifford continued working on *Lake Nemi* into the spring,[8] investing his view of the lake with a supernal calm and all-encompassing light. Its aerial perspective extends beyond the caldera of the extinct volcano and across the distant Campagna to the glistening Mediterranean beyond. The calm surface of the lake, known as the Mirror of Diana,[9] reflects the glowing atmosphere like a disc of molten sunlight. Reviewers in New York praised Gifford's achievement, noting "Gifford's works are remarkable for a luminous atmosphere. Their poetic quality is recognizable in a fine sense of the picturesque, a feeling of repose, and that subordination of minor truths to important truths, the artistic

combination of which is intelligible in the term unity. . . . *Lake Nemi* and *Lago Maggiore* are worthy of study in the particulars indicated."[10]

E. JONES

1. This sketchbook page also includes a small sketch of the huge bed in the Inn at Nemi: "One of the beds for great height and extent of surface was so marvelous that we both made sketches of it." Gifford to Elihu Gifford, October 15, 1856, "European Letters." Private collection.

2. Listed in the Metropolitan Museum of Art, *Memorial Catalogue of the Paintings by Sanford Robinson Gifford, N.A., with a Biography and Critical Essay by Prof. John F. Weir of the Yale School of Fine Arts*, 1881. Reprint (New York: Olana Gallery, 1974) as no. 99. "A Sketch of Lago di Nemi. Dated October 7th, 1856. Size, 10 x 14 [in.]. Owned by the Estate."

3. Gifford to Elihu Gifford, October 7, 1856, "European Letters." Private collection.

4. John Robert Cozens painted nine versions of the view from the town of Nemi, seen at different times of day, all between 1778 and 1790. See Kim Sloan, *Alexander and John Robert Cozens* (New Haven: Yale University Press, 1986), p. 129. Joseph Wright of Derby painted a view that reverses Gifford's composition but has a similar quality of light (National Gallery of Victoria, Melbourne, Australia).

5. Cole set *Il Penseroso* at Nemi; Cropsey painted a view in 1848 from the same vantage point as Gifford would in 1856 (National Academy of Design, New York); Kensett sold a view of Nemi in 1849; Inness executed several views of the lake, including one painted in 1871 from the same vantage point as Gifford. See LeRoy Ireland, *The Works of George Inness: An Illustrated Catalogue Raisonné* (Austin: University of Texas Press, 1965), p. 130, no. 537.

6. Gifford to Elihu Gifford, October 15, 1856, "European Letters." Private collection. Gifford's next letter is dated Rome, February 5, 1857.

7. Gifford to Elihu Gifford, March 11, 1857, "European Letters." Private collection. Gifford glazed the painting in March, and considered it finished in April. In early May Gifford boxed and shipped *Lake Nemi* to New York. See Gifford to Elihu Gifford, April 14, 1857, "European Letters." Private collection. For more on Gifford's first trip to Italy, see Ila Weiss, *Poetic Landscape: The Art and Experience of Sanford R. Gifford* (Newark, Del.: University of Delaware Press, 1987), pp. 69-80. The present painting, now lined, was signed Nemi/S.R. Gifford/Rome 1856-57 on the reverse.

8. Gifford to Elihu Gifford, May 2, 1857, "European Letters." Private collection. Gifford writes: "April 17th. . . . Made oil sketch of Nemi for Lizzie Mulock." He was possibly referring to the oil sketch on paper belonging to Graham Williford (6⅞ x 10⅛ in.), a small replica of this composition. Artists would often paint small sketches for friends as keepsakes, and trade them with other artists.

9. See cat. 68 for a discussion of Nemi's importance in Roman mythology.

10. "Sketchings," *Crayon* 5 (May 1858), p. 147.

Sanford R. Gifford

63. *Riva — Lago di Garda*, 1863
Oil on canvas, 10⅝ x 16¾ in.
Signed l. l.: S R Gifford 1863 and l. r.: S R Gifford
1863
Collection of Jo Ann and Julian Ganz, Jr.

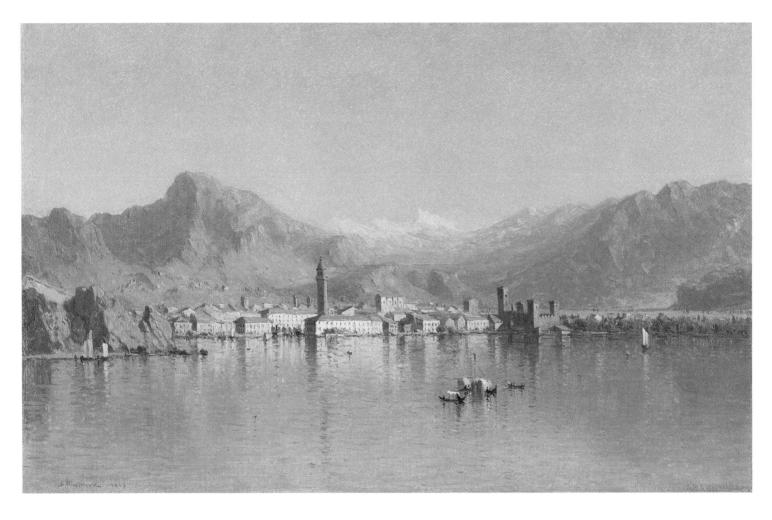

Gifford was one of few American artists drawn to the northern Italian lakes, and he visited Lake Garda on both of his trips to Italy. In July of 1857 Gifford took an Austrian steamer from Peschiera del Garda, an Austrian fortress town on the south shore of the lake, to Riva, nestled at the northwest end. Gifford recorded his first impressions of the lake in a letter, commenting, "The west shore approaching Riva is very bold and precipitous. . . . It [Riva] is finely situated at the head of the lake in an amphitheatre of noble mountains."[1] Gifford highlighted several features of the small town. On the left, he accentuated the height of the lone spire of the Torre

Aponale, built in the thirteenth century and later converted into a clocktower; and at the far end of town the twelfth-century castle, recently garrisoned by the Austrian army.[2] He painted two versions of *Riva, Lago di Garda*, both in 1863, after he had returned to New York.[3] This oil sketch, although painted in Gifford's New York studio, retains the freshness associated with the artist's *plein-air* efforts. His pencil sketches of the lake and town are unlocated,[4] but undoubtedly served as guides for both this preliminary study and the larger painting of the same name (Private collection).

Gifford spent three weeks in the north

ern lake region at the beginning of his second trip to Italy, and passed by Lake Garda on his way home. In his last letter home from this trip, Gifford wrote, "The exquisite blue of the water, the noble forms of the mountains, the tender hues of the mountains as they melted in the tender gray of the sky contrasting strongly with the rich vineyards and bright villas of the near shore made a charming picture to carry away in one's memory."[5]

E. JONES

1. Gifford to Elihu Gifford, August 10, 1857, "European Letters." Private Collection.

2. John Wilmerding, et al., *An American Perspective: Nineteenth-*

Sanford R. Gifford

64. *Galleries of the Stelvio — Lake Como*, 1878
Oil on canvas, 30½ x 24½ in.
Signed l.r.: S. R. Gifford/1878
Munson-Williams-Proctor Institute, Museum of Art, Utica, New York, Proctor Collection.

Century Art from the Collection of Jo Ann and Julian Ganz, Jr. (Washington, D. C.: National Gallery of Art, 1981), p. 132; and Ila Weiss, *Poetic Landscape: The Art and Experience of Sanford R. Gifford* (Newark: University of Delaware Press, 1987), p. 239.

3. Listed in the Metropolitan Museum of Art, *Memorial Catalogue of the Paintings by Sanford Robinson Gifford, N.A., with a Biography and Critical Essay by Prof. John F. Weir of the Yale School of Fine Arts*, 1881. Reprint (New York: Olana Gallery, 1974) as no. 291. Riva, Lago di Garda. Dated 1863. Size, 18 x 32 [in.]. Owned by Isaac T. Frost.; and no. 342. Lago di Garda, Italy. Dated 1863. Size, 9 x 16. Owned by D.H. McAlpin.

4. Gifford to Elihu Gifford, August 10, 1857, "European Letters." Private collection.

5. Gifford to Elihu Gifford, August 4, 1869, "European Letters." Private collection.

Gifford returned to lakes Como and Maggiore for a three-week stay during his second trip to Italy, in late July and early August of 1868. On this trip he retraced his steps and expanded his explorations of the northern lakes that he had first encountered in 1856-57. Gifford spent several days sketching the scenery along the lake shores, including the galleries of the Stelvio road, tunnels cut into the rock along the eastern shore of the lake. Gifford had noted this feature on his first trip, remarking that "there are a great many galleries and tunnels to protect the road from avalanches."[1] The Stelvio road tunnels, the longest of which is over 100 feet long, extend for roughly a mile along the lake shore,[2] and were blasted out of the living rock by the Austrian military between 1820 and 1825. The Stelvio road, which was also called the *Strada militare*, is an extension of the road through the Stelvio Pass, which is still the highest carriage road in Europe.[3]

On August 5, 1868, Gifford used two facing pages of his sketchbook to experiment with compositions incorporating both the tunnels and the view onto the lake (fig. 1). His fascination with the irregular openings of the tunnels is evident, but what captivated him most was the sensation of passing from the cool, dark tunnels into the brilliant warmth of the afternoon sunlight. In his own words, "delightfully cool they were, like wells, going into them from the hot sun."[4] The following day Gifford continued his sketching tour of the area, and after returning to his lodgings painted a small oil sketch of the Galleries, inscribed "Stelvio Road Aug 6 1868 Como" (Thyssen-Bornemisza Collection, Lugano).[5] Two years later Gifford experimented with this subject in a painting that is now lost.[6] It was not until 1878 that Gifford painted this large-scale canvas, *The Galleries of the Stelvio — Lake Como*, which he

Fig. 1. Sanford R. Gifford, *Italian Sketchbook*, detail, page 46, 1868. Pencil. The Brooklyn Museum, Gift of Miss Jennie Brownscombe.

listed among his 'Chief Pictures.' Although Lake Como was a spot popular with artists of all nationalities, most preferred to represent the open vistas of the lake, mountains, and town of Como. Gifford is the only American painter known to have painted these galleries, which call to mind the eighteenth-century tradition of painting grottoes and caves popularized by the British painter Joseph Wright of Derby. American artists like Albert Bierstadt painted views of the grottoes at Capri, extending this tradition into the nineteenth century. Gifford's painting is all

Albert Bierstadt

65. *Olevano*, 1856-7
Oil on canvas on panel, 19⅛ x 26½ in.
Signed l.r.: Bierstadt
The Saint Louis Art Museum, Purchase: Eliza McMillan Fund

the more unusual in its articulation of a modern engineering triumph, albeit one whose results call to mind naturally occurring forms.

E. JONES

1. Gifford to Elihu Gifford, July 28, 1857, "European Letters." Private collection.

2. George Hillard, *Six Months in Italy* (Boston: Ticknor, Reed, and Field, 1853), vol. 1, p. 22.

3. *Murray's Handbook for Travellers in Northern Italy* (London: John Murray, 1863), p. 160. Baedeker noted that "the road skirts the mountain slope and is carried through the Diroccamento Defile (Wormser Loch) by covered galleries. . . . At the egress of the last tunnel (the Galleria dei Bagni), a slab on the rock to the left records that this "Via a Burmio ad Athesim per Braulii juga", begun in 1820, was completed by the architect Donegani in 1825," (*Baedeker's Eastern Alps*, [Leipzig: Karl Baedeker, 1888], p. 281).

4. Gifford to Elihu Gifford, August 5, 1868, "European Letters." Private collection.

5. Gifford noted: "(August) 6. Walked to San Giovanni and made drawing of the northern mts. P.M. Made oil sketch of the 'Gallerie'," (Gifford to Elihu Gifford, August 1868, "European Letters." Private collection). Gifford's sketch is listed in the Metropolitan Museum of Art, *Memorial Catalogue of the Paintings by Sanford Robinson Gifford, N. A., with a Biography and Critical Essay by Prof. John F. Weir of the Yale School of Fine Arts*, 1881, Reprint (New York: Olana Gallery, 1974) as no. 506.

6. Ibid., no. 563, listed as "The Galleries of the Stelvio Road. Dated 1870. Size 20 x 26. Owned by G.H. Beard." In each of the three versions of this subject, nos. 506, 563, and 691, the dimensions are reversed.

In the spring of 1857, when he likely made this large sketch, Bierstadt was frequently in the Alban and Sabine Hills in the company of fellow painters Sanford Gifford, Worthington Whittredge, and Peter Frederick Rothermel. Olevano Romano, nestled in the Sabine Hills about thirty miles east of Rome, is a quintessential medieval Italian hill town, built on a fortified rock and filled with tortuous, narrow streets and steep-sided houses. The rolling countryside between it and Subiaco to the north has long been known as the area that inspired Poussin and Claude Lorrain. Olevano was "rediscovered" in 1804 by Tyrolese painter and longtime Roman resident Joseph Anton Koch, who soon introduced the area to his artist-friends, including Washington Allston. In the decades that followed it became a favorite retreat for German painters. Its visitors ranged from Nazarenes, such as Ferdinand Olivier and Schnorr von Carolsfeld in the 1820s, to painters from Düsseldorf, such as Johann Wilhelm Schirmer, toward midcentury. By the 1850s it had become a familiar destination for touristic strolls and Sunday carriage rides, so it was only natural that Bierstadt and his friends soon made their way there. Artists were attracted to Olevano by its architecture, or the olives and grapes farmed there, or the chalk cliffs in the area.[1] Bierstadt's rendition, one of his largest and most elaborate oil sketches, focuses on the hill town itself. It is a "composition study" of the type commonly made in Düsseldorf, with tack holes in the corners and reference points inscribed along the bottom.[2] Although reworked in places, it has the freshness and precision of a view made in close reference to the site.

Bierstadt set up his easel at the northern part of town, on a hill called Colle Baldi, at the side of a road that today overlooks an olive grove, as it probably did in the

Fig. 1. Albert Bierstadt, *Olevano*, 1860. Oil on canvas. Butler-McCook Collection, Antiquarian and Landmarks Society, Hartford, Connecticut.

artist's time. From there Olevano stretches out exactly as it appears in the sketch, its stuccoed buildings catching the morning light and the man-made hill echoing the natural ones beyond it. From this vantage point, Bierstadt recognized the potential for a composition with metaphorical resonance. Making his one departure from strict visual truth, he separated the thirteenth-century Castello dei Colonna at town's summit from the adjacent buildings, so that the town appears divided into two parts, one in light, the other in shadow. By opposing the crowded, erect, sun-bathed houses below to the shadowy, solitary, shell of the castle above, he suggested a symbolic contrast of vigor and demise, life and death — the sort of dramatic treatment associated with medieval sites in northern Europe.

This sketch preserved an evocative motif that Bierstadt later used as the focal point of a larger canvas (fig. 1). At its right he reintroduced a figure rubbed out of his sketch, a peasant woman adapted from one of his many costume sketches.[3] Framing the castle ruin more elaborately than in the sketch, he extended the panorama of the background so that it dips into a broad

John Gadsby Chapman

Born Alexandria, Virginia, 1808;
died Staten Island, New York, 1889

river valley below, recreating a perfect Italianate landscape in Claude's countryside.

D. STRAZDES

1. See, for example, Franz Horny, *View of Olevano*, pen and wash (1822, Staaliche Museen, Berlin); Michael Neher, *Frauen am Brunnen in Olevano*, oil on canvas (1826, Germanisches Nationalmuseum, Nürnberg); Jean-Baptiste-Camille Corot, *View of Olevano*, oil on canvas (1827, Kimbell Art Museum, Fort Worth, Texas); and W.S. Haseltine, *Oleavana* [sic], pencil and wash (1858, The Metropolitan Museum of Art, New York).

2. From left to right Bierstadt wrote "Volatre," "Olivano," "Roco San Stafano," and "Kapranika," probably referring to the town Velletri seventeen miles to the southwest, Olevano directly ahead, the village Rocca San Stefano 4 miles to the north, and the village Capranica Prenestina 4 miles to the east.

3. Albert Bierstadt, *Italian Costume Studies*, 1857, Lyman Allyn Art Museum, New London, Conn.

John Gadsby Chapman's first trip to Europe in 1828 was financed by loans and gifts from friends and by commissions to copy Italian old masters. After visiting Paris, Chapman proceeded to Rome. On May 4, 1830, Chapman took a month-long sketching trip with Samuel F. B. Morse to some hill towns east of Rome (Tivoli, Vicovaro, Subiaco, and Olevano). A few weeks later, Chapman, Morse, and two others visited the area around Naples, including Capri, Sorrento, and Amalfi.

While in Rome, Chapman painted Hagar and Ishmael Fainting in the Wilderness, which Dunlap reports was the first American work to be published in Rome, engraved for the Giornall di Belle Arti in November, 1830. This painting had probably been commissioned by John Linton of New Orleans (after whom Chapman named his first son) as it was in Linton's possession in 1834. He also made a copy of Guido Reni's Aurora for James Fenimore Cooper. Chapman next went to Florence to study for six months, where he painted a portrait of Horatio Greenough. He then visited Bologna, Venice, Milan, and Paris, arriving back in New York on August 23, 1831 with his friend George Cooke on the Helvetia.

In the spring of 1848, Chapman with his wife, two sons and daughter sailed for Europe to begin his second trip to Italy. After waiting for several months in London for revolutions on the Continent to subside, the Chapmans spent a year in Paris. They reached Florence by November, 1849, where they stayed on the Piazza Santa Maria Novella. By the end of 1850, they had settled in Rome at 135 Via del Babuino, in a top-floor studio-apartment with windows looking towards St. Peter's. Aside from brief trips back to the United States in 1859 and 1877, Chapman remained in Rome until 1884. He made his living catering to American and British tourists, painting small oils and prints and accepting commissions for larger paintings, such as Harvesting on the Roman Campagna, of which

there are several versions in American museums. As an expatriate living in Rome, Chapman often entertained American visitors and made lodging arrangements for friends, including William Cullen Bryant. Of his choice to reside in Rome, Chapman wrote in 1854, as quoted in William P. Campbell, John Gadsby Chapman: Painter and Illustrator, Washington, D. C., 1962:

I have every reason to be happy and contented....In a professional point of view I have all that I could desire, facilities of study and production, quiet, profitable association with art and artists of every nation at all times, and...[I am] free from the wearing toil that I formerly endured in New York.

John Gadsby Chapman

66. *Castel di Leva, Near Rome*, 1874
Oil on canvas, 28½ x 72 in.
Signed l.c.: 18 JGC (in monogram) 74/ ROMA
Peter Tillou Fine Arts Gallery, London

In 1859 a correspondent for the *Crayon* wrote the following description of Chapman's work in Italy:

During Mr. Chapman's residence abroad he has been faithfully at work; he has explored the environs of Rome for artistic material, and has made himself thoroughly acquainted with the people and scenery of that region, the result of which is a series of pictures of Italian life, character, and landscape in almost every style of art. Few of his works are visible in our exhibitions; but they are widely distributed through the country. Travellers possess them to the greatest extent. His compositions illustrate the picturesque aspects of Italian peasant life, associated with the ruins of the Campagna and with the landscape charms of the mountains near Rome, and they constitute some of the most prized souvenirs of an American traveller's sojourn in Italy.[1]

Castel di Leva, a tiny village on the Via Ardeatina about eight miles south of Rome, is the site of the Sanctuary of the Madonna del Divino Amore (Virgin of Divine Love). In the fourteenth century an unknown artist had painted a fresco of the Virgin on a wall of the medieval castle in this town. When in 1740 a missionary priest attributed his miraculous escape from a pack of ferocious dogs to this image of the Virgin, it quickly became a popular destination for pilgrims. In 1745 a church, whose bell tower is visible in the painting, was erected to shelter the fresco. The feast day of the sanctuary is still celebrated on the Monday after Pentecost and attracts many pilgrims from Rome and Albano.

Sir William Gell's description of the town and its festival in *The Topography of Rome and Its Vicinity* (1834) is remarkably similar to Chapman's depiction of the scene forty years later:

At present the buildings here consist of the church and a farm-house, with large outhouses for hay, called in the Roman states *Fenili* A religious festivity is held here in the month of May, at which the lower classes of all the neighbouring villages are accustomed to attend. These poor people often pass the previous night in the fields near the church, bringing with them wine and provisions, with which they regale themselves so copiously, that on the day of the feast a scene of indescribable riot and confusion almost invariably ensues.[2]

Italian peasant life had been the subject of paintings since the seventeenth century when the *Bamboccianti*, beginning with the Dutch artist Pieter van Laer (1592-1642), who painted scenes of the everyday life of the people of Rome. Italian artists and Northern artists, captivated by the colorful costumes and picturesque daily life of Italian peasants, continued the tradition into the nineteenth century. Achille Pinelli (1809-1841) painted a watercolor of the festival of the Madonna del Divino Amore (1832, Museo di Roma). Danish artist Wilhelm Marstrand (1810-1873), who was influenced by Pinelli and his father Bartolomeo, painted *La Festa delle Ottobrate* (1839, Thorvaldsens Museum, Copenhagen), which is similar in setting and spirit to Chapman's painting.[3] American artists and writers were also interested in peasant themes. William Wetmore Story wrote about daily life in Rome in *Roba di Roma* in 1887, describing in detail the worship of the Madonna (cat. 163).

Mrs. Alexander Mitchell, wife of the president of the Chicago, Milwaukee and St. Paul Railroad, commissioned Chapman to paint *Castel di Leva*, one of his largest paintings. Mrs. Mitchell traveled frequently to Europe and was known for her encouragement of the arts through support of art education, by giving exhibitions of works imported from Europe at her own expense, and through her patronage.

J. COMEY

1. *Crayon* 6 (Dcember 1859), pp. 379-380. The best sources for information about Chapman are William P. Campbell, *John Gadsby Chapman* (Washington, D.C.: National Gallery of Art, 1962), Louise F. Catterall, ed., *Conrad Wise Chapman* (Richmond, Virginia: The Valentine Museum, 1962), and Regina Soria, "John Gadsby Chapman e Conrad Wise Chapman, pittori americani nella Roma dell'ottocento," *Strenna dei Romanisti* 24 (April 1963), pp. 432-435.

2. Sir William Gell, *The Topography of Rome and its Vicinity*, (London: Saunders and Otley, 1834), vol. 1, pp. 277-278.

3. See Harald Peter Olsen, *Roma com'era nei dipinti degli artisti danesi dell'Ottocento* (Rome: Newton Compton editori, 1985), p. 166.

John Gadsby Chapman

66. *Castel di Leva, Near Rome,* 1874

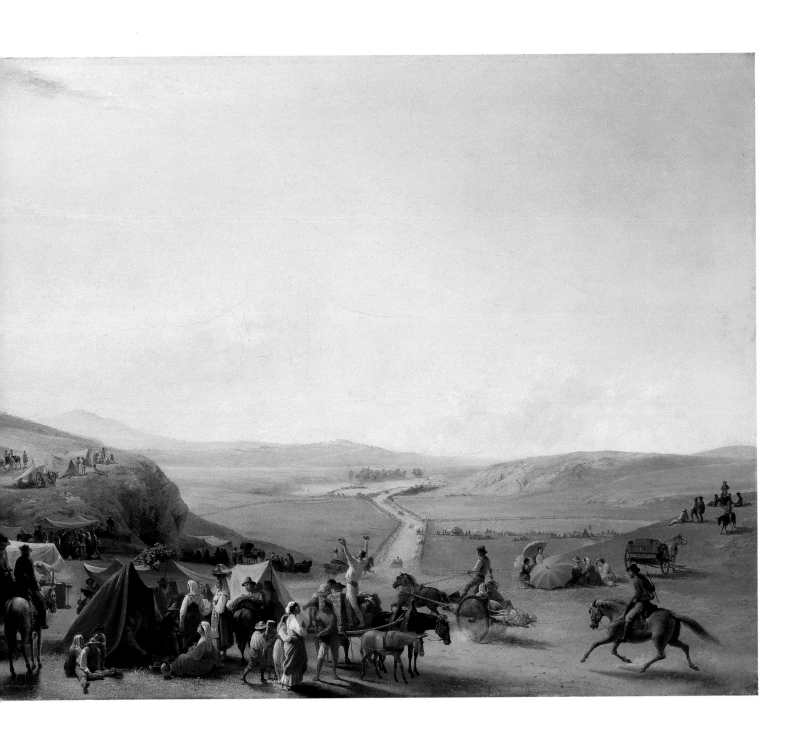

George Inness

67. *Lake Albano,* 1869
Oil on canvas, 30⅜ x 45⅜ in.
Signed l.l.: Geo. Inness 1869
The Phillips Collection, Washington, D. C.

Like nearby Lake Nemi, Lake Albano was a favorite stop for Grand Tourists steeped in the classics. The shores of Lake Albano were traditionally thought to be the site of Alba Longa, founded in 1152 B.C. by Ascanius-Julius, Aeneas's son, which according to Virgil was the capital of the Aeneadae until Romulus and Remus founded Rome. Thus Lake Albano was viewed as one of the very foundations of Roman civilization. Lake Albano was also well known for a feat of Roman engineering described by Livy and Cicero. The Emissarium, or subterranean drainage tunnel, a mile and one half long was excavated in 397 B.C. through solid peperino and basaltic lava and still serves to drain any excess water from the lake. Nineteenth-century guidebooks also described the nearby ruins of Emperor Domitian's great villa and the purported sepulchral monument of the Horatii and Curiatii, whose tragic battle was immortalized in David's famous painting of the *Oath of the Horatii* (1785, Musée du Louvre, Paris).

Tourists and artists were also drawn to the Alban Hills by the moderate summer temperatures and healthy air and by the beauty of this volcanic lake. Situated on the Via Appia about fifteen miles southeast of Rome, Lake Albano was by the 1870s just a short train ride (1¼ hours) from Rome. The papal summer residence is situated at Castel Gandolfo on the northwest rim of the lake. George Hillard, in 1853, described the views of the lake as "of such varied beauty that the pleasure of passing over it only once is alloyed by the thought that it is not to be traversed a second time." Calling it "one of the most beautiful sheets of water in Italy or anywhere else," Hillard found that his "mind seemed prepared for, almost to expect, communications from some sources higher than itself, and the mood which came over

Fig. 1. Jean-Baptiste Camille Corot (French, 1796-1875), *View Near Naples,* 1841. Oil on canvas. The Museum of Fine Arts, Springfield, Massachusetts, The James Philip Gray Collection.

it recalled and explained the fine visions of Greek mythology."[1]

Lake Albano must have had a similar effect on George Inness because he chose Lake Albano as the setting for this idyllic scene of country life.[2] In selecting this tranquil landscape as the site for a rustic country dance, Inness carried on the tradition of the ideal landscape which dates back to Claude Lorrain, who also painted Lake Albano.[3] Here, Inness paints an Arcadian scene with contemporary Italians replacing the classical figures in Claude's paintings of a peaceful, pastoral life. Watched by the couple in the left foreground, two men dance, arms upraised, while others sit conversing or stroll and view the lake. The remains of a picnic, complete with jug of wine, occupy the foreground of the painting. The motif of figures dancing surrounded by a circle of onlookers has special Arcadian resonance; like Inness, both Claude in *The Marriage of Isaac and Rebecca* (1648, National Gallery, London) and Corot in *View near Naples* (fig. 1) include such a grouping near a lake or bay.

Inness pays homage to Claude not only in his choice of subject matter but also in his compositional devices. The road up

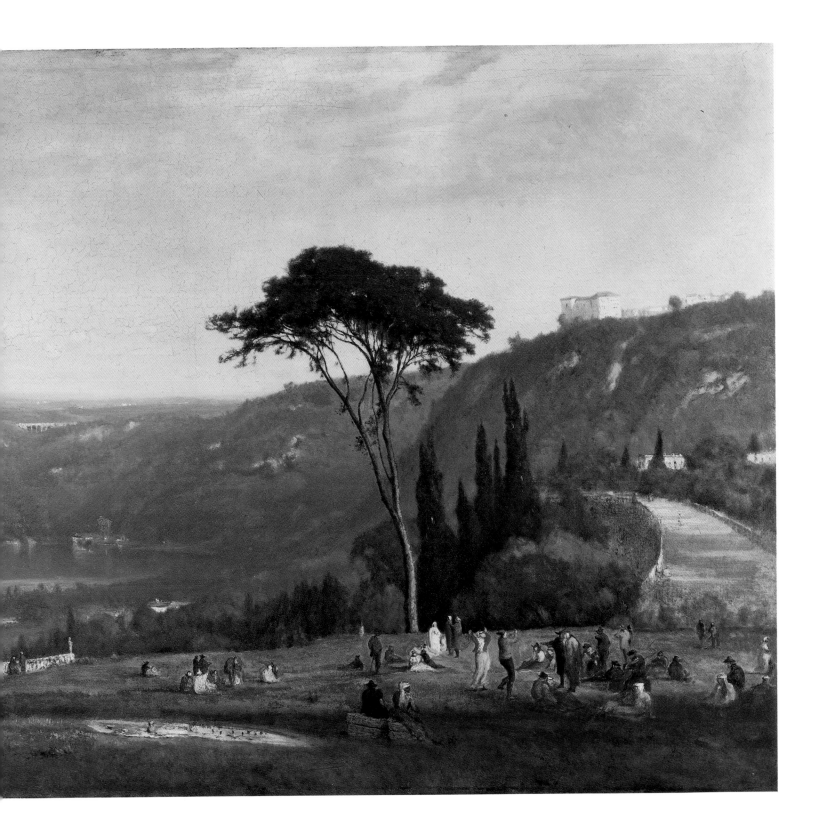

George Inness

68. *Lake Nemi*, 1872

Oil on canvas, 30 x 45⅞ in.
Signed l.r.: Inness Nemi 1872
Museum of Fine Arts, Boston, Gift of the Misses Hersey

the hill to the right, for instance, leads the eye into the receding planes of the painting; the tall stone pine tree in the center acts as a fulcrum balancing the two unequal sections of the composition. The shadow in the right foreground, the gleaming viaduct in the background, and the misty distant view of the horizon are also reminiscent of Claude's paintings of the Virgilian landscape.

Thus in the nineteenth century, American artists continued the pastoral landscape tradition, inspired by the Italian countryside and by the old masters. Cole's *Dream of Arcadia* (cat. 13), and Inness's *Lake Albano* are evocations of the Golden Age and appealed to the imagination, to the taste for classically balanced landscape, and to those who saw Italy through the words of Virgil.

J. COMEY

1. George Stillman Hillard, *Six Months in Italy* (Boston: Ticknor, Reed, and Fields, 1853), vol. 2, p. 203.

2. Although LeRoy Ireland, *The Works of George Inness* (Austin: The University of Texas Press, 1965), lists nineteen paintings that include "Albano" in their titles, there are only about four paintings that actually include Lake Albano: the present painting, no. 465, two similar views across the lake to Castel Gondolfo, nos. 564 and 792, and *A Glimpse of the Lake, Albano, Italy*, no. 568. The other works appear to be scenes from the surrounding countryside in the Alban Hills.

3. Since Claude painted one of his rare topographical views of Lake Albano in the seventeenth century, it has appealed to both European and American artists. British artists of the eighteenth century, such as Richard Wilson and Joseph Wright of Derby painted the lake and Thomas Jones described the area in 1776 as the "Magick Land," and in the nineteenth century, Turner and Corot were among those to paint in the area. John Izard Middleton, who included several views of the lake in his *Grecian Remains in Italy* (cat. 152), was the first American to paint Lake Albano. Christopher Pearse Cranch painted *Castel Gondolfo, Lake Albano* (Corcoran Gallery of Art, Washington, D.C.) in 1852, and Worthington Whittredge painted *Lake Albano, Castel Gandolfo, Italy* (University of Arizona Museum of Art) probably between 1854 and 1857.

"No one who has seen the calm water of the Lake of Nemi, lapped in a green hollow of the Alban Hills, can ever forget it." Thus began Sir James Frazer, Scottish classicist and anthropologist, in his pioneer study of magic and religion, *The Golden Bough*, first published in 1890.[1] He went on to describe the barbarous ritual of the ancient cult of Diana Nemorensis, whereby the high priest, usually a runaway slave, gained office by slaying his predecessor after plucking a golden bough from a certain tree in the grove on the shores of Lake Nemi. This practice, which may have persisted as late as A.D. 150, was well known to visitors to the area from the ancient Roman writers, Virgil and Strabo, to the twentieth-century travel writer, H. V. Morton.[2]

Formed in the crater of an extinct volcano about seventeen miles southeast of Rome, Lake Nemi is nearly circular (about 3½ miles in circumference) with wooded slopes so steep that hardly a breeze can disturb the water surface. It was therefore known to the ancients as Speculum Diana or the mirror of Diana. Lake Nemi has been famous since antiquity not only for the strange rite of succession for the high priest of Diana but also for its scenic beauty and as the resting place for two ships built during the reign of the Roman Emperor Caligula (A.D. 37-41).

The two ships were discovered on the bottom of the lake in 1446 by Leon Battista Alberti and were finally raised in the late 1920s by partially draining the lake. These fascinating artifacts from the ancient world were unfortunately burned by the retreating Germans in 1944. It is not known whether they were pleasure craft or had a connection with the rites of Diana but their discovery was discussed in nineteenth-century travel books and no doubt added to the lure of the lake.

Since the seventeenth century, Lake Nemi has been one of the most frequently painted landscapes in Italy. Beginning with Claude Lorrain and Gaspard Dughet, the lake has attracted the leading landscape painters of each century.[3] John Izard Middleton was the first American to paint Lake Nemi in 1808-09. Thomas Cole included a view of Lake Nemi in *Il Penseroso* (cat. 15) and Jasper F. Cropsey, Joshua Shaw, and Sanford R. Gifford (cat. 62) also painted views of this site. American poets and travel writers visited the area, too. Both Henry Wadsworth Longfellow (in a letter to his mother) and Augustus J. C. Hare (in *Days Near Rome*) quote Byron's description, "Lo, Nemi! navelled in the woody hills . . ." from *Childe Harold*, which Longfellow found "conveys you a perfect picture of the scene."[4]

Inness painted Lake Nemi during his first trip to Italy in 1851-52; it is visible in his *View of Genzano*. Inness completed the present painting in 1872 during his second trip to Italy. He apparently painted this view from the grounds of the Capuchin monastery with the Palazzo Cesarini (built in 1621 for Prince Guiliano Cesarini) visible in the distance. While he painted at least ten views of Lake Nemi,[5] Inness seems to have been particularly pleased with this effort. He wrote to the purchaser, Mr. A. D. Williams of Roxbury, Massachusetts, from Albano on August 13, 1872:

> Your picture was shipped on the 21st of June with several others to W. & E. [Williams and Everett, Inness's Boston dealer] with directions to them to deliver it to you. I thought this the better way, as it would save some expense to both you and them. I trust that you will find the picture of Lake Nemi one of my very best, as I intended it should be, and I am happy to say was so looked upon by all who saw it at my studio. You can assure Mrs. W. that among the

many Ladies who saw my pictures before I sent them away there was but one, who did not like hers better than any I had. I hope she may be as well pleased with it, the knowledge of which would be very grateful to/Yours Truly/Geo. Inness.[6]

Mrs. Williams later wrote to the subsequent owners in about 1905 that the painting "was a great favorite with Mr. Inness. He told me himself most exultantly that at last he had got an atmosphere he had been trying for all his life."[7] With this misty atmosphere, Inness succeeded in capturing not only nineteenth-century Italy with the solitary Capuchin monk but also the lake's mysterious nature which has affected visitors since antiquity.

J. COMEY

1. Sir James George Frazer, *The New Golden Bough* (New York: Criterion Books, 1959), p. 3.

2. Aeneas in Virgil's (70-19 B.C.) *Aeneid*, also plucks a golden bough, which becomes a symbol of his right to rule in Italy. And Strabo (b. 63 B.C.), the Greek geographer and historian, wrote a comprehensive description of Lake Nemi. H. V. Morton in *A Traveller in Rome* (New York: Dodd, Mead & Company, Inc., 1957) describes Lake Nemi as "dark and gloomy" and recounts the stories of the high priest of Diana and of the sunken Roman ships, pp. 219-221.

3. Claude Lorrain, Gaspard Dughet, and Claude Joseph Vernet, as well as such Dutch view-painters as H. F. van Lint, painted Lake Nemi in the seventeenth century. British landscapists, Richard Wilson, Thomas Jones, John Robert

George Inness

69. *The Monk*, 1873
Oil on canvas, 38½ x 64⅛ in.
Signed l.r.: G. Inness 1873
Gift of Stephen C. Clark, Addison Gallery of American Art,
Phillips Academy, Andover, Massachusetts

Cozens, French artists, Charles-Joseph Natoire and Pierre-Henri de Valenciennes, and the German landscapist, Philipp Hackert sketched and painted Lake Nemi in the eighteenth century. During the nineteenth century, an international group of artists including Camille-Jean-Baptiste Corot (French, 1796-1875), J.M.W. Turner (British, 1775-1851), Leon Cogniet (French, 1794-1880), J.A. Knip (Dutch, 1777-1847), Abraham Teerlink (Dutch, 1776-1857), and Johann Joachim Faber (German, 1778-1846) was active in the area.

4. Henry Wadsworth Longfellow to his mother, July 11, 1828, in Andrew Hilen, ed., *The Letters of Henry Wadsworth Longfellow* (Cambridge, Mass.: Belknap Press of Harvard University Press, 1966), p. 274. Augustus J.C. Hare, *Days Near Rome* (Philadelphia: Porter & Coates, 1875), p. 87.

5. Leroy Ireland, *The Works of George Inness* (Austin: The University of Texas Press, 1965) lists the following paintings by Inness of Lake Nemi or that are probably of Lake Nemi: nos. 70, 131, 132, 537, 538, 560, 561, 572, 573, 574, 623.

6. Letter in Museum of Fine Arts, Boston, Paintings Department Files.

7. Undated letter in Museum of Fine Arts, Boston, Paintings Department Files from Susi F(?) Williams to Mr. and Mrs. Hersey.

Inness painted *The Monk* (also known as *The White Monk* and *The Pines and The Olives*) in 1873 during his second visit to Italy. Its setting is thought to be the Villa Barberini on the outskirts of Castel Gandolfo, the summer residence of the Pope, about fifteen miles southeast of Rome. Although the Villa Barberini is now property of the papacy, during the nineteenth century it was open to the public, and American artists such as William Stanley Haseltine, John Gadsby Chapman, and Inness himself painted its famous pines.[1] Augustus J. C. Hare, a British travel writer popular with Americans, described the area in 1875:

> Clambering up the hill again, we find the height crested by the fine trees overhanging the wall of the Villa Barberini. The beautiful grounds of this villa may always be visited by strangers and present an immense variety of lovely views, from a foreground, half cultivated and half wild, ending in a grand old avenue of umbrella pines.[2]

However, in painting *The Monk* Inness seems less interested in depicting topographical detail than in expressing a quiet, melancholic mood. The horizontal format, dark pigments, time of day, and presence of the monk contribute to the mournful aspect of the painting, which may have been Inness's response to the death of one of his daughters in Rome.[3] There are affinities with another famous and rather enigmatic image on the theme of death, painted by the Swiss-German artist, Arnold Böcklin, who had also visited Italy. Böcklin's *Island of the Dead*, of which he painted five versions from 1880 to 1886, includes a mysterious white-clad figure, dark tonalities, and cypress trees, symbolic of mourning. While Inness's painting is less overtly concerned with death (Böcklin was actually commissioned by a widow to paint a picture on the theme of

bereavement), it is part of a Romantic tradition that utilized landscape as a vehicle to convey deep emotions.

The Monk is not only Inness's most haunting image of Italy but also perhaps the most stylistically progressive painting of his Italian sojourn. Dark and brooding, the landscape recalls such earlier American Romantic painters as Allston (cat. 12) and is a forerunner of the mysterious images of Ryder. Its meditative qualities — evoked by the solitary, inward-looking monk and the dreamlike stillness of the setting — are paralleled in the works of such German Romantic painters as Caspar David Friedrich, especially the *Monk by the Sea* (1809, Nationalgalerie, Staatliche Museen Preussischer Kulturbesitz, Berlin). But in its formal qualities — the flatness of the composition and the elegant silhouette of the stone pine trees against the sky — the work prefigures Symbolist art of the late nineteenth century.

Until purchased in 1941 by Stephen C. Clark, a New York collector and chairman of the board of The Museum of Modern Art as well as a trustee of The Metropolitan Museum, *The Monk* was largely ignored in the literature about Inness's work. However, after it was included in the landmark exhibition "Romantic Painting in America" at The Museum of Modern Art in 1943, it became one of Inness's most well-known works. E. P. Richardson called it the "most monumental of all his works."[4]

J. COMEY

1. See John Gadsby Chapman, *Pines of the Villa Barberini* (1856, Museum of Fine Arts, Boston). For William Stanley Haseltine, *Villa Barberini, Albano*, see Edgar P. Richardson and Otto Wittmann, Jr., *Travelers in Arcadia: American Artists in Italy, 1830–1875* (Detroit: Detroit Institute of Arts, 1951), p. 39, no. 52. Inness executed at least nine paintings of the site. See Leroy Ireland, *The Works of George Inness* (Austin: The University of Texas Press, 1965), nos. 566, 596, 597, 656, 657, 658, 671, 786, and 788 and possibly 539.

2. Augustus J. C. Hare, *Days Near Rome* (Philadelphia: Porter & Coates, 1875), p. 71.

3. Alfred Trumble in a memorial to Inness in 1895 reported that "a daughter died while the family resided in Rome and is buried there in the Protestant cemetery." See Alfred Trumble, *George Inness, N. A.: A Memorial of the Student, the Artist, and the Man* (New York City: "The Collector," 1895), p. 23.

4. E. P. Richardson, *Painting in America* (New York: Thomas Y. Crowell Company, 1956), p. 304.

George Inness

70. *Ariccia*, 1874
Oil on canvas, 26½ x 57 in.
Signed l.r.: G. Inness 1874
Putnam Foundation Collection, Timken Art Gallery

Located between Lake Albano and Lake Nemi on the Via Appia Nuova, about sixteen miles southeast of Rome, Ariccia was for centuries a retreat for Romans escaping the oppressive summer heat. The town was described by Henry Wadsworth Longfellow, in the summer of 1828, when the poet traveled there to recover from an illness contracted in Rome:

[It is] a very delightful spot — situated on a gentle hill, surrounded for miles with beautiful forest scenery . . . and the interchange of hill and vale — of woodland and cultivated fields, reminds me more of New England than anything I have seen on the continent.[1]

Ariccia was also a haven for artists, as Longfellow noted in his travel book *Outre-Mer*:

During the summer months, La Riccia is a favorite resort of foreign artists who are pursuing their studies in the churches and galleries of Rome. Tired of copying the works of art, they go forth to copy works of nature; and you will find them perched on their camp-stools at every picturesque point of view, with white umbrellas to shield them from the sun, and paint-boxes upon their knees, sketching with busy hands the smiling features of the landscape.[2]

Painters from many countries had traveled to this picturesque hill town since the seventeenth century. Prosper Barbot, a friend of Corot, wrote after traveling to Ariccia from Rome, that he found "a numerous company of landscapists of all countries: four compatriots, plus Italians, Germans, English, Russians."[3] Among the Americans who painted here were Robert Weir, George Loring Brown, Jasper Cropsey, Sanford Gifford, and Russell Smith (fig. 1).[4]

Inness had visited the area around Ariccia during his first trip to Italy in 1851-52 when he painted a view of nearby Genzano on Lake Nemi for his patron, Ogden Haggerty. When he returned to the Alban Hills during his second trip to Italy (1870-74), he painted at least four views of Ariccia, including one very similar to the present picture and two done from the opposite direction.[5] In *Ariccia*, Inness includes the shallow dome of Bernini's masterpiece Santa Maria dell'Assunzione (1662) and to the right of this dome the towers of the Chigi Palace (1664), which was also designed by Bernini, who was the preeminent architect for the Chigi Pope, Alexander VII.

By using an especially wide canvas, Inness created a panoramic effect, a theatrical setting for dramatic atmospheric effects. He captured the shadows cast on the landscape and buildings in the town and depicted the roiling clouds with startling colors. Darius Cobb, his friend and fellow-artist, recalled Inness exclaiming that artists, "don't put color enough in their skies! Clouds will stand rich color."[6]

Inness structured his painting carefully. He created specific areas of contrast between the sharp-edged hardness of the man-made viaduct and geometric buildings and the softer edges of the trees, hills, and clouds. The movement of oxen and peasants and the wisps of smoke rising from the town and plain animate the scene. Like Corot, Inness sought to preserve the timeless qualities of man and nature that were increasingly threatened by progress in the nineteenth century, and Inness's cubical and spherical geometries, as well as the subtle variety of his greens and terra cottas, recall the structure and hues of Corot's paintings of Italy.

Inness sent *Ariccia* to Williams and Everett, the dealer in Boston who had sponsored his second trip to Italy. It was purchased by Arthur Hunnewell (1845-1904), a member of a prominent family of Boston and Wellesley, Massachusetts. His father, Horatio Hollis Hunnewell (1810-1902), had created the first Italian garden in the United States. The painting was later owned by Arthur's daughter, Jane Boit Hunnewell.

J. COMEY

1. Henry Wadsworth Longfellow to his mother, July 11, 1828, in Andrew Hilen, ed., *The Letters of Henry Wadsworth Longfellow* (Cambridge, Mass.: The Belknap Press of Harvard University Press, 1966), vol 1, p. 274.

2. Henry Wadsworth Longfellow, *Outre-Mer, A Pilgrimage beyond the Sea* (Boston: Ticknor and Fields, 1859), p. 354.

3. Quoted in Peter Galassi's excellent *Corot in Italy* (New Haven: Yale University Press, 1991), p. 134. The long list of European artists who sketched and painted Ariccia begins with Gaspard Dughet (French, 1615-75) and Gaspar van Wittel (Dutch, 1653-1736) and includes such British artists as Richard Wilson (1714-1782), Francis Towne (1739/40-1816), John Robert Cozens (1752-1797), and J. M. W. Turner (1775-1851), German artist Jacob Philipp Hackert (1737-1807), as well as Abraham Louis Ducros (Swiss, 1748-1810), and Jean-Auguste-Dominique Ingres (French, 1780-1867).

4. Robert Weir painted *The Duke of Bourbon's Halt at LaRiccia* (private collection) in 1834. Jasper Cropsey sketched in the area in 1848. George Loring Brown's *August Morning near Rome, Ariccia, Italy* (1855) is owned by the Mead Art Museum, Amherst College. Sanford R. Gifford wrote on October 7, 1856 that he had "walked to Arriccia [sic] . . . and through the beautiful little valley between Ariccia and Albano, which offers pictures ready-made at any turn. All this region is the favorite summer resort of the artists, and of the Roman nobility many of whom have villas here," (Gifford to Elihu Gifford, "European Letters." Private collection).

5. In paintings that Leroy Ireland, *The Works of George Inness* (Austin: The University of Texas Press, 1965) lists as nos. 570 *Viaduct at Laricha, Italy* and 595 *Albano, Italy*, Inness painted the viaduct, built in 1846-53, which connects Albano and Ariccia and is not visible in the present picture. Inness painted a view similar to *Ariccia*, probably from the southeast near the road to Galloro, in Ireland no. 648 *The Roman Campagna or Albano*. These three similar paintings are incorrectly titled but are recognizably of Ariccia.

6. Stanwood Cobb, "Reminiscence of George Inness by Darius Cobb," *The Art Quarterly* 26 (summer 1963), p. 241.

Fig. 1. Russell Smith (American, 1812-1896), *Near Rome, Aric-cia*, 1860. Oil on canvas. Photograph courtesy D. Wigmore Fine Art, Inc.

Elihu Vedder

Born New York, New York, 1836;
died Rome, Italy, 1923

After departing New York in 1856, Vedder arrived in Genoa from Paris in May 1857, and spent the summer traveling throughout northern Italy. He stayed in Rome for the month of July and also visited Venice for several weeks. In the late summer he settled in Florence, where he remained for the duration of this first Italian sojourn, using the city as a base from which to explore smaller towns such as Volterra, Siena, Pisa, and Perugia as well as the countryside of Tuscany and Umbria. His Florentine circle of friends included Charles Caryl Coleman, whom he had met in Paris; Thomas Hiram Hotchkiss; Nino Costa, the Macchiaioli painter; and Kate Field, a Bostonian who became a staunch supporter.

At the end of 1860 Vedder left Italy for the United States, where he divided his time between New York and Boston. In Boston he found his first and sustained patronage. Kate Field introduced Vedder to John LaFarge and William Morris Hunt, among others. He returned to the continent in December 1865, and, after almost a year in France, arrived back in Italy at the end of 1866. In 1867 and 1868 Vedder spent the winter months in Rome, leaving the city for Umbria in the summers with Coleman and Hotchkiss. Also in 1867, Vedder made his first trip down the southern coast of Italy, reaching at least as far as Naples and Pompeii.

Vedder left Italy briefly at the end of 1868 to marry Carrie Rosekrans the following summer; they returned from her family's home in Glens Falls, New York, by way of London. By September 1869 they were in Bordighera, and in October reached Rome, where Vedder kept a studio for the rest of his life. After his marriage, Vedder considered Italy his home, though he returned frequently to the United States for exhibitions.

Vedder and his growing family spent summers in Perugia from 1871 to 1879, but in 1880 Viareggio, on the coast north of Leghorn, became their warm weather destination. In 1900, Vedder built a villa on Capri, Torre Quattro Venti, though he retained his studio in Rome.

Elihu Vedder

71. *Bordighera*, 1872
Oil on canvas, 27½ x 15 in.
Signed l.r.: 18V72
*The Currier Gallery of Art, Manchester, New Hampshire,
Gift of the Friends*

Bordighera is located on the Ligurian coast in the foothills of the Maritime Alps, near Italy's border with France. Vedder first visited the hill town, about twenty miles east of Nice, in the spring of 1857, traveling from Paris to Rome. He returned to Bordighera for three weeks toward the end of 1866, again en route from Paris to Rome, with Carrie Rosekrans, Charles Caryl Coleman (see cats. 100, 105) and Coleman's mother, who served as chaperone. Vedder's biographer, Regina Soria, suggests that Rosekrans and Vedder may have become engaged during this stay in Bordighera.[1] Three years later, in September 1869, the Vedders spent part of their honeymoon in the hill town; for them Bordighera was associated with "happy days."[2]

Vedder's *Bordighera* is exceptional in both its subject matter and its composition. American landscape artists rarely depicted the narrow streets and cramped architecture of the Italian hill towns, preferring instead the panoramic views *from* these sites. For Vedder, however, these less familiar townscapes became a key part of his oeuvre, possibly due to his association with the Macchiaioli, who had turned away from the grandiose themes of history painting to unpretentious scenes of local subjects.

Vedder frequently used a very vertical composition, perhaps finding that it emphasized the close buildings and the winding streets of hill town subjects. In the late 1860s Vedder painted vertical compositions of San Remo and Perugia in addition to Bordighera; at the end of the next decade he returned to this format for views at Subiaco and Tivoli.[3]

Bordighera, dated 1872, was painted in the studio from sketches Vedder produced during either the 1866 or the 1869 visit to the town.[4] In the early 1870s Vedder's various Bordighera subjects were popular with American visitors in Rome; he therefore

produced several versions.[5] In the 1872 painting, Vedder combined elements from earlier works into a new composition, a practice not uncommon for him. The basic vertical arrangement of the architecture framing the vista to the sharp descent to the plane below and mountains in the distance came from an earlier version of the same view.[6] Vedder took the motif of the hunched over man with his pipe as well as the sequence of the building, wall shrine, and garden on the right, from another painting, *Near Perugia* (1870, private collection).

K. QUINN

1. Regina Soria, "Vedder's Happy Days in Bordighera," *The Currier Gallery of Art Bulletin* (January - March 1970), p. 8. In her biography of Vedder, *Elihu Vedder American Visionary Artist in Rome*, (Cranbury, New Jersey: Associated University Presses, Inc., 1970), p. 50, however, Soria states that Vedder and Carrie became engaged before they left Paris.

2. One of the oil sketches Vedder painted during this honeymoon trip is dated August 1869 and inscribed "At Lazeroni's with Carrie, happy days." See Soria, "Vedder's Happy Days in Bordighera," p. 6.

3. These include, for example, *San Remo — Old Stairway* (1866, The Museums at Stony Brook, New York), *Near Perugia*, 1867, (private collection) and *Tivoli, Near Rome*, about 1868 and *Little Shrine Subiaco*, about 1868 (both The Butler
Institute of American Art, Youngstown, Ohio).

4. See Appendix to Vedder's autobiography *The Digressions of V.*, (Boston: Houghton Mifflin Co., 1910), p. 471.

5. Between 1870 and 1872 Vedder painted at least four landscapes specifically identified as Bordighera. Bordighera was also used as the setting for figurative works such as *Girl Spinning with Archway and the Sea*. *Bordighera* (location unknown) may be the "Large Bordighera Landscape" purchased on March 3, 1872 for $500 by Henry A. Dike of New York (see Vedder, *The Digressions of V.*, p. 472 and Soria, "Vedder's Happy Days in Bordighera," p. 8). It is interesting to note that the patrons for the Bordighera landscapes of 1870-72 were all New Yorkers. Vedder had sold well in Boston, but to date he had found little market for his paintings in his hometown.

6. The earlier version is entitled *Bordighera Street* (location unknown) and is reproduced in Soria, "Vedder's Happy Days in Bordighera," p. 6, and dated 1869 in Soria, *Elihu Vedder American Visionary Artist in Rome*, p. 301.

Henry Roderick Newman

Born Easton, New York, 1843;
died Florence, Italy, 1917

72. *Gulf of Spezia*, about 1884
Oil on canvas, 57½ x 80 in.
Signed l.l.: H. R. Newman
Museum of Fine Arts, Boston, Tompkins Collection

Newman was already an established painter in New York and New England and a founding member of the Association for the Advancement of Truth in Art, a group devoted to the ideals of John Ruskin, when he traveled to Europe for the first time in 1870. After a few months in France, where he studied briefly with Gérôme and made elaborate studies of Chartres Cathedral, Newman journeyed to Italy through Switzerland. In September 1870 he arrived in Florence, where, save for an extended stay in Venice in 1871-72, he lived for the rest of his life. His home and studio, on the south side of the Arno at No. 1 Piazza dei Rossi, became a center of the city's expatriate community, and Newman found a ready market among American and English tourists for his highly detailed studies of Italian architecture. His meticulous watercolors earned him the acclaim of his mentor, John Ruskin, who purchased many of them; the two men became close friends. After his 1883 marriage to Mary Willis, an English-woman, Newman made almost annual winter trips to Egypt from 1887 to 1892. In 1893 they visited Athens, and in the late 1890s they went to Japan. Despite these extensive travels, Newman is most closely associated with Italy; he was eulo-gized in American Art News *as "the last of Florence's once famous circle of celebrated people."*

Fig. 1. Henry Roderick Newman, *Grapes and Olives*, 1878. Watercolor on paper. Mr. and Mrs. Wilbur L. Ross, Jr.

One of Henry Newman's favorite land-scapes, besides Florence, was the Gulf of Spezia, on the west coast of Italy halfway between the ports of Genoa and Livorno (Leghorn).[1] Newman painted several views of the bay from the small town of San Terenzo, on the east side of the bay near Lerici, a location his biographer, Henry Buxton Forman, described as "the lovliest spot in the whole Riviera del Levante."[2] The subject was unusual for an American artist, but, as Henry James reported, "the place is classic to all English travellers," and Newman was doubtless familiar with images of the picturesque gulf made by several British painters, including William Bartlett, James Baker Pyne, and Edward Lear.[3] The site was appealing not only for its rocky coast, punctuated by castles, but also for its tragic history — here in 1822, the great English Romantic poet Percy Bysshe Shelley drowned in a shipwreck; his body washed ashore some twenty miles to the south and was burned on the beach, under the supervision of Lord Byron, Leigh Hunt, and Italian health officials (see cat. 30).[4]

Newman first recorded this evocative vista in 1878, using it in the background of his watercolor *Grapes and Olives* of that year (fig. 1). In the summer of 1883, he returned to the area, and included the view south-east from San Terenzo in one of his best-known images, the large watercolor *Italy* (Collection of Mr. and Mrs. Leonard Mil-berg). In *Gulf of Spezia*, as in *Italy*, the dis-tance is held by the stone castle of Lerici, one of the many fortifications built along the coast in the thirteenth century to pro-tect the harbor at La Spezia, which had been an important naval base since Roman times. However, in *Gulf of Spezia*, Newman abbreviated evidence of man's civilizing hand, substituting in the foreground the steep, rugged coast with its wild vegetation

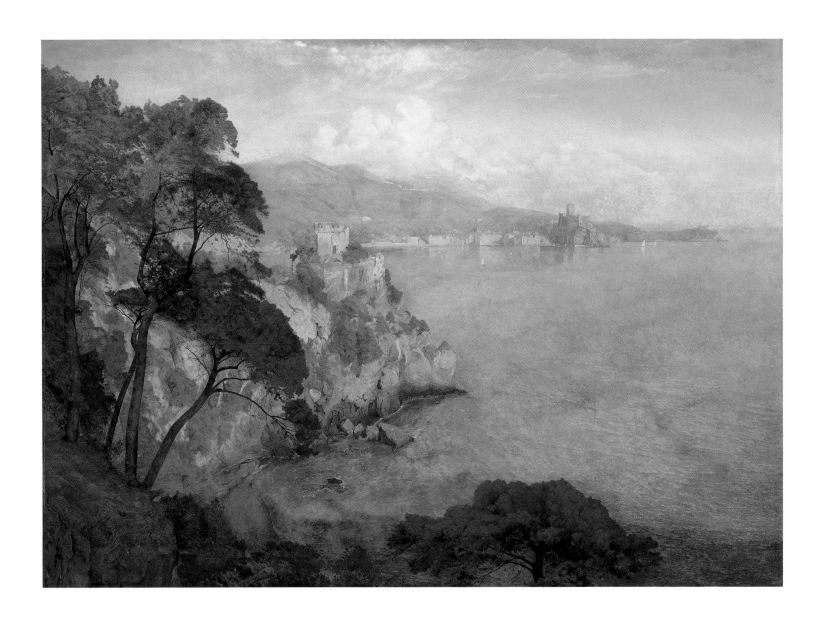

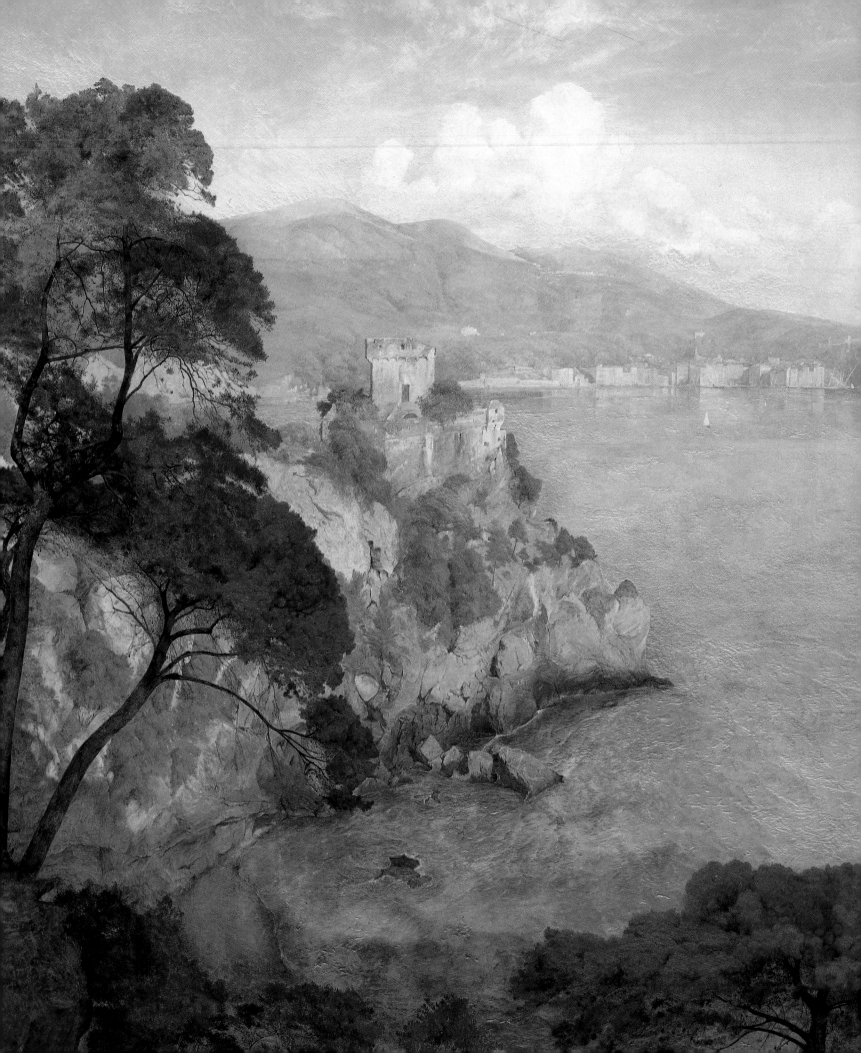

John Singer Sargent

73. *Villa di Marlia: A Fountain*, 1910
Watercolor on paper, 16 x 20¾ in.
Museum of Fine Arts, Boston, The Hayden Collection

and sharp bluffs for the ripe harvest he had included in *Grapes and Olives* or the classical column he had rendered in *Italy*.

Gulf of Spezia is unusually ambitious in scale and medium. Newman seldom worked in such a big format, or in oil, preferring instead the intimacy of works on paper.[5] Yet Newman fashioned *Gulf of Spezia* with the same exacting method he perfected in watercolor. He first coated the canvas with a light ground, and proceeded to apply his paint thinly, using a delicate stipple technique of tiny brushstrokes to render every feature of his subject. His procedure is uniform throughout the composition; both the distant hills and sea and the closest trees and rocks show the same precise attention to detail. The effect is somewhat disconcerting, for the viewer looks down into the rocky cove and across the bay to the large castle simultaneously, with no distinct emphasis on either outlook. Following Ruskin's dictum to treat each object with equal importance, Newman created a mesmerizing world where everything is in focus, as though it were viewed through a sharp lens.

Gulf of Spezia was on Newman's "principal easel in the best working light" when Forman wrote his biographical essay in 1884, and he described it as "a large canvas, an oil picture of the Gulf of Spezia, which is, I believe, soon to be shown in London, and which promised splendidly when I saw it in its early stage."[6] The painting was illustrated in Forman's essay, unframed and half-covered with drapery, amidst the artistic clutter of Newman's Florence studio. Its subsequent history is unknown, until its purchase by the Museum of Fine Arts in 1925.

E. HIRSHLER

1. I would like to thank Rob Leith for generously sharing with me his scholarly expertise on Newman's life and career; numerous details of Newman's itinerary, particularly the dates of his Egyptian visits, are the result of his research.

2. H. Buxton Forman, "An American Studio in Florence," *The Manhattan* 3 (June 1884), p. 536.

3. Henry James, "Italy Revisited," from *Italian Hours*, quoted in *Henry James on Italy* (New York: Weidenfeld and Nicolson, 1988), p. 72.

4. One of Newman's watercolors of the Gulf of Spezia, *Casa Magni, San Terenzo*, was reproduced as the frontispiece for H. Buxton Forman's edition of *The Prose Works of Percy Bysshe Shelley* (London: Reeves and Turner, 1880), vol. 4. Casa Magni was Shelley's home. This area had other popular associations as well, for it was the site of the exile of Dante, who was believed to have abandoned his manuscript of *The Inferno* at a convent in Lerici when he fled to France early in the fourteenth century.

5. Forman mentions another large Newman oil, of Venice, painted in 1881: "The canvas is about six feet by four, and represents Venice in the full heat and throb of a midsummer morning," (Forman, "An American Studio in Florence," pp. 534-535). The painting was a commission; after it was exhibited in Newman's studio in Florence, it passed into the hands of its American owner. Its current location is unknown.

6. Forman, "An American Studio in Florence," p. 539.

In the autumn of 1910, the Marchese Farinola, a friend of the artist, lent John Singer Sargent his Florentine villa, Torre Galli. Sargent made several pictures of his English friends the von Glehns (see cat. 44), Eliza Wedgewood, and Sir William Richmond and his wife enjoying the loggias and grounds of that estate, exploring combinations of figures and foliage in the bright Tuscan sun. But he complained that "so many studies have been started here with the Richmonds figuring in corners that I feel tired."[1] In October, Sargent retreated to another of Farinola's houses, near Lucca at Varramista. The luxurious gardens of several nearby villas, including the Villa di Marlia, provided him with new subjects for his ever-active brush.

Lucca, some seventy miles west of Florence, was described as "one of the pleasantest provincial towns in Italy."[2] Located in a fertile plain of vineyards, olive groves, and sunflower fields, it had been an important Roman municipality, where Julius Caesar met with Pompey and Crassus in 60 B.C. to form the First Triumvirate. The Roman legacy continued in the ordered grid of Lucca's streets, while the ruins of the large amphitheater became both the structural foundation of later buildings and a tourist attraction. During the Romanesque period, the city's distinctive fortified walls and two elaborate cathedrals were constructed; John Ruskin cited them as his inspiration to study architecture, noting that "for the first time I now saw what medieval builders were and what they meant."[3] After a period of domination by neighboring Pisa, Lucca survived as an independent city-state until 1799, when it fell to the invading French. In 1805, Napoleon gave Lucca to his sister Elisa, who, until the defeat of the Bonapartes in 1814, established herself at the Villa di Marlia.[4]

John Singer Sargent

74. *Carrara: Wet Quarries*, 1911
Watercolor on paper, 16 x 20¾ in.
Signed l.l.: John S. Sargent
Museum of Fine Arts, Boston, The Hayden Collection

Elisa Baciocchi purchased the seventeenth-century villa of the Orsetti family in 1806, rechristened it the Villa Reale Marlia, and transformed it into a lavish court, renovating and enlarging its original gardens to conform with a popular taste for the expansive lawns of English landscape architecture. By the early twentieth century, when Sargent visited the villa, it belonged to the son of Penelope Smyth, widow of the Prince of Capua. In his watercolor *Villa di Marlia*, Sargent ignored Elisa Baciocchi's efforts to modernize the estate and depicted instead the oldest part of the gardens, one of the rare seventeenth-century outdoor "rooms," formed by a long basin of water, balustrades, and enclosing walls culminating in a nymphaeum.

Sargent concentrated on the north end of the pool, where two stone reclining figures bearing water jars represent the Arno and Serchio Rivers. He carefully depicted the statuary, encircling balustrade, and the columnar corner of the stone background screen, which contained an alcove dedicated to Leda and the swan. Terracotta pots with lemon trees served to animate the architecture; Sargent rendered them with a few deft strokes of his brush, laying in the lightest colors first and then adding quick touches of darker green to define the negative space between the dense foliage. His mastery of the watercolor medium is clearly evident, for he has worked the whole range of tone from the clear white of blank paper where water pours from the fountain to thick washes of forest green in the shadowed background hedges. On top of these broadly defined areas, Sargent added texture by dragging contrasting colors across the surface with an almost dry brush and by applying paint with a sponge. In *Villa di Marlia: A Fountain*, Sargent demonstrated his own recommendation to students: "get abroad, see the sunlight, and everything that is to be seen."[5]

E. HIRSHLER

1. John Singer Sargent to Vernon Lee, quoted in Richard Ormond, *John Singer Sargent: Paintings, Drawings, Watercolors* (New York: Harper and Row, 1970), p. 76. The Torre Galli paintings include *Breakfast in the Loggia* (Freer Gallery of Art, Washington, D.C.), *At Torre Galli: Ladies in a Garden* (Royal Academy, London), and several watercolors in the Museum of Fine Arts, Boston.

2. *Baedeker's Handbook for Travellers: Northern Italy* (Leipzig: Karl Baedeker, 1889), p. 361.

3. John Ruskin quoted in Ethne Clark, *The Gardens of Tuscany* (New York: Rizzoli, 1990), p. 39. Ruskin's American protegé, Henry Roderick Newman (see cats. 72, 85-87), made several meticulous watercolors of Lucca's cathedral.

4. After 1814, Lucca was ruled by the Dukes of Parma (of the House of Bourbon); in 1847 it was ceded to Tuscany.

5. Evan Charteris, *John Sargent* (New York: Scribner's, 1927), p. 188.

Sargent traveled to the famous marble quarries at Carrara, some sixty miles northwest of Florence, in October 1911, toward the end of one of his annual trips to Italy. He was fascinated with the site, making an extended visit and filling a sketchbook with vigorous pencil drawings of the workers and large blocks of stone (Fogg Art Museum, Harvard University, Cambridge, Mass.). A friend reported that at Carrara, Sargent "slept for weeks in a hut so completely devoid of all ordinary comforts that his companions, far younger men, fled after a few days, unable to stand the Spartan rigors tolerated by their senior with such serene indifference."[1] In addition to his sketches, from which he would create two finished oil paintings, Sargent made a series of at least a dozen watercolors of the quarries.[2] Almost all of these watercolors were purchased by the Museum of Fine Arts, Boston, in 1912.

Carrara had long been a pilgrimage spot for artistic travelers. In 1823, travel-writer Matthias Bruen described it as a "place of great curiosity," and remarked that "a large portion of the population . . . gain[s] their subsistence by the arts of statuary and painting . . . a very polished state of society."[3] Carrara had been the source of fine, pure white marble since antiquity; Michelangelo, Bernini, and Canova had used it, and most of America's neoclassical sculptors traveled there to procure blocks of stone for their work. In 1889, Baedeker recommended a three-hour tour of the "far-famed quarries," to be undertaken between five in the morning and two in the afternoon, when most of the workmen left for the day.[4]

By the time of Sargent's visit, marble-cutting had become mechanized. The city of Carrara and its quarries supported some 13,000 workers, and had taken on the aspect of "an encampment that has somehow become permanent, where everything

has been built in a hurry . . . of the most precious and permanent material."[5] Edward Hutton lamented the contradiction between the snowy "marble that might have built a Parthenon" and the "frightful labor" that produced it, commenting upon the "tyranny of the stones" and the "hideous machinery with a noise like shrieking of iron on iron."[6] Characteristically, Sargent did not comment upon the condition of the workers he portrayed, abstaining from social criticism and concentrating instead on the visual pleasure of sunlight on stone.

Sargent was fascinated with the intense light and deep shadows of the quarries, and the pure white marble allowed him to experiment with his favorite artistic exercise — the rendition of white against white. With wet strokes of lavender and brown, green and gray, Sargent deftly fashioned the large stone blocks, using the white of the paper to suggest the lightest areas of the sun-struck marble. Save for the figures, which add a sense of depth and scale to the scene, the composition is an abstract tumble of broken, angular shapes.

Sargent's workmen are not enslaved by machinery, although an extensive railroad had been built in 1876 to move the large blocks of marble down the mountainside. Instead, the artist elected to portray workers toiling at those jobs that had remained unchanged since Roman times, in this case, shaping the blocks with a hammer and chisel (fig. 1). This captivating echo of antiquity was carefully noted in the issue of the *Museum of Fine Arts Bulletin* announcing the purchase of these watercolors; images of Carrara had special appeal for a museum with a large collection of classical statuary.[7]

E. HIRSHLER

Fig. 1. Cutting a block of marble to order, Carrara, 1910. Photo by Paul Thompson, Courtesy of the National Geographic Society.

1. Unidentified author, *The Living Age* 325 (May 30, 1925), p. 446. Sargent had been given a letter of introduction to the owner of several of the quarries by his friend the Marchese Farinola, who owned a villa outside of Florence (Torre Galli) where Sargent had painted the previous year. See Richard Ormond, *John Singer Sargent: Paintings, Drawings, Watercolors* (New York: Harper and Row, 1970), p. 76.

2. The two oils are *Bringing Down Marble from the Quarries to Carrara* (1911, The Metropolitan Museum of Art, New York) and *Marble Quarries at Carrara* (1913, Collection Lord Harewood, Leeds, Yorkshire).

3. [Matthias Bruen], *Essays, Descriptive and Moral on Scenes in Italy, Switzerland, and France* (Edinburgh: A. Constable, 1823), pp. 96-97. Bruen is described as "An American."

4. *Baedeker's Italy: A Handbook for Travellers* (Leipzig: Karl Baedeker, 1889), pp. 120-121.

5. Edward Hutton, *Florence* (New York: The Macmillan Company, 1907), p. 65.

6. Ibid., pp. 66-67. Hutton wrote, "Out of this insensate hell come the impossible statues that grin about our cities. Here, cut by the most hideous machinery with a noise like the shrieking of iron on iron, the mantelpieces and washstands of every jerry-built house and obscene emporium of machine-made furniture are sawn out of the rock. There is no joy in this labor, and the savage, harsh yell of the machines drown any song that of old might have lightened the toil. Blasted out of the mountains by slaves, some 13,000 of them, dragged by tortured and groaning animals, the marble that might have built a Parthenon is sold to the manufacturer to decorate the houses of the middle classes [and] the studios of the incompetent . . . the quarries, having dehumanised man, have themselves become obscene," (p. 67).

7. "The Water-Colors of Edward D. Boit and John S. Sargent," *Museum of Fine Arts Bulletin* 10 (June 1912), pp. 18-21.

VI Tuscany & Florence

William Edward West

Born Lexington, Kentucky, 1788;
died Nashville, Tennessee, 1857

William Dunlap, in his monumental History
of the Rise and Progress of the Arts of
Design in the United States, *called William
E. West "one of those able artists who do honor to
our country, and raise its reputation for talent
and virtue in Europe," but then lamented, "yet I
have very imperfect information respecting him."
A clearer picture of West's life and career has only
recently become available through the researches of
E.C. Pennington. West, who may have had lessons
at an early date from George Beck (1748-1812)
in Lexington, Kentucky, painted miniatures;
about 1809 he moved to Philadelphia to work
with Thomas Sully, who influenced his portrait
style. In 1817-19 West painted portraits in New
Orleans, then Natchez, Mississippi. Late in 1819
he sailed for Europe, and by February 1820, he
was in Florence studying at its academy, drawing
from classic sculpture, and living at 12 Via Sancti
Apostoli. As he wrote his father, "here are the old
masters and here is nature in perfection." In
1822 he painted both Lord Byron (cat. 75, fig. 1)
and his mistress, Countess Teresa Guiccioli, and
apparently met the poets Percy Bysshe Shelley
(who drowned in July) and Leigh Hunt. West left
Florence, and Italy, in 1824, and went to Paris,
where he frequently saw Washington Irving. In
May 1825, he moved to London, where he painted
both portraits and occasional literary pictures. In
1837 he returned to the U.S., settling in Balti-
more. He moved to New York in 1841 where he
remained until a final move to Nashville in 1855.*

William Edward West

75. *Lord Byron's Visit to the U.S.S.
Constitution,* about 1822-24
Oil on canvas, 12 x 16 in.
Signed l.r.: W. E. W.
H. Richard Dietrich, Jr., Philadelphia

A highlight of West's career came in 1822
when he painted a portrait of the Roman-
tic poet George Gordon, Lord Byron
(1788-1824, see fig. 1).[1] At that time, and for
years to come, Byron was one of the most
influential writers in the world; English-
speaking travelers saw Italy through his de-
scriptions of it in *Childe Harold's Pilgrimage*
(1812-1818). There, Byron speaks of Venice
and Florence, of Rome and Nemi in terms
lamenting the loss of classical greatness:
"Italia! O Italia! Thou who hast/the fatal
gift of beauty, which became/a funeral
dower of present woes and past,/On thy
sweet brow is sorrow plough'd by shame."
At the time West painted him, Byron was
living at Villa Rossa in Monte Nero, four
miles from the port city of Leghorn,
which lies on the Mediterranean, just
south of Pisa.[2] As Tuckerman reports,
"One of our vessels of war was lying in the
harbor of Leghorn, and among her gallant
officers were some warm admirers of *Childe
Harold.* They sought [Byron's] acquain-
tance, and invited him to visit the frigate.
When he went on board he received a
salute, and few compliments ever gratified
him so much."[3] This unusual event oc-
curred on May 21, 1822.[4] The vessel in-
volved was the frigate U.S.S. *Constitution,*
flagship of the American naval fleet in the
Mediterranean under the command of
Captain Jacob Jones. The *Constitution* had
been launched in Boston in 1797; she made
the first of numerous voyages to the
Mediterranean in 1803 to "superintend the
safety of our commerce" in that part of
the world, fought in the Barbary War
(1804-07), and then gained fame for her
victories over the *Guerrière* and the *Java* in
the War of 1812, under Captain Isaac Hull.
In 1821-23, the Constitution returned to
the Mediterranean for the second time, on
a peacetime mission. She arrived in
Leghorn on May 2, 1822, and later stopped

Fig. 1. William Edward West, *George Noel Gordon, Lord Byron,*
1822. Oil on canvas. Scottish National Portrait Gallery,
Edinburgh, Scotland.

also at Naples, Messina, and Syracuse. She
became a familiar sight in the Italian ports,
returning to Leghorn in 1823, then again in
1836, 1837, 1849, 1850, and 1853.[5] In this, his
only marine painting, West depicts Byron
in a top hat, waving a red banner as he sets
off in a longboat for the *Constitution.* The
frigate itself is anchored, with her topsails
hanging limply in the calm air. West
would have known the work of Thomas
Birch from his years in Philadelphia, which
coincide with the time Birch was actively
exhibiting there. Birch was the American
master of marine painting and a specialist
himself in rendering the *Constitution,* so it is
not surprising that West relied on his ex-
ample for both the composition and col-
oring of *Lord Byron's Visit to the U.S.S. Consti-
tution.*

T. STEBBINS

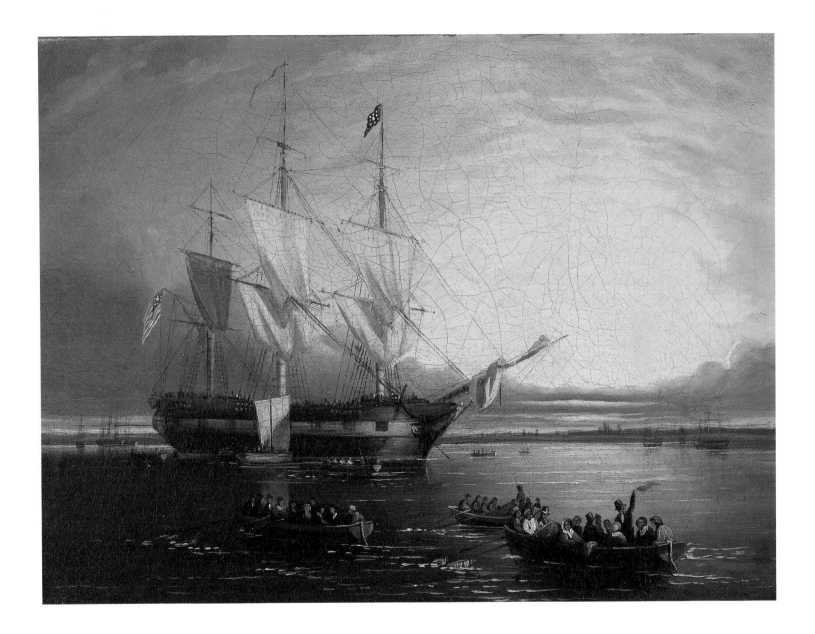

1. West's portrait of Byron, commissioned by an American for the American Academy, New York, somehow remained in the artist's possession for many years. See Estill Curtis Pennington, *William Edward West, 1788-1857: Kentucky Painter* (Washington, D.C., National Portrait Gallery, Smithsonian Institution, 1985), the definitive work on the artist. On the Byron portrait, see also Pennington, "Painting Lord Byron: An Account by William Edward West," *Archives of American Art Journal* 24 (1984), pp. 16-21.

2. Pennington, *West*, p. 18.

3. Henry T. Tuckerman, *Book of the Artists: American Artist Life* (New York: G. P. Putnam & Sons, 1867), p. 200.

4. See Tyrone G. Martin, *A Most Fortunate Ship: A Narrative History of 'Old Ironsides'* (Chester, Conn.: Globe Pequot Press, 1980), p. 177.

5. We are grateful to Donna M. Ridewood, U.S.S. Constitution Museum, Boston, for this information.

Thomas Cole

76. *View of Florence from San Miniato,*
1837
Oil on canvas, 39 x 63⅛ in.
Signed l.r.: T.C.
The Cleveland Museum of Art, Mr. and Mrs. William
H. Marlatt Fund

Thomas Cole painted this view of Florence in New York, during the winter of 1836-37, five years after returning from his first trip to Italy; he completed the canvas in time to include it in the National Academy of Design exhibition in the spring of 1837.[1] Florence had been Cole's favorite city in Italy, and the time he spent there in 1831 and 1832 was the most productive and inspired period in his early career. Writing to William Dunlap in 1834, Cole affirmed, "Florence to me was a delightful residence . . . freedom from the cares and business of life, the vortex of politics and utilitarianism that is forever whirling at home."[2]

Cole's *View of Florence* is the earliest known panoramic view of this city painted by an American artist. The sweeping vista encompasses medieval and Renaissance Florence, from the far bank of the Arno, across the Ponte Vecchio in the left middle ground, to the sea of red tiled roofs following the curve of the river. Out of this mass rises the tall, thin tower of the Palazzo Vecchio; then, on the right, the low dome of the Baptistry, the oldest structure in Florence, dating to the fourth century A.D.; beside it, Giotto's Campanile, erected between 1334 and 1359; and the Duomo, begun in the thirteenth century, its great dome completed in 1436. Cole's vantage point has long been thought to have been from San Miniato al Monte, a small convent church perched high above the Piazzale Michelangelo.[3] In a recent study of Turner's *Florence from the Chiesa al Monte* (fig. 1), Cecelia Powell has identified this as the nearby view from San Salvatore al Monte, situated on a terrace between San Miniato and the Piazzale below.[4] Turner's watercolor was engraved for Hakewill's *Picturesque Tour of Italy*, published in 1820. The compositions are virtually identical, and it seems likely that Cole's choice of viewpoint is indebted to Turner;

Fig. 1. J.M.W. Turner (British, 1775-1851), *Florence from Chiesa al Monte*, about 1816. Watercolor. Private collection, England.

Fig. 2. Thomas Cole, *Panorama of Florence* (pages 4 and 5 of Sketchbook 39.562), 1831/32. Pencil. The Detroit Institute of Arts.

Cole had visited his studio in England and was much impressed by the English master's work.[5]

Cole's most detailed preliminary drawing, dated Florence, June 15, 1831 (fig. 2) extends across two pages of his sketchbook. His extensive notes fill the upper left and right-hand corners of the drawing, elaborating on the quality of light seen roughly one half hour before sunset. Rather than sketching the foreground, Cole relied on his notes, remarking only that "In the foreground was a little lawn with trees –

declined toward a gate which is below a wall," matching the composition of the engraving after Turner. Five years after making this sketch, Cole altered this area to create a clearer division between the panorama of the city itself and the Arcadian pastoral taking place in the foreground. At the left, a monk sits pensively facing back into our space, while just to the right of center, a minstrel plays for two women and an attentive goatherd, figures who are both believably contemporary and yet acting out timeless, golden-age roles. The wall becomes a barrier between this idyllic space and the contemporary cityscape beyond, the deep ravine between these planes becoming a gulf of time as

well as space. The glowing light so closely associated with Italy descends upon the valley, creating a mood of supernal calm. As Louis Legrand Noble noted, the months Cole spent working on this canvas were a kind of golden age, during which he was married, and finished the *Course of Empire* for Luman Reed,[6] both major milestones in the artist's career.

E. Jones

1. Exhibited with this work was *View of the Catskill*, identical in size, which critics read as a pendant, the pair intended to contrast old and new world scenery. An astute critic noted that while *Florence* recalled the past, *Catskill* looked to the future, recognizing Cole's predilection for creating such resonances between otherwise varied subjects. See Ellwood Parry III, *The Art of Thomas Cole: Ambition and Imagination* (Newark, Del.: University of Delaware Press, 1988), pp. 188-192ff.

2. Cole to Dunlap, 1834, published in William Dunlap, *History of the Rise and Progress of The Arts of Design in the United States* (New York: Dover Publications, Inc., 1969), vol. 2, pp. 363-364.

3. Henry James may have helped popularize this identification. His brother Robertson owned this picture, and Henry recalled growing up with *Florence* hanging on the parlor wall. Recalling his youth, James wrote: "the contemplative monk seated on a terrace in the foreground, a constant friend of my childhood, must have been of the convent of San Miniato, which gives me the site from which the painter wrought." See Henry James, *A Small Boy and Others* (New York: Scribner, 1962), p. 268, cited in the curatorial files of the Cleveland Museum of Art.

4. See James Hakewill, *Picturesque Tour of Italy* (London: J. Murray, 1820) plate 57; and Cecelia Powell, *Turner in the South* (New Haven: Yale University Press, 1987), pp. 92-93. Powell points out that most English travel books depicted Florence only from a distance, "a city planted in a garden," as described in Elizabeth Batty, *Italian Scenery* (London: Rodwell and Martin, 1820). Cole's lengthy stay in England prior to arriving in Italy likely exposed him to this tradition as well as to Turner's views of the city.

5. Cole visited Turner on December 12, 1829; he also sketched vivid impressions of Turner's paintings hanging in the National Gallery in London (sketchbook, Detroit Institute of Arts).

6. Louis Legrand Noble, *The Life and Works of Thomas Cole*, (Cambridge: Belknap Press, 1964), p. 174.

Horatio Greenough

Born Boston, Massachusetts, 1805;
died Somerville, Massachusetts, 1852

Horatio Greenough

77. *Bust of George Washington,* 1832
Marble; h. 32½ in., w. 19 in., d. 12 in.
The Andalusia Foundation, Andalusia, Penn.

Interested in sculpture from a young age, Greenough was encouraged by Washington Allston to go to Italy. After his Harvard graduation in 1825, he traveled to Rome. He shared an apartment on Via Gregoriana with the American painter Robert Weir, visited museums, and drew from life at the French Academy. From January to March 1827 he was in Naples but illness (perhaps malaria) forced his return to Boston.

Greenough sailed again for Italy in the fall of 1828, armed with commissions for busts to execute there. This time he went first to Carrara, then to Florence to study with Lorenzo Bartolini (1777-1850), the city's leading sculptor. There he struck up friendships with Thomas Cole, Samuel F.B. Morse and James Fenimore Cooper. Cooper purchased Greenough's first ideal group, The Chanting Cherubs, *which gained a measure of notoriety in the United States because of the figures' nudity. In 1832 Greenough received the first federal sculpture commission in the United States, a statue of George Washington for the Capitol Rotunda. The seated, semi-nude colossus, although never installed in the Capitol, was eventually transferred to the Smithsonian Institution; it remains his best known work.*

Greenough traveled to Paris in the summers of 1831 and 1833, and to the United States in 1836, but by then he had resolved to settle in Florence. There in 1837 he married Louisa Gore of Boston. Their home, first on Via dei Bardi, near the Pitti Palace, then on Via dei Servi near the Duomo, became an international gathering place of artists and writers. Elected to the faculty of the Accademia di Belle Arti in 1840, Greenough took the role of artist-intellectual, interspersing his commissions with writings on art.

Although considered America's leading sculptor, Greenough was in the United States only twice more: in 1842-43 and 1851-52. In 1847 he bought land in Florence on what is now Piazza Indipendenza and built a new studio there. In 1849 he moved his home to the Villa Brichieri,

Bellosguardo. After returning to New England in 1851 to lecture, pursue a new commission, and visit family, Greenough died from a sudden fever. He was the first American artist whose death was as much lamented in Italy as in the United States.

This bust of George Washington, made by Horatio Greenough for Commodore James Biddle (1783-1845), was one of several related to the sculptor's commission for the colossal seated figure of the president for the United States Capitol (1832-40, fig. 1). These busts summarize Greenough's early ideas for the commission, and his departure from previous images of Washington. Greenough's commission for the United States Capitol marked the apex of the twenty-seven-year-old sculptor's professional and patriotic aspirations. Congress formally authorized this commission in February 1832 through the intercession of Greenough's advocates, James Fenimore Cooper and Washington Allston. By the terms of the commission, the head for the sculpture of Washington was to be modeled after the portrait from life by Houdon dating to about 1785; the composition of the figure was to be determined by the sculptor. This was the first portrait of Washington to be commissioned from an American sculptor.

Many years prior to the Congressional commission, Greenough studied likenesses of Washington that were on view at the Boston Athenaeum.[1] In 1826, following his first trip to Italy, Greenough returned to Boston, where he sketched the portrait of Washington by Gilbert Stuart at the Athenaeum. He drew from the bust of Washington by Italian sculptor Raimon Trentanove (1792-1832), one of the more accomplished artists to copy the portrait of the president by Giuseppe Ceracchi (1751-1802), who modeled Washington from life about 1791-92. Greenough was undoubtedly aware of the plaster portrait bust of Washington by Houdon, deposited at the Athenaeum by Thomas Jefferson in March 1828.[2] Greenough was also in Boston when the marble, overlife-size civilian figure of Washington, swathed in a

Fig. 1. Horatio Greenough, *George Washington*, 1840. Marble. National Museum of American Art, Smithsonian Institution, Transfer from the U.S. Capitol.

voluminous cloak by the English sculptor, Sir Francis Chantrey, was unveiled in 1827 at the Massachusetts State House.

This marble bust of Washington was probably the third produced by Greenough in Florence by the early 1830s. In the fall of 1830, James I. Roosevelt (1795-1875), a New York lawyer, judge and congressman, had commissioned a bust of Washington from Greenough. In the winter of 1831, an officer in the squadron of James Biddle, a U.S. naval officer who was commodore of the American squadron in the Mediterranean, saw the Roosevelt bust and requested one for his commander. Greenough received news of the commission in Marseilles, while on his way from Paris to his home in Florence. This was very welcome news for the sculptor, who wrote in April of 1832 to Samuel F.B. Morse that the "'violent pains

in my pocket' have been relieved by the very liberal advancement (voluntarily) on the part of Com' Biddle of the full price of a bust of W[ashingto]n which I am making for him."[3] At the same time, Greenough wrote James Fenimore Cooper the encouraging news from Biddle's Philadelphia agent, James McMurtrie, that Biddle intended to order two other busts, and hoped to "effect a subscription for a statue among the officers of the squadron at Mahon this winter."[4] The Biddle bust, presumably based upon the Roosevelt example (location unknown), shows Washington in a classical manner as he was to appear in the colossal seated version. Washington's hair is swept back *au naturel*, and follows Greenough's preference for a less formal treatment as indicated in his early bust of John Quincy Adams (about 1828, Museum of Fine Arts, Boston), and in an undated, related bust of Washington in the same collection.[5]

The Biddle bust follows Greenough's early drawings for the colossal sculpture, which date to the spring of 1832 following his receipt of the commission. In drawings depicting both standing and seated positions, Greenough envisioned Washington with his left arm upraised or extended in an oratorial gesture, the right pectoral left bare, left shoulder and figure swathed in a toga. However, with the persuasive letters of Edward Everett, beginning in July 1832, Greenough changed his plans to a seated, bare-chested figure based upon the lost colossal sculpture of Zeus by Phidias.[6] Greenough's resulting bust of Washington summarizes his subordination of the realistic Houdon portrait to the Phidian ideal. The Houdon-derived face of Washington is idealized and the concentrated yet distant look of the bust conveys power and strength similar to Greenough's colossal version. Washington's essential humanity, so treasured in national memory, receded

in Greenough's classicized, deifying treatment of his sitter. Yet without the mythological accessories and upper body nudity so vehemently opposed by critics of the seated sculpture, the bust retains essential elements of Washington's presence. It survives as a fine, early portrait of Washington by an American sculptor.[7]

J. FALINO

1. Greenough produced one or two busts of Washington in Boston before his departure for Italy. For a description of the commission and other sculptures of Washington by the sculptor, see Nathalia Wright, *Horatio Greenough, The First American Sculptor* (Philadelphia: University of Pennsylvania Press, 1963), pp. 117-191.

2. Greenough's drawing of the Trentanove bust, found in his Roman Sketchbook, begun in Rome in 1826, dates to 1827 when he copied Trentanove's bust of Washington at the Boston Athenaeum (Wright, *Horatio Greenough, The First American Sculptor*, p. 49, and Nathalia Wright, *Letters of Horatio Greenough American Sculptor*, [Madison, Wisconsin: The University of Wisconsin Press, 1972], p. 21 note 5). This bust was sold by the Boston Athenaeum in 1924 (Curatorial files, Boston Athenaeum). The work of Enrico Causici (working 1822-32) was familiar to Greenough, for he visited with the Italian sculptor in the spring of 1828, while the Italian sculptor was at work on the Washington Monument in Baltimore. Wright, *Letters of Horatio Greenough*, p. 68n. Greenough may have also been aware of Canova's figure of Washington in Roman military dress for the North Carolina State Capitol (1817-21; destroyed 1831).

3. Greenough to Samuel F.B. Morse, April 23, 1832, quoted in Wright, *Letters of Horatio Greenough*, p. 118-121.

4. On October 4, 1831, Roosevelt wrote to Greenough and inquired about the bust that he had ordered the previous year. He authorized the sculptor to draw on his account for its cost. The location of this bust is unknown. Horatio Greenough discussed the the completion of the Roosevelt bust in a December 8, 1831 letter, written from Marseilles, to James I. Roosevelt. The fact that Greenough considered the Roosevelt version an "improvement on the former one" implies that Greenough produced an earlier bust of Washington while he was in Florence. See also Horatio Greenough to James Fenimore Cooper, December 8, 1831, and December 18, 1832, in Wright, *Letters of Horatio Greenough*, pp. 96-97, 118, 152. It does not appear that the additional commissions indicated by McMurtrie were actually placed.

5. Horatio Greenough to Henry Greenough, March 8, 1828, in Frances B. Greenough, ed., *Letters of Horatio Greenough*, (New York: Kennedy Graphics, Inc. and Da Capo Press, 1970), pp. 31-2. Related works, all in the Museum of Fine Arts, Boston, include *John Adams* (1830), *Alexander Hamilton* (about 1832), and *George Washington* (undated).

Horatio Greenough

78. *Love Prisoner to Wisdom*, 1836
Marble, h. 43½, w. 12½, d. 14½ in.
Museum of Fine Arts, Boston, Bequest of Mrs. Horatio Greenough

6. Vivien Green Fryd, "Horatio Greenough's *George Washington*: A President in Apotheosis," *Vergil's Rome and the American Experience* (Washington, D.C.: The Vergilian Society of America, 1987), plates 4-6. A reconstruction of the lost Phidian sculpture was published by Quatremere de Quincy early in the nineteenth century. See Wayne Craven, "Horatio Greenough's Statue of Washington and Phidias' Olympian Zeus," *Art Quarterly* 26 (winter 1963), pp. 429-40.

7. At least two other surviving works by Greenough are closely related to that commissioned by Biddle. One nearly identical bust, bearing the artist's monogram, was ordered by John C. Halsey at an unknown date and given in 1836 to the United States Naval Lyceum (now the United States Naval Academy Museum, Annapolis, Md.). "Miscellany" *The Naval Magazine* 1 (May 1836), p. 282. A second undraped bust having a similar treatment of the head, only recently recognized as the work of Greenough, is in the collection of The Metropolitan Museum of Art. The author wishes to thank James Biddle, Vivian Green Fryd, Donna Hassler, Michael Wentworth, and James W. Cheevers for their helpfulness with this entry.

Since the Renaissance, but especially since the eighteenth century, putti have symbolized the inborn human qualities of innocence, impulsiveness, or creativity, in order to contrast those qualities to learned disciplines such as prudence, logic, and self-restraint. In the nineteenth century, imaginary winged infants assumed all the sentimentality invested in childhood as well.

Love Prisoner to Wisdom followed two earlier Greenough sculptures of naked cherubs. The first was *The Chanting Cherubs* (1829-30, location unknown), purchased by James Fenimore Cooper, who exhibited it in the United States in the hope that it would increase Greenough's visibility among his countrymen and so bolster his commissions in Florence. The second was *The Ascension of a Child Conducted by an Infant Angel* (1832-33, Museum of Fine Arts, Boston), made for Samuel Cabot of Boston and exhibited there with great success.[1] Sometime afterwards, Greenough began *Love Prisoner to Wisdom*; in March 1835 he reported that, in addition to making about fifteen busts that winter, he had his *Love Prisoner to Wisdom* roughed out in marble.[2]

Greenough's correspondence reveals that the work's expression was of great importance to him. He wrote Allston that he tried to represent "that twisting impatience which a boy manifests at restraint in his form and an expression of treachery and mischief."[3] To another friend he stated his intention to "mingle lurking mischief with shame" in the figure's face.[4]

According to Greenough, a sonnet from Petrarch's "Trionfo della Castità" (Triumph of Chastity), which presented Chastity catching and binding Cupid, provided the idea for the sculpture.[5] However, Greenough substituted Wisdom for Chastity, thereby giving Petrarch's theme a broader, less sensual connotation. In any case, Greenough was credited with giving the Cupid theme a new twist. Fanny Appleton, later Mrs. Henry Wadsworth Longfellow (see cat. 136), saw the work in Greenough's studio in May 1835 and noted, "Here is his last work, a lovely Cupid with hands tied — a very original expression to the beautiful face of his hackneyed Godship."[6]

Love Prisoner to Wisdom, which Greenough kept until his death, shows the naturalness that associated him with Bartolini. Tremendous care is taken to create a convincing classical *contrapposto*, while Cupid's flesh has great subtlety and plausibility of surface. This natural-looking body seems deliberately contrasted with the corkscrew hair, the theatrical-prop wings, the perfectly-formed shackle, and the highly stylized owl. At some level, it seems to allegorize naturalness (represented by the putto) constrained by the artifice of the classical tradition itself.

D. STRAZDES

1. See Jan Seidler Ramirez in Kathryn Greenthal et al., *American Figurative Sculpture in the Museum of Fine Arts, Boston* (Boston: Museum of Fine Arts, 1986), pp. 15-16.

2. Greenough to Washington Allston, March 7, 1835, Dana Papers, Massachusetts Historical Society, Boston.

3. Ibid.

4. Greenough to Robert Gilmor, November 28, 1835, Boston Public Library

5. Ramirez, in *American Figurative Sculpture*, p. 19.

6. Diary of Frances E. Appleton, vol. 2, May 15, 1835, Longfellow National Historic Site, Cambridge, Mass. (cat. 136).

Horatio Greenough

79. *Arno,* 1839
Marble, h. 25¼, w. 51½, d. 22½ in.
Museum of Fine Arts, Boston, Arthur Tracy Cabot Fund

In the summer of 1830, Greenough asked his brother Alfred to send him an English greyhound.[1] In 1831 he made a sketch of his dog standing in profile (collection Nathalia Wright), perhaps for a sculpture, but the dog soon died. A few years later, Greenough purchased for five dollars a tall, spirited, milk-white greyhound with a pink nose and ears "like roseleaves," to whom he was instantly devoted and whom he named Arno.[2]

Around 1838 Greenough began a three-dimensional portrait sculpture of Arno. He also made, in December 1838, an ink study (private collection) for a bas-relief of a greyhound standing in profile, probably his third greyhound, which he acquired about that year as a companion for Arno (fig. 1). However, Arno's portrait went forward, perhaps because a Boston patron quickly spoke for it.[3] In the spring of 1839 the work was completed and sent to Boston, where it appeared at the Athenaeum's second annual sculpture exhibition.

No preparatory drawing for *Arno* exists; when exhibited in 1840 at the Boston Athenaeum it was listed in the catalogue as "modeled from life." *Arno* has the endearing attentiveness of a genuine animal while possessing the noble calm appropriate to immutable antiquity, for, indeed, greyhounds were fairly numerous in classical sculpture. It must have given great pleasure to Greenough, who wrote frequently of the virtues of simplicity and functionalism in the ancient and modern worlds, to have found a subject that exemplifies all these. However, while *Arno* has the stylized appearance of classical Greek renditions of the animal,[4] no specific canine prototype exists for the alert yet recumbent pose assumed by him. The guarding posture from antiquity closest to Arno's is that of the sphinx (and, occasionally, the lion).

79. *Arno*, 1839

Fig. 1. William J. Hubard (American, 1807-1862), *Horatio Greenough in His Studio in Florence*, about 1839. Oil on canvas. Valentine Museum, Richmond, Virginia.

Arno in effigy continued to work his charms in the United States; after two owners in Boston, Edward Everett, Secretary of State (1852-53) and former professor of Classics at Harvard University, purchased *Arno*. Probably around 1840, the Boston silversmith Obadiah Rich made an elaborate Neoclassical inkstand (Fogg Art Museum, Harvard University) incorporating *Arno*'s head for another Harvard professor, Andrews Norton, as well as candlesticks to match (Mabel Brady Garvan Collection, Yale University).

D. STRAZDES

1. Frances Boott Greenough, ed., *Letters of Horatio Greenough to his Brother, Henry Greenough* (Boston: Ticknor, 1887) p. 66.

2. Ibid., p. 102.

3. Jan Seidler Ramirez in Kathryn Greenthal et al, *American Figurative Sculpture in the Museum of Fine Arts, Boston* (Boston: Museum of Fine Arts, 1986), p. 21.

4. Cornelius Vermeule, "Neoclassic Sculpture in America: Greco-Roman Sources and Their Results," *Antiques* 108 (November 1975), p. 980.

Hiram Powers

Born Woodstock, Vermont, 1805;
died Florence, Italy, 1873

With financial assistance from Cincinnati patron Nicholas Longworth, Hiram Powers sailed for Italy with his wife and children in early October 1837. After six days in Paris, they traveled to Marseilles, took a steamer to Livorno, and arrived in Florence in late November. Horatio Greenough helped Powers find temporary accommodations near Santa Croce and a studio near Greenough's own. In May 1839 Powers moved to the former Annalena convent across from the Boboli gardens on Via dei Serragli, where he had a studio on the ground floor and a capacious apartment upstairs.

After translating into marble his busts of Andrew Jackson, John Quincy Adams, Daniel Webster, and other Americans, Powers exhibited them at the Accademia di Belle Arti in September 1839 and 1841. An uncanny ability to create a natural likeness distinguished his ideal nudes, which he began making in 1838 and which soon attracted visits from Italy's senior sculptors Lorenzo Bartolini, Bertel Thorvaldsen, and John Gibson. His best-known work, The Greek Slave was exhibited to unprecedented crowds in the United States and Britain and gave Powers a renown never before achieved by an American sculptor.

Portrait busts, ideal busts (his Proserpina sold an astounding 105 copies), and ideal nudes were the backbone of Powers's business. To produce them, he continually developed efficiencies such as an improved pointing machine and a perforated file. To create a lifelike marble surface he invented a roller to simulate pores on flesh. He boasted that he could convey even a blush in white stone.

Powers rarely traveled from Florence. He saw Lucca, went briefly to Rome in 1846 and 1861, visited England in 1863, and toured Rome and Naples in 1871. Despite an honorary professorship bestowed by the Accademia di Belle Arti in 1841, Powers kept distant from Italian artists. Distrustful of Italians generally, he learned little of the language and considered himself a temporary resident until the late 1860s, when he built a villa in a newly developed area outside the Porta Romana, convincing the American sculptor Thomas Ball to purchase the adjacent property. After Powers's death, his studio remained open under his master carvers Remigio Peschi and Antonio Ambuchi, who put his works into marble until their own retirement in 1877.

Hiram Powers

80. *Greek Slave*, modeled 1840–43;
 carved 1849–50
Marble, h. 65½ in., w. 21 in., d. 18¼ in.
Signed on back of base: HIRAM POWERS/*Sculp.*
Yale University Art Gallery, Olive Louise Dana Fund

81. *Greek Slave*, after 1873
Marble, h. 44 in., w. 14 in., d. 13½ in.
Signed on back of base: h. powers sculp.
National Museum of American Art, Smithsonian Institution, Gift of Mrs. Benjamin H. Warder

Although not the first ideal female nude to be made by an American in Italy,[1] *Greek Slave* was the first to gain international fame, earning its maker more public recognition than any other American sculptor of his generation. Powers developed his idea for the sculpture in late 1840 and worked on the clay model until the spring of 1843. Even though models for two other nudes preceded it, *Greek Slave* was his first to be realized in marble and sold. In early 1844 a retired British army captain, John Grant, bought the statue, which was finished and shipped in February 1845. While Grant exhibited his statue in London (where it was seen by numerous Americans on their way to Italy), Powers made two more and arranged for them to tour the United States. The bi-national public appearances culminated with the *Greek Slave*'s exhibition in London's Crystal Palace from May to October 1851 and in New York's Crystal Palace the following year, making it the most widely seen American sculpture of its time.

Greek Slave was a nude that could be judged by the standard of the ancient Greeks. Powers's Greek girl repeats the position of the feet and head of *Venus de Medici* (Uffizi Gallery, Florence), the antique sculpture that Powers knew best, but she stands straighter, her *contrapposto* more evident, her profile sharper and more Greek. Powers dispensed with the goddess's gesture of touching her breast and instead had his Greek girl place one hand on her clothing, like the *Venus of Knidos* (Vatican Museums, Rome) and others similar to it. The extreme smoothness of flesh emulates the

80

81

Aphrodite from Cyrene (Museo Nazionale delle Terme, Rome).

As with his other full-length female nudes (*Eve Tempted*, *America*, *California*, *Eve Disconsolate*), Powers chose an iconography the ancient Greeks did not use. His *Greek Slave* was inspired by the atrocities committed by the Turks on the Greeks during the Greek revolution, which lasted from 1821 to 1830. The Greek struggle attracted such Italian painters as Francesco Hayez, who found it sympathetic to their interest in romanticized pathos from recent history. Powers developed a story in which a Greek girl, her parents killed by Turks, is sold into slavery and forced to stand undressed on the auction block. Powers wished to show her disdain for her situation, her innocence and faith. "It is not her person but her spirit that stands exposed, and she bears it all as Christians only can," he wrote.[2]

Although making an ideal nude was a traditional way for a sculptor in Italy to signal his artistic arrival, nudity in art was less well tolerated in the United States. When Horatio Greenough's *Chanting Cherubs* (1828-30, unlocated) was exhibited in Boston, the celestial infants were promptly diapered. Thomas Crawford was pressed into making a fig leaf for his *Orpheus and Cerberus* before shipping it to America. Powers, therefore, considered carefully the circumstances of his subject's nakedness. That she was not willingly nude became a crucial factor in its acceptance.

Powers's model was said to be the eighteen-year-old daughter of his wife's dressmaker (the mother herself may have been one of Bartolini's models).[3] Like the ancients, Powers must have combined the best of several physiques. The result was a tender and seemingly real human form, to which Elizabeth Barrett Browning penned a sonnet. Powers took great care to ensure that his Seravezza marble was near-flawless, and the chain was cut from a single piece of stone, details that were admired as much as his overall conception.

Powers made six full-sized replicas of his *Greek Slave*. The version shown here was his fifth, purchased by the Florentine resident and collector Prince Anatole Demidoff in 1850. The elaborate pedestal was made to Powers's design by Luigi Rocchi, who furnished him with such items from 1837 to the 1860s. Powers also sold reduced versions of the *Greek Slave*, the first being a bust, created in late 1845, that proved second only to *Prosperpina* as his most requested work. After Powers's death, his carvers Remigio Peschi and Antonio Ambuchi made two two-thirds-size replicas of the full statue, which follow closely his sixth replica, carved in 1865, in which elongated shackles replaced the chains. The reduced version shown here seems to have been the first of these two to be completed.[4] Other manufacturers marketed numerous reduced copies of the *Greek Slave* in materials other than marble. In Britain, John Grant's *Greek Slave* became the basis for copies in cast plaster, alabaster, and Parianware (an unglazed ceramic resembling marble), in heights varying from twenty to twelve inches (see cat. 185).[5]

D. STRAZDES

1. It was preceded by Horatio Greenough's *Venus Victrix* (1837-40, Boston Athenaeum).

2. Hiram Powers to Edwin Stoughton, November 29, 1869, quoted in Donald M. Reynolds, *Hiram Powers and His Ideal Sculpture.* (New York: Garland Press, 1977), p. 141.

3. C. Edwards Lester, *The Artist, the Merchant, and the Statesman* 2 vols. (New York: Paine and Burgess, 1845) vol. 2, p. 190; Reynolds, *Hiram Powers.* p. 147.

4. Richard P. Wunder, *Hiram Powers: Vermont Sculptor* (Newark: University of Delaware Press, 1991), vol. 2, p. 166. The account books of Powers's studio list two two-thirds-life-sized replicas being produced after his death. In fact, three exist (collections of Mr. and Mrs. Julian Ganz, Jr., Stuart Feld, New York, and the National Museum of American Art, Smithsonian Institution), one of which may have been made and sold during the late 1860s.

5. Ibid., p. 168.

Hiram Powers

82. *Bust of Horatio Greenough*, 1838 to about 1854

Marble, h. 26½ in., w. 14 in., d. 9¼ in.
Signed on back: H. Powers / Sculp.
Museum of Fine Arts, Boston, Bequest of Charlotte Gore Greenough Hervosches du Quilliou

Horatio Greenough, whom Powers had met in Washington, D.C., during the summer of 1836, was most supportive of Powers during his first years in Italy. Greenough promoted his work in print and introduced him to potential patrons; the two sculptors cooperated professionally, sharing materials, workmen, and professional contacts. Their families became intertwined as well; Greenough's physician cared for Powers's son during his fatal illness in 1838, and his sister Louisa lived for a time in the Powers's household and attended Mrs. Powers during her pregnancy.

Powers, who typically demonstrated his gratitude to his best friends by modeling their portraits or naming his children after them, bestowed both honors on the Greenoughs. He and his wife named their first daughter after Louisa Greenough; he modeled Horatio Greenough's portrait bust in April 1838, then Louisa's in January 1839. During the fall of 1838 Powers had three carvers blocking out five new busts in marble, including Daniel Webster's, Andrew Jackson's, and Horatio Greenough's. A slip of the chisel in carving Greenough's hair caused him to abandon that piece so that he could concentrate on completing the Webster and Jackson busts, which he had hoped to sell to the U.S. government. He set the work aside and did not return to it until 1854, when Greenough's widow asked Powers to execute the bust in marble. He complied, charging her only the cost of the marble.[1] An entry in Powers's ledger for 1859 again mentions Greenough's bust being carved, perhaps in reference to a second marble whose location is now unknown.[2]

Horatio Greenough typifies Powers's style of portraiture and demonstrates the skills he had developed during his first year in Florence. Before arriving in Italy, Powers knew little about the process of carving in marble but he quickly gained a thorough understanding of the stone's properties and taught himself how to work his clay model so as to achieve the most lifelike qualities in the final carving.[3] At this early stage of his career, he preferred modeling in American clay and imported it in bulk with Greenough.[4] Less grainy than Italian clay, it could better give him the detail and subtle finish he desired of his portraits.

With his head turned slightly to the left, Greenough appears energetic yet slightly melancholy, his cheeks slightly drawn and his eyes puffy. His bare chest, which extends to the shoulders and just beyond the pectoral muscles, allowed Powers to create a continuous expanse of nearly invisible undulations in the flesh. Powers considered this quality to be his trademark, and he took great pride in it. When he arrived in Italy he found "laborers, used to or capable of reproducing my kind of modelling, absolutely unobtainable."[5] By September 1838, when *Horatio Greenough* was initially being put into marble, Powers wrote to a friend, "I am making considerable progress with my busts, having several of them already far advanced in marble. . . . Artists who have visited me . . . all say that a higher finish they have never seen, and one of them told me that it looked as if the marble had been fused & cast into form."[6]

D. STRAZDES

1. Richard P. Wunder, *Hiram Powers, Vermont Sculptor* (Newark: University of Delaware Press, 1991), vol. 2, p. 48.

2. Jan Seidler Ramirez in Kathryn Greenthal et al., *American Figurative Sculpture in the Museum of Fine Arts Boston* (Boston: Museum of Fine Arts, 1986), p. 32.

3. Wunder, *Hiram Powers*, vol. 1, p. 121.

4. Nathalia Wright, *Horatio Greenough: First American Sculptor* (Philadelphia: University of Pennsylvania Press, 1963), p. 210.

5. Wunder, *Hiram Powers*, vol. 1, p. 112.

6. Ibid., p. 113.

William Henry Rinehart

Born Carroll County, Maryland, 1825;
died Rome, Italy, 1874

Considered the "most promising and talented" sculptor of his day by painter and U.S. consul to Rome, Maitland Armstrong, William Henry Rinehart was a self-taught carver of ornamental marble from Baltimore, Maryland. Of humble, agrarian origins, Rinehart made his first trip to Italy in 1855, financed by local patrons who had admired sculptures he had exhibited several years earlier. Rinehart spent two years in Florence, where his work met with the warm approval of Hiram Powers, and he made the acquaintance of Kentucky sculptor Joel Tanner Hart. Following a brief return to Baltimore, where he displayed some of the works completed during his Florentine sojourn, Rinehart sailed back to Italy in 1858, probably with the support of Baltimore collector William T. Walters. This time Rinehart went to Rome, where he stayed until 1866. This second, eight-year stay was a prolific one for Rinehart, during which time he executed Leander *(1859, The Newark [N.J.] Museum), an ideal work influenced by the Belvedere* Antinous *and Michelangelo's* David. *Rinehart also produced numerous portraits for the mercantile elite of the eastern seaboard and the far west. In 1861, he was selected, at the urging of Thomas Crawford's widow, Louisa, to complete bronze doors for the House of Representatives and Senate in the Capitol that were left unfinished at the sudden death of her husband. Following a short trip to Baltimore in 1866, the artist returned to Rome, where he worked at studios on Via Sistina and Via Felice. Rinehart continued to carve portrait busts and ideal works that included* Antigone *(1870, The Metropolitan Museum of Art, New York) and* Clytie *(1872, The Newark [N.J.] Museum). Rinehart was an active and congenial member of the circle in Rome that included Elihu Vedder (who once saved him from drowning), Randolph Rogers, Joseph Mozier, Chauncey Bradley Ives, William Haseltine, Charles C. Coleman, and Frederic Crowninshield, as well as patrons Elizabeth and William Herriman. Following a trip to Baltimore in 1872-73, Rinehart returned to*

Rome for a third and final time, and established himself at the Palazzo Patrizi, on Via Margutta 53. He spent much of the late spring of 1873 obtaining more than twenty-two casts after the antique for Walters before succumbing to a lung ailment that ended his life the following year. In his will, Rinehart established a scholarship fund for sculptors to study in Rome or Paris. This generous gesture was in keeping with his life-long encouragement to young artists.

The brooding, reclining personifications of the times of day carved by Michelangelo for the Medici chapel in Florence were revived in a more lighthearted, decorative form in the nineteenth century. Bertel Thorvaldsen (1770-1844), the preeminent Danish sculptor and practitioner of the neoclassical style in Rome, created reliefs of *Day* and *Night* (1815, Thorvaldsens Museum, Copenhagen) that proved to be immensely popular with artists and the public during and after the artist's lifetime.[1] Various interpretations of Thorvaldsen's reliefs appeared in the works of several American sculptors, including Erastus Dow Palmer and Martin Milmore.[2] Although Palmer never traveled to Italy, both he and Milmore were probably aware of Thorvaldsen's reliefs through prints or clay impressions that found their way to the United States (cat. 176).[3] In Rome, Harriet Hosmer produced a more complex program of four circular reliefs called *Zephyr Descends*, *Night Rises with the Stars*, *The Falling Star*, and *Phosphor and Hesper Circling their Double Star* that were partly inspired by Thorvaldsen.[4]

According to Rinehart's biographers, *Morning* and *Evening* were modeled in clay in 1856, shortly after the artist's arrival in Florence.[5] Since Rinehart was a man of limited financial means when he arrived in Italy, the reliefs may have been intended to generate quick income. *Morning* and *Evening* were two of four reliefs modeled at this time, that included *Winter* (Peabody Institute, Baltimore, Md.) and *Spring* (1874, The Metropolitan Museum of Art, New York).[6] Perhaps due to the overwhelming popularity of Thorvaldsen's versions, Rinehart's *Morning* and *Evening* proved to be the more popular pair, of which about eight are known. Rinehart's account book, *Libro Maestro*, for 1858 enumerated the cost of producing a pair: the marble cost 12 *scudi*, pointing and sawing was 30 *scudi*,

backing and sawing, 8 *scudi*; Rinehart customarily charged about 80 *lire* for the pair.[7]

Considered among the most beautiful relief sculptures by an American sculptor,[8] the evanescent figures of *Morning* and *Evening* seemingly emerge from the marble, where they are suspended in low relief. *Morning*'s streaming hair is crowned with morning glories, whose flowers open in the sunlight. She pulls back her veil and raises her head to meet the sun, while a bird hovers behind her.[9] As a signal to the end of day, *Evening*'s back is turned to the viewer. With her torch, she sets stars blazing in her mantle, a metaphor for the heavens. Rinehart's subtle modeling of the figures, their gossamer drapery, and placement within the oval frame amply demonstrate his talents at this early stage of his career in Italy.

J. FALINO

1. For biographical information discussed in the artist's itinerary, see Maitland Armstrong, *Day Before Yesterday, Reminiscences of a Varied Life* (New York: Charles Scribner's Sons, 1920), p. 194; Elihu Vedder, *The Digressions of V, Written for His Own Fun and That of His Friends* (Boston: Houghton Mifflin Company, 1910), pp. 157, 329-32; William Henry Rinehart to Hiram Powers, Hiram Powers Papers, December 8, 1856, Archives of American Art, Smithsonian Institution, Washington, D.C., roll 1138: 914-15; Samuel Osgood, "American Artists in Italy," *Harper's New Monthly Magazine* 41 (August 1870), pl. 420-23; "Our Artists in Rome," *The Arcadian*, 1 February 13, 1873, p. 10. See William H. Gerdts, *American Neo-Classic Sculpture, The Marble Resurrection* (New York: The Viking Press, 1973), pp. 86-87 for a discussion of Thorvaldsen's reliefs. According to the author, *Night* and *Day* were "probably the most famous relief sculptures of the nineteenth century."

2. Gerdts, *American Neo-Classic Sculpture*, pp. 86-87, and Jan Seidler Ramirez, in Kathryn Greenthal et al., *American Figurative Sculpture at the Museum of Fine Arts, Boston* (Boston: Museum of Fine Arts, 1986), pp. 194-95.

3. William Mitchell Gillespie, *Rome as Seen By a New Yorker in 1843-4* (New York: Wiley and Putnam, 1845), p. 177 notes that Thorvaldsen's "basso-relievo of "Night" has been, like Pliny's doves, too universally popularized by cameos and mosaics to be overlooked." For American parianware reliefs after Thorvaldsen, see Alice Cooney Frelinghuysen, *American Porcelain 1770-1920* (New York: The Metropolitan Museum of Art, 1989), pp. 162-63.

4. These reliefs were used by Hosmer in the Ashridge Gate, at the Earl of Brownlow's estate called Ashridge Hall. Hosmer archives, Watertown Free Public Library, Watertown,

Massachusetts. Marble versions of *The Falling Star* and *Phosphor and Hesper* survive (Collection of Erving and Joyce Wolf). *Phosphor and Hesper* was also made into a bronze relief as described in "Foreign Items of Interest," *American Art Journal* 5 (June 21, 1866), p. 141: "also a lovely medallion of Night and Morning to be executed in bronze – Morning with a torch and roses, Evening with poppies in her hand, morning and evening stars, a lark and a bat, make up the composition." Hosmer was working on the reliefs as early as 1856, according to a June 30, 1856 letter from the sculptor to Cornelia Crow Carr, in Cornelia Carr, ed. *Harriet Hosmer, Letters and Memories* (New York: Moffat, Yard and Company, 1912), p. 70.

5. William Sener Rusk, *William Henry Rinehart, Sculptor* (Baltimore, Maryland: Norman T. A. Munder, 1939) pp. 52-3, and Marvin Chauncey Ross and Anna Wells Rutledge, *A Catalogue of the Work of William Henry Rinehart, Maryland Sculptor, 1825-1874* (Baltimore: Trustees of the Peabody Institute and the Walters Art Gallery, 1948), pp. 28-9.

6. Ross and Rutledge, *A Catalogue of the Work of William Henry Rinehart, Maryland Sculptor, 1825-1874*, cat. 43.

7. From the records and surviving reliefs it appears that copies of *Day* and *Night* were requested at regular intervals throughout Rinehart's career in Rome. Ross and Rutledge, *A Catalogue of the Work of William Henry Rinehart, Maryland Sculptor, 1825-1874*, p. 28.

8. Correspondence from William Gerdts, November 23, 1990, Department of American Decorative Arts and Sculpture files, Museum of Fine Arts, Boston.

9. The bird has been identified as a skylark in Rusk, *William Henry Rinehart*, p. 53.

Henry Roderick Newman

85. *Anemones*, 1876
Watercolor on paper, 18 x 11¾ in.
Signed l.r: H. R. Newman / 1876
Amon Carter Museum, Fort Worth, Ruth Carter Stevenson
Fund Purchase

From 1870, when he first went to Florence, until his death there in 1917, Henry Roderick Newman made the Tuscan capital both his home and a central motif in his work. He was inspired equally by the city's architectural monuments and the surrounding countryside, and he recorded them both with zealous attention to detail. In *Anemones*, Newman depicted his favorite Florentine flower, the wild *Anemone coronaro*, which grows abundantly in the spring.

Instead of isolating the flowers in a traditional still-life arrangement, Newman rendered these thin, papery blossoms in their natural setting, surrounded by weeds and grasses. Both his compositional strategy and his choice of subject reflect Newman's admiration for Ruskin, who had called for painters to study directly from nature, to "paint the leaves as they grow," and to delight in the beauty of indigenous wildflowers rather than only those exotic specimens frequently included in formal table-top still lifes.[1] With fastidious precision, Newman studied each anemone, causing one writer to note that "with the perfect service of a true lover, he makes an individual portrait of every flower he introduces into his picture . . . each blossom . . . seems to have its own life and passion."[2]

Newman's choice of watercolor also reflects Ruskin's influence, for the British artist and critic preferred that medium, and would praise its ability to capture "the subtlest pleasures of sight."[3] Instead of exploiting the broad washes of pigment possible with watercolor, Newman preferred a more self-effacing technique, concentrating on the details of his subject rather than upon painterly effects. In fact, Newman's precise stippling and hatching, created with a small brush and infinite patience, had been dismissed by some poten-

Henry Roderick Newman

86. *Florence, Duomo from the Mozzi Garden,* 1877
Watercolor and bodycolor on paper, 9⅞ x 13¾ in.
Signed l.c.: *H. R. Newman / 1877*
Virginia Steele Scott Collection, Henry E. Huntington Library and Art Gallery

tial patrons as being "too Pre-Raphaelite," and therefore "not fashionable."[4] Yet among devotees of John Ruskin, especially British travelers in Italy, Newman's watercolors had great appeal.

Ruskin especially admired Newman's Florentine anemones, and in 1881, he purchased four of them for the study collection at his St. George's Museum. Three of these were detailed sketches, while the fourth, similar to *Anemones*, showed the flowers in their natural setting. In his first catalogue of that collection, Ruskin wrote that Newman's anemones were "as good as [they] can be," and proposed them as classic models for students of flower painting.[5]

E. HIRSHLER

1. John Ruskin, *Modern Painters*, vol. 5 (1860), quoted in William H. Gerdts, "Through a Glass Brightly: The American Pre-Raphaelites and Their Still Lifes and Nature Studies," in Linda S. Ferber and William H. Gerdts, *The New Path: Ruskin and the American Pre-Raphaelites* (New York: The Brooklyn Museum, 1985), p. 42. Gerdts's essay provides an invaluable overview of Ruskin's influence on American still-life painting.

2. H. Buxton Forman, "An American Studio in Florence," *The Manhattan* 3 (June 1884), p. 534.

3. Letter to the London *Times*, April 14, 1886. See Kathleen A. Foster, "The Pre-Raphaelite Medium: Ruskin, Turner, and American Watercolor," in Ferber and Gerdts, *The New Path*, pp. 79-107. Like many of his American Pre-Raphaelite colleagues, Newman produced only a few works in oil. See, for example, his large *Gulf of Spezia* (cat. 72).

4. Henry Newman to Thomas Farrer, September 11, 1864, New York Public Library, quoted in Kent Ahrens, "Pioneer Abroad, Henry R. Newman (1843-1917): Watercolorist and Friend of Ruskin," *The American Art Journal* 8 (November 1976), p. 88, note 13. For the reception of Pre-Raphaelitism in America, see Ferber and Gerdts, *The New Path*; and Susan P. Casteras, *English Pre-Raphaelitism and its Reception in America in the Nineteenth Century* (Cranbury, N. J.: Associated University Presses, 1990).

5. John Ruskin, *First Catalogue of the St. George's Museum*, vol. 30, p. 240.

Newman's *Florence, Duomo from the Mozzi Garden*, a watercolor promptly purchased by the British aristocrat and connoisseur Lord Spencer, reflects a distinctive English preference for distant views of the Tuscan capital. This bias was popularized by E. M. Forster in his 1908 novel *A Room with a View*, but it had been acknowledged since the early nineteenth century,[1] and British painters as diverse as J. M. W. Turner, Charles Heath Wilson, John Brett, and Edward Lear had all painted the city from the surrounding countryside.[2]

Rather than selecting one of the common vantage points – the Piazzale Michelangelo, the Boboli Gardens, or Bellosguardo – Newman chose the grounds of the Villa Mozzi, across the Ponte alle Grazie from the city center. The villa, once the home of one of Florence's powerful banking families, was built in the mid-thirteenth century. Behind its severe façade was a large garden, acquired by the Mozzi family in the sixteenth century. The grounds abutted the old city walls near the Porta San Giorgio, and they afforded an excellent view across the Arno toward the center of Florence. Open to the public, the grounds of the Villa Mozzi were quite near to Newman's home in the Piazza dei Rossi.

The view of Florence from the Mozzi garden was recommended to travelers who sought a panoramic vista of the city nestled into the neighboring hills. In his travel book *Florence*, Augustus J. C. Hare noted of the Villa Mozzi:

> From the little platform outside the villa gates the view is exquisitely beautiful – of Florence and the rich plain of the Arno, with the villa-dotted hills and the surrounding chain of amethystine mountains. Perhaps spring, when the purple cloud-shadows are falling over the delicate green of the young corn-

fields, and when the tulips and anemones make every bank blaze with color, is the most beautiful season.[3]

This garden setting enabled Newman to combine his two favorite themes, plants in their natural surroundings and the architecture of Florence.

Newman gave both of these subjects equal attention. The architecture – the squat dome of the basilica of San Lorenzo, Arnolfo's Tower above the Palazzo Vecchio, and the Duomo with its square campanile – is precisely rendered to the smallest detail. Yet save for Arnolfo's Tower, which is in shadow, all of these buildings seem subordinate to the natural forms that surround them: the encircling hills in the background and the dense foliage and trees in the foreground. These Newman depicted with identical care, following John Ruskin's well-known recommendation that the right course for young artists was faithful and loving representation of nature, "rejecting nothing, selecting nothing, and scorning nothing."[4] He gave Brunelleschi's great dome, considered to be a masterpiece of early Renaissance architecture, no more consideration than he did the lush fig tree growing in the foreground. For Newman, as for Ruskin, every object was of equal beauty.

E. HIRSHLER

1. See Cecilia Powell, *Turner in the South* (New Haven: Yale University Press, 1987), pp. 90-93.

2. Of his own distant view of Florence, Lear wrote: "Plum pudding-treacle, wedding cake, sugar, barley water, sugar candy, raisins, and peppermint drops would not make a more luscious mixture in the culinary world, than Florence and its Val d'Arno does as a landscape," (Edward Lear to Holman Hunt, June 1861, quoted in *English Watercolors* [New York: Davis and Long Company, 1980], n.p.). Hunt had also painted in Florence.

3. Augustus J. C. Hare, *Florence* (London: George Allen, 1890), p. 200. The view from the Mozzi Gardens is also recommended and described in the *Hand-book of Florence and its Environs* (Florence: F. and J. Pineider, 1878), p. 145; as well as *Murray's Handbook for Travellers in Central Italy* (London: John

Henry Roderick Newman

86. *Florence, Duomo from the Mozzi Garden*, 1877

Murray, 1864), pp. 199-200 and E. Grifi's *Saunterings in Flo-rence* (Florence: R. Bemporad et Figlio, 1896), p. 384.

4. John Ruskin, *Modern Painters*, edited and abridged by David Barrie (New York: Alfred A. Knopf, 1987), p. 178. Ruskin's statement had become the manifesto of the Association for the Advancement of Truth in Art, the American Pre-Raphaelite organization to which Newman belonged before leaving America for Italy. See Linda Ferber, "Determined Realists: The American Pre-Raphaelites and the Association for the Advancement of Truth in Art," in Linda S. Ferber and William H. Gerdts, *The New Path: Ruskin and the American Pre-Raphaelites* (New York: The Brooklyn Museum, 1985), p. 15.

Henry Roderick Newman

87. *Santa Maria Novella, Florence*, 1884
Watercolor over graphite on off-white paper,
25 x 30 in.
Signed l.l.: on step: H.R. Newman 1884
The Fogg Art Museum, The Harvard University Art
Museums, Transferred from the Fine Arts Department

Largely under the influence of John Ruskin, Henry Newman made several images of Santa Maria Novella, considered to be the most important Gothic church in Tuscany.¹ It was one of Ruskin's favorite places; he called it "Giotto's own parish-church," and he devoted to it much of his 1889 travel book, *Mornings in Florence*.² Santa Maria Novella was the home of the Dominican order, one of the most important monastic groups in medieval and renaissance Italy. Begun in 1278, the church was completed in the late fourteenth century in an ornate Tuscan style, with rich green and white marble decoration. In the fifteenth century, Leon Battista Alberti, one of the finest architects of the Renaissance, redesigned the façade, joining the first and

Fig. 1. Henry Roderick Newman, *View of Santa Maria Novella*, 1879. Watercolor on paper. Maier Museum of Art, Randolph-Macon Woman's College, Lynchburg, Virginia.

second stories with elegant spandrels that serve to unify and soften the boxy profile of the basilica (fig. 1).

The church was one of the first monuments a visitor to Florence might see, for in the 1860s the city's major railway station was constructed directly behind it. Once an area of orchards and fields, where a young Ruskin helped local farmers gather hay, the area around Santa Maria Novella quickly became one of the busiest in Florence. The piazza in front, however, remained largely unchanged; here in 1872, in a house on the corner, Henry James began his novel about an American artist in Italy, *Roderick Hudson* (see cat. 166).

Newman painted this church several times, and won the praise of his mentor Ruskin. Ruskin first saw Newman's efforts in 1877, when Charles Herbert Moore, a professor of art at Harvard (see cat. 106), showed him a Newman watercolor of the church and piazza owned by Sarah Choate Sears, an important Boston collector.[3] Ruskin immediately wrote to the painter, stating:

I cannot tell you — without more words than I have time today to write — how much your drawing of Sta. M. Novella has delighted me. I have not for many and many a day seen the sense of tenderness and depth of color so united — still less so much fidelity and affection joined with a power of design . . . I wish you could do those three old arches, seen right in front on the left of the steps going up to Sta. M. Novella. If they are still uninjured and wear their weeds there's nothing lovelier in Florence.[4]

In response, Newman made for Ruskin a large watercolor that focused upon the Gothic arcade and tombs outside the cloisters (still in the Ruskin collection at Brantwood), an aspect of the church that he also carefully included in *Santa Maria Novella, Florence*.

In this meticulous watercolor, Newman concentrated on the Gothic elements of the façade, cropping out completely the innovative roundels created by Alberti, whom Ruskin dubbed a "barbarian Renaissance designer."[5] Newman delineated every aspect of the intricate decoration, taking special care to outline the frieze of billowing sails above the round arches (the symbol of the Rucellai family of Florence), as well as the delicate metal armillary sphere, which casts long shadows across the front of the church.[6] His preoccupation with intricate detail was greeted with disdain by James Jackson Jarves in the American press, who called it "a monotonous imitation of external appearances . . . giving superficial satisfaction to beginners in their art education;" he duly noted Newman's popularity with the English market.[7] One enthusiast of Ruskinian aesthetics in America was Charles Eliot Norton, a close friend of Ruskin and an influential professor of fine arts at Harvard (see

cat. 160); appropriately, this watercolor entered Harvard's teaching collection.

E. HIRSHLER

1. This was one of several images of cathedral façades Newman painted during this period. He also depicted the Duomo and Giotto's Tower in Florence, St. Mark's in Venice (cat. 105, fig. 1), and the cathedral at Lucca.

2. John Ruskin, *Mornings in Florence: Being Simple Studies of Christian Art for English Travellers* (Orpington: George Allen, 1889), p. 25.

3. The current location of Mrs. Sears's watercolor is unknown, but the composition must have been similar to Newman's *View of Santa Maria Novella* (fig. 1). While Moore introduced Newman to Ruskin, Newman, in turn, introduced Francesca Alexander to the English critic (see cats. 89, 90).

4. John Ruskin to Henry R. Newman, June 9, 1877, quoted in H. Buxton Forman, "An American Studio in Florence," *The Manhattan* 3 (June 1884), p. 530.

5. Ruskin, *Mornings in Florence*, p. 121.

6. The sphere, made in 1512 by Ignazio Danti, the court astronomer to Cosimo Medici I, was used to measure the solstice.

7. James Jackson Jarves, "Artists and Art Critics," *The New-York Times*, April 28, 1881, p. 2.

Edward R. Thaxter

Born Yarmouth, Maine, 1857;
died Naples, Italy, 1881

Edward R. Thaxter

88. *Meg Merrilies*, 1880–81
Marble, h. 25½ in., w. 20 in., d. 13 in.
Signed on back of base: E.R. Thaxter
Museum of Fine Arts, Boston, William E. Nickerson Fund

Because his career was so brief, Thaxter's residence in Italy was not widely recorded by his contemporaries and is therefore little known today. He apparently went abroad with a minimal education in the arts. As a boy, he made clever carved-pine imitations of John Rogers's mass-produced plaster genre groups. As a teenager, he spent either six or eight months with the Boston portrait sculptor John D. Perry. He then returned to Portland, Maine, where he began making portrait busts.

In October 1878 Thaxter went to Florence, where the American sculptor William Greene Turner took an interest in him. Following Turner's example, he enrolled in the Accademia di Belle Arti for drawing instruction. When the Maine-born sculptor John Adams Jackson died in August 1879, Thaxter took over his studio on 16 Via Orti Oricellari, near the church of Santa Maria Novella, sharing it with another artist from Portland, Fred R. Shaw. Thaxter began modeling "ideals" in the form of busts, small figures, and bas-reliefs, applying himself with an intensity that some thought undermined his health. Between 1880 and 1881 he modeled seven sculptures, the largest of which, Love's First Dream (1880–81, unlocated), attracted effusive praise from the critic James Jackson Jarves, who wrote of it four times in the New York Times.

In early 1881 Thaxter fell ill with either typhus or malaria. Advised to return to Maine for the summer, he reluctantly left his studio where several works were just about to be translated into marble. At Livorno in June 1881 he boarded a New York–bound steamer scheduled to stop at Palermo and Naples. In Naples, he went ashore for sight-seeing; he died from fever two days later.

William Greene Turner helped Thaxter's mother to buy a plot for her son in Florence's Protestant cemetery, where his body was interred in the spring of 1883. In mid-April 1883, the marbles Thaxter produced in Florence were placed on view in his former studio, along with several studies in plaster and sketches in clay, a display that attracted hundreds of viewers.

When James Jackson Jarves visited Thaxter's studio in early November 1880, he saw the first works in clay the young sculptor had produced in Italy. They showed Thaxter drawing broadly from past and present sculpture as he attempted to develop his own style. The earliest project was a small, unremarkable group of a girl scolding her cat, similar to subjects being produced by many Italians. The next three revealed a versatility that startled Jarves: a portrait bust that recalled "Donatello's feeling for simple form;" a bust, *Meg Merrilies*, that attained "for graphic realism and expression, the apotheosis of decrepit ugliness;" and a larger, allegorical sculpture called *Love's First Dream* that showed a sleeping girl caught in Cupid's net and buoyed sinuously into the air.[1] These prompted Jarves to write that a raw lad from the wild coast of Maine had already surpassed Horatio Greenough in ingenuity and expressive power, and that a new era of American sculpture was at hand.[2]

In *Meg Merrilies* Thaxter presented the wild-eyed, ghoulish old gypsy from Walter Scott's 1815 novel *Guy Mannering*, which had become a popular stage play. The characterization reminded Jarves of Charlotte Cushman, the Boston actress celebrated internationally for her performances as Meg Merrilies from the 1840s to the 1870s. Thaxter's starting point may have been his memory of Cushman (she performed the role in Boston in November 1872 and December 1873, when Thaxter was probably working there) or a photograph of her (or another actress) in character. His image, however, transcends the confines of both portrait and idealized bust. One visitor who saw it being finished in marble in Thaxter's studio noted, "In this he showed . . . the idea of the horrible in as strong a manner as [Gustave] Doré in his illustrations of Dante."[3]

Meg Merrilies derives its facial expression, flowing hair, and inclined head from a print source. Nearly the exact physiognomy represents "Fright" in Charles Le Brun's much-reprinted treatise of 1698, *Conférence sur l'expression générale et particulière*. In marble, the work recalls such Hellenistic sculptures as the *Laocoön* (Vatican Museums, Rome). *Meg Merrilies* also reveals Thaxter's study, perhaps in Rome, of Italian Baroque sculpture, especially that of Giovanni Lorenzo Bernini, who made a similar head, the so-called "*Anima Dannata*" (fig. 1).[4] The drilled pupils, deeply cut mouth, and rope-like hair are derived from Bernini's carving style. So, too, is the windswept drapery, although in a more restrained and tentative interpretation.

Thaxter's interest in Bernini was remarkable because of the near-uninterrupted scorn bestowed on the Baroque master's sculpture during the nineteenth century. By the 1850s Bernini was being called an uncommonly talented yet perverted artist whose productions were marred by affectation and aberrations from nature.[5] Nathaniel Hawthorne saw him as the creator of absurd fountains and disagreeable statues, calling his *Apollo and Daphne* (1622–25, Galleria Borghese, Rome) a "freak in marble."[6] Similarly, the writers of Baedeker's 1881 guide to Italy described his works as flimsy and meretricious, their historical significance all but forgotten amid "their too conspicuous defects."[7]

In *Meg Merrilies* Thaxter channeled Bernini's supposed unnaturalness to his advantage. He shrewdly saw the benefit in appropriating the style of a master of theatricality to enhance a subject from the modern stage. Bernini's manner lent an unfamiliar fire to a literary character who was intended to be aberrant and unnatural.

D. STRAZDES

Esther Frances Alexander

Born Boston, Massachusetts, 1837;
died Florence, Italy, 1917

Fig. 1. Gian Lorenzo Bernini (Italian, 1598-1680), *Anima Dannata*, about 1619. Marble. Palazzo di Spagna, Rome.

1. James Jackson Jarves, "Clay Touched by Genius," *The New York Times*, November 27, 1880, p. 1.

2. Ibid.

3. "Edward R. Thaxter," *Portland Advertiser*, July 5, 1881, "Maine Hall of Fame" scrapbook, Maine Historical Society, Portland.

4. Jan Seidler Ramirez in Kathryn Greenthal et al, *American Figurative Sculpture in the Museum of Fine Arts, Boston* (Boston: Museum of Fine Arts, 1986), pp. 266-67.

5. Charlotte A. Eaton, *Rome in the Nineteenth Century* (London: Henry G. Bohn, 1852), vol. 1, p. 456.

6. Nathaniel Hawthorne, *Passages from the French and Italian Notebooks* 1871 (Boston: Houghton Mifflin, 1883), pp. 96, 143, 169.

7. *Baedeker's Italy. Handbook for Travelers Part 2: Central Italy and Rome* (Leipzig: Karl Baedeker, 1881), pp. lix-lx.

Esther Frances Alexander (known as "Francesca") was the only child of Boston portrait painter Francis Alexander and his wealthy and devoutly religious wife Lucia Grey Swett. As a young girl, she displayed a precocious talent for drawing and her father began tutoring her at home at an early age. Her youth was spent mainly in Boston and Lynn, Massachusetts, but in 1853 she and her parents moved to Italy where, except for a few brief trips to America, they lived for the rest of their lives. In the early years the Alexanders divided their time between a villa at Bellosguardo, just outside of Florence, and summers spent in the environs of Abetone in the Appenines, between Modena and Pistoia. By the late 1860s, however, they had settled in an apartment at the heart of Florence, in the Piazza Santa Maria Novella, which Alexander inhabited for the next forty years.

Unlike the majority of Americans living in Italy, Alexander was deeply involved with the welfare of the poor, as well as the preservation of the traditions and folkways of the local contadini. Although she had not received any formal training in art, she hoped, through her pictures, to appeal to the philanthropic sentiments of wealthy Americans by describing the plight of these needy families. Between 1868 and 1882 Francesca compiled and translated many of the hymns, ballads, and stornelli (ditties) of the region, and illustrated them with stories from the Bible and intricate drawings of native wildflowers. In 1882 Henry Roderick Newman introduced her to John Ruskin, who was greatly impressed by her work and became a lifelong friend and correspondent, bestowing on her the name "Francesca." Ruskin purchased the manuscript of Roadside Songs *of Tuscany and oversaw its publication in 1885. He also edited and wrote prefaces for two of her other books, the* Story of Ida *(1883) and* Christ's Folk in the Appenines *(1888).*

Alexander led a very sheltered existence, never marrying, and after her father's death, caring for her elderly mother well into her own old age. She died a recluse and almost totally blind, and is buried in the Allori Cemetery in Florence.

Esther Frances Alexander

89. *Christmas Hymn of Fiumalbo (Per la Natività di Nostro Signore)*, 1868-82
Pen and ink on paper, 15½ x 11 in.
Wellesley College Library, Special Collections

90. *Life of Saint Zita*, 1868-82
Pen and ink on paper, 15¼ x 11 in.
Virginia Steele Scott Collection, Henry E. Huntington Library and Art Gallery.

In October 1882 John Ruskin wrote to Francesca Alexander's mother: "I wish I could learn an entirely new writing from some pretty hem of an angel's robe, to tell you with what happy and *reverent* admiration I saw your daughter's drawings yesterday."[1] The works that Ruskin described so effusively were the group of 122 original illustrations that made up Alexander's folio of the *Roadside Songs of Tuscany*. Ruskin was taken with the artist's highly finished pen and ink drawings of wildflowers, biblical stories, and musical scores, and urged Alexander to sell him the maruscript and allow him to have printed a facsimile edition of the drawings.[2] When she agreed, Ruskin gave all but about a third of them to the Sheffield Museum, and Oxford and Cambridge Universities, while most of the rest of the images remained in his own private collection at Brantwood.[3]

Soon after that Alexander wrote to a friend in America describing her meeting with Ruskin: "I was a good deal frightened, for I had heard that he was a very hard man, and severe in his judgments, and very difficult to please," but, she went on:

> he proved to be just the contrary
> I never saw any one who could enter so
> entirely into the *meaning* of a picture.
> After he had looked at a few pages, he
> said to me: *I see that you have put pretty much
> all your life into this book.* Which was true
> but I could not see how he knew it.[4]

Alexander spent nearly fourteen years making the illustrations for *Roadside Songs*, but for introducing her to much of the music she credited a local *improvisatrice*, Beatrice Bernardi, whose haunting voice and renditions of the old Tuscan poems and songs had made her famous through-

out the region. Alexander had never had any academic training and her figures sometimes appear slightly awkward, but her painstaking technique, with its microscopic stippling and hatching, fascinated Ruskin, who called it her "engraver's method." In fact, on one occasion he begged to be allowed to sit and watch her draw a single flower, claiming that he had long since given up believing that such exquisite drawing was humanly possible.[5] Alexander chose to decorate her pages of calligraphic text and music with botanically accurate renderings of wildflowers because, as she said, "it seemed natural that roadside songs should have borders of roadside flowers."[6]

The four longest ballads in the book are "The Madonna and the Gypsy," "Saint Zita," "Saint Christopher," and "the Samaritan." Of the group, the story of Saint Zita seems to have been a particular favorite of the artist. The Huntington collection drawing represents one of the scenes from the life of this thirteenth-century servant girl from Lucca, here portrayed with her master in contemporary dress witnessing a miraculous visitation from an angel of the Lord. Zita's story of great self-sacrifice in order to help the needy would have had particular meaning for Alexander, who was herself often described as a kind of modern-day saint for her work on behalf of the poor. The model for the figure of Zita was her young friend, Polissena (see fig. 1), whose difficult life Alexander movingly described in the first chapter of her book, *Christ's Folk in the Appenines*, of 1888.[7] Although Polissena's right hand had been badly disfigured in a fire and she therefore could only do heavy jobs such as gathering wood and driving horses, Alexander nevertheless described her in a letter to Ruskin as "the happiest person whom I ever knew."[8]

Fig. 1. Francesca Alexander, *Polissena*, about 1883-84. Pen and ink on paper. Wellesley College Library, Special Collections. Photo courtesy Museum of Fine Arts, Boston.

Wellesley College's musical score of the Christmas song, "Per la Natività di Nostro Signore," with its accompanying branch of glistening cherries, celebrates the very humble setting of the birth of Christ and is described in Francesca's inscription as a "beautiful little hymn. . . sung all over Italy. Even at Asiago in the Tyrol." It is one of several pieces that were specifically meant to be sung during the Christmas season, and, as the book's preface was dated December 25, 1882, it is interesting to note that several of the volumes were apparently given by her as Christmas gifts for American friends when it finally came out in 1885. Both this page and the Saint Zita sheet were also reproduced in 1897, when *Roadside Songs of Tuscany* was published in the United States under the title *Tuscan Songs*. At that time only 108 of the original leaves could be located, so that the publisher, Houghton, Mifflin & Co., was

forced to leave fourteen of them out of the later edition.

In summing up her purpose in collecting, translating, and illustrating *Roadside Songs*, Alexander wrote in her preface: "It seems to me that there are others who will collect and preserve the thoughts of the rich and great; and I have wished to make my book all of poor people's poetry, . . . I have done my best to save a little of what is passing away."[9]

K. HAAS

1. Ruskin to Lucia Grey Swett (Mrs. Francis Alexander), October 9, 1882 (transcript). Berg Collection, New York Public Library, New York. *Christmas Hymn of Fiumalbo* and *Life of Saint Zita* appear in Alexander's book, *Roadside Songs of Tuscany* (Orpington: George Allen, 1885) as plates 81 and 4, respectively.

2. Alexander had apparently always intended to sell the manuscript in order to raise money to help the poor, but had probably not planned to publish it.

3. These two drawings were originally part of that group that was kept by Ruskin for his own private collection and dispersed following his death in 1900.

4. Alexander to Lily Cleveland, December 9, 1882, Berg Collection, New York Public Library, New York.

5. Ruskin to Lucia Grey Swett, October 9, 1882, Berg Collection; he writes: "one more – quite personal favour – I scarcely like to ask, but will venture – that I might see Miss Alexander draw a little bit of a flower. I have really no conception how that work can be done . . . because it is the glorification and perfection of a method once recommended in my elements of drawing – and afterwards rejected as too difficult."

6. Alexander, *Roadside Songs*, p. vi.

7. According to Alexander, she always tried to choose her models from among her *contadini* friends and to find an individual whose character was most like the one described in the story she was illustrating; see *Roadside Songs*, p. 12.

8. Francesca met Polissena near Abetone when the girl was about fifteen years old. The artist often marvelled at her unfailing spirit and Christian faith in her letters to Ruskin. The portrait of Polissena in Wellesley College's collection appears to be one that Alexander actually drew for Ruskin and which she describes in detail in an undated letter to him; see *Christ's Folk in the Appenines* (New York: John Wiley & Sons, 1888) pp. 22-23.

9. Alexander, *Roadside Songs*, p. vii.

Frank Duveneck

Born Covington, Kentucky, 1848;
died Cincinnati, Ohio, 1919

Of the approximately twenty years Duveneck lived abroad, half were spent in Italy. He first visited Venice and Trieste in the summer of 1873 after studying in Munich, and just before returning to the United States. In 1877, after two more years in Munich, Duveneck traveled to Venice again, with fellow artists William Merritt Chase and John Henry Twachtman, this time staying for nine months.

In 1878 Duveneck organized a painting class in Polling, Bavaria, for American students, one of whom, Elizabeth Boott, convinced him to move it to Italy (see cat. 41). In 1879 about sixteen of "Duveneck's Boys," including John White Alexander, Joseph Decamp, Theodore Wendel, and Louis Ritter, assembled in Florence, wintering there and summering in Venice for the next two years. They were fictionalized in William Dean Howells's 1886 novel, Indian Summer, *as the "Inglehart Boys," a raucous band of Americans who roam Italy oblivious to its art and beauty.*

Duveneck's move to Italy offered him artistic breathing room and an opportunity to experiment with technique, subject matter, and media. In the summer of 1880 he took up etching in Venice with Otto Bacher and James A. McNeill Whistler. From 1880 to 1883 he produced etchings of Venice that were comparable to Whistler's in their deft, airy interpretation of the city's chief sights. In Italy Duveneck's palette grew lighter while his handling of paint became more precise. When he returned to Venice in the fall of 1882 after a year's hiatus in Boston, he began painting large-scale figural works that demonstrated his new concern for light and color, and he increasingly painted outdoors.

Duveneck remained in Venice through 1884. He went to Paris for most of the following year and married Elizabeth Boott there in March 1886 (see cat. 145). They returned to Florence to live with her father at Villa Castellani at Bellosguardo, a hill on the south bank of the Arno, where their son Francis Boott Duveneck was born in December 1886. In October 1887 Duveneck

Frank Duveneck

91. *Italian Courtyard*, 1886
Oil on canvas, 22¼ x 33½ in.
Signed l.r.: FD (in monogram) 1886
Cincinnati Art Museum, Gift of the Artist

moved with his wife and son to Paris where Elizabeth died unexpectedly in March 1888. From 1891 to 1894 Duveneck was again in Florence to complete her grave monument. He returned to Cincinnati where he continued to teach and enjoy the reputation he had earned abroad. His intermittent travels brought him to Italy one last time in 1905.

Duveneck spent the year 1886 at Bellosguardo, at the sprawling Villa Castellani (now called Villa Mercede) where Elizabeth Boott and her father had lived off and on since the 1850s (see cat. 41). Located on a hilltop just south of the Arno in an area of farms and secluded villas, it offered spectacular panoramas of Florence. However, Duveneck took no interest in this picture-book scenery. Instead he sought out more prosaic views of the villa and its surroundings, in order to capture light-reflecting surfaces and empty space, and

thereby solidify a pictorial style that he had begun to formulate in Venice in the early 1880s.

Italian Courtyard demonstrates Duveneck's new pictorial goals. Except for a sliver of flat blue sky, it is painted in a limited palette of ocher and tan. It shows brightly lit, tightly cropped, anonymous building fronts that allow Duveneck to concentrate on their basic structure and ignore the traditional picturesque elements of Italian landscape. Instead, mass and light are his emphasis.

William Merritt Chase

Born Williamsburg (now Nineveh), Indiana, 1849;
died New York, New York, 1916

Duveneck likely found these rustic buildings near Bellosguardo, perhaps around the village of Vallombrosa, which he and his wife visited that year.[1] Although the title "Italian Courtyard" is Duveneck's, the subject is not a courtyard as such, but a group of house fronts on a cul-de-sac, since the doorway at the left shows a street number. These are humble dwellings made of stuccoed fieldstone with wooden lintels and windows without glazing. Duveneck's focus is on the sun-washed blocks of the buildings and their intermittent, dark entries. A human presence is suggested by bits of laundry, pots of herbs, and a half-opened doorway, but the absence of street life gives the image an unexpected austerity.

Duveneck's interest in structuring space and surfaces as areas of light and dark corresponded to the efforts of the Macchiaioli painters then active in Florence, particularly Silvestro Lega (1826-1895), who around 1885 reduced his outdoor views to clear, geometric contrasts of brightness and color.[2] The interest in capturing the sensation of outdoor light was a compelling, widely based phenomenon in which virtually all of Duveneck's former fellow students in Munich has also taken an interest by the mid-1880s.[3]

D. STRAZDES

1. Josephine W. Duveneck, *Frank Duveneck, Painter-Teacher* (San Francisco: John Howell, 1970), p. 117.

2. Norma Broude, *The Macchiaioli: Italian Painters of the Nineteenth Century* (New Haven: Yale University Press, 1987) pp. 5, 175-183.

3. See William H. Gerdts, *American Impressionism* (New York: Abbeville Press, 1984), pp. 47, 61, 108, 111.

In 1872, a group of American patrons raised $2,100 to send twenty-three-year-old art student William Merritt Chase on his first trip to Europe. Chase spent five years in Munich studying under Alexander von Wagner, Karl von Piloty and Wilhelm Leibl. In the spring of 1877 Chase and his colleague Frank Duveneck, also a student in Munich, organized a trip to Italy. In Venice they met John Henry Twachtman, with whom they shared an apartment for nine months. Chase's experience was cut short by economic hardship and poor health.

During his time in Venice Chase concentrated on views of the Italian city and the lagoon. After returning to Munich he sailed back to New York where he had accepted a teaching position at the newly founded Art Students League. During the next decade Chase traveled five times to the Continent, mainly during the summer months, going to France, England, Holland and Spain, but not Italy.

In June 7, 1907, thirty years after his first trip, Chase sailed to Italy aboard the Romanic (arriving in Naples on June 21) with forty art students. The group toured the major Italian cities, among them Rome, Siena, Milan, Venice, and Palermo, finally reaching Florence at the end of July where the actual two-month art course would take place. Here Chase met with his friends, American artists George de Forest Brush and Julius Rolshoven (1858-1930), both of whom had permanent studios in the city. Chase quickly secured a lease of his own: the fifteenth-century Villa Silli located in the hills of Fiesole overlooking Florence. For the next four years he would return to the villa each summer, taking its views, gardens, and interiors as his subjects.

Also during 1907 Chase was honored with a commission from the Uffizi Gallery for a self-portrait for its famous collection of such studies. The artist painted at least four works during this summer including a fish still-life, a subject resurrected from Chase's first visit to Venice in 1878.

The next two summers found Chase in Florence without a class. It was not until 1910 that the artist organized another art class to take abroad. The twenty-five students traveled throughout Italy and were met by Chase in Florence at the end of June. His friends Mr. and Mrs. J. Carroll Beckwith visited Chase during this summer, arriving in Florence in July; Beckwith convinced Chase to purchase Villa Silli, which he had been renting for the last three summers. Chase would only visit Florence once more, during the summer of 1911, again as a teacher to American students. In 1913 Chase offered his last class in Italy but instead of Florence he went to the city of Venice. Here he seems to have painted mostly fish still-lifes with the exception of a large canvas, A Venetian Balcony, exhibited at the 1914 exhibition of "The Ten."

Fig. 1. William Merritt Chase, *Ponte Vecchio*, about 1907. Oil on panel. Courtesy Jordan-Volpe Gallery, Inc.

William Merritt Chase

92. *The Song,* about 1907
Oil on canvas, 28 x 28 in.
Signed l.l.: Wm M. Chase
From a private collection

Villa Silli, Chase's summer home in Florence, after 1907, was described as:

> most picturesque dating back to 1400, and when Mr. Chase bought it it was furnished in part with antique objects corresponding to its age . . . the stone walls of the villa are four feet in thickness . . . all the floors are of glazed clay, and are painted in beautiful colors. The visitor on entering finds himself in a room 40 feet deep by 30 wide, the ceiling is white and gold.[1]

Unknown for many years, *The Song* may represent the main hall in Villa Silli.[2] The work is one of the last in the series of elegant interiors Chase painted throughout his career. From the 1880s through the 1890s Chase had used both the interiors of his Tenth Street studio and of his summer home in Shinnecock Hills as settings for paintings of family gatherings, visits from friends, and children's games. As Cikovsky suggests, Chase's interiors, as opposed to his "plein-air" landscapes, are "in certain ways deeper and more complex as art, more layered in meaning, richer in reference, and more revealing of Chase himself."[3]

In *The Song* Chase explores the delicate relationship between music and women, a theme that fascinated nineteenth-century American artists. The roots of this interest may be found in the nineteenth-century transformation of the American female image into one of "poetic chastity."[4] The woman's place was thought to be in the home, in the interior, where she was considered the pure guardian of culture. Women were usually portrayed without the company of men, and were linked particularly with such leisure pastimes as sewing, reading, or playing an instrument.

The depiction of women and musical instruments has a long tradition, going back to the Italian Renaissance, and then to the work of Vermeer and his contemporaries in seventeenth-century Holland. Since the 1840s, when the piano reached its present form, English and American artists began presenting women at the keyboard as a symbol of cultivation and sensitivity. The first modern exponent of the subject was Whistler who, through such works as *At the Piano*, (1858-59, The Taft Museum, Cincinnati, Ohio), popularized the theory that "a picture should formally express the mellifluous and soothing qualities of music."[5] Thomas Eakins in the 1870s depicted friends and family members singing and playing the piano, in thoughtful or sorrowful moods. Thomas W. Dewing, a friend of Chase since their student days in Munich, became one of the best-known specialists in this subject with works such as *The Spinet* (National Museum of American Art, Smithsonian Institution, Washington, D.C.), *Girl and Lute* (Freer Gallery of Art, Washington, D.C.), and his *Brocard de Venise*, about 1905 (Washington University Gallery of Art, St. Louis) whose composition closely resembles that of *The Song*.

The Song presents all the characteristics admired in Chase by the art critic Royal Cortissoz, "sound drawing, pure and harmonious color, the right play of light, intelligent composition and a swift, confident, powerful and direct movement of the brush."[6] The room is lit from above as if from a skylight, with the upper half of the work in monochromatic tones of pink-gray that represent the "pietra serena," the building material of most of the fifteenth-century Italian palaces and villas, and the lower half more richly colored in brilliant reds, whites, and greens.

The great empty space of the interior, with its large column topped by a Corinthian capital, with high pendentive arches, massive furniture, sculpture, and flowers, dominates the two women in the room. Yet one's attention is drawn to the seated female figure in the right foreground, who is locked in space by the red chair she is sitting on, the column to the left, the crimson oriental rug under her feet, and the dark piano behind her. Her pose is ambiguous: one wonders whether she is simply concentrating on the music or whether the song has provoked sorrow or grief.

As there is no evidence that Chase's wife or his daughters traveled with him during the 1907 summer sojourn, it is likely that the female subjects in *The Song* are students from his art class.[7]

N. OTERO-SANTIAGO

1. Gustav Kobbe, "The Artist of Many Studios," *The New York Herald*, November 20, 1910, Magazine Section, p. 11.

2. I am indebted to Ronald Pisano for suggesting this idea. However, existing photographs of the Villa Silli's interior do not allow a positive identification.

3. Nicolai Cikovsky, Jr., "Interiors and Interiority," *William Merritt Chase: Summers at Shinnecock 1891-1902* (Washington, D.C.: National Gallery of Art, 1987), p. 39.

4. Bailey Van Hook, "'Milk White Angels of Art': Images of Women in Turn-of-the-Century America," *Woman's Art Journal* 11 (fall 1990/winter 1991), p. 24. The newly cultivated American bourgeoisie considered the voice "the most transparent of instruments," and because of their pure character, women were thought to be the best vehicles for it. See Elizabeth Johns, *Thomas Eakins: The Heroism of Modern Life* (Princeton: Princeton University Press, 1983), p. 132.

5. Julie Anne Springer, "Art and the Feminine Muse: Women in Interiors by John White Alexander," *Woman's Art Journal* 6 (fall 1985/winter 1986), pp. 1-8.

6. Royal Cortissoz, *Exhibition of Works by William Merritt Chase*, (New York: American Academy of Arts and Letters), April 26-July 15, 1928, pp. 5-10.

7. Fond of portraying his own students, Chase painted his student Annie Traquair Lang (1911, Philadelphia Museum of Art) inside one of the rooms of his villa; the same room was used for the other known interior of the villa, *A Memory: In the Italian Villa* (Christie's, New York, December 1, 1989).

John Singer Sargent

93. *In a Medici Villa*, about 1907
Watercolor and graphite on paper, 21¼ x 14⅜ in.
The Brooklyn Museum, Purchased by special subscription

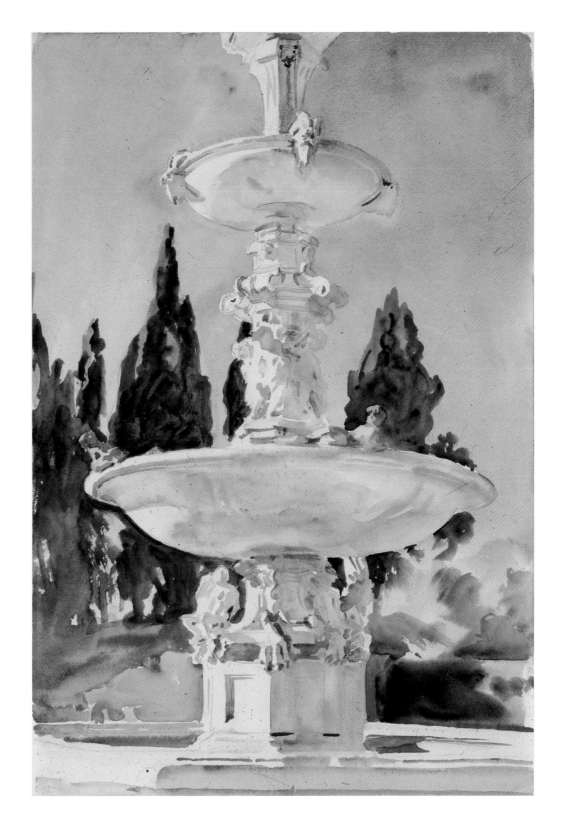

After 1900, when he was the most admired portraitist in England and America, John Singer Sargent turned increasingly toward watercolor, a medium that he quickly mastered. He may have seen his watercolors as a respite from his portraits and mural commissions, for they were not directed by the desires of his patrons, and Sargent could paint what he pleased. He did not intend to keep them private, however, and he exhibited them regularly after 1903. Soon there was a great demand for Sargent's watercolors, and even Isabella Stewart Gardner, a close friend, had trouble obtaining them. Because they were portable, Sargent regularly used watercolors on his travels, settling in with a folding camp stool and table beneath the shelter of several white umbrellas, an arrangement that made him look like "a newly hatched chicken, surrounded by broken eggshells," according to one observer.[1] Among his favorite motifs were the elaborate formal gardens of Italy.

In a Medici Villa depicts the most famous fountain in the garden of the Villa di Castello, just outside of Florence. The estate entered the Medici family in 1477, when Lorenzo and Giuliano Medici acquired it. Great patrons of the arts, they commissioned works by both Michelangelo and Botticelli, whose masterpieces *The Birth of Venus* and *Primavera* remained in the villa until 1815. The gardens were the creation of Grand Duke Cosimo I, who retired to Castello in the 1530s and hired the architect and sculptor Niccolò Tribolo (1485-1550) to renovate the villa and plan the grounds. Although they were incomplete at Tribolo's death, the gardens were highly admired, and Georgio Vasari described them as the "most rich, magnificent, and ornamental garden[s] in Europe."[2] The nucleus of the garden was a square, walled enclosure, full of espaliered orange and pomegranate trees. At its cen-

ter stood an elaborate sculpted fountain, surrounded by a labyrinth of bay, myrtle, and cypress.[3]

The gardens at Castello were included in the first illustrated American book on the subject, Charles Platt's *Italian Gardens* of 1894. By the time Sargent painted *In a Medici Villa*, there were voluminous publications on landscape design in Italy, including Edith Wharton's well-known *Italian Villas and Their Gardens* of 1904, which also mentioned Castello (see cat. 170). Wharton's book was dedicated to Sargent's close friend Vernon Lee, and the artist shared this contemporary passion for Renaissance gardens, depicting them frequently at this time; he painted the fountains and grounds of villas in Florence, Lucca, and Frascati (see cats. 44, 73).

At Castello, Sargent concentrated upon Tribolo's central fountain, a rich confection of marble topped with the grappling bronze figures of Hercules and Antaeus, whose throat gushed water as he lost his strength. Additional bronzes of nude boys lolled on the edges of the large lower basin.[4] Sargent cropped the heroic figures out of his composition, selecting instead a foreshortened perspective, which allowed him to isolate the white fountain against the dark cypresses and the rich cobalt blue sky. He began the picture by outlining the main forms with loose, vigorous pencil drawing, which is clearly visible beneath the loose washes of color. The whitest areas, where the sun struck polished stone, are clean paper, which Sargent probably reserved by using a type of frisket, a liquid blocking agent that was later rubbed away.[5] Sargent painted quickly; his friend Adrian Stokes later recalled that "the rapidity and directness with which he worked was amazing . . . his hand seemed to move with the same agility as when playing the keys of a piano."[6] Despite his speed, Sargent faithfully captured the richness of the elaborate carving, the graceful swell of the two basins, and the subtle color modulations of the shadowed stone.

In a Medici Villa was first exhibited in 1907 at the Royal Water-Colour Society in London.[7] In 1909, it was displayed in a group of eighty-six watercolors at Knoedler's in New York; all but three of them were purchased immediately for a lump sum of $20,000 by the Brooklyn Museum. This was the first of several such sales of large groups of watercolors to major American museums, a strategy that Sargent seems to have carefully planned, taking special care to support the institutions that had sponsored his work in the past and allowing his exceptional watercolors to remain in public collections.[8]

E. Hirshler

1. Martin Birnbaum, quoted in Richard Ormond, *John Singer Sargent: Paintings, Drawings, Watercolors* (New York: Harper and Row, 1970), p. 68.

2. Giorgio Vasari, quoted in Georgina Masson, *Italian Gardens* (New York: Harry N. Abrams Inc., 1961), p. 77.

3. The central fountain has been changed. The original fountain, designed by Tribolo, was called the Fountain of Fiorenza, and above its marine monsters and dancing cherubs stood a bronze statue (attributed to Gianbologna) of Florence, wringing water from her hair. This fountain was removed to the nearby Villa della Petraia in the late eighteenth century, where it was renamed the Fountain of Venus. At the same time, Tribolo's Fountain of Hercules, which had originally stood nearer to the house at the Villa di Castello, was moved into the central enclosure in place of the Fountain of Fiorenza. See Masson, *Italian Gardens*, pp. 77-79, and Judith Chatfield, *A Tour of Italian Gardens* (New York: Rizzoli, 1988), pp. 97-102. The villa at Castello, called "Il Vivaio," has housed the Accademia della Crusca since the Second World War.

4. Many of the sculpted figures, including all of the bronzes, have now been removed from the fountain for restoration or preservation.

5. Conversation with Antoinette Owen, paper conservator at the Brooklyn Museum. See also Judith C. Walsh, "Observations on the Watercolor Techniques of Homer and Sargent," in Susan E. Strickler, *American Traditions in Watercolor* (Worcester, Mass.: Worcester Art Museum, 1987), p. 58.

6. Adrian Stokes, "John Singer Sargent, R. A., R. W. S.," *Old Water-Colour Society Club, Third Annual Volume*, ed. Randall Davies (London: Chiswick Press, 1926), p. 60.

7. It was shown with the title "In a Florentine Villa."

8. Other institutions that purchased blocks of Sargent's watercolors included the Museum of Fine Arts, Boston, the Metropolitan Museum of Art, and the Worcester Art Museum. See Trevor J. Fairbrother, *John Singer Sargent and America* (New York: Garland Publishing, Inc., 1986), pp. 327-332; and Annette Blaugrund, "'Sunlight Captured': The Development and Dispersement of Sargent's Watercolors," in Hills, et al., *John Singer Sargent* (New York: Whitney Museum of American Art, 1986), pp. 224-238.

VII *Renaissance Revival*

Elihu Vedder

94. *Volterra*, about 1860
Oil on canvas, 12¼ x 25½ in.
Signed l.l.: Vedder
National Museum of American Art, Smithsonian Institution

In July 1860 Vedder traveled from Florence southwest to the medieval hill town of Volterra. He stayed for about a month "to sketch from nature,"[1] accompanied by Thomas Hiram Hotchkiss (see cat. 52) and Giovanni (Nino) Costa (fig. 1) who had suggested the unusual destination. American artists did not typically visit Volterra.[2]

Volterra itself was built on Etruscan ruins, and the rocky cliffs of the surrounding countryside, known as *le Balze*, date to the Pliocene era. This strange, almost lunar landscape attracted Vedder, as he wrote to his father on August 6:

> The present town, the vallies (sic) around and the extensive views in all directions are the things that interest us most . . . on one side of the town there is a great ravine and the hillside has been crumbling away in it for centuries . . . the soil is of clay, and the gullies and pinnacles left in it by the rain make the cene (sic) one of the wildest beauty. I have . . . a painting of it, and another looking over the plain (sic) with the mountains of Carrara in the distance.[3]

Volterra is the second of the two paintings described by Vedder,[4] with the cliffs in the foreground and the expanse of the Arno River plain in the middleground stretching in the distance to the foothills of Carrara. Two tiny figures in the foreground provide a sense of scale, emphasizing the massiveness of the craggy cliffs; they are also the sole evidence of human presence.

Fig. 1. Nino Costa (Italian, 1826-1903), *Roman Campagna*, 1849-59. Oil on panel. Museum of Fine Arts, Boston, Bequest of Sarah Wyman Whitman.

Unlike other American artists, Vedder rejected the literary circle of expatriates in Florence to associate with contemporary Italian painters, the Macchiaioli. In a style similar to that favored by the Macchiaioli artists, Vedder painted the cliffs in *Volterra en plein air* with thick brushstrokes in almost flat splashes of color.[5] Also like the Macchiaioli, Vedder finished his composition in the studio, but retained the freshness of direct observation. Nino Costa, Vedder's sketching companion on this trip, was a leading proponent of this anti-academic movement, although Vedder's landscapes are stylistically closer to those of such other Macchiaioli as Giovanni Fattori (1825-1908) or Telemaco Signorini (1835-1901).[6]

K. QUINN

1. Elihu Vedder to his father, Elihu Vedder, Sr., August 6, 1860, Elihu Vedder Papers, Archives of American Art, Smithsonian Institution, Washington, D.C.

2. Joshua Taylor, "Perceptions and Digressions," in *Perceptions and Evocations: The Art of Elihu Vedder* (Washington, D.C.: Smithsonian Institution Press, 1979), pp. 52-53. Other than Vedder, Thomas Cole, John Cranch (1807-1891) and Henry Greenough (1807-1883, the brother of Horatio) sketched at Volterra in August 1831. French artist Jean Baptiste Camille Corot (1796-1875) painted at Volterra in 1834 (see Peter Galassi, *Corot in Italy* [New Haven: Yale University Press, 1991, pp. 214-215]).

3. Elihu Vedder to his father, Elihu Vedder, Sr., August 6, 1860, Elihu Vedder Papers, Archives of American Art, Smithsonian Institution, Washington, D.C.

4. The first painting is *Cliffs of Volterra*, about 1860 (The Butler Institute of American Art, Youngstown, Ohio).

5. Vedder met the Macchiaioli at their informal meeting place in Florence, the Caffè Michelangiolo, through Francesco Saverio Altamura (1829-1897), a painter with whom he had found lodgings upon his arrival in Florence. See Regina Soria "An American Macchiaiolo New Insights into Elihu Vedder's Florentine Experience, 1857-1860," in Irma Jaffe, ed., *The Italian Presence in American Art* (New York: Fordham University Press, 1989), pp. 165-175. For the Macchiaioli in general see Norma Broude, *The Macchiaioli: Italian Painters of the Nineteenth Century* (New Haven: Yale University Press, 1987), and Edith Tonelli and Katherine Hart, eds., *The Macchiaioli Painters of Italian Life 1850-1900* (Los Angeles: University of California, 1986). It is interesting to note that although Vedder is not mentioned in Macchiaioli literature, his paintings in this style are contemporaneous with the earliest Italian examples.

6. Costa's oil sketches, do, however, relate in style to Vedder's work.

Elihu Vedder

95. *The Cumaean Sibyl*, 1876
Oil on canvas, 38 x 59 in.
Signed l.r.: Elihu Vedder / Rome 1876
The Detroit Institute of Arts, Merrill Fund

The Cumaean Sibyl, according to ancient legend, offered to sell nine books of prophecy to Tarquinius Superbus (about 534-509 B.C.), the last king of pre-Republican Rome. He refused to pay the amount she asked, so she left and burned three of the books. The Sibyl then re-offered the six remaining books to the king at the price of the original nine. Again, Tarquinius balked at the exorbitant figure she named. The Sibyl burned three more books and then returned to offer the last three, once again at her first price. Tarquinius, uncertain of her motives, conferred with his augurs about the situation and was told he had, in effect, rejected a gift from the gods and must immediately purchase the remaining books at the Sibyl's price. Once this was accomplished the Sibyl disappeared from Rome. The books, known thereafter as the Sibylline oracles, were consulted by order of the Roman senate in times of emergency.[1]

In his 1876 painting, Vedder has depicted the Cumaean Sibyl on her way to Tarquinius to make her final offer.[2] In a forbidden landscape she strides resolutely toward Rome with the aid of a walking stick. Her facial expression reveals her tragic determination: her mouth is set and her eyes are riveted on her distant destination. She clutches to her chest three remaining scrolls while small brushfires to her left burn the already-rejected books.

Vedder wrote in his autobiography that the ultimate source for the figure in *The Cumaean Sibyl* was a portrait he had drawn in 1863 of Jane Jackson, an ex-slave whose acquaintance he had made in New York between his first and second European trips.[3] When, in 1865, Vedder was elected to the National Academy of Design, his diploma piece was an oil portrait based on the drawing and entitled *Jane Jackson — Formerly a Slave*. This painting, in turn, inspired the 1866 poem by Herman Melville, "Formerly a Slave," which ends with the verse:

> Far down the depth of thousand years,
> And marks the revel shine;
> Her dusky face is lit with sober light,
> Sibylline, yet benign.[4]

The reference to Jane Jackson as "Sibylline" is important as a connection between Vedder's realistic portrait and his later Cumaean Sibyl, since the latter does not appear as a separate subject in Vedder's oeuvre until 1869.[5] Vedder's choice of specifically the *Cumaean* Sibyl may have been influenced by a revival of interest in the legend after the first systematic archeological excavations began in Cumae in 1852.[6]

K. QUINN

1. Recounted in Dionysius of Halicarnassus (about 60/55 B.C. – after 7 B.C.), *The Roman Antiquities*, Book 4, chapter 62.

2. The alternate title for the painting is *The Cumaean Sibyl Returning to Tarquin*.

3. Elihu Vedder, *The Digressions of V* (Boston: Houghton Mifflin Co., 1910), p. 236ff. The drawing is in a private collection.

4. "Formerly a Slave," subtitled "An Idealized Portrait by E. Vedder, in the Spring Exhibition of the National Academy, 1865," was published in Melville's 1866 volume of Civil War-related poetry *Battle-Pieces and Aspects of the War*. Regina Soria in *Elihu Vedder American Visionary Artist in Rome* (Cranbury, New Jersey: Associated University Presses, Inc., 1970), p. 37, discusses the Vedder/Melville connection and credits Hennig Cohen with the specific discovery of the relationship between the painting and poem.

5. The Cumaean Sibyl first appears as a subject in Vedder's oeuvre in two drawings (location unknown) and a small painting commissioned by David Gray of the *Buffalo Courier*, all dated 1869. Vedder repeated the subject in a watercolor of 1872 (Brooklyn Museum), a sepia of about 1876 (location unknown), the Detroit painting dated 1876 and a bust length oil in 1898. In 1898 Vedder also executed a bust of the Cumaean Sibyl in bronze. See Soria, *Elihu Vedder American Visionary Artist in Rome*, p. 286ff.

6. The Count of Syracuse excavated at Cumae between 1852 and 1857. Soria, however, believes Vedder's choice of the Cumaean Sibyl is rooted in his depression following the death of his son Philip in 1875, but Vedder first treated the subject in 1869, well before Philip or even his second son, Alexander died (d. 1871). See Regina Soria, "Some Background Notes for Elihu Vedder's *Cumean Sibyl* and *Young Marsyas*," *The Art Quarterly* 13 (spring 1960), p. 75. About the subject of the Cumaean Sibyl Vedder himself states in his autobiography, *The Digressions of V*, p. 236ff., "Time went on and I found myself in a mood. As I always try to embody my moods in some picture, this mood found its resting-place in the picture of 'The Cumean Sibyl.'. . . thus Jane Jackson became the Cumean Sibyl. The story of the Sibyl is well known . . . but the story of the embodied mood has not been translated. In plain English it meant: If you don't buy my pictures now when they are cheap, you will have to pay dearer for them later on."

Elihu Vedder

96. *In Memoriam*, 1879
Oil on canvas, 44¼ x 20 in.
Signed l.l.: Elihu Vedder/Rome 1879
In the collection of the Corcoran Gallery of Art, Museum Purchase, Anna E. Clark Fund

Painted in Rome, *In Memoriam* was dedicated to Vedder's son, Philip,[1] who had died in Perugia of diphtheria in July 1875 at the age of five. Vedder used a combination of classical and Christian iconography to create a personal image of death, sacrifice, and salvation. A statuesque female figure in heavy drapery stands in a field of poppies that have gone to seed.[2] She holds an urn cradled in her right arm and steadied by her left. Her long hair is worn loose, but kept off of her face by a ribbon, and a small pearl earring dangles from her right ear. The woman gazes thoughtfully off to her left, beyond a truncated and decaying column in front of her. A boar's skull has been placed on top of the column, and a passionflower blossom[3] and leaves have somehow been affixed to the front of the column, visible to the viewer. Below the flower a small plaque inscribed in Latin is attached to the shaft. In translation it reads:

> Also, as one surviving flower
> lives among his dead companions,
> Thus in the desolated heart still
> that name lives.[4]

The column has been identified as funereal and the skull a sacrifice to the Manes, the Roman spirits of the dead.[5] The boar itself can be associated with death.[6] The passionflower and its leaves are Christian symbols for the Passion of Christ: the petals of the flower represent Christ's wounds, the color, His suffering and the leaves the sacrifice of His own life leading to the redemption of mankind.[7] The passionflower in Vedder's painting is fresh, while the surrounding poppies, emblems of sleep and death, are dried up. Thus, the passionflower is a physical representation of the "surviving flower" of Vedder's inscription; Philip Vedder, then, becomes associated with the passionflower and its symbolism.

The figure in *In Memoriam* first appears in *Woman among Poppies Holding Etruscan Jar* (private collection), in 1876, a year after Philip Vedder's death. Significantly, this painting is inscribed "In Perugia — Carrie posed for this sketch — Vedder,"[8] thus bringing in Philip's mother as the ultimate source for the woman in *In Memoriam*, as well as the place of his death — Perugia. The same theme reappears in 1877 in *Girl with Poppies* (High Museum of Art, Atlanta, Georgia) and Vedder paints a variation of the figure as *Fortune* (private collection) the same year.[9] The woman in *In Memoriam* is fully clothed, which may be a reference to classical mourning practices.[10] The urn she carries is called "Etruscan" in the title of the early version of the composition, although it is not archaeologically identifiable as such. More likely the vase was one of the local pieces Vedder had collected.[11] Finally, the earring worn by the figure may only be decorative, but it should be noted that the pearl is the birthstone for June, the month of Philip's birth, and this gem is a Christian symbol of salvation.[12] Although Vedder did not subscribe to any one faith, a message of hope seems to underscore the grief inherent in *In Memoriam*.

K. QUINN

1. Richard Murray, "The Art of Decoration," in *Perceptions and Evocations: The Art of Elihu Vedder* (Washington, D.C.: Smithsonian Institution Press, 1979), p. 189.

2. The flowers are identified as poppies in W.H. Bishop, "Elihu Vedder," *American Art Review* 1 (June-July 1880), p. 328.

3. Murray, "The Art of Decoration," p. 189.

4. Soria, *Elihu Vedder American Visionary Artist in Rome* (Cranbury, New Jersey: Associated University Presses, 1970), p. 321. The Latin reads: "Heu flos unus superstes/Inter mortuos iam socios vigens/Sic at in corde desolato/Vivit adhuc nomen illud."

5. Bishop, "Elihu Vedder," p. 328. The Manes can also specifically refer to the Greek and Roman Gods of the underworld.

6. Gertrude Jobes, *Dictionary of Mythology, Folklore and Symbols* (New York: Scarecrow Press, 1962), vol. 1, p. 231. The boar and boar-hunting were associated with the month of October, the beginning of the hunting season. October, an autumnal month, leads into winter, and thus death.

7. Murray, "The Art of Decoration," p. 189 and Jobes, *Dictionary of Mythology, Folklore and Symbols*, vol. 2, p. 1242. The passionflower is also a June birthday flower and Philip Vedder was born June 25, 1870.

8. Soria, *Elihu Vedder American Visionary Artist in Rome*, p. 314.

9. For a discussion of the similarities between *Fortune* and *In Memoriam* see Murray, "The Art of Decoration," p. 189. *Fortune* was Vedder's first iconographically complex composition, though the symbolism in *Fortune* is largely classical.

10. See, for example, Larissa Bonfante, "Daily Life and Afterlife," in Larissa Bonfante, ed., *Etruscan Life and Afterlife* (Detroit: Wayne State University Press, 1986), pp. 258 and 277, which discusses Etruscan (and Roman) mourning dress.

11. See Vedder, *The Digressions of V.* (Boston: Houghton Mifflin Co., 1910), pp. 314-317 on his collecting.

12. Jobes, *Dictionary of Mythology, Folklore and Symbols*, vol. 2, p. 1248.

Frank Duveneck

97. *Francis Boott*, 1881
Oil on canvas, 47¾ x 31¼ in.
Signed l.l.: FD (in monogram) / Florence 1881
*Cincinnati Art Museum, The Edwin and Virginia Irwin
Memorial*

Duveneck's portrait of Francis Boott (1813-1904) was begun shortly after Duveneck's engagement to Boott's daughter, Elizabeth (an engagement that would be broken by the end of 1881), perhaps to demonstrate the subtlety of his skills to a future father-in-law skeptical of his artistic sophistication. It must have been completed in a month or two, to allow it sufficient time to be framed, packed, and shipped to Paris for submission to the next Salon, which opened May 2, 1881.[1] One of only a very few formal portraits Duveneck ever produced, it is a work that summed up the painting technique Duveneck had mastered in the course of his career, in which the living subject mingled freely with allusions to past art.

The portrait is simple and direct, yet at the same time undeniably aristocratic. The subject stands against a plain, dark background, his gloved right hand lightly grasping his fur-trimmed topcoat. Duveneck reverted to the use of bitumen that had been his practice in Munich, but which he otherwise abandoned in Italy. His technique is true to the *alla prima* old-master tradition, although it is more controlled and highly finished than had been his practice in Munich. Duveneck's students noted that he reworked this painting so much, they made him stop working on it out of fear that he would spoil it.[2]

By making careful reference to Titian, the artist sought to capture the elusive combination of psychological penetration and aloofness that typified Titian's portraiture. The pose here is exactly that of Titian's so-called *Filippo Strozzi* (about 1560, Kunsthistorisches Museum, Vienna).[3]

In creating a "new" Titian in Florence, Duveneck invited visual comparison with the most famous Titian male portrait in the city, that of *Pietro Aretino* (about 1545, Pitti Palace, Florence). The comparison be-

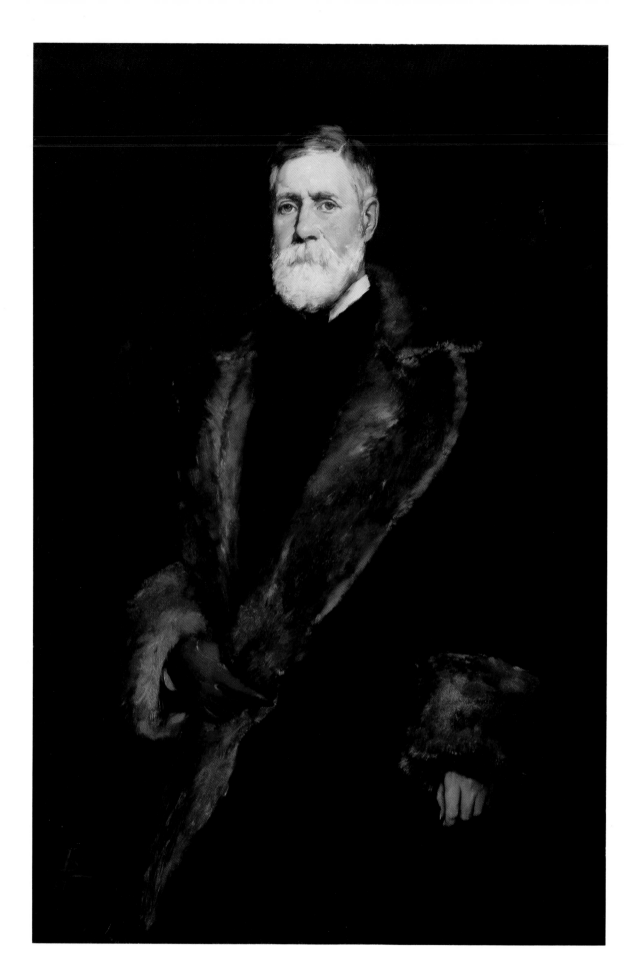

Frank Duveneck and
Clement J. Barnhorn

98. *Tomb Effigy of Elizabeth Boott Duveneck*, modeled 1891; carved 1894
Marble, h. 28, w. 86 x h. 39½ in.
Signed, on left side below head: F. Duveneck. 1891
Museum of Fine Arts, Boston, Gift of Frank Duveneck

tween the two sitters was likewise sufficiently close that Duveneck could cast Boott as the modern-day Aretino. Aretino, the Tuscan son of a shoemaker, was a self-taught writer of plays, poetry, and satire, and was closely associated with other artists and writers. Francis Boott, son of a textile manufacturer, was a self-taught musician, composer, who had lived in Tuscany since 1848 and was closely associated with America's expatriate artists and writers.

D. STRAZDES

1. The painting was no. 833 in the Salon of 1881, exhibited under the title, *Portrait de M. B. F. G. Dumas*, ed., *Catalogue des ouvrages de peinture & de sculpture exposés au Palais des Champs-Elysées* (Paris, 1881).

2. Jan Newstrom Thompson, *Duveneck: Lost Paintings Found* (Santa Clara, Calif.: Triton Museum of Art, 1987), p. 13.

3. Duveneck's figures frequently strike poses derived from portraits of past masters. One of his early Munich figure paintings, for example, *Lady with a Fan* (1873, The Metropolitan Museum of Art, New York) adopted the pose of Titian's *Lavinia as Bride* (about 1555, Gemäldegalerie Alte Meister, Dresden). Michael Quick, *An American Painter Abroad: Frank Duveneck's European Years* (Cincinnati: Cincinnati Art Museum, 1987) pp. 24-25.

On March 22, 1888, after just two years of marriage, Elizabeth Boott Duveneck died in Paris of pneumonia (see cat. 41). Her death was an untimely, devastating loss for both her husband and her father, Francis Boott (cat. 97). She was buried in late April not far from Bellosguardo in the southern outskirts of Florence, at Campo Santo degli Allori, a small cemetery for foreigners in use since about 1880. Duveneck, probably with his father-in-law's financial backing, returned to Cincinnati to create a tomb for her. The product of collaboration on two continents, it became one of the most lavish monuments in Allori cemetery and one of the most highly praised American tomb sculptures.

Because he had never made a sculpture before, Duveneck sought as his collaborator Clement Barnhorn (1857-1935), a Paris-trained portrait sculptor and fellow Cincinnatian who lent him tools and studio space, and assisted him in making the plaster model. It was a life-size, recumbent figure that recalled the effigy of Ilaria del Carretto by Jacopo della Quercia (fig. 1),

Fig. 1. Jacopo della Quercia (Italian, 1372-1438) Sarcophagus of Ilaria del Carretto, about 1405. Marble. Lucca, San Martino.

then believed to be the earliest Renaissance sculpture.[1] European artists had been inspired by the effigy figures of late medieval and early Renaissance tombs since the 1840s. Similar tomb sculpture became fashionable in America around the turn of the century, coinciding with the embellishment of such churches as New York's Trinity Church and Cathedral of St. John the Divine.[2] In France, such effigies began to be treated as sculptures in their own right, worthy of exhibition to the public.[3]

Fig. 2. Frank Duveneck, *Memorial to Elizabeth Boott Duveneck*, 1889. Bronze. Allori Cemetary, Florence, Italy, Photo: Joel Leivick, about 1985, courtesy Museum of Fine Arts, Boston.

Portrayed as asleep rather than dead, Elizabeth Boott appears both more natural and more ethereal than her Renaissance prototype. Her braids and her nightgown's gathered neck are plausible modern equivalents of Ilaria's headdress and high collar; her pillow is softer, her head and hands more relaxed. Yet for all this naturalism, the body beneath the nightgown is much less substantial than its prototype. The drapery, tossed over a stone block, is a mass of nervous folds into which the body dissolves, like the form-defying brushwork that indicates clothing in some of Duveneck's figure paintings. A palm frond, nearly as long as the body, appears more substantial than the body itself. Found on early sepulchral monuments, the palm was a symbol of martyrdom — appropriate for a woman whose friends felt that she had been struck down by the demands of marriage and motherhood.

In 1891 when the plaster model was complete, Duveneck brought it to Florence to be cast in bronze while Barnhorn went to Paris to work and study. The casting, by the Galli Brothers foundry, was undertaken in 1892. The figure (the first bronze in Allori cemetery) was placed on a block of pink granite atop a white marble base (fig. 2). When Henry James saw it in July 1893 he wrote Francis Boott, "What a meaning and eloquence that whole thing has — and one is touched to tears by this particular example which comes home to one so — of the jolly great truth that it is *art* alone that triumphs over fate."[4]

Francis Boott soon requested that a version of the tomb be carved in marble. William Couper, Duveneck's former student and Thomas Ball's son-in-law, offered Ball's large studio on Via Dante da Castiglione and agreed to act as contractor for the project. Couper selected the Severezza marble, hired a stone cutter named Elisio to block out and finish it, and a carver named Gabriella to execute the palm frond.[5] Duveneck traveled back and forth to Barnhorn in Paris, while Barnhorn may have made a trip to Florence to inspect the sculpture's progress. Duveneck is said to have done the final work on the face himself.[6] The marble shows carving styles suggestive of the different hands that worked on it. The drapery is thin, rumpled, relieflike; the face and hands are polished and delicate. The palm frond, undercut and pierced through, is a *tour de force* of stone transformed into thick, limp vegetation.

Completed in late 1894, the marble was lent at Boott's request to the Museum of Fine Arts, Boston. Duveneck, meanwhile, returned to Cincinnati with the plaster, stopping in Paris to exhibit it at the Salon of 1895, where it won an honorable mention. After Boott's death, Duveneck arranged to give the marble to the Museum of Fine Arts, where at least two casts were made from it, one for the Art Institute of Chicago and one for The Metropolitan Museum of Art in New York.

D. STRAZDES

1. *Baedeker's Italy; Handbook for Travellers, First Part: Northern Italy* (Leipzig: Karl Baedeker, 1886), p. 362.

2. See Francis Hamilton, "Contemporary Tomb Figures," *International Studio* (October, 1925), pp. 23-27.

3. Fred Licht in Peter Fusco and H.W. Janson, *The Romantics to Rodin* (Los Angeles: Los Angeles Country Museum of Art, 1980), pp. 100-101.

4. Leon Edel, ed., *Henry James: Letters* (Cambridge: Harvard University Press, Belknap Press, 1980), vol. 3, pp. 417-418.

5. Paula M. Kozol in Kathryn Greenthal et al, *American Figurative Sculpture in the Museum of Fine Arts Boston* (Boston: Museum of Fine Arts, 1986), pp. 211-213. The Couper-Duveneck correspondence is in the Archives of American Art, Smithsonian Institution, Washington, D.C.

6. Josephine W. Duveneck, *Frank Duveneck, Painter-Teacher* (San Francisco: Howell, 1970), p. 127.

H. Siddons Mowbray

Born Alexandria, Egypt, 1858;
died Washington, Connecticut, 1928

H. Siddons Mowbray

99. *Le Destin*, 1896
Oil on canvas, 30 x 40½ in.
Signed l.r.: H SIDDONS MOWBRAY
Museum of Fine Arts, Boston, Tompkins Collection

For the early part of his career, Mowbray was more oriented to the art of France than to that of Italy. Raised in North Adams, Massachusetts, and educated briefly at West Point, he trained for a few months with a local landscape painter before going abroad in 1878. He spent his student years in Paris (1878-1885) under the tutelage of Léon Bonnat, and was strongly influenced by such French academic painters as Jean-Léon Gérôme. Upon his return, he settled in New York, and exhibited widely the orientalist genre paintings that were then in vogue in both Paris and New York.

A trip to Italy in 1896, and a longer stay, from 1901 to 1904, during which period Mowbray served as director of the American Academy, converted him to the art of the Italian Renaissance. Thereafter, he applied his smooth technique and idealized figure style to allegorical and mythological subjects, and he concentrated on mural paintings, producing few easel pictures. Working with the American Renaissance architect Charles F. McKim, Mowbray painted wall and ceiling decorations for the homes of such magnates as Collis P. Huntington, F. W. Vanderbilt, and Larz Anderson, and for the University Club (1904) and the Pierpont Morgan Library (1905) in New York, often populating his decorations with figures from classical mythology and with ornamental motifs derived from Italian Renaissance designs.

Although he would claim that during his first trip to Italy, "a fondness for the Italian Renaissance came over me,"[1] Mowbray's easel paintings reflect an orientation toward Italian art that is much tempered by French academic painting and British Pre-Raphaelitism. The decorative landscape and opalescent palette of *Le Destin* owe a debt to Puvis de Chavannes; the auburn-haired women with their aristocratic profiles and sumptuously patterned robes parallel the interpretations of late-medieval and Renaissance culture painted by Rossetti and Burne-Jones. Also echoing the interests of the Pre-Raphaelite painters are a preference for antiquarian subjects and a taste for decorative details evoking the Renaissance (for example, the conspicuously, if illogically, placed Corinthian columns, and the tabernacle frame, whose pattern echoes Venetian facade ornamentation).

Mowbray's presentation of the classical subject of the Fates is quite unorthodox. The Fates (Greek: *Moirai*; Latin: *Parcae*) are usually shown as three women, not five; typically, they are old and ugly.[2] They are often shown spinning; they would break the thread when a life was over. Instead, Mowbray shows three young women weaving a tapestry, presumably meant to signify the tapestry of life, depicting a medieval tournament or joust. The other two women have no clear identities. The standing figure at right may have been intended to represent Fortuna, who is associated with the Fates in some accounts of the legend. She holds the golden threads from which the Parcae weave the tapestry, while at left, a figure with scissors (whose role, presumably, is to snip the threads and so cut off life) consults a crystal globe. The globe is an attribute of Ananke, or Necessity. According to Plato she is the mother of the Fates[3] – although in Mowbray's conception, all five women appear to be about the same age. This unconventional illustration, with its mysterious subject, its iridescent, unnatural palette, and its figures at once alluring and forbidding, parallels the fin-de-siècle tendency in England and France toward sensational or at least self-consciously strange images of women.[4]

Mowbray began *Le Destin* in Florence in 1896; it was first seen in a solo exhibition at Knoedler Galleries in New York early the next year. Most of the paintings in that show (such as *Schererzade* and *Abou Hassan, or the Sleeper Awakened*) presumably displayed the orientalist manner that Mowbray adopted after his years in France; like *Le Destin*, one or two even bear titles in French. Along with *Le Destin*, however, there were several that presage Mowbray's interest in a more classical subject matter and in mural painting. He would later claim that "I have always considered [*Le Destin*]the best of my easel pictures";[5] ironically, the artist would thereafter develop its attributes not on canvas but in mural decorations.[6]

C. TROYEN

1. Herbert F. Sherwood, ed., *H. Siddons Mowbray, Mural Painter, 1858-1928* (Stamford, Conn.: Privately printed, 1928), p. 56.
2. James Hall, *Dictionary of Subjects and Symbols in Art* (New York: Harper & Row, 1974), p. 302.
3. "Fate," *The Oxford Classical Dictionary*, ed. M. Cary et al. (Oxford, England: Clarendon Press, 1950), p. 357.
4. See Roland Elzea, *The Pre-Raphaelite Era* (Newark, Del.: Delaware Art Museum, 1976), p. 159.
5. Sherwood, *H. Siddons Mowbray*, p. 59.
6. Not only the style, but actual elements of *Le Destin*, recur in Mowbray's later work. A beautiful drawing of drapery (Fogg Art Museum, Harvard University, Cambridge, Mass.) anticipated the standing figure at right; the same figure reappeared many years later in the ceiling decoration of the Gunn Memorial Library, Washington, Conn. This information is courtesy of Stephanie Wiles, assistant curator, Drawings and Prints, The Pierpont Morgan Library, New York.

99. *Le Destin*, 1896

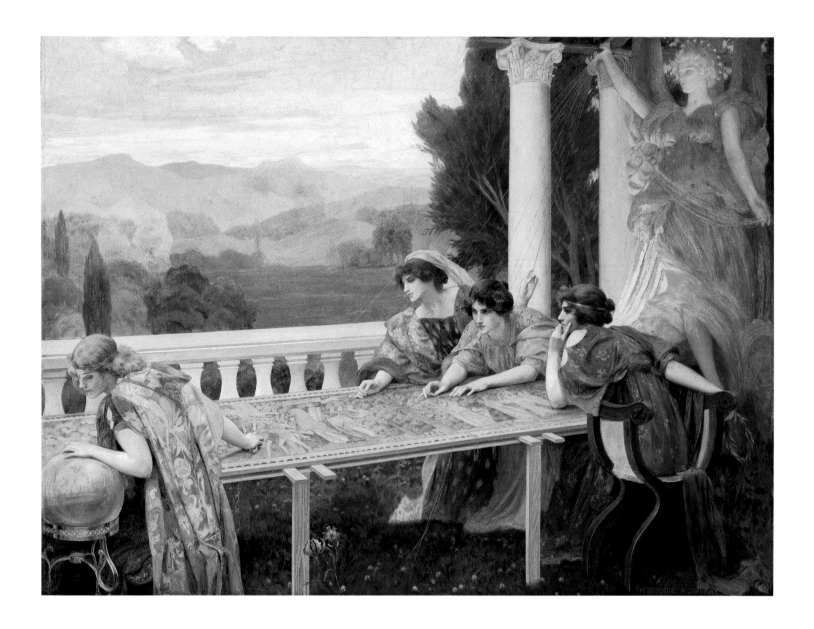

Charles Caryl Coleman

Born Buffalo, New York, 1840;
died Capri, Italy, 1928

Coleman first traveled to Europe in 1856, spending three years in Paris and then two years in Florence, where he studied at the Accadèmia Galli and where he first met his close friend Elihu Vedder. He returned to the United States in September 1862 to serve in the Union Army. Wounded in South Carolina, he was honorably discharged in 1863; by 1866 he was in France, having joined Vedder, with whom he sketched in Brittany and Bordighera, Italy. Coleman worked briefly in Venice, but had established himself in Rome by December 1866. Based in Rome for ten years, he traveled frequently to Venice, Perugia, Baden-Baden, and the United States. In 1869, he shared an apartment in the Piazza di Spagna that had once belonged to John Keats, and he occupied a studio on the Via Margutta. During his brief marriage (1875-1879) to Mary Grey Alsager, an English musician, Coleman lived near the Palazzo Barberini on the Via Quattro Fontane. In 1880, he bought a villa on Capri, where he settled permanently by 1885. Although he often traveled to the United States before 1915, Coleman dedicated himself to his Villa Narcissus and, with Vedder, became a leader of the local art community.

Charles Caryl Coleman

100. *Villa Castello, Capri,* 1895
Oil on panel, 12¼ x 21½ in.
Signed l.r.: c c c (in monogram)/ Capri/ 1895
Lent by Mr. Graham Williford

Charles Caryl Coleman settled permanently in Capri in 1885, moving into a villa he had purchased on the island in 1880. He soon became one of the island's most memorable residents, joining a community of expatriates from many countries that had been established in the 1820s. "Uncle Charlie," as Coleman was known, transformed a portion of a convent guest-house into a virtual palace for art, crowding his Villa Narcissus with Roman, Moorish, Persian, and Renaissance antiquities and hundreds of his own landscapes. In this exotic setting he entertained students from the American School of Archeology in Rome and acted as the leader of the circle of painters active on Capri, which by 1901 would include Coleman's close friend Elihu Vedder (see cats. 71, 94-96).[1]

The quiet courtyard Coleman depicted in *Villa Castello* reflects the peaceful charm that visitors to the island sought to capture. Directly accessible by ferry from Naples, Capri offered a glimpse of traditional country life that, by the end of the nineteenth century, had been lost in many parts of the mainland (see cats. 60, 61). As the American artist Frank Millet noted, "most of the facets of this gem of the Mediterranean are still untarnished and flawless. The primitive life of the peasant remains much the same in all essential features . . . undisturbed by the gleam of the white umbrella or the red flash of the Baedeker."[2] In Coleman's painting, the island seems to have been untouched since ancient times.

In *Villa Castello, Capri,* Coleman portrayed the home of Sophie and Walter Anderson, both British painters, who were tireless organizers of the many social activities of the island expatriates. Sophie Anderson (1823-about 1898), born in France and trained as a portraitist in America, moved with her husband to Capri in 1871. There she specialized in mythological sub-

Fig. 1. Charles Caryl Coleman, *In the Shade of the Vines,* 1898.
Oil on canvas. Courtesy of Berry-Hill Galleries, New York

jects, often setting them in the courtyard of her own villa, while her husband favored Greco-Roman genre themes. Their garden, where elegant strawberries-and-cream receptions were held every spring, was designed in the Roman manner and featured a stately pergola of Doric columns roofed with a trellis of grapevines. It provided a picturesque setting for both costume parties and paintings in a classical mood.[3]

In Coleman's *Villa Castello,* the setting is ambiguous; the deserted arcade scattered with amphorae might simply be an autumnal moment in Mrs. Anderson's garden. Yet Coleman's other scenes of terraces in Capri, such as *In the Shade of the Vines* (fig. 1), are populated with young women in classical dress. There Coleman recreated the classical past in a romantic and sentimental mood similar to that found in the popular work of the British painter Sir Lawrence Alma-Tadema and the pictures of Coleman's friends, the American artists Frank Millet and Elihu Vedder. *Villa Castello* may also depict the ancient world; it appears as a stage-set from which the players have vanished.

Coleman painted several images of courtyard gardens at Capri,[4] as well as many elaborate still lifes that combined the island's flowering almond branches

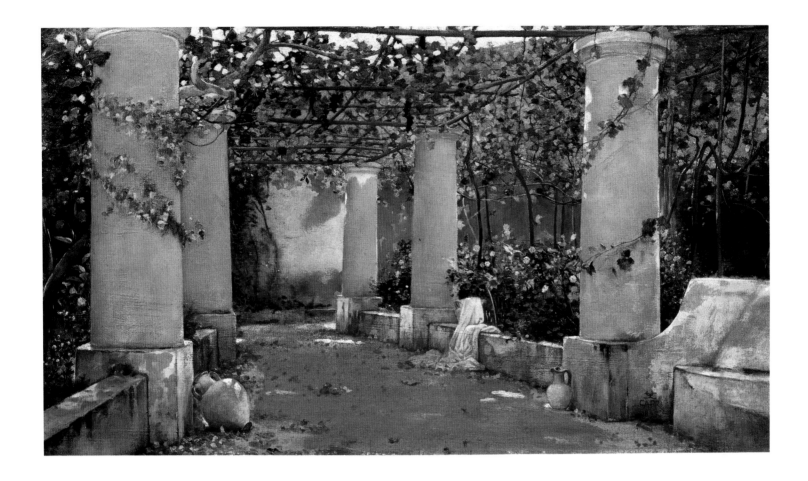

with art objects from the Villa Narcissus. In the 1890s, he began a large series of images of Vesuvius, viewed from Capri, with changing effects of smoke. His studio was described as a veritable "picture factory,"[5] and most of his work was sent to the United States for exhibition and sale. Coleman's paintings were admired for both their decorative elegance and their skill at capturing the picturesque charm of Capri.[6]

E. HIRSHLER

1. Coleman's Villa Narcissus is described in detail in Charles de Kay, "A Villa in Capri," *The Architectural Record* 12 (May 1902), pp. 71-92.

2. Frank D. Millet, "'Home of the Indolent:' The Island of Capri," *The Century Illustrated Monthly Magazine* 56 (October 1898), p. 858. Coleman provided five illustrations for this article.

3. The Andersons are described in Edwin Cerio, *The Masque of Capri* (London: Thomas Nelson and Sons, Ltd., 1957), pp. 77-80. The Villa Castello was purchased by the American collector Charles Lang Freer and his friend Thomas Gerome in about 1900; Coleman continued to visit the garden there. See "The Lure of the Golden Bowl," *Apollo* 118 (August 1983), pp. 119, 121. The gardens of the Villa Castello are pictured and described in detail in Rusticus, "A Letter to Pliny The Younger Relating to the Villa Castello on Capri," *House and Garden* 2 (August 1902), pp. 343-354.

4. See, for example, *Garden of the Villa Castello, Capri*, in the Detroit Institute of Arts.

5. Cerio, *Masque of Capri*, p. 11.

6. See, for example, Charles de Kay, "As an American Sees Capri," *The New York Times Illustrated Magazine* (April 23, 1890), p. 3.

Charles Keck

Born New York, New York, 1875;
died Carmel, New York, 1951

Charles Keck traveled to Rome in 1900 as a re-
cipient of the William Henry Rinehart fellowship
for young sculptors. Prior to his scholarship, he
had studied for two years in New York with
Philip Martiny (1858-1927), and worked for
five years as an assistant to Martiny's teacher,
Augustus Saint-Gaudens. Since Saint-Gaudens
was one of the trustees of the Rinehart fund,
Keck's selection may have been partly due to the
urging of his friend and mentor, whose naturalis-
tic realism he was to emulate. Keck corresponded
with Saint-Gaudens from the American Academy
in Rome, then situated at Villa Aurora, Via
Lombardia 42. He encouraged Saint-Gaudens,
apparently unsuccessfully, to travel with him to
Greece. During his years in Rome, the young
sculptor saw much of Italy, visited Paris, and
eventually made his way to Greece. As part of his
fellowship, Keck produced a variety of sculptures
that demonstrated his ability to create works of
single and group compositions, freestanding figures
and reliefs. Among these were the Sleepwalker,
or Somnambulist (1900, probably destroyed),
of a draped, partially nude figure, and an acade-
mically rendered medallion of Thetis Consol-
ing Achilles on the Death of Patroclus
(1901, location unknown). A third work, The
Awakening of Egypt (1904, location un-
known) stemmed from his interest in ancient civi-
lizations. These works and three others were
shown at the annual exhibition of 1905 held by
the American Academy. Keck was the sole sculptor
among the fellows represented, and received high
praises for his efforts.

Charles Keck

101. *Elihu Vedder*, 1900-04
Bronze, 20¾ x 19¾ in.
Inscribed l.r.: Rome
Lent by The Metropolitan Museum of Art, Gift of Mrs.
Charles Keck, 1952

During Keck's period in Rome, he became
acquainted with painter and illustrator
Elihu Vedder, who was then in his late six-
ties. By this date, Vedder was one of the
few surviving elder American artists in
Rome, and his studio on Via Flaminia had
replaced that of William Wetmore Story
as a gathering place for artists and travel-
ers.[1] With the success of his illustrations
for the *Rubáiyát of Omar Khayyám*, Vedder
achieved the financial security that enabled
him to build the Villa Torre Quattro Ven-
tri in 1900 on the island of Capri, where he
entertained a stream of visitors.[2] Keck
spent a great deal of time with the artist
and his family in Rome and Capri. Vedder

encouraged Keck in his work, and even financed the casting of two of his sculptures, *David* and *Lacrosse Player* (fig. 1).[3]

Elihu Vedder's well-loved visage and picturesque appearance were the subject of numerous portraits by his friends and admirers.[4] Keck represented Vedder in his "quaint Hollandish-looking cap,"[5] a possible reference to his Dutch lineage, with his broad, drooping moustache, and artist's smock. The bust is rendered in a Renaissance style, truncated below the shoulders, just as in Vedder's own sculpture, *Sibilla Cumaea* (1898, American Academy and Institute of Arts and Letters, New York, also see cat. 95). Rather than following Vedder's lead in creating a prominent architectural framework around the bust, Keck chose instead to encircle the base of the portrait with a frieze inspired by Vedder's drawings for the *Rubáiyát*, a copy of which the elder artist had inscribed to the sculptor.[6] As with Vedder's illustrations for the *Rubáiyát*, Keck's frieze did not follow the sequence of quatrains published in the original translation of the Persian poem.[7] Keck wove a number of Vedder's images into his frieze, including those from *The Soul's Answer*, *The Cup of Death*, *The Cup of Despair*, and *The Magdalen*. Although the figures were partly selected by Keck for their compositional effect, he was surely cognizant of the highly personal symbolism employed by Vedder in joining image and text. Keck's use of *The Soul's Answer* directly below the head of the bust may signify Vedder himself in his own search for self-knowledge.[8] Similarly, Keck's choice of *The Cup of Despair* that appears at the rear center of the bust is notable for the energized, double swirl of S-shapes that became Vedder's trademark, and which in Vedder's words, represented "the sudden pause through the reverse of the movement which marks the instant of life; and then

Fig. 1. *Keck's Studio or an Exhibition Gallery*, location unknown, about 1905. Photograph. Collection of the Keck family. Photograph courtesy Museum of Fine Arts, Boston.

the gradual, ever-widening dispersion again of these elements into space."[9]

Keck's friendship with Vedder may have evolved from the latter's long-standing involvement with the decorative arts, as demonstrated by his modeling of bronze sculpture and such cast elements as bellpulls and firebacks for domestic use. One surviving example of a collaboration between the two artists is a bronze fountain called *The Boy* (1900-1902, The Art Institute of Chicago), which was modeled by Keck based upon a Vedder drawing.[10] Keck's continuing admiration for Vedder in later years can be documented by his purchase of several works by the artist from Vedder's estate.[11] Elihu Vedder received the plaster version of his portrait from Keck and kept it until his death in 1923.[12] Keck retained the bronze bust, which he placed, upon his return to the United States, in the outer office of his New York studio. There it remained until Keck's death in 1951. The portrait was seen by all visitors and served as a reminder of Keck's association with Vedder and the sculptor's own formative years in Rome.[13]

J. FALINO

1. Vedder was called "the Dean of the American Art Colony" in Maud Howe, "American Artists in Rome" *Art and Progress* 1 (July 1910), pp. 247-252. For a recent biographical review of Keck, see Kathryn Greenthal in Greenthal et al., *American Figurative Sculpture in the Museum of Fine Arts, Boston* (Boston: Museum of Fine Arts, 1986), pp. 334-36.

2. *Rubáiyát of Omar Khayyám, the Astronomer Poet of Persia, Rendered into English Verse by Edward Fitzgerald with an Accompanyment of Drawings by Elihu Vedder* (Boston: Houghton, Mifflin & Co., 1884).

3. The locations of these works are unknown.

4. At least seventeen portraits of Vedder were made by as many artists. Regina Soria, *Elihu Vedder, American Visionary Artist in Rome (1863-1923)* (Rutherford, New Jersey: Fairleigh Dickinson University Press, 1970), p. 401.

5. Howe, "Americans in Rome," p. 250.

6. Undated inscription from Vedder to Keck in the *Rubáiyát of Omar Khayyám*, collection of John William Keck, New York.

7. The translation by Edward Fitzgerald (1809-1883) was so free that his *Rubáiyát of Omar Khayyám* is considered an original work in itself. William Rose Benét, *The Reader's Encyclopedia* (New York: Thomas Y. Crowell Company, 1965), p. 352. The 1884 publication of the book includes an explanation of Fitzgeralds's translation and Vedder's selection of text for the book. For further discussion of the text, see Regina Soria et al., *Perceptions and Evocations: The Art of Elihu Vedder* (Washington, D.C.: Smithsonian Institution Press, 1979), pp. 130-31.

8. Fitzgerald's text for plate 35 reads, *The Soul's Answer*: stanza 70: I sent my soul through the Invisible / Some letter of that After-Life to Spell / And by and by my Soul returned to me, / and answered, "I myself am Heaven and Hell"; stanza 71: Heaven but the Vision of a fulfilled Desire / And Hell the Shadow of a Soul on fire, / Cast on the Darkness into which Ourselves / So late emerg'd from, shall so soon expire."

9. Soria et al., *Perceptions and Evocations*, pp. 132-33.

10. For a review of Vedder's work in murals and the decorative arts, see Soria et al., *Perceptions and Evocations*, pp. 167-234; for *The Boy*, see pp. 232-34, figures 303-305.

11. Keck purchased a drawing of Beatrice Cenci, a painting of Cumaean Sibyl (now lost), and a painting of Fortune (illustrated in Soria et al., *Perceptions and Evocations*, fig. 238), when he visited Capri in 1928.

12. The bust is now in a private collection. Telephone conversation between the author and Dr. Regina Soria, November 25, 1991.

13. The location of the Vedder bust in the artist's New York studio was recalled by the artist's son, John William Keck, telephone conversation November 21, 1991. Regina Soria, *Dictionary of Nineteenth-Century American Artists in Italy 1760-1914* (Rutherford, New Jersey: Fairleigh Dickinson University Press, 1982), pp. 180-81.

George DeForest Brush

Born, Shelbyville, Tennessee, 1855;
died, Hanover, New Hampshire, 1941

George DeForest Brush

102. *Mother Reading*, 1905
Oil on canvas, 41⅛ x 32 in.
Signed l.r.: Geo De. Forest Brush/Florence 1905
*In the Collection of The Corcoran Gallery of Art, Gift of
Mrs. Francis S. Smither*

Brush's interest in the art of the Italian Renaissance was the last in a series of enthusiasms for exotic and historic cultures that marked his long career. His first artistic training was with a photographer in Danbury, Connecticut; in the 1870s, he studied at the National Academy of Design in New York, then with Gérôme and at the Ecole des Beaux-Arts in Paris. In 1881, the year he was elected to the Society of American Artists, he made his first trip to the West. As a result, Brush began painting portraits and genre scenes featuring Native Americans that became his principal subject matter for well over a decade. In the 1880s and '90s Brush was active as a portrait painter, illustrator, and teacher. His family — he would eventually have eight children — would become his favorite and most frequent models.

In 1898 he made his first trip to Italy, residing in Florence that fall and making a brief trip to Venice with painter Abbott Thayer. In 1903 he returned to live in Florence for two years; thereafter he would alternate periods of residency in Dublin, New Hampshire (the permanent home of the Brush family from 1901 on) with extended visits to Italy, primarily Florence. At about the turn of the century, the influence of Italian Renaissance art became increasingly apparent in his work, and images of a secularized Madonnna and Child replaced that of the Indian as his favorite ideal subject. In 1928 Brush made his last trip to Italy, where a reception was held in his honor at the American Academy in Rome. Two years later, he was given his first retrospective exhibition, at the Grand Central Galleries in New York, to critical acclaim.

Like several other turn-of-the-century artists, Brush was a frequent painter of his own family. His wife and various children were frequent models for portraits; for secularized renderings of ideal themes, particularly those with religious overtones; and for charming domestic genre scenes. Some of these were meant as family mementos; others, like the present picture, found a ready market among contemporary art collectors with traditional tastes.[1]

Mother Reading represents Brush's wife Mary ("Mittie") reading to their youngest child, Thea, then about two years old, and to Mary and Jane, two of their five older daughters. He made his first attempt at this sort of charming domestic picture in 1892 (*Portrait*, collection Mr. and Mrs. Willard Clark) and refined it over the next two decades. It is likely that the impetus for such subjects grew naturally out of an intimate family moment spontaneously observed. However, in some of these pictures, such as the 1898 *Family Group*, with its obvious quotation from Raphael's *Madonna del Granduca* (Pitti Palace, Florence) or the *Family Group* of 1907 (Art Institute of Chicago), where son Gerome's gesture is quite clearly taken from Titian's *Man with a Glove* (Musée du Louvre, Paris),[2] Brush's affection for the art of the Italian Renaissance was an equal impetus. *Mother Reading*, which was painted in Florence, is more complex still. In this painting, family members are lovingly portrayed; their deep-colored dresses, in styles clearly meant to evoke Renaissance attire, are handsome foils to their fair skin and the rosy nudity of the baby. The theme of a mother reading to her child has many precedents in the Madonnas of Raphael (see, for example, *The Solly Madonna* [Staatliche Museen, Berlin] or *Madonna and Child with Book* [Norton Simon, Inc. Museum of Art, Pasadena, California]), and Thea's pose is somewhat reminiscent of that of the Child in Raphael's *Madonna della Tenda* (Alte Pinakothek, Munich) or the *Madonna dell'Impannata* (Pitti Palace, Florence) now given to Raphael's workshop. However, in this picture, Brush's homage to the art of the Italian Renaissance seems filtered through the tradition of English portraiture. The domestic tenderness of the subject, the poses of mother and baby, and the lush red, green, and gold color scheme, are reminiscent in particular of the work of Sir Joshua Reynolds, and of his exercises in the manner of the old masters.[3]

Mother Reading was exhibited in Brush's first retrospective exhibition, at the Grand Central Art Galleries, in 1930. The reviewer for *Art News* was especially impressed by the works painted from 1900 to 1915 (that is, the domestic, rather than the Western subjects) and credited them with demonstrating "a mastery of pure pigment, a delicacy of modeling and a feeling for group composition that cannot but command respect, even among the advance guard."[4] It is unlikely that modernists were truly impressed by Brush's technical superiority; certainly his rich yet sentimental style held appeal for those collectors charmed by both Raphael and grand-manner portraiture.

C. TROYEN

1. *Mother Reading* made its debut in 1906, the year after it was painted, at the 28th Annual Exhibition of the Society of American Artists. It had already found a buyer, F. S. Smithers, Esq., whose wife would give it to the Corcoran in 1949.

2. Joan B. Morgan, *George de Forest Brush, 1855-1941, Master of the American Renaissance* (New York: Berry-Hill Galleries, 1985), pp. 27, 29.

3. See, for example, Reynolds's *Mrs. Richard Hoare and Child* (Wallace Collection, London), his *Hon. Mrs. Edward Bouverie of Delapre and her Child* (the Earl of Radnor), and especially his *The Child Baptist in the Wilderness* (Wallace Collection, London).

4. "George de Forest Brush, Edward Redfield. Grand Central Galleries," *Art News* 28 (January 11, 1930), p. 10.

Paul Manship

Born St. Paul, Minnesota, 1885;
died New York, New York, 1966

Paul Manship came to Rome in 1909 at the age
of twenty-three as a fellow of the American
Academy in Rome. For three years, he lived and
maintained a studio at the Villa Mirafiori on the
Via Nomentana, the Academy's home before it es-
tablished its present quarters on the Janiculum in
1914. Like many artists of his generation, Man-
ship had originally intended to study sculpture in
Paris, which by this date had replaced Rome as a
dynamic center for the arts. His decision to apply
to the American Academy in Rome was probably
encouraged by his respected friend and mentor,
Isidore Konti (1862-1938). The Vienna-born
Konti had spent two years in Rome from 1886-
88 and likely encouraged Manship in his success-
ful bid for the fellowship. Although there was no
formal program at the American Academy in
Rome, the institution's founders hoped that the
classical surroundings would have a formative ef-
fect upon the artists' studio work. Unlike many
artists who were accepted by the Academy, Man-
ship applied himself to studying ancient art with
singular energy, and traveled extensively in west-
ern Europe to enhance his education. He studied
the accumulated riches of Mediterranean culture
from Minoan and mainland Greek art to Etrus-
can and republican Rome, and drew copiously
from these sources. Manship's letters to Konti
from Rome further document the young sculptor's
earnest attempts to create his new works in the
spirit of the antique. The lessons gained during
Manship's study of ancient art, particularly that
of archaic Greece, exerted a powerful influence
upon the content and style of his work from that
time forward. As a requirement of his fellowship
at the American Academy, Manship produced sev-
eral works of art during his period in Rome. Of
these, the life-size bronze Duck Girl (1911,
Fairmount Park, Philadelphia), is notable for its
spirited interpretation of a Hellenistic figure dis-
covered in Pompeii. At the end of Manship's fel-
lowship, Duck Girl, along with Lyric Muse
(cat. 103) and many other works were exhibited
to critical acclaim in New York. The overwhelm-

ing popularity of Manship's sculptures in the early
decades of this century fulfilled the sculptor Her-
bert Adams's belief that Manship's achievements
rewarded all the efforts of the American Academy
in Rome.

Paul Manship

103. *Lyric Muse*, modeled 1912; cast
about 1913

Bronze; lost wax casting, with dark green patina;
copper wire; h. 12¾ in., w. 6⅞ in., d. 5½ in.
Signed (on tip of base at front): PAUL MANSHIP /
ROME 1912
Museum of Fine Arts, Boston, Gift of Mary C. Wheelwright

"Rome is a great place. Each day I find
new places of interest . . . Am having the
time of my young life."[1] So wrote Paul
Manship to his cousin Sevilla shortly after
his arrival in Rome in 1909. Manship's en-
thusiastic embrace of foreign languages,
classical literature, and ancient statuary
would have a lasting effect upon his career.
Lyric Muse displays Manship's synthesis of a
variety of cultural influences, from the Et-
ruscan-styled hair of the muse to the metic-
ulously worked surface, evidence of Man-
ship's close technical observations of
Hellenistic and Renaissance bronzes. And
while the pronounced twist of the figure is
archaic in its adherence to a frontal plane,
it is timelessly modern in its vivacity. As ti-
tled by Manship, *Lyric Muse* was probably
intended to be a representation of Erato,
one of the nine daughters of Zeus and
Memnosyne. The lyre she holds is an em-
blem of inspiration to the writers of lyric
and amorous poetry. Manship was to use
the image of Erato again in 1916 for the
obverse of the *Saint Paul Art Institute Medal*
(fig. 1). In 1913, shortly after Manship's re-
turn to the United States, *Lyric Muse* was
exhibited at the Architectural League in
New York. In anticipation of popular re-
sponse, Manship had the sculpture cast in
an edition of fifteen at Roman Bronze
Works, New York, prior to its exhibition
in Boston, New York, and a number of lo-
cations around the country between 1914
and 1917. *Lyric Muse* received a gold medal
at the Panama-Pacific International Exhi-
bition in 1915.[2]

J. FALINO

Paul Manship

104. *Pauline Frances*, 1914
Bronze and marble; h. 31 in., w. 22 in., d. 7 in.
Signed on left side of base: OPUS PAUL MANSHIP
Lent by The Metropolitan Museum of Art, Gift of Mrs. Edward F. Dwight, 1916

Fig. 1. Paul Manship, *Saint Paul Art Institute Medal*, 1916. Bronze. Minnesota Museum of Art, Bequest of the Artist.

This tender image of the artist's infant daughter was the first realistic portrait attempted by Manship. Although the sculpture was created in New York shortly after Manship's return from Rome, its overwhelming kinship with Italian Renaissance sources is clear.[1] The most important of these influences may have been fifteenth-century artist Desiderio da Settignano (about 1430-1464), who created numerous sculptures of children that Manship may have seen. The delicate handling of the skin and fabric of *Pauline Frances* is reminiscent of Settignano's own sensitive approach to his youthful subjects. Manship's composition and the unorthodox combination of marble and multi-patinated bronze lent a devotional aspect to the secular sculpture that suggests a resemblance to the Christ Child. Although Manship may have distanced himself from such overt references to Roman Catholicism in Italian sculpture,[2] he probably was aware of one of the best-loved images of the Infant Jesus in Rome: the so-called Bambino of the Church of Santa Maria in Ara Coeli. This wooden sculpture, bedecked with precious stones and metals, was celebrated throughout the nineteenth century for its miraculous curative powers.[3] He may also have been aware of a series of swaddled *bambini* with outstretched arms made by Andrea della Robbia (1435-1525?) for the Ospedale degli Innocenti, Florence, about 1460.[4] Manship's sensitivity to the relationship between sculpture and architecture was conveyed in a lecture he gave to the Art Students League in 1915. Manship noted that:

> Donatello and in fact all the sculptors of the Renaissance seemed to have a wonderful feeling for the setting which they gave their sculpture. If a sculptor had to make, for instance, a wall monument, it was not necessary for him to

1. Paul Manship papers, Archives of American Art, Smithsonian Institution, Washington, D.C., 59-15. For a review of Manship's period in Rome, see Susan Rather, "The Origins of Archaism and the Early Sculpture of Paul Manship," Ph.D diss., University of Delaware, 1986, pp. 142-205. The observations of Herbert Adams, then president of the National Society of Sculpture and trustee of the board of the American Academy in Rome, are quoted in Susan Rather, "Rome and the American Academy: Art Mecca or Artistic Backwater," in Irma Jaffe, ed., *The Italian Presence in American Art 1860-1920* (New York: Fordham University Press, 1992).

2. For a description of these exhibitions and other awards, see Paula Kozol, in Kathryn Greenthal et al., *American Figurative Sculpture in the Museum of Fine Arts, Boston* (Boston: Museum of Fine Arts, 1986), pp. 402-403.

Paul Manship

104. *Pauline Frances,* 1914

call in an architect to collaborate, for he felt, it seems instinctively, the appropriate way in which to frame his reliefs or figures, and gave as much attention to the modelling of an ornament of an architectural detail as to the carving of an eye on the figure itself.[5]

J. FALINO

1. The sculpture was first reviewed by M. G. Van Rensselaer, "'Pauline' (Mr. Manship's Portrait of his daughter at the age of three weeks)" in *Scribner's Magazine* 60 (December 1916), pp. 772-76, and by Frank Owen Payne, "Two Amazing Portraits by Paul Manship," *International Studio* 71 (October 1920), pp. 75-76.

2. Manship's somewhat diffident attitude toward Roman Catholic sculpture was addressed by the artist's son, the painter John Manship in conversation with the author, fall 1991.

3. The responses of Margaret Fuller and William Wetmore Story to the "Bambino" are mentioned in Joseph Jay Deiss, *The Roman Years of Margaret Fuller* (New York: Thomas Y. Crowell Co., 1969), pp. 122-23; Francis Way, *Rome* (New York: D. Appleton & Co., 1888), pp. 194-96. The devotional quality of *Pauline Frances* was observed in *Touchstone Magazine* 4, (1918-1919), p. 36 with the title "An Altarpiece." The author wishes to thank Susan Ricci for calling her attention to the Bambino of Ara Coeli.

4. Maud Cruttwell, *Lucca and Andrea Della Robbia and their Successors* (London: J.M. Dent & Co., 1902), pp. 150-54.

5. Lecture to students of the Art Students League, December 4, 1915. Paul Manship Papers, Archives of American Art, Smithsonian Institution, Washington, D.C., NY 59-15. The author wishes to thank Susan Rather for her thoughtful reading of this text.

VIII Venetian Life

Charles Caryl Coleman

105. *The Bronze Horses of San Marco,
Venice,* 1876
Oil on canvas, 40¼ x 32½ in.
Signed l.l. center: c c c (in monogram)/ Venice
1876
The Minneapolis Institute of Arts, Gift of the Regis Collection

Made on commission for his most important patron, Lady Ashburton,[1] *The Bronze Horses of San Marco* is one of Coleman's most striking compositions, combining several of Venice's most picturesque and familiar icons. Some ten years before he made this painting, Coleman had occupied a studio near the brightly colored Renaissance clock tower, and the area was very familiar to him. He recorded this scene from the small rooftop gallery over the west porch of St. Mark's Cathedral, a narrow balcony accessible only by a steep flight of stairs. From his limited vantage point, Coleman created an elegant pageant of some of Venice's best-loved sculpture: the bronze bell-ringers, called the "Moors" because of their dark patina; the gilt lion of Saint Mark; the annual mechanical procession of the Magi offering gifts to the Virgin and Child;[2] and the great bronze horses of St. Mark's.

The origin of these celebrated horses has never been determined. While scholars agree that the group is the only bronze quadriga to survive from classical times, there has been no firm consensus as to whether the horses are Greek or Roman. The sculptor has been variously identified as one of the finest artists of Greece (Lysippus, Polyclitus, and Phidias have all been proposed) or an unknown Roman craftsman familiar with their style.[3] It is certain, however, that the horses were taken to Venice from Constantinople in 1204, plunder from the celebrated Venetian sack of the Byzantine capital during the Fourth Crusade. First stored at the Arsenal in Venice, the bronzes were exposed to destruction in the foundries of one of Europe's largest arms manufactories, but by the last quarter of the thirteenth century, they had been placed on the roof of the new portico just constructed at St. Mark's Cathedral.[4] There they were described by the great Renaissance poet Pe-

trarch, who wrote that the horses "stand as if alive, seeming to neigh from on high and to paw with their feet."[5] The horses of St. Mark's became the symbol of Venice, and it was not without reason that Napoleon removed them in triumph to Paris in 1798, a year after the Most Serene Republic had lost its independence. After Napoleon's defeat in 1815, the horses were returned to the façade of St. Mark's, largely through the efforts of the Venetian neoclassical sculptor Antonio Canova.

At the time Coleman made his colorful image of the horses, St. Mark's was the topic of passionate debate in the arts community of Venice. The cathedral was in disrepair, an emblem of the decay of the once-great city. Two restoration efforts under the direction of G. B. Meduna, 1860-1864 and 1865-1875, had replaced much of the north and south façades with inferior, although stable, new material. Outraged by the destruction of his beloved stones of Venice, John Ruskin helped to organize the campaign that would successfully halt the restoration before it reached the famous west façade, which he had described as "a confusion of delight, amidst which the breasts of the Greek horses are seen blazing in their breadth of golden strength."[6] Coleman alluded to the disintegration of the cathedral by carefully recording its cracked columns and capitals and including several detached architectural fragments in the lower right corner of his composition.

This faithful rendering of architectural detail is akin to Ruskin's own watercolor studies of the west porches of St. Mark's, which he made the following year in the same meticulous style he had perfected in his cathedral views of the 1850s. Two of Ruskin's closest associates also concentrated upon the west façade. John W. Bunney (1828-1882) made many watercolor studies in the 1870s which he used at

Fig. 1. Henry Roderick Newman, *Horses of St. Mark's,* 1890. Watercolor on paper. Collection of Rob and Mary Joan Leith.

Fig. 2. Carlo Ponti (Italian, active about 1858-1875), *Horses of St. Mark's,* 1870s. Albumen print. Photograph courtesy of Sotheby's, New York.

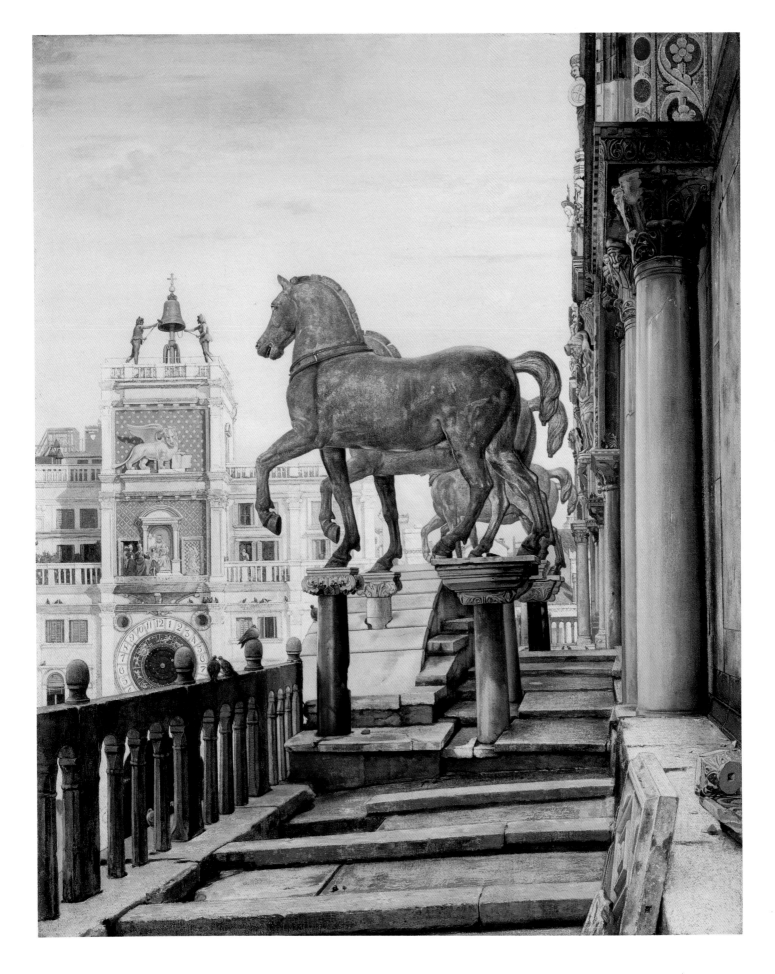

Ruskin's request to create a monumental oil painting of the entire west front of St. Mark's (1877-1882, The Guild of St. George). Henry Roderick Newman created an image of the great bronze horses almost identical in conception to Coleman's, though looking south toward the Piazetta rather than north to the clock tower (fig. 1). Coleman himself made a replica of his own composition in 1883-85 (art market), while F. Hopkinson Smith repeated the composition in watercolor in the 1880s. It is likely that all of these painters were aided in part by the extensive photographic documentation of the cathedral that had been undertaken in the 1860s by Carlo Ponti (fig. 2).[7]

Coleman was pleased with his dramatic image, and exhibited it at the Paris Salon in 1877 and at the London Art Club later that year. Singled out for praise in the press for its brilliant color and its distinct decorative qualities, the painting helped to establish Coleman's popularity with both the English and American markets.[8]

E. HIRSHLER

1. Lady Ashburton was the wife of the 4th Baron Ashburton.

2. The hourly mechanical parade is presented only during Ascension week (six weeks after Easter), which gives a firm date to Coleman's painting.

3. The issue is discussed in detail in John and Valerie Wilton-Ely, trans., *The Horses of San Marco* (London: Thames and Hudson, 1979).

4. Major architectural changes made to St. Mark's at this time gave the cathedral its current configuration — the walls were strengthened and the porches were built, thus enabling the structure to support the newly enhanced domes, which were transformed from low hemispheres to elongated cupolas. See Guido Perocco, "The Horses of San Marco in Venice," ibid., pp. 56-59.

5. Petrarch's remarks are contained in a letter of 1364; they are the earliest documentation of the horses' position on the cathedral façade. See Marilyn Perry, "The Trophies of San Marco: Legend, Superstition, and Archeology in Renaissance Venice," ibid., p. 104.

6. John Ruskin, *The Stones of Venice*, edited by Jan Morris (Mount Kisco, N.Y.: Moyer Bell Limited, 1989), p. 80. Ruskin wrote to an English correspondent, "it is impossible for any one to know the horror and contempt with which I regard modern restoration — but it is so great it simply paralyses me with despair." He joined the passionate attack on the restoration launched by Count A. P. Zorzi, whose book, *Osservazioni intorno ai ristauri interni ed esterni della Basilica di S. Marco* (Venice, 1877), was instrumental in stopping the project, which was finally halted in 1880. See John Unrau, *Ruskin and St. Mark's* (New York: Thames and Hudson, 1984), pp. 191-205.

7. Many of Ponti's photographs are held by the Gernsheim Collection at the University of Texas at Austin; a print of his horses of St. Mark's was sold at Sotheby's in 1979 (fig. 2). Ponti's images, including the horses, also appeared on stereocards, which were popular souvenirs. Ruskin and his associate John Hobbs also made daguerreotypes of St. Mark's in 1845 and 1852; because of the reversal of the image, it can be established that Ruskin copied the daguerreotypes in some of his own watercolors.

8. See, for example, "American Art at Paris," *The New York World*, April 12, 1878, p. 5 and "Charles C. Coleman," *The Art Amateur*, February 2, 1880, pp. 45-46.

Charles Herbert Moore, trained as a draftsman in New York City, established himself in the renowned Tenth Street Studio Building by 1859. There, in the company of many artists, Moore probably first became acquainted with the critical writings of John Ruskin. Like Henry Roderick Newman (see cats. 72, 85-87), Moore was a founding member of the American Pre-Raphaelite organization, the Association for the Advancement of Truth in Art, in 1863. Two years later, he met the Harvard educator Charles Eliot Norton, Ruskin's closest American supporter. Moore exhibited precise Catskill Mountain landscapes throughout the 1860s, but in 1871, he left his professional painting career to become, at Norton's request, an instructor of drawing and watercolor at Harvard University. Moore went abroad for the first time in 1876, bearing a letter of introduction from Norton to Ruskin. Throughout 1876-77, Moore worked and traveled in Italy with Ruskin, focusing on Venice, Verona, and Florence, and sharing the English critic's enthusiasm for Gothic art. Moore returned to Europe in 1885, spending most of his time in France; he moved to England following his retirement from Harvard in 1909.

Charles Herbert Moore

106. *Venetian Doorway*, 1877
Watercolor over graphite on off-white paper, 15⅜ x 11⅛ in.
Signed l.r.: c. h. m./ venice. 1877.
*The Fogg Art Museum, The Harvard University Art
Museums. Gift of Miss Elizabeth Norton in memory of
Charles Eliot Norton and Charles Herbert Moore*

Charles Herbert Moore spent the fall and
winter of 1876-77 in Venice with the Eng-
lish critic John Ruskin, whom he had first
met that summer at Oxford through his
Harvard colleague Charles Eliot Norton
(see cat. 160). Ruskin, a notoriously diffi-
cult individual, took to the American
painter and his family immediately, report-
ing to Norton that he was "delighted with
Mr. Moore," and that they had made plans
to meet again in Venice.[1] Their planned
four-week stay lengthened to four months,
and they found themselves, in Ruskin's
words, to be in "perfect sympathy in all art
matters."[2]

Moore spent most of his time in Venice
at the Accadèmia galleries, copying
Carpaccio's *Dream of St. Ursula*, a series of
eight canvases and an altarpiece commis-
sioned in 1488. Carpaccio was one of the
most admired early Renaissance masters,
renowned for his brilliant use of color, but
Moore's concentration on the St. Ursula
cycle reflects his intimacy with Ruskin,
who had become entranced with the paint-
ings.[3] Their affinity is also expressed in
Moore's *Venetian Doorway*, which recalls
Ruskin's fascination with fragments of the
stones of Venice.

The particular location of Moore's
doorway is unknown; it is perhaps a side
or service entrance to one of the grand
palaces or the gateway to a more modest
building. It presents a distinctly Venetian
architectural form of doorway that Ruskin
had catalogued in *The Stones of Venice*.[4] For
Moore, it represented a unique combina-
tion of the man-made and the natural.
When this watercolor was exhibited at
Harvard in 1878, the painter noted that
"the old masonry, whose edges have been
shaped and whose hues harmonized by
time, has acquired a character akin to that
of some beautiful natural object."[5] Using
rich colors, and a fine, wet brush, Moore
carefully delineated the rosy bricks, soft-

ened and blurred over the ages; the cracked steps, leading into a shadowy void; and the dark green algae, enlivened with deep purples, that covers the base of the wall, encroaching over the man-made structure.

Moore clearly sketched this canal-side entrance from a gondola, separating the viewer from the solid steps by a barrier of blue-green water. The doorway itself is a familiar motif, but its aquatic foundations lend a mysterious element to the scene. This unusual vantage point, which emphasized the exotic nature of the city of Venice, was just becoming popular in the last quarter of the nineteenth century. Such fashionable British painters as Luke Fildes and Marcus Stone used watery doorways in their picturesque genre scenes, and they would become a frequent motif in the work of both James A. McNeill Whistler and John Singer Sargent.

Moore's watercolor had the distinction of being rejected from the 1882 exhibition of the American Watercolor Society; it was installed instead in the "salon des refusés" of more than three hundred watercolors exhibited at the American Art Gallery in New York. A critic from the New York *Herald* remarked that "Ruskin would buy it on sight."[6] Instead, *Venetian Doorway* was given to Charles Eliot Norton, who considered it one of his prized possessions.[7]

E. HIRSHLER

1. John Ruskin to Charles Eliot Norton, summer 1876, quoted in Frank Jewett Mather, Jr., *Charles Herbert Moore, Landscape Painter* (Princeton, N. J.: Princeton University Press, 1957), p. 48.

2. John Ruskin to Charles Eliot Norton, October 5, 1876, in E. T. Cook and Alexander Wedderburn, *The Works of John Ruskin* (London: George Allen, 1909), vol. 37, p. 211.

3. Ruskin's passion for the St. Ursula cycle was the result of his unhappy love affair with Rosie La Touche, a young girl thirty years his junior with whom the critic became obsessed. La Touche died insane in 1875, and Ruskin was convinced that the St. Ursula cycle reflected her spirit.

4. See "The Orders of Venetian Arches," no. 7c, in John Ruskin, *The Stones of Venice*, edited by Jan Morris (Mount Kisco, N. Y.: Moyer Bell, Limited, 1989), p. 153.

5. Charles Herbert Moore, *Catalogue with Notes of Studies and Facsimiles from Examples of the Works of Florence and Venice* (Cambridge, Mass.: John Wilson and Son, 1878), p. 18. The exhibition was sponsored by the Harvard Art Club, and was held in December 1878.

6. "Fine Arts: The Exhibition of the Rejected Water Colors," New York *Herald*, February 23, 1882, p. 5, quoted in Kathleen A. Foster, "The Watercolor Scandal of 1882: An American Salon des Refusés," *Archives of American Art Journal* 19 (1979), p. 22.

7. See Mather, *Charles Herbert Moore, Landscape Painter*, p. 50. Moore later copied his composition as a mezzotint engraving.

James A. McNeill Whistler

Born Lowell, Massachusetts, 1834; died London, England, 1903

Whistler's fifteen months in Venice (September 1879-November 1880) were a kind of exile for him. Though he had long sought to visit Italy, this trip — the only one he would ever make — followed a period of acute financial embarrassment and loss of patronage. Abandoned by his disillusioned sponsor Frederick Leyland (who paid Whistler only half the agreed-upon fee for the Peacock Room, *completed in 1877), and horribly overextended from the building of his magnificent "White House" and his Pyrrhic victory in the lawsuit against John Ruskin, Whistler was declared bankrupt in May of 1879. His house, his works of art, and his porcelain collection were sold at auction as he left for Venice, where he had only the (London) Fine Art Society's commission for twelve etchings to sustain him. His months in Venice were marked by his extreme poverty. He lived for part of his stay at the Casa Jankowitz on the Riva degli Schiavoni in the company of several younger American artists, who wrote repeatedly of his cadging materials and even meals from them, while they imitated his style. Nonetheless, Venice's magic was restorative, and the works he produced there are among his most admired.*

James A. McNeill Whistler

107. *The Lagoon, Venice: Nocturne in Blue
 and Silver,* 1879-80
Oil on canvas, 20¾ x 25¾ in.
Signed, l.r.: butterfly symbol
Museum of Fine Arts, Boston, Emily L. Ainsley Fund

Whistler's vantage point for this picture is a familiar one: standing near the Piazzetta in front of the Royal Gardens, he directs our eyes southwest across the lagoon. The island church of San Giorgio Maggiore is on the right, and along the horizon, between the church and the tall-masted ship at left, are the distant lights of the Lido, already a popular resort in Whistler's day.

The view across the lagoon to the church was favored by many nineteenth-century painters.[1] Whistler converted the conventionally picturesque view into one of his evocative nocturnes, which even in his own time were highly regarded. As Harper Pennington, a young contemporary and sometime imitator of Whistler, wrote of this picture: "So, dear Dick [Richard A. Can-

field of Providence, the first owner of *The Lagoon, Venice*], you have let the Whistlers go! You will miss the great Nocturne – possibly the most peace-bringing of all of Jimmy's pictures; certainly his finest night scene."[2]

Although he was prolific in other media, Whistler painted relatively few oils while in Venice, and of the dozen or so that have

Fig. 1. James A. McNeill Whistler, *Nocturne*, 1880. Etching. Museum of Fine Arts, Boston, Bequest of Mrs. Henry Lee Higginson, Sr.

been recorded, only three have been located.[3] It is possible that his infatuation with works on paper during this period — he made some fifty etchings and more than ninety pastels while in Venice — as well as the expense of canvas and paints, accounts for his relatively meager production in oils. And in contrast with the etchings and pastels, which frequently focus on less well-known corners of Venice, in the oils Whistler represented some of the city's most beloved monuments: Santa Maria della Salute, San Giorgio Maggiore, San Marco (the last, now at the National Museum of Wales, Cardiff, is also a misty nocturne that dematerializes the architectural masterpiece that inspired it).[4]

Unlike his archrival Ruskin, whose *Stones of Venice* celebrated the sumptuous materials and lacy forms of local Gothic architecture and imputed a lesser morality to Palladio's majestic San Giorgio Maggiore,[5] Whistler found the Renaissance church evocative. He described it under cover of mist and darkness — just as he had Battersea Reach at the beginning of the decade, and Valparaiso Harbor some fif-

teen years before — so as to convey its magic. In these nocturnes, surface luster becomes shadow and monumental forms appear dreamlike. Here Whistler's delicate washes of ultramarine and black reduce the muscular gondoliers to ghostly silhouettes; the church's bulky dome and tower are likewise dematerialized. The only substantial-seeming forms are in fact the most emphemeral: the points of light on the horizon, whose brilliant flickerings Whistler portrays as seductive and ungraspable as the city itself.

C. TROYEN

1. Among the best-known of the many paintings of San Giorgio Maggiore are Turner's watercolor (about 1840, National Gallery of Ireland, Dublin) and Monet's two late views (*San Giorgio Maggiore*, 1908, and *Crepuscule, San Giorgio Maggiore*, 1908), both owned by the National Museum of Wales. Among Americans, Samuel Colman featured the church in a painting of 1902 (private collection) and Whistler himself repeated the composition of *The Lagoon, Venice* (though from a slightly different vantage point) in an elegant etching, *Nocturne*, of 1880 (fig. 1).

2. Harper Pennington to Richard Canfield, March 20, 1914. Museum of Fine Arts, Boston, Paintings Department files. This painting was stolen from Whistler's Paris studio by his model Carmen Rossi in 1902; the artist never prosecuted. She sold the painting at auction in Paris after his death in 1903, where it was bought for Canfield by a London agent. See Andrew McLaren Young, et al., *The Paintings of James McNeill Whistler* (New Haven and London: Yale University Press, 1980), cat. 212.

3. Although the majority of Whistler's Venetian oils depict architecture or canal views, a surprising number were portraits. See Young et al., *The Paintings of James McNeill Whistler*, nos. 211–222a.

4. Ibid., no. 213.

5. Of San Giorgio Maggiore, Ruskin wrote, "It is impossible to conceive a design . . . more contemptible under every point of rational regard," John Ruskin, *The Stones of Venice*, 4th ed. (London: J. Wiley & Sons, 1886), vol. 3, p. 292.

James A. McNeill Whistler

108. *Note in Flesh Color: Giudecca,*
 1879-80
Pastel on paper, 5 x 9 in.
Mead Art Museum, Amherst, College, Gift of George D. Pratt, Class of 1895

109. *Venetian Scene,* 1879-80
Pastel on brown paper, 11 x 7½ in.
Signed l. l.: butterfly symbol
Harriet Russell Stanley Memorial Fund, Permanent Collection, The New Britain Museum of American Art, Conn.

110. *Calle San Trovaso, Venice,* 1879-80
Pastel on brown paper, 10⅞ x 5 in.
Signed, l.r.: butterfly symbol
James Biddle

111. *A Canal in Venice (Tobacco Warehouse),* 1879-80
Pastel and charcoal on paper, 11⅝ x 8 in.
Signed l.l.: butterfly symbol
Hirshhorn Museum and Sculpture Garden, Smithsonian Institution, Gift of Joseph H. Hirshhorn, 1966

Whistler fled to Venice in the fall of 1879 in disgrace, endured poverty and an exceptionally harsh winter there, and returned to London in November of 1880 in triumph.

His first show of the pictures he produced in Venice, a group of twelve etchings ("The First Venice Set") shown at the Fine Art Society in December, 1880, was moderately well received. Whistler predicted the popularity of his second exhibition, of the pastels he made in Venice, months before he returned: "I shall bring fifty or sixty if not more pastels totaly [sic] new and of a brilliancy very different from the customary watercolor — and [they] will sell — I don't see how they can help it."[1] But even Whistler's braggadocio seems restrained compared to the public's reaction to the fifty-three pastels, which were shown at the Fine Art Society in January, 1881. Maud Franklin, Whistler's mistress, expressed astonishment at the show's extraordinary artistic, social, and financial success:

As to the pastels, well — they are the *fashion* — There has never been such a success known — Whistler has decorated a room for them — an arrangement in brown gold and Benedictine red which is very lovely — out in it they look perfectly fine. All the London world was at the private view — princesses painters beauties actors — everybody — in fact at one moment of the day it was impossible to move — for the room was crammed.[2]

And critics who had hounded him out of London just sixteen months before vied with one another to find accolades to be-

stow on this stunning show.[3]

Both the exhibition — which included three of the four works shown here — and the pastels themselves were innovative. Whistler himself took charge of the installation, choosing dull olive green fabric to go behind the pastels, its matte surface making the tiny pastels in their gold frames seem all the more jewel-like. At about nine feet, there was a molding of "citron" gold, a band of Venetian red, and another of a reddish gold color at the top — a system of horizontal bands that has perceptively been interpreted as recalling "the standard Whistlerian sunset composition — an example of the artist's consistency of vision."[4]

tency of vision."[4]

The individual pastels reflect the variety of Whistler's responses to Venice. Some — such as *Venetian Scene* — are somewhat conventional, featuring one of the city's most favored landmarks, Santa Maria della Salute. But even as he takes on such a historic subject, Whistler diffuses it by showing it small scale, high on the horizon and at a great distance, and separated from the viewer by a nearly empty (and relatively unarticulated) expanse of water in the foreground. Whistler's disregard for traditional notions of composition and finish are further indicated by the fact that, here and in *Canal in Venice* as well, he

executed the pastel on top of the fragments of another, unrelated drawing, whose spidery remains, like the marginal images in many etchings of the period, serve as a ghostly commentary on the scene.

Though Venice's architectural monuments are featured in several of Whistler's pastels – Il Redentore in *The Giudecca* is another example – Whistler seems to have been drawn equally to the uncelebrated, or formerly grand, buildings and alleys of Venice. His *Canal in Venice* features a once-handsome palazzo, which in his day functioned as a tobacco warehouse. *Calle San Trovaso* records a narrow side street near the Accademia, built up with tenements between which laundry is strung. These picturesque scenes become romantic vignettes in Whistler's hands. They are heavily worked in the center, with detail and color fading away as he moved outward, until there is little but the warm middle tone of the richly textured colored paper (brown, buff, or blue) to contain our vision.

The charm of these pastels was immediately apparent to collectors: as Maud Franklin noted, the pastels sold briskly, and for high prices.[5] Despite their small scale and fragility, they have been exhibited frequently and won the enthusiastic endorsement of both traditional and avant-garde artists and critics. Even so thorough-going a modernist as A. E. Gallatin, in a 1912 essay on Whistler, found in them much to admire: "These drawings, outlined with black crayon on tinted paper, usually of a brownish tone and tinted with pastel, in which much of the paper itself is visible, are marvelous little pictures, sparkling with sunlight, and recording the very spirit of the city in the sea. His subjects were always unhackneyed and treated in an entirely personal way."[6]

C. TROYEN

Otto Henry Bacher

Born Cleveland, Ohio, 1856;
died Bronxville, New York, 1909

1. Whistler to Marcus Huish, undated letter, Glasgow University Library, quoted in Robert H. Getscher, *James Abbott McNeill Whistler Pastels* (New York: George Braziller, 1991), p. 24.

2. Maud Franklin to Otto Bacher, postmarked March 25, 1881 (no. 177, Freer Gallery of Art, Washington, D.C.), quoted in Margaretta M. Lovell, *Venice: The American View, 1860-1920* (San Francisco: Fine Arts Museums of San Francisco, 1984), p. 135.

3. Many contemporary reviews are reprinted in Getscher, *James Abbott McNeill Whistler Pastels*, pp. 177-189.

4. David Park Curry, "Total Control: Whistler at an Exhibition," *Studies in the History of Art, vol. 19: James McNeill Whistler, A Reexamination* (Washington, D.C.: National Gallery of Art, 1987), p. 77.

5. "The best of it is all the pastels are selling — Four hunderd pounds worth went the first day now over a thousand pounds worth are sold — the prices ran from 20 to 60 guineas — and nobody grumbles at paying that for them." Franklin to Bacher, quoted in Lovell, *Venice*, p. 135.

6. A. E. Gallatin, *Whistler's Pastels and Other Modern Profiles* (New York: J. Lane Co., 1912), p. 6.

Otto Bacher studied art in Cleveland, learning painting from DeScott Evans and etching from S. L. Wenban. Like many art students from the midwest, Bacher was drawn to Germany for his first European sojourn. He studied at the Royal Academy in Munich in 1878-79, and then joined Frank Duveneck's classes, making his first trip to Italy with Duveneck in the late autumn of 1879. Bacher spent that winter in Florence and the following summer traveled to Venice with Duveneck and Robert Blum. Bacher met James A. McNeill Whistler in Venice the summer of 1880; the two artists became friends and shared an etching press, producing portfolios of Venetian scenes. Bacher would later recount their experiences in his 1909 book, With Whistler in Venice. *Bacher remained in Italy until the fall of 1882, based in Venice at the Casa Jankowitz. He made an extended visit to Florence in the winter of 1880-81 to work once again with Duveneck, and visited Rome, Naples, and Sicily at that time. He returned to Cleveland in December 1882, after a short visit with Whistler in London. Bacher returned to Venice only once, spending about six months there in 1886. He lived in the Palazzo Contarini degli Scrigni on the Grand Canal with Blum and Charles Ulrich, devoting himself to a large genre scene of lacemakers (current location unknown). Bacher settled in New York in 1887, married in 1888, and spent the rest of his career in the United States.*

Otto Henry Bacher

112. *Doge's Palace from the Lagoon,* about 1880
Oil on panel, 11⅝ x 18¼ in.
Signed l.r.: Otto H. Bacher/ Italia
Lent by Mr. Graham Williford

During his two-year stay in Venice in 1880-82, Otto Bacher portrayed the city's churches, canals, palaces, and bridges in a variety of media. He is best known for his etchings, which, like those of his friend Whistler, show Venice in a carefully composed, atmospheric manner, frequently rendered from the window of his room at the Casa Jankowitz on the Riva degli Schiavoni. In 1882, Bacher produced a bound limited edition of twelve of his etchings, a project he considered to be one of his most important Venetian efforts. He also worked in oil, and although few of his canvases have been located, he is known to have painted city scenes, views of St. Mark's, and genre scenes of the nearby fishing community at Chiogga.[1]

In 1884, Bacher exhibited a painting entitled "Venice from San Giorgio" at the National Academy of Design in New York.[2] *Doge's Palace from the Lagoon* may be that picture or a study for it, for its distant view of the seat of the Venetian republic likely was made looking north from the northwest corner of the large campo in front of the church of San Giorgio Maggiore, across the Bacino San Marco from the palace. The location was an unusual one, for most painters selected as their vantage point the tip of the Fondamenta Dogana, whence the Doge's Palace was viewed from the left. Bacher shows the building head-on, and must have been further east than the Dogana. The French painter Pierre-Auguste Renoir had made a similar image of the Doge's Palace in the fall of 1881 (Sterling and Francine Clark Art Institute, Williamstown, Mass.), claiming in a letter to a friend that he had found a unique vantage point, and that at least six other artists were ready to follow him.[3]

Painted over a dark ground, Bacher's tiny strokes of white, gray, and pink define the buildings and set them off like small

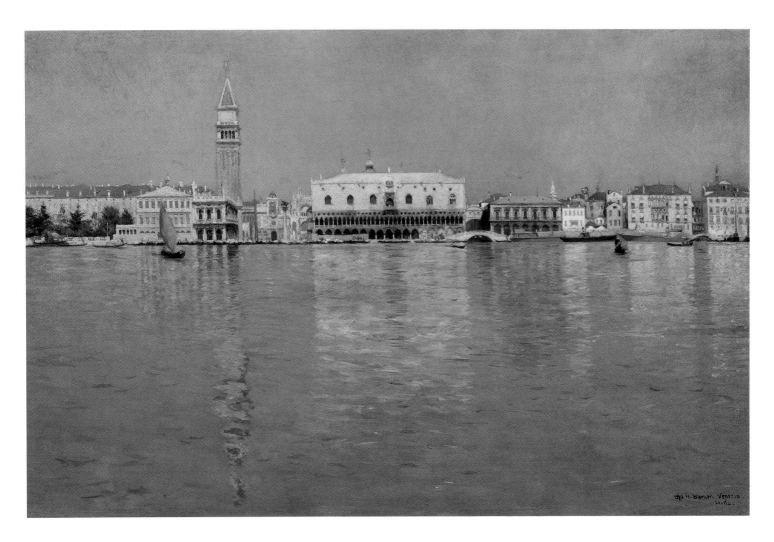

jewels from the quiet gray-blue sky and water. Every architectural detail is clearly legible: the trees of the Giardino Reale at the far left; the hip-roofed Zecca, or mint, flanked by the elaborately sculpted façade of the sixteenth-century Libreria Sansovino; the Campanile; the Molo with its columns dedicated to saints Theodore and Mark in the foreground and the fifteenth-century Clock Tower behind; the south façades of St. Mark's and the Doge's Palace; the Bridge of Sighs and the elongated Ponte della Paglia before it, connecting the Doge's Palace to the prison; and a few small houses along the Riva degli Schiavoni, ending at the Palazzo Dandolo, by this time one of the city's finest hotels. Bacher rendered these monuments with considerable care, but it is the centrally placed Doge's Palace that stands out as an icon, magnified by its elongated reflection in the calm waters of the lagoon. Bacher later recalled the palace's "exquisite beauty," and noted that it was one of Whistler's favorite buildings. [4]

Bacher's diligent attention to architectural details, his somewhat blanched colors, and his academic approach ally his efforts with an international circle of artists active in Venice at this time. His view of Venice recalls similar images by the Spanish painter Martin Rico, who would later share his lodgings at the Palazzo Contarini degli Scrigni, or those of English artist Arthur Meadows, who worked in Venice in the 1870s and 1880s. The artistic affinities between these painters reflects the cosmopolitan appeal of Venice, where, as F. Hopkinson Smith would relate, "They have all had a corner at Florian's. No matter what their nationality or speciality, they speak the common language of the brush." [5]

E. HIRSHLER

John Singer Sargent

113. *Venetian Street,* 1880-82
Oil on canvas, 29 x 23¾ in.
Signed l.l.: John S. Sargent
Collection of Rita and Daniel Fraad

1. See William W. Andrew, *Otto H. Bacher* (Madison, Wisc.: Education Industries, Inc., 1973).

2. *Fifty-ninth Annual Exhibition of the National Academy of Design,* New York, April 7-May 17, 1884, no. 376.

3. See Rafael Fernandez, *A Scene of Light and Glory: Approaches to Venice* (Williamstown, Mass.: Sterling and Francine Clark Art Institute, 1982), pp. 44-45.

4. Otto Bacher, *With Whistler in Venice* (New York: The Century Company, 1908), p. 289. The form of the Doge's Palace dates to the fourteenth century, though a large part of it was rebuilt in the sixteenth century after a major fire. It typifies the Venetian Gothic style; Ruskin devoted a whole chapter to it in his *Stones of Venice.*

5. F. Hopkinson Smith, *Gondola Days* (Boston: Houghton Mifflin and Company, 1897), p. 56.

During his early working trips to Venice, at the same time as he painted his series of dark and luminous interior scenes (see cat. 114), John Singer Sargent created a parallel group of pictures with an outdoor setting. *Venetian Street* is one of three images Sargent made of the small alleyways in the area behind the church of SS. Apostoli, near the Ca' d'Oro.[1] Rather than portray the grand public buildings and piazzas for which Venice was best known, Sargent instead chose to represent the anonymous corridors that William Dean Howells had described as "the narrowest, crookedest, and most inconsequent little streets in the world."[2]

Sargent's street scenes share the intimate, confined character of his interiors. By cropping out the sky and by using a perspectival scheme that recedes sharply into the distance only to end abruptly at a wall, Sargent created a space that conflates exterior and interior, public and private. While the interiors are populated mostly by women, the street scenes explore the relationship between the sexes. The encounter that Sargent portrays between these two cloaked figures is enigmatic and suggestive; Sargent's upper-class audience would have found the scene provocative and unconventional: "In Venice a woman has to encounter upon the public street a rude license of glance . . . which falls little short of outrage," reported Howells.[3] The virtually monochromatic palette, relieved only by a touch of red, and the limited space of the small street add to the mood of sexual tension.[4] Ralph Curtis, the painter's cousin with whom he lived during his 1882 Venice trip, nicknamed this picture "Flirtation Lugubre."[5]

The scene has the flavor of a quickly captured chance meeting, but in fact it is the product of considerable study. The woman is probably Gigia Viani, Sargent's favorite Venetian model, who appears in

Fig. 1. John Singer Sargent, *Man in a Fur Cape (Studies for Venetian Street Scenes),* 1880-82. Pen and ink on paper. Collection of Rita and Daniel Fraad.

several of the genre scenes as well as in two portrait studies.[6] The man with the fur-trimmed cape is unidentified, but he appears in all of the street scenes and is the subject of a sheet of preliminary drawings Sargent made exploring the figure from several different angles (fig. 1). In addition, two empty Venetian street scenes survive, suggesting the possibility that Sargent added the figures in last, inserting them in poses selected from his sketches. In *Venetian Street,* the caped man clearly was painted in after the rest of the street was rendered, for the thick white strokes defining the sunlight at the end of the alley continue uninterrupted beneath his cloak.[7] Nevertheless, Sargent successfully conveys the impression of a swiftly observed exchange by including such details as the man opening an umbrella in the background, the hunting cat at left, and the forward stride of the woman as she turns to speak to her male acquaintance.

The critical reception of Sargent's Venetian street scenes was mixed, like that

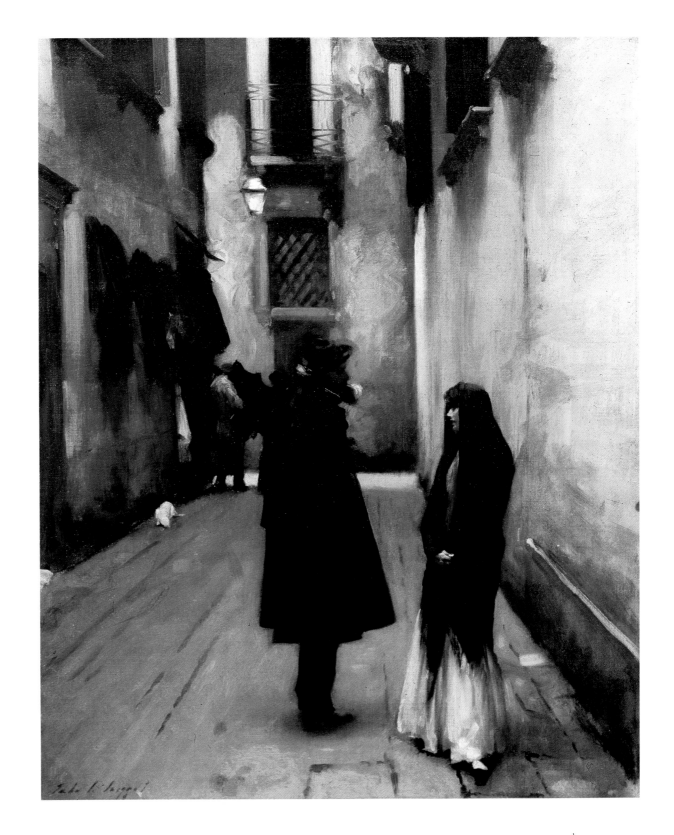

John Singer Sargent

114. *A Venetian Interior*, 1880-82
Oil on canvas, 19 x 23⅞ in.
Signed l.r.: To my friend J. C. Cazin/
John S. Sargent
*Sterling and Francine Clark Art Institute, Williamstown,
Massachusetts*

of the interiors. A French critic complained that the painter "leads us into obscure squares and dark streets where only a single ray of light falls. The women of his Venice, with their messy hair and ragged clothes, are no descendents of Titian's beauties."[8] But a writer for the *New York Times* admired Sargent's rendering of "the slouchy picturesqueness of the Venetian girls," noting particularly "how well he paints the curves inside the inevitable shawl drawn closely around the figure."[9] Sargent sold *Venetian Street* to the French actor Benoît-Constant Coquelin, who hung it in his dressing room at the Comédie Française.[10]

E. HIRSHLER

1. The other images are *A Street in Venice* (Sterling and Francine Clark Art Institute, Williamstown, Mass.) and *Street in Venice* (National Gallery of Art, Washington, D.C.). Only the location of the National Gallery's picture has been securely identified, as the Calle Larga dei Proverbi, but the other street scenes are believed to represent the same neighborhood. See Linda Ayres, "Sargent in Venice," in Patricia Hills, et al., *John Singer Sargent* (New York: Whitney Museum of American Art, 1986), p. 56.

2. William Dean Howells, *Venetian Life* (Boston: Houghton Mifflin and Company, 1892), vol. 1, p. 40 (first published 1866).

3. Ibid., vol. 2, p. 189.

4. Trevor Fairbrother discusses these issues in his compelling essay "Sargent's Genre Paintings and the Issues of Suppression and Privacy," in "American Art around 1900, Lectures in Memory of Daniel Fraad," edited by Doreen Bolger and Nicolai Cikovsky, Jr., *Studies in the History of Art* 37, Center for Advanced Study in the Visual Arts, National Gallery of Art, Washington, pp. 29-49.

5. Ayres, "Sargent in Venice," p. 56. For the Curtis family, see cat. 116.

6. Richard Ormond, *John Singer Sargent* (New York: Phaidon, 1970), p. 29.

7. See Fairbrother, "Sargent's Genre Paintings," p. 34.

8. Arthur Baignères, "Première exposition de la Société des Peintres et Sculpteurs," *Gazette des Beaux Arts* 26 (February 1883), p. 190, quoted in Ayres, p. 68.

9. "Portraits at the Academy," *The New York Times*, April 8, 1888, p. 10, quoted in ibid.

10. Few of Sargent's early Venetian scenes sold. See Fairbrother, "Sargent's Genre Paintings," p. 46.

Sargent's first important Venetian paintings were created during two extended trips in the early 1880s. It seems likely that he made *A Venetian Interior* during his 1880-81 visit, along with two other images set in the same long hall.[1] Sargent arrived in the city in September 1880, joining his parents at the fashionable Hotel d'Italie. After their departure, he moved to rooms on the Piazza San Marco, near the Clock Tower, and took a studio at the Palazzo Rezzonico on the Grand Canal. This elegant seventeenth-century palace provided a haven for several painters including James A. McNeill Whistler, who had been there the previous year (see cats. 107-111). Unlike most of his colleagues, Sargent at this time ignored the picturesque canals, festive crowds, and elegant architecture for which Venice was renowned. Instead, fascinated by the suffused, glistening Venetian light, he concentrated upon the obscure streets and worn interiors inhabited by the working class.

A Venetian Interior is set on the main floor, or *piano nobile*, of an old palazzo, probably one of the once-elegant palaces that had become a home for the poor or had been converted into glass works.[2] Two figures in the background string small glass beads, a common cottage industry by the late nineteenth century. Sargent's long view is shadowy and mysterious; the sparsely furnished hall is dark. Paintings line the walls, but they are unidentifiable in the oblique light. *A Venetian Interior* reflects Sargent's admiration for the complicated interiors of Velázquez, whose work he had studied in Madrid the previous year. Like the Spanish master, Sargent used a restricted palette of cool gray and rich black, and he contrasted the bright areas at the front and back of the hall with a shadowy middle ground. He carefully delineated the many different aspects of light in this opalescent space: the hazy, dust-filled shimmer from the

stairwell at the back of the room, the luminous gray walls, the glint of gold picture frames and strands of beads, and the piercing stab of bright sunlight, which he rendered with a thick streak of buttery paint interrupted by the woman standing in the center of the picture. Sargent rejected meticulous realism, preferring instead to define only selected features illuminated by the glistening atmosphere, leaving the figures freely painted and sketchy.

Sargent's choice of subject matter and his casual rendering of figures displeased some of his audience. Bostonian Martin Brimmer, an astute collector, discussed these Venetian scenes in a letter to his friend Sarah Wyman Whitman, calling them "half-finished." He added that "they are clever, but a good deal inspired by the desire of finding what no one else has sought here — unpicturesque subjects, absence of color, absence of sunlight. It seems hardly worthwhile to travel so far for these."[3] But the painter's friend Henry James, who had seen two of these interiors exhibited in London in May 1882, disagreed:

[It is] a pure gem, a small picture . . . representing a small group of Venetian girls of the lower class, sitting in gossip together one summer's day in the big, dim hall of a shabby old palazzo. The shutters let in a clink of light; the scagliola pavement gleams faintly in it; the whole place is bathed in a kind of transparent shade . . . The figures are extraordinarily natural and vivid; wonderfully light and fine is the touch by which the painter evokes the small familiar Venetian realities . . . the whole thing [is] free from that element of humbug which has ever attended most attempts to reproduce the Italian picturesque.[4]

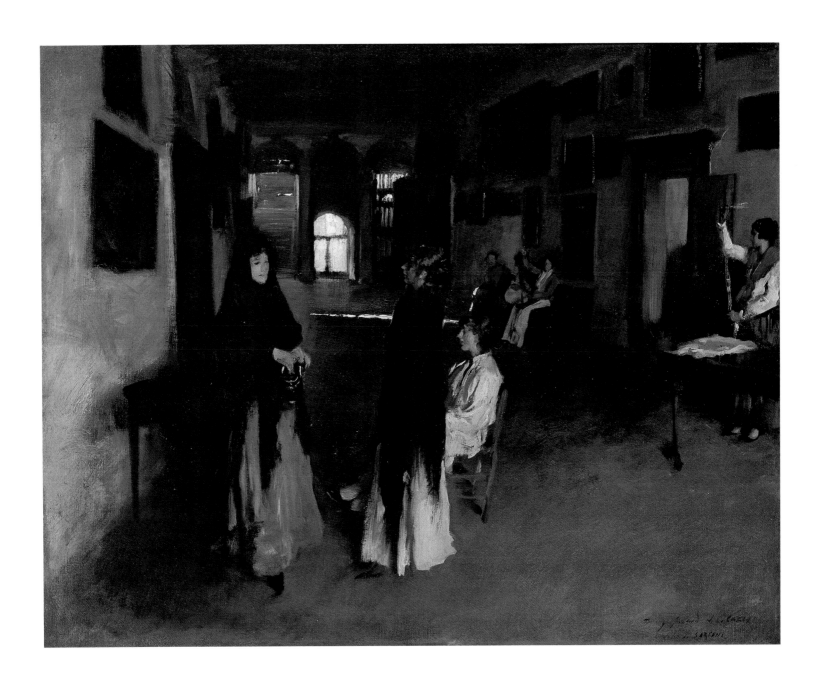

John Singer Sargent

115. *The Pavement of St. Mark's,* 1898
Oil on canvas, 21 x 28½ in.
Signed l.r.: John S. Sargent
Private Collection, New York

Despite James's praise, Sargent did not sell *A Venetian Interior.* Instead, he presented it to his friend, the French painter Jean Charles Cazin,[5] who admired its subtle beauty and its undisguised love of paint.

E. HIRSHLER

1. The others are *Venetian Interior* (1880-1882, Museum of Art, Carnegie Institute, Pittsburgh) and *Venetian Bead Stringers* (1880-1882, Albright-Knox Gallery, Buffalo, N.Y.). Linda Ayres convincingly argues for the early date in her essay "Sargent in Venice," in Patricia Hills, et al., *John Singer Sargent* (New York: Whitney Museum of American Art, 1986), pp. 49-50.

2. The site has not been clearly identified, but it was also depicted by Whistler in a pastel titled *Palace in Rags* of 1879-1880 (private collection). The room is evidently not in the Palazzo Rezzonico. See Ayres, pp. 54, 57.

3. Martin Brimmer to Sarah Wyman Whitman, October 26, 1882, Martin Brimmer Papers, Archives of American Art, Smithsonian Institution, Washington, D.C.

4. Henry James, "John S. Sargent," *Harper's New Monthly Magazine* 75 (October 1887), p. 689.

5. The painting is inscribed to Cazin. See Ayres, "Sargent in Venice," pp. 71-72 and Margaret C. Conrads, *American Paintings and Sculpture at the Sterling and Francine Clark Art Institute* (New York: Hudson Hills Press, 1990), pp. 179-182.

John Singer Sargent made this moody, subdued image of the deserted interior of St. Mark's cathedral in Venice the same year he painted his aristocratic portrait of the Curtis family in the Palazzo Barbaro (see cat. 116). Driven by the challenge of his commission to paint murals for the Boston Public Library, Sargent had returned to Italy in 1897 for the first time in many years to study the great mural and mosaic cycles in Sicily, Rome, and Florence. The following year he continued his research, visiting cities with the finest surviving examples of Byzantine mosaics. These ancient icons provided Sargent with models for his own decorative work, particularly for the Christian frieze and lunette with its sculpted crucifix that Sargent planned for the south side of Boston's library hall.

Some of the finest Byzantine mosaics in Italy were in Venice, inside the basilica of St. Mark's. The present cathedral was built between 1063 and 1094; the innovative brick vaulting of its Greek architect allowed for mosaics on the ceilings as well as the walls. The decoration was planned in a Byzantine style, enhanced in the early thirteenth century by objects looted by the Crusaders from the eastern capital itself, Constantinople, including the fabled bronze horses (see cat. 105). Further ornaments were added throughout the church's history, until, as Ruskin described it, the interior was "a continual succession of crowded imagery, one picture passing into another, as in a dream."[1] The mosaics must have intrigued Sargent, who, after visiting the cathedral, cut short his stay in Venice to travel to Ravenna, where he made many sketches of the Byzantine mosaics at S. Apollinare in Classe.

In *The Pavement of St. Mark's,* Sargent depicts the interior of St. Mark's from the edge of the north aisle near the crossing, looking southwest towards the main en-

Fig. 1. Robert Blum, *A Morning in St. Mark's (Venice),* 1880s. Watercolor on paper. Cincinnati Art Museum, Gift of Henrietta Haller.

trance of the cathedral. Robert Blum had painted this same area in a small watercolor of the mid-1880s (fig. 1), indeed the church was often crowded with worshippers, tourists, and artists (see cat. 130). Maitland Armstrong recalled that in St. Mark's:

> The artists were priveleged; we could sit and paint wherever we pleased, no one ever interfering with us; we were allowed to store our easels in the sacristy — there were so many of them that it looked more like a studio than the robing-room of a church Never was there a more delightful place to work in.[2]

Sargent's view however, is deserted, an empty nave reminiscent of the shadowy Venetian halls he had painted in the 1880s (see cat. 114). Light streams in from the great west window and the doorway below it, illuminating the marble floors and golden walls with a subtle luster. Above the doorway, the thirteenth-century Deesis mosaic, representing Christ, the Virgin, and St. Mark, gleams from the shadows. However, Sargent gave most of his attention to the irregular paving of the ancient floor, set in geometrical patterns softened by several centuries of wear.

The pavement of St. Mark's had been

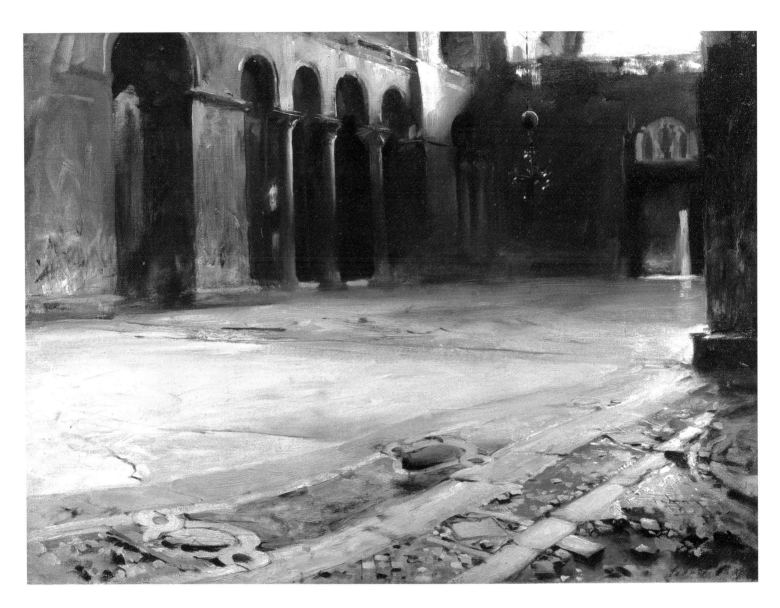

the topic of controversy in the 1860s and '70s, when some of it was removed and replaced. John Ruskin, who had described in detail the "waves of marble that heave and fall in a thousand colors along the floor" in his *Stones of Venice*,[3] was not the only Venetian enthusiast to denounce the renovations. Sargent's friend Henry James remarked that the restorers imitated "the floor of a London clubhouse or of a New York hotel"; he much preferred "that dark and rugged old pavement — those deep

undulations of primitive mosaic in which the fond spectator was thought to perceive an intended resemblance to the waves of the ocean."[4] It was these ancient stones of Venice Sargent chose to portray, rendering in thick, rich strokes of paint the floor worn smooth by countless visitors.[5] The following year, Sargent included *The Pavement* in his solo exhibition in Boston; the painting remained in his family until 1981.

E. HIRSHLER

1. John Ruskin, *The Stones of Venice*, edited by Jan Morris, (Mount Kisco, N.Y.: Moyer Bell Limited, 1989), p. 84.

2. Maitland Armstrong, *Day Before Yesterday* (New York: Charles Scribner's Sons, 1920), p. 244.

3. Ruskin, *The Stones of Venice*, p. 81.

4. Henry James, "Venice," *Italian Hours*, quoted in Hugh Honour and John Fleming, *The Venetian Hours of Henry James, Whistler and Sargent* (Boston: Little, Brown, and Company, 1991), pp. 97-98.

5. Sargent also painted a watercolor depicting the pavement of the cathedral of Monreale in Palermo, where he was studying another Byzantine mosaic cycle in 1901. See lot 66, Christie's, March 14, 1991.

John Singer Sargent

116. *An Interior in Venice*, 1899
Oil on canvas, 25½ x 31¾ in.
Signed l.l.: John S. Sargent 1899
Royal Academy of Arts, London

Sargent began to paint *An Interior in Venice* in the summer of 1898, during one of his first visits to that city since the early 1880s. Set in the elaborate salon of the Palazzo Barbaro, on the Grand Canal near the Accadèmia Bridge, the picture is an informal portrait of the artist's hosts, his cousins and close friends, the Curtises. Sargent had last been their guest in 1882, when he had painted Venice's worn interiors and anonymous streets (see cats. 113 and 114). He called the Palazzo Barbaro "a sort of 'Fontaine de Jouvence,' for it sends one back twenty years besides making the present seem remarkably all right."[1] He now sought to record an equally intimate, if considerably wealthier, aspect of Venetian life.

Daniel Curtis and his wife Ariana Wormely Curtis, seen in the right foreground of Sargent's painting, had taken over two floors of the Palazzo Barbaro in 1881.[2] They were important members of the city's expatriate community, and counted among their frequent visitors not only Sargent, but also Isabella Stewart Gardner, Robert Browning, Henry James, and Vernon Lee. Lee described the Curtises as the "sort of Americans who shudder at Howells [and] look up to James as a sort of patron saint of cosmopolitan refinement," and remarked that their home was a "vast and luxurious and exquisite place, full of beautiful furniture and pictures and at the same time absolutely unpretentious."[3] Browning read his poetry there, and James used it as the model for Palazzo Leporelli in his 1902 romance, *The Wings of the Dove* (fig. 1).

In that novel, James described the salon, which Sargent fluidly rendered with quick, concise touches of paint:

Fig. 1. Alvin Langdon Coburn (American, 1882-1966). *The Venetian Palace* (illustration to *The Wings of the Dove* by Henry James), 1906. Photogravure. Museum of Fine Arts, Boston, Gift of Elmar Seibel.

Fig. 2. *The Salon of the Palazzo Barbaro* (from Isabella Stewart Gardner's travel book). Photograph. Isabella Stewart Gardner Museum, Boston.

high, florid rooms, palatial chambers where hard, cool pavements took reflections in their lifelong polish, and where the sun on the stirred sea-water, flickering up through open windows, played over the painted 'subjects' in the splendid ceilings ... embossed and beribboned, all toned with time and all flourished and scolloped and gilded about, set in their great moulded and figured concavity (a nest of white cherubs, friendly creatures of the air) ... which did everything, even with the Baedekers and photographs ... to make of the place an apartment of state.[4]

Sargent captures the dichotomy of informality and grandeur in his composition. By concentrating only upon the glimmering highlights of the architecture and furnishings, Sargent forces the elaborate room to become a backdrop for his unusual portrait, a stage set for the actions of two generations of the Curtis family. In the words of a contemporary critic, a "great rococo room of a Venetian palace [is] occupied by ordinary modern people" (fig. 2).[5] In the foreground, Daniel Curtis leafs through a large journal while his wife Ariana regards the viewer with the forthright aristocratic gaze that earned her the sobriquet "la dogaressa." Behind them, their son Ralph, a painter and close friend of Sargent, leans against a gilt table, while his new wife, Lisa Colt Curtis, pours tea.[6] There is no interaction between the two generations, nor much rapport between the couples; the strongest sensation is that of privileged ennui.

Perhaps for that reason Ariana Curtis refused Sargent's gift of the painting in 1898, although she only voiced her objections to the artist's unflattering depiction of the strong light on her face and to her son's indecorous pose. Sargent himself thought highly of *An Interior in Venice*, and

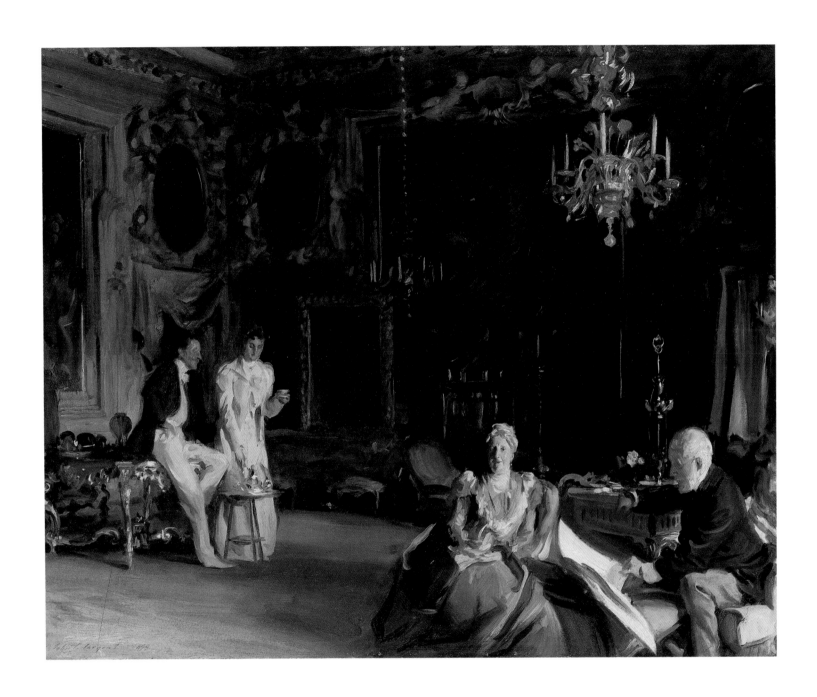

John Singer Sargent

117. *The Salute, Venice,* about 1909
Watercolor over preliminary drawing in pencil on
paper, 20 x 14 in.
Yale University Art Gallery, Christian A. Zabriskie Fund

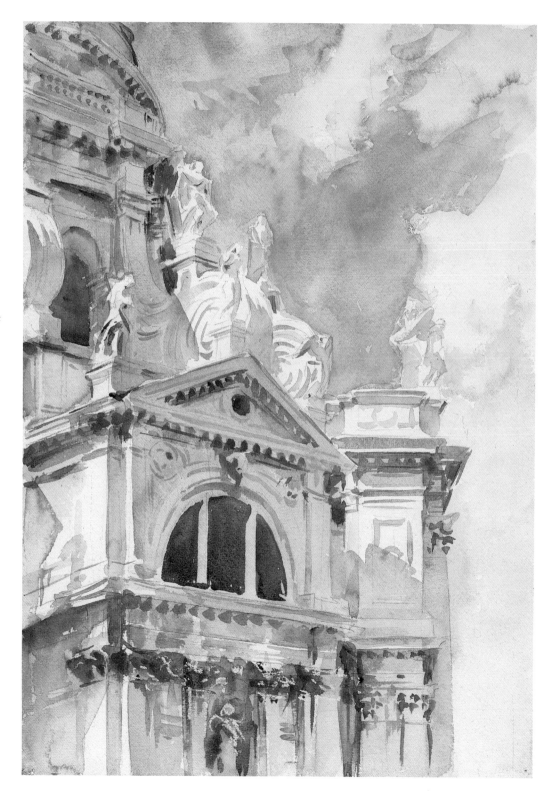

gave it to the Royal Academy in 1899 as his
diploma picture, substituting it for a por-
trait he had placed there the previous year.
The painting was warmly received by the
critics when it was first exhibited in 1900;
the lone dissenting opinion came from
James A. McNeill Whistler, who claimed
the composition was "smudge every-
where."[7]

E. Hirshler

1. John Singer Sargent to Ariana Curtis, May 1898, quoted
in Richard Ormond, *John Singer Sargent: Paintings, Drawings,
Watercolors* (New York: Harper and Row, 1970), p. 251.

2. The Palazzo Barbaro, a Gothic palace of 1425, was exten-
sively remodeled and enlarged in 1694, when an adjoining
palace was incorporated and the elaborate library, dining
room (with a Tiepolo ceiling), and stucco ballroom were
designed by Antonio Gaspari. The palazzo was the home
of the Barbaro family, descendants of the procuratore Marc
Antonio. It was purchased by Count and Countess Pisani
when they sold their own huge palazzo. The Tiepolo ceil-
ing, representing the triumph of Francesco Barbaro at Bres-
cia, was sold in Paris in 1874. The Curtises bought the
palace from Countess Pisani in 1885; it remains in the
family.

3. *Vernon Lee's Letters*, ed. Irene Cooper Willis (London: pri-
vately printed, 1937), p. 202.

4. Henry James, *The Wings of the Dove* (New York: The
Modern Library, 1946), p. 145.

5. Quoted in William Howe Downes, *John S. Sargent: His Life
and Work* (Boston: Little, Brown and Company, 1925), p.
190.

6. Ralph Curtis (1854-1922) studied painting along with
Sargent at Carolus-Duran's Paris studio. The two became
close friends, and traveled and painted together frequently.
In 1897, Ralph married Lisa Colt Rotch, the wealthy young
widow of Arthur Rotch and the heiress to a firearms for-
tune.

7. James McNeill Whistler, May 7, 1900, quoted by E. R.
and J. Pennell, *The Whistler Journal* (Philadelphia: J. B. Lip-
pincott Company, 1921), p. 39.

From about 1898 until the outbreak of World War I, Sargent made almost annual visits to Italy. Venice was one of his favorite and most frequent destinations. He usually stayed with his cousins the Curtises in their elaborate apartments at the Palazzo Barbaro (see cat. 116). From there, he would set out by foot or private gondola to paint different aspects of the shimmering city (fig. 1). After 1900, Sargent's preferred technique was watercolor, and he made more than 150 pictures of Venice in that medium.

One of Sargent's favorite Venetian architectural subjects was the seventeenth-century church of Santa Maria della Salute. Built at the entrance to the Grand Canal in 1631-87, the church was the masterpiece of the Baroque architect Baldassare Longhena (1604-1692).[1] It was one of the city's most opulent landmarks, built of white Istrian stone with an enormous cupola, massive curled buttresses, and a broad, stepped platform leading into the sea. Sargent's friend Henry James described the building as:

> some great lady on the threshold of her saloon. She is more ample and serene . . . with her domes and scrolls, her scolloped buttresses and statues forming a pompous crown, and her wide steps disposed on the ground like the train of a robe.[2]

Sargent made more than a dozen images of the church, delighting in the play of light across its plastic, sculptural surface.

The Salute had been a popular subject for painters ever since it was completed. From Canaletto's day forward, images of the majestic structure "lording it over the noblest breadth of the Grand Canal" were cherished souvenirs.[3] But Sargent was able to make novel and daring compositions from this commonplace subject, for he never painted the building in its entirety.

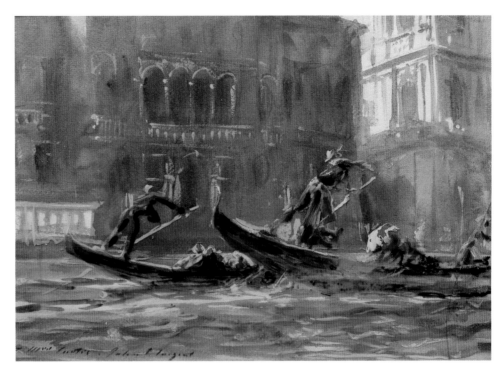

Fig. 1. John Singer Sargent, *Festa della Regatta* (Palazzo Barbaro in background), about 1903. Watercolor on paper and oil on glass. Courtesy of Altman-Burke Fine Art Inc.

His views are always fragmentary, capturing only small portions of the façade or the stepped platform. In this way, Sargent created distinctly modern images, rejecting a conventional vista in order to show the building in small segments, as if the viewer were on the spot, glancing at the scene before him.[4]

In *The Salute, Venice*, Sargent concentrated upon the northeast corner of the octagonal structure, cropping out both the dome and the steps. His view is barely foreshortened, and Margaretta Lovell has suggested that Sargent painted from the vantage point of a temporary platform, possibly one erected for an architectural photographer.[5] He worked quickly, for the shadow patterns created by the morning sun would

have remained constant for only a short time. Sargent began by outlining the basic details of the complex structure in pencil, and then used broad washes to define the details of sunlight and shadow. He abbreviated the building's ornate sculptural ornament to deft touches of the brush, which nevertheless fully capture the baroque exuberance of the decoration. In the lower center of the sheet, Sargent used a wax crayon to distinguish intricate moldings and sculpture, then painted over it with a dark brown wash. This wax-resist technique allowed Sargent to render bright highlights even in the darkest areas; in the words of his biographer Evan Charteris, "to live with Sargent's water-colours is to live with sunshine captured and held."[6]

John Singer Sargent

118. *The Rialto*, about 1911

Oil on canvas, 22 x 36 in.
Signed l.l.: John S. Sargent
Philadelphia Museum of Art, The George W. Elkins Collection

While this particular painting remained in the artist's family until it was purchased by Yale University, Sargent exhibited his watercolors regularly and sold them in large groups to public collections.[7] Albert Gallatin, one of the first American critics to write about watercolors, remarked that Sargent's works were "arresting snapshots which dazzle us by their brilliancy, shorthand notes which display the painter's astounding skill."[8]

E. HIRSHLER

1. Santa Maria della Salute was dedicated to the Virgin Mary in thanks for her intercession ending the plague of 1630, in which over fifty thousand people died. The Festival of the Salute, held in November, is one of the city's most important public spectacles.

2. Henry James, *Italian Hours*, 1892, in *Henry James on Italy* (New York: Weidenfeld and Nicolson, 1988), p. 37.

3. William Dean Howells, *Venetian Life* (Boston: Houghton Mifflin and Company, 1892), vol. 1, p. 207 (first published 1866).

4. Around 1880, Edgar Degas had remarked that "No one has ever done monuments or houses from below, from beneath, from up close, as one sees them going by on the streets," (Theodore Reff, ed., *The Notebooks of Edgar Degas* [New York: Hacker Art Books, 1985], vol. 1, pp. 134-135). See Margaretta Lovell, *Venice: The American View, 1860-1920* (San Francisco: The Fine Arts Museums of San Francisco, 1984), p. 112.

5. It is also possible that Sargent worked from photographs. See Margaretta Lovell, *A Visitable Past: Views of Venice by American Artists, 1860-1915* (Chicago: University of Chicago Press, 1989), p. 97.

6. Evan Charteris, *John Sargent* (New York: Scribner's, 1927), p. 225.

7. See Trevor J. Fairbrother, *John Singer Sargent and America* (New York: Garland Publishing, Inc., 1986), pp. 327-332; and Annette Blaugrund, "'Sunlight Captured': The Development and Dispersement of Sargent's Watercolors," in Hills, et al., *John Singer Sargent* (New York: Whitney Museum of American Art, 1986), pp. 209-243.

8. Albert Gallatin, *American Water-Colourists* (New York, E. P. Dutton and Company, 1922), p. 6.

Shortly after he painted his brilliant watercolor of Santa Maria della Salute (cat. 117), John Singer Sargent recorded another of Venice's most famous landmarks, the Rialto Bridge. In both of these works Sargent depicted a monument that was instantly recognizable to his audience. Yet in each case, he selected vantage points so original and so different from those of his artistic predecessors that familiar subjects seemed completely new.

The Rialto Bridge was built in 1588, designed by the aptly named architect Antonio da Ponte, who had won a competition to replace an older wooden structure. Until 1854, it was the only bridge over the Grand Canal, and its broad span was admired by English critic John Ruskin, who described it in *The Stones of Venice*:

> At the extremity of the bright vista, the shadowy Rialto threw its colossal curve slowly forth from behind the palace of the Camerlenghi; that strange curve, so delicate, so adamantine, strong as a mountain cavern, graceful as a bow just bent.[1]

The underside of the Rialto Bridge was a refuge from the heat of the sun, as well as "the waterman's friend in wet weather," as Henry James remarked, "and who in Venice is not a waterman?"[2]

Sargent first tried his innovative composition of the Rialto in watercolor, capturing the dark sweep of the underside of the bridge with broad washes of color (fig. 1). He then made two versions in oil, retaining the broad curve of the bottom of the bridge and the graceful gondolier in the background, and adding a variety of other laden vessels.[3] All three pictures were made from the wide embankment on the southwest side of the bridge, the Fondamenta del Vin (see cat. 127). The area was Venice's market district, a busy center for both pedestrian and marine traffic, as

Fig. 1. John Singer Sargent, *Venice, Under the Rialto Bridge*, before 1910. Watercolor on paper. Museum of Fine Arts, Boston, The Hayden Collection.

workers unloaded fresh produce shipped in from the nearby islands of Torcello and Malamocco, housewives bargained for purchases, and Shakespeare-loving tourists came to "realize the locality of Shylock and Antonio."[4]

Sargent referred to all aspects of the scene in his painting *The Rialto*.[5] In the foreground, two women converse while a boy reclines in the bow of a shallow skiff. The boy's sensuous pose, the dark shawls of the women, and the cargo of loose cabbages identify them as local Venetians, who were as fascinating to visitors as were their architectural surroundings. Writer Julia Cartwright had remarked in 1884:

> They are among the most picturesque craft in Venice, these market boats, piled up with grapes and pomegranates and vegetables . . . a curly-headed child lies asleep in the stern, his head resting on a big cabbage . . . [and] a brown-faced maiden . . . sat enthroned like a goddess among the fruitbaskets. . . . if you want to study them at leisure, you must go to the Rialto at evening.[6]

Behind these modern Venetians, in a fleet gondola poled by an athletic figure in white, three elegantly dressed ladies turn their heads to watch. They are American or English tourists, enjoying the singular pleasure of sight-seeing from their private gondola, an experience eloquently de-

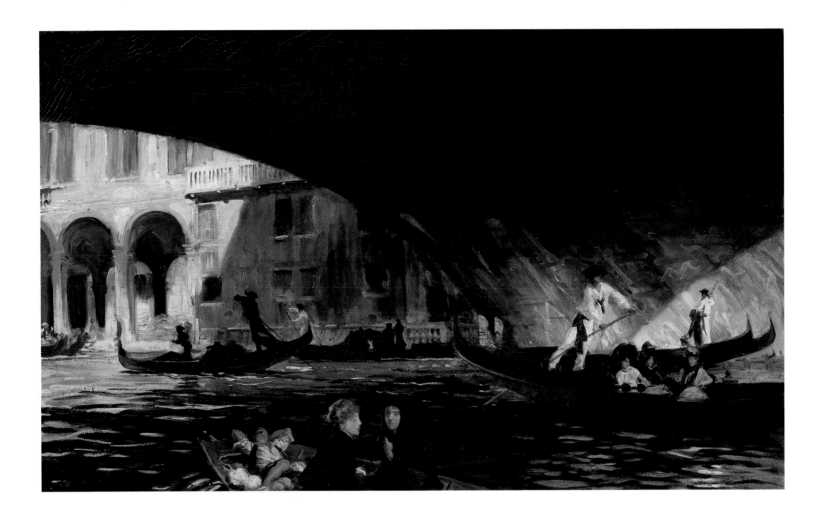

scribed by American painter Francis Hopkinson Smith in his book, *Gondola Days* (see cat. 169). Surrounding them all is the history of Venice, made tangible in the arch of the sixteenth-century bridge and in the glimpse beyond it of the Fondaco dei Tedeschi, an office and storehouse once decorated with frescoes by Giorgione and Carpaccio, where foreign merchants had transacted their business.

In *The Rialto*, Sargent combined views of the privileged lifestyle he had recorded in *An Interior in Venice* with the sensuous images of working class life he had created in the 1880s (see cats. 113, 114, 116). Yet his

own delight likely was not the convenient mix of social classes, but the extraordinary juxtaposition of light and shadow, of movement and permanence, in this remarkable image.

E. HIRSHLER

1. John Ruskin, *The Stones of Venice*, edited by Jan Morris (Mount Kisco, N.Y.: Moyer Bell Limited, 1989), p. 54.

2. Henry James, *Italian Hours* (New York: Horizon Press, 1968), p. 64.

3. The other oil, *The Rialto* (about 1909, private collection), differs from the present composition in the number of gondolas passing under the bridge and in the absence of women in the foreground boat (only the reclining boy appears, eating a peach).

4. *Murray's Handbook for Travellers in Northern Italy* (London: John Murray, 1863), p. 370.

5. See Margaretta Lovell's engaging analysis in *Venice: The American View, 1860-1920* (San Francisco: The Fine Arts Museums of San Francisco, 1984), pp. 120-121.

6. Julia Cartwright, "The Artist in Venice," *The Portfolio* 15 (1884), p. 39.

Robert Frederick Blum

Born Cincinnati, Ohio, 1857;
died New York, New York, 1903

Robert Frederick Blum

119. *Venetian Lace Makers,* 1885-86
Oil on canvas, 16⅛ x 12¼ in.
Stamped u.c.: Blum
Collection of Mr. and Mrs. Raymond J. Horowitz

Born and raised in Cincinnati, Blum first met his early mentor Frank Duveneck in the winter of 1874-75 at the Ohio Mechanics' Institute, where Duveneck was teacher of a life drawing class also attended by John Henry Twachtman. After nine months of study at the Pennsylvania Academy of the Fine Arts in 1876-77, Blum moved to New York City, and in 1879 began work as an illustrator for Scribner's Monthly and St. Nicholas magazines. It was as an artist for Scribner's that Blum made his first trip to Europe in the spring of 1880. Traveling with his editor, A.W. Drake, he toured London, Paris, Genoa, Pisa, and Rome. By the end of May the two had reached Venice — the first foreign city to capture Blum's imagination. There he met and worked closely with James McNeill Whistler, who had joined Duveneck and his "boys" at the Casa Jankowitz on the Campo S. Biagio, off the Riva degli Schiavoni (see cats. 107-111). Blum departed Venice in early August but was soon planning his return.

The opportunity for a second visit arose the following year. Blum spent the summer and early fall of 1881 working at the Casa Jankowitz, and a series of drawings done during this stay were published in an article about Venice written by Henry James for Century magazine. His third voyage to Europe came in the summer of 1882, when he traveled with a large party of American artists to Belgium, France, and Spain.

He did not return to Italy until June of 1885, after a protracted stay in Holland with William Merritt Chase and Charles Ulrich, waiting out a reported cholera epidemic in eastern Europe. For the next year and a half Blum worked in Venice, sharing a large studio at the Palazzo Contarini de Scrigni with Ulrich, Duveneck, Twachtman, and Otto Bacher, among others. Because the Contarini was for sale when he returned the next July, Blum rented the nearby Palazzo Dario instead, and he and Ulrich spent the summer and fall of 1887 working in the San Trovaso section of the city once again.

Very few details are known of Blum's final sojourn in Venice, which lasted from the late spring to November of 1889. The following year he realized his dream of working in Japan, and after returning to New York in 1892 he accepted commissions for several mural projects, one of which was in progress when he died suddenly at the age of forty-five.

Fig. 1. Robert Blum, *Venetian Lace Makers,* 1887. Oil on canvas. Cincinnati Art Museum, Gift of Mrs. Elizabeth S. Potter.

During his 1885-86 stay in Venice, Blum painted his best-known work, *Venetian Lace Makers,* now in the Cincinnati Art Museum (fig. 1). With its large format and complex multi-figural composition, it was the young artist's first attempt at a salon-sized painting, and was a great success when shown at the Third Prize Fund Exhibition of the American Art Association in 1887. One critic described this ambitious canvas as "much the best work he has ever exhibited," and in 1889 it was awarded a bronze medal at the Exposition Universelle in Paris.[1] The painting's seemingly effortless effects of brilliant color and light, and the almost universally positive critical reception it enjoyed, belie the fact that this work alternately obsessed and discouraged Blum, monopolizing nearly two years of his career.

In the summer of 1885, Blum and his friend, the Munich-trained painter Charles Ulrich, took apartments at the Palazzo Contarini near the Iron Bridge on the Grand Canal. Soon after their arrival they set out for the small island of Burano, northeast of Venice. Blum described their three-week stay in a letter to his family, noting that the island was "unspoiled by the plague of foreigners."[2] At the time Burano was not much more than a small fishing village, but it soon became a center for

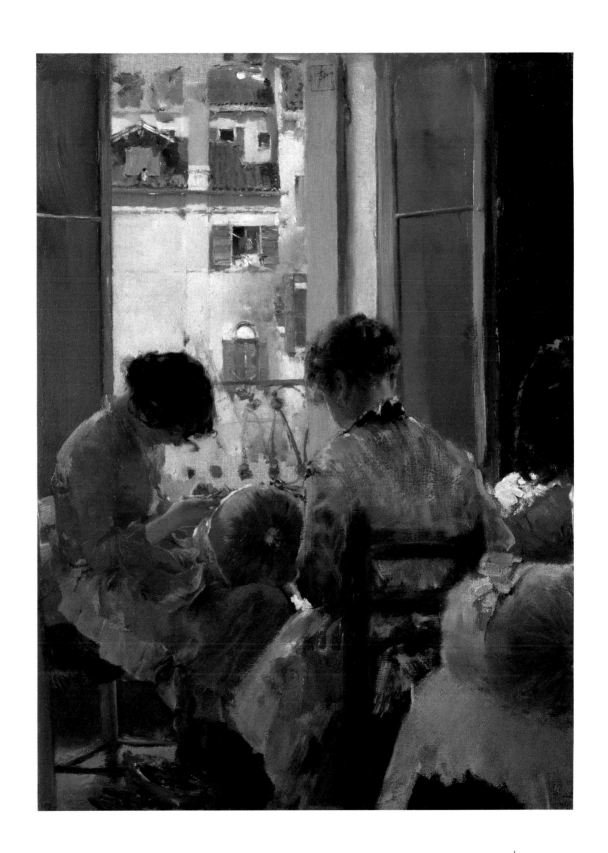

the revival of lace making in Venice. By the mid-nineteenth century the craft had almost completely died out, and it was not until the early 1870s that a few schools were founded to re-introduce the lace-making techniques to local women. By 1897 there were about 3400 lace makers in all of Venice and, according to Baedeker's guide book, by 1906 there were more than 400 women employed by the largest workshop in Burano alone.[3]

That Blum and Ulrich went to Burano's Scuolo dei Merletti (School of Lace) so soon after their arrival in Venice suggests that they had decided to paint lace maker subjects before leaving Holland to come to Italy. The theme of women at work had been a favorite of Blum's since the early 1880s, when he first began rendering laundresses, seamstresses, and women knitting in window-lit interiors.[4] The choice of subject also reflects the artist's contact with the paintings of seventeenth-century Dutch masters Vermeer and DeHooch, as well as his association with contemporary artists of the Hague School, known for their picturesque studies of local women at their chores. This, however, was not an isolated phenomenon, and the Italian, Spanish, English, and Austrian painters who made up the so-called neo-Venetian School were experimenting with similar motifs; one of them, Martin Rico, a follower of Fortuny, had a profound influence on Blum's brilliant palette and bravura technique.[5]

The three surviving studies for *Venetian Lace Makers* indicate that Blum experimented with several different figural groupings before settling on a final composition. No finished canvases are known to have resulted from his visit to Burano, but it seems likely that an oil sketch in the Canajoharie Public Library, New York, reflects an early stage in Blum's thinking.[6] Very cursory in its finish, this small panel

may have been judged unsatisfactory and set aside; six months later, Blum had apparently begun another version of the painting, and wrote to Otto Bacher: "I'm at work on a 'lace makers' picture but am hardly progressing with it."[7]

In the summer of 1886, Bacher and Ulrich had rejoined Blum at the Palazzo Contarini, where they were all sharing the expense of a studio and models in order that they each might do a painting of lace makers.[8] Even as late as October, Blum was bemoaning his ongoing troubles with the project, claiming:

[I am] busy with a painting which gave me a lot of work . . . so that I have been working on it already for three months, and at the end I had to start all over again. Now things are going pretty well and I hope that it will be finished in a month because I want to leave here if it is at all possible in early November It all depends on this picture. As soon as it is finished I will leave Venice.[9]

The delicate oil sketch in the Horowitz collection probably belongs to this summer's work, because a letter from Bacher to a friend, dated September 20, describes the canvas that Bacher was then occupied with as very similar to Blum's group of three lace makers — seated in front of a window with a balcony and "small view" beyond.[10] Rendered in Blum's characteristically fine, thinly layered technique, the young women in this painting are shown hunched over their *tomboli* (sewing cushions) with their faces in shadow. Visible through the window behind them is the sunny stucco wall of a neighboring building.

The last of the oil sketches (private collection) is a study for the figures of two of the women in the background of the final version of the painting. In the finished work they are joined by another standing woman, who is set off against the bright

wall behind her.[11] The seated women in the foreground chat among themselves as they work; Blum has detailed their ruffled dresses, coral beads, and animated faces brightened by the sunshine entering the room through the slats of the Venetian blinds. Unlike Sargent's images of solemn women stringing beads and cutting glass in cavernous, dark *palazzi* and empty courtyards (see cat. 114), Blum's lace makers are young, elegantly dressed, and uniformly pretty, and their workroom seems bustling and cheerful. Although it was well known that the hours for such jobs were often long, the work taxing, and the pay obscenely low, that reality is not recorded here. As Royal Cortissoz said of Blum: "No painter of Venice has surpassed [him] in the fragility of his impressions, in their delicacy of fibre, in their ravishing precision . . . His Venice is a dreamy pageant."[12]

K. HAAS

Robert Frederick Blum

120. *Venetian Bead Stringers*, 1887-88
Oil on canvas, 30¼ x 40¾ in.
Signed l.l.: Blum 87/8
Private Collection

1. Annette Blaugrund, *Paris 1889: American Artists at the Universal Exposition* (Philadelphia: Pennsylvania Academy of Fine Arts, 1990), p. 117.

2. Blum to his family, June 22, 1885, quoted in Bruce Weber, "Robert Frederick Blum and his Milieu," Ph.D. diss., City University of New York, 1985, p. 279.

3. For a short discussion of the lace-making revival in nineteenth-century Venice, see Margaretta Lovell, *Venice: The American View, 1860-1920* (San Francisco: Fine Arts Museums of San Francisco, 1984), p. 27; and Lovell, *A Visitable Past: Views of Venice by American Artists, 1860-1915* (Chicago: University of Chicago Press, 1989), pp. 77-79. This effort was a deliberate attempt to diversify the island's fishing economy; handmade lace, which had been a specialty of the region since the fifteenth century, was seen as a product that would appeal to the growing numbers of tourists coming to Venice.

4. These include, for example, pastels *In the Laundry* (location unknown) and *The Chat* (Cincinnati Art Museum), a watercolor *Dutch Girl by a Window* (location unknown), and an oil entitled *Knitting* (Cincinnati Art Museum), all from 1884.

5. This loosely defined international group included artists Ludwig Passini, Ettore Tito, Luigi Nono, Giuseppe Favretto, Franz Ruben, Cecil Van Haanen, Henry Woods, and Luke Fildes. Blum's early admiration for the work of Spanish painter Mariano Fortuny is well documented; see, for example, Weber's chapter entitled "Blumtuny," in "Robert Frederick Blum and his Milieu," pp. 65-96. In 1885 Rico was living next door to Blum at the Contarini and, according to Blum, "doing some charming things"; Archives of American Art, Chapellier Papers, quoted in Lovell, *Venice: The American View*, p. 23.

6. This painting was, until recently, incorrectly titled *Parisian Flowermakers*; see Weber, "Robert Frederick Blum and his Milieu" pp. 279, 284 and 325, note 6. He argues that this panel, and the etching, *Busy Hands*, which relates to it, in fact portray students sewing flowers to lace.

7. Blum to Bacher, January 1886, quoted in Julian Halsby, *Venice: The Artist's Vision* (London: B.T. Batsford Ltd., 1990), p. 104.

8. Blaugrund, *Paris 1889*, p. 117. Unfortunately, no paintings of this subject by either Ulrich or Bacher are known.

9. Blum to his parents, October 7, 1886, quoted in Weber, "Robert Frederick Blum and his Milieu," p. 283.

10. Bacher to an unidentified friend, September 20 1886, quoted in ibid., p. 285.

11. Work on *Venetian Lace Makers* was frustrating and slow; Blum wrote home on November 10 1886: "I haven't had much luck with the picture. I don't make any progress with it, and I'm inconsolable about it," ibid., pp. 283-284. He carried the canvas home incomplete, hired models and finished it in his Greenwich Village studio just in time for exhibition at the American Art Association in April.

12. Royal Cortissoz, *Personalities in Art* (New York: Scribner's and Sons, 1925), p. 411.

In the summer of 1887 Blum returned to Italy to do an outdoor painting of Venetian bead stringers, a pendant to his large *Venetian Lace Makers* (cat. 119, fig. 1), which he had completed only a few months before. He began the canvas while sharing a studio at the Palazzo Dario with Charles Ulrich, who was well known for his paintings of working-class people and may have inspired his friend's choice of subject. Blum would certainly also have been familiar with the prints, pastels and oils of bead stringers by his contemporaries, Whistler and Sargent (see cat. 114). According to Bruce Weber, Blum had already done both an etching and a watercolor of bead stringers in 1886 but, like his lace making pictures, they were set in interiors rather than out-of-doors.[1] Picturesque images of Venetian women doing local crafts were popular with American audiences during this period, and Blum hoped this second painting of young women at work would be as highly acclaimed as his earlier picture had been.

Bead stringing, like lace making, was a craft that enjoyed a significant revival in Venice during the second half of the nineteenth century. The unskilled labor of stringing beads paid poorly (according to Otto Bacher, often as little as eighteen cents a day),[2] but the brightly colored necklaces made by female workers were among the most popular souvenirs purchased by foreign tourists. Americans James Jackson Jarves and Herman Melville both describe visiting the workshops on the island of Murano to witness the manufacture of the glass rods from which the beads were cut, then polished, and finally strung. William Dean Howells wrote that, "beads are exported to all quarters in vast quantities and the process of making them is one of the things that strangers feel they must see when visiting Venice."[3] Not sur-

Fig. 1. Carlo Naya (Italian, 1816-1882), *Bead-Workers*, undated. Gelatin photograph Naya Archives, Osvaldo Böhm, Venice.

prisingly, this activity, which was so characteristic of the city, was also frequently recorded by local photographers, as, for example, in Carlo Naya's *Bead Stringers* (fig. 1).[4] Blum's pretty young women are portrayed stringing and tying their necklaces; active and lively, they seem unaffected by the tedium of their task. The models' clothing is simpler and less elegant than the costumes in Blum's earlier *Lace Makers* picture, and here the artist has taken the additional step of including several anecdotal details in his composition — the crumpled newspaper with its clearly legible title, *La Venezia*; the delicate cage of songbirds in the shuttered window above the women's heads; and the small still-life on the foreground chair composed of a green shawl, large water jug and glass.

In October 1887, Blum wrote to his parents complaining about the inclement weather and his lack of progress with the canvas:

> For little over a week now I have been working in the studio of my friend Ulrich because it became impossible to continue working out of doors and I had to try my best to continue with the picture under somewhat difficult conditions. With a little bit of luck I hope I'll

Robert Frederick Blum

120. *Venetian Bead Stringers,* 1887-88

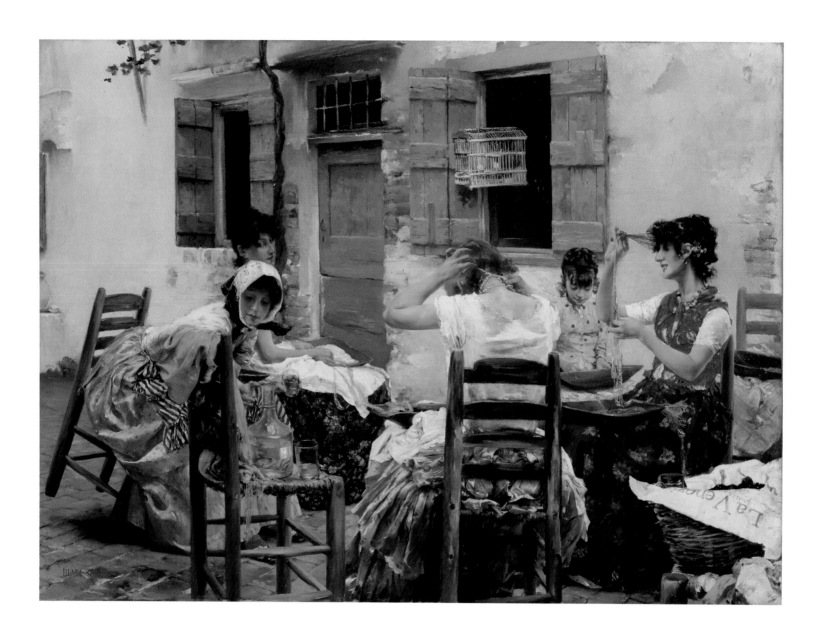

121. *Flower Girl*, about 1887
Oil on canvas, 24 x 19 in.
Mr. and Mrs. Arthur G. Altschul

be far enough along in the next two weeks to be able to pack up but I can't say anything definite yet. One thing is sure, I'll stay here till I finish my figures.[5]

Then, in the middle of November, he wrote once again, this time claiming that the *Venetian Bead Stringers* was "a far better picture than the one I painted last year and for that reason alone I'm anxious to finish it as far as possible."[6] For all his determination to be done before leaving Venice in December, Blum was unable to complete the painting until after returning to his studio in New York. In fact, a last letter from Italy to his friend William Merritt Chase includes several of Blum's quick sketches for the figure of the dark-haired woman at the far right of the canvas.[7] The slight differences between the details of the sketch and the features of the woman in the final painting suggest that her face and costume were ultimately based on those of a New York model, rather than a Venetian one. Blum exhibited *Venetian Bead Stringers* at the National Academy in the spring of 1888 and, as a result, was elected an associate academician. This work and the *Venetian Lace Makers* were both purchased by the prominent collector, Alfred Corning Clark, who became one of the artist's most important patrons, ultimately owning more than thirty of his works.

K. HAAS

1. Bruce Weber, "Robert Frederick Blum and his Milieu," Ph.D. diss., City University of New York, 1985, p. 329, note 49.

2 William W. Andrews, *Otto H. Bacher* (Madison, Wisc.: Education Industries, Inc., 1973), n.p., quoted in Weber, 299-300.

3. William Dean Howells, *Venetian Life* (Boston: Houghton Mifflin and Company, 1892), vol. 1, p. 230.

4. There is no proof that Blum actually knew this photograph by Naya, but it is clear that he sometimes used photographs of his own making as *aides memoires* in his work. For information on the influence of photography in Blum's painting, I am indebted to Bruce Weber for referring me to Julia Meech and Gabriel P. Weisberg, *Japonisme Comes to America: The Japanese Impact on the Graphic Arts, 1876-1925* (New Brunswick, N.J.: Jane Voorhees Zimmerli Art Museum, Rutgers University, 1990), pp. 62-71. For Carlo Naya and his popular photographic establishment located in the Piazza San Marco, see Italo Zannier, *Venice, The Naya Collection* (Venice: Böhm, 1981).

5. Weber, "Robert Frederick Blum and his Milieu," p. 298.

6. Ibid.

7. Blum to William Merritt Chase, November 24, 1887, Cooper-Hewitt Museum, New York; he writes: "I said I would write you another letter before I left but I haven't anything of importance to communicate and so to fill up with Venetian news fell to telling you them pictorially – I'm off next Monday or Tuesday . . . If you have time and it don't bore you too much come down to see me off the ship – will you – Good bye old fellow till then Bob."

The most ambitious of Duveneck's Italian works are the large-scale figure paintings that he produced between 1884 and 1887. This interest originated in Venice in 1882, when he began planning multi-figured compositions that would be suitable as exhibition pieces. Two of these, *Water Carriers, Venice* (fig. 1) and *Washerwomen, Venice* (1886, location unknown) featured young Venetian women hauling water from wells and washing clothes, themes from daily life that also attracted Whistler and Sargent.

Figure painting continued to be on Duveneck's mind as he left Venice for Paris in 1885. There he enrolled in an academy (it is unclear which one) to make studies from the nude. By May 1886 he was back in Florence at Villa Castellani, availing himself of the local models that his wife hired and often sketched with him. At this time Duveneck began a sequence of canvases that emulated the idealized peasants of the Paris Salons, particularly those of Bastien-Lepage.[1] Two of these, *Italian Girl with a Rake* (1886, formerly Vose Galleries of Boston) and *Siesta* (about 1886-87, Queen City Club, Cincinnati), featured a young, dark-haired girl posed in the fields behind Villa Castellani. She wears a peasant's costume of Duveneck's own devising: a Venetian scarf, skirt, and mules similar to those worn in *Water Carriers, Venice*, and a wide-brimmed straw hat.

A third canvas, the unfinished *Florentine Flower Girl, Seated* (about 1886, Cincinnati Museum of Art) shows the same model sitting on a ledge outdoors, a flower pot sketched in beside her. That pose became the basis for *Venetian Flower Girl*, in which the girl is indoors, perched on a table, and holding a fan in one hand while offering the viewer a blossom in the other. It is one of Duveneck's last paintings of an Italian subject, and one that is most purely a sym-

Frank Duveneck

121. *Flower Girl*, about 1887

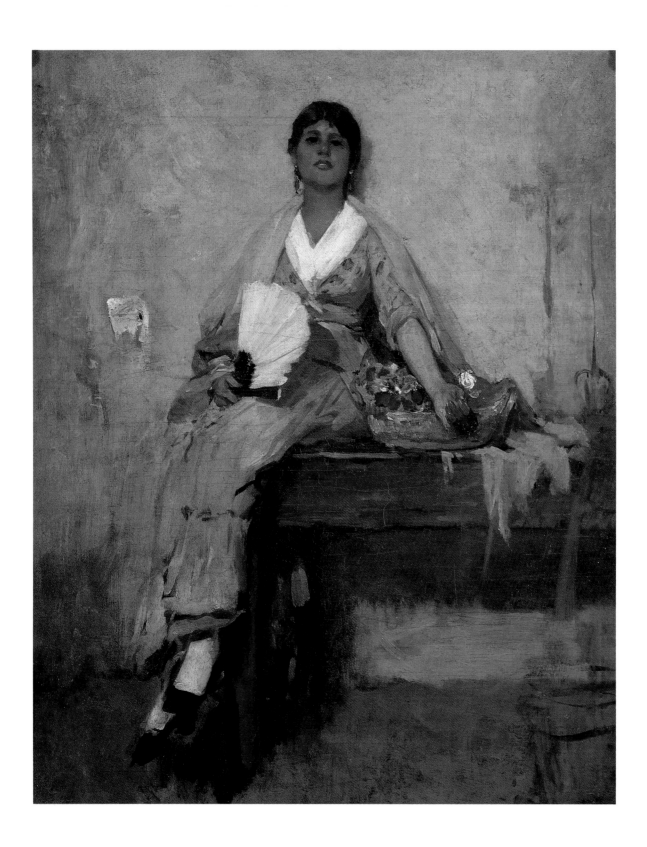

John Henry Twachtman

Born Cincinnati, Ohio, 1853;
died Gloucester, Massachusetts, 1902

Fig. 1. Frank Duveneck, *Water Carriers, Venice*, 1884. Oil on canvas. Courtesy National Museum of American Art, Smithsonian Institution, Bequest of Rev. F. Ward Denys.

bol. The young woman becomes both an emblem and memory image of Italy, a blend of nature and artifice like the potted flowers around her.

Duveneck made two versions of this composition, the present canvas and a larger, more finished painting.[2] The present work corresponds to the smaller, partial renderings of his compositions that often preceded Duveneck's finished canvases. The final composition shows additional potted plants on and beneath the table, but lacks the bold, spontaneous brushwork so evident here. Both works may have been painted in Florence during the cold months of early 1887 or in Paris late that year, before the Duvenecks gave up hiring local models because they were so much more expensive than in Florence.[3]

The model in *Venetian Flower Girl* is arranged among still-life elements in a manner characteristic of Parisian paintings of oriental themes. Here the motif is Italian; the young woman wears a typically Venetian costume: the flowered blouse and striped skirt that previously appeared in *Washerwomen, Venice* and the long shawl, fan, and high-heeled mules that together create the Venetian women's distinctively slim silhouette. Here, the young woman has become part of the still life: her shawl be-

comes the tablecloth on which the basket of flowers is placed. The palette is light, high-keyed, and although her features are tightly and carefully rendered, the brushwork elsewhere is exuberantly broad, some the boldest Duveneck ever attempted.

D. STRAZDES

1. Jan Newstrom Thompson, *Duveneck: Lost Paintings Found* (Santa Clara, Calif.: Triton Museum of Art, 1987), p. 21.

2. 32 x 25 inches, private collection, Cincinnati, no. 69 in Robert Neuhaus, *Unsuspected Genius: The Art and Life of Frank Duveneck* (San Francisco: Bedford Press, 1987).

3. Josephine W. Duveneck, *Frank Duveneck, Painter-Teacher* (San Francisco: John Howell, 1970), p. 120.

Although Twachtman is most often remembered for his distinctive late landscapes done in Greenwich and Cos Cob, Connecticut, in the first decade of his career Italy was a favorite subject, and he went there on at least four separate occasions. In late 1877, Twachtman traveled to Venice for the first time, accompanying Frank Duveneck and William Merritt Chase, with whom he had been working at the Royal Academy in Munich. Their sojourn in Venice lasted through the summer of 1878, when Twachtman was called home by the death of his father in Cincinnati.

In the fall of 1880 Twachtman returned to Italy, joining Duveneck to teach a group of Munich-trained artists in Florence. Duveneck's school was disbanded the following spring and Twachtman returned to Cincinnati. A few months later he married Martha Scudder, and the couple embarked on a lengthy European honeymoon, during which the artist worked in England, Holland, and Belgium, with a brief stop-over in Venice late in 1881.

After two years of studying at the Académie Julian in Paris and traveling and painting in Holland and Normandy, Twachtman sent his family home ahead of him and passed the autumn of 1885 in Venice, this time in the company of another Cincinnati-born painter, Robert Frederick Blum. They lived in the Palazzo Contarini de Scrigni in the San Trovaso quarter of the city, a working-class neighborhood admired by Sargent for its narrow canals and picturesque subjects.

Twachtman left Italy in January of 1886 and never returned. He died suddenly in 1902, just five years after founding, along with Childe Hassam and J. Alden Weir, the group known as the Ten American Painters.

John Henry Twachtman

122. *The Lagoon, Venice,* 1885 (?)

Pastel on paper, 13½ x 15¾ in.
Signed l.l.: J.H. Twachtman —
Isabella Stewart Gardner Museum, Boston

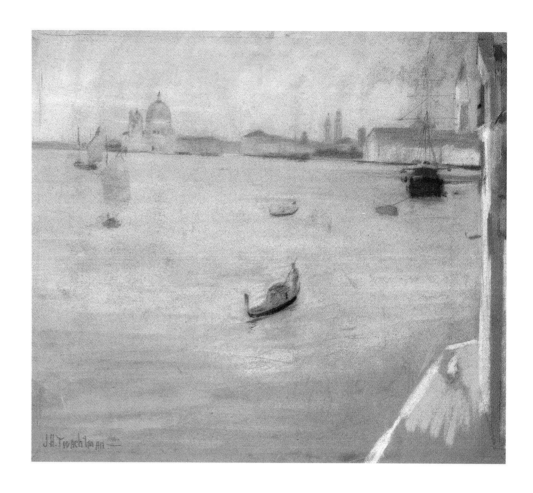

In September 1880, John Twachtman wrote to J. Alden Weir that Frank Duveneck had offered him "certain inducements to join him at Florence" to teach at his small private art school there.[1] Twachtman left for Italy in early October. His exact itinerary is unknown; he may have traveled directly to Florence to join the "Duveneck boys," or he may have gone to Venice on his way. If he stopped in Venice, he would have crossed paths with James A. McNeill Whistler and had an opportunity to see firsthand the many pastels that the older artist had done during his fourteen months in the city.[2] Whistler's experimentation with the medium "lifted pastel from the commonplace,"[3] and Twachtman's *Lagoon, Venice* clearly echoes his innovative style.

Striking similarities between Twachtman's drawing and several of Whistler's pastels done in 1879-80, such as *Stormy Sunset* (Fogg Art Museum, Harvard University, Cambridge, Mass.) and *Venetian Scene* (cat. 109), make it tempting to conjecture that the two were working side by side that fall. The debt to Whistler is unmistakable, but certain aspects of this picture indicate a more likely date of 1885, during Twachtman's final trip to Venice. No other pastels are known that can definitely be dated to his three earlier visits to the city. Furthermore, the delicate tonalism of *The Lagoon* is very different from the dark and somber Munich-style canvases that Twachtman continued to paint in the early 1880s. It seems much more plausible that the overall lightening of his palette came somewhat later, as a result of his Parisian training, and his contact, not only with the work of his fellow Americans in Venice, but with Bastien-Lepage and artists of the Hague School, particularly Anton Mauve, whom he met in 1881 and again in 1885.

Although only a few of Twachtman's Venetian pastels survive, all of them show

a debt to Whistler's technique of drawing on toned paper and using a black chalk outline to suggest form. Color was only added as the last step, rarely blended, and sketched in sparingly. This affinity to Whistler was noted by the critics in 1888, when Twachtman showed several works at the exhibition of the Society of American Painters in Pastel. One writer claimed that "of [his] pastels, *Grey Venice*, hardly yields to the best of Whistler and is better than many of the latter's."[4] That the influence of the older artist's style was still so strongly felt is not surprising when we learn from his biographer (who was then in Venice), that "[she] heard far more of

the few little inches of Whistler's etchings and of Whistler's pastels, than of the great expanse of Tintoretto's Paradise" from the circle of American artists who continued to gather there.[5]

Twachtman's perspective in *The Lagoon, Venice* originates from a point not far from the Casa Jankowitz along the Riva degli Schiavoni, a popular promenade stretching from the Molo to the Public Garden at the city's eastern tip. The view is of Santa Maria della Salute across the lagoon, the outline of its distinctive domes softened by fog. At the far right the Campanile in the Piazza San Marco is just barely visible. The artist appears to have been working

from an upper-story window, looking sharply down upon the solitary figure of a gondolier in his boat, the only sign of life in this otherwise silent, mist-shrouded scene. Twachtman employs a nearly square format, flattening and abstracting the image, tilting the glassy surface of the water to establish a high horizon line, and denying the horizontality characteristic of so many Venetian *veduti*.[6] He radically cropped the edge of a neighboring building along the right-hand side of the sheet, further enhancing the sense of the image as a flat, decorative surface. The monumental architecture that dots the lagoon appears insubstantial and dreamlike, and although the picture encompasses a broad sweep of water, Twachtman still manages to maintain the sense of intimacy and hushed quiet typical of his late paintings and pastels.

K. HAAS

1. Twachtman, quoted in Richard J. Boyle, *John Twachtman* (New York: Watson-Guptill Publications, 1979), p. 17.

2. Several writers on Twachtman repeat the story that he and Whistler met in Venice that fall; see, for example, Boyle, *John Twachtman*, p. 16; and Diane Pilgrim, "The Revival of Pastels in Nineteenth-Century America: The Society of Painters in Pastel," *American Art Journal* 10 (November 1978), p. 46. Lisa Peters, author of the upcoming Twachtman *catalogue raisonné*, cautions against jumping to that conclusion, noting that there is no record of such an encounter, and that if they had met, it could only have been for a brief moment at the end of October, since Whistler left the city in November of 1880; see, *Ten American Painters* (New York: Spanierman Gallery, 1990), p. 133, note 18.

3. Otto Bacher, *With Whistler in Venice* (New York: The Century Co., 1909), p. 77.

4. *The New York Times*, May 5, 1888, quoted in Boyle, *John Twachtman*, p. 16.

5. Elizabeth Robbins Pennell, *Nights: Rome and Venice in the Aesthetic Eighties, London and Paris in the Fighting Nineties* (Philadelphia, 1916), quoted in Richard J. Boyle, "John H. Twachtman's Mastery of the Method," from *In the Sunlight: The Floral and Figurative Art of J.H. Twachtman* (New York: Spanierman Gallery, 1989), pp. 51-52.

6. For a discussion of the interest in the square among American artists during this period, see William H. Gerdts, "The Square Format and Proto-Modernism in American Painting," *Arts* 50 (June 1976), pp. 70-75.

Thomas Moran

Born Bolton, Lancashire, England, 1837;
died Santa Barbara, California, 1926

Moran came to the United States as a boy of seven, settling with his parents first in Maryland, then in Philadelphia. Along with his brother Edward, who also became a landscape painter, Moran studied art with their Philadelphia neighbor James Hamilton (see cat. 51). Moran began as a watercolorist, and he continued to work in that medium throughout his career. His delicate landscapes, suffused with color, were indebted to an English tradition fostered in Philadelphia and cultivated in London, where Moran traveled to study the work of J.M.W. Turner in 1861. In 1866-67, Moran came back to Europe and made his first trip to Italy, studying the old masters in Rome, Naples, Florence, Bologna, and Milan. Upon his return, he exhibited paintings of the Roman Campagna and Lake Como. After establishing his reputation as a painter of the American West, which he observed during his participation in several government survey expeditions, Moran went to Italy again in 1886, visiting Venice for the first time. He spent about six weeks there, and declared that Venice was "an inexhaustible mine of treasures for the artist." He returned to Venice a second time in the summer of 1890, and from the sketches made during these two trips, Moran made more paintings of Venice than he did of any other subject, including the Rocky Mountain scenes for which he is best known.

Thomas Moran

123. *The Fisherman's Wedding Party*, 1892
Oil on canvas, 24 x 33 in.
Signed l.r.: TMoran. (T and M in monogram)/
1892
The Detroit Institute of Arts, Bequest of Alfred J. Fisher

Thomas Moran first visited Venice in 1886, remarking that the city "is all, and more, than travellers have reported of it. It is wonderful."[1] Fascinated with its exotic scenery and pearly light, Moran painted Venice throughout the rest of his career, drawing upon the sketches he made in 1886 and 1890. His romantic vision of Venice became one of his most popular subjects.

Like most of Moran's Venetian pictures, *The Fisherman's Wedding Party* reflects the artist's enthusiasm for the work of J. M. W. Turner. Moran had studied Turner's paintings at the National Gallery in London in 1861, copying several of them, and adopting the British master's predilection for jewel-like colors, majestic compositions, and a romantic mood. As early as 1868, Moran's paintings were described as "Turneresques."[2] Both painters favored views of the Bacino San Marco, looking west toward the entrance to the Grand Canal; they often took liberties with architectural details, concentrating upon atmospheric effect rather than topographical accuracy.[3]

Moran focused his attention in *Fisherman's Wedding Party* upon the picturesque fishing boats characteristic of Venice, letting the architectural monuments of the Salute, Campanile, Doge's Palace, and the domes of St. Mark's function as an ethereal and fantastic backdrop. The boats were one of the city's marvels; they were described as "a wonderful confusion of many-colored, many-shaded nets . . . many artists are painting or trying to paint them from under the trees of the gardens, or from gondolas."[4] James Jackson Jarves felt that the fishermen were among the few Venetians to retain the brilliant, sumptuous aspect of the old Republic:

> Then the canals must have glistened with opalescent tints, and the general effect been exceedingly rich, especially as the national costumes, and even the

Fig. 1. Gondola, before 1850, once in the collection of Thomas Moran. Courtesy of The Mariners' Museum, Newport News, Virginia.

architecture, all showed the same fondness for deep and rich coloring . . . some fishermen retain, with their manly forms and finely-bronzed complexions, their red caps and colored sails, with quaint devices.[5]

Moran invested his characters with oriental grandeur, using rich colors and thick paint to describe their exotic costumes and the luxuriant display of fabrics and banners that decorate the boats. The fisherman pause in their festivities, presenting a glamorous tableau, while toward the center of the picture a few figures, holding baskets and nets, wade in the shallow water, performing everyday chores in a fantastic, shimmering wonderland.

The colorful light that captivated Moran was one of the city's most pleasing attributes. William Dean Howells described the lagoon in his book, *Venetian Life* (see cat. 167):

The water forever trembles and changes, with every change of light, from one rainbow glory to another, as with the restless hues of an opal; and even when

the splendid tides recede and go down with the sea, they leave a heritage of beauty to the empurpled mud of the shallows, all strewn with green, dishevelled seaweed.[6]

Moran used a light palette of blue, green, and pink to render the shifting surfaces of sky and water, painting thinly over a rosy ground in some areas while building up a thick impasto in others. The pastel fantasy that he created in *Fisherman's Wedding Party* and his other Venetian scenes was immensely popular in America. In 1898, one of Moran's Venetian sunsets was reproduced by the calendar company, Brown and Bigelow; twenty-two million copies were printed.

Moran found Venice so inspiring that he resolved to bring a bit of it home with him to the United States. In 1890, he purchased an ornate gondola and had it shipped to his home in East Hampton, Long Island (fig. 1). There, poled by George Fowler, a Mohawk Indian employed by the Morans, the gondola became a pleasure craft for the family and

guests, a unique memento of Moran's interest in the traditions of both Europe and America.[7]

E. HIRSHLER

1. Thomas Moran to Mary Nimmo Moran, May 3, 1886, in *Home-Thoughts from Afar*, ed. Amy O. Bassford (East Hampton, N. Y.: East Hampton Free Library, 1967), p. 77.

2. *The Art Journal* 1 (May 1, 1868), p. 89. Like Moran, Turner had spent only a few weeks in Venice over a period of twenty-one years. He hired a gondola and worked from the water, filling his sketchbooks and making watercolor studies, which he later used to create large oil paintings. The city became one of Turner's favorite motifs in the 1830s and '40s. As interest in Venice grew in the late nineteenth century, Turner enjoyed a popular revival, stimulated by the exhibition of his work at Marlborough House and at the National Gallery. Many artists were inspired by Turner, including Albert Goodwin, Hercules Brabazon, Felix Ziem, and Moran. For Turner in Venice, see H. George, "Turner in Venice," *Art Quarterly* 53 (1971), pp. 81-87; Julian Halsby, *Venice: The Artist's Vision* (London: B. T. Batsford Ltd., 1990), pp. 13-19; and Lindsay Stainton, *Turner's Venice* (New York: George Braziller, 1985).

3. For Turner, this approach served to distinguish his Venetian scenes from those painted by Canaletto in the eighteenth century; Canaletto's topographical images were tremendously popular in England. Moran's manipulation of pictorial space was inspired by Turner. Many of Moran's Venetian paintings share the same vantage point as *The Fisherman's Wedding Party*; these include *View of Venice* (1895, Wellesley College Art Museum, Wellesley, Mass.), *The Splendor of Venice* (1899, Thyssen-Bornemisza Collection, Lugano), and *Sunset, Venice* (1902, The Newark [N.J.] Museum), among others.

4. Elizabeth Robins Pennell, "Venetian Boats," *Harper's New Monthly Magazine* 80 (March 1890), p. 554.

5. James Jackson Jarves, *Italian Sights and Papal Principles Seen through American Spectacles* (New York: Harper and Brothers, 1856), pp. 378, 367-368. This concentration upon Venetian fishing boats may also be attributed to an interest in Turner, who rendered them frequently.

6. William Dean Howells, *Venetian Life* (Boston: Houghton, Mifflin, and Company, 1892), vol. 1, p. 219.

7. Moran appreciated Fowler's skill in handling the canoe-like gondola, which he attributed to Fowler's Native American heritage. The story that this gondola once belonged to Browning is probably apocryphal, but it was repeated consistently by Moran's biographers. In 1950, the gondola was consigned to the Mariner's Museum in Newport News, Virginia. See *Home-Thoughts from Afar*, pp. 144-145, and Thurman Wilkins, *Thomas Moran, Artist of the Mountains* (Norman, Okla.: University of Oklahoma Press, 1966), pp. 191-193.

Thomas Moran

123. *The Fisherman's Wedding Party*, 1892

John Leslie Breck

Born at sea in the Pacific Ocean, 1860;
died Boston, Massachusetts, 1899

John Leslie Breck

124. *Santa Maria della Salute*, 1897
Oil on canvas, 32⅛ x 24 in.
Private Collection

The son of a clipper ship captain, John Leslie Breck was raised in San Francisco and Boston and first studied art in Leipzig, Munich, and Antwerp from 1878 to 1882. He returned to Europe in 1886, where he continued his training at the Académie Julian in Paris. In the summer of 1887, Breck joined several of his American friends at Giverny, Monet's home, where, under the direct influence of the French master, Breck developed a mature Impressionist style. He remained in Giverny throughout 1888 and 1889, returning there the following two summers. Breck then spent almost a year in England, finally coming home to Boston in the fall of 1892. He made only one other trip to Europe, visiting Venice for at least several weeks in 1896-97. Very little is known of Breck's stay in Venice, and his sudden death in 1899, just nine years after his first solo exhibition, precluded any reminiscences or collaborative biographies. However, the city clearly inspired him, for his 1899 memorial exhibition included a dozen Venetian scenes, and he is known to have produced several more. Their titles reveal that Breck was drawn to some of Venice's most popular sights: the Riva degli Schiavoni, San Giorgio Maggiore, the Giudecca Canal, Santa Maria della Salute, picturesque Venetian fishing baskets, and Torcello, a nearby island admired as an unspoiled refuge from the crowds of Venice.

John Leslie Breck's *Santa Maria della Salute* shows the seventeenth-century architect Baldassare Longhena's finest building, situated at the entrance to the Grand Canal.[1] Dedicated to the Virgin Mary, the elaborate baroque church was an offering of gratitude for the end of a devastating plague in 1630; its central plan was said to recall the shape of a crown, emblem of Mary as Queen of Heaven. The Salute was consecrated in 1687, and quickly became one of the city's most distinctive landmarks,[2] as well as a popular subject for painters (see cats. 117, 128). Breck's view was taken from the northeast, across the Grand Canal, a vantage point repeated by many artists, possibly because of its convenience – some of the city's most famous hotels faced the Salute from this angle.[3] Should a room at one of these establishments prove too expensive, the same vista was available from the ferry station at the end of the Calle di Traghetto, near the Palazzo Contarini-Fasan.[4]

Breck's choice of a nocturnal view of the Salute is more innovative than either his subject matter or his vantage point. He had often worked by moonlight since 1888, when he rendered the streets and grainstacks of Giverny "en pleine lune," and his interest in light effects parallels Monet's own. In Venice, moonlit tours were recommended in guidebooks, and the beauty of the city at night was described by many writers. The British critic John Addington Symonds wrote a lengthy tribute to the "melodrama of Venetian moonlight" in 1898, while Americans from Ralph Waldo Emerson to Henry James had been enchanted by nighttime views.[5] Yet other than Maurice Prendergast, who would make a number of watercolors of festivals at night in 1899, Breck was one of the few American artists to paint Venice by moonlight. He made several tiny watercolor nocturnes of Venetian subjects, including a

small sketch of Santa Maria della Salute (private collection) which appears to be a study for this large oil.

In Breck's image, the spectral form of the great white church dominates the composition. A few lanterns attached to gondolas moored along the church steps cast quivering reflections on the Grand Canal, but the primary source of light, the moon, is absent, creating the impression that the Salute glows from within. Despite the dusky illumination, Breck carefully rendered the exuberant architectural ornament of Santa Maria della Salute, first drawing a complete and detailed pencil sketch of the building on his primed canvas, then painting over it.[6] His efforts were admired by American critics, who called his *Santa Maria della Salute* "a ghostly and majestic form, set in a sea of azure . . . [a] happy inspiration . . . [and] the beginning of a new chapter."[7]

E. HIRSHLER

1. The length of Breck's Venetian visit is unknown. The biographical outline in his memorial exhibition catalogue (St. Botolph Club, Boston, 1899) states that he painted in Venice for a few weeks in 1896; however the paintings of Venetian subjects are dated 1897. I would like to thank Jeffrey Brown and Kathryn Corbin for their assistance; Corbin's article remains the major source on Breck's work (Kathryn Corbin, "John Leslie Breck: American Impressionist," *Antiques* 134 [November 1988], pp. 1142-49).

2. For more information on Longhena and the Salute, see John Varriano, *Italian Baroque and Rococo Architecture* (New York: Oxford University Press, 1986), pp. 201-206.

3. These included the Hotel Europa, once the Palazzo Giustiniani; the Grand Hotel, formerly the Palazzo Ferro; and the Hotel Britannia, in the Palazzo Tiepolo-Zucchelli. Margaretta Lovell discusses this point in her book *A Visitable Past: Views of Venice by American Artists, 1860-1915* (Chicago: University of Chicago Press, 1989), p. 30.

4. Breck's composition is repeated almost exactly by Walter Launt Palmer, in his *Salute at Noon* (about 1890-1900, The Metropolitan Museum of Art, New York) and by Walter Sickert, in *Santa Maria della Salute, Venice* (about 1901, Royal Academy, London).

Henry Ossawa Tanner

Born Pittsburgh, Pennsylvania, 1859;
died Paris, France, 1937

5. John Addington Symonds, "A Venetian Medley," 1898, quoted in *Venice: An Illustrated Anthology*, compiled by Michael Marqusee (Topsfield, Mass.: Salem House Publishers, 1989), p. 35.

6. Corbin, "John Leslie Breck: American Impressionist," p. 1147.

7. The writer had found his earlier landscapes overly indebted to Monet, a "hazardous model to follow." The reviewer continued: "Had Mr. Breck lived longer, he would have diverged from the influence named more and more widely. The Venetian pictures . . . testify to the transition that was taking place," ("The Memorial Exhibition of Paintings by Mr. Breck," *Boston Transcript*, May 3, 1899, p. 16).

Born in Pittsburgh, Tanner moved with his family to Philadelphia in 1868. Having determined as a youth to become a painter, he began his studies at the Pennsylvania Academy of the Fine Arts in December, 1879, under Thomas Eakins, remaining as Tanner recalled for "four or five years." A newspaper account of April 1880 (in the Christian Recorder*), reported that Tanner "will be sent to Rome by some interested gentlemen to study the works of the old masters," but his hope did not become a reality until many years later. He lived in Philadelphia, largely painting landscapes, until he moved to Atlanta in 1889 to open a photography gallery and "art room." In 1891, a sale of some works to Bishop Joseph C. Hartzell of Cincinnati, together with money from a commission, enabled him to go to Europe. Intending to study in Rome, he instead settled in Paris, where he studied with Jean-Joseph Benjamin-Constant and Jean-Paul Laurens at the Académie Julian. He turned increasingly to painting dramatically lit biblical scenes, many of which won him critical acclaim both in Europe and America; his* Resurrection of Lazarus, *for example, was shown at the Paris Salon of 1897, won a medal, and was purchased by the French Government for the Musée du Luxembourg. In the same year, the patronage of Rodman Wanamaker enabled him to travel to Egypt and Palestine; then on his return to Paris he finally reached Italy.*

According to his travel notes, Tanner sailed from Alexandria, stopping at Messina, and arriving in Naples about the second week of April 1897; he then went "second class on the express to Rome," where he obtained a room not far from the American Academy. Most of his time in Rome was apparently spent in its baroque churches, which he found "magnificent." He next went to Pisa, where he visited the Leaning Tower, the Baptistry, and the Cathedral. He was in Florence by April 24 where he admired the tombs of Michelangelo and Dante, the Church of Santa Croce, and Sodoma's Last Supper *at the*

Church of San Bartolomeo. After passing through Bologna, he was in Venice at least from May 3 to May 7, after which he returned to Paris.

Tanner had a second trip to the Near East, from October 1898 to March 1899, and may well have visited Italy again at this time, but no details are known. In later years he again traveled to the Near East spending the winter of 1908 in Algeria and the winter of 1912 based in Tangier.

Henry Ossawa Tanner

125. *Venetian Bridge*, about 1897
Oil on canvas on panel, 8¼ x 10¼ in.
Signed l.r.: H. O. Tanner
Michael Rosenfeld Gallery, New York

Only two paintings made in Italy by Tanner are known to survive: a vertical *Venice* (fig. 1), and the more horizontal *Venetian Bridge*. Both of these small works have the look of the *plein-air* oil sketch; both are quickly yet surely executed. These are luminous color studies that make use of a range of warm ocher, cream, and sky blue tones, all frequently used in Tanner's palette. Both of these studies represent fragments of Venice, anonymous small canals in out-of-the-way locations (perhaps the island of Burano, which is noted for its brightly painted houses and miniature canals); both demonstrate with their broad, fluid brushstrokes Tanner's confidence with the medium.

Much of Tanner's approach to painting

126. *Umbrellas in the Rain, Venice,* 1899
Watercolor and pencil on paper, 14 x 20⅞ in.
Signed l.l.: Prendergast/ Maurice B. Prendergast
Venice/ 1899/ Prendergast
Museum of Fine Arts, Boston, Charles Henry Hayden Fund

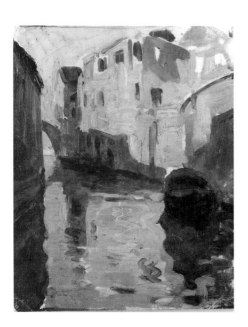

Fig. 1. Henry O. Tanner, *Venice,* about 1897. Oil on artist's board. Richard A. Long.

gious pictures for which he won his reputation. In these mature years, he seems never to have found the occasion to use his studies of Venice for a larger work.

S. RICCI

1. From Eakins and again at the Académie Julian, Tanner would also have learned the importance of drawing, particularly the making of strong, realistic charcoal studies of male and female life models in the studio; Tanner himself became a superb academic draftsman, as Dewey Mosby has demonstrated in the excellent recent study by Dewey F. Mosby and Darrel Sewell, *Henry Ossawa Tanner* (Philadelphia: Philadelphia Museum of Art, 1991). For Tanner's travel notes and itinerary in Italy see Henry O. Tanner papers, Archives of American Art, Smithsonian Institution, Washington, D.C.

2. See H. Barbara Weinberg, *The Lure of Paris* (New York: Abbeville Press, 1991), pp. 222-23, 227. See also ibid., Mosby and Sewell, *Henry Ossawa Tanner,* p. 132-134. Only a handful of Tanner's oil sketches survive. See for example Tanner's *Moroccan Man,* (about 1908, Museum of Fine Arts, Boston); quickly painted in thick, broadly brushed strokes, this sketch may have been a study for a biblical scene.

3. See Mosby and Sewell, *Henry Ossawa Tanner,* p. 85, no. 15 (Estate of Sadie J. M. Alexander).

is traceable to his years of training at the Pennsylvania Academy, where he studied with Thomas Eakins, who himself typically made small preparatory oil sketches on panel or board for both landscapes and figurative works.[1] This approach would have been reinforced at the Académie Julian where Tanner studied from 1891 to 1896, and where the preparation of compositional sketches was emphasized.[2]

Tanner may well have made his oil studies of Venetian canals with the prospect of painting a larger view of Venice in mind. He had begun his career in the seventies as a landscape and marine painter, and some of his most successful paintings of the eighties, such as *Sand Dunes at Sunset, Atlantic City* were original, tonalist landscapes.[3] Even after moving to France in 1891, the mood and color of landscape painting continued to attract him; however by the time he visited Italy, he had turned increasingly to the ambitious figurative, reli-

Charles Hovey Pepper, a Boston watercolorist who knew Prendergast, wrote of his friend that he "soaked up Venice. Then saturated, he worked."[1] The description seems particularly apt for Prendergast's delight in painting Venice not only in sunlight, but also in rain (see cats. 128, 129), when "all its colors take on a fine, deep richness, seen through water, like polished stones in sea-pools."[2] In *Umbrellas in the Rain,* Prendergast captured a moment just after a summer storm has passed, leaving wet, reflective pavements full of pedestrians hurrying across one of the city's most populous thoroughfares.[3]

Looking northwest from one of Venice's busy boat landings, Prendergast depicts three architectural monuments in *Umbrellas in the Rain:* the Doge's Palace, the prison, and the Ponte della Paglia, which straddles the narrow Rio di Palazzo separating the two buildings. The white marble bridge, part of the major thoroughfare between the Molo and the Riva degli Schiavoni, is shown completely. One of the oldest bridges in Venice, the Ponte della Paglia had been rebuilt and enlarged in 1847, atop the foundations of the original fourteenth-century structure.[4] From it, visitors to Venice could enjoy a clear view of the famous Bridge of Sighs, a baroque span linking the state offices in the Doge's Palace to the prison that Byron had romantically described in *Childe Harold.* Prendergast depicted only a corner of the prison in *Umbrellas in the Rain;* its dark gray stones and rounded arches anchor the right edge of his composition.[5] To the west of it, Prendergast has filled the background of his watercolor with the lacy arcade of the fourteenth-century Doge's Palace, once the seat of the Venetian Republic, described by Ruskin as the consummation of Venetian Gothic architecture.[6]

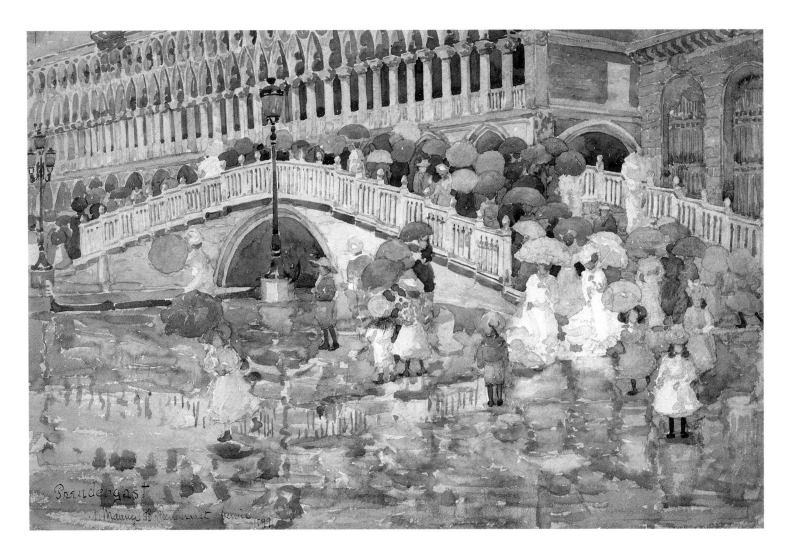

Fig. 1. Maurice Prendergast, *Sunlight on the Piazzetta, Venice*, 1898-99. Watercolor over graphite on paper. Museum of Fine Arts, Boston, Gift of Mr. and Mrs. William T. Aldrich.

Prendergast often used Venice's celebrated architecture as a backdrop to the panoply of daily life that was his main subject. His cropped view of the Doge's Palace is repeated in two other watercolors of this period, *Sunlight on the Piazzetta* (fig. 1) and *Festival Day, Venice* (1898-9, Mount Holyoke College Art Museum, South Hadley, Mass.). In all of these images, Prendergast shows only the most insubstantial portion of the building, the ground-level arcade and the elaborate gallery above it, ornamented with pointed arches and spandrels pierced in a delicate

quatrefoil pattern. He eliminates from these pictures the solid pink brick of the upper levels of the palace, emphasizing decorative pattern instead of architectural solidity, and forcing the well-known structure to play a subservient role to the pedestrians who crowd the scene before it.

In *Umbrellas in the Rain*, Prendergast gave the largest portion of his composition to the colorful reflections in the wet pavement. He used thin, loose watercolor washes to capture the shimmering echoes of the strolling figures with their bright parasols, the balustrade of the bridge, and

Maurice Brazil Prendergast

127. *The Grand Canal, Venice,* 1898-99
Watercolor and pencil on paper, 18⅛ x 14¼ in.
Signed l.c.: Prendergast
Daniel J. Terra Collection

the tall lamppost that bisects it. This almost abstract swirl of wet color was apparently laid in last, for an unfinished version on the reverse of this watercolor, and a related sketch in The Metropolitan Museum show a carefully defined background, a partially completed bridge, and only a hint of the pedestrians placed in a blank foreground.

It has been suggested that *Umbrellas in the Rain* directly reflects Prendergast's admiration for the work of the early Renaissance Venetian master Vittore Carpaccio, whose *Return of the Ambassadors*, in the Accadèmia Galleries, includes an oblique view of a balustraded bridge crowded with people.[7] Van Wyck Brooks noted in his biography of Prendergast that the artist "was always talking about Carpaccio . . . his figures on the steps of canals and his spots of color. Once he sent this line to his brother: 'The work of the grand Venetians makes me ashamed to call myself an artist.'"[8] Despite his doubt, Prendergast's Venetian scenes evoke as colorful a pageant of the city's life in the nineteenth century as Carpaccio's had in the fifteenth.

E. HIRSHLER

1. Charles Hovey Pepper, "Is Drawing to Disappear in Artistic Individuality? A Sketch of the Work of Maurice Prendergast," *World To-Day* 19 (July 1910), p. 719.

2. Arthur Symons, *Cities of Italy*, 1907, quoted in Margaretta Lovell, *Venice: The American View, 1860-1920* (San Francisco: The Fine Arts Museums of San Francisco, 1984), p. 83.

3. The white dresses on many of the women and girls and the straw hats worn by several figures would indicate the summer season. Several figures stand in the open without umbrellas, while a lady at the left closes her red parasol to board an open gondola, leading to the conclusion that the storm has passed.

4. First built in 1360, the bridge took its name from the boats laden with straw that once anchored at its base. Near its large arch is a sixteenth-century tabernacle decorated with a relief of the Madonna of the Gondoliers; the shrine is dedicated to the Fraglia del Traghetto (the Brotherhood of Ferrymen). See Giulio Lorenzetti, *Venice and its Lagoon* (Rome: Istituto Poligrafico dello Stato, 1961), pp. 289-290. Prendergast also painted the Ponte della Paglia from its western steps, looking east towards the Riva, in a related watercolor of 1898-1899 (Collection of Mr. and Mrs. Arthur G. Altschul). That watercolor served as a model for Prendergast in his only oil painting of Venice, the *Ponte della Paglia* of about 1907-1910 (completed about 1914-1915, The Phillips Collection, Washington, D.C.).

5. The prison (the Carceri or Prigioni) was built in the sixteenth century by Antonio da Ponte, the architect of the Rialto Bridge. By the late nineteenth century, despite the descriptions of such famous inmates as Casanova, some of the mystique surrounding the prison and the Bridge of Sighs had been debunked. Baedeker's guidebook noted that "too much sentiment need not be wasted on the Bridge of Sighs, as the present structure – that 'pathetic swindle' as Mr. Howells calls is – has scarcely ever felt the foot of a prisoner," (*Baedeker's Handbook for Travellers: Northern Italy* [Leipzig, Karl Baedeker, 1889], p. 250).

6. John Ruskin, *The Stones of Venice*, edited and introduced by Jan Morris (Mount Kisco, N.Y.: Moyer Bell Limited, 1989), p. 170.

7. See Gwendolyn Owens, *Watercolors by Maurice Prendergast in New England Collections* (Williamstown, Mass.: Sterling and Francine Clark Art Institute, 1978), p. 48. Carpaccio may not have specifically portrayed the Ponte della Paglia, which took its present form in the nineteenth century.

8. Van Wyck Brooks, "Anecdotes of Maurice Prendergast," in *The Prendergasts* (Andover, Mass.: Addison Gallery of American Art, 1938), p. 38.

Prendergast was fascinated not only by the masterpieces of art and architecture he saw in Italy, but also by the circumstances of daily life, which he translated into colorful watercolor tableaus. In *The Grand Canal*, Prendergast typically depicted a busy area, the Fondamenta del Vin, a seven-block long embankment bordering Venice's main waterway. The Fondamenta was usually bustling with shoppers on their way to the city's main market at the Rialto; even in Prendergast's late afternoon image, lit by a setting sun, the street is still crowded with pedestrians and expectant gondoliers. In an essay on the city's artistic aspects, Julia Cartwright wrote:

> It would be impossible to conceive any street in the world more stately or more full of exquisite and varied loveliness than this of the Grand Canal . . . Its beautiful sweep and fascinating surroundings always attract artists who, like Mr. Ruskin himself, can overcome the difficulties of any subject by the force of his love.[1]

Prendergast most loved crowds of pedestrians, and in his image of the Grand Canal, he selected one of the few locations along its serpentine length where there was an extended adjacent sidewalk. He was not the only observer of the colorful parade, for several figures sit on a balcony at the upper right of the picture, looking back toward the Rialto Bridge and the artist himself.

Prendergast recorded the scene from above, looking south from the western end of the Rialto Bridge, a vantage point he repeated in two other watercolors, one an image of the opposite side of the Grand Canal, and one directed towards the market itself.[2] His elevated position allowed an extended view along the pavement and watery street, providing an excuse for the tipped-up composition with a high hori-

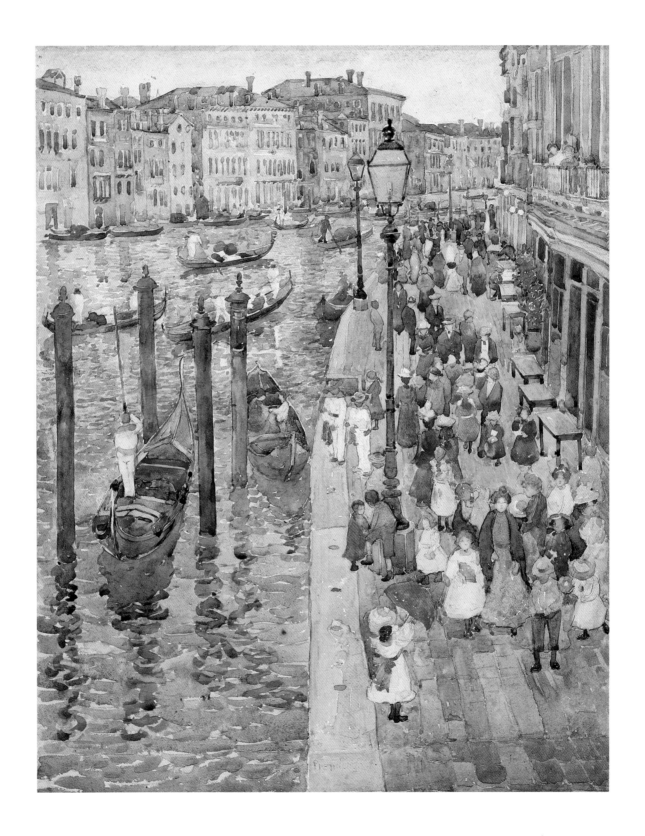

zon line that Prendergast most favored.

Despite its air of spontaneity, *The Grand Canal, Venice*, is carefully arranged. Prendergast divided the composition vertically between land and water, further bisecting it with a steady line of lamp-posts, intrusions of the modern world which he felt no need to disguise, but rather used as land-locked counter-parts to the mooring posts or *pali* in the canal.[3] The shadowy lower half of the picture is dominated by rich blues and purple, while in the upper part, the opulent palaces along the Grand Canal (including the palazzi Dandolo, Loredan, Farsetti, and Grimani) are struck by the last yellow rays of sunlight. The care Prendergast gave to the final proportions of his work is made evident by the artist's addition of a small strip along the bottom of his composition to lengthen it slightly, which he carefully painted to match the existing design. Probably at the same time, Prendergast eliminated a figure of a woman at lower center, just behind the girl with a red parasol.

Some of Prendergast's Venetian watercolors were exhibited in Chicago in 1900, along with paintings by his friend and fellow Bostonian Hermann Dudley Murphy. One critic noted that the pictures of Venice dissolved into "tangible ideas full of life, color, and spirit . . . he likes a crowd [and] we were attracted by the jolly good time the Venetians were having."[4] In *The Grand Canal, Venice*, Prendergast captured the vital spirit of a city not only wedded to its past, but also committed to the contemporary world.

E. HIRSHLER

1. Julia Cartwright, "The Artist in Venice II," *The Portfolio* 15 (1884), p. 41.

2. *Venice* (1898, Collection of Rita and Daniel Fraad), although it is inscribed Fondamenta del Vin [?], is a view from the Rialto Bridge of the Riva del Ferro, an embankment directly across the Grand Canal from the Fondamenta del Vin. In the background of *Venice* are represented several of the same palaces visible in *The Grand Canal, Venice*. The third watercolor Prendergast made from the Rialto Bridge is *Market Place, Venice* (1898-1899, private collection), which shows the lower steps of the bridge and a view into the market area of the Ruga d. Orefici. These watercolors are illustrated in Carol Clark, Nancy Mowll Mathews, and Gwendolyn Owens, *Maurice Prendergast, Charles Prendergast: A Catalogue Raisonné* (Williamstown, Mass.: Williams College Museum of Art, 1990), pp. 384-385.

3. In contrast, English critic John Ruskin had decried the street-lights when he first saw them in 1845: "It began to look a little better as we got up to the Rialto, but, it being just solemn twilight, as we turned under the arch, behold, all up to the Foscari palace — *gas lamps!* on each side, grand new iron posts of last Birmingham fashion . . . Imagine the new style of serenades — by gas light." John Ruskin to John James Ruskin, quoted in Robert Hewison, *Ruskin and Venice* (Louisville, Kentucky: The J. B. Speed Art Museum, 1978), p. 11.

4. "Arts for America," January 9, 1900, p. 28 (photocopy of an otherwise unidentified clipping reviewing the exhibition of Prendergast and Murphy at the Art Institute of Chicago in January 1900). Special thanks to William H. Gerdts for sharing this item with me.

Maurice Brazil Prendergast

128. *Rainy Day, Venice*, 1898-99
Watercolor over pencil on heavy paper,
16⅝ x 12½ in.
Signed l.l.: Maurice Prendergast/ Prendergast
Roland P. Murdock Collection, Wichita Art Museum, Wichita, Kansas

During his extended visits to Venice in 1898-99, Prendergast painted most of the city's most famous landmarks: St. Mark's Cathedral, the Clock Tower, the Doge's Palace, the Rialto Bridge, the Ponte della Paglia, and Santa Maria della Salute (see cats. 126-130). He selected traditional, straightforward views for many of them, but occasionally chose to represent only a fragment of these well-known monuments. *Rainy Day, Venice* is an example of the latter approach, for in this watercolor Prendergast depicted just the patterned pavement and steps of the great seventeenth-century church of the Salute that dominates the entrance to the Grand Canal.

Prendergast selected a vantage point high above the Fondamenta della Salute, looking down at its marble walkway and across the Grand Canal toward the elaborate Gothic palazzi west of St. Mark's, some of which had been renovated into deluxe hotels.[1] The Fondamenta was often a busy place, for it was next to one of the stops for *traghetti*, the small ferries that crossed the Grand Canal; it was also a popular place to board a gondola. Even on such a rainy day as Prendergast depicted, the pavement is crowded with figures and a line of gondolas wait to be boarded next to the stairs leading down to the water. The only concessions to the weather are the black umbrellas held by a few pedestrians and the rounded *felzi* (removable cabins) that adorn the gondolas.

Venice in the rain was intriguing to American visitors. Some, like F. Hopkinson Smith, maintained that in the rain, "all the light, all the color, all the rest and charm and loveliness of Venice, are dead," but he then proceeded to describe his enchantment with the consequent effects of high water, as "the Adriatic has come to wed the city . . . and only the altar steps of San Marco will suffice for the ceremony."[2] Henry James remarked that rainy days

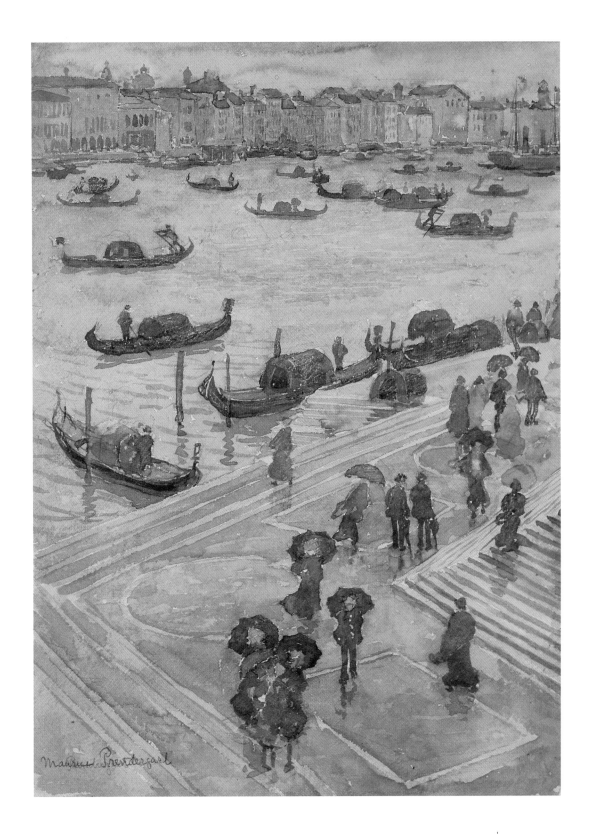

129. *Splash of Sunshine and Rain*, 1899
Watercolor and pencil on paper, 19⅜ x 14¼ in.
Signed l.l.: Prendergast/ Venice 1899
From the Collection of Alice M. Kaplan

were best for "converting your impressions into prose," but he was fascinated with the view nevertheless, writing in *Italian Hours* that "it was all cold color, and the steel-grey floor of the lagoon was stroked the wrong way by the wind."[3] And Herman Melville noted in his 1856-7 diary that he would "rather be in Venice on [a] rainy day, than in . . . [a] capital on [a] fine one."[4] For Prendergast, the inclement weather was an opportunity to experiment with a subdued palette, restricted to blue-gray, dull pink, and black. The effect is almost monochromatic, for Prendergast suffused the sky, water, buildings, and pavement with a dark gray tonality that stands in marked contrast to his usual bright colors.

Prendergast's composition in *Rainy Day, Venice* is equally inventive. He abandoned the rectilinear grid that underlies many of his Venetian watercolors of this period, choosing instead an undulating zig-zag design across the surface of his picture, formed by the patterns of the multi-colored pavement, the steps, the precise placement of the black boats, and the band of buildings on the far side of the canal. That Prendergast arranged the gondolas in a deliberate order is made evident by the pencil underdrawing that is clearly visible under the thin watercolor, indicating slightly different positions for many of them, particularly at the very center of the canal, where Prendergast eliminated one of the dark boats altogether.

The tipped-up composition of *Rainy Day, Venice* is reminiscent of the Japanese wood block prints that were so popular among contemporary artists. Prendergast would have been familiar with eastern pictorial devices not only by direct observation, but also through the efforts of his friend and fellow Bostonian, the influential teacher Arthur Wesley Dow, who sought to apply the principles of Japanese design

and color harmonies to contemporary art. In *Rainy Day, Venice*, Prendergast realized one of Dow's basic themes, that "art should be approached through composition rather than through imitative drawing."[5]

E. HIRSHLER

1. The drawing is inscribed on the verso "Quay and Steps/ of the Saluta." Prendergast may have painted from a building on the opposite side of the narrow Rio della Salute, which borders the church. Margaretta Lovell has suggested that the artist took advantage of a temporary photographer's platform (Lovell, *A Visitable Past: Views of Venice by American Artists, 1860-1915* [Chicago: University of Chicago Press, 1989], p. 89).

2. F. Hopkinson Smith, *Gondola Days* (Boston: Houghton Mifflin and Company, 1897), p. 146, 148.

3. Henry James, "Venice," in *Italian Hours*, 1882, excerpted in Hugh Honour and John Fleming, *The Venetian Hours of Henry James, Whistler, and Sargent* (Boston: Little, Brown, and Company, 1991), pp. 101-102.

4. Herman Melville, *Journal of a Visit to Europe and the Levant, October 11, 1856-May 6, 1857*, quoted in Margaretta Lovell, *Venice: The American View, 1860-1920* (San Francisco: The Fine Arts Museums of San Francisco, 1984), p. 87.

5. Arthur Wesley Dow, *Composition* (Garden City, N. Y.: Doubleday, Page, and Company, 1913), p. 3. *Composition* was first published in 1899; it codified Dow's theories of the 1890s.

"There is but one grand piazza the world over," declared F. Hopkinson Smith in his travel book *Gondola Days*, "and that lies today in front of the Church of San Marco."[1] The large public square in front of the cathedral had been the center of Venetian life since the late twelfth century, when the narrow space in front of St. Mark's was expanded by demolishing a small church, filling in a canal, and surrounding the open area with a series of houses and arcades. It was a place of ceremony, of celebration, and of commerce. It was also the site of Venice's most popular cafés, Florian's and Caffè Quadri, where Maurice Prendergast often sat exchanging ideas with the many painters who gathered there.[2]

In *Splash of Sunshine and Rain*, Prendergast concentrated upon the east end of the great square, bounded by the cathedral. While Ruskin's followers had meticulously recorded every detail of the elegant façade (see cat. 105), Prendergast rendered it much more freely, using short, wet strokes and transparent washes to capture the lacy conglomeration of arches, domes, columns, and pinnacles that make up the west front of St. Mark's. His composition is an updated version of Gentile Bellini's *Procession in the Piazza San Marco* (fig. 1), one of the best-known paintings in the Accadèmia. Both Prendergast and Bellini placed the church high in the background, slightly cropping its tallest elements. Bellini's view is broader, encompassing the buildings lining the sides of the piazza, while Prendergast shows only St. Mark's, but for both painters, the elaborate cathedral stands as a backdrop to the public activity in the piazza before it.

Prendergast shows the square just after a rain shower has passed, leaving the pavement shimmering wet. Rainstorms could be dangerous, raising the level of the canals at high tide and easily flooding the piazza, one of the lowest spots in Venice.

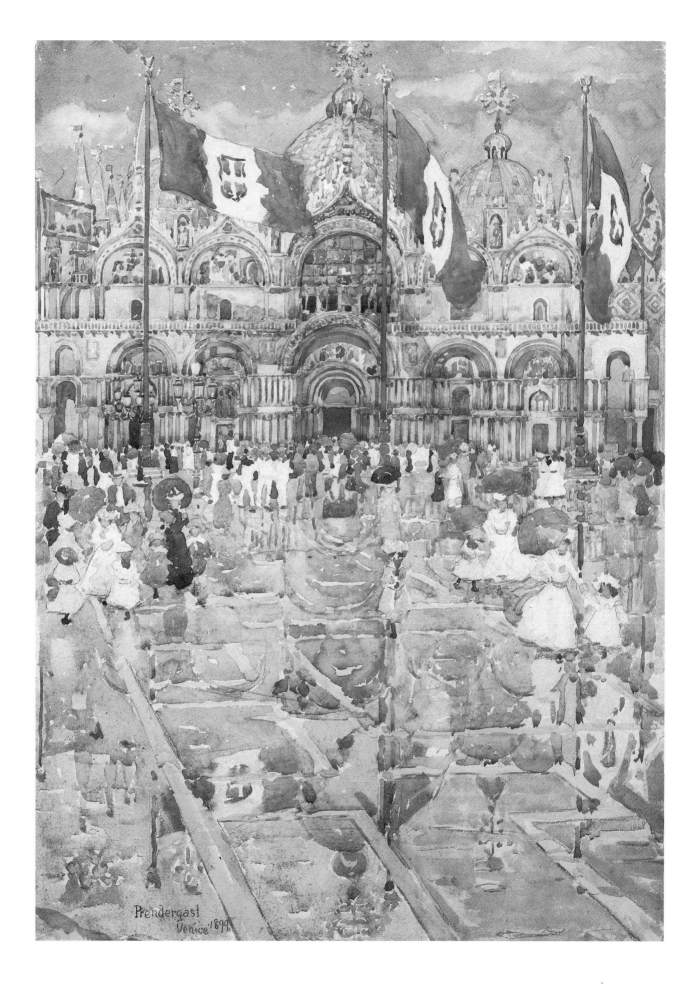

Maurice Brazil Prendergast

130. *Easter Procession at St. Mark's,*
1898-99
Watercolor and pencil on paper, 18 x 14 in.
Signed l.l.: Prendergast
Erving and Joyce Wolf Collection

Fig. 1. Gentile Bellini (Italian, 1429-1507), *Procession in the Piazza San Marco*, about 1496. Mixed technique. Accadèmia, Venice, Photo Courtesy of Art Resources, Inc.

But in *Splash of Sunshine and Rain*, the puddles are an artistic opportunity, allowing Prendergast to capture the temporary reflections of the entire façade of St. Mark's, the flags and flagpoles before it, and the omnipresent groups of pedestrians with their bright parasols. As in *Umbrellas in the Rain* (cat. 126), the majority of the composition is given over to these reflections, which Prendergast rendered with loose, wet washes, emphasizing the watery characteristics of his paint and of the city itself.

The large flags that figure so prominently in the composition were of special interest to Prendergast, who carefully rendered them in all of his views of the Piazza San Marco as well as in several images of the flags alone.[3] The green, white, and red banners were the emblem of the newly united Italy, which the liberated city of Venice had joined in 1866, after a lengthy period of Austrian occupation. The smaller flags to either side, displaying gold winged lions on a red ground, were the standards of the city of Venice, once one of the most important independent republics in Europe.[4] Prendergast delighted in the pageantry of the flags, which enhance the festival air of his colorful parade of strolling pedestrians.

Splash of Sunshine and Rain was included in Prendergast's important solo exhibition at New York's Macbeth Gallery in 1900.

While one critic remarked of the Venice pictures that "here and there the Italian parasols may make the composition dotty," he concluded that in Prendergast's work, one found "a rare treat to art lovers."[5]

E. HIRSHLER

1. F. Hopkinson Smith, *Gondola Days* (Boston: Houghton Mifflin and Company, 1897), p. 42.

2. "In the evening, Prendergast joined the other artists, French, Italian, Russian or whatever, and gathered in the latest news from Paris. They usually met at Florian's. Few of them spoke the language of the others, but they all gestured so much it made no difference," (Van Wyck Brooks, "Anecdotes of Maurice Prendergast," in *The Prendergasts* [Andover, Mass.: Addison Gallery of American Art, 1938], p. 38). For the history of the Piazza, see Giulio Lorenzetti, *Venice and its Lagoon* (Rome: Istituto Poligrafico dello Stato, 1961), pp. 137-150.

3. For a complete list of Prendergast's views of the Piazza San Marco and its flags, see Carol Clark, Nancy Mowll Mathews, and Gwendolyn Owens, *Maurice Prendergast, Charles Prendergast: A Catalogue Raisonné* (Williamstown, Mass.: Williams College Museum of Art, 1990), pp. 372-77.

4. See Margaretta Lovell, *Venice: The American View, 1860-1920* (San Francisco: The Fine Arts Museums of San Francisco, 1984), p. 78. The winged lion was the symbol of Mark the Evangelist, patron saint of Venice.

5. *The Collector and the Art Critic* 11 (March 15, 1900), pp. 163-164. F. Hopkinson Smith, however, used the term "dotty" to describe the actual appearance of Venice in the sunlight: "In the morning the great sweep of dazzling pavement [along the Riva] is a blaze of white light, spotted with moving dots of color. These dots carry gay-colored parasols and fans," (Smith, *Gondola Days*, p. 28).

Maurice Prendergast painted St. Mark's Cathedral many times during his extended visit to Venice in 1898-99, delighting in its rich, decorative façade and in the festive throngs who crowded the piazza before it. However, in contrast to many of his colleagues, Prendergast also depicted the continuation of that activity into the cathedral itself. Prendergast was not the only American to paint the interior of St. Mark's, but he was one of the few to show it as a natural extension of Venetian daily life, instead of as a mysterious or exotic experience (see cat. 115).[1]

Many painters and writers were captivated by the rich interior of St. Mark's. Francis Hopkinson Smith described its glamorous beauty in his book *Gondola Days* (see cat. 169):

> As you sit there in the shadow, the spell of its exquisite color will enchant you — color mellowing into harmonies of old gold and porphyry reds; the dull silver of dingy swinging lamps, with the soft light of candles and the dreamy haze of dying incense; harmonies of rich brown carvings and dark bronzes rubbed bright by a thousand reverent hands.[2]

Prendergast depicted the heart of the cathedral in *Easter Procession*, the crossing of the nave and the transept. At the center of his picture he faithfully rendered the colorful fourteenth-century iconostasis, or screen, topped with marble statues of the Virgin, the apostles, and a silver-gilt crucifix, which divides the nave from the chancel. Prendergast used this screen to organize his composition, dividing it into distinct registers and adding a definite structure to the vast cathedral's "shadowy aisles, and . . . dim recesses."[3] In front of the screen, in the foreground, Prendergast arranged a crowd of men and women in irregular clusters, while at the top of the painting, he created a geometric order to

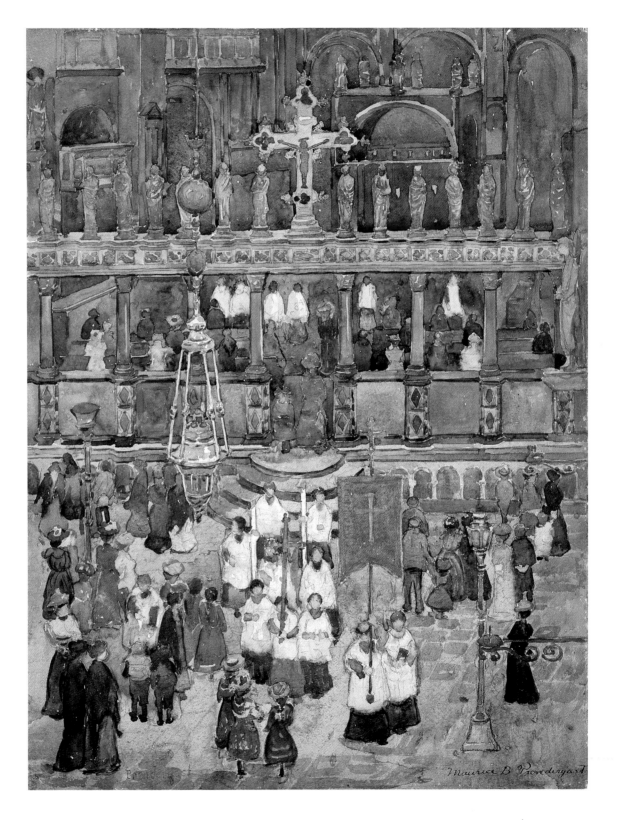

the paired figures who sit in worship, surrounded by columns, niches, and statuary.

Unlike most of his American colleagues, Prendergast apparently was comfortable with the Catholic rituals that were fundamental to Italian daily life. Indeed, Prendergast was baptized a Roman Catholic, his father was a member of Saint Mary's Church in Winchester, Massachusetts, and the artist would have been familiar with Catholic ceremony.[4] In *Easter Procession*, the small group of clerics in the middle of the picture holding candles, a gold cross, and a red banner are not depicted as exotic or strange, but as an integral part of the pattern of every-day life; they are central to the assortment of local men, women, and children who surround them. A related watercolor, *Interior of St. Mark's* (1898-99, Estate of Robert Brady), while unfinished, records even more specific liturgical details, showing three priests at the altar. For Prendergast, daily life presented an artistic panorama.

Easter Procession was likely one of a group of watercolors Prendergast exhibited after his return at the Boston Water Color Club and at his important solo exhibition at Macbeth Gallery in New York. Reviewers in Boston had admired his Italian scenes as a "veritable kaleidoscope of life,"[5] while the Macbeth exhibition helped to establish Prendergast's reputation in New York, considered to be the capital of art in the United States.

E. Hirshler

1. Other Americans to show the interior of St. Mark's include David Neal, whose *Interior of St. Mark's* (1869, The Art Institute of Chicago) is a large, carefully detailed costume piece; George H. Yewell, who rendered the pulpit and a section of the iconostasis, the great church empty save for a lone figure in prayer in the background (*Interior, St. Mark's, Venice*, about 1870, The Metropolitan Museum of Art, New York); Frank Hill Smith, who painted the small north aisle altar ("Il Capitello") *Chapel of the Crucifix, St. Mark's* (1871, Museum of Fine Arts, Boston); Theodore Wores, who set his anecdotal figure study of a nun in the cathedral in his *Interior of St. Mark's Cathedral, Venice* (about 1881-82, private collection); Robert Blum, who depicted a stark, almost empty corner of the nave in a small watercolor (*A Morning in St. Mark's*, cat. no. 115, fig. 1); and John Singer Sargent, who created a similarly mysterious, empty vista of the nave in *The Pavement of St. Mark's* (cat. 115). John Ruskin, of course, had made many watercolors of details of the interior of St. Mark's; some of his English followers, including Thomas M. Rooke, depicted it in a similar fashion.

2. F. Hopkinson Smith, *Gondola Days* (Boston: Houghton Mifflin and Company, 1897), p. 49.

3. Ibid. , p. 50.

4. These issues are pointed out by Ellen Glavin in her thesis "Maurice Prendergast: The Development of an American Post-Impressionist, 1900-1915," Ph.D. diss., Boston University, 1988, pp. 35-36.

5. "Twelfth Annual Exhibition of the Water Color Club," *Boston Evening Transcript*, March 4, 1899, p. 10.

Related Works

Oil Sketches and Sketchbooks

Thomas Cole (1801-1848)
131. *Salvator Rosa Sketching Banditti*, about 1832-40
Oil on panel, 7 x 9½ in.
Museum of Fine Arts, Boston, Gift of Maxim Karolik to the M. and M. Karolik Collection of American Paintings, 1815-1865

Cole greatly admired Salvator Rosa (1615-1673), paying homage in this small oil to the Italian master's own *plein-air* oil sketches. Rosa's romantic landscapes of the Abruzzi region, especially those with *banditti*, had a profound impact on both British and American art during the eighteenth and nineteenth centuries.

Unknown artist
132. *Beatrice Cenci*
Gouache on ivory, 4¾ x 4⅞ in.
From the collection of the Middleton Place Foundation, Charleston, South Carolina

Beatrice Cenci, a painting believed to be a masterpiece by Guido Reni, was a nineteenth-century icon, described by George Stillman Hillard as a "world-renowned portrait." It was frequently copied in oil, crayon, cameo, and engraving; this version was acquired in Italy by John Izard Middleton or a member of his family. Cenci (1577-1599), condemned to death by Pope Clement VIII for patricide, figures prominently in Shelley's tragedy *The Cenci* (1819), and Hawthorne used the portrait of her in *The Marble Faun* (cat. 162).

Sanford R. Gifford (1823-1880)
133. *In St. Peter's, Rome*, 1868
Oil on canvas, 10⅞ x 8 in.
Elma Shoemaker

Gifford made this small sketch on November 1, 1868, of the room below the Vatican's Sala Regia, which was intersected by Bernini's famous staircase. He noted in his journal that he was fascinated to observe "the sunlight and color and gorgeous costumes of the people passing to and fro . . . the whole scene . . . has come down to us precisely as it was hundreds of years ago, with all its pomp and magnificence." See cats. 34-35.

Frederic E. Church (1826-1900)
134. *Rome Rooftops*, 1868-69
Oil on thick buff-colored wove paper, 7⅛ x 10⅛ in.
Cooper-Hewitt, National Museum of Design, Smithsonian Institution, Gift of Louis P. Church

131

132

133

135. *St. Peter's, Rome, Shown from the Pincio*, 1868-69
Oil on thick buff-colored wove paper, 4½ x 9 in.
Cooper-Hewitt, National Museum of Design, Smithsonian Institution, Gift of Louis P. Church

Church traveled with his wife, her mother, their two-year-old son, and fellow painter Jervis McEntee across the Simplon to northern Italy in September 1868. After sketching at Ponte Grande, Monte Rosa, Florence, Perugia, and Terni, Church and his party were greeted by Sanford Gifford in Rome on October 1. In Rome, Church purchased nearly sixty old master paintings for his home, Olana, as well as many photographs of ancient Roman monuments. He worked in his studio on paintings of the Near East, and assisted G.P.A. Healy on several pictures including *The Arch of Titus* (cat. 40). While he painted no major views of Rome, Church made a number of oil sketches from the top floor of his apartment on Via Gregoriana, as Gerald Carr has pointed out; typically he looked west over the roofs of Rome, past the Column of the Immaculata toward the dome of St. Peter's in the distance. In early April 1869, Church visited Pompeii and Sicily; late that month he was in Athens, after a relatively unproductive stay in Italy.

Frances Elizabeth Appleton (1817-1861)
136. Sketchbook from her European travels, 1835-37
Pencil and watercolor on paper, 8¾ x 11¾ in. (closed)
United States Department of the Interior, National Park Service, Longfellow National Historic Site

Frances Elizabeth Appleton, known throughout her life as Fanny, was the daughter of Nathan Appleton, a wealthy Massachusetts banker, politician, and a founder of the city of Lowell. She made this small sketchbook during her first trip abroad, from 1835 until 1837. Her charming pencil drawings, sometimes embellished with watercolor, capture the many sites that the Appletons visited on their extended tour, including the Italian lakes and countryside, as well as Florence, Rome and the Bay of Naples. While in Europe, Fanny met her future husband, the writer Henry Wadsworth Longfellow; after a lengthy courtship they were married in 1843.

John Gadsby Chapman (1808-1889)
137. *Artist on Donkey (Looking for Good Scenery)*, 1850-84
Oil on mahogany palette, 11⅛ x 8½ in.
The Valentine Museum, Richmond, Virginia

In addition to producing oil paintings (see cat. 66) and hand-colored etchings as souvenirs for tourists visiting Italy, Chapman occasionally painted scenes on artists' palettes. This humorous self-portrait shows the artist riding a donkey with his painting materials strapped to his back, his easel and umbrella folded in his lap, and a collapsible stool clutched like a scepter in his left hand. Other palettes depict Chapman busily painting while his donkey rests nearby.

Sanford R. Gifford (1823-1880)
138. Italian sketchbook, 1857
Pencil on paper, 3⅝ x 5⅝ in.
Private Collection

Among the mid-century landscape painters who traveled from America to Italy, Sanford Gifford left some of the most complete records, including letters, journals, sketches, oil studies, finished paintings, and even his passport (see cats. 133, 201). This pocket-sized sketchbook, from Gifford's first Italian trip, includes quick pencil and ink drawings of the lake region near Rome, the Campagna, and Capri, as well as images of architectural fragments, local peasants, oxen, and donkeys. Gifford traveled with Albert Bierstadt, and drew his companion as he sketched at Capri (see Stebbins, p. 50).

Julian Abele (1881-1950)
139. *Basilica Palladiana, Vicenza*, about 1914
Lithographic crayon on paper, 12 x 8½ in.
Private Collection

After attending the Institute for Coloured Youth in Philadelphia, Abele studied at the University of Pennsylvania and the Ecole des Beaux-Arts, eventually becoming chief designer for Horace Trumbauer's prominent Philadelphia architectural firm. During a trip to Italy in 1913-14, Abele visited Vicenza, where he sketched the arched entryway of Palladio's Basilica, the building that had established the Italian architect's reputation. Abele's accomplished sketch was published in the yearbook of the T-Square Club of Philadelphia in 1915.

Hamilton Wilde (or Wild, 1827-1884)
140. *Wall of the Browning's Villa*, about 1859
Oil on artist's board, 16 x 13 in.
Mr. and Mrs. Thomas A. Rosse

Although he exhibited frequently, had many friends, and was highly regarded by his contemporaries, Wilde is virtually unknown today. He was in Rome as early as 1846, and lived in Italy again from 1855 to about 1860, based in Rome and often summering in Venice. Details of his later travels are unknown, although he continued to exhibit Italian scenes until at least 1871. Wilde was with the Storys and the Brownings in Siena in 1859, when he painted young Penini Browning on horseback. This simple, delicate study of sunlight and blooming oleanders on a crumbling brick wall — one of two surviving Italian pictures by the artist — may have been executed during this visit.

139

140

141 (Photograph courtesy Joseph Levy, Saratoga Springs, New York.)

Photographs

William James Stillman (1828-1901)
141. Album with photographs of Italy, about 1870-80
Albumen and gelatin prints, various sizes
Schaffer Library, Union College

Perhaps best known for founding the weekly art journal *The Crayon* in 1855, Stillman was at various times in his career a landscape painter, writer, diplomat, and photographer. His *Autobiography of a Journalist* (1901) hardly mentions his photography, although he produced photographic books on Cambridge, the Adirondacks, and the Athenian Acropolis. Stillman was one of the few American photographers in Italy before 1900. This album includes not only views of Rome and its ancient monuments, but also scenes of Tuscan hilltowns and the well-preserved Greek temples at Segesta, Agrigento, and Selinus in Sicily.

Longworth Powers (1835-1904)
142. *Hiram Powers in his Studio*, before 1873
Albumen photograph, 2½ x 4 in.
Archives of American Art, Smithsonian Institution, Washington, D.C., Hiram Powers and Powers Family Papers, 1827-1953

Portrayed in his work clothes in this carte-de-visite, Powers stands next to one of his most famous idealized busts, *Proserpina* (1843-44). This image has been attributed to Powers's son Longworth, who became a professional photographer known for his portraits and pictures of his father's studio and sculpture.

Bingham
143. *Elizabeth Barrett Browning*, 1861
Albumen photograph, 6½ x 5 in.
Inscribed: "Taken at Rome 1861. This was always in the study of Robert Browning. F.B.B"
Wellesley College Library, Special Collections, Browning Collection

Robert and Elizabeth Barrett Browning spent most of their married life in Italy and their poetry often celebrated the beauty and romance of their adopted country. Included in their circle were many Americans, among them Harriet Hosmer, William Wetmore Story, and Margaret Fuller. The Brownings considered the Casa Guidi in Florence their home, but because of Elizabeth's fragile health they regularly spent the winter months in Rome. This photograph was made there in May 1861, just one month before Elizabeth's death at the age of fifty-five. Antonio D'Alessandri (active 1856-1890s), who made the original photograph from which this carte-de-visite derives, was the official photographer to Pope Pius IX and his court. See cat. 184.

Unknown artist
144. *Harriet Hosmer and her Workmen in Rome*, 1867
Albumen photograph, 7¾ x 9½ in.
Watertown Free Public Library

Throughout her career, Hosmer struggled with the public's perception of her as a woman sculptor working in Rome (see p. 226). Following the exhibition of her monumental figure of the Palmyran queen Zenobia in 1862, a controversy arose over whether Hosmer actually carved her own pieces.

This undated photograph may have been made in response to the unfounded criticism of her rivals; the diminutive sculptor is portrayed as the confident director of the large group of Italian workmen who surround her.

Alvino and Company, Florence
145. *Frank Duveneck and Elizabeth Boott Duveneck,* 1886
Albumen photograph, 6½ x 4¼ in.
Elizabeth Dana

Elizabeth Lyman Boott (see cat. 41) and Frank Duveneck (see cats. 91, 97, 98, 121) were married in Paris on March 25, 1886, after a lengthy engagement. This photograph, in which Elizabeth Boott Duveneck wears her brown wedding dress, was taken in Florence, probably shortly after their return to the Villa Castellani. Lizzie also wore this dress in the formal portrait Duveneck painted of her the following year (Cincinnati Art Museum).

145

Unknown artist (possibly Charles Keck, 1875-1951)
146. *Charles Caryl Coleman and Elihu Vedder in Capri,* about 1901
Silver print, 5⅝ x 3⅜ in.
Keck Family

Lifelong friends, Coleman (see cats. 100, 105) and Vedder (see cats. 71, 94-96) met in Paris in 1856. Coleman settled on Capri at the Villa Narcissus in 1885; Vedder bought land there in 1900 and built a summer villa he named Torre Quattro Venti. This photograph of the two elderly painters garbed in theatrical robes in a Capri garden may have been taken by the sculptor Charles Keck, who studied in Italy from 1901-05 (see cat. 101).

Letters

147. John Singleton Copley (1738-1815) to his wife Susannah Farnum Clarke Copley (1745-1836)
Parma, July 28, 1775
Massachusetts Historical Society

Copley made a copy of a painting by the Italian master Correggio during his stay in Parma. He wrote that it was "now far advanced . . . if I should leave it unfinished it would be a very great loss to me not less than two hundred guineas, perhaps three."

148. Horatio Greenough (1805-1852) to Washington Allston (1779-1843)
Florence, December 8, 1833
Massachusetts Historical Society

In a letter to his friend Allston (see cats. 10-12, 18), Greenough discussed the completion of his two-and-one-half-foot model for the seated, full-length figure of George Washington, as well as William Dunlap's research for a book "relating to arts and artists in America." He also confessed his own homesickness, writing that Allston should "pity me as a sojourner in the land of Strangers. I am a poor land-bird at sea – I am tired – but there is as yet no lighting place."

149. Margaret Fuller (1810-1850) to Giuseppe Mazzini (1805-1872)
Rome, March 3, 1849
Houghton Library, Harvard University

Margaret Fuller (see cat. 22) met the revolutionary Giuseppe Mazzini in London in 1846, where Mazzini, in exile, was working to unify Italy. In February 1849, Rome declared itself a republic and

invited Mazzini to return. Fuller wrote to him the following month: "When I think that only two years ago, you thought of coming to Rome with us in disguise, it seems very glorious, that you are about to enter Republican Rome as a Roman Citizen. It seemed almost the most sublime and poetical fact of history. Yet, even in the first thrill of joy, I felt, 'He will think his work but beginning now.' . . . For your sake I would wish at this moment to be an Italian and a man of action."

Hiram Powers (1805-1873)
150. *Recipe for Cooking Squash Flowers*
Florence, July 1844
Albert Duveen Collection of Artist's Letters and Ephemera, 1808-1910, Archives of American Art, Smithsonian Institution, Washington, D.C.

In this recipe, Powers (see cats. 80-82) describes an Italian dish he apparently greatly enjoyed, noting: "The *male* flowers should be taken *before blooming* . . . remove the pistils or interior part which is not good Throw them into batter made of flour with salt and yilk [sic] of eggs . . . to do them nicely they ought to be dropped *one by one* into hot oil or lard. They should be fried until quite brown – but not too fast, a little experience will enable any body to cook them well." Powers included a note discussing the possibility of substituting pumpkin flowers for the Italian squash, and illustrated the size of the squash bud to be used.

Manuscripts and Books

Thomas Jefferson (1743-1826)
151. Monticello Building Notebook, about 1771
Massachusetts Historical Society

With the idea of acquiring an ideal art collection for Monticello, Jefferson made two lists of desired works of art, one largely of classical sculpture and the other of mostly Baroque paintings. Included among the thirteen sculptures he mentions are the "Venus of Medici, Herculese Farnese, Apollo of Belvidere and Dancing Faunus." The six paintings ranged from Salvator Rosa's *Belisarius* and *Prodigal Son* to Peter Paul Rubens's *Susanna and the Elders.*

John Izard Middleton (1785-1849)
152. *Grecian Remains in Italy, A Description of Cyclopian Walls, and of Roman Antiquities. With Topographical and Picturesque Views of Ancient Latium,* 1812
London: W. Bulmer and Co., 1812
Museum of Fine Arts, Boston, William Morris Hunt Memorial Library

Middleton, the son of Arthur Middleton, signer of the Declaration of Independence, was educated at Cambridge, England, and spent most of his life in Italy and France pursuing his interests in archeology and painting. In 1808-09, traveling near Rome, he studied the "topography of Latium and its antiquities." Working with a *camera obscura*, he drew the ancient ruins and immense "Cyclopean" walls at Cora, Segni, and Alatri, which he recorded in his important folio *Grecian Remains in Italy*. Middleton also made a series of elegant watercolors in a classical style of sites throughout Italy, including Tivoli, Vesuvius, Paestum, and Mt. Etna.

Jacob Crowninshield (1799-1849)

153. Journal kept on board U.S.S. *Washington*, May 1816 to February 1818
Phillips Library, Peabody Museum of Salem

Jacob Crowninshield, a member of an influential Salem, Massachusetts, family and later a naval commander, kept a journal during his service as a midshipman on board U.S.S. *Washington*, a 74-gun man-of-war that was the flagship of the American squadron in the Mediterranean Sea from 1816 to 1818. Crowninshield's journal not only shows evidence of his training to become an officer, but also includes his observations of Italy and other Mediterranean countries. In 1816, he arrived at Naples, and sketched his ship sailing between the islands of Capri and Ischia on its way into the bay. Crowninshield also recounted his visits to nearby Herculaneum and Pompeii, observing that "Mount Vesuvius appeared to be agitated in isueing forth collums of smoke."

Washington Irving (1783-1859)

154. *Tales of a Traveller*, 1824
Philadelphia: Lea and Blanchard, 1840
Inscribed: "To Herman Melville Esq. from his friend Richard Lathers"
By permission of the Houghton Library, Harvard University

Irving toured Italy in 1804-1805, recording his impressions and experiences in journals that served as references for his later works of fiction. Captured by Mediterranean pirates, traveling through mountains infested with robbers, Irving drew upon his own experiences for many of the thirty-two stories in *Tales of a Traveller*, especially for the chapter entitled "The Italian Banditti." This copy of Irving's book was given to Herman Melville, who also wrote of his own Italian travels.

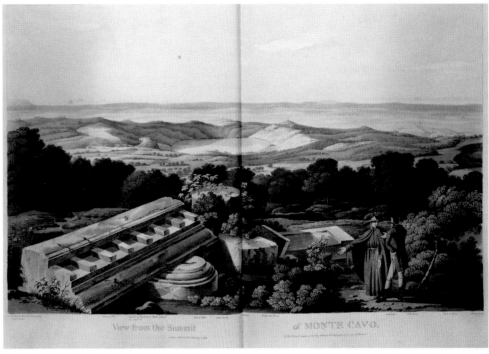

View from the Summit of MONTE CAVO.

152

James Fenimore Cooper (1789-1851)

155. *The Bravo*, 1831
London: Henry Colburn and Richard Bentley, 1831
By permission of the Houghton Library, Harvard University

Set in Venice during the early eighteenth century, and inspired by his own trip to that city in 1830, Cooper's historical novel was adapted from German novelist J.H.D. Zschokke's *Abaellino the Bravo of Venice* (1804). In Cooper's colorful tale, an innocent man is blackmailed and finally executed by the city's cruel aristocratic rulers. It was received in America as an affirmation of republican principles and a warning against impending oligarchy. Cooper's book was itself the basis for an Italian opera, Rossi and Mercadante's *Il Bravo*, first performed in Milan on March 9, 1839.

Washington Allston (1779-1843)

156. *Monaldi*, 1841
Boston: Charles C. Little and James Brown, 1841
Inscribed: "To Professor Longfellow from his friend the Author"
By permission of the Houghton Library, Harvard University

Allston's Romantic response to Italy found expression not only in his paintings (see cats. 10-12), but also in this novel, written in 1822, thirteen years

after his return from Italy and first published in 1841. In this tale of love, jealousy, intrigue and death, a painter, a poet, and a beautiful young woman are the Italian protagonists. The novel is set in Rome, the Campagna, Florence, and Naples during the eighteenth century. Allston gave this copy to his friend and fellow Italophile Henry Wadsworth Longfellow.

Mariano Vasi (active late 18th, early 19th century) and Antonio Nibby (1792-1839)

157. *Guide of Rome and the Environs*, 1847
Rome: L. Piale, 1847
Newington-Cropsey Foundation

The guidebooks of the Italian antiquarian Mariano Vasi were translated into English early in the nineteenth century, revised by Antonio Nibby after 1818, and published in numerous editions during the first half of the century. These books enjoyed their greatest popularity before the appearance of Murray's guidebooks in 1843, but even after that date, travelers seriously interested in archeology and architecture often preferred the guidebooks of Vasi and Nibby. This copy belonged to the painter Jasper Cropsey and his wife (see cats. 24, 49, 50).

Henry Tuckerman (1813-1871)

158. *The Italian Sketch Book,* 1835
Boston: Light and Stearns, 1837
Courtesy of The Trustees of The Boston Public Library

Tuckerman, who became one of America's best-known art critics, traveled abroad for the first time in 1833-34, spending the greater part of his stay in Italy. Written in the first person as an annotated travelogue, his *Italian Sketch Book* was published upon his return. Tuckerman's commentary begins with Rome and Florence, but meanders across the peninsula; he includes both illustrations and descriptions of various sites. Tuckerman not only comments on the locations themselves, but also upon a variety of other topics, including translations of Italian stories ("Tales") and a section called "Miscellany," which incorporates "The Opera," "Greenough" and "Modern Italy." This edition features an engraved frontispiece by James Smillie after Thomas Cole's *Aqueduct Near Rome* (cat. 45).

George Stillman Hillard (1808-1879)

159. *Six Months in Italy,* 1853
Boston: Ticknor, Reed, and Fields, 1853
Inscribed presentation slip, volume 1: "H.W. Longfellow from his friend G.S. Hillard; inscribed in volume 2: "Henry W. Longfellow From the Author"
By permission of the Houghton Library, Harvard University

A prominent New England lawyer; man of letters; and friend of Hawthorne, Longfellow, and Howells, George S. Hillard wrote this two-volume book after his trip to Italy in 1847-48. Dedicated to the sculptor Thomas Crawford and his wife, this publication became America's most popular guide to Italy in the mid-nineteenth century.

Charles Eliot Norton (1827-1908)

160. Travel journal of Italy, 1856
Inscribed: "C. E. Norton/ Naples April 1856."
By permission of the Houghton Library, Harvard University

In 1875 Charles Eliot Norton became the first professor of art history at Harvard. Over the course of his long career, he gained wide renown for his teaching, writing, and Dante scholarship. Two decades earlier, at the age of twenty-eight, Norton had begun what was to be a nearly two-year hiatus in Europe. As he was in poor health, his doctor recommended he spend the winter of 1855-56 in Rome, where he quickly fell under the spell of Italy. By April 1856 Norton was feeling more fit, and he and his good friends, James Russell Lowell;

162 *The Arch of Titus,* plate from *The Marble Faun* by Nathaniel Hawthorne.

John W. Field; and an Englishman, Charles C. Black, set off on a two-hundred-mile trek throughout Sicily on muleback. This often humorous small journal includes contributions by each of the four travelers. They refer to one another by their chosen nicknames: Norton was Don Carlos, Black was Nero, Field was Campo, and Lowell the Hospodar. Their accounts are filled with descriptions of the wildflowers of Palermo, the peasants' costumes at Girgenti, the island's many ancient Greek temples, the Cathedral at Monreale, and the terrible inns in which they were forced to stay. By May 8 they had reached the summit of Mt. Etna and their ascent is described by Black in rhyming form. After five weeks together the four dispersed, and the journal concludes with Norton's travels back to Venice via Naples, Rome, Perugia, Arrezzo, and Padua.

James Jackson Jarves (1818-1888)

161. *Italian Sights and Papal Principles,* 1856
New York: Harper and Brothers, 1856
Library of the Boston Athenaeum, Boston, Mass.

Journalist, art critic, and collector James Jackson Jarves lived in Florence from 1852 until his death in

1888. *Italian Sights and Papal Principles* is both a travel memoir and a critique of Catholicism and Italian society. Jarves published an important history of American painting, *Art-Hints,* in 1855, and a second collection of essays, *Italian Rambles,* in 1883.

Nathanial Hawthorne (1804-1864)

162. *The Marble Faun, or the Romance of Monte Beni,* 1860
Leipzig: Tauchnitz, 1860
Museum of Fine Arts, Boston, Anonymous Gift

The Marble Faun, Hawthorne's last completed novel, was the result of the writer's seventeen-month sojourn in Rome and Florence in 1858-59. In it, Hawthorne examines the life, and especially the problems, of American painters and sculptors living in Rome. The novel made extensive use of Hawthorne's own detailed Italian notebooks, which describe his friendship with William Wetmore Story (cats. 16, 32), Harriet Hosmer (cats. 33, 184), Cephas Thompson and other American artists there. Published simultaneously in London (with the title *Transformation*) and in Boston, *The Marble Faun* became as indispensable to tourists visiting Rome as their Murray's guidebooks; numerous travelers purchased copies inter-

leaved with photographs of the sites in Rome Hawthorne mentions.

William Wetmore Story (1819-1895)
163. *Roba di Roma,* 1862
London: Chapman and Hall, 1871
Library of the Boston Athenaeum, Boston, Mass.

Story is best known as a sculptor (see cats. 16, 32), but he also dabbled in poetry and wrote several books based on his experiences as an American expatriate in Italy. *Roba di Roma* was his most popular book, and by 1887 was already in its eighth printing. In two volumes, Story described the city he knew intimately, focusing on its seasons and customs, folk music, theater, working-class neighborhoods, and street markets. Deemed too critical of the Catholic church, Story's book was banned in Italy for some time after its publication. The author's tone is nostalgic rather than irreverent, clearly longing for the old, pre-Unification Rome he had first discovered in the 1840s and 1850s.

Henry Wadsworth Longfellow (1807-1882)
164. Manuscript translation of *The Divine Comedy* by Dante, 1867
By permission of the Houghton Library, Harvard University

Longfellow had reached the height of his career when, in the summer of 1861, his beloved wife Fanny (see cat. 136) died in a tragic accident: a candle flame ignited the sleeve of her gown. For several years after her death, the poet found it impossible to write. He turned to translation as a form of solace, and once again picked up Dante's fourteenth-century masterpiece, *The Divine Comedy,* which he had set aside nearly two decades earlier. On October 25, 1865, Longfellow held the first meeting of the Dante Club at Craigie House, hosting a group of interested scholars including James Russell Lowell, Charles Eliot Norton (cat. 160), and William Dean Howells (cat. 167). Longfellow's translation of the *Divine Comedy* was published two years later, and today remains one of the standard versions of Dante's text.

Samuel Langhorne Clemens [Mark Twain] (1835-1910)
165. *The Innocents Abroad,* 1869
Hartford, Connecticut: American Publishing Company, 1869
Inscribed: Oliver Wendell Holmes
By permission by the Houghton Library, Harvard University

167

Mark Twain was commissioned by the *Alta California,* a San Francisco newspaper, to provide travel letters from Europe and the Holy Land; he sailed on June 10, 1867, on the *Quaker City,* the first American ship chartered for pleasure cruises. Twain's resulting book established his reputation, and its caustic, humorous attitude toward the great sights of Italy marks the beginning of the modern era of the irreverent American traveler. See William L. Vance's essay in this volume.

Henry James (1843-1916)
166. *Roderick Hudson,* 1876
Boston: James R. Osgood and Company, 1876
Wellesley College Library, Special Collections, Bequest of Elizabeth W. Manwaring

Although Henry James traveled widely in Europe and settled permanently in London in 1876, he was particularly enamored of Italy and journeyed there frequently throughout his life. *Roderick Hudson,* his first full-length novel, which he began while living in Florence, describes the lure, and then the

destructiveness, of Rome for a young American sculptor during the late 1860s.

William Dean Howells (1837-1920)
167. *Venetian Life,* 1866
Boston: Houghton Mifflin and Company, 1892
Illustrated by **Childe Hassam** (1859-1935)
Private Collection

Novelist and man of letters, William Dean Howells served as the American consul to Venice from 1861 to 1865. During his tenure, Howells devoted himself to observing and recording Italian manners and customs. *Venetian Life* was first published in 1866; it was reissued in a popular illustrated edition in 1892 (see William L. Vance's essay in this volume). Many of the images for the second edition were provided by Childe Hassam, who based his delicate watercolors on sketches he had made in Venice in 1883-4. The other illustrators included Ross Turner, Rhoda Holmes Nicholls, and F. Hopkinson Smith (see cat. 169).

Bernard Berenson (1865-1959)
168. *Venetian Painters of the Renaissance,* 1894
New York: G. P. Putnam's Sons, 1894
Inscribed: Isabella S. Gardner/from/Bernhard
Berenson/1894 [in Gardner's hand]
Isabella Stewart Gardner Museum

Berenson, who became one of the nineteenth cen-
tury's leading scholars of Renaissance art, met the
wealthy Bostonian Isabella Stewart Gardner
through his Harvard professor Charles Eliot
Norton (see cat. 160). When Berenson published
his first book, *Venetian Painters,* in 1894, he sent this
copy to Mrs. Gardner as thanks for her early
patronage. This gesture apparently renewed their
friendship, which had been interrupted by
Berenson's extended European study tour begun in
1887. From that point on, Berenson acted as Mrs.
Gardner's agent, advising her on her celebrated col-
lection of paintings. Mrs. Gardner purchased her
first painting through Berenson (Botticelli's *Tragedy
of Lucretia*) not long after receiving this volume.

Francis Hopkinson Smith (1838-1915)
169. *Venice of To-Day,* 1894
New York: The Henry T. Thomas Company, 1896
Illustrated by F. Hopkinson Smith
*Museum of Fine Arts, Boston, William Morris Hunt
Memorial Library*

Smith left a successful career as an engineer to
become a full-time painter specializing in *plein-air*
watercolors of picturesque sites in England,
Holland, France, and Italy. He began to combine
his images with written travel accounts in about
1886. The most ambitious of these projects was
Venice of To-Day, a deluxe volume devoted to Smith's
favorite city. The book was republished in a small-
er format in 1897, with the title *Gondola Days.*

Edith Wharton (1862-1937) and **Maxfield Parrish**
(1870-1966)
170. *Italian Villas and their Gardens,* 1904
New York: The Century Company, 1904
Library of the Boston Athenaeum, Boston, Mass.

First serialized in *The Century Magazine* and later
published as a book, *Italian Villas and their Gardens* is
among the early studies of the subject. The pub-
lishers, The Century Company, sent Wharton and
Parrish to Italy in early 1903 for research, although
scheduling difficulties prevented their traveling
together. Returning to the United States, author
and artist collaborated closely, resulting in a beau-

170

171

tiful and scholarly publication emphasizing the harmony of architecture and landscape. For both it was a departure from their usual work: Wharton is best known for her novels and short stories and Parrish for his illustrations for magazines and children's books.

Henry James (1843-1916)
171. *Italian Hours*, 1909
Boston: Houghton Mifflin Company, 1909
By permission of the Houghton Library, Harvard University

Italian Hours is a compilation of James's travel essays on Italy, some of which first appeared in *The Atlantic Monthly* and *The Nation*, for which he was the Rome correspondent from 1872 to 1874. He discusses both well-known (Rome, Florence, and Venice) and less-traveled destinations, including Ravenna, Lucca, and Siena. He wrote that the charm of Italy was "in the tone and the air and the happy hazard of things."

172. *Murray's Handbook of Rome and its Environs*, 1858
London: John Murray, 1858
Museum of Fine Arts, Boston, William Morris Hunt Memorial Library

The London firm of John Murray, specialists in travel books for English readers, produced its first guide to Rome in 1843. Subsequent editions covered northern, central, and southern Italy, and included fold-out maps and abundant practical information in addition to basic facts about Italy's cities, towns, art, architecture, institutions, and customs. Murray's guidebooks were popular with American travelers from the 1840s to the end of the century.

173. *Baedeker's Italy, Handbook for Travellers, First Part: Northern Italy*, 1889
Leipzig: Karl Baedeker, 1889
Museum of Fine Arts, Boston, William Morris Hunt Memorial Library

The German firm of Karl Baedeker began producing English language guides to Italy during the 1860s. Frequently updated, these books were full of dining, lodging, and travel suggestions for every budget, as well as information on the sites themselves. The Baedeker guides were the best-selling travel books in America during the late nineteenth and early twentieth centuries.

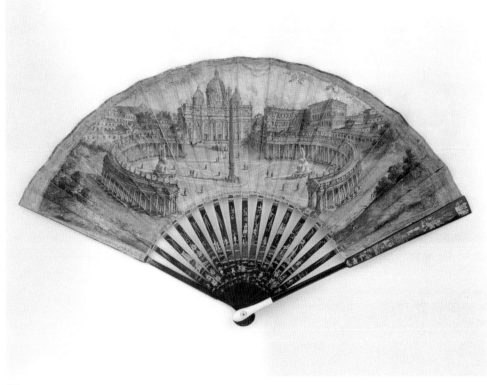

174

Furniture and Decorative Arts

174. Italian souvenir fan with St. Peter's Basilica (obverse) and Castel Sant'Angelo (reverse), 1750-80
Skin leaf (double), painted in opaque watercolor and India ink, 11½ x 20¾ in.
Museum of Fine Arts, Boston, Esther Oldham Collection

175. Italian souvenir fan with view of Mount Vesuvius by night (obverse) and by day (reverse), about 1820
Skin leaf (double), painted in opaque watercolor, 11½ x 22 in.
Museum of Fine Arts, Boston, Esther Oldham Collection

The wide range of imagery found on fans suggests that they played a social role far beyond that of utility and courtship. As ephemeral barometers of popular culture, politics, and literature, fans were also used to introduce conversational topics. When open, these two Italian-made fans offered vivid illustrations of requisite sites on the Grand Tour in Rome and Naples and colorful images of *contadini* in various attitudes of work and play.

176. "Liberotti Impronte," Book of Impressions, nineteenth century
Paper, cardboard, leather case; plaster impressions with cardboard frame; 10¼ x 6½ x 2 in. (closed)
Essex Institute, Salem Massachusetts, John Robinson Collection

This book of clay medallions contains impressions of sculpture ranging from the *Laocoön* of Hellenistic Greece and Renaissance sculptor Giovanni Bologna's *Mercury*, to such nineteenth-century masterpieces as *Day* and *Night* by Bertel Thorvaldsen. Books like these enabled travelers who could not afford bronze statuettes or parianware to assemble inexpensive reproductions of the most highly regarded sculpture in Italy.

177. Roman micro-mosaic table top, about 1850
Black marble with inlaid mosaic of lapis lazuli, malachite, and other stone, 23½ in. (diameter)
Museum of Art, Rhode Island School of Design, Bequest of Richard B. Harrington

Table tops, particularly those with scenes of Italy, were popular with tourists, who purchased them

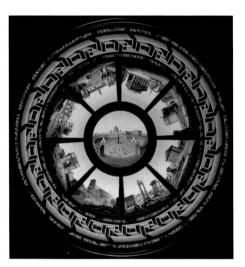

177

181. Italian open armchair ("Gondola Chair"), late nineteenth century
Carved walnut, 45 x 23½ x 44½ in.
Mark Twain Memorial, Hartford, Connecticut

Nineteenth-century cabinetmaking in Italy was characterized by a revival of styles such as this open armchair, its sixteenth-century form known from a painting by the Venetian master Carpaccio. This piece was called a "gondola chair" by its owners for its physical resemblance to the prow of the famed canal boats of Venice, but due to the sweep of the backrest, such chairs would be impractical on any vessel. Most were probably purchased by tourists who wished to recall their Venetian experiences; this one was bought by the Whitmore family of Hartford, Connecticut.

182. Model of the Leaning Tower of Pisa, late nineteenth century
Alabaster, marble, and glass, 4½ x 3¼ in. (diameter)
Lyndhurst: A Property of the National Trust for Historic Preservation

In 1887, financier and railroad magnate Jay Gould (1836-1892) took his family to the Mediterranean on their 300-foot yacht, the *Atalanta*. The family hoped the trip would improve the health of Mrs. Gould (Helen Day Miller, 1838-1889); they visited not only such coastal cities as Naples and Rome (via Ostia), but also disembarked to tour Italy extensively. Mrs. Gould purchased this souvenir in Pisa.

for their homes, and later had them set into stands by local cabinetmakers. Visitors to mosaic workshops admired the painterly style achieved by Italian craftsmen, many of whom achieved renown.

178. Venetian goblet, late nineteenth century
Blown, colorless glass with opaque white threads, blown, drawn and applied handles with free-hanging air-twist rings, 6⅛ x 4 in. (diameter of top)
Museum of Art, Rhode Island School of Design, Gift of Mrs. Frank L. Mauran and John O. Ames

179. Venetian footed bowl, late nineteenth century
Blown, colorless glass with applied blue prunts, 9¾ x 8¾ in. (diameter of top)
Museum of Art, Rhode Island School of Design, Gift of Mrs. Frank L. Mauran and John O. Ames

180. Venetian goblet, late nineteenth century
Blown, greenish glass with blown and applied decoration, 11⅞ x 4⅜ in. (diameter of base)
Museum of Art, Rhode Island School of Design, Gift of Mrs. Frank L. Mauran and John O. Ames

A revival of interest in sixteenth-century Venetian glassmaking techniques took place during the second half of the nineteenth century. The recreation of the light, colorful, and fantastic forms of Venice's golden age of glass was dominated by a few dedicated craftsmen, who produced an astonishing range of vessels, employing near-forgotten techniques. These fragile objects were popular souvenirs.

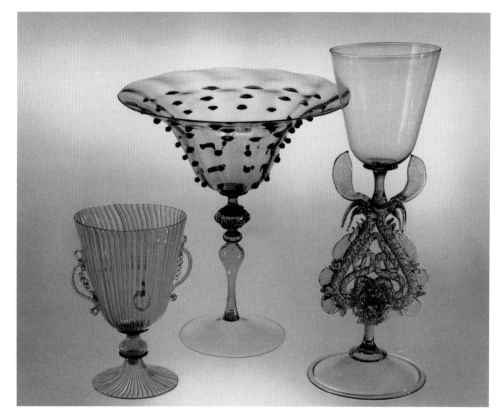

178, 179, 180 (Photograph courtesy Cathy Carver.)

Augustus Saint-Gaudens (1848-1907)

183. *John Singer Sargent*, 1880
Bronze, 2½ in. (diameter)
Signed and inscribed: MY.FRIEND IOHN/SARGENT.
PARIS/IULY[?].M.D.C.CCLXXX./FECE./A ST G [in
monogram]/BRUTTO RITRATTO
*Lent by The Metropolitan Museum of Art, Gift of Mrs.
Edward Robinson, 1913*

Saint-Gaudens's medallion of Sargent, made a few
years after the sculptor left Rome, signals Saint-
Gaudens's familiarity with classical coins and
medals. This portrait of Sargent, whom Saint-
Gaudens had befriended in Paris in the 1870s, may
have been based upon fifteenth-century Italian
reliefs rather than ancient examples. Saint-Gaudens
is known to have owned casts after medallions by
Antonio Pisano (called Pisanello, before 1395-1455).
It has been speculated that the sculptor's selection
of a tiny medallion to portray his tall friend was
an inside joke, made more humorous by the in-
scription, "brutto ritratto." The literal translation
is "crude" or "bad" portrait, but Saint-Gaudens
may have intended these words to connote vigor
and realism, qualities of Sargent which he admired.
To their mutual friend Isabella Stewart Gardner,
Saint-Gaudens wrote that he wished his medallion
"were more worthy of the original."

Harriet Hosmer (1830-1908)

184. *Clasped Hands of Robert and Elizabeth Barrett
Browning*, 1853
Cast bronze, 8¼ in. (length)
Inscribed on end of Elizabeth's hand: *Copyright*;
inscribed on end of Robert's hand: HANDS-of-
ROBERT/AND/*Elizabeth Barrett Browning/Cast/By/
Harriet Hosmer/Rome 1853*
Collection of Jo Ann and Julian Ganz, Jr.

During Hosmer's second year in Rome, the artist
formed a warm friendship with the poets Robert
and Elizabeth Browning (see cat. 143). As a mem-
ber of their small circle in the years before the
Brownings became internationally known, the
twenty-three-year-old Hosmer was in a special
position to witness the matrimonial bliss for
which the couple was later acclaimed. In the winter
of 1853, the Brownings consented to Hosmer's
offer to pay tribute to their marriage by casting
their clasped hands in bronze. These clasped
hands are among Hosmer's earliest accomplish-
ments in Rome and remain among her best-known
work.

184

Attributed to Copeland and Garrett

185. *The Greek Slave* (after Hiram Powers), 1860s
Parianware, 13 x 3½ in. (diameter)
The Valentine Museum, Richmond, Virginia

Parianware, a slightly translucent, finely textured,
unglazed porcellaneous material, was developed in
England during the 1840s as an inexpensive alter-
native to bronze and marble. Less fragile than
plaster, parianware was named for its resemblance
to Greek marble from the island of Paros. The
English ceramics firm Copeland and Garrett
secured the rights to reproduce Powers's *The Greek
Slave* in parianware, but other English and Ameri-
can manufacturers soon produced unauthorized
versions, especially following the sculpture's two-
year tour of the United States in 1847-49. *The Greek
Slave* inspired a tremendous outpouring of poetry,
music, engravings, and reproductions when it was
exhibited at London's Great Exhibition of 1851 (see
cats. 80-81).

Jewelry

186. Italian cameo parure (necklace, comb, pair
of earrings, pair of bracelets, belt clasp), about
1820-30
Shell, gold, and other metals; necklace: 17½ x 1⅝
in., comb: 5⁶⁄₁₆ x 7½ in., earrings: 1½ x ½ in. (each),
bracelet A: 7 x ⅝ in., bracelet B: 6⅞ x ⅝ in., belt
clasp: 4¼ x 1¼ in., case: 13 x 9½ in.
*Essex Institute, Salem, Massachusetts, Jane Appleton (Peele)
Phillips Collection*

This exceptional cameo parure in its original fitted
case was probably a wedding gift to Jane Appleton
Peele, the daughter of a Salem merchant. She mar-
ried Stephen C. Phillips, a prosperous ship owner,
on November 7, 1822. Both Peele's and Phillips's
vessels often visited Italian ports. Cameo parures
were popularized by the Empress Josephine at the
beginning of the century. The carvings were often
based upon classical portrait busts, but works by
well-known contemporary sculptors were also
favored, especially those of Canova and Thorvald-
sen. Here, cameos based on Thorvaldsen's reliefs,
including *Night* and *Day*, are set "en esclavage"
(linked by three or more thin gold chains).

Giocondo Torrini (Italian, active about 1860-80)
187. Brooch, about 1845
Pietra dura and gold, 2 x 2½ in.
Incised on verso: Par G. Torrini/ et C.e/ Nouveau
Lungarno/ No. 6/ Florence
*Museum of Art, Rhode Island School of Design, Gift of Mrs.
John Carter Brown II*

Murray's guidebook named Giocondo Torrini as
one of the leading practitioners of work in pietra
dura, a technique in which precious and semi-pre-
cious stones and marble were cut and fitted to-
gether to form a design. Floral motifs were espe-
cially popular in Florence. This brooch descended
in the family of Nicholas Brown II (1792-1859),
who served as the American consul to Rome from
1846 to 1849.

188. Italian earrings and a brooch, about 1870
Marked "INNOCENTI" in oval
Micro-mosaic and gold, brooch 3½ x 2 in., ear-
rings 2 x ¾ in.
*Museum of Fine Arts, Boston, Bequest of Miss C. L. W.
French*

Like pietra dura, the technique of micro-mosaic
was originally practiced during the sixteenth cen-
tury in Rome. The technique involves setting
together small glass *tesserae* to form a design. This
brooch and matching earrings, with a motif of
birds and grapevines, was purchased in Rome by
Miss French, of Boston, in 1883.

189. Italian brooch with St. Peter's, about 1850
Gold, onyx, and micro-mosaic, 1⅞ x ½ in.
*Essex Institute, Salem, Massachusetts, Misses Lander
Collection*

190. Italian brooch with the Colosseum, about
1850
Gold, onyx, and micro-mosaic, 2⅛ x 1¾ in.
*Essex Institute, Salem, Massachusetts, Misses Lander
Collection*

191. Italian stick pin with the Pantheon, about
1850
Gold, micro-mosaic, pin head: ½ x ⅝ in., overall
length 2¾ in.
*Essex Institute, Salem, Massachusetts, Misses Lander
Collection*

The rediscovery of ancient mosaic techniques in
sixteenth-century Italy led to a revival of that art
form, particularly in the service of the Vatican. By
the nineteenth century, waning religious commis-
sions were supplemented by a burgeoning market
for secular mosaics, including such luxury acces-

188

sories as gift boxes, jewelry, and furniture. These
three pieces, purchased by Miss Helen Dodge
Lander and Miss Lucy Allen Lander of Salem,
Massachusetts, depict some of the most popular
tourist attractions in Rome.

192. Italian brooch of a bacchante, about 1860
Carved lava mounted in gold, 2 x 2¼ x ¾ in.
Courtesy of the Stowe-Day Foundation, Hartford, Conn.

Archeological sites, particularly Pompeii and
Herculaneum, destroyed by Mount Vesuvius and
first excavated in 1748, were major tourist attrac-

tions throughout the nineteenth century. Carved
lava jewelry, often in the form of grotesque masks
or bacchantes, became a popular souvenir of
Mount Vesuvius. Harriet Beecher Stowe (1811-
1896), author of *Uncle Tom's Cabin* and the lesser-
known *Agnes of Sorrento*, probably bought this
brooch during her visit to Italy in 1859-60.

193. Italian earrings, 1870-1900
Gold, 1 x ¾ in.
*Museum of Fine Arts, Boston, Gift of Edward Jackson
Holmes*

The Roman jeweler Fortunato Pio Castellani
(1793-1865), along with his sons and pupils, was at
the center of a revival of archeological motifs and
techniques inspired by contemporary excavations
in Italy, Greece, Egypt, and Southern Russia. Their
shops in Rome and Naples were required visits for
tourists, who enjoyed being draped in jewels of the
classical style. The Castellani firm and its competi-
tors emulated the ancient techniques of granulation
and filigree work.

194. Italian necklace, about 1860
Gold, 13¾ in. (length)
*Museum of Fine Arts, Boston, Bequest of Mrs. Turner
Sargent*

This elegant necklace is a stylized version of an
unusual Greek piece of the fourth to third cen-
turies B.C. in the collection of the National
Museum of Naples. Braided bands with small
droplets were popular Greek forms, but the heart-
shaped clasp with floral ornament and a frog to
either side was unusual. This necklace belonged to
the daughter of Oliver Wendell Holmes, Amelia
Holmes Sargent, whose collection included Italian
paintings and lace as well as jewelry.

Manner of the **Castellani Firm** (Italian, 19th cen-
tury
195. Demi-parure, 1860-70
Gold and Sicilian amber, 20½ in. (length)
*Museum of Fine Arts, Boston, Bequest of William Arnold
Buffum*

This elegant set, comprising a necklace, earrings
and brooch, belonged to William Arnold Buffum
(1821-1901), an American connoisseur and collector
of amber. Buffum, the author of *The Tears of the
Heliades*, an 1896 book about amber, traveled
throughout the United States, the Far East, and

195

Europe in search of different varieties of the translucent resin. This demi-parure is composed of amber from Sicily, which was particularly admired for its rich variation of color. It was set after Greek and Etruscan patterns in Rome under Mr. Buffum's supervision.

Giacinto Melillo (Italian, 1846-1915)
196. Hat pin, 1860-80
Gold, 6⅞ x 1 x ½ in.
Elaine Cooper & Company

A gifted jewelry craftsman, Giacinto Melillo was about fifteen years old when he began to work in the Naples shop of the Castellani company. By 1870 he had taken it over, continuing to work in the archeological style Castellani had established. This tiny putto, with its granular hair and filigreed wings, is similar in design to many of Castellani's productions. This pin descended in a Philadelphia family.

Attributed to **Giacinto Melillo** (Italian, 1846-1915)
197. Necklace, before 1903
Gold and intaglios, 15½ in. (length)
New York, Private Collection

Melillo's craftsmanship was renowned and his jewelry prized, but he rarely signed his pieces, making secure attributions difficult. This necklace, likely part of a group of objects purchased in 1903 from Melillo by Henry Walters of Baltimore, incorporates beautifully carved intaglios representing ancient Greek gods and goddesses. These delicate reliefs are incised into precious and semi-precious stones (the reverse of a cameo, which has raised figures).

Augustus Saint-Gaudens (1848-1907)
198. *Hannah Rohr Tuffs*, 1872
Shell cameo, 1⅞ x 1½ in.
Lent by The Metropolitan Museum of Art, Purchase, Sheila W. and Richard J. Schwartz Gift and Morris K. Jesup Fund, 1990

While many American artists worked briefly as cameo-cutters in Italy, few did so with as much talent as Saint-Gaudens. He learned the craft in New York, and had worked for an Italian cameo cutter in Paris before moving to Rome in 1870, where he shared a studio in the garden of the Palazzo Barberini. Before his ambitious sculpture *Hiawatha* won him acclaim, Saint-Gaudens supported himself copying ancient busts, carving portraits, and cutting cameos for the Roman dealer Rossi. Hannah Rohr Tuffs, traveling in Rome with her sister, an aspiring opera singer, commissioned Saint-Gaudens to create two portraits — this delicate cameo and a marble bust of Eva Rohr (1872, The Metropolitan Museum of Art, New York).

Augustus Saint-Gaudens (1848-1907)
199. *Youthful Mars*, about 1873-74
Stone and onyx cameo set in gold with pearls, 2¾ x 1¾ in.
U. S. Department of the Interior, National Park Service, Saint-Gaudens National Historic Site, Cornish, N. H., Gift of Mary M. Saint-Gaudens, 1974

Saint-Gaudens's *Youthful Mars*, made in Rome, is a finely detailed portrait; the superb modeling and finish evidence of the sculptor's training with Louis Avet, renowned for his talents as a stone cameo cutter. Saint-Gaudens's source for this image is unknown. Mars, the god of war, was not commonly portrayed in antiquity, nor is his elaborate dragon helmet a classical motif. It is more

199

likely that Saint-Gaudens produced this cameo in response to fanciful Renaissance interpretations of Roman gods and emperors.

Ephemera

200. Thomas Cole's Passport, 1841
Museum of Fine Arts, Boston, M. and M. Karolik Collection

This passport was used by Cole on his second trip to Europe, which lasted from August 1841 to July 1842. It is stamped with the seals of the many Italian cities he visited, including Genoa, Milan, Livorno, Rome, and Naples, as well as the island of Sicily. For Cole's complete itinerary, see p. 178.

201. Sanford R. Gifford's Passport, 1855
Private Collection

Gifford carried this travel document on his European trip of 1855-57, soon after his decision to become a landscape painter. The many stamps and signatures on it record the progress of his travels through Italy, first in the north at Lake Como and later in Milan, Genoa, Florence, Rome, and Naples. Gifford then headed north again, to Bologna and Venice, and departed for America in July 1857. For his exact itinerary, see p. 229.

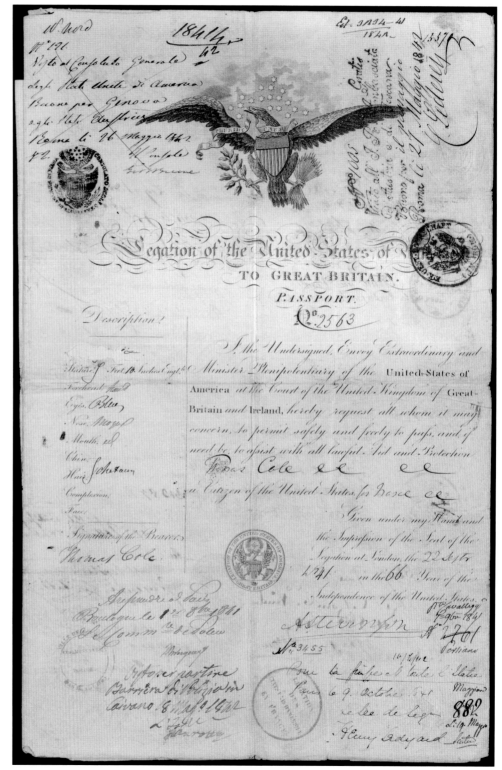

200

202. Fragments of the Baths of Caracalla, Rome
United States Department of the Interior, National Park Service, Longfellow National Historic Site

The poet Longfellow, in Italy during 1868-69, collected these pieces of marble from the massive ruins of the Baths of Caracalla (about A.D. 215). Ancient "souvenirs" such as these greatly appealed to the Victorian sensibility, and were frequently collected by American travelers.

203. Piece of lava from Mount Vesuvius
Lyndhurst: A Property of the National Trust for Historic Preservation

The Gould family (see cat. 182) visited the Vatican, the Catacombs, and then traveled south to Naples, where they saw artifacts excavated at Pompeii and Herculaneum. The Goulds hiked up Mt. Vesuvius, collecting a piece of lava as a memento.

204. Isabella Stewart Gardner's Palazzo Barbaro guestbook, 1897
Isabella Stewart Gardner Museum Archives

Isabella Stewart Gardner (1840-1924) made her first trip as an adult to Venice in 1884. She and her husband, Jack, fell in love with the city, and returned for lengthy visits nearly every other year until his death in 1898. They regularly rented the Palazzo Barbaro, on the Grand Canal, owned by the Curtis family of Boston (see cat. 116). The Barbaro guestbooks are fascinating records of the Gardners' distinguished visitors, including Henry James and Bernard Berenson.

205. Dealer's invoice for Isabella Stewart Gardner Consiglio Ricchetti, Venice, 1897
Isabella Stewart Gardner Museum Archives

By the time of Jack and Isabella Gardner's 1897 trip to Venice, they had already begun making plans for a museum to house their growing collection of Italian Renaissance art. This invoice, from one of many dealers the couple patronized during their last trip to Venice together, demonstrates the remarkable diversity of their purchases, including damasks and velvets, furniture and panel paintings, enamels, marbles, metalwork, and glass.

206. Advertising pamphlet and bill of sale from Ditta G. Accarsi & N.te, jewelers, Florence
Courtesy of the Stowe-Day Foundation, Hartford, Conn.

207. Advertising pamphlet from Francesco Navone, manufacturor of lace, Florence
Courtesy of the Stowe-Day Foundation, Hartford, Conn.

208. Advertisement and admission ticket for Pagliarini & Franco, manufacturors of furniture and artistic glassware, Venice
Courtesy of the Stowe-Day Foundation, Hartford, Conn.

209. Postcard and advertisement for the Grand Hotel de Catane, Catane
Courtesy of the Stowe-Day Foundation, Hartford, Conn.

210. Official program of the festivities during the Carnival of Rome, 1891
Courtesy of the Stowe-Day Foundation, Hartford, Conn.

211. Advertisement with fold-out map of Florence, for Ugolino's High Class Underwear, Hosiery, and Shirts, Florence
Courtesy of the Stowe-Day Foundation, Hartford, Conn.

212. Luggage tag from the Hotel des Temples, Girgenti
Courtesy of the Stowe-Day Foundation, Hartford, Conn.

213. Advertisement and bill of sale from L. Galli, shop for gloves, "Confections for Ladies," laces, silks, and tortoise shell articles, Florence
Courtesy of the Stowe-Day Foundation, Hartford, Conn.

214. Advertisement for the Hotel Chapman, Florence
Courtesy of the Stowe-Day Foundation, Hartford, Conn.

Born in Hartford, Connecticut, Katharine S. Day (1870-1914) was the granddaughter of the famous suffragist Isabella Beecher Hooker, as well as a grandniece of the author Harriet Beecher Stowe (see cat. 192). Katharine's father, a successful lawyer, decided to take his family on an extended trip to Europe in 1887; they spent seven years abroad. Unlike many travelers, the Days saved even the most ephemeral of their travel souvenirs and memorabilia. These fascinating mementos include a program of the festivities surrounding the Roman carnival of 1891, with a listing of the various masked balls, parades, flower battles, and horse races at the circus in the Piazza del Popolo. The collection also features tickets, postcards, luggage stickers, invoices, hotel fliers, and advertisements from the many shops that Katharine patronized on later visits to Italy.

Selected Bibliography

The following are the most useful references for the study of American artists in Italy and the Grand Tour. For bibliography on the artists in the exhibition, see the entries on their works. The footnotes of the essays also contain valuable references.

Adams, William Howard, ed. *The Eye of Thomas Jefferson*. Washington, D.C.: National Gallery of Art, 1976.

All'ombra del Vesuvio: Napoli nella veduta europea dal Quattrocento all'Ottocento. Naples: Electa Napoli, 1990.

Americans in Venice: 1879-1913. New York: Coe Kerr Gallery, 1983.

Amfitheatrof, Erik. *The Enchanted Ground: Americans in Italy, 1760-1980*. Boston: Little, Brown and Company, 1980.

Armstrong, David Maitland. *Day Before Yesterday, Reminiscences of a Varied Life*. New York: Charles Scribner's Sons, 1920.

Ashby, Thomas. *The Aqueducts of Ancient Rome*. Oxford: Clarendon Press, 1935.

———. *The Roman Campagna in Classical Times*. London: Ernest Benn Limited, 1970.

———. *Thomas Ashby: Un archeologo fotografa la campagna romana tra '800 e '900*. Rome: British School at Rome, 1986.

Baedeker's Handbook for Travellers: Central Italy and Rome. Leipzig: Karl Baedeker, 1877. (See also 1881 and 1893 editions.)

Baedeker's Handbook for Travellers: Northern Italy. Leipzig: Karl Baedeker, 1882. (See also 1886 and 1889 editions.)

Baedeker's Handbook for Travellers: Southern Italy and Sicily. Leipzig: Karl Baedeker, Publisher, 1877. (See also 1893 and 1896 editions.)

Bailey, Brigitte Gabcke. "Pictures of Italy: American Aesthetic Response and the Development of the Nineteenth-Century American Travel Sketch." Ph.D. diss., Harvard University, 1985. Ann Arbor: University Microfilms International, 1986.

Baker, Paul R. *The Fortunate Pilgrims: Americans in Italy 1800-1860*. Cambridge: Harvard University Press, 1964.

Ball, Thomas. *My Threescore Years and Ten: An Autobiography*. 2d ed. Boston: Roberts Brothers, 1892.

Brilli, Attilio. *Il "Petit Tour": Itinerari Minori del Viaggio in Italia*. Milan: Silvana Editoriale, 1988.

———. *Le Voyage d'Italie: Histoire d'une Grande Tradition Culturelle du XVI au XIX Siècles*. Paris: Flammarion, 1989.

Brooks, Van Wyck. *The Dream of Arcadia: American Writers and Artists in Italy 1760-1915*. New York: E. P. Dutton & Co., 1958.

Broude, Norma. *The Macchiaioli: Italian Painters of the Nineteenth Century*. New Haven: Yale University Press, 1987.

Brown, David Alan. *Raphael and America*. Washington, D.C.: National Gallery of Art, 1983.

[Bruen, Matthias]. *Essays, Descriptive and Moral; on Scenes in Italy, Switzerland, and France, by an American*. Edinburgh: Archibald Constable and Co., 1823.

Bull, Duncan. *Classic Ground: British Artists and the Landscape of Italy, 1740-1830*. New Haven: Yale Center for British Art, 1981.

Byron, George Gordon. *Childe Harold's Pilgrimage*. In *Lord Byron: The Complete Poetical Works*. Vol. 2. Edited by Jerome J. McGann. New York: Oxford University Press, 1980.

Cabell, Joseph Carrington. *Diaries, 1802-1806*. Charlottesville: Alderman Library, University of Virginia, unpublished manuscript.

Champney, Benjamin. *Sixty Years' Memories of Art and Artists*. Woburn, Mass.: Wallace & Andrews, 1900.

Chateaubriand, François-René, Vicomte de. *Recollections of Italy, England, and America*. Philadelphia: M. Carey, 1816.

Chatfield, Judith. *A Tour of Italian Gardens*. New York: Rizzoli, 1988.

Coffey, John W. *Twilight of Arcadia: American Landscape Painters in Rome, 1830-1880*. Brunswick, Maine: Bowdoin College Museum of Art, 1987.

Cooper, James Fenimore. *Gleanings in Europe: Italy*. 1838. Reprint edited by John Conron and Constance Ayers Denne. Albany: State University of New York Press, 1981.

Cranch, Christopher Pearse. *The Life and Letters of Christopher Pearse Cranch*. Edited by Leonora Cranch Scott. Boston: Houghton Mifflin Company, 1917.

Crane, Sylvia. *White Silence: Greenough, Powers and Crawford, American Sculptors in Nineteenth-Century Italy*. Coral Gables, Fla.: University of Miami Press, 1972.

Craven, Wayne. *Sculpture in America*. New York: Thomas Y. Crowell Co., 1968.

The Crayon. 8 vols. 1855-1861. Reprint (8 vols. in 4). New York: AMS Press, Inc., 1970.

Davidson, Rebecca Warren. "Past as Present: Villa Vizcaya and 'The Italian Garden' in the United States." *Journal of Garden History* 12 (January-March 1992), pp. 1-28.

Dentler, Clara Louise. *Famous Americans in Florence*. Florence: Giunti Marzocco, 1976.

DeStaël, Madame. *Corinne, or Italy*. Translated by Emily Baldwin and Paulina Driver. London: George Bell & Sons, 1902.

Dickens, Charles. *Pictures from Italy*. New York: Hurd and Houghton, 1869.

Dinnerstein, Lois. "The Significance of the Colosseum in the First Century of American Art." *Arts Magazine* 58 (June 1984), pp. 116-120.

Dunlap, William. *A History of the Rise and Progress of the Arts of Design in the United States*. 1834. Reprint (2 vols. in 3). New York: Dover Publications, Inc., 1969.

Dwight, Theodore. *A Journal of a Tour in Italy in the Year 1821*. New York: Abraham Paul, 1824.

Edel, Leon, ed. *Henry James Letters*. 4 vols. Cambridge: Harvard University Press, 1984.

Eldredge, Charles. *The Arcadian Landscape: Nineteenth Century American Painters in Italy*. Lawrence, Kansas: University of Kansas Museum of Art, 1972.

———. 'Torre Dei Schiavi: Monument and Metaphor." *Smithsonian Studies in American Art* 1 (Fall 1987), pp. 15-33.

Eustace, John C. *A Classical Tour Through Italy*. London: J. Mawman, 1817.

Feifer, Maxine. *Tourism in History: From Imperial Rome to the Present*. New York: Stein and Day, 1985.

Ferber, Linda S., and William H. Gerdts. *The New Path: Ruskin and the American Pre-Raphaelites*. New York: The Brooklyn Museum, 1985.

Fernandez, Rafael. *A Scene of Light and Glory: Approaches to Venice*. Williamstown, Mass.: Sterling and Francine Clark Art Institute, 1982.

Flagg, Edmund. *Venice: The City of the Sea*. New York: Charles Scribner, 1853.

Forsyth, Joseph. *Remarks on Antiquities, Arts, and Letters during an Excursion in Italy, in the Years 1802 and 1803*. Boston: Wells and Lilly, 1818.

Freeman, James E. *Gatherings from an Artist's Portfolio in Rome*. Boston: Roberts Brothers, 1883.

Fuller, Margaret. *'These Sad But Glorious Days': Dispatches from Europe, 1846-1850*. Edited by Larry J. Reynolds and Susan B. Smith. New Haven: Yale University Press, 1991.

Galassi, Peter. *Corot in Italy: Open-Air Painting and the Classical-Landscape Tradition*. New Haven: Yale University Press, 1991.

Gerdts, William H. *American Neo-Classic Sculpture: The Marble Resurrection*. New York: The Viking Press, 1973.

——. "Washington Allston and the German Romantic Classicists in Rome." *The Art Quarterly* 32 (Summer 1969), pp. 166-96.

——. *The White Marmorean Flock: Nineteenth Century American Women Neo-classical Sculptors.* Poughkeepsie, N.Y.: Vassar College Art Gallery, 1972.

Gillespie, William Mitchell. *Rome: As Seen by a New-Yorker in 1843-4.* New York: Wiley and Putnam, 1845.

Goethe, Johann Wolfgang von. *Italian Journey 1786-1788.* Edited by Thomas P. Saine and Jeffrey L. Sammons. New York: Suhrkamp Publishers Inc., 1989.

Greenthal, Kathryn, Paula M. Kozol, and Jan Seidler Ramirez. *American Figurative Sculpture in the Museum of Fine Arts, Boston.* Boston: Museum of Fine Arts, 1986.

Griswold, Mac, and Eleanor Weller. *The Golden Age of American Gardens.* New York: Harry N. Abrams, Inc., 1991.

Halsby, Julian. *Venice: The Artist's Vision.* London: B.T. Batsford Ltd., 1990.

Hare, Augustus J. C. *Days Near Rome.* Philadelphia: Porter & Coates, 1875.

——. *Walks in Rome.* 2 vols. London: Daldy, Isbister & Co., 1876.

Haskell, Francis, and Nicholas Penny. *Taste and the Antique: The Lure of Classical Sculpture 1500-1900.* New Haven: Yale University Press, 1981.

Hawthorne, Nathaniel. *The Marble Faun.* 1860. Boston: Houghton Mifflin & Co., 1889.

——. *Passages from the French and Italian Note-Books.* 2 vols. Edited by Thomas Woodson. Columbus, Ohio: Ohio State University Press, 1980.

Hewins, Amasa. *A Boston Portrait-Painter Visits Italy.* Edited by Francis H. Allen. Boston: The Boston Athenaeum, 1931.

Hewison, Robert. *Ruskin and Venice.* Louisville, Kentucky: The J. B. Speed Art Museum, 1978.

Hibbert, Christopher. *The Grand Tour.* London: Thames Methuen, 1987.

——. *Rome: The Biography of a City.* New York: W.W. Norton and Company, 1985.

——. *Venice: The Biography of a City.* New York: W.W. Norton and Company, 1989.

Hillard, George S. *Six Months in Italy.* 2 vols. Boston: Ticknor, Reed, and Field, 1853.

Hofer, Evelyn, and Evelyn Barish. *Emerson in Italy.* New York: Henry Holt & Co., 1989.

Honour, Hugh, and John Fleming. *The Venetian Hours of Henry James, Whistler, and Sargent.* Boston: Little, Brown, and Company, 1991.

Howells, William Dean. *Italian Journeys.* Boston: James R. Osgood, 1877.

——. *Venetian Life.* 2 vols. Boston: Houghton Mifflin and Company, 1892.

Igoe, Lynn Moody, and James Igoe. *250 Years of Afro-American Art, An Annotated Bibliography.* New York: R.R. Bowker Co., 1981.

Irving, Washington. *Journals and Notebooks,* vol. 1, 1803-1806. Edited by Nathalia Wright. Madison: University of Wisconsin Press, 1969.

——. *The Sketchbook of Geoffrey Crayon, Gent.* Boston: Twayne Publishers, 1978.

——. *Tales of a Traveller.* New York: G.P. Putnam and Son, 1968.

Italian Influence on American Literature. Address by C. Waller Barrett and exh. cat. New York: The Grolier Club, 1962.

The Italian Presence in American Art, 1860-1920. New York: Richard York Gallery, 1989.

Jaffe, Irma B., ed. *The Italian Presence in American Art 1760-1860.* New York: Fordham University Press and Rome: The Italian Encyclopedia Institute, 1989.

——. *The Italian Presence in American Art 1860-1920.* New York: Fordham University Press and Rome: The Italian Encyclopedia Institute, 1992.

James, Henry. *The Aspern Papers.* Vol. 12 of *The Novels and Tales of Henry James.* New York: Charles Scribner's Sons, 1908.

——. *Daisy Miller.* Vol. 18 of *The Novels and Tales of Henry James.* New York: Charles Scribner's Sons, 1909.

——. *The Golden Bowl.* Vols. 23 and 24 of *The Novels and Tales of Henry James.* New York: Charles Scribner's Sons, 1909.

——. *Italian Hours.* Boston: Houghton Mifflin Company, 1909.

——. *The Portrait of A Lady.* Vols. 3 and 4 of *The Novels and Tales of Henry James.* New York: Charles Scribner's Sons, 1908.

——. *Roderick Hudson.* Boston: James R. Osgood and Co., 1876.

——. *William Wetmore Story and His Friends.* 2 vols. Boston: Houghton Mifflin Company, 1903.

——. *The Wings of the Dove.* Vols. 19 and 20 of *The Novels and Tales of Henry James.* New York: Charles Scribner's Sons, 1909.

Jarves, James Jackson. *Art-Thoughts: The Experiences and Observations of an American Amateur in Europe.* New York: Hurd & Houghton, 1861.

——. *Italian Rambles: Studies of Life and Manners in New and Old Italy.* New York: G.P. Putnam's Sons, 1883.

——. *Italian Sights and Papal Principles Seen Through American Spectacles.* New York: Harper and Brothers, 1856.

LaPiana, Angelina. *Dante's American Pilgrimage: A Historical Survey of Dante Studies in the United States, 1800-1944.* New Haven: Yale University Press, 1948.

Leland, Henry P. *Americans in Rome.* New York: C.T. Evans, 1863.

Longfellow, Henry Wadsworth. *The Letters of Henry Wadsworth Longfellow.* Edited by Andrew Hilen. Cambridge: The Belknap Press of Harvard University Press, 1966.

Lorenzetti, Giulio. *Venice and Its Lagoon.* Rome: Istituto Poligrafico dello Stato, 1961.

Lovell, Margaretta. *Venice: The American View, 1860-1920.* San Francisco: The Fine Arts Museums of San Francisco, 1984.

——. *A Visitable Past: Views of Venice by American Artists, 1860-1915.* Chicago: University of Chicago Press, 1989.

Manwaring, Elizabeth Wheeler. *Italian Landscape in Eighteenth Century England: A Study Chiefly of the Influence of Claude Lorrain and Salvator Rosa on English Taste, 1700-1800.* New York: Oxford University Press, 1925.

Martyn, Thomas. *The Gentleman's Guide in his Tour through Italy.* London: G. Kearsley, 1787.

Mead, William Edward. *The Grand Tour in the Eighteenth Century.* Boston: Houghton Mifflin, 1914.

Melville, Herman. *Journals.* Edited by Howard C. Horsford and Lynn Horth. Evanston, Ill.: Northwestern University Press, 1989.

——. "Statues in Rome." *The Piazza Tales and Other Prose Pieces, 1839-1860.* Evanston, Ill.: Northwestern University Press, 1987.

Moore, John. *A View of Society and Manners in Italy.* 2 vols. London: W. Strahan & T. Cadell, 1781. Philadelphia: Robert Bell, 1783.

Morgan, John. *The Journal of Dr. John Morgan.* Philadelphia: J. B. Lippincott Company, 1907.

Murray's Handbook for Travellers in Central Italy: Rome and Environs. London: John Murray, 1853. (See also 1858, 1864, 1867, 1869, 1892 and 1894 editions.)

Murray's Handbook for Travellers in Northern Italy. London: John Murray, 1863.

Murray's Handbook for Travellers in Southern Italy and Sicily. London: John Murray, 1858. (See also 1892 edition.)

Norton, Charles Eliot. Notes of Travel and Study in Italy. Boston: Ticknor and Fields, 1860.

Novak, Barbara. Nature and Culture: American Landscape and Painting, 1825-1875. New York: Oxford University Press, 1980.

Nugent, [Sir Thomas]. The Grand Tour, or, A Journey Through the Netherlands, Germany, Italy and France. 4 vols. London: D. Browne, A. Millar, et al, 1756.

Peale, Rembrandt. Notes on Italy Written During a Tour in the Years 1829 and 1830. Philadelphia: Carey and Lea, 1831.

Pine-Coffin, R. S. Bibliography of British and American Travel in Italy to 1860. Florence: L.S. Olschki, 1974.

Putnam, G.P. The Tourist in Europe. New York: Wiley & Putnam, 1838.

Queen of Marble and Mud: The Anglo-American Vision of Venice, 1880-1910. Nottingham: Nottingham University Art Gallery, 1978.

Quick, Michael. American Expatriate Painters of the Late Nineteenth Century. Dayton: Dayton Art Institute, 1976.

Rahv, Philip, ed. Discovery of Europe: The Story of American Experience in the Old World. Boston: Houghton Mifflin Co., 1947.

Randall, Lilian M.C. "An American Abroad: Visits to Sculptor's Studios in the 1860's." The Journal of the Walters Art Gallery 33-34 (1970-71), pp. 42-51.

Reinhold, Meyer. Classica Americana: The Greek and Roman Heritage in the United States. Detroit: Wayne State University Press, 1984.

Reynolds, Joshua, Sir. Discourses on Art. Edited by Robert R. Wark. New Haven: Yale University Press, 1975.

Richardson, Edgar P., and Otto Wittmann, Jr. Travelers in Arcadia: American Artists in Italy, 1830-1875. Detroit: Detroit Institute of Arts, 1951.

Ruskin, John. The Stones of Venice. 3 vols. In The Works of John Ruskin. Edited by E. T. Cook and Alexander Wedderburn. 39 vols. London: George Allen; New York: Longmans, Green & Co., 1903.

[Sansom, Joseph]. Letters from Europe During a Tour Through Switzerland and Italy in the Years 1801 and 1802, Written by a Native of Pennsylvania. 2 vols. Philadelphia: A. Bartram, 1805.

Sass, Henry. A Journey to Rome and Naples, Performed in 1817: Giving an Account of the Present State of Society in Italy and Containing Observations on the Fine Arts. New York: James Eastburn & Co., 1818.

Scherer, Margaret R. The Marvels of Ancient Rome. London: The Phaidon Press, 1955.

Sloan, James. Rambles in Italy in the Years 1816-1817 by an American. Baltimore: N.G. Maxwell, 1818.

Smith, F. Hopkinson. Gondola Days. Boston: Houghton Mifflin and Company, 1897.

Soria, Regina. Dictionary of Nineteenth-Century American Artists in Italy 1760-1914. Rutherford, N.J.: Fairleigh Dickinson University Press; East Brunswick, N.J., London, and Toronto: Associated University Presses, 1982.

—. "Gli Artisti Americani al Cimitero del Testaccio." Studi Romani 28, (April-June 1980), pp. 201-211.

Stainton, Lindsay. Turner's Venice. New York: George Braziller, Inc., 1985.

Stein, Roger B. John Ruskin and Aesthetic Thought in America, 1840-1900. Cambridge, Mass.: Harvard University Press, 1967.

Stendahl [Henri Beyle]. A Roman Journal. 1829. Edited and translated by Haakon Chevalier. New York: The Orion Press, 1957.

Stern, Madeleine B. "New England Artists in Italy, 1835-1855." The New England Quarterly 14 (1941), pp. 243-271.

Story, William Wetmore. Roba di Roma. 2 vols. Boston and New York: Houghton Mifflin, 1896.

Sutton, Denys. "Magick Land." Apollo 99 n.s.(June 1974), pp. 392-407.

Taylor, Bayard. Picturesque Europe, vol. 2. New York: D. Appleton & Co., 1878.

—. Views A-Foot or Europe Seen with Knapsack and Staff. New York: Wiley and Putnam, 1847.

Thorp, Margaret. The Literary Sculptors. Durham, N.C.: Duke University Press, 1965.

Trease, Geoffrey. The Grand Tour. London: Heinemann, 1967.

Tuckerman, Henry T. Book of the Artists: American Artist Life. New York: G.P. Putnam & Sons, 1867.

—. Isabel: or Sicily. Philadelphia: Lea and Blanchard, 1839.

—. Italian Sketchbook. New York: J.C. Ricker, 1848.

Tuttleton, James W. and Agostino Lombardo, eds. The Sweetest Impression of Life: The James Family and Italy. New York: New York University Press, 1990.

Twain, Mark [Samuel Langhorne Clemens]. The Innocents Abroad. Hartford: American Publishing Co., 1869.

Unrau, John. Ruskin and St. Mark's. New York: Thames and Hudson, 1984.

Valentine, Lucia, and Alan Valentine. The American Academy in Rome 1894-1969. Charlottesville, Virginia: University Press of Virginia, 1973.

Vance, William L. America's Rome. 2 vols. New Haven: Yale University Press, 1989.

Vasi, Mariano, and Antonio Nibby. Guide of Rome and the Environs. Rome: L. Piale, 1847.

Vedder, Elihu. The Digressions of V. Boston: Houghton Mifflin Co., 1910.

Venice Rediscovered. London: Wildenstein, 1972.

Vermeule, Cornelius. "America's Neoclassic Sculptors: Fallen Angels Resurrected." Antiques 102 (November 1972), pp. 868-875.

—. "Neoclassic Sculpture in America: Greco-Roman Sources and Their Results." Antiques 108 (November 1975), pp. 972-981.

Walker, Corlette Rossiter. The Anglo-American Artist in Italy, 1750-1820. Santa Barbara, Cal.: University Art Museum, University of California, Santa Barbara, 1982.

Wallace, Richard W. Salvator Rosa in America. Wellesley, Mass.: Wellesley College Museum, 1979.

Watson, Wendy M. Images of Italy: Photography in the Nineteenth Century. South Hadley, Mass.: Mount Holyoke College Art Museum, 1980.

Willis, Nathaniel Parker. Pencillings by the Way. New York: Morris & Willis, 1844.

—. Summer Cruise in the Mediterranean: On Board An American Frigate. New York: Charles Scribner, 1853.

Wittman, Otto, Jr. "Americans in Italy." College Art Journal 17 (Spring 1958), pp. 284-293.

—. "The Attraction of Italy for American Painters." Antiques 85 (May 1964), pp. 552-56.

—. "The Italian Experience (American Artists in Italy)." American Quarterly 4 (1952), pp. 3-15.

Wright, Nathalia. American Novelists in Italy: The Discoverers: Allston to James. Philadelphia: University of Pennsylvania Press, 1965.

Wynne, George. Early Americans in Rome. Rome: Dapco, 1966.

Index

Exhibition Checklist (Paintings & Sculpture)

For information on an artist's travels in Italy, please refer to the page following that artist's name.

Abele, Julian, 438
Basilica Palladiana, Vicenza, 438
Alexander, Esther Frances ("Francesca"), 353
Christmas Hymn of Fiumalbo (Per la Natività di Nostro Signore), 354
Life of Saint Zita, 354
Allston, Washington, 172
Diana in the Chase, 172
Italian Landscape, 174
Moonlit Landscape, 176
Self-Portrait, 190
Bacher, Otto Henry, 396
Doge's Palace from the Lagoon, 396
Bierstadt, Albert, 213
The Arch of Octavius (Roman Fish Market), 214
Mt. Aetna (Vesuvius), 276
Olevano, 302
Blum, Robert Frederick, 410
Venetian Bead Stringers, 413
Venetian Lace Makers, 410
Breck, John Leslie, 422
Santa Maria della Salute, 422
Brown, George Loring, 288
Monte Pellegrino at Palermo, Italy, 291
Tivoli (The Falls of Tivoli), 289
Brush, George DeForest, 380
Mother Reading, 380
Chapman, John Gadsby, 304
Artist on Donkey (Looking for Good Scenery), 438
Castel di Leva, Near Rome, 305
Chapman, John Linton, 218
Appian Way, 278
Tombs of Keats and Shelley, 219
Chase, William Merritt, 358
The Song, 359
Church, Frederic E., 437
Arch of Titus (with Healy and McEntee), 244
Rome Rooftops, 437
St. Peter's, Rome, Shown from the Pincio, 438
Cole, Thomas, 178
Aqueduct near Rome, 260
Dream of Arcadia, 178
Il Penseroso, 180
Interior of the Colosseum, Rome, 192
L'Allegro, 180
Mount Etna from Taormina, 262
Salvator Rosa Sketching Banditti, 437

A View near Tivoli, 286
View of Florence from San Miniato, 331
Coleman, Charles Caryl, 376
The Bronze Horses of San Marco, Venice, 386
Villa Castello, Capri, 376
Copley, John Singleton, 156
Mr. and Mrs. Ralph Izard (Alice De Lancey), 156
Crawford, Thomas, 166
Christian Pilgrim in Sight of Rome, 196
Hyperion, 167
Orpheus and Cerberus, 167
Cropsey, Jasper Francis, 203
Evening at Paestum, 267
Roman Forum, 203
Temple of Paestum by Moonlight, 268
Duncanson, Robert Scott, 186
Recollections of Italy, 187
Durand, Asher B., 194
Head of a Roman, 194
Duveneck, Elizabeth Lyman Boott, 247
Narcissus on the Campagna, 248
Duveneck, Frank, 356
Flower Girl, 415
Francis Boott, 369
Italian Courtyard, 357
Tomb Effigy of Elizabeth Boott Duveneck (with Clement J. Barnhorn), 371
Gifford, Sanford Robinson, 229
Galleries of the Stelvio—Lake Como, 300
In St. Peter's, Rome, 437
Italian Sketchbook, 438
Lake Nemi, 296
Riva—Lago di Garda, 299
St. Peter's from Pincian Hill, 230
Villa Malta, Rome, 232
Greenough, Horatio, 333
Arno, 337
Bust of George Washington, 333
Love Prisoner to Wisdom, 336
Hall, George Henry, 206
Roman Wine Cart, 206
Hamilton, James, 270
The Last Days of Pompeii, 270
Haseltine, William Stanley, 293
Capri, 295
Marina Piccola, Capri, 293
Heade, Martin Johnson, 201
Roman Newsboys, 201
Healy, George Peter Alexander, 244
Arch of Titus (with Church and McEntee), 244
Hicks, Thomas, 198
Margaret Fuller, 198

Hosmer, Harriet, 226
Clasped Hands of Robert and Elizabeth Barrett Browning, 447
The Sleeping Faun, 227
Hotchkiss, Thomas Hiram, 273
Torre di Schiavi, 273
Hunt, William Morris, 234
Italian Peasant Boy, 234
Inness, George, 210
Ariccia, 314
Lake Albano, 308
Lake Nemi, 310
The Monk, 312
St. Peter's, Rome, 211
Keck, Charles, 378
Elihu Vedder, 378
Lewis, Edmonia, 241
Bust of Henry Wadsworth Longfellow, 242
Manship, Paul, 382
Lyric Muse, 382
Pauline Frances, 383
McEntee, Jervis, 236
Arch of Titus (with Church and Healy), 244
The Ruins of Caesar's Palace, 236
Moore, Charles Herbert, 388
Venetian Doorway, 389
Moran, Thomas, 419
The Fisherman's Wedding Party, 419
Morse, Samuel F. B., 282
Chapel of the Virgin at Subiaco, 284
Sketch for The Chapel of the Virgin at Subiaco, 282
Mowbray, H. Siddons, 373
Le Destin, 373
Newman, Henry Roderick, 318
Anemones, 346
Florence, Duomo from the Mozzi Garden, 347
Gulf of Spezia, 318
Santa Maria Novella, Florence, 349
Page, William, 216
Mrs. William Page (Sophia Candace Stevens Hitchcock), 216
Peale, Rembrandt, 159
Madonna della Seggiola, after Raphael, 162
Portrait of William Short, 160
Powers, Hiram, 339
Bust of Horatio Greenough, 342
Greek Slave, 339
Prendergast, Maurice Brazil, 252
Easter Procession at St. Mark's, 434
The Grand Canal, Venice, 428
Monte Pincio, Rome, 252
Rainy Day, Venice, 430

Splash of Sunshine and Rain, 432
Umbrellas in the Rain, Venice, 426
Rimmer, William, 250
Torso, 250
Rinehart, William Henry, 344
Evening, 344
Morning, 344
Rogers, Randolph, 208
Columbus Departing from the Convent of La Rabida, 1492, 208
Nydia, The Blind Flower Girl of Pompeii, 264
Saint-Gaudens, Augustus, 449
Hannah Rohr Tuffs, 449
John Singer Sargent, 447
Youthful Mars, 449
Sargent, John Singer, 255
Carrara: Wet Quarries, 323
The Fountain, Villa Torlonia, Frascati, Italy, 255
In a Medici Villa, 361
An Interior in Venice, 404
The Pavement of St. Mark's, 402
The Rialto, 408
The Salute, Venice, 406
A Venetian Interior, 400
Venetian Street, 398
Villa di Marlia: A Fountain, 321
Story, William Wetmore, 183
Arcadian Shepherd Boy, 184
Sappho, 224
Tanner, Henry Ossawa, 424
Venetian Bridge, 425
Thaxter, Edward R., 351
Meg Merrilies, 351
Twachtman, John Henry, 417
The Lagoon, Venice, 418
Vanderlyn, John, 164
Caius Marius Amid the Ruins of Carthage, 164
Vedder, Elihu, 316
Bordighera, 316
The Cumaean Sibyl, 366
In Memoriam, 368
Volterra, 364
Weir, Robert Walter, 221
Taking the Veil, 221
West, Benjamin, 150
Agrippina Landing at Brundisium with the Ashes of Germanicus, 152
Angelica and Medoro, 150
Portrait of Mrs. West with her son Raphael, 154
West, William Edward, 328
Lord Byron's Visit to the U.S.S. Constitution, 328

Whistler, James A. McNeill, 390
Calle San Trovaso, Venice, 392
A Canal in Venice (Tobacco Warehouse), 392
The Lagoon, Venice: Nocturne in Blue and Silver, 391
Note in Flesh Color: Giudecca, 392
Venetian Scene, 392
Whitney, Anne, 238
Roma, 238
Wilde, Hamilton, 438
Wall of the Browning's Villa, 438

A

Abbey, Edwin Austin 255
Abele, Julian 8, 438
 Basilica Palladiana, Vicenza 438
Abetone 353, 356
Accarsi, Ditta G. 451
Acton, Lord 293
Adam, Robert 154
Adams, Henry 64, 87, 93
Adams, Herbert 382-383
Adams, John 35, 351
Adams, John Quincy 335, 339
Adams, William A. 287
Aeneas 308, 311
Aeneid 311
African Americans 186-188, 241-242, 424-425, 438
Agrigento 131, 178, 292, 439
Agrigentum 40
Ainsley, Samuel 178, 262
Alaska 293
Alatri 42, 441
Alba Longa 308
Alban hills 49, 176, 210, 260, 278, 308, 310, 314
Albano 39, 41-43, 47-49, 57, 164, 174, 178, 198, 218, 288, 296, 305, 308, 310, 313-314
Alberti, Leon Battista 310, 349
Alessandria 244
Alexander VII 314
Alexander, Esther Frances ("Francesca") 8, 248, 350, 353-356
 Roadside Songs of Tuscany 353-356
 Story of Ida 353
 Christ's Folk in the Appenines 353-356
 Christmas Hymn of Fiumalbo (Per la Natività di Nostro Signore) 354
 Life of Saint Zita 354-356
 Polissena 355-356
Alexander, Francis 76, 118, 127-128, 178, 248, 260-261, 353, 356
Alexander, John White 356, 360
Alexandria, Egypt 373
Algeria, the 210
Alinari 28, 52, 66, 129, 158, 224, 236, 244, 288
Alison, Archibald, the Rev. 30
Allen, Harriet Emily Trowbridge 91
Allen, Henry 83, 88, 92-93
Allen, John 28, 31-32, 62, 150
Allen, Theodore 53, 64
Allen, William 31, 115, 150
Allori Cemetery, Florence 353

Allston, Washington 25, 38, 44, 63, 80, 95, 113, 164, 172-177, 184, 190-191, 218, 232, 282-283, 288, 302, 333, 336, 441
 Diana in the Chase 172-174
 Italian Landscape (1805, Addison Gallery) 39
 Italian Landscape (c. 1805, Baltimore) 39
 Italian Landscape (1814, Toledo) 39, 174-175
 Italian Shepherd Boy 184
 Jason Returning to Demand his Father's Kingdom 164, 172
 Landscape with a Lake 172, 174
 Marius at Minturnae 164
 Monaldi 41, 54, 172, 441
 Moonlit Landscape 176
 Samuel Taylor Coleridge 172, 174, 218
 Self-Portrait 190
 "Sonnet to Coleridge" 176
 "Sylphs of the Seasons" 176
 Thunderstorm at Sea 174
Alma-Tadema, Sir Lawrence 376
Alps 116, 159, 164, 172, 203, 213, 229, 236, 255, 293, 302, 316
Alsager, Mary Grey 376
Alta California 96, 443
Altamura, Francesco Saverio 364
Altobelli 244
Alvino & Co., Florence
 Frank Duveneck and Elizabeth Boott Duveneck 249, 440
Amalfi 58, 194, 203, 213, 267, 282, 293, 296, 304
Ambuchi, Antonio 339, 341
American Academy of the Fine Arts, New York 62, 164, 166
American Academy, Rome 15, 61, 69, 137, 141, 144, 246, 293-294, 378, 380, 382-383
American Art Gallery, New York 390
American Church 90
American Philosophical Society, Philadelphia 62, 162
American School of Archeology, Rome 376
American School of Architecture 61
American Watercolor Society 390
Ampere, Jean Jacques 212
Ancona 160
Anderson, Hendrik Christian 136-137
Anderson, Larz 373
Anderson, Sophie 376
Anderson, Walter 376
Anio Novus River 260
Anio River 286, 290

Annalena convent 339
Antonelli, Giacomo, Cardinal 238
Anzio 210
Aphrodite from Cyrene 341
Apollo Belvedere 22, 33-38, 41, 56, 129-130, 167-168, 227, 238
Apollo Musagetes 167
Appenines 58, 287, 353, 355-356
Appiani, Andrea 131
Appleton, Frances Elizabeth 432, 438
 Sketchbook from her European Travels 432
Appleton, Nathan 438
Apthorp, John 33
Aquila 200
Ara Pacis Augustae, Rome 153
Arcadia 7-8, 24-27, 43, 63-64, 91, 130, 173, 175, 177-181, 183, 185, 187-188, 310, 313
Arch of Constantine, Rome 32, 236
Arch of Nero 44, 286-288
Arch of Septimius Severus 205
Arch of Titus 50, 164, 205, 244, 246, 438, 442
Archipenko, Alexander 133
Arco Oscuro 212
Aretino, Pietro 369
Arezzo 22, 229
Ariccia 178, 203, 314-315
Ariosto, Ludovico 150
Armstrong, David Maitland 46, 63-64, 93, 274
Arno River 47, 60, 318, 323, 331, 337-347, 356, 357, 364
Arnold, C.D. 61
Arnolfo's Tower 347
Arsenal, Venice 112
Art Journal 62, 74, 127-128, 168, 188, 226, 228, 246, 248, 276, 279, 296, 329, 345, 347, 360, 390, 419-420, 439
Art Students League 358, 383-384
Arte Povera 142
Artemis 158
Ashburton, Lady 386, 388
Ashcan School 132
Ashe, George 29
Ashridge Hall 345
Asiago 356
Asselijn, Jan 176
Assisi 57, 229, 252
Association for the Advancement of Truth in Art 124, 318, 348, 388
Athens 37-38, 62, 284, 318, 438
Attatant, the 23

Atterbury, Grosvenor 125
Augustus, Emperor 236
Aurelian wall 220
Austin, Edward 196
Austria 120, 201, 229
Austro-Prussian War 128
Avet, Louis 449

B

Bacher, Otto 356, 396, 398, 410, 412-413, 419
 Doge's Palace from the Lagoon 396
 With Whistler in Venice 396, 398, 419
Baciocchi, Elisa 323
Baedeker, Karl 256, 302, 323, 325, 353, 372, 428, 445
Bagni Caldi, Lucca 184
Bagni di Lucca 184, 244
Baiae, Bay of 296
Balbo, Italo 145
Ball, Thomas 83, 90, 213, 236, 238, 241, 339, 372
Balla, Giacomo 132
Baltimore, Maryland 344-345
Bambino, Santa Maria in Ara Coeli, Rome 383
Banditti 23, 40, 51, 437, 441
Baptistery, Florence 209
Barbaro, Francesco 406
Barbary War 328
Barbee, William Randolph 83
Barberini Faun 184, 214, 228
Barbizon School 210
Barbot, Prosper 314
Barnhorn, Clement J. 371
Bartholomew, Edward Sheffield 69, 87-88, 224
Bartlett, Alice 248
Bartlett, William 318
Bartolini, Lorenzo 67, 134, 208, 333, 339
Basilica Palladiana, Vicenza 438
Baths of Caracalla, Rome 220, 451
Baths of Diocletian 166
Batoni, Pompeo 34, 62, 150, 154, 158, 160
Battersea Reach 392
Batty, Elizabeth 332
Bavaria 232, 293, 356
Bay of Naples 21, 40, 47, 50, 63, 109-110, 175, 276, 438
Bay of Naxos 262
Beard, William Holbrook 229
Beck, George 328
Beggars 23, 54-55, 205
Belgium 244, 410, 417
Belisarius 164, 440
Bellini, Gentile 101, 432, 434

Bellinzona 172
Bellosguardo 247-248, 333, 347, 353, 356-358, 371
Belvedere Antinous 344
Belvedere Torso 34, 57, 250
Benbridge, Henry 62
Benedict XIV 192
Benedict, Erastus 83
Benson, Eugene 230
Benvenuti, Pietro 221
Benzoni, Giovanni Maria 67
Berenson, Bernard 33, 123, 126, 128, 444, 451
 The Venetian Painters of the Renaissance 126, 234, 444
Berkeley, George, Bishop 29
Bernardi, Beatrice 354
Bernini, Gian Lorenzo 353
Bethmann's Museum, Frankfurt 91
Betty Sally, the 150
Biddle, James, Commodore 333
Bierstadt, Albert 48, 64, 213-214, 229, 232, 260, 269, 276, 283, 293, 300, 302, 304, 438
 The Arch of Octavius (Roman Fish Market) 214
 Fishing Boats at Capri 294
 Italian Costume Studies 304
 Lake Lucerne 172, 213
 Mt. Aetna (Vesuvius) 276
 Mount Vesuvius at Midnight 276
 Olevano 302-304
 Marina Piccola, Capri 50, 213
Bingham, George Caleb 56-57
Birch, Thomas 328
Blue Rider 130
Blum, Robert Frederick 123, 410, 413-415, 417
 A Morning in St. Mark's 402, 436
 Busy Hands 314, 413
 Dutch Girl by a Window 413
 In the Laundry 413
 Knitting 412-413
 The Chat 413
 The Libreria, Venice 124
 Venetian Lace Makers 410
 Venetian Bead Stringers 402, 413-415
Blume, Peter 138-139
Boccaccio 30
Boccioni, Umberto 132
Böcklin, Arnold 312
Boghosian, Varujan 143
Boit, Edward Darley 105, 248
Boker, George Henry 266
Bologna 22, 31, 150, 156, 160, 164, 167, 172, 194, 198, 229, 255, 304, 419, 424, 445, 450

Bolognese 22
Bonaparte, Napoleon 116
Bonfigli, F. Saverio 92
Bonheur, Rosa 208
Bonington, Richard Parkes 117
Boott, Francis 247, 356, 369-372
Bordighera 58, 316, 376
Borghese Gardens 252
Borromini 144
Boston Art Club 240, 247
Boston Athenaeum 11, 14, 57, 74, 166-167, 184, 196, 200, 214, 250, 252, 292, 333, 335, 337, 341, 442-444
Boston Public Library 11, 14, 184, 196, 255, 336, 402, 442
Boston Water Color Club 436
Boston, Massachusetts 4, 62, 64, 126, 156, 206, 210, 238, 244, 288, 333, 353, 422
Boswell, James 62
Both, Jan 57
Botticelli, Sandro 361, 444
Bouguereau, William Adolphe 234
Bowdoin, James III 62
Brabazon, Hercules 420
Brackett, Edward 241
Bramante 144, 211
Brancusi, Constantin 133
Breck, John Leslie 422-424
 Santa Maria della Salute 422-424
Breenbergh, Bartholomeus 289
Brera Gallery, Milan 270
Breton, Jules 206
Brett, John 347
Brewster, Anne Hampton 92
Bridge of Sighs 97, 99, 117, 397, 426, 428
Brimmer, Martin 400, 402
Brindisi 152, 229, 278
Bristol, England 174
Briullov, Karl Pavlovic 270
Bronson, Charlotte Brinckerhoff 92
Bronzino 162
Brooklyn Museum 11, 64, 128, 234, 270, 278-279, 300, 347-348, 361-362, 366
Brown, George Loring 44, 48, 50, 67, 78, 119, 128, 212, 229, 288-292, 314
 August Morning near Rome, Ariccia, Italy 314
 Bay of Naples 63
 Monte Pellegrino at Palermo, Italy 291-292
 Sunset on the Tiber, Rome 212
 The Doge's Palace at Moonlight 119
 Tivoli (The Falls of Tivoli) 289-290

View of Tivoli at Sunset 290
View of the Grand Canal, Venice, Recollections of Turner 119
Brown, Henry Kirke 68, 72, 82, 86, 196, 234
Brown, Nicholas II 448
Browning, Elizabeth Barrett 216, 226, 341, 439, 447
Browning, Penini 438
Browning, Robert 224, 404, 439
Brownlow, Earl of 345
Bruen, Matthias 75, 92, 116, 124, 127, 323, 325
Brunelleschi 347
Brush, George de Forest 358, 380-381
 Family Group 380
 Mother Reading 380
 Portrait 380
Brutus 44, 164
Bryan, Thomas Jefferson 33
Bryant, William Cullen 43, 50-51, 72, 81, 86, 92, 119, 261, 269, 304
Bucks County, Pennsylvania 159, 201
Buffum, William Arnold 448
Bulfinch, Charles 26
Bullard, Anne T.J. 92
Bullard, Laura Curtis 241-242
Bulwer-Lytton, Edward 57, 86, 264, 266, 270, 272
Bunce, William Gedney 252
Bunney, John W. 386
Burano 410, 412, 425
Burnham, Daniel 61
Burr, Aaron 164
Byron, George Gordon, Lord 41, 76, 116-117, 127, 192-193, 328

C

Ca' d'Oro 117, 125-126, 398
Cabell, Joseph Carrington 41, 63
Cabot, Samuel 336
Cadmus, Paul 138
Caffi, Ippolito 118
Calabria 38, 206
Calder, Alexander 136
Caligula, Emperor 310
Caltagirone 262
Calvert, George Henry 70, 77, 92
Cambridge, Massachusetts 121, 198, 247
Cambridgeport, Massachusetts 172
Campagna, Roman 39, 45, 53, 176, 182, 212, 260, 273-274, 286, 304, 314, 364, 419
Campanile 125, 331, 347, 397, 418-419
Campidoglio 286

Campo Santo Monumentale, Milan 135
Canaletto 115, 117-118, 121-122, 203, 407, 420
Canfield, Richard A. 391
Canina, Luigi 278
Canova, Antonio 66, 226, 386
Capitoline Hill 205
Capitoline Museum, Rome 38, 184, 214, 224, 266
Capitoline Runner 167
Capranica Prenestina 304
Capri 19, 21, 47, 49-50, 58, 109, 198, 203, 206, 213, 229, 244, 252, 255, 267, 282, 288, 293-296, 300, 304, 316, 376-379, 438, 440-441
Caproni, P.P. and Brothers, Boston 39
Capua 278, 323
Caravaggio 59, 174
Carey, Henry 221
Carnival 59, 115, 198, 238, 451
Carpaccio, Vittore 389, 428
Carpeaux, Jean-Baptiste 131
Carracci, Annibale 150
Carracci, the 156
Carrara 21, 60, 68-69, 75, 91-92, 135, 229, 255, 282, 323-325, 333, 364
Carter, George 156
Carthage 127, 164
Cartwright, Julia 408-409, 428, 430
Casa Guidi 439
Casa Jankowitz 390, 396, 410, 418
Casanova, Giovanni 115
Cascata Grande 290
Casilear, John 194
Cassatt, Mary 59
Castel Gandolfo 184, 308, 310, 312
Castel Madama 286
Castel Sant'Angelo 230, 445
Castel di Leva 305-306
Castellani, Fortunato Pio 448
Castello 302, 361-362, 376-377
Casts 21, 34-36, 38, 56, 62, 166, 198, 221, 228, 250, 252, 284, 344
Catacombs of St. Callistus, Rome 279
Catania 53, 178, 264
Catel, Franz 278-279
Cathedral of St. John the Divine, New York 371
Catholicism 26, 33, 48-49, 58, 208, 286, 383, 442
Catskill, New York 178
Catullus 44
Causici, Enrico 335
Cavalleri, Fernando 50-51
Cavallon, Giorgio 138
Cazin, Jean Charles 402

Cellini 133
Cenci, Beatrice 88, 226, 379, 437
Centennial Exposition, Philadelphia 248, 266
Central America 201
Century Magazine 128, 410, 444
Ceppo Morelli 229
Cerberus 166-168, 196, 341
Cervara 49, 283-284
Champney, Benjamin 45, 49, 198, 212, 250, 252, 260
Chantrey, Sir Francis 335
Chapman, Conrad Wise 218, 221, 274, 305
Chapman, John Gadsby 48, 50-51, 64, 67, 108, 118, 218, 221, 282, 304-306, 312-313, 438
 Artist on Donkey (Looking for Good Scenery) 438
 Castel di Leva, Near Rome 305-306
 Hagar and Ishmael Fainting in the Wilderness 304
 Harvesting on the Campagna near Rome 278
 Harvesting on the Roman Campagna 304
 John Gadsby Chapman in his Studio 51
 Pines of the Villa Barberini 313
 Vesuvius from Marina Grande, Sorrento 48, 63
Chapman, John Linton 218-221, 230, 278
 Appian Way 278-279
 Tombs of Keats and Shelley 219
Charles III, King of Two Sicilies 270
Charleston, South Carolina 51, 64, 119, 156, 437
Chase, William Merritt 59, 356, 358-360, 410, 415, 417
 A Memory: In the Italian Villa 360
 A Venetian Balcony 358
 Ponte Vecchio 331, 358
 The Song 242, 359-360
Chateaubriand, Francois René 72, 90
Chekov, Anton 112, 127
Child, Lydia Maria 242
Chiogga 396
Choate, Mabel 128
Christina of Sweden, Queen 230
Church, Frederic Edwin 46, 50, 53, 244, 437-438
 Arch of Titus (with Healy and McEntee) 50, 244-246, 438
 Rome Rooftops 437-438
 St. Peter's, Rome, Shown from the Pincio 438
Cincinnati Anti-Slavery League 24, 186
Cincinnati, Ohio 201, 356, 360, 410, 417
Cincinnatus 32
Circus of Maxentius 279
Civita Castellana 293
Civitavecchia 178, 229
Civitella 283

Clark, Alfred Corning 415
Clarke, James Freeman 91
Claudian Aqueduct 46, 166, 260, 286
Claudius, Emperor 45, 260
Cleveland, Mrs. Henry Russell 196
Clevenger, Shobal 68-69, 80-81
Clock Tower 386, 388, 397, 400, 430
Cobb, Darius 314
Coburn, Alvin Langdon 126, 404
Cogniet, Leon 312
Col de Seigne Pass 229
Cole, Thomas 21-22, 27, 30, 39, 42, 44, 46-47,
 49-51, 54, 60-61, 63, 95, 116, 118, 127-128, 178, 180,
 182-183, 187, 192-193, 203, 220, 260-262, 264,
 269, 273, 286, 288, 290, 298, 310, 331-333, 364,
 437, 442, 450
 Aqueduct Near Rome 45, 260, 442
 Course of Empire 45, 61, 179, 182, 262, 264, 332
 Dream of Arcadia 178-180, 310
 "Essay on American Scenery" 43-44, 52, 63,
 180
 Evening in Arcady 182, 260
 Il Penseroso 43, 180-183, 298, 310
 Interior of the Colosseum, Rome 192
 L'Allegro 43, 180-183
 Mount Etna from Taormina 47, 262-264
 Roman Campagna 45, 260
 Salvator Rosa Sketching Banditti 437
 Schroon Mountain 180
 "Sicilian Scenery and Antiquities" 27, 264
 Study for Aqueduct Near Rome 260
 Subsiding of the Waters of the Deluge 261
 Sunny Morning on the Hudson 44
 The Cascatelli, Tivoli, Looking Towards Rome 44
 The Protestant Cemetery in Rome 220-221
 The Return 182, 410
 The Temple of Segesta with the Artist Sketching 46
 A View Near Tivoli 44, 286-288
 View of Florence from San Miniato 47, 331
 View of Mt. Etna 262, 264
 View of the Catskill 332
Coleman, Charles Caryl 123, 128, 229, 316, 376,
 386, 440
 Garden of the Villa Castello, Capri 377
 In the Shade of the Vines 376
 The Bronze Horses of San Marco, Venice 386
 Villa Castello, Capri 376-377
Coleridge, Samuel Taylor 172, 174, 218
College of William and Mary, Virginia 160
Colman, Henry 81, 92
Colman, Samuel 122, 392

Colosseum 21, 23, 34, 48, 57, 156, 192-193, 205-206,
 216, 218, 236, 244, 246, 448
Columbus, Christopher 134, 208, 210
Column of the Immaculata 438
Column of Phocas 205
Compton, Anne, Countess of Northampton 113
Conca d'Oro 291
Connelly, Pierce 63, 90
Conservatorio di Santa Cecilia 222
Constable, John 178
Constantinople 114, 205, 386, 402
Convent of San Benedetto, Subiaco 284
Cooke, George 37, 48, 62, 304
Cooper, James Fenimore 21, 25, 27, 38, 46, 63, 76,
 87, 97, 113, 124, 127-128, 178, 282, 304, 333, 335-
 336, 441
 Gleanings in Europe 27, 38, 63-64, 128
 The Bravo 97, 113, 441
Copeland & Garrett 447
Copley, John Singleton 33-34, 62, 113, 126, 156, 158,
 268, 440
 Ascension 34, 336, 388
 Boy with a Squirrel 33, 150
 Mr. and Mrs. Ralph Izard (Alice De Lancey) 34, 156,
 158
Cori 42
Corné, Michele Felice 23
Cornelius, Peter von 190
Corot, Jean-Baptiste Camille 230, 304, 308
Correggio 31-35, 40, 59, 62-63, 112, 150, 156, 162,
 440
Corsica 62
Cosmopolitan Hospital, Venice 252
Costa, Giovanni (Nino) 364
Couper, William 372
Couture, Thomas 198, 208, 234, 244, 247
Cox, Samuel Sullivan 75
Cozens, Alexander 30
Cozens, John Robert 298, 314
Cranch, Christopher Pearse 48-49, 63-64, 121,
 184, 269, 283, 310
Cranch, John 49, 178, 364
Crassus 321
Crawford, Thomas 68, 74, 77, 91, 166-168, 196,
 198, 203, 208, 216, 220, 224, 229, 288, 341, 344,
 442
 Adam and Eve 78
 Anacreon and a Nymph 77
 Babes in the Woods 86
 Boy Playing Marbles 78
 Bride of Abydos 78

Christ Ascending from the Tomb 196
Christ Blessing the Children 196
Christ and the Woman of Samaria 196
Christian Pilgrim in Sight of Rome 196
Daughter of Herodias 85
Flora 86, 162, 192, 216
George Washington 85
Hebe and Ganymede 78, 86
Hyperion 167-168, 244
Mexican Girl Dying 85
Mrs. Schermerhorn 77
Orpheus and Cerberus 166-168, 196, 341
Patrick Henry 85
Sappho 78
The Genius of Mirth 78
Thomas Jefferson 85
Crevecoeur, St. John de 51, 64
Cromeck, Thomas 246
Cropsey, Jasper Francis 203-204, 267, 273
 Evening at Paestum 267-269
 Roman Forum 203-205
 Temple of Ceres 268-269
 Temple of Paestum by Moonlight 267-269
Crowninshield, Frederic 248, 344
Crowninshield, Jacob 441
Cumaean Sibyl 162, 366, 379
Curtis, Ariana Wormely 404
Curtis, Burril 198
Curtis, Daniel 404
Curtis, George 198
Curtis, Lisa Colt Rotch 404
Curtis, Ralph 398, 406
Cushman, Charlotte 24, 216, 226, 351
Cuyp, Aelbert (after) 184

D
Dahl, Johann Christian 276
Dana, Richard Henry 176, 220
Dana, William Coombs 91
Dance, Nathaniel 62, 150
Dancing Faun 34-35, 57, 181
Dannecker, Johann Heinrich von 86, 91
Dante 41, 59, 130, 221, 240, 244, 321, 351, 372, 424,
 442-443
Danti, Ignazio 350
David, Jacques-Louis 152, 190, 308
Day, Katharine S. 451
De Veaux, James 49, 62-63, 118-119, 128, 220, 288
Debussy, Claude 360
Decamp, Joseph 356
Degas, Edgar 131, 408

Delafield, John 221
Deman, Esther van 26, 69
Demidoff, Anatole, Prince 72, 341
Descamps, Alexandre-Gabriel 208
Desiderio da Settignano 383
Dewing, Thomas Wilmer 360
Diana Nemorensis, cult of 310
Diana of Ephesus 172
Dickens, Charles 278-279
Dike, Henry A. 316
Dillis, Georg von 212
Diocletian, Emperor 154, 244
Discobolus 34
Dix, Charles Temple 220
Dixwell, Anna P. 248
Doge's Palace 116-117, 119, 122, 124, 126, 200, 396-
 398, 419, 426-427, 430
Domenichino 22, 31, 62, 150, 162, 366, 379
Domitian, Emperor 308
Domodossola 116
Don Pirlone, Il 201
Donatello 133, 351, 383
Dow, Arthur Wesley 432
Downman, John 154, 162
Drake, A.W. 410
Drummond, Robert Hay 152
Ducros, Abraham Louis 314
Dughet, Gaspard 39, 43-44, 63, 290, 298, 310-311,
 314
Dumond, Frank 230
Duncanson, Robert Scott 180, 186-188
 Recollections of Italy 180, 187-188
Dunlap, William 51, 62-63, 282, 288, 328, 331-332,
 440
Duomo, Florence 331-332, 347-348
Dupré, Giovanni 224, 226
Durand, Asher B. 51, 64, 118, 178, 180, 194, 286
 Head of a Roman 194
 Il Pappagallo 194
Dürer, Albrecht 19
Duveneck, Elizabeth Lyman Boott 247-248
 Narcissus on the Campagna 248
Duveneck, Frank 95, 123, 247-249, 356-358, 369-
 372, 396, 410, 415-418, 440
 Florentine Flower Girl 415
 Flower Girl 415-417
 Francis Boott 369-372
 Italian Courtyard 357-358
 Italian Girl with a Rake 415
 Lady with a Fan 371

Siesta 415
Tomb Effigy of Elizabeth Boott Duveneck (with
 Clement J. Barnhorn) 371-372
 Water Carriers, Venice 415, 417
Dwight, Theodore 63
Dying Gaul 238

E

Eakins, Thomas 59, 62, 64, 360, 424, 426
Eames, Jane Anthony 77, 80, 92
Eastlake, Charles 196, 228
Eckersberg, Christoffer Wilhelm 48, 192
Ecole des Beaux-Arts, Paris 380
Eddy, Daniel Clarke 92
Edmonds, Francis W. 194
Egeria, Fountain of 284
Elgin Marbles 38
Emerson, Ralph Waldo 39, 51, 63-64, 127, 198,
 244, 422
Emmet, Lydia Field 255
Erasmus 33
Erato 220, 382
Erhardt, Wolfgang 293
Eros of Centocelle 200
Errard, Charles 230
Etruscan 212, 364, 368, 449
Etty, William 117
Eurydice 167
Eustace, John, the Rev. 112
Evans, DeScott 396
Everett, Edward 56, 87, 89-91, 335, 338
Exposition Universelle, Paris 123, 128, 212, 410

F

Faber, Joachim 312
Falconnet, Julie 88
Farinola, Marchese 321, 325
Fascism 132, 137-138, 141
Fates, the 373
Fattori, Giovanni 131, 364
Faun in Repose 228
Faun of Praxiteles 52
Favretto, Giuseppe 413
Fazzini, Pericle 143
Fellini, Federico 142
Ferrara 159, 194, 198
Festa Infiorata, Genzano 284
Feuerbach, Anselm 131
Field, Kate 316
Fiesole 58, 180, 358

Fildes, Luke 390, 413
Fine Art Society, London 390
First Triumvirate 321
Fisk, Wilbur 76, 92
Fiske, Samuel 83, 86
Fitzgerald, Edward 379
Fitzgerald, F. Scott 140
Flagg, Edmund 115, 120, 128
Flavian Amphitheater 192
Flaxman, John 238
Florence 7, 19-22, 24-25, 28-31, 33-34, 36-37, 42-43,
 47, 49-50, 54, 56, 58, 60, 66-70, 72, 74-86, 89-
 91, 93, 96, 98, 105, 109, 111, 114, 119, 133, 150, 152,
 154, 156, 159-160, 162, 164, 167, 172, 174, 178, 180,
 183, 186, 194, 198, 200-201, 203, 208-210, 213, 216,
 218, 220-221, 224, 229, 234, 236, 238, 241-242,
 244, 247, 250, 252, 255, 260, 269, 273, 282, 287-
 288, 291, 296, 304, 316, 318, 321, 323, 325, 327-362,
 364, 369, 371-373, 376, 380, 383, 388, 390, 396,
 402, 415, 417-419, 424, 438-443, 445, 448, 450-
 451
Foggia 229
Foley, Margaret 24, 73, 90, 238
Forney, John 90
Forster, E.M. 347
Forsyth, Joseph 63
Forum 21, 38, 48, 203-205, 227, 236
Fortuny y Carbo, Mariano José Maria 412
Fowler, George 124, 420
Fraccaroli, Innocenzo 72
Fragonard, Jean-Honoré 290
Franco-Prussian War 244
Franklin, Benjamin 51
Franklin, Maud 392, 395-396
Franklin, Sir Arthur and Lady 244
Franque, Joseph 272
Frascati 4, 40, 164, 206, 255-256, 283, 362
Fraser, Charles 56
Frazee, John 166
Frazer, Sir James 310
Freeman, Florence 24, 89
Freeman, James E. 64
Freer, Charles Lang 377
French Academy, Rome 31, 156, 230
Friedrich, Caspar David 312
Fuller, Hiram 75, 83, 89, 92-93
Fuller, Margaret 25, 39, 52, 63-64, 80, 84-86, 92-
 93, 198-201, 384, 439-440
Futurism 130, 132, 145
Futurist Manifesto 132

G

Galleria Colonna, Rome 194
Galli Brothers Foundry 372
Galloro 314
Galt, Alexander 82, 93
Gardens 22, 26, 49, 60, 101, 114, 232, 252, 255-256, 290, 292, 321, 323, 339, 347, 358, 361-362, 376-377, 391, 419, 444
Gardner, Isabella Stewart 11, 33, 125-126, 128, 361, 404, 418, 444, 447, 451
Garibaldi 238
Garrison, William Lloyd 24, 241
Gaspari, Antonio 214, 406
Gell, William 305
Genoa 22, 40, 76, 94, 96-97, 108, 135, 156, 159-160, 178, 198, 203, 213, 229, 244, 255, 282, 316, 318, 410, 450
Genzano 198, 284, 310, 314
George III, King 152
German Artists' Club 232
Gerome, Thomas 377
Geta 205
Ghetto 214
Ghiberti, Lorenzo 209
Giambologna 133
Gibbon, Edward 114, 121, 127
Gibson, John 21, 67, 78, 85-86, 88, 226, 228, 339
Gifford, Sanford Robinson 229-230, 232, 296, 298, 300, 302
 Bierstadt Sketching at the Piccola Marina, Capri 50, 438
 Galleries of the Stelvio - Lake Como 300
 In St. Peter's, Rome 212, 437
 Italian Sketchbook 300, 438
 Lake Nemi 296-298
 Riva—Lago di Garda 299-300
 Sketch for Lake Nemi 298
 St. Peter's From Pincian Hill 230
 Venetian Sails: A Study 122
 Villa Malta, Rome 232
Gillespie, Gregory 143
Gillespie, William 78
Gilmor, Robert 76, 116, 336
Ginain, Paul-René-Léon 264
Gioberti, Vincenzo 201
Giorgione 409
Giotto 22, 33, 55, 229, 331, 349-350
Giudecca 102, 392, 395, 422
Glackens, William 126
Glehn, Jane Emmet von (de) 255-258
Glehn, Wilfred, von (de) 255-258

Gleyre, Charles 123
Goethe, Johann Wolfgang von 41, 51, 162, 292
Goldoni, Carlo 104
Goodwin, Albert 420
Gould, Helen Day Miller 446
Gould, Jay 446
Gould, Thomas 73, 90
Gounod, Charles 244
Goupil's Gallery, New York 221
Grand Hotel de Catane, Catane 451
Grand Hotel, Frascati 255
Grand Tour 7, 29-31, 33-34, 36, 41, 50-51, 54, 56, 61-62, 64, 1, 66-67, 69, 71, 73, 75, 77, 79, 81, 83, 85, 87, 89, 91, 93, 107, 1, 113, 115, 117, 119, 121, 123, 125, 127, 129, 149-153, 155-157, 159-161, 163, 165, 167, 169, 270, 272, 284, 445
Grandi, Giuseppe 134
Gray, David 366
Gray, Thomas 54, 64
Greco, Emilio 143
Greece 21, 35, 48, 51, 73, 143, 166, 184, 227, 229, 267-268, 278, 378, 382, 386, 445, 448
Greeley, Horace 81-82, 92, 198
Greenough, Alfred 45
Greenough, Henry 178, 247, 335, 338, 364
Greenough, Horatio 25, 68, 70, 74-75, 91, 136, 159, 178, 194, 221, 229, 252, 282, 304, 333, 335-339, 341-342, 351, 440
 Arno 337-338
 Bust of George Washington 333-336
 Chanting Cherubs 74, 76, 333, 336, 341
 Head of Christ 196
 Lafayette 76
 Love Prisoner to Wisdom 336-337
 Lucifer 196
 Medora 76
 The Ascension of a Child Conducted by an Infant Angel 336
 The Rescue 82
Greenough, Richard 73, 86
Gregorovius 293
Grice, Hawks le, Count 77, 92, 286
Gubbio 273
Guercino 22, 62, 174
Guggenheim, Peggy 141
Guiccioli, Countess Teresa 328
Guild of St. George 388
Gulf of Spezia 4, 220, 318, 321, 347
Guston, Philip 140-141

H

Haanen, Cecil van 413
Hackert, Jacob Philipp 276, 314
Hadrian 236
Hadzi, Dimitri 143, 145
Hague School 412, 418
Haiti 241
Hakewill, James 117, 332
Hale, Edward Everett 87, 91
Hall, George Henry 206
 A Fountain in Frascati 206
 A Parisian Market Cart 208
 Adio: Peasants of Olevano 206
 Graziella, a Little Neapolitan Girl 206
 Nenilla: A Neapolitan Girl 206
 Roman Wine Cart 206-208
 Un Carro de Sevilla 208
Halsey, John C. 336
Hamerton, Philip 212
Hamilcar Barca 291
Hamilton, Alexander 35, 335
Hamilton, Gavin 34, 150, 152, 158
Hamilton, James 31, 57, 115, 150, 270, 419
 The Last Days of Pompeii 270-272
 Marine View 270
 Venice 270
 View in Venice after Prout 270
Hamilton, James, Lt. Gov. 150
Hansen, Constantine 48
Hare, Augustus J.C. 212, 310, 312-313, 347
Harnett, William Michael 259
Hart, Joel Tanner 68, 71, 82-83, 90, 344
Harvard Art Club 390
Haseltine, James 90
Haseltine, William Stanley 122, 220, 236, 273, 283, 293-296, 312-313
 Capri 295-296
 Marina Piccola, Capri 293-294
 Natural Arch, Capri 296
 Oleavana 304
 Piccola Marina, Capri 293-294
 Villa Barberini, Albano 313
Hassam, Childe 59, 248, 417, 443
Hawthorne, Sophia Peabody 228
Hawthorne, Nathaniel 23, 27, 30, 52, 54, 58, 62, 64, 67, 70, 80, 84, 87-88, 91-94, 183, 193, 216, 224, 228, 248, 288, 351, 353, 442
 Marble Faun 27, 52, 54, 64, 87, 94, 145, 183, 193, 203, 224, 228, 279, 437, 442
Hayez, Francesco 131, 341
Head of an Old Woman 240

Heade, Martin Johnson 201, 203
 Goat-Herd 201
 Roman Newsboys 201, 203
Headley, Joel Tyler 92
Healy, George Peter Alexander 244
 The Arch of Titus (with Church and McEntee)
 50, 244-246, 438
 The Peacemakers 246
Heckscher, August 89
Heemskerck, Marten van 203
Helvetia 304
Hemans, Felicia 193
Hemingway, Ernest 132
Henri, Robert 126
Henry, Edward Lamson 23
Herculaneum 31, 33-34, 40, 47, 55, 156, 178, 194,
 229, 264, 266, 270, 448, 451
Hercules 31, 238, 362, 420
Hermes 180
Herriman, William and Elizabeth 344
Herring, Silas C. 278
Hewins, Amasa 113, 118, 127
Hicks, Edward 198, 201
Hicks, Sarah 182
Hicks, Thomas 24, 49, 167-168, 198, 200-201, 203,
 274, 283
 Fountain in Front of the French Academy 198
 House on the Piazza Barberini 198
 Italia 198
 Margaret Fuller 198-200
Hildebrand, Adolf von 137
Hillard, George Stillman 92, 114, 120, 127, 211,
 214, 218, 221, 236-237, 252, 254, 274, 290, 310,
 437, 442
Hobbes, Thomas 29
Hobbs, John 388
Homer 168, 242
Homer, Winslow 59, 124-125, 362
Holmes, Oliver Wendell 443, 448
Hone, Philip 77, 115
Hopkins, James 89
Horace 44, 244, 289
Horatii and Curiatii, Monument of 308
Horny, Franz 304
Horwitz, Orville 75, 84, 86, 93
Hosmer, Harriet 23, 46, 70, 73, 88, 183-184, 216,
 226-228, 241, 266, 344-345, 439, 442, 447
 Beatrice Cenci 88, 226
 *Clasped Hands of Robert and Elizabeth Barrett
 Browning* 447
 Daphne 86, 88
 Fountain of Hylas 88

Head of Medusa 88
Miner 89
Night Rises with the Stars 344
Phosphor and Hesper Circling their Double Star 344
Pompeiian Sentinel 266
Puck on a Toadstool 228
Queen Isabella of Castile 226
Sailor 89
The Sleeping Faun 88, 184, 227-228
The Falling Star 344-345
Zenobia in Chains 73
Zephyr Descends 344
Hotchkiss, Thomas Hiram 273, 316, 364
 Torre di Schiavi 273-274
Houdon, Jean Antoine 333
House of the Faun, Pompeii 181
How, Charles 240
Howells, William Dean 26, 59, 94, 98-99, 103, 111,
 356, 398, 400, 408, 420, 443
Hoxie, Vinnie Ream 89, 244
Hubard, William J. 338
Hudson River School 19, 21, 37, 42, 45-47, 51, 53,
 57, 175, 188, 237, 264
Huidekoper, Alfred 83, 88-89, 92
Humboldt, Alexander von 232
Humboldt, Wilhelm von 232
Hunnewell, Arthur 314
Hunnewell, Hollis 124-125, 314
Hunnewell, Jane Boit 314
Hunt, Leigh 184, 318, 328
Hunt, William Morris 234, 247-248, 316
 Agostina 234
 Italian Peasant Boy 234
 Roman Girl 234
Huntington, Collis P. 373
Huntington, Daniel 78, 118
Hutton, Edward 325

I

Ilissus 250, 252
Ingres, Jean-Auguste-Dominique 212
Inness, George 45, 57, 183, 210-212, 230, 288, 298,
 308, 310, 312-314
 Ariccia 314-315
 Lake Albano 308-310
 Lake Nemi 310-312
 The Monk 312-313
 St. Peter's, Rome 211-212
 The Commencement of the Galleria 288
 Viaduct at Laricha 314
 View of Genzano 310, 314
Institute for Coloured Youth, Philadelphia 438

Irving, Washington 25, 27, 40, 46, 63, 172, 210,
 222, 328, 441
 Tales of a Traveller 40, 63, 441
Isabey, Louis Gabriel 288
Ischia 96, 110, 296, 441
Ives, Chauncey Bradley 82, 86, 90, 91, 220, 344
Izard, Mr. and Mrs. Ralph 34, 156, 158, 268

J

Jackson, Andrew 78, 90, 339, 342
Jackson, Jane 366
Jackson, John 90, 339
Jackson, John Adams 339, 351
James, Alice 248
James, Henry 19, 25-27, 46, 55, 58, 60-61, 63-65,
 69, 92, 95, 99, 105, 111, 124, 126, 128, 130, 145, 221,
 247-248, 254-255, 318, 321, 332, 350, 372, 400,
 402-404, 406-410, 422, 430, 432, 443, 445, 451
 "Daisy Miller" 111, 254
 "Roman Rides" 46, 63, 248
 "The Art of Fiction" 111
 Italian Hours 105, 111, 221, 321, 403, 408-409,
 432, 444-445
 Portrait of a Lady 106, 109, 111, 113, 248
 Roderick Hudson 25, 54, 111, 145, 350, 443
 The Aspern Papers 111
 The Golden Bowl 111, 377
 The Princess Casamassima 106
 William Wetmore Story and His Friends 27, 64, 92,
 111
 Wings of the Dove 25, 111, 126, 404, 406
James, William 27, 57, 64, 92, 94, 248, 439
Jameson, Anna 178
Jarves, James Jackson 33, 38, 51, 54, 58, 63-64, 121-
 122, 128, 162, 205, 224, 266, 273, 350-351, 353, 413,
 419-420, 442
 Art-Hints 51, 64
 Italian Rambles 58, 64, 128, 442
 Italian Sights and Papal Principles 58, 63-64, 128,
 162, 205, 420, 442
Jefferson, Thomas 26, 33, 35, 62, 85, 160, 333, 440
 Monticello Building Notebook 440
Jerusalem 244
Jewett, Isaac Appleton 92
Johnson, Eastman 206, 234
Jones, Thomas 46, 232, 310-311
Joyant, Jules 118
Julius Caesar 321
Julius III, Pope 212
Jupiter 77, 82, 205, 237

K

Kauffmann, Angelica 32-33, 62, 150, 156
Keats, John 220, 376
Keck and Vedder 379
 The Boy 379
Keck, Charles 378, 440
 David 379
 Elihu Vedder 378-379
 Lacrosse Player 379
 Sleepwalker (Somnambulist) 379
 The Awakening of Egypt 378
 Thetis Consoling Achilles on the Death of Patroclus 378
Keiserman, Franz 159
Kellogg, Miner 118-119
Kensett, John 49, 118-119, 198
Kimball, Francis 125
Kinney, Abbot 125
Knife Grinder 34
Knoedler's, New York 362
Koch, Joseph Anton 39, 172-173, 190, 302
Konti, Isidore 382
Kooning, Willem de 140

L

La Spezia 58, 108, 229, 318
La Touche, Rosie 390
LaFarge, John 61, 248, 316
Ladies' Clay Association, Richmond 82
Laer, Pieter van 305
Laing, Caroline 89
Lake Albano 48, 174, 308, 310, 314
Lake Como 96, 200, 229, 293, 300, 419, 450
Lake Garda 159, 229, 255, 299
Lake Lucerne 172, 213
Lake Maggiore 159, 172, 178, 203, 213, 229
Lake Nemi 53, 181, 203, 296, 298, 308, 310-312, 314
Lake Orta 229
Lake Waban 124-125
Lake of Avernus 47
Lander, Helen Dodge 448
Lander, Louisa 24
Lander, Lucy Allen 448
Lang, Annie Traquair 360
Lang, Louis 118
Laocoön 34, 36, 38, 445
Latrobe, John H.B. 79, 92
Launitz, Robert 166
Laurens, Jean-Paul 424
Lawrence, Thomas 178
Lazio 206

LeVert, Octavia Walton 93
Lear, Edward 48, 230, 264, 283, 318, 347
Leda 323
Lee, Rensselaer 150
Lee, Vernon 323, 362, 404, 406
Lega, Silvestro 358
Leghorn (Livorno) 56, 77, 94, 96, 150, 156, 159, 166, 172, 178, 198, 203, 220-221, 229, 284, 316, 318, 328
Leibl, Wilhelm 358
Leighton, Frederick 226
Lenbach, Franz von 208, 246
Lenox, James 290
Lentini 262
Leonardo da Vinci 96, 178, 424
Leopardi, Giacomo 131
Lerici 108, 318, 321
Leslie, Charles Robert 178
Leutze, Emanuel 78, 118, 293
Lewis, Edmonia 24, 73, 89-90, 241-242
 Abraham Lincoln 89
 Bust of Henry Wadsworth Longfellow 242-243
 Colonel Robert Gould Shaw 89, 241
 Death of Cleopatra 90, 241
 Forever Free 241
 Hagar 89, 241, 304
 Hiawatha 89-90, 242, 244
 Hiawatha's Wedding 89
 Hiawatha's Wooing 89
 Indians Wrestling 89
 Minnehaha 242
 The Freed Woman and Her Child 241
 The Old Arrow Maker and His Daughter 242
Leyland, Frederick 390
Leys, Hendrik 206, 208
Lint, H.F. van 311
Lipchitz, Jacques 133
Lippincott, Sara Jane 92
Lippold, Richard 143
Liszt, Franz 89, 244
Livingston, Philip 62
Livy 33, 308
Locke, John 29
Lombardi, Giovanni Battista 67
Lombardy 120
Longfellow, Edith 244-246
Longfellow, Frances Appleton 432, 438
Longfellow, Henry Wadsworth 8, 23-24, 50, 61, 113, 127-128, 168, 242, 244, 246, 310, 312, 314, 336, 438, 441, 443

 "Song of Hiawatha" 242
 "Evangeline" 244
 Translation of the *Divine Comedy* 443
Longworth, Nicholas 24, 186, 339
Lorenzana, Carlotta 222
Lorrain, Claude 31, 40, 43, 45, 57, 173-174, 178, 194, 203, 221, 238, 287, 289, 298, 302, 308, 310-311
Louvre, Paris 164, 174, 234, 308, 380
Lowell, James Russell 216, 442-443
Lowell, John 41, 63, 442
Lucca 184, 244, 282, 321, 323, 339, 350, 355, 362, 371, 384, 445
Ludovisi Mars 164
Ludwig of Bavaria, Crown Prince 232
Lyell, Charles 264
Lyman, Charles 261
Lyman, Elizabeth Otis 247
Lysippus 386

M

MacGavock, Randal 81
MacPherson, Robert 229-230
Macchiaioli 131, 316, 358, 364
Madonna del Divino Amore, Festival of 305
Maecenas 44
Magoon, Elias Lyman 269
Major, Thomas 64, 269
Malamocco 408
Malden, Massachusetts 120, 288
Manes, the 368
Maney, Henry 82, 86, 92
Manhattan 229, 236
Manigault, Charles Izard 50
Manin, Daniele 120
Manning, Adeline 238
Manship, Paul 136-137, 382-384
 Atlas 137
 Duck Girl 382
 John D. Rockefeller 10, 214
 Lyric Muse 382
 Pauline Frances 383-384
 Prometheus 137, 220
 Saint Paul Art Institute Medal 382-383
Mantegna, Andrea 55
Manzoni 131, 200
Manzoni, Alessandro 131
Maratta, Carlo 63
Marca-Relli, Corrado 139
Marin, John 126
Marinetti, Filippo Tommaso 130
Marius, Caius 164

Marsh, George Perkins 238
Marstrand, Wilhelm 305
Martin, John 89, 264, 266, 272
Martiny, Philip 378
Martyn, Thomas 63
Masaccio 22, 141
Mauve, Anton 418
Mazzini, Giuseppe 198, 440
McCormick, Richard Cunningham 92
McEntee, Jervis 45, 122, 128, 229, 236-237, 244,
 246, 269, 278, 288, 438
 Arch of Titus (with Church and Healy) 50,
 244-246, 438
 Paestum, Twilight 269
 Scene on the Via Appia, Near Rome 279
 The Ruins of Caesar's Palace 236
McFarland, Andrew 80, 84, 92
McHenry, James Howard 80, 92
McKim, Charles Follen 26, 61
McMurtrie, James 335
Mead, Larkin 68, 83, 90, 99
Meadows, Arthur 397
Medici Chapel, Florence 344
Meduna, G.B. 386
Meigs, Montgomery C. 208
Meleager 31, 62, 167
Melillo, Giacinto 449
Melville, Herman 36, 62, 124, 128, 366, 413, 432,
 441
Mengs, Anton Raphael 31, 150, 154
Mentona 295
Messina 229, 328, 424
Meyer, Ernst 214
Michelangelo 21-22, 34, 38, 58, 62, 66, 112, 131, 133,
 144, 211-212, 221, 228, 250, 252, 323, 331, 344, 347,
 361, 424
Mickiewiez, Adam 198
Middleton, Alicia 50, 64
Middleton, Arthur 62, 441
Middleton, John Izard 19, 42, 310, 437, 440-441
 Grecian Remains in Italy 19, 42, 310, 440-441
 *Greek Theater at Taormina with Mt. Etna in the
 Distance* 42
Milan 51, 54, 66, 96, 98, 130, 135, 142, 159-160, 164,
 172, 178, 194, 198, 203, 216, 229, 244, 255, 266,
 269-270, 282, 304, 358, 419, 441, 450
Millet, Frank 376
Mills, Clarke 84
Milmore, Martin 344
Milton, John 180

Modena 156, 159, 164, 353
Monet, Claude 122
Monreale, Cathedral of, Palermo 403
Monte Nero 328
Monte Pellegrino, Sicily 291-292
Monte Pincio, Rome 230, 252-253
Monte Rosa 229, 438
Monteverde, Giulio 134
Monticello 35, 62, 440
Moore, Charles Herbert 121, 124, 350, 388-390
 Venetian Doorway 389-390
Moorhead, W.G. 278
Moran, Thomas 120, 124, 419-421
 The Fisherman's Wedding Party 419-421
More, Jacob 272
Morgan, Dr. John 62, 112, 127
Morghen, Raphael 162
Morse, Samuel F.B. 36-37, 46-47, 49, 63, 113, 116,
 118, 282-284, 286, 304, 333, 335
 Chapel of the Virgin at Subiaco 282, 284, 286
 Contadina 187, 284
 Gallery of the Louvre 282
 Interior of the Convent of San Benedetto 284
 Miracle of St. Mark (after Tintoretto) 282
 Sketch for The Chapel of the Virgin at Subiaco 282
 *Sketch of the Contadini: Study for the Chapel of the
 Virgin* 284
 *The Brigand Alarmed. Scene on the Road from Rome to
 Naples* 47
Morton, John L. 283-284, 286
Motherwell, Robert 140
Moulton, Louise Chandler 86, 93
Mount Cenis 164
Mount Etna 42, 47, 178, 262, 264, 292, 441, 442
Mount Pilatus 172
Mount Vesuvius 21, 42, 47, 63, 109, 178, 213, 229,
 264, 270, 276, 441, 445, 448, 451, 453
Mount, William Sidney 56
Mowbray, H. Siddons 373-374
 Abou Hassan, or the Sleeper Awakened 373
 Le Destin 373-374
 Schererzade 373
Mozier, Joseph 68, 72, 86-87, 89, 91, 220, 229,
 236, 344
Mulock, Lizzie 298
Munthe, Axel 109
Murano 123-124, 413
Murphy, Hermann Dudley 430
Murray, John 22, 127, 193, 214, 221, 254, 256, 279,
 290, 292, 296, 302, 409, 445

N

Naples 21-23, 33-34, 36, 40, 42, 47, 49-50, 54, 57-
 58, 63-64, 66, 77, 96, 98, 109-110, 119, 133, 156,
 159-160, 175, 178, 181, 184, 193-194, 198, 206, 213,
 216, 221, 229, 240, 244, 252, 255, 267-268, 270,
 272, 276, 282, 288, 291, 295, 304, 308, 316, 328,
 333, 339, 351, 358, 376, 396, 419, 424, 438, 441-
 442, 445-446, 448-451
Naples, Bay of 21, 40, 47, 50, 63, 109-110, 175, 276,
 438
Napoleon 36, 116, 162, 164, 176, 238, 282, 321, 386
Narni 57, 273
National Academy of Design, New York 125,
 166, 221, 274, 286, 298, 380, 396, 398
National Gallery, London 228, 308, 332, 419
Natoire, Charles-Joseph 312
Natural Arch, Capri 296
Navone, Francesco 451
Naya, Carlo 294, 413, 415
Nazarenes 302
Neal, David 49, 63, 436
Neher, Michael 304
Nemi 39, 41, 44, 47, 53, 57, 178, 181-182, 198, 203,
 296, 298, 308, 310-312, 314, 328
Nero, Emperor 288
Nevin, Robert J., the Rev. Dr. 90
Newman, Henry Roderick 4, 121, 123-124, 318,
 323, 346-350, 353, 386, 388
 Anemones 248, 346-347
 Casa Magni, San Terenzo 321
 Florence, Duomo from the Mozzi Garden 347-348
 Grapes and Olives 302, 318, 321
 Gulf of Spezia 4, 318-321
 Italy 318
 Santa Maria Novella, Florence 349-350
 View of Santa Maria Novella 350
Nibby, Antonio 205, 288, 441
Nicholls, Rhoda Holmes 443
Nieriker, May Alcott 64
Nineveh 272, 358
Niobe Group 266
Noguchi, Isamu 137
Nono, Luigi 413
Norton, Andrews 338
Norton, Charles Eliot 42, 55, 59, 61, 63-65, 121,
 350, 388-390, 442-444
Nugent, Thomas 33, 54

O

Old St. Joseph's Church, Philadelphia 162
Olevano 39, 57, 172, 176, 198, 206, 283, 293, 302, 304
Olivier, Ferdinand 302
Olmsted, Bertha 216
Olmsted, Frederick Law 125, 216
Oneglia 229
Orestes and Electra 156, 158
Orpheus 77-78, 85, 87, 166-168, 196, 341
Orsetti family 323
Orvieto 252
Ossoli, Angelino 200
Ossoli, Angelo, Marchese 200
Ovid 167, 224, 226

P

Padua 33, 100, 159-160, 229, 252, 442
Paestum 20, 31, 34, 42, 47-48, 53, 56, 64, 156, 160, 166, 176, 178, 187, 194, 203, 221, 229, 267-269, 441
Page, Sophia Candace Stevens Hitchcock 216
Page, William 37, 216, 218, 226, 229
 Mrs. William Page 216-218
 Self Portrait 216
 Titian, copies after 216
Palatine Hill 236-237
Palazzo Barbaro 126, 255, 402, 404, 406-407, 451
Palazzo Barberini 183, 208, 376, 449
Palermo 40, 128, 131, 178, 201, 229, 252, 255, 291-292, 351, 358, 403, 442
Palestrina 198, 200
Palffy, Janos, Count 72
Palladio 33, 392, 438
Palmer, Erastus Dow 344
Palmer, Samuel 44, 63, 283
Palmer, Thomas 33
Palmer, Walter Launt 422
Palmyra 226
Pan 180, 184
Pantheon 40-41, 67, 168, 174, 176, 448
Papal States 201, 282
Park, Richard 90
Parma 31-34, 59, 150, 156, 158-159, 164, 323, 440
Parrish, Maxfield 444
Parthenon 38, 250, 325
Passini, Ludwig 49, 413
Pazzi, Enrico 250
Peabody, George 90, 234
Peale, Charles Willson 32, 56, 62, 162

Peale, Rembrandt 32, 36-38, 42, 44, 62-63, 75, 92, 113, 115, 127, 154, 159-160, 162, 269
 George Washington, Pater Patriae 162
 Madonna della Seggiola, after Raphael 162
 Notes on Italy 63, 76, 92, 127, 159-160, 162
 The Roman Daughter 159
 Thomas Jefferson 160
 Tivoli 159
 Portrait of William Short 160-161
Peele, Jane Appleton 447
Pelham, Henry 34, 62, 127, 158
Pennell, Elizabeth Robbins 419
Penniman, John Ritto 64
Pennington, Harper 391-392
Pepper, Beverly 143
Pepper, Charles Hovey 426, 428
Perkins, Charles 196
Perkins, Stephen Higginson 250
Perkins, Thomas Handasyd, Colonel 252
Perlstein, Philip 143
Perry, John D. 351
Persia 379
Persico, Luigi 84
Perugia 22, 57, 203, 210, 229, 273, 316, 368, 376, 438, 442
Pescaglia 58
Peschi, Remigio 339, 341
Peschiera del Garda 299
Petrarch 30, 41, 240, 336, 386, 388
Phidias 38, 81, 335-336, 386
Phillips, Stephen C. 447
Phocas, Emperor 205
Piacenza 159, 164
Pickering, Henry 176, 269
Piedmont 120
Piero della Francesca 22, 55, 140
Pietrasanta 135
Piloty, Karl von 358
Pine, Robert Edge 36
Pinelli, Achille 305
Piranesi, Giovanni Battista 31, 45, 160, 212, 269
Pisa 92, 96, 156, 159, 203, 210, 221, 229, 236, 244, 282, 316, 321, 328, 410, 424, 446
Pisani, Count and Countess 406
Pisano, Giovanni 133
Pistoia 353
Pitti Palace 34, 113, 154, 162, 333, 369, 380
Pius IX 89, 183, 201, 246, 278, 439
Plato 373
Platt, Charles 26, 362
Plutarch's Lives 164, 166

Pollock, Jackson 141
Pompeii 21, 31, 33-34, 40, 47, 55-57, 71, 86, 93, 96, 156, 178, 181, 186, 194, 208, 228-229, 264, 266, 270, 272, 316, 382, 438, 441, 448, 451
Pompey 321
Ponte, Antonio da 408, 428
Ponti, Carlo 386, 388
Pontine Marshes 234, 278
Porta, Giacomo della 212
Porter, Harriet 210
Poseidonia 267, 269
Posillipo, Grotto of 47
Poussin, Nicolas 172, 175
Powel, Samuel 33
Powers, Hiram 67-71, 74, 76, 78-80, 83, 85, 90-92, 136, 186, 196, 216, 229, 236, 241, 339, 341-342, 344-345, 439-440, 447
 Andrew Jackson 78, 90, 339, 342
 Anna Barker 78
 Bust of Horatio Greenough 342-343
 California 83-84
 Charles Sumner 90
 Daniel Webster 71, 78, 83, 90, 339, 342
 Eve Disconsolate 73, 341
 Eve Tempted 73-74, 79, 81, 196, 341
 Fisher-Boy 81
 Ginevra 79
 Greek Slave 73, 79-81, 83, 90, 339, 341, 447
 John Calhoun 78
 John Farrar 78
 Last of the Tribes 73
 Martin Van Buren 78
 Proserpina 339, 439
 Psyche 80-81, 83-84
Powers, Longworth 439
 Hiram Powers in His Studio 439
Pozzuoli 40, 47, 178
Praxiteles 38, 52, 228
Pre-Raphaelites 128, 347-348
Prendergast, Charles 252, 254, 430, 434
Prendergast, Maurice Brazil 252-253, 426, 428, 430, 432, 434
 Afternoon Pincian Hill 254
 Monte Pincio, Rome 252-253
 Easter Procession at St. Mark's 434
 Festival Day, Venice 427
 Interior of St. Mark's 434-436
 Market Place, Venice 430
 Ponte della Paglia 428
 Rainy Day, Venice 430, 432
 Splash of Sunshine and Rain 432-434

Sunlight on the Piazzetta 427
 The Grand Canal, Venice 428-430
 Umbrellas in the Rain, Venice 426
Procida 110
Protestant Cemetery, Rome 220-221
Prout, Samuel 117
Puccini, Giacomo 272
Punch 70, 201
Punic Wars 291
Putnam, George Palmer 80, 92
Pyne, James Baker 318

Q

Quaker City 94-95, 111, 443
Quercia, Jacopo della 371
Quincy, Quatremere de 336
Quo Vadis, Church of 279

R

Rand, Ellen Emmet 255
Raphael 21-22, 30, 32-35, 37-38, 40, 62, 66, 112-113,
 154-156, 162, 164, 190, 211, 221, 284
Ravel, Julius 128
Ravenna 22, 58, 402, 445
Read, Thomas Buchanan 59
Ream, Vinnie 89, 244
Rebell, Joseph 308
Reed, Luman 53, 64, 194, 262, 332
Reinhart, Johann Christian 173
Rembrandt 129, 190, 194, 222
Remus 308
Reni, Guido 22, 35, 55, 62, 150, 162, 304, 437
Renoir, Pierre-Auguste 122, 396
Reyna, Antonio 124
Reynolds, Joshua 37, 43, 63, 152, 154, 380
Ricchetti, Consiglio, Venice 451
Ricci, Stefano 79
Richards, Frederick De Bourg 84, 86
Richardson, Jonathan 29, 36, 61
Rico, Martin 397, 412
Rieti 200
Rimini 160
Rimmer, William 56-57, 238, 250, 252
 Dying Centaur 252
 Falling Gladiator 250, 252
 Gladiator and Lion 57
 Head of St. Stephen 250
 Sunset/Contemplation 56-57
 Torso 250-252
Rinehart, William Henry 68, 89-90, 92, 208,
 228-229, 236, 344-345, 378

Clytie 344
Evening 344-345
Leander 344
Morning 344-345
Spring 344
Thetis 90, 378
Winter 344
Risorgimento 107, 130, 132, 201, 203
Ritchie, A.H. after Thomas Hicks, *Authors of the*
 United States 200
Ritter, Louis 356
Robbia, Andrea della 383-384
Robert, Hubert 214, 290
Robert, Leopold 196, 208, 214, 234
Roberts, Marshall O. 246
Rocca San Stefano 304
Rocchi, Luigi 341
Rodin, Auguste 135
Rogers, Samuel 79, 116, 120, 127, 269
Rogers, Randolph 68-69, 71-72, 82, 86, 89-91, 93,
 208, 210, 229, 264, 288, 344
 Abraham Lincoln 89
 Atala 72, 90
 Atala and Chacas 72
 Columbus Departing from the Convent of La Rabida,
 1492 208-209
 Columbus Doors 208, 210
 Lost Pleiad 73
 Nydia, The Blind Flower Girl of Pompeii 71-73, 86,
 89, 93, 208, 264-266
 Ruth Gleaning 72, 86, 89, 208
 The Sentinel 89
 The Truant 86
Rohr, Eva 449
Rollin's Roman History 164
Rolshoven, Julius 358
Roman Bronze Works, New York 382
Romanic 358
Romano, Giulio 164
Rome 7, 10, 15, 19-25, 27, 30-70, 72, 74, 77-78, 82-
 83, 85-94, 96-98, 105, 109, 111-112, 114, 118-119,
 121, 124, 126-127, 129-130, 132-133, 136-137, 141-
 145, 150, 152-154, 156, 158-160, 162, 164, 166-168,
 172-174, 176, 178, 180, 182-184, 189-258, 260-261,
 264, 266-267, 270, 273-274, 276, 278-279, 282-
 284, 286, 288-291, 293-296, 298, 302, 304-306,
 308, 310-316, 328, 333, 335-336, 339, 341, 344-345,
 351, 353, 358, 366, 368, 376, 378-380, 382-384, 396,
 402, 410, 419, 424, 428, 434, 437-443, 445-451
Romen, Amides 128
Romulus 236, 308

Rooke, Thomas M. 436
Roosevelt, James I. 335
Ropes, Joseph 44
Rosa, Salvator 21, 39-40, 46, 55, 62-63, 94, 162,
 164, 221, 282, 437, 440
Rossi, Carmen 392
Rossi, Count 201
Rossini, Gioacchino 131
Rossiter, Thomas P. 127-128, 178, 288
Rosso, Medardo 134
Roszak, Theodore 136
Rotch, Arthur 406
Rothermel, Peter Frederick 229, 302
Rousseau, Jean-Jacques 115, 127
Rovigo 167
Royal Bavarian Foundry, Munich 210
Ruben, Franz 413
Rubens, Peter Paul 156, 190, 440
Rucellai family 350
Ruskin, John 37, 118, 120-121, 128, 229, 318, 321,
 323, 347-350, 353-354, 386, 388-390, 392, 403, 408-
 409, 428, 430, 436
Russia 30, 132, 448
Rutledge, John, Jr. 160

S

S.S. Elizabeth 15, 200, 369, 410, 439, 447
S.S. Great Britain 210
Sabine hills 198, 260, 282, 290, 302
Saint Anne 222
Saint Cecilia 222
Saint Gotthard Pass 172, 213, 293
Saint Lucy 222
Saint Margaret 222
Saint Mark 98, 106, 116, 120, 282, 386
Saint Peter 228
Saint Rosalia 292
Saint Zita 354-356
Saint-Gaudens, Augustus 90, 103, 378, 447, 449
 Hannah Rohr Tuffs 449
 Hiawatha 89-90, 242, 244, 449
 John Singer Sargent 447
 William Dean Howells with Daughter, Mildred Howells
 103
 Youthful Mars 449-450
Salemme, Atillio 138
Salerno 178, 267
Salisbury, Stephen II 284, 286
Salmon, Robert 118-119
San Remo 234, 255, 316
Sand, George 198

Sansom, Joseph 48, 63
Sargent, John Singer 4, 49, 59-60, 95, 123, 126, 136,
 255-256, 321-325, 361-362, 390, 398, 400, 402,
 404, 406-408, 436, 447
 A Venetian Interior 400, 402
 An Interior in Venice 404, 409
 At Torre Galli: Ladies in a Garden 323
 Breakfast in the Loggia 323
 Bringing Down Marble from the Quarries 325
 Carrara: Wet Quarries 323-325
 In a Medici Villa 361-362
 In the Garden, Corfu 256
 Marble Quarries at Carrara 323, 325
 Study of Architecture, Florence 60
 The Fountain, Villa Torlonia, Frascati, Italy 4, 255
 The Pavement of St. Mark's 402, 436
 The Rialto, Venice 408
 The Salute, Venice 406-407
 The Sketchers 256
 Venetian Street 398, 400
 Venice, Under the Rialto Bridge 408
 Villa di Marlia: A Fountain 321-323
 *Wilfred de Glehn and Mrs. de Glehn Sketching in a
 Gondola* 256
Sarto, Andrea del 190
Savoy, House of 130
Schiavo, Vincenzo Rossi dello 274
Schick, Gottlieb 39, 172, 174
Schirmer, Johann Wilhelm 302
Sears, Sarah Choate 252, 350
Seated Agrippina 224
Seated Mercury 184
Sebastiano, Antonio 192
Segantini, Giovanni 131
Segesta 40, 46-48, 178, 181, 439
Segni 42, 441
Selden, Dudley 82
Selinute 178
Seravezza 68, 341
Severini, Gino 132
Severn, Joseph 220
Shaftesbury, Earl of 29
Shakespeare, William 29, 90, 97, 220, 228
Shaw, Fred R. 351
Shaw, Joshua 310
Shaw, Robert Gould, Colonel 89, 241
Sheffield fraternity 125
Shelley, Mary Wollstonecraft 220
Shelley, Percy Bysshe 220, 318, 321, 328
Sherwood, Rosina Emmet 255
Shippen, Joseph 31, 150

Short, William 160, 269
Sicily 19, 21, 36, 40, 42-43, 47, 51, 63, 92, 178, 229,
 255, 262, 264, 268-269, 273, 288, 291-293, 396,
 402, 438-439, 442, 449-450
Sickert, Walter 422
Siena 22, 58, 159, 172, 174, 178, 184, 221, 229, 244,
 252, 255, 284, 316, 358, 438, 445
Signorini, Telemaco 364
Silliman, Benjamin 236-237
Simmons, Franklin 90
Simplon Pass 159, 194, 203, 236
Singleton, Henry 34-35
Sleeping Endymion 214
Sloan, John 132
Smibert, John 29, 61
Smillie, James 260, 442
Smith, Adam 29
Smith, Amy Grinnel 92
Smith, Francis Hopkinson 409, 434, 444
Smith, Frank Hill 436
Smith, J.R. 119, 128
Smith, John "Warwick" 193
Smith, Joseph Allen 36
Smith, Joseph Lindon 123
Smith, Mary Erminia 92
Smith, Russell 314-315
Smith, William 35, 150
Smither, Mr. and Mrs. F.S. 380
Smyth, Penelope 323
Soby, James Thrall 145
Sodom and Gomorrah 272
Sodoma 424
Sonntag, William Louis 188
Sorrento 48, 63, 110, 184, 194, 196, 203, 229, 267,
 282, 295-296, 304, 448
Spence, Benjamin 67
Spencer, Lord 347
Spinario 184
Spoleto 57
Spring Grove Cemetery, Cincinnati 89
Spring, Margaret 200
Staël, Madame de (Anne Louise Germaine
 Necker) 41, 42, 44, 453
Stanfield, Clarkson 117
Stankiewicz, Richard 136
Stebbins, Emma 24, 89
Steele, Fletcher 128
Steichen, Edward 126-127
Steinberg, Saul 141
Stella, Frank 143
Stella, Joseph 145

Stelvio Pass 229, 300
Stendahl's Syndrome 53
Stieglitz, Alfred 26, 126-127
Stillman, William James 439
Stokes, Adrian 362
Stone, Marcus 390
Story, Judge Joseph 90, 183
Story, Thomas Waldo 183
Story, William Wetmore 19, 25, 27, 46, 58, 63-64,
 68, 84, 86-87, 92, 111, 183-184, 208, 216, 220,
 224, 226-228, 234, 267, 305, 378, 384, 439, 442-
 443
 Arcadian Shepherd Boy 86, 184
 Beethoven 90
 Cleopatra 72-73, 87, 183, 224
 Edward Everett 89-91
 George Peabody 90, 234
 Hero 87
 Josiah Quincy 90
 Judge Joseph Story 90, 183
 Judith 72
 Libyan Sibyl 183, 224
 Little Red Riding Hood 184
 Marguerite 87
 Medea 72, 90
 Roba di Roma 25, 63, 183, 305, 443
 Salome 72
 Sappho 73, 78, 224, 226
 Semiramis 72
 William Shakespeare 90
Stowe, Harriet Beecher 91, 448, 451
Strabo 310-311
Stresa 229
Struss, Karl 26, 126-127
Stuart, Gilbert 333
Sturges, Jonathan 194
Sturgis, Howard 105
Subiaco 49, 176, 198, 260, 282-284, 286, 302, 304,
 316
Sully 282
Sully, Thomas 154, 328
Sumner, Charles 90, 166-168, 184, 196
Swanwick, John 62
Symonds, John Addington 422, 424
Syracuse 40, 63, 178, 292, 328, 366

T

Tacitus 152
Tait, John Robinson 186
Tanner, Henry Ossawa 424-426
 Canal in Venice 426

Moroccan Man 426
 Resurrection of Lazarus 424
 Sand Dunes at Sunset, Atlantic City 426
 Venetian Bridge 425-426
Taormina 42, 178, 262, 264, 273, 292
Tarquinius Superbus 366
Tasso 41
Taylor, Bayard 38, 60, 63, 65, 81, 92
Teerlink, Abraham 312
Tenerani, Pietro 67
Terni 203, 229, 438
Terracina 237, 260, 278
Terry, Luther 49, 52, 64, 78, 118, 198, 203, 220
Thackeray, William Makepeace 226
Thaxter, Edward R. 351-353
 Love's First Dream 351
 Meg Merrilies 351-352
Thayer, Abbott 380
Theocritus 110, 179
Theseus 250
Thompson, Launt 236, 246
Thompson, Samuel 236
Thorvaldsen, Bertel 66, 77, 159, 166, 172, 190, 238,
 339, 344, 445
Tiberius, Emperor 152
Tiepolo 140, 406
Tilton, John Rollin 52, 121, 220, 229, 260, 269,
 273-274
Tintoretto 30, 37, 105-106, 112, 119, 126, 282, 418
Tischbein, Johann Heinrich Wilhelm August 45
Titian 21-22, 30-31, 33-34, 40, 62, 112-113, 119, 122,
 126-127, 131, 140, 150, 156, 162, 172, 194, 210, 216,
 218, 221, 244, 369, 371, 380, 400
Tito, Ettore 123, 413
Titus 50, 164, 192, 205, 244, 246, 261, 438, 442
Tivoli 19, 39-40, 42, 44, 49, 57, 63, 159-160, 162,
 172, 176, 178, 181, 186-187, 194, 203, 210, 236,
 282-283, 286-290, 304, 316, 441
Tomb of Cecilia Metella 278-279
Tomb of Virgil 47
Tomb of the Rabiri 278
Torcello 408, 422
Torlonia, Don Giulio 256
Torre Galli, Florence 325
Torre de Schiavi 274
Torrini, Giocondo 448
Tousey, Sinclair 82, 92
Towne, Francis 314
Trelawny, Edward 220
Trentacoste, Domenico 134
Trentanove, Raimon 333

Tribolo, Niccolò 361-362
Tribuna 34-35, 37-38, 55, 62
Trieste 356
Trollope, Anthony 76
Trollope, Frances 76, 79, 92
Trowbridge family 67
Troy 16, 272
Trumbull, John 32, 62
Tuckerman, Henry T. 27, 62-63, 92, 128, 166, 203,
 274, 296, 329
Tudor, William 63
Tuffs, Hannah Rohr 449
Turin 107-108, 164, 229, 244, 255
Turner, Joseph Mallord William 117-118, 178, 331
Tuscany 7, 22, 58, 71, 144, 175, 234, 293, 316, 323,
 327, 329, 331, 333, 335, 337, 339, 341, 343, 345, 347,
 349, 351, 353-357, 359, 361, 371
Twachtman, John Henry 356, 358, 410, 417-418
 Grey Venice 418
 The Lagoon, Venice 418
Twain, Mark 12, 26, 56, 64, 94-101, 105, 111, 124,
 128, 278, 443, 446
Twombly, Cy 141, 143

U

U.S.S. Constitution 328-329
U.S.S. Washington 240, 441
Uccello, Paolo 140
Uffizi Gallery, Florence 28, 30, 60, 152, 339
Ulrich, Charles Frederick 123
Umberto, King of Italy 208
Umbria 273, 316

V

Val d'Aosta 229, 255
Valenciennes, Pierre Henri de 46, 272, 284
Vallombrosa 105, 358
Van Bree, Philippe Jacques 246
Vanderbilt, F.W. 373
Vanderlyn, John 62, 164, 166, 172, 175, 210, 232
 Caius Marius on the Ruins of Carthage 164-166
 The Landing of Columbus 210
Varramista 321
Vasari, Giorgio 362
Vasi, Mariano 205, 441
Vasi, M. and Nibby, A.
 Guide of Rome and the Environs 441
Vatican 31, 33-35, 37-38, 55, 57, 129, 154, 166-167,
 200, 212, 221, 250, 266, 282, 284, 339, 351, 437,
 448, 451

Vedder and Keck 379
 The Boy 379
Vedder, Elihu 27, 57, 61, 123, 128, 206, 210, 212-
 213, 220, 234, 273-274, 283, 316, 344-345, 364,
 366, 368, 376, 378-379, 440
 Beatrice Cenci 379
 Bordighera 316, 376
 Bordighera Street 316
 Fortune 379
 Girl Spinning with Archway and the Sea, Bordighera
 316
 Girl with Poppies 368
 In Memoriam 368
 Jane Jackson - Formerly a Slave 366
 Little Shrine, Subiaco 316
 Near Perugia 57, 316
 Rome 61
 Ruins, Torre dei Schiavi 274
 San Remo - Old Stairway 316
 Sibilla Cumaea 379
 The Cumaean Sibyl 366
 The Cup of Death 379
 The Cup of Despair 379
 The Flood 212
 The Magdalen 379
 The Soul's Answer 379
 Tivoli, Near Rome 290, 316
 *Tops of the Piers in the Central Hall of the Baths of
 Caracalla* 212
 Volterra 364
 Woman Among Poppies Holding Etruscan Jar 368
Vela, Vincenzo 134
Velletri 304
Venetia 114
Venice 7, 21-22, 24-25, 27, 30-31, 36-37, 40, 47,
 49-51, 54, 58-63, 66, 94, 96-97, 99-107, 111-128,
 131, 150, 156, 159-160, 167, 172, 194, 198, 200-201,
 210, 216, 221, 229, 232, 234, 236, 244, 247, 252,
 255, 270, 273, 282, 288, 293-294, 304, 316, 318,
 321, 328, 350, 356-358, 376, 380, 386, 388-398, 400,
 402-404, 406-410, 412-413, 415, 417-420, 422,
 424-428, 430, 432, 434, 436, 438, 441-446, 450-
 451
Venus de' Medici 22, 28, 30, 34-38, 55, 58, 62, 79-81,
 224, 339
Venus of Knidos 339
Verga, Giovanni 131
Vernet, Claude-Joseph 298
Vernet, Horace 159
Verona 159-160, 229, 388
Veronese 112, 116, 119, 122, 126

Versilia 136
Vespasian, Emperor 192, 261
Via Appia 260, 278-279, 308, 314
Via Appia Nuova 314
Via Ardeatina 305
Via Gregoriana 164, 244, 333, 438
Viani, Gigia 398
Viareggio 220, 316
Vicenza 159-160, 438
Vicovaro 304
Victor Emmanuele Monument, Rome 137
Victoria, Queen 81
Villa Albani, Rome 224
Villa Aurora
Villa Castellani, Bellosguardo 247-249, 252, 356-
357, 415
Villa Medici 230, 244, 252, 361-362
Villa Narcissus 376-377, 440
Villa Torlonia, Frascati 4, 255-256
Villa Torre Quattro Ventri 378
Villa d'Este 44, 290
Villa di Marlia 321-323
Virgil 30, 35, 47, 110, 179, 289, 308, 310-311
Volterra 178, 273, 316, 364

W
Wagner, Alexander von 358
Wallace, Horace Binney 80-81, 92
Wallis, George A. Wallis 39
Wallis, Henry 273
Walpole, Horace 54, 64
Walter, Thomas U. 212
Walters, Henry 449
Walters, William T. 228, 344
Wanamaker, Rodman 424
Ware, William 80, 82, 91
Washington, E.K. 93
Washington, George 32, 76, 83, 127, 162, 166, 190,
333, 335-336, 440
Webster, Daniel 71, 78, 83, 90, 339, 342
Wedgewood, Eliza 255, 321
Weed, Thurlow 71, 85-86, 92
Weir, J. Alden 417-418
Weir, John Ferguson 236
Weir, Robert W. 183, 221-222
 Portico of the Palace of Octavia 214
 Presentation in the Temple 222
 Taking the Veil 40, 49, 221-222
 The Duke of Bourbon's Halt at La Riccia 314
Wenban, S.L. 396
Wendel, Theodore 356

Werner, Carl Friedrich 118
West, Benjamin 8, 19, 26, 28, 31-32, 34-35, 55, 62,
78, 94, 112-113, 115, 126-127, 129-130, 141, 150, 152,
154, 159, 162, 282
 Agrippina Landing at Brundisium with the Ashes of
 Germanicus 31, 152-154
 Agrippina and the Children Mourning Over the Ashes of
 Germanicus 153
 Angelica and Medoro 150
 Anne Compton, Countess of Northampton, with her
 Daughter Elizabeth 113
 Choice of Hercules 31
 Cymon and Iphegenia 150
 Death of General Wolfe 152
 Departure of Regulus from Rome 153
 John Allen 28, 31-32, 62, 150
 Portrait of Mrs. West with son Raphael 154, 162
 Self Portrait 154
 Self Portrait with Raphael West 154
 The Cricketeers 62
 Thomas Robinson 32
West, Raphael 154
West, William Edward 328-329
 George Noel Gordon, Lord Byron 328
 Lord Byron's Visit to the U.S.S. Constitution 328
Weyden, Rogier van der 19
Wharton E. and Parrish, M.
 Italian Villas and Their Gardens 444-445
Wharton, Edith 59-60, 256, 362, 444
Wheelock, M.J. 269
Whistler, James McNeill 392, 396, 406, 410
 A Canal in Venice (Tobacco Warehouse) 392-395
 At the Piano 360
 Calle San Trovaso, Venice 392-395
 Nocturne 391-392
 Note in Flesh Color: Giudecca 392, 395
 Palace in Rags 402
 Peacock Room 390
 Stormy Sunset 418
 The Lagoon, Venice: Nocturne in Blue and Silver 390-
 392
 Venetian Scene 392-395
Whitman, Sarah Wyman 364, 400, 402
Whitney, Anne 238, 240-242
 Chaldean Shepherd 238
 Lotus Eater 238
 Roma 238-240
 Samuel Adams 238
 Toussaint L'Ouverture 238
Whittredge, Worthington 45, 53, 64, 213, 229,
232, 260, 283, 288, 293, 302, 310

Wider, Wilhelm 50
Wight, Peter B. 124-125
Wild, Hamilton Gibbs 8, 438-439
 Wall of the Brownings' Villa 438-439
Wilde, Richard Henry 229
Williams, A.D. 310
Willis, Nathaniel Parker 45, 63, 261
Wilson, Charles Heath 347
Wilson, Richard 27, 30, 62, 232, 298, 310-311, 314
Winckelmann, Johann 31
Winged Psyche 266
Wint, Peter de 264
Witmer, Theodore B. 75
Wittel, Gaspar van 43, 193, 314
Wolf, Emil 67
Wood, Jacob 82-83, 92
Woods, Henry 413
Wordsworth 198
Wores, Theodore 49, 63, 436
World's Columbian Exposition, Chicago 61, 124,
240
Wouwermann, Philips 56
Wrestlers 34, 82
Wright of Derby, Joseph 156, 276, 298, 300, 310
Wright, Frank Lloyd 137
Wyatt, Matthew Cotes 86

Y
Yewell, George Henry 49, 229, 236
Young, Josephine 86, 93, 266
Young, Samuel 92
Yunkers, Adja 141

Z
Zadkine, Ossip 133
Ziem, Felix 122, 128, 420
Zmaragdus 205
Zoffany, Johann 34
Zorzi, A.P., Count 388
Zschokke, J.H.D. 441